CONTENTS

ART HISTORY
PORTABLE EDITION · THIRD EDITION

Eighteenth to Twenty-First Century

MARILYN STOKSTAD

Judith Harris Murphy Distinguished Professor of Art History Emerita
The University of Kansas

CONTRIBUTOR

Patrick Frank

PEARSON
Prentice
Hall

Upper Saddle River, NJ 07458

Editor-in-Chief: Sarah Touborg
Sponsoring Editor: Helen Ronan
Editorial Assistant: Christina DeCesare
Editor in Chief, Development: Rochelle Diogenes
Development Editors: Jeannine Ciliotta, Margaret Manos, Teresa Nemeth, and Carol Peters
Media Editor: Alison Lorber
Director of Marketing: Brandy Dawson
Executive Marketing Manager: Marissa Feliberty
AVP, Director of Production and Manufacturing: Barbara Kittle
Senior Managing Editor: Lisa Iarkowski
Production Editor: Barbara Taylor-Laino
Production Assistant: Marlene Gassler
Senior Operations Specialist: Brian K. Mackey
Operations Specialist: Cathleen Peterson
Creative Design Director: Leslie Osher
Art Director: Amy Rosen
Interior and Cover Design: Anne DeMarinis
Layout Artist: Gail Cocker-Bogusz
Line Art and Map Program Management: Gail Cocker-Bogusz, Maria Piper

Line Art Studio: Peter Bull Art Studio
Cartographer: DK Education, a division of Dorling Kindersley, Ltd.
Pearson Imaging Center: Corin Skidds, Greg Harrison, Robert Uibelhoer, Ron Walko, Shayle Keating, and Dennis Sheehan
Site Supervisor, Pearson Imaging Center: Joe Conti
Photo Research: Laurie Platt Winfrey, Fay Torres-Yap, Mary Teresa Giancoli, and Christian Peña, Carousel Research, Inc.
Director, Image Resource Center: Melinda Patelli
Manager, Rights and Permissions: Zina Arabia
Manager, Visual Research: Beth Brenzel
Manager, Cover Visual Research and Permissions: Karen Sanatar
Image Permission Coordinator: Debbie Latronica
Manager, Cover Research and Permissions: Gladys Soto
Copy Editor: Stephen Hopkins
Proofreaders: Faye Gemmellaro, Margaret Pinette, Nancy Stevenson, and Victoria Waters
Composition: Prepare, Inc.
Portable Edition Composition: Black Dot
Cover Printer: Phoenix Color Corporation
Printer/Binder: R. R. Donnelley

Maps designed and produced by DK Education, a division of Dorling Kindersley, Limited, 80 Strand London WC2R 0RL. DK and the DK logo are registered trademarks of Dorling Kindersley Limited.

Credits and acknowledgements borrowed from other sources and reproduced, with permission, in this textbook appear on the appropriate page within text or on the credit pages in the back of this book.

Cover Photo:
Dorothea Lange, *Migrant Mother, Nipomo, California.* February 1936. Gelatin-silver print. Photo: Library of Congress, Washington, D.C.

Copyright © 2009 by Pearson Education, Inc., Upper Saddle River, New Jersey, 07458. All rights reserved. Printed in the United States of America. This publication is protected by copyright, and permission should be obtained from the publisher prior to any prohibited reproduction, storage in a retrieval system, or transmission in any form or by any means, electronic, mechanical, photocopying, recording, or likewise. For information regarding permission(s), write to: Rights and Permissions Department.

Pearson Prentice Hall™ is a trademark of Pearson Education, Inc.
Pearson® is a registered trademark of Pearson plc
Prentice Hall® is a registered trademark of Pearson Education, Inc.

Pearson Education LTD.
Pearson Education Australia PTY, Limited
Pearson Education Singapore, Pte. Ltd
Pearson Education North Asia Ltd

Pearson Education, Canada, Ltd
Pearson Educación de Mexico, S.A. de C.V
Pearson Education—Japan
Pearson Education Malaysia, Pte. Ltd

10 9 8 7 6 5 4 3 2 1

ISBN 0-13-605409-9
ISBN 978-0-13-605409-2

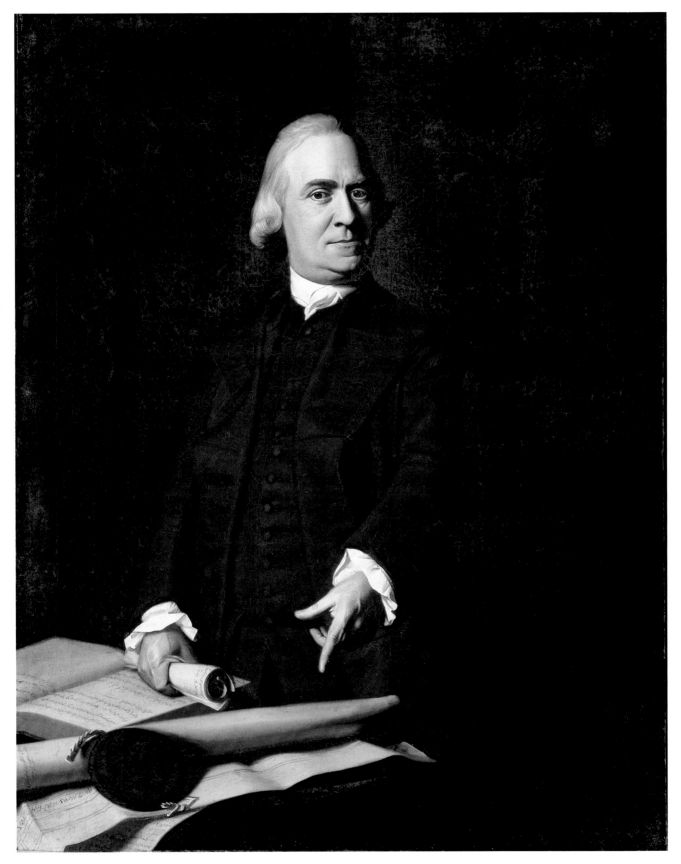

29–1 | John Singleton Copley **SAMUEL ADAMS** c. 1770-72. Oil on canvas, 50 × 40″ (127 × 102.2 cm).
Museum of Fine Arts, Boston.
Deposited by the City of Boston

CHAPTER TWENTY-NINE

EIGHTEENTH-CENTURY ART IN EUROPE AND THE AMERICAS

On March 5, 1770, a street fight broke out between several dozen residents of Boston and a squad of British soldiers. The British fired into the crowd, killing three men and wounding eight others, two of whom later died. Dubbed the Boston Massacre by anti-British patriots, the event was one of many that led to the Revolutionary War of 1775–83, which won independence from Britain for the thirteen American colonies.

The day after the Boston Massacre, Samuel Adams, a member of the Massachusetts legislature, demanded that the royal governor, Thomas Hutchinson, expel British troops from the city—a confrontation that Boston painter John Singleton Copley immortalized in oil paint (FIG. 29–1). Adams, conservatively dressed in a brown suit and waistcoat, stands before a table and looks sternly out at the viewer, who occupies the place of Governor Hutchinson. With his left hand, Adams points to the charter and seal granted to Massachu-

setts by King William and Queen Mary; in his right, he grasps a petition prepared by the aggrieved citizens of Boston.

The vivid realism of Copley's style makes the life-size figure of Adams seem almost to be standing before us. Adams's head and hands, dramatically lit, surge out of the darkness with a sense of immediacy appropriate to the urgency of his errand. The legislator's defiant stance and emphatic gesture convey the moral force of his demands, which are impelled not by emotion but by reason. The charter to which he points insists on the rule of law, and the faintly visible classical columns behind him connote republican virtue and rationality—important values of the Enlightenment, the major philosophical movement of eighteenth-century Europe as well as Colonial America. Enlightenment political philosophy provided the ideological basis for the American Revolution, which Adams ardently supported.

THE ENLIGHTENMENT AND ITS REVOLUTIONS

The eighteenth century marks a great divide in Western history. When the century opened, the West was still semifeudal economically and politically. Wealth and power were centered in an aristocratic elite, who owned or controlled the land worked by the largest and poorest class, the farmers. In between was a small middle class composed of doctors, lawyers, shopkeepers, artisans, and merchants—most of whom depended for their livelihood on the patronage of the rich. Only those involved in overseas trade operated outside the agrarian system, but even they aspired to membership in the landed aristocracy.

By the end of the century, the situation had changed dramatically. A new source of wealth—industrial manufacture—was then developing, and social visionaries expected industry not only to expand the middle class but also to provide a better material existence for all classes, an interest that extended beyond purely economic concerns. What became known as the Industrial Revolution was complemented by a revolution in politics, spurred by a new philosophy that conceived of all white men (some thinkers included women and racial or ethnic minorities) as deserving of equal rights and opportunities. The American Revolution of 1776 and the French Revolution of 1789 were the seismic results of this dramatically new concept.

Developments in politics and economics were themselves manifestations of a broader philosophical revolution: the Enlightenment. The Enlightenment was a radically new synthesis of ideas about humanity, reason, nature, and God that had arisen during classical Greek and Roman times and during the Renaissance. What distinguished the Enlightenment proper from its antecedents was the late seventeenth- and early eighteenth-century thinkers' generally optimistic view that humanity and its institutions could be reformed, if not perfected. Bernard de Fontenelle, a French popularizer of seventeenth-century scientific discoveries, writing in 1702, anticipated "a century which will become more enlightened day by day, so that all previous centuries will be lost in darkness by comparison." At the end of the seventeenth and beginning of the eighteenth century, such hopes were expressed by a handful of people; after 1740, the number and power of such voices grew, so that their views increasingly dominated every sphere of intellectual life, including that of the European courts. The most prominent and influential of these thinkers, called *philosophes* (to distinguish their practical concerns from the purely academic ones of philosophers), included Jean-Jacques Rousseau, Denis Diderot, Thomas Jefferson, Benjamin Franklin, and Immanuel Kant.

The philosophes and their supporters did not agree on all matters. Perhaps the matter that most unified these thinkers was the question of the purpose of humanity. Rejecting conventional notions that men and women were here to serve God or the ruling class, the philosophes insisted that humans were born to serve themselves, to pursue their own happiness and fulfillment. The purpose of the state, they agreed, was to facilitate this pursuit. Despite the pessimism of some and the reservations of others, Enlightenment thinkers were generally optimistic that men and women, when set free from their political and religious shackles, could be expected to act both rationally and morally. Thus, in pursuing their own happiness, they would promote the happiness of others.

The new emphasis on rationality proceeded in part from new mathematical and scientific discoveries by such thinkers as René Descartes, Gottfried Wilhelm von Leibnitz, Blaise Pascal, and, perhaps most significantly, Isaac Newton. Newton brought a new emphasis on empirical proof to his scientific studies and rejected the supernatural realm as a basis for theory. Fellow Englishman John Locke transferred this empiricism to his consideration of human society, concluding that ideas and behavior are not inborn or predetermined by God but rather the result of perception and experience. Each individual was born a blank slate with certain basic rights that a government was obligated to protect.

Thus, most Enlightenment thinkers saw nature as both rational and good. The natural world, whether a pure mecha-

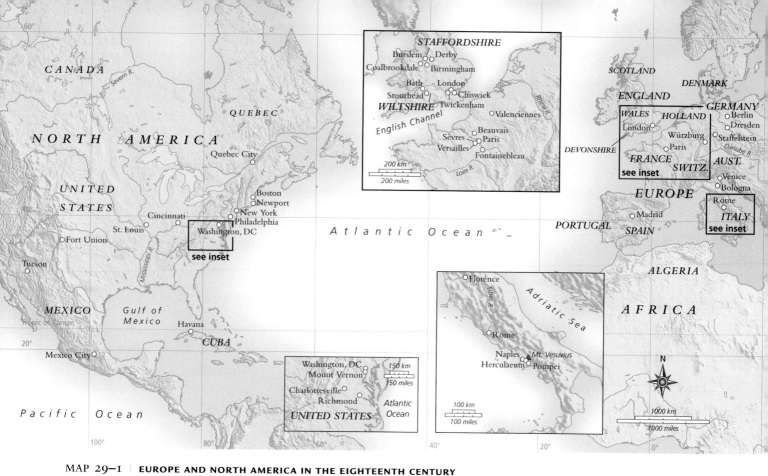

MAP 29–1 | **EUROPE AND NORTH AMERICA IN THE EIGHTEENTH CENTURY**

During the eighteenth century, three major artistic styles—Rococo, Neoclassicism, and Romanticism—flourished in Europe and North America.

nism or the creation of a beneficent deity, was amenable to human understanding and, therefore, control. Once the laws governing the natural and human realms were determined, they could be harnessed for our greater happiness. From this concept flowed the inextricably intertwined industrial and political revolutions that marked the end of the century. Before the Enlightenment took hold, however, most of aristocratic Europe had a fling with the art style known as Rococo, a sensuous variation on the preceding Baroque.

THE ROCOCO STYLE IN EUROPE

The term *Rococo* was coined by critics who combined the Portuguese word *barroco* (which refers to an irregularly shaped pearl and may be the source of the word *baroque*) and the French word *rocaille* (the artificial shell or rock ornament popular for gardens) to describe the refined, fanciful, and often playful style that became fashionable in France at the end of the seventeenth century and spread throughout Europe in the eighteenth century. This was the favored style of an aristocracy that devoted itself to the enjoyment of superficial pleasures, including witty conversation, cultivated artifice, and playful sensuality. The Rococo style is characterized by pastel colors, delicately curving forms, dainty figures, and a lighthearted mood. It may be seen partly as a reaction at all levels of society, even among kings and bishops, against the art identified with the formality and rigidity of seventeenth-century court life. The movement began in French architectural decoration at the end of Louis XIV's reign (ruled 1643–1715) and quickly spread across Europe (MAP 29–1). The Duke of Orléans, regent for the boy-king Louis XV (ruled 1715–74), made his home in Paris, and the rest of the court—delighted to escape the palace at Versailles—also moved there and built elegant town houses (in French, *hôtel*), whose smaller rooms dictated new designs for layout, furniture, and décor. They became the lavish settings for intimate and fashionable intellectual gatherings and entertainments, called **salons**, that were hosted by accomplished, educated women of the upper class whose names are still known today—Mesdames de Staël, de La Fayette, de Sévigné, and du Châtelet being among the most familiar. The **SALON DE LA PRINCESSE** in **THE HÔTEL DE SOUBISE** in Paris (FIG. 29–2), designed by Germain Boffrand (1667–1754) beginning in 1732, is typical of the delicacy and lightness seen in French Rococo hôtel design during the 1730s.

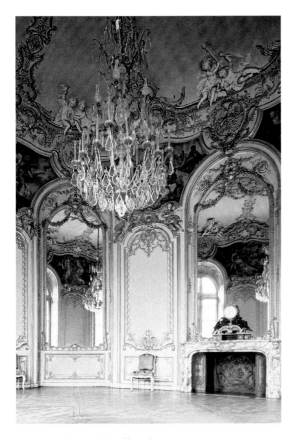

29–2 | Germain Boffrand **SALON DE LA PRINCESSE, HÔTEL DE SOUBISE**
Paris, France. Begun 1732.
Library, Getty Research, Institute, Los Angeles.
Wim Swaan Photograph Collection (96, p.21)

29–3 | Johann Balthasar Neumann
KAISERSAAL (IMPERIAL HALL), RESIDENZ, WÜRZBURG
Bavaria, Germany. 1719-44.
Fresco by Giovanni Battista Tiepolo. 1751-52
(SEE FIG. 29-4).

Typical Rococo elements in architectural decoration were **arabesques** (characterized by flowing lines and swirling shapes), S-shapes, C-shapes, reverse–C-shapes, volutes, and naturalistic plant forms. The glitter of silver or gold against expanses of white or pastel color, the visual confusion of mirror reflections, delicate ornament in sculpted stucco, carved wood panels called *boiseries*, and inlaid wood designs on furniture and floors were all part of the new look. In residential settings, pictorial themes were often taken from classical love stories, and sculpted ornaments were rarely devoid of *putti*, cupids, and clouds.

Architecture and Its Decoration in Germany and Austria

After the end of the War of the Spanish Succession in 1714, rulers in central Europe felt the need to replace damaged buildings and display their power and wealth more impressively. Interior designs for some of these new palaces and churches, though based on traditional Baroque plans, were also animated by the Rococo spirit, especially in Germany and Austria. In occasional small-scale buildings, the Rococo style was successfully applied to architectural planning as well.

THE RESIDENZ AT WÜRZBURG. The first major architectural project influenced by the new Rococo style was the Resi-

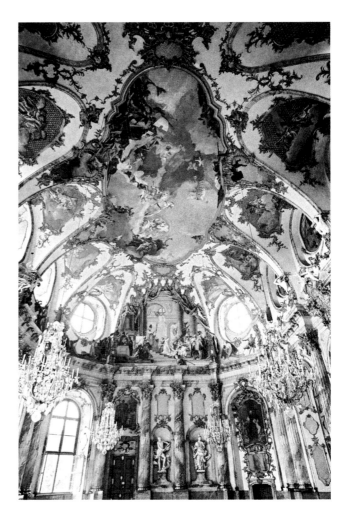

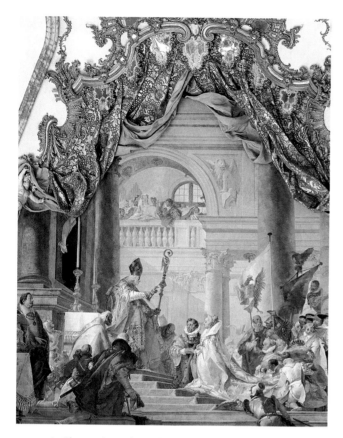

29–4 Giovanni Battista Tiepolo **THE MARRIAGE OF THE EMPEROR FREDERICK AND BEATRICE OF BURGUNDY**
Fresco in the Kaisersaal (Imperial Hall), Residenz. Würzburg, Germany. 1751-52.

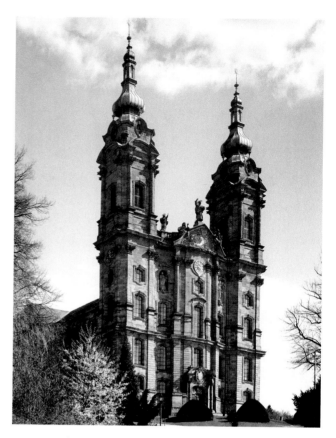

29–5 Johann Balthasar Neumann **CHURCH OF THE VIERZEHNHEILIGEN**
Near Staffelstein, Germany. 1743-72.

denz, a splendid palace that Johann Balthasar Neumann (1687–1753) designed for the prince-bishop of Würzburg from 1719 to 1744. The oval **KAISERSAAL,** or Imperial Hall (**FIG. 29–3**), illustrates Neumann's great triumph in planning and decoration. Although the clarity of the plan, the size and proportions of the marble columns, and the large windows recall the Hall of Mirrors at Versailles (SEE FIG. 19–23), the decoration of the Kaisersaal, with its white-and-gold color scheme and its profusion of delicately curved forms, embodies the Rococo spirit. Here we see the earliest development of Neumann's aesthetic of interior design that culminated in his final project, the Church of the Vierzehnheiligen (Fourteen Auxiliary Saints) near Staffelstein (SEE FIG. 29–7).

Neumann's collaborator on the Residenz was the Venetian painter Giovanni Battista Tiepolo (1696–1770), who began to work there in 1750. Venice by the early eighteenth century had surpassed Rome as an artistic center, and Tiepolo gained international acclaim for his confident and optimistic expression of the illusionistic fresco painting pioneered by sixteenth-century Venetians such as Veronese (SEE PAGE 700). Tiepolo filled the niches in the Kaisersaal with frescoes—three scenes glorifying the twelfth-century crusader-emperor Frederick Barbarossa, who had been an early patron of the bishop of Würzburg—in a superb example of his architectural painting. **THE MARRIAGE OF THE EMPEROR FREDERICK**

AND BEATRICE OF BURGUNDY (FIG. 29–4) is presented as if it were theater, with painted and gilded stucco curtains drawn back to reveal the sumptuous costumes and splendid setting of an imperial wedding. Like Veronese's grand conceptions, Tiepolo's spectacle is populated with an assortment of character types, presented in dazzling light and sun-drenched colors with the assured hand of a virtuoso. Against the opulence of their surroundings, these heroic figures behave with the utmost decorum and, the artist suggests, nobility of purpose. The pale colors and elaborately cascading draperies they wear foreshadow the emerging Rococo style.

ROCOCO CHURCH DECORATION. Rococo decoration in Germany was as often religious as secular. One of the many opulent Rococo churches still standing in Germany and Austria is that of the **CHURCH OF THE VIERZEHNHEILIGEN,** or "Fourteen Auxiliary Saints" (FIG. 29–5), which Neumann began in 1743. The exterior shows an early Rococo style, with its gently bulging central pavilion and delicately arched windows. The façade offers only a foretaste of the overall plan (FIG. 29–6), which is based on six interpenetrating oval spaces of varying sizes around a domed ovoid center. The plan recalls Borromini's Baroque design of the Church of San Carlo alle Quattro Fontane (SEE FIG. 22–10), but surpasses it in airy lightness. On the interior of the nave (FIG. 29–7), the Rococo love of undu-

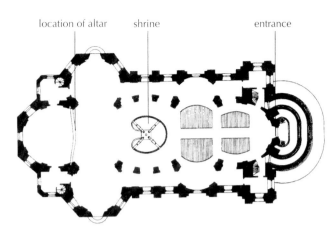

29–6 | **PLAN OF THE CHURCH OF THE VIERZEHNHEILIGEN**
c. 1743.

location of altar shrine entrance

lating surfaces with overlays of decoration creates a visionary world where flat wall surfaces scarcely exist. Instead, the viewer is surrounded by clusters of pilasters and engaged columns interspersed with two levels of arched openings to the side aisles and large clerestory windows illuminating the gold and white of the interior. The foliage of the fanciful capitals is repeated in arabesques, wreaths, and the ornamented frames of the irregular panels that line the vault. What Neumann had begun in the Kaisersaal at Würzburg he brought to full fruition here in the ebullient sense of spiritual uplift achieved by the complete integration of architecture and decoration.

Rococo Painting and Sculpture in France

The death of the Sun King in 1715 brought important changes to French court life, and to art. The formality and seriousness that Louis XIV encouraged gave way to an increased devotion to pleasure, frivolity, and sensuality. As nobles forsook Versailles for pleasure palaces in the city such as the Hôtel de Soubise, artists decorated their salons with works that moved away from Academic precedent into realms redolent with casualness and fantasy. The Rococo style of painting and sculpture that French artists created reverberated across Europe until the rise of Neoclassicism in the 1760s brought Greece and Rome back in favor.

WATTEAU. The originator of the French Rococo style in painting, Jean-Antoine Watteau (1684–1721), was also its greatest exponent. Born in the provincial town of Valenciennes, Watteau around 1702 came to Paris, where he studied Rubens's Medici cycle (SEE FIG. 22–36), then displayed in the Luxembourg Palace, and the paintings and drawings of sixteenth-century Venetians such as Giorgione (SEE FIG. 20–23), which he saw in a Parisian private collection. After perfecting a graceful personal style informed by the fluent brushwork and rich colors of Rubens and the Venetians, Watteau created a new type of painting when he submitted his official examination canvas, **PILGRIMAGE TO THE ISLAND OF CYTHERA**

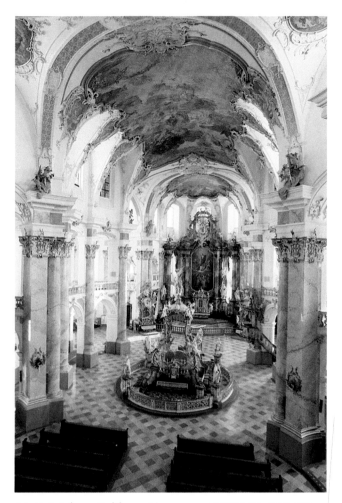

29–7 | Johann Balthasar Neumann **INTERIOR, CHURCH OF THE VIERZEHNHEILIGEN**
1743–72.

In the center of the nave of the Church of the Vierzehnheiligen (Fourteen Auxiliary Saints), an elaborate shrine was built over the spot where, in the fifteenth century, a shepherd had visions of the Christ Child surrounded by saints. The saints came to be known as the Holy Helpers because they assisted people in need.

(FIG. 29–8), for admission to membership in the Royal Academy of Painting and Sculpture in 1717 (see "Academies and Academy Exhibitions," page 948). The work so impressed the academicians that they created a new category of subject matter to accommodate it: the *fête galante,* or elegant outdoor entertainment. Watteau's painting depicts a dream world in which beautifully dressed couples, accompanied by *putti,* conclude their day's romantic adventures on the mythical island of love sacred to Venus, whose garlanded statue appears at the extreme right. The verdant landscape would never soil the characters' exquisite satins and velvets, nor would a summer shower ever threaten them. This kind of idyllic vision, with its overtones of wistful melancholy, had a powerful attraction in early eighteenth-century Paris and soon charmed most of Europe.

Tragically, Watteau died from tuberculosis when still in his thirties. During his final illness, while staying with the art dealer Edme-François Gersaint, he painted a signboard for Gersaint's shop (FIG. 29–9). The dealer later wrote that

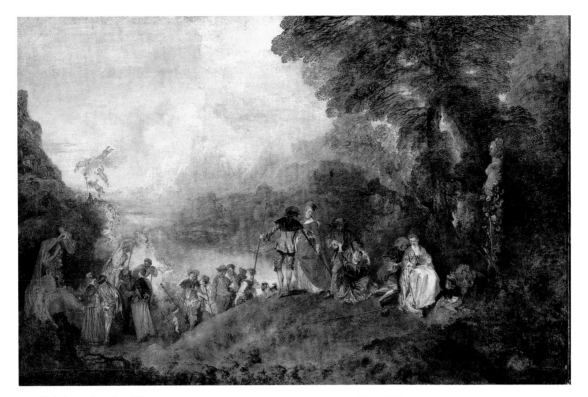

29–8 | Jean-Antoine Watteau **PILGRIMAGE TO THE ISLAND OF CYTHERA**
1717. Oil on canvas, 4'3" × 6'4½" (1.3 × 1.9 m). Musée du Louvre, Paris.

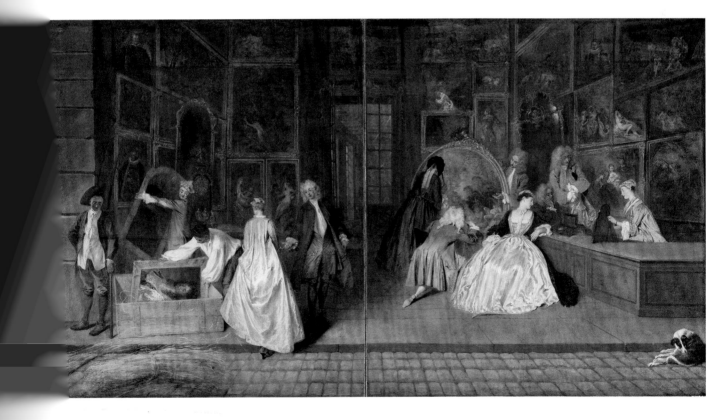

29–9 | Jean-Antoine Watteau **THE SIGNBOARD OF GERSAINT**
c. 1721. Oil on canvas, 5'4" × 10'1" (1.62 × 3.06 m). Stiftung Preussische Schlössen und Gärten
Berlin-Brandenburg, Schloss Charlottenburg.

Watteau's signboard painting was designed for the Paris art gallery of Edme-François Gersaint, who introduced to France
the English idea of selling paintings by catalogue. The systematic listing of works for sale gave the name of the artist and the
title, the medium, and the dimensions of each work of art. The shop depicted on the signboard is not Gersaint's but an
ideal gallery visited by elegant and cultivated patrons. The sign was so admired that Gersaint sold it only fifteen days after it
was installed. Later it was cut down the middle and each half was framed separately, which resulted in the loss of some can-
vas along the sides of each section. The painting was restored and its two halves reunited in the twentieth century.

Defining Art
ACADEMIES AND ACADEMY EXHIBITIONS

During the seventeenth century, the French government founded a number of royal **academies** for the support and instruction of students in literature, painting and sculpture, music and dance, and architecture. In 1664, the Royal Academy of Painting and Sculpture began to mount occasional exhibitions of their members' recent work. These exhibitions came to be known as **Salons** because for much of the eighteenth century they were held in the Salon Carré in the Palace of the Louvre. Beginning in 1737, the Salons were held every other year, with a jury of members selecting the works to be shown. Illustrated here is a view of the Salon of 1787, with its typical floor-to-ceiling hanging of paintings. As the only public art exhibitions of any importance in Paris, the Salons were enormously influential in establishing officially approved styles and in molding public taste, and they helped consolidate the Royal Academy's dictatorial control over the production of art.

Among the most influential ideas promoted by the academy was that **history painting** (based on historical, mythological, or biblical narratives and generally conveying a high moral or intellectual idea) was the most important form of pictorial art, followed in prestige by landscape painting, portraiture, genre painting, and still life. As a result, most ambitious French artists of the later seventeenth and eighteenth centuries sought recognition as history painters, and devoted considerable effort to the creation of large-scale history paintings for the Salon. Several examples are visible in the upper registers of the illustrated view of the Salon of 1787, although the painting at the center is a portrait—Élisabeth Vigée-Lebrun's *Portrait of Marie Antoinette and Her Children* (SEE FIG. 29–38), doubtless given pride of place because it depicts members of the royal family.

In recognition of the importance of Rome as a training ground for artists—especially those aspiring to master history painting, which often treated subjects from ancient history or mythology—the French Royal Academy of Painting and Sculpture opened a branch there in 1666. The competitive Prix de Rome, or Rome Prize, was also established, which permitted the winners to study in Rome for three to five years. A similar prize was established by the French Royal Academy of Architecture in 1720.

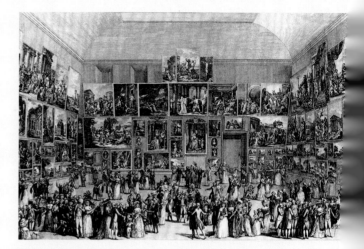

Piero Antonio Martini **THE SALON OF 1787**
1787. Engraving.

Many Western cultural capitals emulated the French model and opened academies of their own. Academies were established in Berlin in 1696, Dresden in 1705, London in 1768, Boston in 1780, Mexico City in 1785, and New York in 1802.

In France, the Revolution of 1789 brought a number of changes to the Royal Academy. In 1791, the jury system was abolished as a relic of the monarchy, and the Salon was democratically opened to all artists. In 1793, all of the royal academies were disbanded and, in 1795, reconstituted as the newly founded Institut de France, which was to administer the art school—the École des Beaux-Arts—and sponsor the Salon exhibitions. The number of would-be exhibitors was soon so large that it became necessary to reintroduce some screening procedure, and so the jury system was revived. In 1816, with the restoration of the monarchy following the defeat of Napoleon, the division of the Institut de France dedicated to painting and sculpture was renamed the Académie des Beaux-Arts, and thus the old academy was in effect restored.

Watteau had completed the painting in eight days, working only in the mornings because of his failing health. When the sign was installed, it was greeted with almost universal admiration, and Gersaint sold it shortly afterward.

The painting shows an art gallery filled with paintings from the Venetian and Netherlandish schools that Watteau admired. Indeed, the glowing satins and silks of the women's gowns pay homage to artists such as Gerard Ter Borch (SEE FIG. 22–51). The visitors to the gallery are elegant ladies and gentlemen, at ease in these surroundings and apparently

knowledgeable about paintings. Thus, they create an atmosphere of aristocratic sophistication. At the left, a woman shimmering pink satin steps across the threshold, ignoring her companion's outstretched hand to look at the two porte packing. While one holds a mirror, the other carefully lowe into the wooden case a portrait of Louis XIV, which may a reference to the name of Gersaint's shop, Au Gra Monarque ("At the Sign of the Great King"). It also sugge the passage of time, for Louis had died six years earlier. Otl elements in the work also gently suggest transience. On

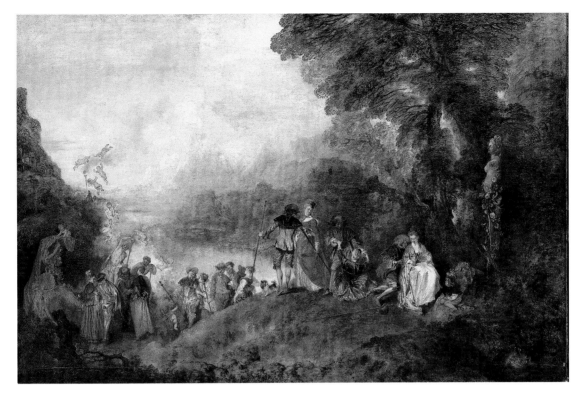

29–8 | Jean-Antoine Watteau **PILGRIMAGE TO THE ISLAND OF CYTHERA**
1717. Oil on canvas, 4'3" × 6'4½" (1.3 × 1.9 m). Musée du Louvre, Paris.

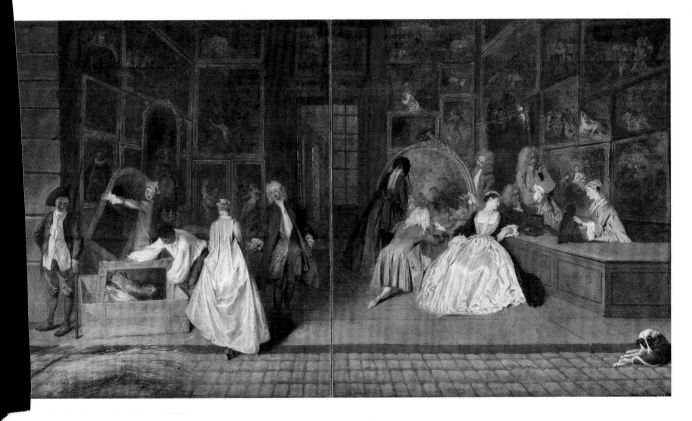

29–9 | Jean-Antoine Watteau **THE SIGNBOARD OF GERSAINT**
c. 1721. Oil on canvas, 5'4" × 10'1" (1.62 × 3.06 m). Stiftung Preussische Schlössen und Gärten
Berlin-Brandenburg, Schloss Charlottenburg.

Watteau's signboard painting was designed for the Paris art gallery of Edme-François Gersaint, who introduced to France
the English idea of selling paintings by catalogue. The systematic listing of works for sale gave the name of the artist and the
title, the medium, and the dimensions of each work of art. The shop depicted on the signboard is not Gersaint's but an
ideal gallery visited by elegant and cultivated patrons. The sign was so admired that Gersaint sold it only fifteen days after it
was installed. Later it was cut down the middle and each half was framed separately, which resulted in the loss of some can-
vas along the sides of each section. The painting was restored and its two halves reunited in the twentieth century.

Defining Art
ACADEMIES AND ACADEMY EXHIBITIONS

During the seventeenth century, the French government founded a number of royal **academies** for the support and instruction of students in literature, painting and sculpture, music and dance, and architecture. In 1664, the Royal Academy of Painting and Sculpture began to mount occasional exhibitions of their members' recent work. These exhibitions came to be known as **Salons** because for much of the eighteenth century they were held in the Salon Carré in the Palace of the Louvre. Beginning in 1737, the Salons were held every other year, with a jury of members selecting the works to be shown. Illustrated here is a view of the Salon of 1787, with its typical floor-to-ceiling hanging of paintings. As the only public art exhibitions of any importance in Paris, the Salons were enormously influential in establishing officially approved styles and in molding public taste, and they helped consolidate the Royal Academy's dictatorial control over the production of art.

Among the most influential ideas promoted by the academy was that **history painting** (based on historical, mythological, or biblical narratives and generally conveying a high moral or intellectual idea) was the most important form of pictorial art, followed in prestige by landscape painting, portraiture, genre painting, and still life. As a result, most ambitious French artists of the later seventeenth and eighteenth centuries sought recognition as history painters, and devoted considerable effort to the creation of large-scale history paintings for the Salon. Several examples are visible in the upper registers of the illustrated view of the Salon of 1787, although the painting at the center is a portrait—Élisabeth Vigée-Lebrun's *Portrait of Marie Antoinette and Her Children* (SEE FIG. 29–38), doubtless given pride of place because it depicts members of the royal family.

In recognition of the importance of Rome as a training ground for artists—especially those aspiring to master history painting, which often treated subjects from ancient history or mythology—the French Royal Academy of Painting and Sculpture opened a branch there in 1666. The competitive Prix de Rome, or Rome Prize, was also established, which permitted the winners to study in Rome for three to five years. A similar prize was established by the French Royal Academy of Architecture in 1720.

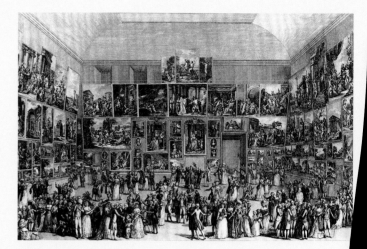

Piero Antonio Martini **THE SALON OF 1787**
1787. Engraving.

Many Western cultural capitals emulated the French model and opened academies of their own. Academies were established in Berlin in 1696, Dresden in 1705, London in 1768, Boston in 1780, Mexico City in 1785, and New York in 1802.

In France, the Revolution of 1789 brought a number of changes to the Royal Academy. In 1791, the jury system was abolished as a relic of the monarchy, and the Salon was democratically opened to all artists. In 1793, all of the royal academies were disbanded and, in 1795, reconstituted as the newly founded Institut de France, which was to administer the art school—the École des Beaux-Arts—and sponsor the Salon exhibitions. The number of would-be exhibitors was soon so large that it became necessary to reintroduce some screening procedure, and so the jury system was revived. In 1816, with the restoration of the monarchy following the defeat of Napoleon, the division of the Institut de France dedicated to painting and sculpture was renamed the Académie des Beaux-Arts, and thus the old academy was in effect restored.

Watteau had completed the painting in eight days, working only in the mornings because of his failing health. When the sign was installed, it was greeted with almost universal admiration, and Gersaint sold it shortly afterward.

The painting shows an art gallery filled with paintings from the Venetian and Netherlandish schools that Watteau admired. Indeed, the glowing satins and silks of the women's gowns pay homage to artists such as Gerard Ter Borch (SEE FIG. 22–51). The visitors to the gallery are elegant ladies and gentlemen, at ease in these surroundings and apparently

knowledgeable about paintings. Thus, they create an atmosphere of aristocratic sophistication. At the left, a woman in shimmering pink satin steps across the threshold, ignoring her companion's outstretched hand to look at the two porters packing. While one holds a mirror, the other carefully lowers into the wooden case a portrait of Louis XIV, which may be a reference to the name of Gersaint's shop, Au Grand Monarque ("At the Sign of the Great King"). It also suggests the passage of time, for Louis had died six years earlier. Other elements in the work also gently suggest transience. On the

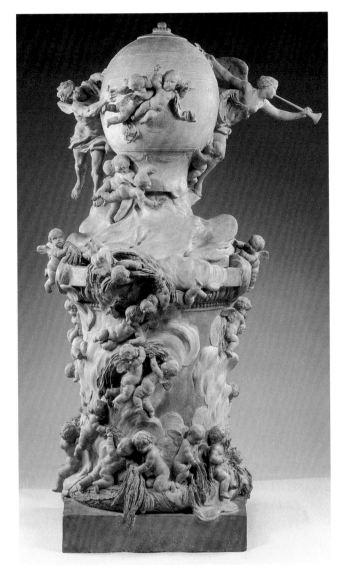

29–12 | Clodion **THE INVENTION OF THE BALLOON**
1784. Terra-cotta model for a monument, height 43½"
(110.5 cm). The Metropolitan Museum of Art, New York.
Rogers Fund and Frederick R. Harris Gift, 1944 (44.21a b)

Clodion had a long career as a sculptor in the exuberant, Rococo
manner seen in this work commemorating the 1783 invention of the
hot-air balloon. During the austere revolutionary period of the First
Republic (1792-95), he became one of the few Rococo artists to
adopt successfully the more acceptable Neoclassical manner. In
1806, he was commissioned by Napoleon to provide the relief
sculpture for two Paris monuments, the Vendôme Column and the
Carrousel Arch near the Louvre.

ter, bright colors, and lush painting style typify the Rococo.
Fragonard lived for more than thirty years after completing
this work, long enough to see the Rococo lose its relevance
in the newly complicated world of revolutionary France.

CLODION. In the last quarter of the eighteenth century,
French art generally moved away from the Rococo style and
toward Neoclassicism. But one sculptor who clung to
Rococo up to the threshold of the French Revolution in
1789 was Claude Michel, known as Clodion (1738–1814).
His major output consisted of playful, erotic tabletop sculp-
ture, mainly in uncolored terra cotta. Typical of Clodion's
Rococo designs is the terra-cotta model he submitted to win
a 1784 royal commission for a large monument to the inven-
tion of the hot-air balloon (FIG. 29–12). Although Clodion's
enchanting piece may today seem inappropriate to com-
memorate a technological achievement, hot-air balloons then
were elaborately decorated with painted Rococo scenes, gold
braid, and tassels. Clodion's balloon, decorated with bands of
classical ornament, rises from a columnar launching pad in
billowing clouds of smoke, assisted at the left by a puffing
wind god with butterfly wings and heralded at the right by a
trumpeting Victory. A few *putti* stoke the fire basket that pro-
_____ on which the balloon ascended as others
_____ up toward them.

Stockholm.

THE ROCOCO STYLE IN EUROPE

Art and Its Context
WOMEN AND ACADEMIES

Although several women were made members of the European academies of art before the eighteenth century, their inclusion amounted to little more than honorary recognition of their achievements. In France, Louis XIV had proclaimed in the founding address of the Royal Academy that its intention was to reward all worthy artists, "without regard to the difference of sex," but this resolve was not put into practice. Only seven women gained the title of Academician between 1648 and 1706, the year the Royal Academy declared itself closed to women. Nevertheless, four more women had been admitted to the cademy by 1770, when the men became worried that women members would become "too numerous," and declared four women members to be the limit at any one time. Young women were not admitted to the academy school nor allowed to compete for academy prizes, both of which were nearly indispensable for professional success.

Women fared even worse at London's Royal Academy. After the Swiss painters Mary Moser and Angelica Kauffmann were named as founding members in 1768, no other women were elected until 1922, and then only as associates. Johann Zoffany's 1771-72 portrait of the London academicians shows the men grouped around a male nude model, along with the academy's study collection of classical statues and plaster copies. Propriety prohibited the presence of women in this setting (women were not allowed to see or work from the male nude), so Zoffany painted Moser's and Kauffmann's portraits on the wall. In more formal portraits of the academy, however, the two women were included.

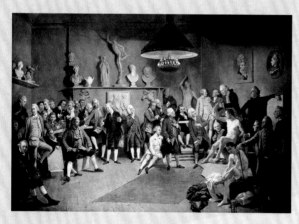

Johann Zoffany **ACADEMICIANS OF THE ROYAL ACADEMY**
1771-72. Oil on canvas, 47½ × 59½" (120.6 × 151.2 cm). The Royal Collection, Windsor Castle, Windsor, England.

or woman began in Paris, moved on to southern France to visit a number of well-preserved Roman buildings and monuments there, then headed to Venice, Florence, Naples, and Rome. As repository of the classical and the Renaissance pasts, Italy was the focus of the Grand Tour and provided inspiration for the most characteristic style to prevail during the Enlightenment, Neoclassicism. Neoclassicism (*neo* means "new") presents classical subject matter—mythological or historical—in a style derived from classical Greek and Roman sources. While some Neoclassical art was conceived to please the senses, most of it was intended to teach moral lessons. In its didactic manifestations—usually history paintings—Neoclassicism was an important means for conveying Enlightenment ideals such as courage and patriotism. It arose, in part, in reaction to the perceived frivolity and excess of the Rococo. Most Enlightenment thinkers held Greece and Rome in high regard as fonts of democracy and secular government, and the Neoclassical artists likewise revived classical stories and styles in an effort to instill those virtues.

Beginning in 1738, extraordinary archaeological discoveries made at two sites near Naples also excited renewed interest in classical art and artifacts. Herculaneum and Pompeii, two prosperous Roman towns buried in 79 CE by the sudden volcanic eruption of Mount Vesuvius, offered sensational new material for study and speculation. Numerous illustrated books on these discoveries circulated throughout Europe and America, fueling public fascination with the ancient world and contributing to a taste for the Neoclassical style.

Italian Portraits and Views

Most educated Europeans regarded Italy as the wellspring of Western culture, where Roman and Renaissance art flourished in the past and a great many artists still practiced. The studios of important Italian artists were required stops on the Grand Tour, and collectors avidly bought portraits and landscapes that could boast an Italian connection.

CARRIERA. Wealthy northern European visitors to Italy often sat for portraits by Italian artists. Rosalba Carriera (1675–1757), the leading portraitist in Venice during the first half of the eighteenth century, began her career designing lace patterns and painting miniature portraits on the ivory lids of snuffboxes. By the early eighteenth century she was making portraits with **pastels**, crayons of pulverized pigment bound to a chalk base by weak gum water. A versatile medium, pastel can be employed in a sketchy manner to create a vivacious and fleeting effect or can be blended through rubbing to produce a highly finished image. Carriera's pastels earned her honorary membership in Rome's Academy of Saint Luke in 1705, and she later was admitted to the academies in Bologna and Florence. In 1720 she traveled to Paris, where she made a pastel portrait of the young Louis XV and was elected to the Royal Academy of Painting and Sculpture,

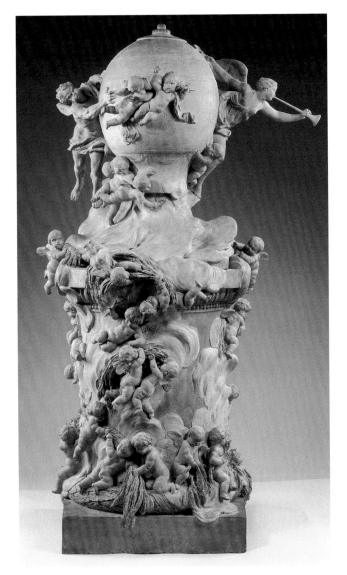

29–12 | Clodion **THE INVENTION OF THE BALLOON**
1784. Terra-cotta model for a monument, height 43½"
(110.5 cm). The Metropolitan Museum of Art, New York.
Rogers Fund and Frederick R. Harris Gift, 1944 (44.21a b)

Clodion had a long career as a sculptor in the exuberant, Rococo
manner seen in this work commemorating the 1783 invention of the
hot-air balloon. During the austere revolutionary period of the First
Republic (1792–95), he became one of the few Rococo artists to
adopt successfully the more acceptable Neoclassical manner. In
1806, he was commissioned by Napoleon to provide the relief
sculpture for two Paris monuments, the Vendôme Column and the
Carrousel Arch near the Louvre.

Fragonard produced fourteen canvases commissioned
around 1771 by Madame du Barry, Louis XV's last mistress,
to decorate her château. These marvelously free and seem-
ingly spontaneous visions of lovers explode in color and lux-
uriant vegetation. **THE MEETING** (FIG. 29–11) shows a secret
encounter between a young man and his sweetheart, who
looks anxiously over her shoulder to be sure she has not been
followed, and clutches the letter that arranged the tryst. The
rapid brushwork that distinguishes Fragonard's technique is at
its freest and most lavish here. The entertaining subject mat-

ter, bright colors, and lush painting style typify the Rococo.
Fragonard lived for more than thirty years after completing
this work, long enough to see the Rococo lose its relevance
in the newly complicated world of revolutionary France.

CLODION. In the last quarter of the eighteenth century,
French art generally moved away from the Rococo style and
toward Neoclassicism. But one sculptor who clung to
Rococo up to the threshold of the French Revolution in
1789 was Claude Michel, known as Clodion (1738–1814).
His major output consisted of playful, erotic tabletop sculp-
ture, mainly in uncolored terra cotta. Typical of Clodion's
Rococo designs is the terra-cotta model he submitted to win
a 1784 royal commission for a large monument to the inven-
tion of the hot-air balloon (FIG. 29–12). Although Clodion's
enchanting piece may today seem inappropriate to com-
memorate a technological achievement, hot-air balloons then
were elaborately decorated with painted Rococo scenes, gold
braid, and tassels. Clodion's balloon, decorated with bands of
classical ornament, rises from a columnar launching pad in
billowing clouds of smoke, assisted at the left by a puffing
wind god with butterfly wings and heralded at the right by a
trumpeting Victory. A few *putti* stoke the fire basket that pro-
vided the hot air on which the balloon ascended as others
gather reeds for fuel and fly up toward them.

ITALY AND THE CLASSICAL REVIVAL

From the late 1600s until well into the nineteenth century, the
education of a wealthy young northern European or Ameri-
can gentleman—and increasingly over that period, gentle-
woman—was completed on the **Grand Tour**, a prolonged
visit to the major cultural sites of southern Europe. Accompa-
nied by a tutor and an entourage of servants, the young man

WOMEN AND ACADEMIES

Although several women were made members of the European academies of art before the eighteenth century, their inclusion amounted to little more than honorary recognition of their achievements. In France, Louis XIV had proclaimed in the founding address of the Royal Academy that its intention was to reward all worthy artists, "without regard to the difference of sex," but this resolve was not put into practice. Only seven women gained the title of Academician between 1648 and 1706, the year the Royal Academy declared itself closed to women. Nevertheless, four more women had been admitted to the cademy by 1770, when the men became worried that women members would become "too numerous," and declared four women members to be the limit at any one time. Young women were not admitted to the academy school nor allowed to compete for academy prizes, both of which were nearly indispensable for professional success.

Women fared even worse at London's Royal Academy. After the Swiss painters Mary Moser and Angelica Kauffmann were named as founding members in 1768, no other women were elected until 1922, and then only as associates. Johann Zoffany's 1771–72 portrait of the London academicians shows the men grouped around a male nude model, along with the academy's study collection of classical statues and plaster copies. Propriety prohibited the presence of women in this setting (women were not allowed to see or work from the male nude), so Zoffany painted Moser's and Kauffmann's portraits on the wall. In more formal portraits of the academy, however, the two women were included.

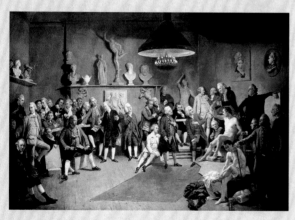

Johann Zoffany **ACADEMICIANS OF THE ROYAL ACADEMY**
1771–72. Oil on canvas, 47½ × 59½"
(120.6 × 151.2 cm). The Royal Collection, Windsor Castle, Windsor, England.

or woman began in Paris, moved on to southern France to visit a number of well-preserved Roman buildings and monuments there, then headed to Venice, Florence, Naples, and Rome. As repository of the classical and the Renaissance pasts, Italy was the focus of the Grand Tour and provided inspiration for the most characteristic style to prevail during the Enlightenment, Neoclassicism. Neoclassicism (*neo* means "new") presents classical subject matter—mythological or historical—in a style derived from classical Greek and Roman sources. While some Neoclassical art was conceived to please the senses, most of it was intended to teach moral lessons. In its didactic manifestations—usually history paintings—Neoclassicism was an important means for conveying Enlightenment ideals such as courage and patriotism. It arose, in part, in reaction to the perceived frivolity and excess of the Rococo. Most Enlightenment thinkers held Greece and Rome in high regard as fonts of democracy and secular government, and the Neoclassical artists likewise revived classical stories and styles in an effort to instill those virtues.

Beginning in 1738, extraordinary archaeological discoveries made at two sites near Naples also excited renewed interest in classical art and artifacts. Herculaneum and Pompeii, two prosperous Roman towns buried in 79 CE by the sudden volcanic eruption of Mount Vesuvius, offered sensational new material for study and speculation. Numerous illustrated books on these discoveries circulated throughout Europe and America, fueling public fascination with the ancient world and contributing to a taste for the Neoclassical style.

Italian Portraits and Views

Most educated Europeans regarded Italy as the wellspring of Western culture, where Roman and Renaissance art flourished in the past and a great many artists still practiced. The studios of important Italian artists were required stops on the Grand Tour, and collectors avidly bought portraits and landscapes that could boast an Italian connection.

CARRIERA. Wealthy northern European visitors to Italy often sat for portraits by Italian artists. Rosalba Carriera (1675–1757), the leading portraitist in Venice during the first half of the eighteenth century, began her career designing lace patterns and painting miniature portraits on the ivory lids of snuffboxes. By the early eighteenth century she was making portraits with **pastels**, crayons of pulverized pigment bound to a chalk base by weak gum water. A versatile medium, pastel can be employed in a sketchy manner to create a vivacious and fleeting effect or can be blended through rubbing to produce a highly finished image. Carriera's pastels earned her honorary membership in Rome's Academy of Saint Luke in 1705, and she later was admitted to the academies in Bologna and Florence. In 1720 she traveled to Paris, where she made a pastel portrait of the young Louis XV and was elected to the Royal Academy of Painting and Sculpture,

despite the 1706 rule forbidding the admission of any more women (see "Women and Academies," page 952). Returning to Italy in 1721, Carriera spent much of the rest of her career in Venice, where she produced sensitive portraits of distinguished sitters such as the British aristocrat Charles Sackville (FIG. 29–13).

CANALETTO. Even more than portraits of themselves, visitors to Italy on the Grand Tour desired paintings and prints of city views, which they collected largely as fond reminders of their travels. These city views were two types: the *capriccio* ("caprice;" plural *capricci*), in which the artist mixed actual features, especially ruins, into imaginatively pleasing compositions; and the *veduta* ("view;" plural *vedute*), a naturalistic rendering of a well-known tourist attraction, which often took the form of a panoramic view that was meticulously detailed, topographically accurate, and populated with a host of contemporary figures engaged in typical activities. The Venetian artist Giovanni Antonio Canal, called Canaletto (1697–1768), became so popular among British clients for his *vedute* that his dealer arranged for him to work from 1746 to 1755 in England, where he painted topographic views of London and the surrounding countryside, giving impetus to a school of English landscape painting.

In 1762, the English king George III purchased Canaletto's **SANTI GIOVANNI E PAOLO AND THE MONUMENT TO BARTOLOMMEO COLLEONI** (FIG. 29–14), painted probably in 1735–38. The Venetian square, with its famous fifteenth-century equestrian monument by Verrocchio (SEE FIG. 19–16),

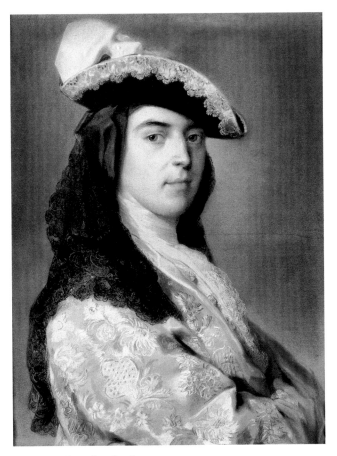

29–13 | Rosalba Carriera **CHARLES SACKVILLE, 2ND DUKE OF DORSET**
c. 1730. Pastel on paper, 25 × 19″ (63.5 × 48.3 cm). Private collection.

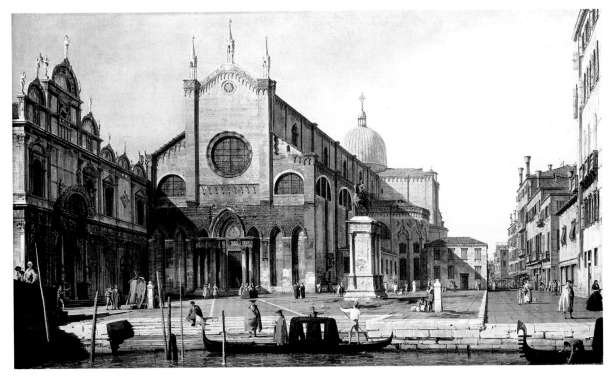

29–14 | Canaletto **SANTI GIOVANNI E PAOLO AND THE MONUMENT TO BARTOLOMMEO COLLEONI**
c. 1735–38. Oil on canvas, 18⅜ × 30⅞″ (46 × 78.4 cm). The Royal Collection, Windsor Castle, Windsor, England.

is shown as if the viewer were in a gondola on a nearby canal. The roofline of the large church of Santi Giovanni e Paolo behind the monument creates a powerful orthogonal that draws the viewer's eye toward the vanishing point at the lower right. Many of Canaletto's views, like this one, are topographically correct. In others he rearranged the buildings to tighten the composition, even occasionally adding features to produce a *capriccio*.

PIRANESI. Very different are the Roman views of Giovanni Battista Piranesi (1720–78), one of the century's greatest printmakers. Trained in Venice as an architect, Piranesi went to Rome in 1740. After studying etching, he began in 1743 to produce portfolios of prints, and in 1761 he established his own publishing house. Piranesi created numerous *vedute* of ancient Roman ruins, crumbling and overgrown with vegetation, and exemplary of the new taste for the **picturesque**, which contemporary British theorists defined as a quality seen in a landscape (actual or depicted) with an aesthetically pleasing irregularity in its shapes, composition, and lighting. Piranesi's fame today rests primarily, however, on a series of *capricci*: his *Carceri d'invenzione (Imaginary Prisons)*, which he began etching in 1741 and published in their definitive form in 1761. Recent discoveries at Herculaneum and Pompeii stimulated Piranesi's and his patrons' interest in Roman ruins—a major source of inspiration for the *Carceri*.

Informed both by his careful study of ancient Roman urban architecture and his knowledge of Baroque stage set design, Piranesi's *Carceri*, such as **THE LION BAS-RELIEF** **(FIG. 29–15)**, depict vast, gloomy spaces spanned by the remnants of monumental vaults and filled with mazes of stairways and catwalks traversed by tiny human figures. Throughout Piranesi's series, motifs such as barred windows, dangling ropes and tackle, and the occasional torture device generate a sinister mood, but the overall effect created by the immense interiors and dwarfed figures is that of the **sublime**, an awesome, nearly terrifying experience of vastness described by the British writer Edmund Burke in his influential essay *A Philosophical Enquiry into the Origin of our Ideas of the Sublime and the Beautiful* (1756). Through their evocation of the sublime, which would later engage Romantic painters such as Joseph Mallord William Turner, and more fundamentally due to their powerfully imaginative qualities, Piranesi's *Carceri* are an early manifestation of Romanticism.

Neoclassicism in Rome:
The Albani-Winckelmann Influence

A notable sponsor of the classical revival was Cardinal Alessandro Albani (1692–1779), who amassed a huge collection of antique sculpture, sarcophagi, **intaglios** (objects in which the design is carved out of the surface), cameos, and vases. In 1760–61, he built a villa just outside Rome to house

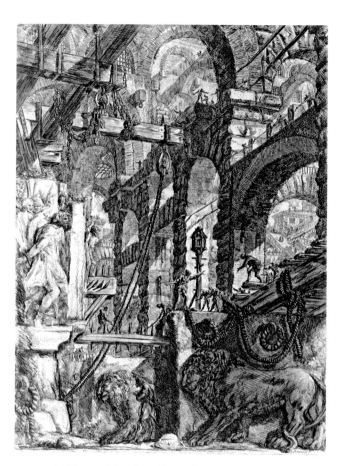

29–15 | Giovanni Battista Piranesi **THE LION BAS-RELIEF**
Plate V from the series *Carceri d'invenzione (Imaginary Prisons)*. 1761. Etching and engraving, 21⅛ × 16⅕″ (56.2 × 41.1 cm). The Fine Arts Museums of San Francisco.
Achenbach Foundation for the Graphic Arts purchase 1969.32.7.5

This print owes its name to the shadowy bas-reliefs of lions carved on the pedestals of a foreground stairway. At the left side of the composition is a brightly lit fragment of another ancient bas-relief showing a bound captive being paraded past spear-bearing Roman soldiers. Art historians have noted that this carved captive and another glimpsed to his right are the only prisoners actually pictured in Piranesi's print; the other human figures seem to be contemporary visitors to this fantastic ancient space, gesticulating with wonder at its sublime marvels.

and display his holdings, and the Villa Albani became one of the most important stops on the Grand Tour. The villa was more than a museum, however; it was also a kind of shop, where many of the items he sold to satisfy the growing craze for antiquities were faked or heavily restored by artisans working in the cardinal's employ.

Albani's credentials as the foremost expert on classical art were solidified when he hired as his secretary and librarian Johann Joachim Winckelmann (1717–68), the leading theoretician of Neoclassicism. The Prussian-born Winckelmann had become an advocate of classical art while working in Dresden, where the French Rococo style he deplored was fashionable. In 1755, he published a pamphlet, *Thoughts on the*

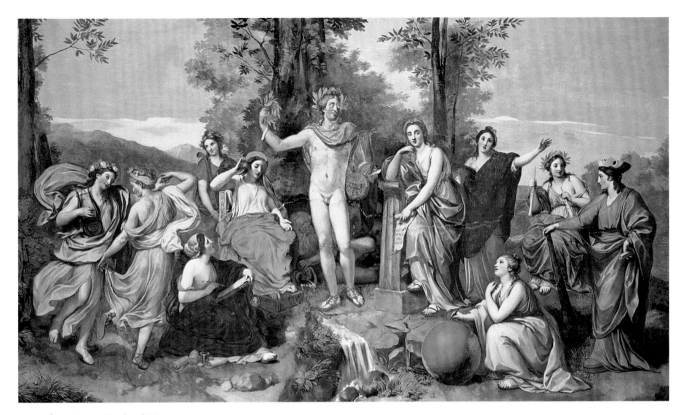

29–16 | Anton Raphael Mengs **PARNASSUS**
Ceiling fresco in the Villa Albani, Rome. 1761.

Imitation of Greek Works in Painting and Sculpture, in which he attacked the Rococo as decadent and argued that only by imitating Greek art could modern artists become great again. Winckelmann imagined that the temperate climate and natural ways of the Greeks had perfected their bodies and made their artists more sensitive to certain general ideas of what constitutes true and lasting beauty. Shortly after publishing this pamphlet, Winckelmann moved to Rome, where in 1758 he went to work for Albani. In 1764 he published the second of his widely influential treatises, *The History of Ancient Art*, which many consider the beginning of modern art history. There he analyzed the history of art in terms of a logical succession of period styles, an approach which later became the norm for art history books (including this one).

MENGS. Winckelmann's closest friend and colleague in Rome was a fellow German, Anton Raphael Mengs (1728–79). Winckelmann's employer, Cardinal Albani, commissioned Mengs to create a painting for the ceiling of the great gallery in his new villa. The **PARNASSUS** ceiling **(FIG. 29–16)**, from 1761, is usually considered the first true Neoclassical painting, though to most modern eyes the poses in the work seem forced and the atmosphere overly idealized. The scene takes place on Mount Parnassus in central Greece, which the ancients believed to be sacred to Apollo (the god of poetry, music, and the arts) and the nine Muses (female personifications of artistic inspiration). At the center of the composition is Apollo, his pose modeled on that of the famous *Apollo Belvedere*, an ancient marble statue in the Vatican collection. Mengs's Apollo holds a lyre and a laurel branch, symbol of artistic accomplishment. Next to him, resting on a Doric column, is Mnemosyne, the mother of the Muses, who are shown in the surrounding space practicing the various arts. Inspired by relief sculpture he had studied at Herculaneum, Mengs arranged the figures in a generally symmetrical, pyramidal composition parallel to the picture plane. Winckelmann, not surprisingly, praised the work for achieving the "noble simplicity and calm grandeur" that he had found in Greek originals. Shortly after completing this work Mengs left for Spain, where he served as court painter until 1777.

CANOVA. The aesthetic ideals of the Albani-Winckelmann circle soon affected contemporary Roman sculptors, who remained committed to this paradigm for the next 100 years. The leading Neoclassical sculptor of the late eighteenth and early nineteenth centuries was Antonio Canova (1757–1822). Born near Venice into a family of stonemasons, Canova in 1781 settled in Rome, where under the guidance of the Scottish painter Gavin Hamilton (1723–98) he adopted the Neoclassical style and quickly became the most sought-after European sculptor of the period.

Canova specialized in two types of work: grand public monuments for Europe's leaders, and erotic mythological subjects, such as **CUPID AND PSYCHE** (FIG. 29–17), for the pleasure of private collectors. *Cupid and Psyche* illustrates the love story of Cupid, Venus's son, and Psyche, a beautiful mortal who had aroused the goddess's jealousy. Venus casts Psyche into a deathlike sleep; moved by Cupid's grief and love for her, the sky god Jupiter (the Roman name for the Greek Zeus) takes pity on the pair and gives Psyche immortality. In this sculpture, Canova chose the most emotional and tender moment in the story, when Cupid revives the lifeless Psyche with a kiss. Here Canova combined a Rococo interest in eroticism with a more typically Neoclassical appeal to the combined senses of sight and touch. Because the lovers gently caress each other, the viewer is tempted to run his or her fingers over the graceful contours of their cool, languorous limbs.

REVIVALS AND EARLY ROMANTICISM IN BRITAIN

British tourists and artists in Italy became the leading supporters of Neoclassicism partly because they had been prepared for it by the architectural revival of Renaissance classicism in their homeland earlier in the century. While the terms Rococo and Neoclassicism identify distinct artistic styles—the one complex and sensuous, the other more simple and restrained—a third term applied to later eighteenth-century art, *Romanticism*, describes not only a style but also an attitude. Romanticism is chiefly concerned with imagination and the emotions, and it is often understood as a reaction against the Enlightenment focus on rationality. Romanticism celebrates the individual and the subjective rather than the universal and the objective. The movement takes its name from the *romances*—novellas, stories, and poems written in Romance (Latin-derived) languages—that provided many of its themes. Thus, the term *Romantic* suggests something fantastic or novelistic, perhaps set in a remote time or place, infused by a poetic or even melancholic spirit. One of the best examples of early Romanticism in literature is *The Sorrows of Young Werther* by Johann Wolfgang von Goethe (1749–1832), in which a sensitive, outcast young man fails at love and kills himself. Goethe believed that the artist's principal duty was to communicate feeling to the audience, rather than to entertain or to recall ancient virtues; this soon became a basic precept of the Romantic movement.

Neoclassicism and Romanticism existed side by side in the later eighteenth and early nineteenth centuries. Indeed, because a sense of remoteness in time or place characterizes both Neoclassical and Romantic art, some scholars argue that Neoclassicism is a subcategory of Romanticism.

Classical Revival in Architecture and Landscaping

Just as the Rococo was emerging in France, a group of British professional architects and wealthy amateurs led by the Scot Colen Campbell (1676–1729) took a stance against what they saw as the immoral extravagance of the Italian Baroque. As a moral corrective, they advocated a return to the austerity and simplicity found in the architecture of Andrea Palladio.

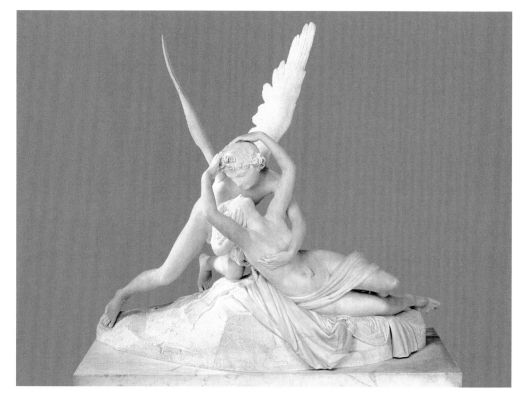

29–17 | Antonio Canova
CUPID AND PSYCHE
1787–93. Marble,
6′1″ × 6′8″
(1.55 × 1.73 m).
Musée du Louvre, Paris.

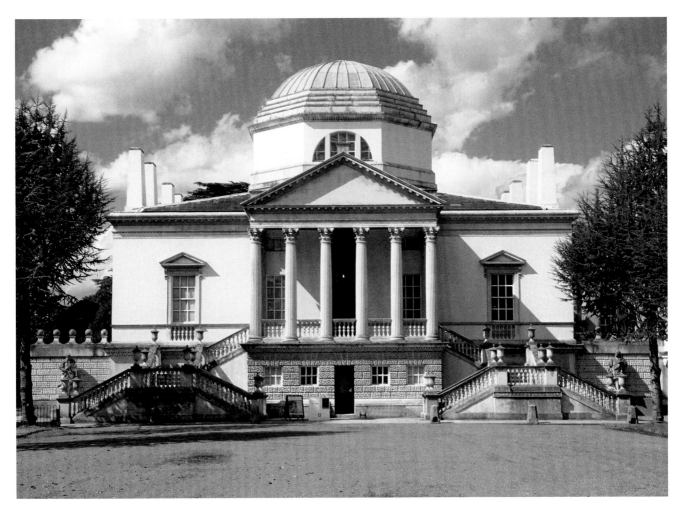

29–18 | Richard Boyle (Lord Burlington) **CHISWICK HOUSE**
West London, England. 1724–29. Interior decoration (1726–29) and new gardens (1730–40) by William Kent.

CHISWICK HOUSE. The most famous product of this group was **CHISWICK HOUSE** (FIG. 29–18), designed in 1724 by its owner, Richard Boyle, the third Earl of Burlington (1695–1753). Burlington sought out Palladio's architecture in Italy, especially his Villa Rotunda (SEE FIG. 20–47), which inspired Burlington's plan for Chiswick House. The building plan (FIG. 29–19) shares the bilateral symmetry of Palladio's villa, although its central core is octagonal rather than round and there are only two entrances. The main entrance, flanked now by matching staircases, is a Roman temple front, a flattering reference to the building's inhabitant. Chiswick's elevation is characteristically Palladian, with a main floor resting on a basement, and tall rectangular windows with triangular pediments. The result is a lucid evocation of Palladio's design, with few but crisp details that seem perfectly suited to the refined proportions of the whole.

In Rome, Burlington had persuaded the English expatriate William Kent (1685–1748) to return to London as his collaborator. Kent designed Chiswick's surprisingly ornate interior as well as the grounds, the latter in a style that became known throughout Europe as the English landscape

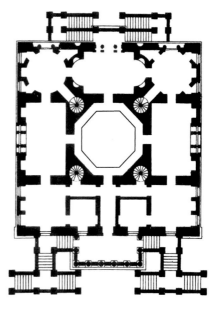

29–19 | **PLAN OF CHISWICK HOUSE** 1724.

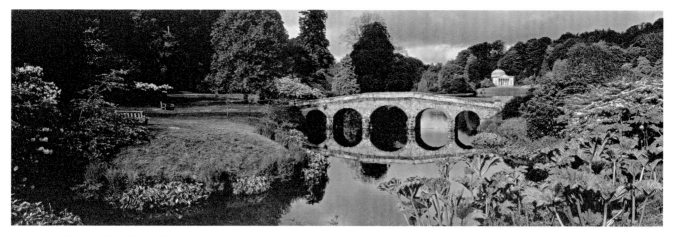

29–20 | Henry Flitcroft and Henry Hoare **THE PARK AT STOURHEAD**
Wiltshire, England. Laid out 1743; executed 1744-65, with continuing additions.

garden. Kent's garden, in contrast to the regularity and rigid formality of Baroque gardens (SEE FIG. 22–56), featured winding paths, a lake with a cascade, irregular plantings of shrubs, and other effects imitating the appearance of the natural rural landscape. The English landscape garden was another indication of the growing Enlightenment emphasis on the natural.

STOURHEAD. Following Kent's lead, landscape architecture flourished in the hands of such designers as Lancelot ("Capa-bility") Brown (1716–83) (SEE FIG. 22–67) and Henry Flitcroft (1697–1769). In the 1740s the banker Henry Hoare began redesigning the grounds of his estate at Stourhead in Wiltshire (**FIG. 29–20**) with the assistance of Flitcroft, a protégé of Burlington. The resulting gardens at Stourhead carried Kent's ideas much further. Stourhead is, in effect, an exposition of the picturesque, with orchestrated views dotted with Greek- and Roman-style temples, grottoes, copies of antique statues, and such added delights as a rural cottage, a Chinese bridge, a Gothic spire, and a Turkish tent. In the view illustrated here, a

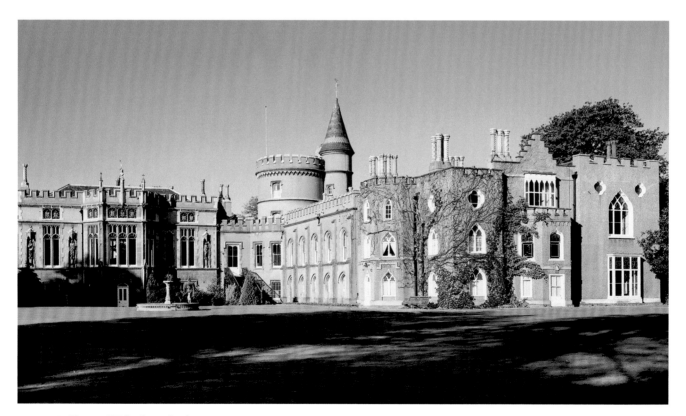

29–21 | Horace Walpole and others **STRAWBERRY HILL**
Twickenham, England. 1749-76.

replica of the Pantheon in Rome is just visible across a carefully placed lake. While the nostalgic evocation of an idyllic classical past recalls the work of the seventeenth-century French landscape painter Claude Lorrain (SEE FIG. 22-63), who had found a large market in Britain, the exotic elements here are an early indication of the Romantic taste for the strange and the novel. The garden is therefore an interesting mixture of the Neoclassical and the Romantic. For a wall inside the house, Hoare commissioned Mengs to paint *The Meeting of Antony and Cleopatra*, a work that similarly combines classical history with an exotic, Romantic subject.

Gothic Revival in Architecture and Its Decoration

Alongside the British classical revival of the mid-eighteenth century came a revival of the Gothic style, a manifestation of architectural Romanticism that spread to other nations after 1800. An early advocate of the Gothic revival was the conservative politician and author Horace Walpole (1717–97), who shortly before 1750 decided to remodel his house, called **STRAWBERRY HILL,** in the Gothic manner (FIG. 29–21). Gothic renovations were commonly performed in Britain before this date, but only to buildings that dated from the medieval period. Working with a number of friends and architects, Walpole spent nearly thirty years, from 1749 to 1776, transforming his home into a Gothic castle complete with **crenellated battlements** (alternating high and low sections of a wall, giving a notched appearance and creating permanent defensive shields), tracery windows, and turrets.

The interior, too, was totally changed. One of the first rooms Walpole redesigned, with the help of amateurs John Chute (1701–76) and Richard Bentley (1708–82), was the library (FIG. 29–22). Here the three turned for inspiration to illustrations in the antiquarian books that the library housed. For the bookcases, they adapted designs from London's old Saint Paul's Cathedral, which had been destroyed in the Great Fire of 1666. Prints depicting two medieval tombs inspired the chimneypiece. For the ceiling, Walpole incorporated a number of coats of arms of his ancestors—real and imaginary. The reference to fictional relatives offers a clue to Walpole's motives in choosing the medieval style. Walpole meant his house to suggest a castle out of the medievalizing Romantic fiction that he himself was writing. In 1764, he published *The Castle of Otranto*, a Romantic story set in the Middle Ages that helped launch the craze for the Gothic novel. Sir Walter Scott would later achieve fame as the best exponent of the genre in his novels *Ivanhoe* (1819) and *Kenilworth* (1821).

Neoclassicism in Architecture and the Decorative Arts

The vogue for classical things spread to most of the arts in late eighteenth-century England, as patrons regarded Greece and Rome as impeccable pedigree for their buildings, uten-

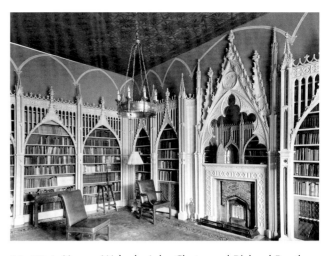

29–22 Horace Walpole, John Chute, and Richard Bentley
LIBRARY, STRAWBERRY HILL
After 1754.

sils, poetry, and even clothing fashions. Alexander Pope translated Homer, and wrote his own poetry in iambic pentameter, a style based on the heroic couplets of Latin poets. Women often donned white muslin gowns in order to make themselves resemble classical statues.

ADAM: SYON HOUSE. The most important British contribution to Neoclassicism was a style of interior decoration developed by the Scottish architect Robert Adam (1728–92). On his Grand Tour in 1754–58, during which he joined Albani's circle of Neoclassicists, Adam largely ignored the civic architecture that had interested British classicists such as Burlington and focused instead on the applied ornament of Roman domestic architecture. When he returned to London to set up an architectural firm, he brought with him a complete inventory of decorative motifs, which he then modified in pursuit of a picturesque elegance. His stated aim to "transfuse the beautiful spirit of antiquity with novelty and variety" met with considerable opposition from the Palladian architectural establishment, but it proved ideally suited both to the evolving taste of wealthy clients and to the imperial aspirations of the new king, George III (ruled 1760–1820). In 1761, George appointed Adam and Adam's rival William Chambers (1723–96) as joint Architects of the King's Works.

Adam achieved wide renown for his interior renovations, such as those he carried out between 1760 and 1769 for the Duke of Northumberland at his country estate, Syon, near London. The opulent colored marbles, gilded relief panels, classical statues, spirals, garlands, rosettes, and gilded moldings in the anteroom (FIG. 29–23) are luxuriously profuse yet are restrained by the strong geometric order imposed on them and by the plain wall and ceiling surfaces. Adam's preference for bright pastel grounds and

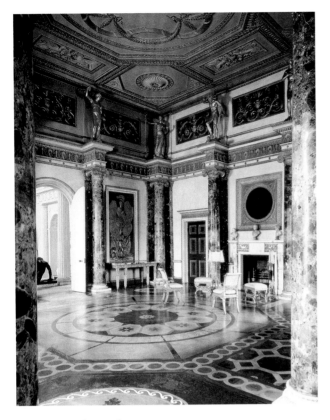

29–23 | Robert Adam **ANTEROOM, SYON HOUSE**
Middlesex, England. 1760–69.

Adam's conviction that it was acceptable to modify details of the classical orders was generally opposed by the British architectural establishment. As a result of that opposition, Adam was never elected to the Royal Academy.

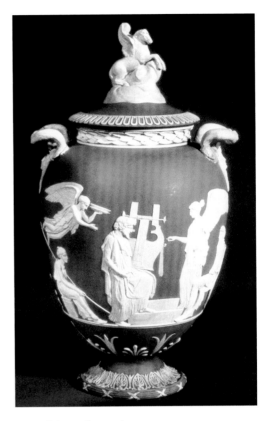

29–24 | Josiah Wedgwood **VASE: THE APOTHEOSIS OF HOMER**
Made at the Wedgwood Etruria factory, Staffordshire, England. 1786. White jasper body with a mid-blue dip and white relief, height 18″ (45.7 cm). Relief of *The Apotheosis of Homer* adapted from plaque by John Flaxman, Jr. 1778. Trustees of the Wedgwood Museum, Barlaston, Staffordshire, England.

small-scale decorative elements derives both from the Rococo (SEE FIG. 29–5), and from the recently uncovered ruins of Pompeii.

WEDGWOOD. Such interiors were designed partly as settings for the art collections of British aristocrats, which included antiquities as well as a range of Neoclassical painting, sculpture, and decorative ware (see "Georgian Silver," page 962). The most successful producer of Neoclassical decorative art was Josiah Wedgwood (1730–95). In 1769, near his native village of Burslem, he opened a pottery factory called Etruria after the ancient Etruscan civilization in central Italy known for its pottery. This production-line shop had several divisions, each with its own **kilns** (firing ovens) and workers trained in individual specialties. In the mid-1770s Wedgwood, a talented chemist, perfected a fine-grained, unglazed, colored pottery, which he called **jasperware**. The most popular of his jasperware featured white figures against a blue ground, like that in **THE APOTHEOSIS OF HOMER** (FIG. 29–24). The relief on the front of the vase was designed by the sculptor John Flaxman, Jr. (1755–1826), who worked for Wedgwood from 1775 to 1787. Flaxman based the scene on a book illustration documenting a classical Greek vase in the

collection of William Hamilton (1730–1803), a leading collector of antiquities and one of Wedgwood's major patrons. Flaxman's design simplified the original according to the prevailing idealized notion of Greek art and the demands of mass production.

The socially conscious Wedgwood—who epitomized Enlightenment thinking—established a village for his employees and cared deeply about every aspect of their living conditions. He was also active in the organized international effort to halt the African slave trade and abolish slavery. To publicize the abolitionist cause, Wedgwood asked the sculptor William Hackwood (c. 1757–1839) to design an emblem for the British Committee to Abolish the Slave Trade, formed in 1787. The compelling image Hackwood created was a small medallion of black-and-white jasperware, cut like a cameo in the likeness of an African man kneeling in chains, with the legend "Am I Not a Man and a Brother?" (FIG. 29–25). Wedgwood sent copies of the medallion to Benjamin Franklin, the president of the Philadelphia Abolition Society, and to others in the abolitionist movement. Later, those active in the women's suffrage movement in the United States adapted the image by representing a woman in chains with the motto "Am I Not a Woman and a Sister?"

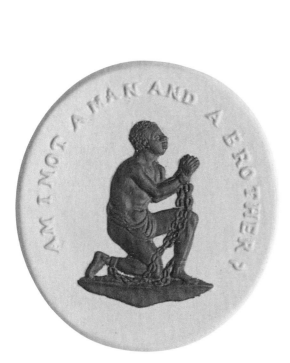

29–25 | William Hackwood for Josiah Wedgwood
"AM I NOT A MAN AND A BROTHER?"
1787. Black and white jasperware, 1⅜ × 1⅜" (3.5 × 3.5 cm).
Trustees of the Wedgwood Museum, Barlaston, Staffordshire,
England.

Painting

When the newly prosperous middle classes in Britain began to buy art, they first wanted portraits of themselves. But taste was also developing for other subjects, such as moralizing satire and caricature, ancient and modern history, the British landscape and people, and scenes from English literature.

Whatever their subject matter, many of the paintings that emerged in Britain reflected Enlightenment values, including an interest in social progress, an embrace of natural beauty, and faith in reason and science.

THE SATIRIC SPIRIT. After the end of government censorship in 1695, a flourishing culture of literary satire emerged in Britain directed at a variety of political and social targets. John Gay's 1728 play *The Beggar's Opera* showed aristocrats as grasping and lazy, in contrast to the hardworking lower classes. Henry Fielding wrote in his *Historical Register of the Year 1738* that he hoped to "expose the reigning follies in such a manner that men shall laugh themselves out of them." The first painter inspired by the work of these pioneering novelists and essayists was William Hogarth (1697–1764), a friend of Fielding who at times illustrated works by Gay. Trained as a portrait painter, Hogarth believed art should contribute to the improvement of society. About 1730, he began illustrating moralizing tales of his own invention in sequences of four to six paintings, which he then produced in sets of prints, both to maximize his profits and to influence as many people as possible.

Between 1743 and 1745, Hogarth produced the *Marriage à la Mode* suite, whose subject was inspired by Joseph Addison's 1712 essay in the *Spectator* promoting the concept of marriage based on love rather than aristocratic intrigue. The opening scene, **THE MARRIAGE CONTRACT** (FIG. 29–26), shows the gout-ridden Lord Squanderfield, at the right, arranging the marriage of his son to the daughter of a wealthy merchant. The merchant gains entry for his family into the aristocracy, while the lord gets the money he needs

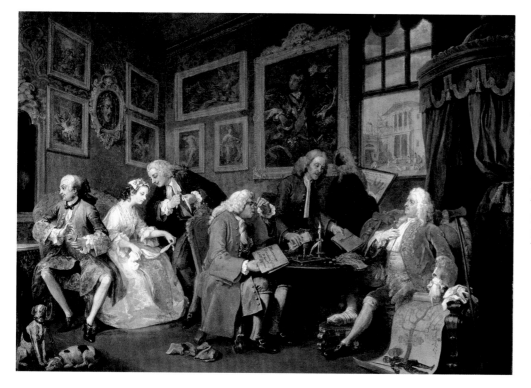

29–26 | William Hogarth
THE MARRIAGE CONTRACT
From *Marriage à la Mode.*
1743–45. Oil on canvas,
27½ × 35¾"
(69.9 × 90.8 cm).
The National Gallery,
London.

Reproduced by Courtesy of the Trustees

THE ●BJECT SPEAKS

GEORGIAN SILVER

Since ancient times, Europeans have prized silver for its rarity, reflectivity, and beautiful luster. At times, its use was restricted to royalty; at others, to liturgical applications such as statues of saints, manuscript illuminations, and chalices. But by the Georgian period—the years from 1714 to 1830, when Great Britain was ruled by four kings named George—wealthy British families filled their homes with a variety of objects made of fine silver—utensils and vessels that they collected not simply as useful, practical articles, but as statements of their own high social status.

British gentlemen employed finely crafted silver vessels, for example, to serve and consume punch, a potent alcoholic beverage that lubricated the wheels of Georgian society. Gentlemen took pride in their own secret recipes for punch, and a small party of drinkers might pass around an elegant punch bowl, consuming its contents as they admired its exterior. Larger groups would drink from cups or goblets, such as the simple yet elegant goblet by Ann and Peter Bateman, which has a gilded interior to protect the silver from the acid present in alcoholic drinks. (Hester Bateman's double beaker, also with a gilded interior, was made for use while traveling.) The punch would be poured into the goblets with a ladle such as the one shown here, by Elizabeth Morley, which has a twisted whalebone handle that floats, making it easy to retrieve from the bowl. Then, the filled goblets would be served on a flat salver like the one made by Elizabeth Cooke. Gentlemen also used silver containers to carry snuff, a pulverized tobacco that was inhaled by well-to-do members of both sexes. (The gentleman at the extreme left in William Hogarth's painting, *The Marriage Contract* (FIG. 29–26), is taking a pinch of snuff from a snuffbox.) The fairly flat snuffbox illustrated here, by Alice and George Burrows, has curved sides for easy insertion into the pockets of gentlemen's tight-fitting trousers.

All of the objects shown here bear the marks of silver shops run either wholly or partly by women, who played a significant role in the production of Georgian silver. While some women served formal apprenticeships and went on to become members of the goldsmiths guild (which included silversmiths), most women became involved with silver through their relation to a master silversmith—typically a father, husband, or brother—and they frequently specialized in a specific aspect of the craft, such as engraving, **chasing** (ornamentation made on metal by hammering or incising the surface), or polishing. The widows of silversmiths often took over their husbands' shops and ran them with the help of journeymen or partners.

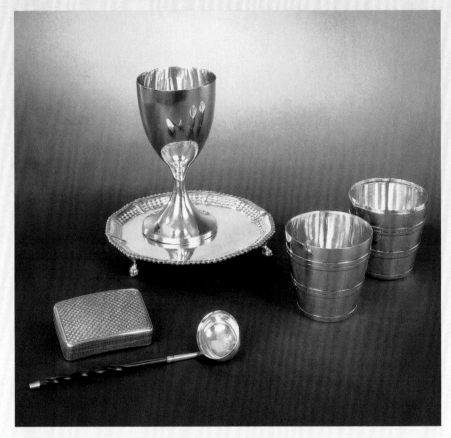

Elizabeth Morley, **GEORGE III TODDY LADLE** 1802; Alice and George Burrows, **GEORGE III SNUFFBOX** 1802; Elizabeth Cooke, **GEORGE III SALVER** 1767; Ann and Peter Bateman, **GEORGE III GOBLET** 1797; **HESTER BATEMAN, GEORGE III DOUBLE BEAKER** 1790. National Museum of Women in the Arts, Washington, D.C.

Silver Collection assembled by Nancy Valentine, purchased with funds donated by Mr. and Mrs. Oliver Grace and family

Hester Bateman (1708–94), the most famous woman silversmith in eighteenth-century Britain, inherited her husband's small spoon-making shop at the age of 52 and transformed it into one of the largest silver manufactories in the country. Adapting new technologies of mass production to the manufacture of silver, Bateman marketed her well-designed, functional, and relatively inexpensive wares to the newly affluent middle class, making no attempt to compete with those silversmiths who catered to the monarchy or the aristocracy. She retired when she was 82 after training her daughter-in-law Ann and her sons and grandson to carry on the family enterprise. Both Hester's double beaker and Ann and Peter's goblet show the restrained elegance characteristic of Bateman silver.

to complete his Palladian house, which is visible out the window.

The loveless couple who will be sacrificed to this deal sit on the couch at the left. While the young Squanderfield vainly admires himself in the mirror, his unhappy fiancée is already being wooed by lawyer Silvertongue, who suggestively sharpens his pen. The next five scenes show the progressively disastrous results of such a union, culminating in the young lord's murder of Silvertongue and the subsequent suicide of his wife.

Stylistically, Hogarth's works combine the additive approach of seventeenth-century Dutch genre painters with the elegance and casual poses of the Rococo. Hogarth wanted to please and entertain his audience as much as educate them. He also hoped to create a distinctively English style of painting, free of obscure mythological references and encouraging the self-improvement in viewers that would lead to the progress of society. In this way he opposed both the frivolous Rococo and the at-times abstruse and remote Neo-classicism. By at least one measure, he was a success: His work became so popular that in 1745 he was able to give up portraiture, which he considered a deplorable form of vanity.

PORTRAITURE. A generation younger than Hogarth, Sir Joshua Reynolds (1723–92) specialized in the very form of painting—portraiture—that the moralistic Hogarth despised. After studying Renaissance art in Italy, Reynolds settled in London in 1753 and worked vigorously to educate artists and patrons to appreciate classical history painting. In 1768 he was appointed the first president of the Royal Academy (see "Academies and Academy Exhibitions," page 948). Reynolds's *Fifteen Discourses to the Royal Academy* (1769–90) set out his theories on art: Artists should follow the rules derived from studying the great masters of the past, especially those who worked in the classical tradition; art should generalize to create the universal rather than the particular; and the highest kind of art is history painting.

Because British patrons preferred portraits of themselves to scenes of classical history, Reynolds attempted to elevate portraiture to the level of history painting by giving it a historical or mythological veneer. A good example of this ambitious type of portraiture, a form of Baroque classicism that Reynolds called the **Grand Manner**, is **LADY SARAH BUN-BURY SACRIFICING TO THE GRACES** (FIG. 29–27). Dressed in a classicizing costume, Bunbury plays the part of a Roman priestess making a sacrifice to the personifications of female beauty, the Three Graces. The figure is further aggrandized through the use of the monumental classical pier and arch behind her, the emphatic classical contrapposto (Italian for "set against"; used to describe the twisted pose resulting from parts of the body set in opposition to each other around a central axis), and the large scale of the canvas. Such works were intended for the public rooms, halls, and stairways of aristocratic residences.

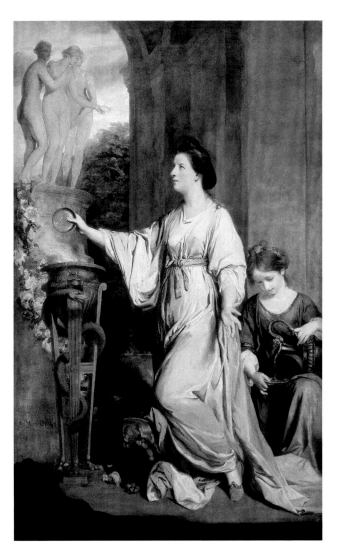

29–27 Joshua Reynolds **LADY SARAH BUNBURY SACRIFICING TO THE GRACES**
1765. Oil on canvas, 7'10" × 5' (2.42 × 1.53 m).
The Art Institute of Chicago.
Mr. and Mrs. W. W. Kimball Collection, 1922.4468

Lady Bunbury was one of the great beauties of her era. A few years before this painting was done, she turned down a request of marriage from George III.

A number of British patrons, however, remained committed to the kind of portraiture Van Dyck had brought to England in the 1620s, which had featured more informal poses against natural vistas. Thomas Gainsborough (1727–88) achieved great success with this mode when he moved to Bath in 1759 to cater to the rich and fashionable people who had begun going there in great numbers. A good example of his mature style is the **PORTRAIT OF MRS. RICHARD BRINSLEY SHERIDAN** (FIG. 29–28) which shows the professional singer (the wife of a celebrated playwright) seated informally outdoors. The sloping view into the distance and the use of a tree to frame the sitter's head appear borrowed directly from Van Dyck (SEE FIG. 22-38). But Gainsborough modernized the formula not simply through his lighter, Rococo palette and

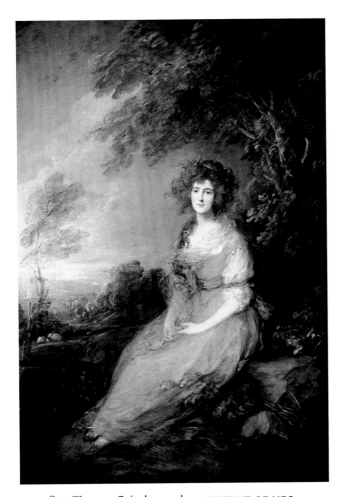

29–28 | Thomas Gainsborough **PORTRAIT OF MRS. RICHARD BRINSLEY SHERIDAN**
1785–87. Oil on canvas, 7'2⅜" × 5'⅝" (2.2 × 1.54 m).
National Gallery of Art, Washington, D.C.
Andrew W. Mellon Collection (1937.1.92)

feathery brushwork but also by integrating the woman into the landscape, thus identifying her with it. The effect is especially noticeable in the way her windblown hair matches the tree foliage overhead. The work thereby manifests one of the new values of the Enlightenment: the emphasis on nature and the natural as the sources of goodness and beauty.

THE ROMANCE OF SCIENCE. We see Enlightenment fascination with developments in the natural sciences in the dramatic depiction of **AN EXPERIMENT ON A BIRD IN THE AIR-PUMP** (FIG. 29–29) by Joseph Wright of Derby (1734–97). Trained as a portrait painter, Wright made the Grand Tour in 1773–75 and then returned to the English Midlands to paint local society. Many of those he painted were the self-made entrepreneurs of the first wave of the Industrial Revolution, which was centered in the Midlands in towns such as Birmingham. Wright belonged to the Lunar Society, a group of industrialists (including Wedgwood), mercantilists, and progressive nobles who met in Derby. As part of the society's attempts to popularize science, Wright painted a series of "entertaining" scenes of scientific experiments.

The second half of the eighteenth century was an age of rapid technological advances (see "Iron as a Building Material," page 967), and the development of the air pump was among the many innovative scientific developments of the time. Although it was employed primarily to study the property of gases, it was also widely used to promote the public's interest in science because of its dramatic possibilities. In the experiment shown here, air was pumped out of the large glass bowl until the small bird inside collapsed from lack of oxy-

29–29 | Joseph Wright
AN EXPERIMENT ON A BIRD IN THE AIR-PUMP
1768. Oil on canvas, 6 × 8'
(1.82 × 2.43 m). The National Gallery, London.

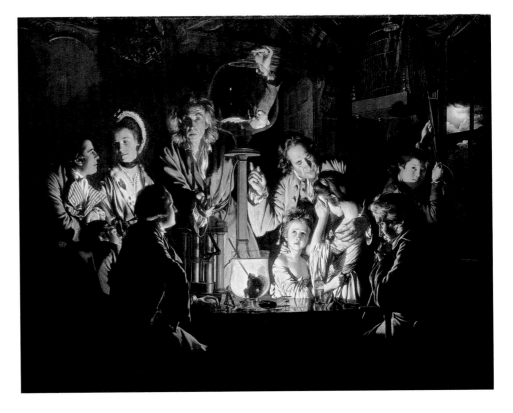

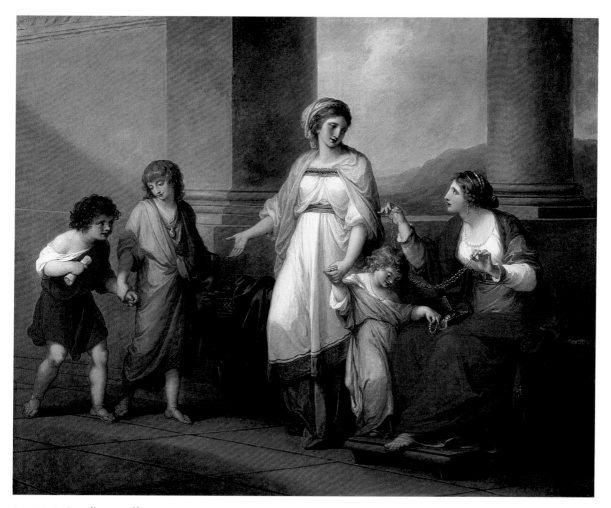

29–30 | Angelica Kauffmann **CORNELIA POINTING TO HER CHILDREN AS HER TREASURES**
c. 1785. Oil on canvas, 40 × 50″ (101.6 × 127 cm). Virginia Museum of Fine Arts, Richmond, Virginia.
The Adolph D. and Wilkins C. Williams Fund

gen; before the animal died, air was reintroduced by a simple mechanism at the top of the bowl. In front of an audience of adults and children, a lecturer prepares to reintroduce air into the glass receiver. Near the window at right, a boy stands ready to lower a cage when the bird revives. (The moon visible out the window is a reference to the Lunar Society.) By delaying the reintroduction of air, the scientist has created considerable suspense, as the reactions of the two girls indicate. Their father, a voice of reason, attempts to dispel their fears. The dramatic lighting, stylistically derived from the Baroque religious paintings of Caravaggio and his followers (SEE FIG. 22–60) but here applied to a secular subject, not only underscores the life-and-death issue of the bird's fate but also suggests that science brings light into a world of darkness and ignorance.

HISTORY PAINTING. European academies had long considered history painting as the highest form of artistic endeavor, but British patrons were reluctant to purchase such works from native artists. Instead, they favored Italian paintings bought on the Grand Tour or acquired through agents in

Italy. Thus, the arrival in London in 1766 of the Italian-trained Swiss history painter Angelica Kauffmann (1741–1807) greatly encouraged those artists in London aspiring to success as history painters. She was welcomed immediately into Joshua Reynolds's inner circle and in 1768 was one of two women artists named among the founding members of the Royal Academy (see "Women and Academies," page 952).

Kauffmann had assisted her father on church murals and was already accepting portrait commissions at age fifteen. She first encountered the new classicism in Rome, where she painted Johann Winckelmann's portrait, and where she was elected to the Academy of Saint Luke. In a move unusual for a woman—most eighteenth-century women artists specialized in portraiture or still life—Kauffmann embarked on an independent career as a history painter. In London, where she lived from 1766 to 1781, she produced numerous history paintings, many of them with subjects drawn from classical antiquity. Kauffmann painted **CORNELIA POINTING TO HER CHILDREN AS HER TREASURES** (FIG. 29–30) for an English patron after returning to Italy. The story takes place in the

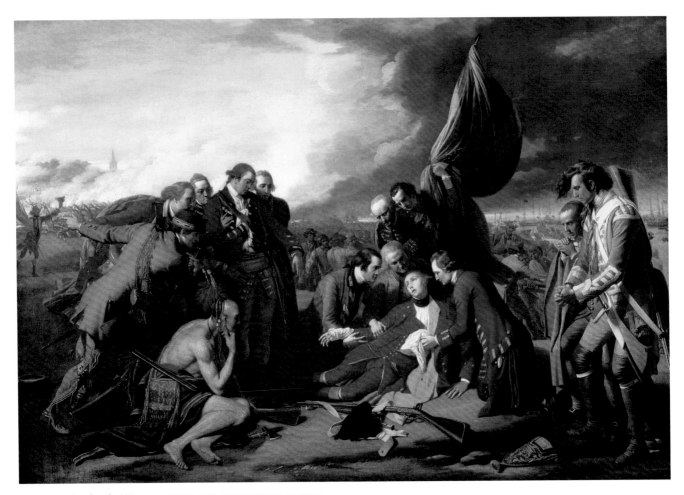

29–31 | Benjamin West **THE DEATH OF GENERAL WOLFE**
1770. Oil on canvas, 4'11½" × 7' (1.51 × 2.14 m).
The National Gallery of Canada, Ottawa.
Transfer from the Canadian War Memorials, 1921 (Gift of the 2nd Duke of Westminster, Eaton Hall, Cheshire, 1918)

The famous Shakespearean actor David Garrick was so moved by this painting that he enacted an impromptu interpretation of the dying Wolfe in front of the work when it was exhibited by the Royal Academy. The mid-eighteenth-century revival of interest in Shakespeare's more dramatic plays, in which Garrick played a leading role, was both a manifestation of and a major factor in the rise of Romantic taste in Britain.

second century BCE, during the republican era of Rome. A woman visitor has been showing Cornelia her jewels and then requests to see those of her hostess. In response, Cornelia shows her daughter and two sons and says, "These are my most precious jewels." Cornelia exemplifies the "good mother," a popular subject among later eighteenth-century history painters who, in the reforming spirit of the Enlightenment, often depicted subjects that would teach lessons in virtue. The value of Cornelia's maternal dedication is emphasized by the fact that under her loving care, the sons, Tiberius and Gaius Gracchus, grew up to be political reformers. Although the setting of Kauffmann's work is as severely simple as the message, the effect of the whole is softened by the warm, subdued lighting and by the tranquil grace of the leading characters.

Kauffmann's devotion to Neoclassical history painting was at first shared by her American-born friend Benjamin

West (1738–1820), who, after studying in Philadelphia, left for Rome in 1759. There he met Winckelmann and became a student of Mengs. In 1763, West moved permanently to London, where he specialized in Neoclassical history paintings. In 1768, he became a founding member of the Royal Academy. Two years later, he shocked Reynolds and his other academic friends with his painting **THE DEATH OF GENERAL WOLFE** (FIG. 29–31) because rather than clothing the figures in ancient garb in accordance with the tenets of Neoclassicism, he chose to depict them in modern dress. When Reynolds learned what West was planning to do, he begged him not to continue this aberration of "taste." George III informed West he would not buy a painting with British heroes in modern dress.

West's painting glorifies the British General James Wolfe, who had died in 1759 in a British victory over the French for the control of Quebec during the Seven Years' War

(1756–63). West depicted Wolfe in his red uniform expiring in the arms of his comrades under a cloud-swept sky, rather than at the base of a tree, surrounded by two or three attendants—the actual situation of his death. Thus, though West's painting is naturalistic, it is not an objective document, nor was it intended to be; West employed the Grand Manner, which Reynolds promulgated in his *Discourses*, to celebrate the valor of the fallen hero, the loyalty of the British soldiers, and the justice of their cause. To indicate the North American setting, West also included at the left a Native American warrior who contemplates the fallen Wolfe—another fiction, since the Native Americans in this battle fought on the side of the French. The dramatic illumination increases the emotional intensity of the scene, as do the poses of Wolfe's attendants, arranged to suggest a Lamentation over the dead Christ. Extending the analogy, the British flag above Wolfe replaces the Christian cross. Just as Christ died for humanity, Wolfe sacrificed himself for the good of the State.

The Death of General Wolfe enjoyed such an enthusiastic reception by the British public that Reynolds apologized to West, and the king was among four patrons to commission replicas. West's innovative decision to depict a modern historical subject in the Grand Manner established the general format for the depiction of contemporary historical events for all European artists in the later eighteenth and early nineteenth centuries. And the emotional intensity of his image helped launch the Romantic movement in British painting.

ROMANTIC PAINTING. The Enlightenment's faith in reason and empirical knowledge, dramatized in such works of art as Joseph Wright's *An Experiment on a Bird in the Air-Pump* (SEE FIG. 29–29), was countered by Romanticism's celebration of the emotions and subjective forms of experience. Many Romantic artists glorified the irrational side of human nature that the Enlightenment sought to deny.

One such Romantic was John Henry Fuseli (1741–1825), who arrived in London from his native Switzerland in 1764. Trained in theology, philosophy, and the Neoclassical aesthetics of Winckelmann (whose writings he translated into English), Fuseli quickly became a member of the London intellectual elite. Joshua Reynolds encouraged Fuseli to become an artist, and in 1770 Fuseli left to study in Rome, where he spent most of the next eight years. Fuseli's encounter with ancient Roman sculpture and the painting of Michelangelo led him to develop a powerfully expressive style based on these sources rather than on the ancient Greek works admired by Winckelmann.

Back in London, Fuseli established himself as a history painter specializing in dramatic subjects drawn from such authors as Homer, Dante, Shakespeare, and Milton. Rejecting the Enlightenment emphasis on science and reason, Fuseli often depicted supernatural and irrational subjects, as in his

Elements of Architecture
IRON AS A BUILDING MATERIAL

In 1779, Abraham Darby III built a bridge over the Severn River at Coalbrookdale in England—a town typical of the new industrial environment, with factories and workers' housing filling the valley. The bridge itself is important because it represents the first use of structural metal on a large scale, with iron replacing the heavy, hand-cut stone **voussoirs** used to construct earlier bridges. Five pairs of cast-iron, semicircular arches form a strong, economical hundred-foot span. In functional architecture such as this bridge, the available technology, the properties of the material, and the requirements of engineering in large part determine form and often produce an unintended and revolutionary new aesthetic. Here, the use of metal at last made possible the light, open, skeletal structure desired by builders since the twelfth century. Cast iron was quickly adopted by builders, giving rise to such architectural feats as the soaring train stations of the nineteenth century and leading ultimately to such marvels as the Eiffel Tower.

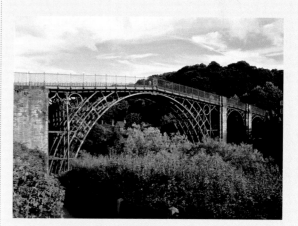

Abraham Darby III **SEVERN RIVER BRIDGE** Coalbrookdale, England. 1779.

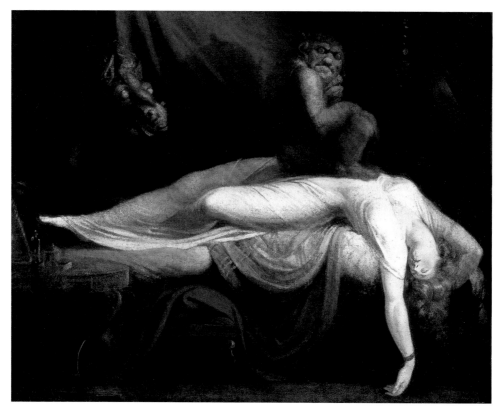

29–32 | John Henry Fuseli **THE NIGHTMARE**
1781. Oil on canvas, 39¾ × 49½" (101 × 127 cm). The Detroit Institute of Arts.
Gift of Mr. and Mrs. Bert Smokler and Mr. and Mrs. Lawrence A. Fleischmann

Fuseli was not popular with the English critics. One writer said Fuseli's 1780 entry in the London Royal Academy exhibition "ought to be destroyed," and Horace Walpole called another painting in 1785 "shockingly mad, mad, mad, madder than ever." Even after achieving the highest official acknowledgment of his talents, Fuseli was called the Wild Swiss and Painter to the Devil. But the public appreciated his work, and *The Nightmare*, exhibited at the Academy in 1782, was repeated in at least three more versions and its imagery disseminated by means of prints published by commercial engravers. One of these prints would one day hang in the office of the Austrian psychoanalyst Sigmund Freud, who believed that dreams were manifestations of the dreamer's repressed desires.

most famous work, **THE NIGHTMARE** (FIG. 29–32). In this painting, Fuseli depicts a somnolent white-clad woman, sprawled across a divan, who is oppressed by an erotic dream caused by an incubus (or *mara*, an evil spirit), the gruesome demon sitting on her chest. According to legend, the incubus was believed to steal upon sleeping women and have intercourse with them—a subject Fuseli also depicted in other works. Adding to the erotic suggestiveness of *The Nightmare* is the horse with phosphorescent eyes that thrusts its head into the room through a curtain at the left. This was the first of at least four versions of the theme Fuseli would paint. His motives are perhaps revealed by the portrait on the back of the canvas, which may be that of Anna Landolt. Fuseli had met her in Zürich in the winter of 1778–79 and had fallen in love with her. Too poor to propose marriage to her, he did not declare his feelings, but after his return to London he wrote to her uncle that she could not marry another because they had made love in one of his dreams and she therefore belonged to him. The painting may be an illustration of that dream.

Also opposed to the Enlightenment emphasis on reason and artistically inspired by Michelangelo was Fuseli's friend William Blake (1757–1827), a highly original poet, painter, and printmaker. Trained as an engraver, Blake enrolled briefly at the Royal Academy, where he was subjected to the teachings of Reynolds. The experience convinced him that all rules hinder rather than aid creativity, and he became a lifelong advocate of unfettered imagination. For Blake, imagination offered access to the higher realm of the spirit, while reason could only provide information about the lower world of matter.

Deeply concerned with the problem of good and evil, Blake developed an idiosyncratic form of Christian belief and drew on elements from the Bible, Greek mythology, and British legend to create his own mythology. The "prophetic books" that he designed and printed in the mid-1790s combined poetry and imagery dealing with themes of spiritual crisis and redemption. Their dominant characters include Urizen ("your reason"), the negative embodiment of ratio-

nalistic thought and repressive authority; Orc, the manifestation of energy, both creative and destructive; and Los, the artist, whose task is to create form out of chaos.

Thematically related to the prophetic books are an independent series of twelve large color prints that Blake executed for the most part in 1795, including the awe-inspiring **ELOHIM CREATING ADAM** (FIG. 29–33). The sculpturesque volumes and muscular physiques of the figures reveal the influence of Michelangelo, whose works Blake admired in reproduction, and the subject invites direct comparison with Michelangelo's famous *Creation of Adam* on the ceiling of the Sistine Chapel (SEE FIG. 20–14). But while Michelangelo, with humanist optimism, viewed the Creation as a positive act, Blake presents it in negative terms. In Blake's print, a giant worm, symbolizing matter, encircles the lower body of Adam, who, with an anguished expression, stretches out on the ground like the crucified Christ. Above him, the winged Elohim (*Elohim* is one of the Hebrew names for God) appears anxious, even desperate—quite unlike the confident deity pictured by Michelangelo. For Blake, the Creation is tragic because it submits the spiritual human to the fallen state of a material existence. Blake's fraught and gloomy image challenges the viewer to recognize his or her fallen nature and seek to transcend it.

LATER EIGHTEENTH-CENTURY ART IN FRANCE

The late eighteenth century in France witnessed the fading fortunes of the Rococo under the impact of Enlightenment ideas, Neoclassicism, and the gathering clouds of revolution. These new currents led artists away from the Rococo's breezy if entertaining subjects and toward art that was more edifying or inspiring. Architects hewed a line closer to Roman sources, while painters and sculptors increasingly embraced either a down-to-earth naturalism or didactic narratives. The era also saw the rise of the most important exponent of Neoclassicism in painting, Jacques-Louis David.

Architecture

French architects of the late eighteenth century generally considered classicism not one of many alternative styles but *the* single, true style. In the increasingly secular, Enlightenment-oriented culture of the period, the Rococo seemed frivolous, the Baroque was associated (rightly or wrongly) with corrupt and scheming Roman Catholicism, while the Gothic called up the superstitions of the medieval period. In order to achieve greatness, many believed along with Winckelmann that "imitation of the ancients" was the key to success. He wrote in *Reflections on the Imitation of Greek Works*, "Good

29–33 | William Blake **ELOHIM CREATING ADAM**
1795. Color print finished in pen and watercolor, 17 × 21⅛" (43.1 × 53.6 cm).
Tate Gallery, London.

Made through a monotype process, Blake's large color prints of 1795 combine printing with painting and drawing. To make them, the artist first laid down his colors (possibly oil paint) on heavy paperboard. From the painted board Blake then pulled a few impressions, usually three, on separate sheets of paper. These impressions would vary in effect, with the first having fuller and deeper colors than the subsequent ones. Blake then finished each print by hand, using watercolor and pen and ink.

29–34 | Jacques-Germain Soufflot **PANTHÉON (CHURCH OF SAINTE-GENEVIÈVE)**
Paris. 1755–92.

This building has a strange history. Before it was completed, the Revolutionary government in control of Paris confiscated all religious properties to raise desperately needed public funds. Instead of selling Sainte-Geneviève, however, they voted in 1791 to make it the Temple of Fame for the burial of Heroes of Liberty. Under Napoleon I (ruled 1799–1814), the building was resanctified as a Catholic church and was again used as such under King Louis-Philippe (ruled 1830–48) and Napoleon III (ruled 1852–70). Then it was permanently designated a nondenominational lay temple. In 1851, the building was used as a physics laboratory. Here the French physicist Jean-Bernard Foucault suspended his now-famous pendulum on the interior of the high crossing dome and by measuring the path of the pendulum's swing proved his theory that the earth rotated on its axis in a counter-clockwise motion. In 1995, the ashes of Marie Curie, who had won the Nobel Prize in chemistry in 1911, were moved into this "memorial to the great men of France," making her the first woman to be enshrined there.

taste, which is becoming more prevalent throughout the world, had its origins under the skies of Greece." Original examples of Greek art were mostly inaccessible because the region was then dominated by the Ottoman Turks; but Roman art, its nearest equivalent, was close at hand.

The leading Neoclassical architect was Jacques-Germain Soufflot (1713–80); his Church of Sainte-Geneviève (FIG. 29–34), known today as the **PANTHÉON,** is the most typical Neoclassical building. Here Soufflot attempted to integrate three traditions: the kind of Roman architecture he had seen on his two trips to Italy; French and English Baroque classicism; and the Palladian style being revived at the time in England. The façade, with its huge portico, is modeled directly on ancient Roman temples. The dome, on the other hand, was inspired by several seventeenth-century examples, including Wren's Saint Paul's in London (SEE FIG. 22–66). Finally, the radical geometry of its plan (FIG. 29–35), a central-plan Greek cross, owes as much to Burlington's Chiswick House (SEE FIG. 29–19) as it does to Christian tradition. Note that he replaced the interlocking ovals and bulges of the Rococo with clear and pure rectangles, squares, and circles. Soufflot also seems to have been inspired by the plain, undecorated surfaces Burlington used in his home. The result is a building that attempts to maintain and develop the historical continuity of the classical tradition.

Painting and Sculpture

While French painters such as Boucher, Fragonard, and their followers continued to work in the Rococo style in the later decades of the eighteenth century, a strong reaction against the Rococo had set in by the 1760s. A leading detractor of the Rococo was Denis Diderot (1713–84), an Enlightenment figure whom many consider the founder of modern art criticism. In 1759, Diderot began to write reviews of the official Salon for a periodic newsletter for wealthy subscribers. Diderot believed that it was art's proper function to "inspire virtue and purify manners." He therefore criticized the adherents of the Rococo, whose characteristic works he con-

29–35 | **SECTION AND PLAN OF THE PANTHÉON (CHURCH OF SAINTE-GENEVIÈVE)**

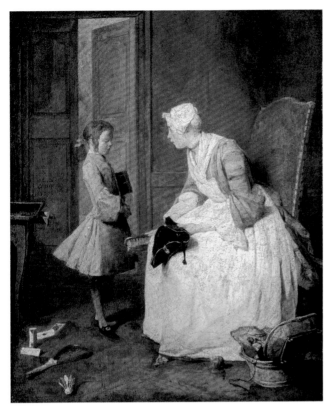

29–36 | Jean-Siméon Chardin **THE GOVERNESS**
1739. Oil on canvas, 18⅛ × 14¾" (46 × 37.5 cm).
National Gallery of Canada, Ottawa.
Purchase, 1956

Chardin was one of the first French artists to treat the lives of
women and children with sympathy and to honor the dignity of
women's work in his portrayals of young mothers, governesses,
and kitchen maids. Shown at the Salon of 1739, *The Governess* was
praised by contemporary critics, one of whom noted "the gracious-
ness, sweetness, and restraint that the governess maintains in
her discipline of the young man about his dirtiness, disorder,
and neglect; his attention, shame, and remorse; all are expressed
with great simplicity."

sidered frivolous at best and immoral at worst. Diderot's most
notable accomplishment was editing, in collaboration with
Jean le Rond d'Alembert, the *Encyclopédie* (1751–77), a
thirty-two-volume compendium of knowledge and opinion
that served as an archive of Enlightenment thought in fields
as diverse as agriculture, aesthetics, and penology.

CHARDIN. Diderot found in Jean-Siméon Chardin (1699–
1779) an artist to his liking. A painter whose output was lim-
ited essentially to still lifes and quiet domestic scenes, Chardin
tended to work on a small scale, meticulously and slowly. As
early as the 1730s, Chardin began to create moral genre pic-
tures in the tradition of seventeenth-century Dutch genre
paintings, which focused on simple, mildly touching scenes of
everyday middle-class life. One such picture, **THE GOVERNESS**
(**FIG. 29–36**), shows a finely dressed boy, with books under his
arm, who listens to his governess as she prepares to brush his
tricorn (three-cornered) hat. Scattered on the floor behind
him are a racquet, a shuttlecock, and playing cards, evoking
the childish pleasures that the boy leaves behind as he pre-
pares to go to his studies and, ultimately, to a life of responsi-
ble adulthood. The work equally encourages benevolent
exercise of authority, and willing submission to it.

GREUZE. Diderot's highest praise went to Jean-Baptiste
Greuze (1725–1805)—which is hardly surprising, because
Greuze's major source of inspiration came from the kind of
middle-class drama that Diderot had inaugurated with his
plays of the late 1750s. In addition to comedy and tragedy,
Diderot thought the range of theatrical works should include
a "middle tragedy" that taught useful lessons to the public
with clear, simple stories of ordinary life. Greuze's domestic
genre paintings, such as **THE DRUNKEN COBBLER** (**FIG. 29–37**),

29–37 | Jean-Baptiste Greuze
THE DRUNKEN COBBLER
1780-85. Oil on canvas, 29⅝ × 36⅜"
(75.2 × 92.4 cm). Portland Art Museum,
Portland, Oregon.
Gift of Marion Bowles Hollis

In 1769, Greuze submitted a classical history paint-
ing to the Salon and requested the French Academy
to change his official status from genre painter to
the higher rank of history painter. The work was
accepted but the request was refused. Greuze was so
angry that he did not again exhibit at the Salon until
1800, preferring to show his works privately or in
exhibitions sponsored by other organizations than
the academy.

became the visual counterparts of that new theatrical form, which later became known as melodrama. On a shallow, stagelike space and under a dramatic spotlight, a drunken father returns home to his angry wife and hungry children. The gestures of the children make clear that he has spent the family's grocery money on drink. In other paintings, Greuze offered wives and children similar lessons in how not to behave.

VIGÉE-LEBRUN. French portrait painters before the Revolution of 1789 moved toward naturalistic poses and more everyday settings. Elegant informality continued to be featured, but new themes were introduced, figures tended to be larger and more robust, and compositional arrangements were more stable. Many leading portraitists were women. The

most famous was Marie-Louise-Élisabeth Vigée-Lebrun (1755–1842), who in the 1780s became Queen Marie Antoinette's favorite painter. In 1787, she portrayed the queen with her children (FIG. 29–38), in conformity with the Enlightenment theme of the "good mother," already seen in Angelica Kauffmann's painting of Cornelia (SEE FIG. 29–30). The portrait of the queen as a kindly, stabilizing presence for her offspring was meant to counter her public image as selfish, extravagant, and immoral. The princess leans affectionately against her mother, proof of the queen's natural goodness. In a further attempt to gain the viewer's sympathy, the little dauphin—the eldest son and heir to a throne he would never ascend—points to the empty cradle of a recently deceased sibling. The image also alludes to the well-known allegory of Abundance, suggesting the peace and prosperity of society under the reign of her husband, Louis XVI, who began his rule in 1774 but fell victim to revolutionary turmoil and was executed in 1792.

In 1783, Vigée-Lebrun was elected to one of the four places in the French Academy available to women. Also elected that year was Adélaïde Labille-Guiard (1749–1803), who in 1790 successfully petitioned to end the restriction on women. Labille-Guiard's commitment to increasing the number of women painters in France is evident in a self-portrait with two pupils that she submitted to the Salon of 1785. The monumental image of the artist at her easel (FIG. 29–39) was also meant to answer the sexist rumors that her paintings and those by Vigée-Lebrun had actually been painted by men. In a witty role reversal, the only male in this work is *her* muse—her father, whose bust is behind her. While the self-portrait flatters the painter's conventional feminine charms in a manner generally consistent with the Rococo tradition, a comparison with similar images of women by artists such as Fragonard (SEE FIG. 29–11) reveals the more monumental female type Labille-Guiard favored, in keeping with her conception of women as important contributors to national life, which is an Enlightenment impulse. The solid pyramidal arrangement of the three women adds to the effect.

DAVID. The most important French Neoclassical painter of the era was Jacques-Louis David (1748–1825), who dominated French art during the Revolution and subsequent reign of Napoleon. In 1774, David won the Prix de Rome and spent six years there, studying antique sculpture and assimilating the principles of Neoclassicism. After his return, he produced a series of severely undecorated, anti-Rococo paintings that extolled the antique virtues of stoicism, masculinity, and patriotism. In a career that rode the cresting waves of the Revolution, David was the dominant artist in France for over twenty years, creating memorable paintings and training the next generation.

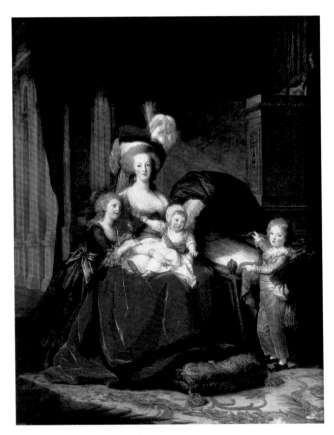

29–38 | Marie-Louise-Élisabeth Vigée-Lebrun
PORTRAIT OF MARIE ANTOINETTE WITH HER CHILDREN
1787. Oil on canvas, 9′½″ × 7′⅝″ (2.75 × 2.15 m).
Musée National du Château de Versailles.

As the favorite painter to the queen, Vigée-Lebrun escaped from Paris with her daughter on the eve of the Revolution of 1789 and fled to Rome. After a very successful self-exile working in Italy, Austria, Russia, and England, the artist finally resettled in Paris in 1805 and again became popular with Parisian art patrons. Over her long career, she painted about 800 portraits in a vibrant style that changed very little over the decades.

29–39 | Adélaïde Labille-Guiard **SELF-PORTRAIT WITH TWO PUPILS**
1785. Oil on canvas, 6′11″ × 4′11½″ (2.11 × 1.51 m). The Metropolitan Museum of Art, New York.

Gift of Julia A. Berwind, 1953 (53.225.5)

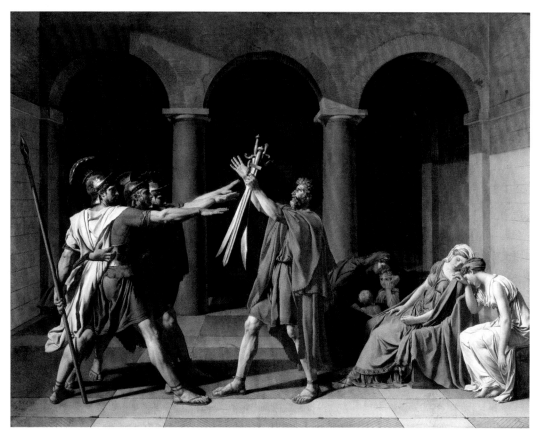

29–40 | Jacques-Louis David **OATH OF THE HORATII**
1784–85. Oil on canvas, 10′8¼″ × 14′(3.26 × 4.27 m). Musée du Louvre, Paris.

The most famous and influential of these works was the **OATH OF THE HORATII** (FIG. 29–40), of 1784–85. A royal commission, the work reflects the taste and values of Louis XVI, who along with his minister of the arts, Count d'Angiviller, was sympathetic to the Enlightenment. Following Diderot's lead, d'Angiviller and the king believed art should improve public morals. Among his first official acts, d'Angiviller banned indecent nudity from the Salon of 1775 and commissioned a series of didactic history paintings. David's commission in 1784 was part of that general program.

This work was inspired by Pierre Corneille's seventeenth-century drama *Horace*, which was itself based on ancient Roman historical texts, although the patriotic oath-taking incident depicted by David is found in none of these sources and seems to have been his own invention. The story concerns an episode from the seventh century BCE when Rome and its rival Alba, a neighboring city-state, agreed to settle a border dispute and avert a war by means of a battle to the death between the three sons of Horace (the Horatii), representing Rome, and the three Curatii, representing Alba. In David's painting, which he set in an austere Roman interior, the triplet Horatii stand with arms outstretched toward their father, who holds up the swords on which the young men pledge to fight to the death for

Rome. In contrast to the upright, muscular angularity of the men is a group of limp and weeping women and frightened children at the right. The women are upset not simply because the Horatii might die but also because one of them (Sabina, in the center) is a sister of the Curatii, married to one of the Horatii, and another (Camilla, at the far right) is engaged to one of the Curatii. David's composition, which spatially separates the men from the women and children through the use of the framing background arches, effectively contrasts the men's stoic willingness to sacrifice themselves for the state with the women's emotional commitment to family ties.

David's painting soon became an emblem of the French Revolution of 1789, which, ironically, precipitated the downfall of the monarchy that had commissioned the work. The painting's lesson in the sacrifices required for the good of the state effectively captured the mood of the leaders of the new French Republic established in 1792, as the revolutionaries abolished the monarchy, extinguished titles of nobility, took education out of the hands of the Church, and wrote a declaration of human rights. David sympathized with all of these causes. He joined the leftist Jacobin party, and they in turn appointed him national minister of the arts when they achieved power in 1792.

reductive Neoclassical style with a dramatic naturalism to liken Marat to a martyred saint. Marat's dangling right arm echoes that of Christ in both Michelangelo's Sistine *Pietà* and Caravaggio's *Entombment* (SEE FIGS. 20–9 AND 22-17), making Marat a Christ-like figure who has given his life for a greater cause—in this case not religious but political.

The Revolution degenerated into mob rule in 1793–94, as various political parties ruthlessly executed thousands of their opponents in what became known as the Reign of Terror. David himself, as a member of the Jacobins, served a two-week term as president, during which he signed several arrest warrants. When the Jacobins lost power in 1794, David was twice imprisoned, but he later emerged as a partisan of Napoleon and reestablished his career at the pinnacle of French art.

GIRODET-TRIOSON. A charismatic and influential teacher, David trained most of the important French painters who emerged in the 1790s and early 1800s. The lessons of David's teaching are evident, for example, in the **PORTRAIT OF JEAN-BAPTISTE BELLEY** (FIG. 29–42) by Anne-Louis Girodet-Trioson (1767–1824). Stylistically, the work combines a

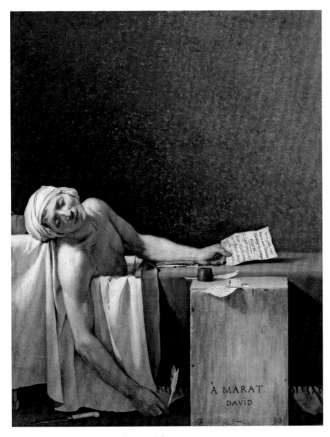

29–41 | Jacques-Louis David **DEATH OF MARAT**
1793. Oil on canvas, 5′5″ × 4′2½″ (1.65 × 1.28 m). Musées Royaux des Beaux-Arts de Belgique, Brussels.

In 1793, David was elected a deputy to the National Convention and was named propaganda minister and director of public festivals. Because he supported Robespierre and the Reign of Terror, he was twice imprisoned after its demise in 1794, albeit under lenient circumstances that allowed him to continue painting.

David's greatest painting commemorates the death of one of the Jacobin leaders, Jean-Paul Marat (FIG. 29–41). A radical journalist, Marat lived simply among the packing cases that he used as furniture, writing pamphlets that urged the abolition of aristocratic privilege. A young supporter of an opposition party, Charlotte Corday, saw Marat as partly responsible for the 1792 riots in which hundreds of political prisoners deemed sympathetic to the king were killed. She decided that Marat should pay for his actions. Because Marat suffered from a painful skin ailment, he conducted his official business sitting in a medicinal bath. After using a ruse to gain entry to his house, Corday stabbed him, dropped her knife, and fled. Instead of handling the event in a sensational manner as Greuze might have, David played down the drama and showed us its quiet, still aftermath: the dead Marat slumped in his bathtub, a towel wrapped around his head, his right hand still holding a quill pen, his left hand grasping the letter Corday handed him on her entry. The simple wood block at the right, which Marat used as a desk, becomes his tombstone, inscribed with the painter's dedication. David combined his

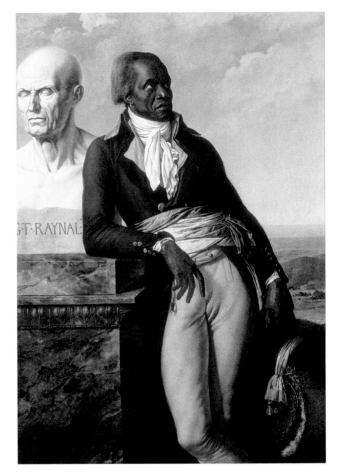

29–42 | Anne-Louis Girodet-Trioson **PORTRAIT OF JEAN-BAPTISTE BELLEY**
1797. Oil on canvas, 5′2½″ × 3′8½″ (1.59 × 1.13 m). Musée National du Château de Versailles.

graceful pose recalling a classical sculpture with the kind of descriptive naturalism found in David's *Marat*. The work also has a significant political dimension. The Senegal-born Belley (1747?–1805) was a former slave sent by the colony of Saint-Domingue (now Haiti) as a representative to the French Convention. In 1794, he led the successful legislative campaign to abolish slavery in the colonies and grant black people full citizenship. Belley leans casually on a pedestal with the bust of the abbot Guillaume Raynal (1713–96), the French philosophe whose 1770 book condemning slavery had prepared the way for such legislation. (Unfortunately, in 1801 Napoleon reestablished slavery in the Caribbean Islands.) Girodet's portrait is therefore more of a tribute to the egalitarian principles of Raynal and Belley than it is a conventional portrait meant to flatter a sitter.

HOUDON. The heroes of the Enlightenment found their sculptor in Jean-Antoine Houdon (1741–1828), who combined naturalism with Neoclassicism in a way that influenced public monuments until the twentieth century. Houdon studied in Italy between 1764 and 1768 after winning the Prix de Rome. His commitment to a Neoclassical style began

during his stay in Rome, where he came into contact with some of the leading artists and theorists of the movement. Houdon carved busts and full-length statues of many important figures of his era, such as Diderot, Voltaire, Jean-Jacques Rousseau, Catherine the Great, Thomas Jefferson, Benjamin Franklin, Lafayette, and Napoleon. On the basis of his bust of Benjamin Franklin, Houdon was commissioned by the Virginia state legislature to do a portrait of its native son George Washington. Houdon traveled to the United States in 1785 to make a cast of Washington's features and a bust in plaster. He then executed a life-size marble figure in Paris (FIG. 29–43). For this work, Houdon combined contemporary naturalism with the new classicism that many were beginning to identify with republican politics. Although the military leader of the American Revolution of 1776 is dressed in his general's uniform, Washington's serene expression and relaxed contrapposto pose derive from sculpted images of classical athletes. Washington's left hand rests on a *fasces*, a bundle of rods tied together with an axe face, used in Roman times as a symbol of authority. The thirteen rods bound together are also a reference to the union formed by the original states. Attached to the *fasces* are a sword of war

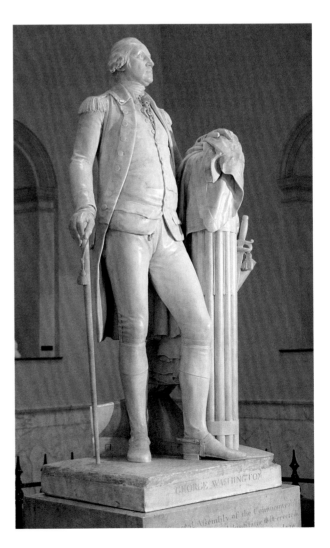

29–43 | Jean-Antoine Houdon
GEORGE WASHINGTON
1788–92. Marble, height 6'2" (1.9 m).
State Capitol, Richmond, Virginia.

The plow blade behind Washington alludes to Cincinnatus, a Roman soldier of the fifth century BCE who was appointed dictator and dispatched to defeat the Aequi, who had besieged a Roman army. After the victory, Cincinnatus resigned the dictatorship and returned to his farm. Washington's contemporaries compared him with Cincinnatus because, after leading the Americans to victory over the British, he resigned his commission and went back to farming rather than seeking political power. Just below Washington's waistcoat hangs the badge of the Society of the Cincinnati, founded in 1783 by the officers of the disbanding Continental Army who were returning to their peacetime occupations. Washington lived in retirement at his Mount Vernon, Virginia, plantation for five years before his 1789 election as the first president of the United States.

and a plowshare of peace. Houdon's studio turned out a regular supply of replicas of such works as part of the cult of great men promoted by Enlightenment thinkers as models for all humanity.

EIGHTEENTH-CENTURY ART OF THE AMERICAS

New Spain

In the wake of the Spanish conquest of central and south America, the conquerors suppressed local beliefs and practices and imposed Roman Catholicism throughout Spanish America. Native American temples were torn down, and churches were erected in their place. The early work of conversion fell to Franciscan, Dominican, and Augustinian religious orders. Several missionaries were so appalled by the conquerors' treatment of the people they called Indians that they petitioned the Spanish king to improve their conditions.

In the course of the Native Americans' conversion to Roman Catholicism, their own symbolism was to some extent absorbed into Christian symbolism. This process can be seen in the huge early colonial **atrial crosses**, so called because they were located in church atriums, where large numbers of converts gathered for education in the new faith. Missionaries recruited Native American sculptors to carve these crosses. One sixteenth-century **ATRIAL CROSS,** now in the Basilica of Guadalupe near Mexico City, suggests pre-Hispanic sculpture in its stark form and rich surface symbols in low relief, even though the individual images were probably copied from illustrated books that the missionaries brought (FIG. 29–44). The work is made from two large blocks of stone that are entirely covered with images known as the Arms of Christ, the "weapons" Christ used to defeat the devil. Jesus's Crown of Thorns hangs like a necklace around the cross bar, and with the Holy Shroud, which also wraps the arms, it frames the image of the Holy Face (the impression on the cloth Veronica used to wipe Jesus's face). Blood gushes forth where nails pierce the ends of the cross. Symbols of regeneration, such as winged cherub heads and pomegranates, surround the inscription at the top.

The cross itself suggests an ancient Mesoamerican symbol, the Tree of Life. The image of blood sacrifice also resonates with indigenous beliefs. Like the statue of the Aztec earth mother Coatlicue (SEE FIG. 26–4), the cross is composed of many individual elements that seem compressed to make a shape other than their own, the dense low relief combining into a single massive form. Simplified traditional Christian imagery is clearly visible in the work, although it may not yet have had much meaning or emotional resonance for the artists who put it there.

Converts in Mexico gained their own patron saint after the Virgin Mary was believed to have appeared as an Indian to an Indian named Juan Diego in 1531. Mary is said to have

29–44 | **ATRIAL CROSS**
Before 1556. Stone, height 11′ 3″ (3.45 m). Chapel of the Indians, Basilica of Guadalupe, Mexico City.

asked that a church be built on a hill where an Aztec mother goddess had once been worshiped. As evidence of this vision, Juan Diego brought the archbishop flowers that the Virgin had caused to bloom, wrapped in a cloak. When Juan Diego opened his bundle, the cloak bore the image of a dark-skinned Mary, an image that, light-skinned, was popular in Spain and known as the Virgin of the Immaculate Conception. The site of the vision was renamed Guadalupe after Our Lady of Guadalupe in Spain, and it became a venerated pilgrimage center. In 1754, the pope declared the Virgin of Guadalupe the patron saint of the Americas, seen here (FIG. 29–45) in a 1779 work by Sebastian Salcedo.

Spanish colonial builders quite naturally tried to replicate the architecture of their native country in their adopted lands. In the colonies of North America's Southwest, the builders of one of the finest examples of mission architecture, **SAN XAVIER DEL BAC,** near Tucson, Arizona (FIG. 29–46), looked to Spain for its inspiration. The Jesuit priest Eusebio Kino (1644–1711) began laying the foundations in 1700, using stone quarried locally by Native Americans of the Pima nation. The desert

29–45 | Sebastian Salcedo **OUR LADY OF GUADALUPE**
1779. Oil on panel and copper, 25 × 19″ (63.5 × 48.3 cm). Denver Art Museum.

At the bottom right is the female personification of New Spain (Mexico) and at the left is Pope Benedict XIV (papacy 1740–58), who in 1754 declared the Virgin of Guadalupe to be the patroness of the Americas. Between the figures, the sanctuary of Guadalupe in Mexico can be seen in the distance. The four small scenes circling the Virgin represent the story of Juan Diego, and at the top, three scenes depict Mary's miracles. The six figures above the Virgin represent Old Testament prophets and patriarchs and New Testament apostles and saints.

29–46 │ **MISSION SAN XAVIER DEL BAC**
Near Tucson, Arizona. 1784-97.

site had already been laid out with irrigation ditches, and Father Kino wrote in his reports that there would be running water in every room and workshop of the new mission, but the building never proceeded. The mission site was turned over to the Franciscans in 1768, after King Charles III ousted the Jesuit order from Spain and asserted royal control over Spanish churches. Father Kino's vision was realized by the Spanish Franciscan missionary and builder Juan Bautista Velderrain (d. 1790), who arrived at the mission in 1776.

The huge church, 99 feet long with a domed crossing and flanking bell towers, was unusual for the area since it was built of brick and mortar rather than adobe, which is made of earth and straw. The basic structure was finished by the time of Valderrain's death in 1790, and the exterior decoration was completed by 1797 under the supervision of his successor.

Although San Xavier is far from a copy, the focus on the central entrance area, with its Spanish Baroque decoration, is clearly in the tradition of the earlier work of Pedro de Ribera in Madrid. The mission was dedicated to Francis Xavier, whose statue once stood at the apex of the portal decoration. In the niches are statues of four female saints tentatively indentified as Lucy, Cecilia, Barbara, and Catherine of Siena. Hidden in the sculpted mass is one humorous element: a cat confronting a mouse, which inspired a local Pima saying: "When the cat catches the mouse, the end of the world will come" (cited in Chinn and McCarty, page 12).

North America

Eighteenth-century art by the white inhabitants of North America remained largely dependent on the styles of the European countries—Britain, France, and Spain—that had colonized the continent. Throughout the century, easier and more frequent travel across the Atlantic contributed to the assimilation of the European styles, but in general North American art lagged behind the European mainstream. In the early eighteenth century, the colonies grew rapidly in population, and rising prosperity led to an increased demand among the wealthy for fine works of art and architecture. (Apart from gravestone reliefs, sculpture was all but unknown.) Initially this demand was met by European immigrants who came to work in the colonies, but by the middle of the century a number of native-born American artists were also achieving professional success.

ARCHITECTURE. Professional architects, as we know them today, did not exist in the American colonies; rather, most fine houses and important public buildings were designed by amateur architects, sometimes called gentlemen-architects, who had the means and leisure to acquire and read books on architectural theory and the principles of design. These amateurs usually adapted, and sometimes copied outright, their building designs from the illustrated books of the sixteenth-century Italian architect Andrea Palladio (see Chapter 20) or the published designs of his English followers such as Inigo

29–47 | Thomas Jefferson **MONTICELLO**
Charlottesville, Virginia. 1769–82, 1796–1809.

Jones, who had introduced the Palladian style to England in the seventeenth century.

The tremendously accomplished Thomas Jefferson (1743–1826), principal author of the Declaration of Independence, governor of Virginia (1779–81), American minister to France (1785–89), second vice president (1797–1801), and third president of the United States (1801–09), was also a gentleman-architect. While serving in France, Jefferson was asked by the Virginia legislature to procure a design for the new state capitol in Richmond. In consultation with the French archaeologist and Neoclassical architect Charles-Louis Clérisseau (1721–1820), Jefferson produced a design for the capitol based on an ancient Roman temple. Jefferson's political convictions led him to this choice: He felt that the United States, having won its independence from Britain, should also free itself from the influence of British architecture and turn for inspiration to the buildings of republican Rome, which provided an ancient example of a representative, rather than monarchical, form of government. Jefferson's Virginia State Capitol (1785–89) thus adapted the Roman temple form to symbolize the values of American democracy, republicanism, and humanism, and inaugurated Neoclassicism as the official style of governmental architecture in the United States. In

succeeding decades most other state and federal government buildings, such as the U. S. Capitol in Washington, D.C. (SEE FIG. 30–22), were built in the Neoclassical style.

Prior to his sojourn in France, Jefferson had between 1769 and 1782 designed and built, near Charlottesville, Virginia, a mountaintop home he called **MONTICELLO** (Italian for "little mountain") (FIG. 29–47), in a style based on eighteenth-century English Palladian models. In a second building campaign at Monticello (1796–1809) following his return from France, Jefferson enlarged the house and redesigned its brick and wood exterior so that its two stories would appear to be one, in the manner then fashionable for Parisian houses. He accented the entrance and garden façades by means of porticoes capped by triangular pediments, and he unified the exterior by means of a continuous Doric entablature and balustrade. Behind the garden portico rises a hexagonal drum, its walls pierced by white-framed oculi and supporting a saucer dome. The combination of pedimented portico fronting a domed space derives from the most famous of all ancient Roman temples, the Pantheon (second-century CE), also quoted in Palladio's Villa Rotonda and Burlington's Chiswick House (FIGS. 20–47, 29–18), and imparts to Monticello a distinctively Neoclassical note.

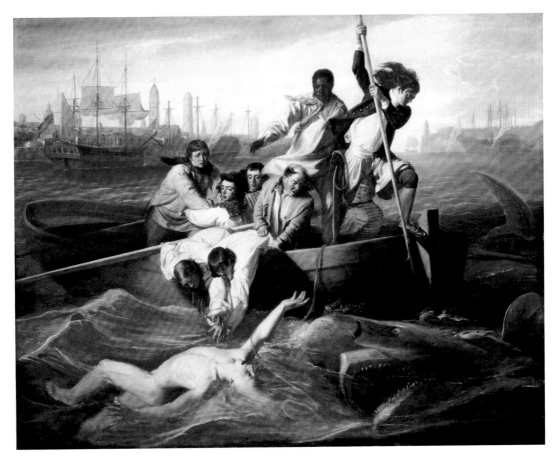

29–48 | John Singleton Copley **WATSON AND THE SHARK**
1778. Oil on canvas, 5'10¾" × 7'6½" (1.82 × 2.29 m). National Gallery of Art,
Washington, D.C.
Ferdinand Lammot Belin Fund.

PAINTING. Most painters in England's American colonies relied on native talents rather than formal training. Portraiture dominated the market in the increasingly prosperous colonies, and portraitists studied engravings to learn figure poses and backdrops. The American-born Benjamin West, a member of the Royal Academy in London from 1768, encouraged colonial artists to travel to Europe for study; the most ambitious artists accepted his invitation.

John Singleton Copley (1738–1815) grew up to be colonial America's first native-born artist of genius. Copley's sources of inspiration were meager—principally his stepfather's collection of engravings—but his work was already drawing attention when he was 15 years old. Key to Copley's success was his intuitive understanding of his upper-class clientele. They valued not only his excellent technique, which equaled that of European artists, but also his ability to dignify them while recording their features with unflinching realism, as seen in his powerful portrait of *Samuel Adams* (SEE FIG. 29–1).

Copley's talents so outdistanced those of his colonial contemporaries that the artist aspired to a larger reputation. In 1766, he sent a portrait of his half brother to an exhibition in London, where it received a favorable critical response.

Benjamin West, the expatriate artist from Pennsylvania, encouraged Copley to study in Europe. At that time, family ties kept him from following the advice, but the impending Revolutionary War soon caused him to reconsider. In 1773, rebellious colonists dressed as Native Americans boarded a ship and threw its cargo of tea into Boston Harbor to protest the British East India Company's monopoly and the tax imposed on tea by the colonial government—an event known as the Boston Tea Party.

The shipment of tea belonged to Copley's merchant father-in-law, Richard Clarke. Copley was thus torn between two circles: his affluent pro-British in-laws and clients, and his radical friends, including Paul Revere, John Hancock, and Samuel Adams. Reluctant to take sides, Copley sailed in June 1774 for Europe, visiting Italy and settling in London, where his family joined him. Like West, he never returned to his native country.

In London, Copley established himself as a portraitist and painter of modern history in the vein of West. His most distinctive effort in the latter arena was **WATSON AND THE SHARK** (FIG. 29–48), commissioned by Brook Watson, a wealthy London merchant and Tory politician. Copley's 1778 painting dramatizes a 1749 episode during which the 14-year-old Watson, while swimming in the harbor of Havana,

was attacked by a shark and lost part of his right leg before being rescued by his comrades. Against the backdrop of a view of the Havana harbor, Copley deployed his foreground figures in a pyramidal composition inspired by classical prototypes. As the ferocious shark rushes on the helpless, naked Watson, a harpooner at the rescue boat's prow raises his spear for the kill. At the left, two of Watson's mates lean out and strain to reach him while the others in the boat look on in alarm. Prominent among these is a black man at the apex of the pyramid, who holds a rope that curls over Watson's extended right arm, connecting him to the boat and symbolizing his impending rescue.

While many have seen the black figure simply as a servant waiting to hand the rope to one of his white masters, art historians have also interpreted his presence in political terms. Watson's fateful swim in Havana Harbor occurred while he was working in the transatlantic shipping trade, one aspect of which involved the shipment of slaves from Africa to the West Indies. At the time Watson commissioned Copley's painting, a debate raged in Parliament not only over the Americans' recent Declaration of Independence, but also over the slave trade. Watson and other Tories opposed American independence and highlighted the hypocrisy of American calls for freedom from the British Crown while the colonists continued to deny freedom to African slaves. Furthermore, during the Revolutionary War the British used slavery to their advantage by promising freedom to every runaway American slave who joined the British army or navy.

Copley's painting, its subject doubtless dictated by Watson, therefore could be interpreted as a demonstration of Tory sympathy for the plight of the American slaves (though it should be noted that Watson ultimately did not support the outright abolition of slavery but rather gradual emancipation). In the context of Tory opposition to American independence, the shark-infested waters could symbolize the colonies themselves, a breeding ground of dangerous revolutionary ideas, while Watson's severed leg could stand for the dismemberment of the British Empire through the loss of its American colonies. Further connecting Watson, slavery, and the American colonies was the slavers' practice of throwing dead slaves overboard to the sharks during the journey from Africa to America. Yet Watson himself, through his involvement in the slave trade, had acted like a devouring shark and Copley represents him, metaphorically, as a victim of divine wrath (symbolized by the attacking shark) whose suffering redeems his guilty past. Significantly, Watson's arm reaches not toward his white comrades but toward the black man, whose reciprocal gesture seems to confer forgiveness.

The chaotic and uncertain mood of *Watson and the Shark* speaks of Romanticism, the movement that began in the late eighteenth century and would increasingly dominate the early nineteenth as the social forces unleashed by the Enlightenment and industrialization took hold across the Western world.

IN PERSPECTIVE

The eighteenth century in the West began under the sunny skies of the Rococo, as court artists decorated the salons of aristocrats with paintings that portrayed a life of ease. These works, whether by Tiepolo, Watteau, or Fragonard, generally took the aristocracy itself as subject matter, and depicted them in relaxed poses not based on classical norms, frolicking or relaxing in lush settings. The Rococo building style, initiated by Johan Balthasar Neumann in Bavaria, is a sensuous version of the Baroque. Spaces consist of complex, interpenetrating circles and ovals, with delicately scaled decoration.

The intellectual movement known as the Enlightenment influenced both society and art beginning in the middle years of the century. Based on scientific research rather than traditional belief, this movement led directly to the concept of universal human rights that many countries still aspire to today. Denis Diderot and others urged artists to work for the common good, and this encouraged artists such as Vigée-Lebrun to paint portraits in a down-to-earth style. Others, such as Wright, glorified science, and still others, such as Hogarth and Greuze, criticized aspects of the culture in the hope of improving it.

The discovery of the ruins of Pompeii and Herculaneum helped to set off the Neoclassical movement just after mid-century. Neoclassical painters such as David and Kauffmann, and sculptors such as Canova, rebelled against the entertaining Rococo and created art based on inspiring classical stories, with figure poses modeled after Roman reliefs in clear, evenly lit compositions. Neoclassicism also infused architecture with new, simpler designs based on Renaissance or Roman models. Leading architects included Jefferson, Boyle, Adam, and Soufflot.

Near the end of the century, the Romantic movement began to flower in England. Walpole redesigned Strawberry Hill to capture the flavor of the Middle Ages, Blake reinterpreted the Bible in his highly imaginative way, and John Henry Fuseli painted his nightmares. This movement, based on dreams, fantasies, and literature, would reach its height in the next century.

The eighteenth century ended in the smoke of the French Revolution, with Neoclassicism and incipient Romanticism the dominant movements.

WATTEAU
PILGRIMAGE TO THE ISLAND OF CYTHERA
1717

CHARDIN
THE GOVERNESS
1739

CHURCH OF THE VIERZEHNHEILIGEN
1743–72

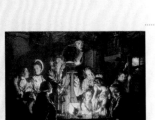

WRIGHT
AN EXPERIMENT ON A BIRD IN THE AIR-PUMP
1768

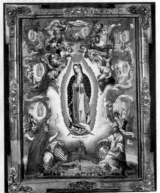

SALCEDO
OUR LADY OF GUADALUPE
1779

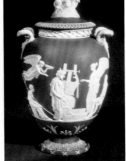

WEDGWOOD
VASE
1786

1700

1720

1740

1760

1780

1800

EIGHTEENTH-CENTURY ART IN EUROPE AND THE AMERICAS

◀ **Louis XIV of France Dies** 1715
◀ **Louis XV Rules France** 1715–74

◀ **Seven Years' War** 1756–63

◀ **Women Were Founding Members of English Royal Academy** 1768

◀ **Louis XVI Rules France** 1774–92

◀ **American Revolution Begins** 1776

◀ **French Revolution Begins** 1789

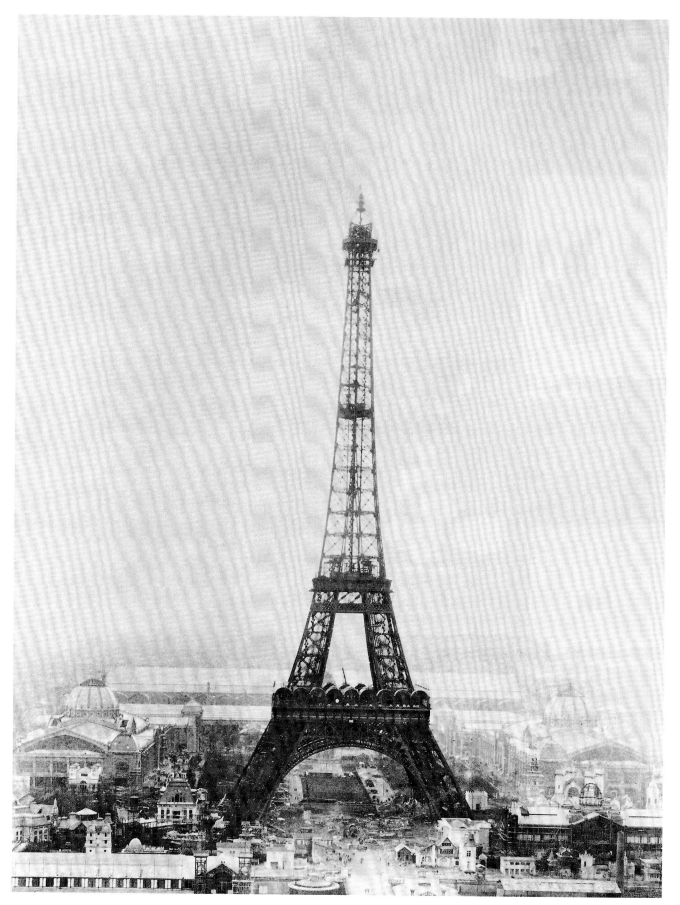

30–1 Gustave Eiffel **EIFFEL TOWER** Paris. 1887–89.

NINETEENTH-CENTURY ART
IN EUROPE AND THE UNITED STATES

"We writers, painters, sculptors, architects, and devoted lovers of the beauty of Paris . . . do protest with all our strength and all our indignation . . . against the erection, in the very heart of our capital, of the useless and monstrous Eiffel Tower, which public spitefulness . . . has already baptized, 'the Tower of Babel.' " With these words, published in *Le Temps* on February 14, 1887, a group of conservative artists announced their strong opposition to the immense iron tower just beginning to be built on the River Seine. The work of the engineer Gustave Eiffel (1832–1923), the 300-meter (984-foot) tower would upon its completion be the tallest structure in the world, dwarfing even the Egyptian pyramids and Gothic cathedrals.

The **EIFFEL TOWER** (FIG. 30–1) was the main attraction of the 1889 Universal Exposition, one of several large fairs staged in Europe and the United States during the late nineteenth century to showcase the latest international advances in science and industry, while also displaying both fine and applied arts. But because Eiffel's marvel lacked architectural antecedents and did not conceal its construction, detractors saw it as an ugly, overblown work of engineering. For its admirers, however, it achieved a new kind of beauty derived from modern science and was an exhilarating symbol of technological innovation and human aspiration. One French poet called it "an iron witness raised by humanity into the azure sky to bear witness to its unwavering determination to reach the heavens and establish itself there." Perhaps more than any other monument, the Eiffel Tower embodies the nineteenth-century belief in the progress and ultimate perfection of civilization through science and technology.

EUROPE AND THE UNITED STATES IN THE NINETEENTH CENTURY

The Enlightenment set in motion powerful forces that would dramatically transform life in Europe and the United States during the nineteenth century. Great advances in manufacturing, transportation, and communications created new products for consumers and new wealth for entrepreneurs, fueling the rise of urban centers and improving living conditions for many (SEE MAP 30–1). But this so-called Industrial Revolution also condemned masses of workers to poverty and catalyzed new political movements for social reform. Animating these developments was the widespread belief in "progress" and the ultimate perfectibility of human civilization—a belief rooted deeply in Enlightenment thought (Chapter 29).

The Industrial Revolution had begun in eighteenth-century Britain, where the new coal-fired steam engine ran such innovations in manufacturing as the steam-powered loom. Increasing demands for coal and iron necessitated improvements in mining, metallurgy, and transportation. Subsequent development of the locomotive and steamship in turn facilitated the shipment of raw materials and merchandise, made passenger travel easier, and encouraged the growth of new cities.

Displaced from their small farms and traditional cottage industries by technological developments in agriculture and manufacturing, the rural poor moved to the new factory and mining towns in search of employment, and industrial laborers—many of them women and children—suffered miserable working and living conditions. Although new government regulations led to improvements during the second half of the nineteenth century, socialist movements condemned the exploitation of laborers by capitalist factory owners and advocated communal or state ownership of the means of production and distribution. The most radical of these movements was communism, which called for the abolition of private property.

Efforts at social reform reached a peak in 1848, as workers' revolts broke out in several European capitals. In that year, Karl Marx and Friedrich Engels also published the *Communist Manifesto*, which predicted the violent overthrow of the bourgeoisie (middle class) by the proletariat (working class) and the creation of a classless society. At the same time, the Americans Lucretia Mott and Elizabeth Cady Stanton organized the country's first women's rights convention, in Seneca Falls, New York. They called for the equality of women and men before the law, property rights for married women, the acceptance of women into institutions of higher education, the admission of women to all trades and professions, equal pay for equal work, and women's suffrage.

Continuing scientific discoveries led to the telegraph, telephone, and radio. By the end of the nineteenth century, electricity powered lighting, motors, trams, and railways in most European and American cities. Developments in chemistry created many new products, such as aspirin, disinfectants, photographic chemicals, and explosives. The new material of steel, an alloy of iron and carbon, was lighter, harder, and more malleable than iron, and replaced it in heavy construction and transportation. In medicine and public health, Louis Pasteur's purification of beverages through heat (pasteurization) and the development of vaccines, sterilization, and antiseptics led to a dramatic decline in death rates all over the Western world.

Some scientific discoveries challenged traditional religious beliefs and affected social philosophy. Geologists concluded that the earth was far older than the estimated 6,000 years sometimes claimed for it by biblical literalists. Contrary to the biblical account of creation, Charles Darwin proposed that all life evolved from a common ancestor and changed through genetic mutation and natural selection. Religious conservatives attacked Darwin's account of evolution, which seemed to deny the divine creation of humans and even the existence of God. Some of Darwin's supporters, however, suggested that "survival of the fittest" had advanced the human race, with certain types of people—particularly the

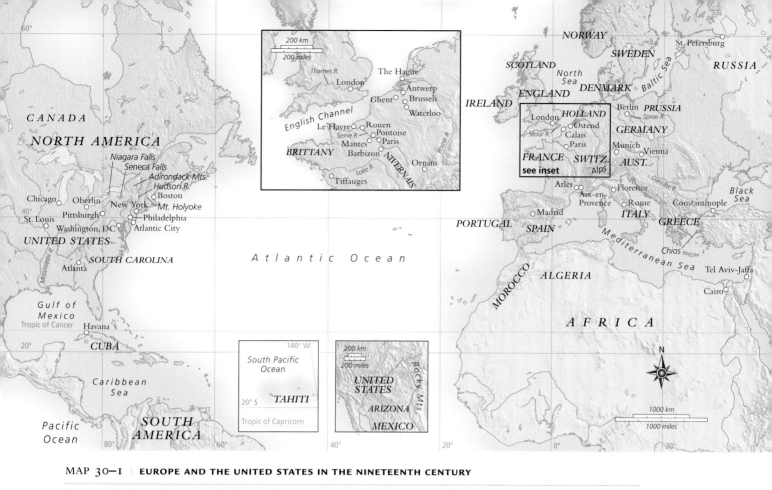

MAP 30—1 | **EUROPE AND THE UNITED STATES IN THE NINETEENTH CENTURY**

Europe took the lead in industrialization, and France became the cultural beacon of the Western world.

Anglo-Saxon upper classes—achieving the pinnacle of social evolution. "Social Darwinism" provided a rationalization for the "natural" existence of a less "evolved" working class and a justification for British and American colonization of "underdeveloped" parts of the world.

The nineteenth century also witnessed the rise of imperialism. To create new markets for their products and to secure access to cheap raw materials and cheap labor, European nations established colonies in most of Africa and nearly a third of Asia. Colonial rule brought some technological improvements to non-Western regions but also threatened traditional native cultures and suppressed the economic development of the colonized areas.

As the power of both the Church and the Crown declined in the nineteenth century, so did their influence over artistic production. In their place, the capitalist bourgeoisie, nation-states, and national academies became major patrons of the arts. Large annual exhibitions in European and American cultural centers took on increasing importance as a means for artists to show their work, win prizes, attract buyers, and gain commissions. Art criticism proliferated in mass-printed periodicals, helping both to make and to break artis-

tic careers. And, in the later decades of the century, commercial art dealers gained in importance as marketers of both old and new art.

EARLY NINETEENTH-CENTURY ART: NEOCLASSICISM AND ROMANTICISM

Both Neoclassicism and Romanticism (see Chapter 29) remained vital in early nineteenth-century European and American art. Neoclassicism survived past the middle of the century in both architecture and sculpture, as patrons and creators held to the belief that recalling Greece and Rome ensured a connection to democracy. Neoclassical painters tended to dominate academies, where teachers urged students to learn from antique sculpture and great artists of the past such as Raphael. Most academicians regarded art as a repository of tradition in changing times, a way to access what was universal, abiding, and beautiful. They still hoped that art could inspire viewers to virtue and taste.

Romanticism took a variety of forms in the early decades, but the emphasis everywhere moved away from the

universal toward the personal, away from thought and toward feeling. Romantics respected the Enlightenment but regarded it as too narrowly focused on rationality, encouraging a certain coldness and detachment. Enlightenment rule by reason had, after all, led to the Reign of Terror in France. Humans are not only creatures of reason, the Romantics argued: Humans also possess deep and not always rational longings for self-expression, understanding, and identification with their fellows. The Romantic tools of feeling and imagination seemed the most appropriate aids to reach these goals. Thus Neoclassical art, embodied in the sandal-shod heroes of *The Oath of the Horatii*, seemed unconnected to the issues of the day. Many Romantic paintings and sculptures featured dramatic or emotional subject matter drawn from literature, the landscape, current events, or the artist's own imagination. In architecture, Romantics broadened the vocabulary of historical allusion that the Neoclassicists had pioneered: If recalling Rome instilled one set of feelings, then recourse to other periods could stimulate other kinds of sentiments. Ideally, each building type could use the style most appropriate to the personal wish of the patron.

Neoclassicism and Romanticism in France

The undisputed capital of the nineteenth-century Western art world was Paris. The École des Beaux-Arts attracted students from all over Europe and the Americas, as did the **ateliers** (studios) of Parisian academic artists who offered private instruction. Virtually every ambitious nineteenth-century artist aimed to exhibit in the Paris Salon, to receive positive reviews from the Parisian critics, and to find favor with the French art-buying public.

Conservative juries controlled the Salon exhibitions, however, and from the 1830s onward they routinely rejected paintings and sculpture that did not conform to the academic standards of slick technique, mildly idealized subject matter, and engaging, anecdotal story lines. As the century wore on, progressive and independent artists ceased submitting to the Salon and organized private exhibitions to present their work directly to the public without the intervention of a jury. The most famous of these was the first exhibition of the Impressionists, held in Paris in 1874.

DAVID AND HIS STUDENTS. With the rise of Napoleon, Jacques-Louis David reestablished his dominant position as chief arbiter of French painting. David saw in the general his best hope for realization of his Enlightenment-oriented political goals, and Napoleon saw in the artist a tested propagandist for revolutionary values. As Napoleon gained power and took his crusade across Europe, reforming law codes and abolishing aristocratic privilege, he commissioned David and his students to document his deeds. David's new artistic task, the glorification of Napoleon, appeared in an early, idealized portrait of Napoleon leading his troops across the Alps into

30–2 | Jacques-Louis David **NAPOLEON CROSSING THE SAINT-BERNARD**
1800–1801. Oil on canvas, 8'11" × 7'7" (2.7 × 2.3 m).
Musée National du Château de la Malmaison,
Rueil-Malmaison.

David flattered Napoleon by reminding the viewer of two other great generals from history who had accomplished this difficult feat—Charlemagne and Hannibal—by etching the names of all three in the rock in the lower left.

Italy in 1800 (FIG. 30–2). Napoleon—who actually made the crossing on a donkey—is shown calmly astride a rearing horse, exhorting us to follow him. His windblown cloak, an extension of his arm, suggests that Napoleon directs the winds as well. While Neoclassical in the firmness of its drawing, the work also takes stylistic inspiration from the Baroque—for example, in the dramatic diagonal composition used instead of the classical pyramid of the *Oath of the Horatii* (SEE FIG. 29–40). When Napoleon fell from power in 1814, David went into exile in Brussels, where he died in 1825.

Antoine-Jean Gros (1771–1835), who began to work in David's studio as a teenager, eventually vied with his master for commissions from Napoleon. Gros traveled with Napoleon in Italy in 1797 and later became an official chronicler of Napoleon's military campaigns. His painting **NAPOLEON IN THE PLAGUE HOUSE AT JAFFA** (FIG. 30–3) is an idealized account of an actual incident: During Napoleon's campaign against the Ottoman Turks in 1799, bubonic plague broke out among his troops. Napoleon decided to quiet the fears of the healthy by visiting the sick and dying, who were housed in a converted mosque in the Palestinian town of Jaffa (Palestine was then part of the Ottoman

30–3 | Antoine-Jean Gros **NAPOLEON IN THE PLAGUE HOUSE AT JAFFA**
1804. Oil on canvas, 17'5" × 23'7" (5.32 × 7.2 m). Musée du Louvre, Paris.

Empire). The format of the painting—a shallow stage and a series of arcades behind the main actors—is inspired by David's *Oath of the Horatii*. The overall effect is Romantic, however, not simply because of the dramatic lighting and the wealth of emotionally stimulating elements, both exotic and horrific, but also because the main action is meant to incite veneration rather than republican virtue. At the center of a small group of soldiers and a doctor, Napoleon calmly reaches toward the sores of one of the victims—the image of a Christ-like figure healing the sick with his touch is consciously intended to promote him as semidivine. Not surprisingly, Gros gives no hint of the event's cruel historical aftermath: Two months later, Napoleon ordered the remaining sick to be poisoned.

Jean-Auguste-Dominique Ingres (1780–1867) represents the Neoclassical wing of David's legacy, but Ingres significantly broadened both the sources and techniques of Neoclassicism. Inspired more by Raphael than by antique art, Ingres emulated the Renaissance artist's precise drawing, formal idealization, classical composition, and graceful lyricism, but interpreted them in a personal manner. Ingres won the

Prix de Rome and lived in Italy from 1806 to 1824, returning to serve as director of the French Academy in Rome from 1835 to 1841. As a teacher and theorist, Ingres became the most influential artist of his time.

Although Ingres, like David, fervently desired acceptance as a history painter, his paintings of literary subjects and contemporary history were less successful than his erotically charged portraits of women and female nudes, especially his numerous representations of the **odalisque**, a female slave or concubine in a sultan's harem. In **LARGE ODALISQUE** (FIG. 30–4), the cool gaze this odalisque levels at her master, while turning her naked body away from what we assume is *his* gaze, makes her simultaneously erotic and aloof. The cool blues of the couch and the curtain at the right heighten the effect of the woman's warm skin, while the tight angularity of the crumpled sheets accentuates the languid, sensual contours of her form. Although Ingres's commitment to fluid line and elegant postures was grounded in his Neoclassical training, he treated some Romantic themes, such as the odalisque, in an anticlassical fashion. Here the elongation of the woman's back (she seems to have several extra vertebrae), the widening of her hip, and her

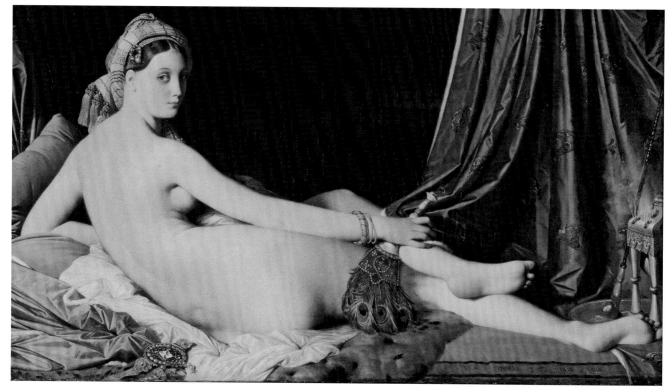

30–4 Jean-Auguste-Dominique Ingres **LARGE ODALISQUE**
1814. Oil on canvas, approx. 35 × 64″ (88.9 × 162.5 m). Musée du Louvre, Paris.

During Napoleon's campaigns against the British in North Africa, the French discovered the exotic Near East. Upper-middle-class European men were particularly attracted to the institution of the harem, partly as a reaction against the egalitarian demands of women of their class that had been unleashed by the French Revolution.

tiny, boneless feet are anatomically incorrect but aesthetically compelling.

Although Ingres complained that making portraits was a "considerable waste of time," he was unparalleled in rendering a physical likeness and the material qualities of clothing, hair-styles, and jewelry. In addition to polished life-size oil portraits, Ingres produced—usually in just a day—small portrait draw-ings that are extraordinarily fresh and lively. The exquisite **POR-TRAIT OF MADAME DESIRÉ RAOUL-ROCHETTE (FIG. 30–5)** is a flattering yet credible interpretation of the relaxed and elegant sitter. With her gloved right hand Madame Raoul-Rochette has removed her left-hand glove, simultaneously drawing attention to her social status (gloves traditionally were worn by members of the European upper class, who did not work with their hands) and her marital status (on her left hand is a wed-ding band). Her shiny taffeta dress, with its fashionably high waist and puffed sleeves, is rendered with deft yet light strokes that suggest more than they describe. Greater emphasis is given to her refined face and elaborate coiffure, which Ingres has drawn precisely and modeled subtly through light and shade.

FRENCH ROMANTIC PAINTING. Romanticism, already antici-pated in French painting during Napoleon's reign, flowered during the royal restoration that lasted from 1815 to 1830.

French Romantic painters took further the innovations of David's pupils as they based their art more on imagination and feeling than on Neoclassical reason. The French Roman-tics painted literary subjects as expressions of imagination, and current events as vehicles of feeling. They depicted these subjects using loose, fluid brushwork, strong colors, complex and off-balance compositions, powerful contrasts of light and dark, and expressive poses and gestures.

Théodore Géricault (1791–1824) was the leading inno-vator of early French Romanticism, though his career was cut short by early death. After a brief stay in Rome in 1816–17, where he discovered Michelangelo, Géricault returned to Paris determined to paint a great contemporary history painting. He chose for his subject the scandalous and sensa-tional shipwreck of the *Medusa* (see "*Raft of the 'Medusa,'*" page 992). In 1816, the ship of French colonists headed for Senegal ran aground near its destination; its captain was an incompetent aristocrat appointed by the newly restored monarchy for political reasons. Because there were insuffi-cient lifeboats, a raft was hastily built for 152 of the passengers and crew, while the captain and his officers took the seawor-thy boats. Too heavy to pull to shore, the raft was set adrift. When it was found thirteen days later, only fifteen people remained alive, having survived their last several days on

30–5 | Jean-Auguste-Dominique Ingres **PORTRAIT OF MADAME DESIRÉ RAOUL-ROCHETTE**
1830. Graphite on paper, 12 ⅝ × 9 ½" (32.2 × 24.1 cm). The Cleveland Museum of Art,
Cleveland, Ohio.
Purchase from the J. H. Wade Fund (1927.437)

Madame Raoul-Rochette (1790–1878), née Antoinette-Claude Houdon, was the youngest daughter of the
famous Neoclassical sculptor Jean-Antoine Houdon (SEE FIG. 29–43). In 1810, at the age of 20, she married
Desiré Raoul-Rochette, a noted archaeologist, who later became the secretary of the Academy of Fine Arts
and a close friend of Ingres. Ingres's drawing of Madame Rochette is inscribed to her husband, whose por-
trait Ingres also drew around the same time.

human flesh. Géricault chose to depict the moment when the survivors first spot their rescue ship.

At the Salon of 1819 the painting caused a great deal of controversy. Most contemporary French critics interpreted the painting as political commentary, with liberals praising it for exposing a difficult issue and royalists condemning it as closer to sensational journalism than art. Such a large, multifigured composition might normally be expected to portray a mythological or historic subject with a recognizable hero; this work, in contrast, showed a recent sensational event with no hero except the anonymous sufferers who desperately plead for rescue. Rather than offering a heroic narrative, the work engages the sympathy of anyone who has ever felt lost. Because the monarchy refused to buy the canvas, Géricault exhibited it commercially on a two-year tour of Ireland and England, where the London exhibition attracted more than 50,000 paying visitors.

THE **O**BJECT SPEAKS

RAFT OF THE "MEDUSA"

Théodore Géricault's monumental *Raft of the "Medusa"* is a history painting that speaks powerfully through a composition in which the victims' largely nude, muscular bodies are organized on crossed diagonals. The diagonal that begins in the lower left and extends to the waving figures registers their rising hopes. The diagonal that begins with the dead man in the lower right and extends through the mast and billowing sail, however, directs our attention to a huge wave. The rescue of the men is not yet assured. They remain tensely suspended between salvation and death. Significantly, the "hopeful" diagonal in Géricault's painting terminates in the vigorous figure of a black man, a survivor named Jean Charles, and it may therefore carry political meaning. By placing him at the top of the pyramid of sur-

vivors and giving him the power to save his comrades by signaling to the rescue ship, Géricault suggests metaphorically that freedom for all of humanity will only occur when the most oppressed member of society is emancipated.

Géricault's work was the culmination of extensive study and experimentation. An early pen drawing depicts the survivors' hopeful response to the appearance of the rescue ship on the horizon at the extreme left. Their excitement is in contrast with the mournful scene of a man grieving over a dead youth on the right side of the raft. A later pen-and-wash drawing reverses the composition, creates greater unity among the figures, and establishes the modeling of their bodies through light and shade. These developments look ahead to the final composition of the *Raft of the "Medusa,"* but the

study still lacks the figures of the black man at the apex of the painting and the dead bodies at the extreme left and lower right, which fill out the composition's base.

Géricault also made separate studies of many of the figures, as well as studies of actual corpses, severed heads, and dissected limbs supplied to him by friends who worked at a nearby hospital. For several months, according to Géricault's biographer, "his studio was a kind of morgue. He kept cadavers there until they were half-decomposed, and insisted on working in this charnel-house atmosphere. . . ." However, Géricault did not use cadavers directly in the *Raft of the "Medusa."* To execute the final painting, he traced the outline of his composition onto a large canvas, then painted each body directly from a living model, gradually

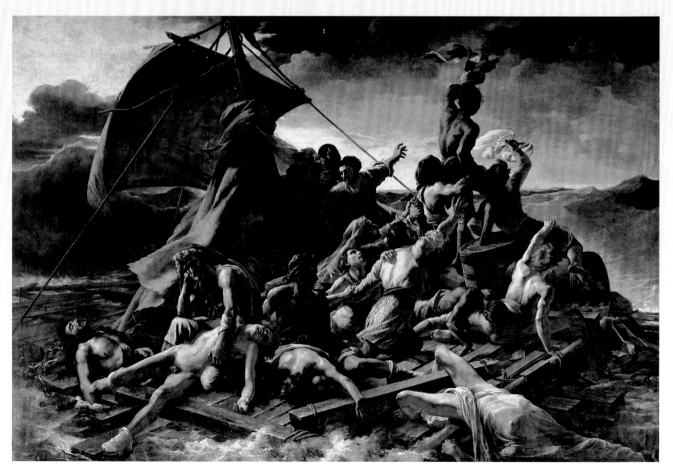

Théodore Géricault **RAFT OF THE "MEDUSA"**
1818–19. Oil on canvas, 16'1" × 23'6" (4.9 × 7.16 m). Musée du Louvre, Paris.

building up his composition figure by figure. He seems, rather, to have kept the corpses in his studio only to create an atmosphere of death that would provide him with a more authentic understanding of his subject.

Nevertheless, Géricault did not depict the actual physical condition of the survivors on the raft: exhausted, emaciated, sunburned, and close to death. Instead, following the dictates of the Grand Manner, he gave his men athletic bodies and vigorous poses, evoking the work of Michelangelo and Rubens (Chapters 20 and 22). He did this to generalize and ennoble his subject, elevating it above the particulars of a specific shipwreck so that it could speak to us of more fundamental conflicts: humanity against nature, hope against despair, life against death.

THE SIGHTING OF THE "ARGUS" (TOP) 1818.
Pen and ink on paper, 13 ¾ × 16 ⅛"
(34.9 × 41 cm). Musée des Beaux-Arts, Lille.

THE SIGHTING OF THE "ARGUS" (MIDDLE) 1818.
Pen and ink, sepia wash on paper,
8 ⅛ × 11 ¼" (20.6 × 28.6 cm). Musée des Beaux-Arts, Rouen.

STUDY OF HANDS AND FEET (BOTTOM) 1818–19.
Oil on canvas, 20 ½ × 25" (52 × 64 cm). Musée Fabre, Montpellier.

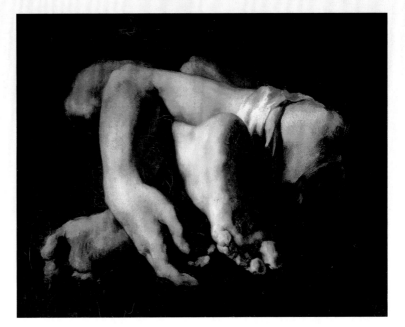

Technique
LITHOGRAPHY

Lithography, invented in the mid-1790s, is based on the natural antagonism between oil and water. The artist draws on a flat surface—traditionally, fine-grained stone—with a greasy, crayonlike instrument. The stone's surface is wiped with water, then with an oil-based ink. The ink adheres to the greasy areas but not to the damp ones. A sheet of paper is laid face down on the inked stone, which is passed through a flatbed press. Holding a scraper, the lithographer applies light pressure from above as the stone and paper pass under the scraper, transferring ink from stone to paper, thus making lithography a direct method of creating a printed image. Francisco Goya, Théodore Géricault, Eugène Delacroix, Honoré Daumier, and Henri de Toulouse-Lautrec used the medium to great effect.

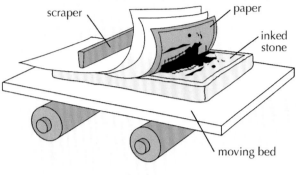

Diagram of lithographic press

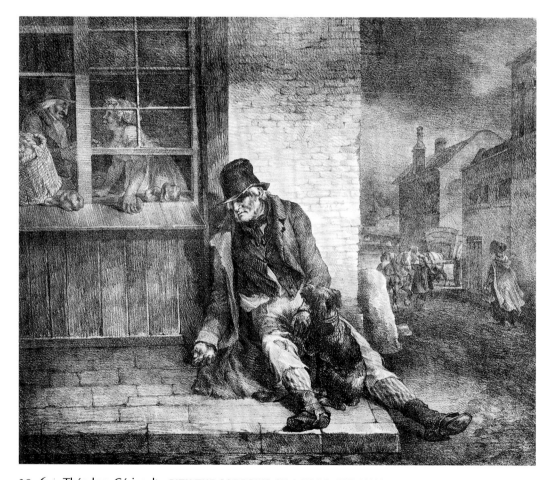

30–6 | Théodore Géricault **PITY THE SORROWS OF A POOR OLD MAN**
1821. Lithograph, 12.5 × 14.8″ (31.6 × 37.6 cm). Yale University Art Gallery, New Haven, Connecticut.
Gift of Charles Y. Lazarus, B.A. 1936

One of the first artists to use the recently invented medium of lithography to create fine art prints, Géricault published his thirteen lithographs of *Various Subjects Drawn from Life and on Stone* in London in 1821. The title of *Pity the Sorrows of a Poor Old Man* comes from a popular English nursery rhyme of the period that began: "Pity the sorrows of a poor old man whose trembling limbs have borne him to your door. . . ."

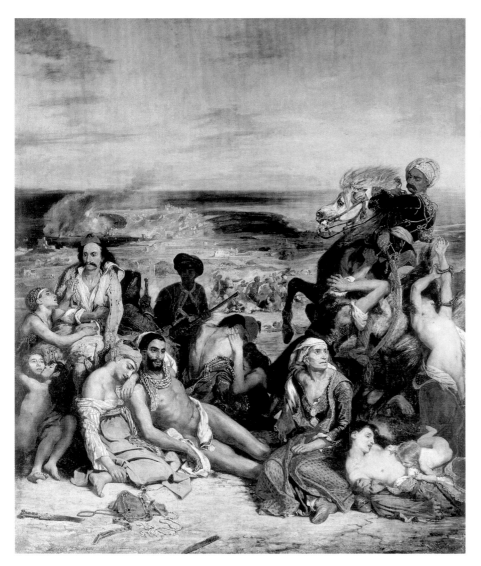

30–7 | Eugène Delacroix
SCENES FROM THE MASSACRE AT CHIOS 1822-24. Oil on canvas, 13′ 10″ × 11′ 7″ (4.22 × 3.53 m). Musée du Louvre, Paris.

While in Britain, Géricault turned from Romantic history painting to the depiction of the urban poor in a series of **lithographs** (see "Lithography," page 994) entitled *Various Subjects Drawn from Life and on Stone*. **PITY THE SORROWS OF A POOR OLD MAN** (FIG. 30–6) depicts a haggard beggar, slumping against a wall and limply extending an open hand. Through the window above him, we see a baker who ignores the hungry man's plight and prepares to pass a loaf of bread to a paying customer. Although the subject's appeal to the emotions is Romantic, the print does not preach or sentimentalize. Viewers are invited to draw their own conclusions.

More insistent on the use of imagination was Eugène Delacroix (1798–1863), the most important Romantic after Géricault's early death. Stendhal (pen name of the French poet Henri Beyle) wrote, "Romanticism in all the arts is what represents the men of today and not the men of those remote, heroic times which probably never existed anyway." Delacroix fits the

description as well as any artist. Like Géricault, Delacroix depicted victims and antiheroes. One of his first paintings exhibited at a Salon was **SCENES FROM THE MASSACRE AT CHIOS** (FIG. 30–7), an event even more terrible than the shipwreck of the *Medusa*. In 1822, during the Greeks' struggle for independence from the Turks, the Turkish fleet stopped at the peaceful island of Chios and took revenge by killing about 20,000 of the 100,000 inhabitants and selling the rest into slavery in North Africa. Delacroix based his painting on journalistic reports, eyewitness accounts, and study of Greek and Turkish costumes. The painting is an image of savage violence and utter hopelessness—the entire foreground is given over to exhausted victims awaiting their fate—paradoxically made seductive through its opulent display of handsome bodies and colorful costumes. The Greek struggle for independence engaged the minds of many during that period, and it led the Romantic poet Lord Byron to enlist on the Greek side and give his life.

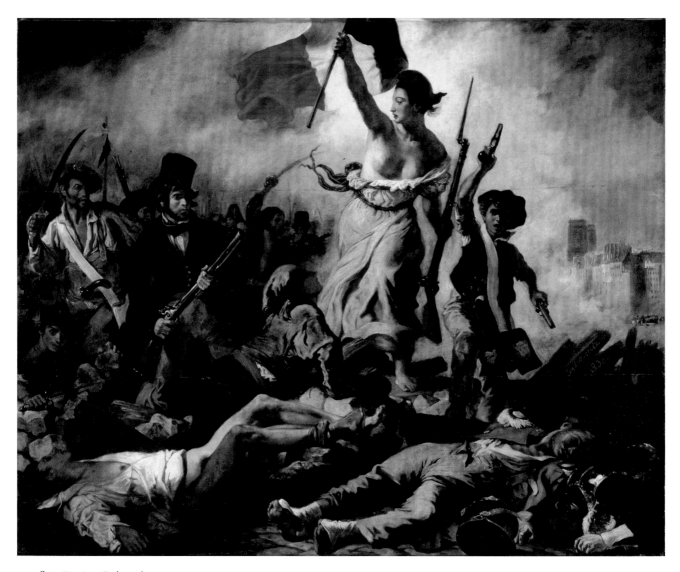

30–8 | Eugène Delacroix **LIBERTY LEADING THE PEOPLE: JULY 28, 1830**
1830. Oil on canvas, 8' 6½" × 10' 8" (260 × 325 cm). Musée du Louvre, Paris.

The work that brought Delacroix the most renown was **LIBERTY LEADING THE PEOPLE: JULY 28, 1830** (FIG. 30–8), which summed up for many the destiny of France after the fall of Napoleon. When Napoleon was defeated in 1815, the victorious neighboring nations reimposed a monarchy on France under Louis XVIII, brother of the last pre-Revolutionary monarch. The king's power was limited by a constitution and a parliament, but the government became more conservative as years passed, and undid many of the Revolutionary reforms. Louis's successor Charles X reinstated press censorship, returned education to Catholic Church control, and limited voting rights. This led to a massive uprising over three days in July 1830 that overthrew the Bourbon monarchical line, replacing Charles with a more moderate king from the Orleanist line who promised to abide by a constitution. The term "July Monarchy" captures its initially mild-mannered character. Delacroix memorialized the revolt in this large painting a few months after it took place.

The work reports and departs from facts in ways that are typically Romantic. The Revolutionaries were indeed a motley crew of students, craft workers, day laborers, and even children and top-hatted lawyers. They stumble forward through the smoke of battle, crossing a barricade of refuse and dead bodies. This much of the work is plausibly accurate. Their leader, however, is the energetic flag-bearing allegorical figure of Liberty, personified by the muscular woman who carries the Revolutionary flag in one hand and a bayoneted rifle in the other. Delacroix took a classical allegorical figure and placed her, weapon and all, in the thick of battle. Like most Romantic paintings, the work is obviously not a mere transcription of an actual event. Rather, the artist applied his imagination to the story and created a work that, while not exactly faithful to fact, is indeed faithful to the emotional climate of the moment as the artist felt it. This was the essence of Romanticism.

Romantic Sculpture in France and Beyond

Romanticism gained general acceptance in France after the July Monarchy was established, bringing with it a new era of middle-class taste. This shift is most evident in sculpture, where a number of practitioners turned away from Neoclassical principles to more dramatic themes and approaches.

Early in the July Monarchy, the minister of the interior decided, as an act of national reconciliation, to complete the triumphal arch on the Champs-Elysées in Paris, which Napoleon had begun in 1806. François Rude (1784–1855) received the commission to decorate the main arcade to commemorate the volunteer army that had halted a Prussian invasion in 1792–93. Beneath the urgent exhortations of the winged figure of Liberty, the volunteers surge forward, some nude, some in classical armor (FIG. 30–9). Despite such Neoclassical elements, the effect is Romantic. The crowded, excited grouping so stirred the patriotism of French spectators that it quickly became known as **THE MARSEILLAISE,** the name of the French national anthem written in the same year, 1792.

Marble sculpture remained closer to Neoclassical norms until after 1850, when Romanticism began to infect it. The American sculptor Edmonia Lewis (1845–c. 1911) was a leader in this tendency. Born in New York State to a Chippewa mother and an African American father and originally named Wildfire, Lewis was orphaned at the age of four and raised by her mother's family. As a teenager, with the help of abolitionists, she attended Oberlin College, the first college in the United States to grant degrees to women, then moved to Boston. Her highly successful busts and medallions of abolitionist leaders and Civil War heroes financed her move to Rome in 1867.

Galvanized by the struggle of newly freed slaves for equality, Lewis created **FOREVER FREE** (FIG. 30–10) as a memorial of the Emancipation Proclamation. The kneeling figure prays thankfully, while the standing man seems to dance on the ball that once bound his ankle as he raises the broken chain to the sky. In true Romantic fashion, Lewis's enthusiasm for the cause outran her financial abilities, so that she had to borrow money

30–9 | François Rude **DEPARTURE OF THE VOLUNTEERS OF 1792 (THE MARSEILLAISE)**
1833-36. Limestone, height approx. 42′ (12.8 m). Arc de Triomphe, Place de l'Étoile, Paris.

30–10 | Edmonia Lewis **FOREVER FREE**
1867. Marble, 41¼ × 22 × 17″ (104.8 × 55 × 43.2 cm). Howard University Art Gallery, Washington, D.C.

to pay for the marble. Lewis sent this work back to Boston hoping that a subscription drive among abolitionists would redeem her loan. The effort was only partially successful, but her steady income from the sale of medallions eventually paid it off.

Romanticism in Spain: Goya

In the career of Francisco Goya y Lucientes (1746–1828), we see the birth of Romanticism in a single lifetime. In the 1770s and 1780s he was a court painter, making tapestry designs in a style based on the Rococo. The dawn of the French Revolution filled him with hope, as he belonged to an intellectual circle that was nourished by Enlightenment ideas. After the early years of the French Revolution, however, Spanish king Charles IV reinstituted the Inquisition, stopped most of the French-inspired reforms, and even halted the entry of French books into Spain. Goya responded to this new situation with *Los Caprichos (The Caprices)*, a folio of eighty etchings produced between 1796 and 1798 whose overall theme is suggested by **THE SLEEP OF REASON PRODUCES MONSTERS** (FIG. 30–11). The print shows a slumbering personification of Reason, behind whom lurk the dark creatures of the night—owls, bats, and a cat—that are let loose when Reason sleeps. The rest of the *Caprichos* enumerate the specific follies of Spanish life that Goya and his circle considered monstrous. Goya hoped the series would show Spanish people the errors of their ways and reawaken reason. He even tried to sell the etchings, as Hogarth had done in England, but they only aroused controversy with his royal patrons. In order to deflect blame from himself, he made the metal plates an elaborate gift to the king. The disturbing quality of Goya's portrait of human folly suggests he was already beginning to feel the despair that would dominate his later work.

Goya's large portrait of the **FAMILY OF CHARLES IV** (FIG. 30–12) expresses some of the alienation that he felt. The work openly acknowledges the influence of Velázquez's earlier royal portrait *Las Meninas* (SEE FIG. 22–29) by placing the painter behind the easel on the left, just as Velázquez had. The artist somehow managed to make his patrons appear faintly ridiculous: The bloated and dazed king, chest full of medals, standing before another relative who appears to have seen a ghost; the double-chinned queen, who stares obliquely out (she was then having an open affair with the prime minister); her eldest daughter, to the left, stares into space next to another older relative who seems quizzically surprised by the attention. One French art critic described this frightened bunch as "The corner baker and his family after they have won the lottery." Yet the royal family seem to have been perfectly satisfied with Goya's realistic rather than flattering depiction of them. Indeed, if everyone was in fact posed in those positions, with the artist to one side, they must have all been admiring themselves in a huge mirror. As the authority of the Spanish aristocracy was crumbling, this complex rendition may have been the only possible type of royal portrait.

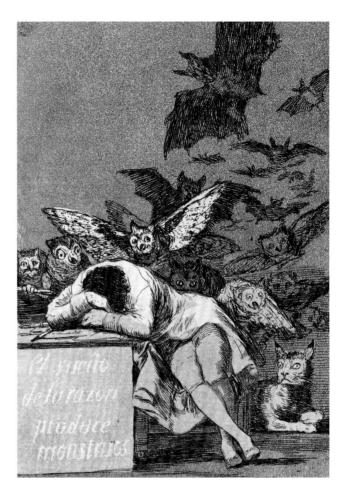

30–11 | Francisco Goya **THE SLEEP OF REASON PRODUCES MONSTERS,**

No. 43 from *Los Caprichos (The Caprices)*. 1796–98; published 1799. Etching and aquatint, 8½ × 6″ (21.6 × 15.2 cm). Courtesy of the Hispanic Society of America, New York.

After printing about 300 sets of this series, Goya offered them for sale in 1799. He withdrew them from sale two days later without explanation. Historians believe that he was probably warned by the Church that if he did not he might have to appear before the Inquisition because of the unflattering portrayal of the Church in some of the etchings. In 1803 Goya donated the plates to the Royal Printing Office.

In 1808 Napoleon conquered Spain and placed on its throne his brother Joseph Bonaparte. Many Spanish citizens, including Goya, welcomed the French at first because of the reforms they inaugurated, including a new, more liberal constitution. On May 2, 1808, however, a rumor spread in Madrid that the French planned to kill the royal family. The populace rose up, and a day of bloody street fighting ensued, followed by mass arrests. Hundreds of Spanish people were herded into a convent, and a French firing squad executed these helpless prisoners in the predawn hours of May 3. Goya commemorated the event in a painting (FIG. 30–13) that, like Delacroix's *Massacre at Chios* (SEE FIG. 30–7), focuses on victims and antiheroes, the most prominent of which is a Christ-like figure in white. Everything about this work is Romantic: the sensational current event, the loose brushwork, the poses based on reality, the off-balance composition, the dramatic lighting. But

Romantic Sculpture in France and Beyond

Romanticism gained general acceptance in France after the July Monarchy was established, bringing with it a new era of middle-class taste. This shift is most evident in sculpture, where a number of practitioners turned away from Neoclassical principles to more dramatic themes and approaches.

Early in the July Monarchy, the minister of the interior decided, as an act of national reconciliation, to complete the triumphal arch on the Champs-Elysées in Paris, which Napoleon had begun in 1806. François Rude (1784–1855) received the commission to decorate the main arcade to commemorate the volunteer army that had halted a Prussian invasion in 1792–93. Beneath the urgent exhortations of the winged figure of Liberty, the volunteers surge forward, some nude, some in classical armor (FIG. 30–9). Despite such Neoclassical elements, the effect is Romantic. The crowded, excited grouping so stirred the patriotism of French spectators that it quickly became known as **THE MARSEILLAISE,** the name of the French national anthem written in the same year, 1792.

Marble sculpture remained closer to Neoclassical norms until after 1850, when Romanticism began to infect it. The American sculptor Edmonia Lewis (1845–c. 1911) was a leader in this tendency. Born in New York State to a Chippewa mother and an African American father and originally named Wildfire, Lewis was orphaned at the age of four and raised by her mother's family. As a teenager, with the help of abolitionists, she attended Oberlin College, the first college in the United States to grant degrees to women, then moved to Boston. Her highly successful busts and medallions of abolitionist leaders and Civil War heroes financed her move to Rome in 1867.

Galvanized by the struggle of newly freed slaves for equality, Lewis created **FOREVER FREE** (FIG. 30–10) as a memorial of the Emancipation Proclamation. The kneeling figure prays thankfully, while the standing man seems to dance on the ball that once bound his ankle as he raises the broken chain to the sky. In true Romantic fashion, Lewis's enthusiasm for the cause outran her financial abilities, so that she had to borrow money

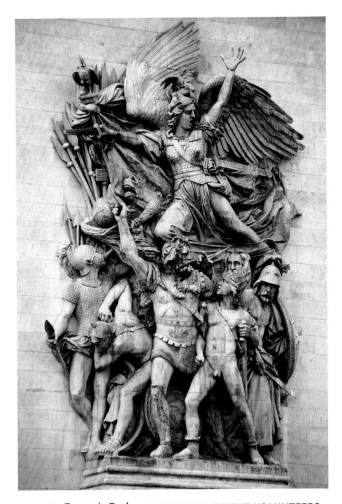

30–9 | François Rude **DEPARTURE OF THE VOLUNTEERS OF 1792 (THE MARSEILLAISE)**
1833-36. Limestone, height approx. 42′ (12.8 m). Arc de Triomphe, Place de l'Étoile, Paris.

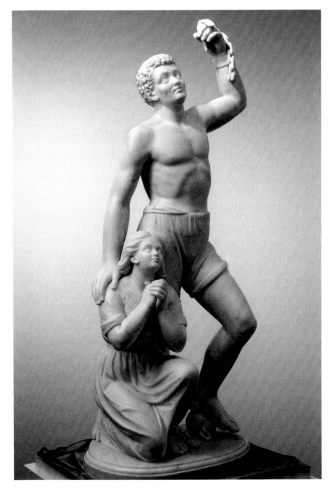

30–10 | Edmonia Lewis **FOREVER FREE**
1867. Marble, 41¼ × 22 × 17″ (104.8 × 55 × 43.2 cm). Howard University Art Gallery, Washington, D.C.

to pay for the marble. Lewis sent this work back to Boston hoping that a subscription drive among abolitionists would redeem her loan. The effort was only partially successful, but her steady income from the sale of medallions eventually paid it off.

Romanticism in Spain: Goya

In the career of Francisco Goya y Lucientes (1746–1828), we see the birth of Romanticism in a single lifetime. In the 1770s and 1780s he was a court painter, making tapestry designs in a style based on the Rococo. The dawn of the French Revolution filled him with hope, as he belonged to an intellectual circle that was nourished by Enlightenment ideas. After the early years of the French Revolution, however, Spanish king Charles IV reinstituted the Inquisition, stopped most of the French-inspired reforms, and even halted the entry of French books into Spain. Goya responded to this new situation with *Los Caprichos (The Caprices)*, a folio of eighty etchings produced between 1796 and 1798 whose overall theme is suggested by **THE SLEEP OF REASON PRODUCES MONSTERS (FIG. 30–11).** The print shows a slumbering personification of Reason, behind whom lurk the dark creatures of the night—owls, bats, and a cat—that are let loose when Reason sleeps. The rest of the *Caprichos* enumerate the specific follies of Spanish life that Goya and his circle considered monstrous. Goya hoped the series would show Spanish people the errors of their ways and reawaken reason. He even tried to sell the etchings, as Hogarth had done in England, but they only aroused controversy with his royal patrons. In order to deflect blame from himself, he made the metal plates an elaborate gift to the king. The disturbing quality of Goya's portrait of human folly suggests he was already beginning to feel the despair that would dominate his later work.

Goya's large portrait of the **FAMILY OF CHARLES IV (FIG. 30–12)** expresses some of the alienation that he felt. The work openly acknowledges the influence of Velázquez's earlier royal portrait *Las Meninas* (SEE FIG. 22–29) by placing the painter behind the easel on the left, just as Velázquez had. The artist somehow managed to make his patrons appear faintly ridiculous: The bloated and dazed king, chest full of medals, standing before another relative who appears to have seen a ghost; the double-chinned queen, who stares obliquely out (she was then having an open affair with the prime minister); her eldest daughter, to the left, stares into space next to another older relative who seems quizzically surprised by the attention. One French art critic described this frightened bunch as "The corner baker and his family after they have won the lottery." Yet the royal family seem to have been perfectly satisfied with Goya's realistic rather than flattering depiction of them. Indeed, if everyone was in fact posed in those positions, with the artist to one side, they must have all been admiring themselves in a huge mirror. As the authority of the Spanish aristocracy was crumbling, this complex rendition may have been the only possible type of royal portrait.

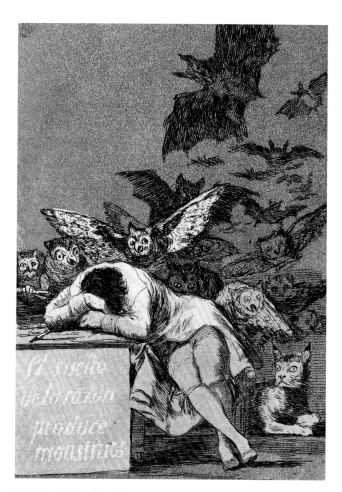

30–11 Francisco Goya **THE SLEEP OF REASON PRODUCES MONSTERS,**

No. 43 from *Los Caprichos (The Caprices)*. 1796-98; published 1799. Etching and aquatint, 8 ½ × 6″ (21.6 × 15.2 cm). Courtesy of the Hispanic Society of America, New York.

After printing about 300 sets of this series, Goya offered them for sale in 1799. He withdrew them from sale two days later without explanation. Historians believe that he was probably warned by the Church that if he did not he might have to appear before the Inquisition because of the unflattering portrayal of the Church in some of the etchings. In 1803 Goya donated the plates to the Royal Printing Office.

In 1808 Napoleon conquered Spain and placed on its throne his brother Joseph Bonaparte. Many Spanish citizens, including Goya, welcomed the French at first because of the reforms they inaugurated, including a new, more liberal constitution. On May 2, 1808, however, a rumor spread in Madrid that the French planned to kill the royal family. The populace rose up, and a day of bloody street fighting ensued, followed by mass arrests. Hundreds of Spanish people were herded into a convent, and a French firing squad executed these helpless prisoners in the predawn hours of May 3. Goya commemorated the event in a painting (FIG. 30–13) that, like Delacroix's *Massacre at Chios* (SEE FIG. 30–7), focuses on victims and antiheroes, the most prominent of which is a Christ-like figure in white. Everything about this work is Romantic: the sensational current event, the loose brushwork, the poses based on reality, the off-balance composition, the dramatic lighting. But

boat row out to a larger one. Fog has drawn a veil over most of the details of this landscape, but such facts matter much less to Friedrich than the overall mood, which is hushed and solemn. This place resembles none that we can visit, because the artist invented it based on his sketches and memories. He wrote, "Close your physical eyes in order that you may first see your painting with your spiritual eye. Then bring to the light of day what you have seen in the darkness so that it can affect others." We are left wondering about the possible reasons for this journey: Escape is one possibility; so is a more symbolic reading, such as death, or, in common parlance, passage to the other side.

TURNER. Friedrich's English contemporary Joseph Mallord William Turner (1775–1851) devoted much of his early work to the Romantic theme of nature as a cataclysmic force that overwhelms human beings and their creations. Turner entered the Royal Academy in 1789, was elected a full academician at the unusually young age of twenty-seven, and later became a professor in the Royal Academy school. During the 1790s, Turner helped revolutionize the British watercolor tradition by rejecting underpainting and topographic accuracy in favor of a freer application of paint and more generalized atmospheric effects. By the late 1790s, Turner was also exhibiting large-scale oil paintings of grand natural scenes and historical subjects.

Turner's **SNOWSTORM: HANNIBAL AND HIS ARMY CROSSING THE ALPS** (FIG. 30–15) epitomizes the Romantic view of awesome nature, as an enormous vortex of wind, mist, and

snow threatens to annihilate the soldiers below it and even to obliterate the sun. Barely discernible in the distance is the figure of the Carthaginian general Hannibal, who, mounted on an elephant, led his troops through the Alps to defeat Roman armies in 218 BCE. Turner probably intended this painting as an allegory of the Napoleonic Wars—Napoleon himself had crossed the Alps, an event celebrated in Jacques-Louis David's *Napoleon Crossing the Saint-Bernard* (SEE FIG. 30–2). But while David's painting, which Turner saw in Paris in 1802, depicts Napoleon as a powerful figure who seems to command not only his troops but also nature itself, Turner reduced Hannibal to a speck on the horizon and showed his troops

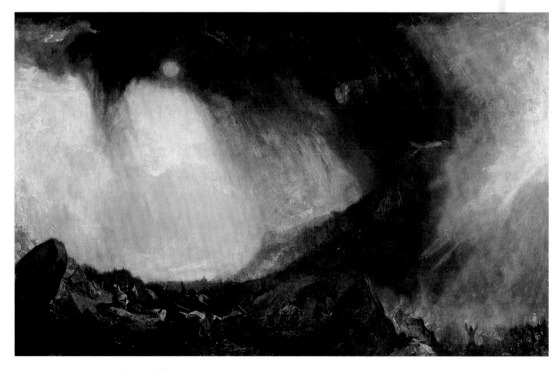

30–15 Joseph Mallord William Turner **SNOWSTORM: HANNIBAL AND HIS ARMY CROSSING THE ALPS** 1812. Oil on canvas, 4′9″ × 7′9″ (1.46 × 2.39 m). The Tate Gallery, London.

threatened by a cataclysmic storm, as if foretelling their eventual defeat. In 1814, just two years after the exhibition of Turner's painting, Napoleon suffered a decisive loss to his European opponents and met final defeat at Waterloo in 1815.

Closer to home both physically and temporally, Turner based another thrilling work on a tragic fire that severely damaged London's ancient Parliament building, an important national monument. Most of the complex was erected in the eleventh century and had witnessed some of the most dramatic events in English history, but the fire that broke out on October 16, 1834, completely destroyed the House of Lords and left the Commons unusable because its roof fell in. Contemporary accounts tell of flames lighting the night sky, and hundreds of spectators gathering in boats on the Thames and along the shore to witness the cataclysm. Turner himself hurriedly sketched watercolors at the scene and within a few months made a large painting, **THE BURNING OF THE HOUSE OF LORDS AND COMMONS, 16TH OCTOBER 1834** (FIG. 30–16).

More faithful to feeling than to fact, the work accurately depicts the crowds and the bridge but greatly exaggerates the size of the fire. Turner's main interest was in capturing the feelings attending the loss of one of England's most historic structures, and in order to do this he resorted to some of the loosest and most painterly brushwork ever seen in Western art up to that time. In those years, the Parliament was in the midst of reforming its electoral districts in order to broaden its political base and equalize representation. The Reform Bill of 1832 was a landmark in this democratic quest, but Turner's painting points out that Mother Nature often has the last word, thwarting or hindering even our most noble aspirations.

Both this work and *Hannibal Crossing the Alps* partake of the sublime, an aesthetic category beloved of some Romantic artists. According to Edmund Burke, who defined it in a 1756 essay (see Chapter 29), when we witness something that instills fascination mixed with fear, or if we stand in the presence of something far larger than ourselves, we may have sublime feelings. Turner focused his vision on this aspect of nature.

30–16 | Joseph Mallord William Turner **THE BURNING OF THE HOUSE OF LORDS AND COMMONS, 16TH OCTOBER 1834** Oil on canvas, 36¼ × 48½" (92.1 × 123.2 cm). Philadelphia Museum of Art.
The John Howard McFadden Collection, 1928

sketched and painted the landscape, which quickly became his chief interest, and his paintings launched what became known as the Hudson River School. With the help of a patron, Cole traveled in Europe between 1829 and 1832. In the mid-1830s, Cole went on a sketching trip that resulted in **THE OXBOW** (FIG. 30–19), which he painted for exhibition at the National Academy of Design in New York. He believed that a too-close focus on factual accuracy was murderous to art, so he made paintings months after his sketches were complete, the better, he said, for memory to "draw a veil" over the scene. Cole considered *The Oxbow* one of his "view" paintings, which were usually small, although this one is monumental. The scale suits the dramatic view from the top of Mount Holyoke in western Massachusetts across a spectacular oxbow-shaped bend in the Connecticut River. To Cole, such ancient geological formations constituted America's "antiquities." The work's title tells us that it depicts an actual spot, but the artist orchestrated the scene in order to convey his interpretation of its grandeur. He exaggerated the steepness of the mountain, and set the scene below a dramatic sky. Along a great sweeping arc produced by the departing dark clouds and the edge of the mountain, Cole contrasts the two sides of the American landscape: its dense, stormy wilderness and its congenial, pastoral valleys. The fading storm suggests that the wild will eventually give way to the civilized.

Orientalism

European art patrons during the Romantic period not only wanted landscapes depicting areas that they knew; part of the Romantic urge is to stimulate the imagination through escape to new places, the more exotic the better. Some artists traveled the world in order to fill this need. This Romantic fascination with foreign cultures dates as far back as Napoleon's 1798 invasion of Egypt, which had the goal not only of conquest but also of study of that culture. After Napoleon's fall, the Restoration government continued to send study missions to Egypt and the Mideast, and published between 1809 and 1822 the twenty-four volume *Description de l'Egypte,* which recorded copious information about the people, lands, and culture of that area. Artists soon began painting subjects set in those foreign lands, whether they had been there or not. Gros, for example, never went to Jaffa but still he painted *Napoleon in the Plague House* (SEE FIG. 30–3). Ingres likewise never ventured farther away than Italy but scored a great success with his *Large Odalisque* (SEE FIG. 30–4), a portrait of a harem girl. The vogue for Oriental subjects, as they were called, engaged artists of both Romantic and Neoclassical persuasions.

ROBERTS. One of the first professional European artists to actually travel to the Mideast was the Scottish landscape painter David Roberts (1796–1864), whose background is notable for a lack of academic training. Rather, he learned

Sequencing Works of Art

1830	Delacroix, *Liberty Leading the People: July 28, 1830*
1834	Turner, *The Burning of the House of Lords and Commons, 16th October 1834*
1836	Cole, *The Oxbow*
1836–60	Barry and Pugin, Houses of Parliament, London
1837	Daguerre, *The Artist's Studio.*

painting as an apprentice theater set designer. His wanderlust was probably awakened by an early assignment to paint sets for Mozart's comic opera set in Turkey, *The Abduction from the Seraglio,* in 1827. Roberts went to Spain and Morocco in 1832–33, returning to exhibit paintings, watercolors, and lithographs of the scenes he witnessed. (Eugène Delacroix also went to Morocco at the same time, though not in Roberts's company.) Emboldened by the success of that first trip, Roberts then set off for the Holy Land in 1838, and on his return he created a series of works, among them **GATEWAY TO THE GREAT TEMPLE AT BAALBEK** (FIG. 30–20).

30–20 | David Roberts
GATEWAY TO THE GREAT TEMPLE AT BAALBEK
1841. Oil on canvas, 75 × 62 cm. Royal Academy of Arts, London.

This painting shows both the pleasures and pitfalls of the Orientalist movement. Views of ancient ruins fed the fashion for the picturesque in European viewers, and Roberts focused on those aspects of life in the lands he visited. Here we see a ruined Roman temple doorway in Lebanon, its keystone perched precariously. Later photographs document this curious feature of this most impressive building, which was later restored. Like most Orientalists, however, Roberts painted only "exotic" people in his works, not the Western members of his party. When this painting was turned into a lithograph for sale as part of a set, it was inscribed as follows: "These beautiful structures carry with them regret that such proud relics of genius should be in the hands of a people incapable of appreciating their merits and consequently heedless of their complete destruction."

GÉRÔME. The example of Roberts suggests that Orientalist paintings give us a selective view of the lands the artists visited, calculated to pique curiosity while allowing Western viewers to remain convinced of their cultural superiority, if indeed they felt it. Most Orientalists depicted either the spectacular sights or the carefully selected everyday scenes of the Mideast. The most prolific Orientalist in the latter category was Jean-Léon Gérôme (1824–1904). Gérôme went to Constantinople in 1853, the first of many trips to Asia Minor and Egypt. **CAFE HOUSE, CAIRO** (FIG. 30–21) shows the results of the artist's classical training under an academic master: The figures are tightly rendered, the poses believable, their scaling in space perfectly appropriate. Many Orientalist paintings tended to show Middle Eastern people as sultry and sexual (as in the *Odalisque* of Ingres) or prone to violence. This

30–21 | Jean-Léon Gérôme **CAFE HOUSE, CAIRO (CASTING BULLETS)**
Probably 1870s. Oil on canvas, 21½ × 24¾″ (54.6 × 62.9 cm). Metropolitan Museum of Art, New York.
Bequest of Henry H. Cook, 1905 (05.13.4).

30–22 | Benjamin Henry Latrobe
U.S. CAPITOL
Washington, D.C. c. 1808. Engraving by
T. Sutherland, 1825. New York Public
Library. I. N. Phelps Stokes Collection, Myriam and
Ira Wallach Division of Art, Prints, and Photographs

work shows a group of mercenaries in a coffee house using the heat of the fireplace to melt metal for bullets. Orientalist subjects remained attractive to artists and patrons through most of the nineteenth century, as European nations colonized the Mideast and other parts of the world. In addition to his Orientalist scenes, Gérôme was an accomplished painter of Neoclassical subjects. He remained active until the end of the century.

Revival Styles in Architecture Before 1850

Both Neoclassicism and Romanticism motivated architects in the early nineteenth century, and many architects worked in either mode, depending on the task at hand. Neoclassicism, which evoked both Greek democracy and Roman republicanism, became the favored style for government buildings in the United States. In Europe, many different kinds of public institutions, including art museums, were built in the Neoclassical style.

NEOCLASSICAL STYLE. The most significant and symbolic Neoclassical edifice in Washington, D.C. was the U.S. Capitol, initially designed in 1792 by William Thornton (1759–1828), an amateur architect. His monumental plan featured a large dome over a temple front flanked by two wings to accommodate the House of Representatives and the Senate. In 1803, President Thomas Jefferson, also an amateur architect, hired a British-trained professional, Benjamin Henry Latrobe (1764–1820), to oversee the actual construction of the Capitol. Latrobe modified Thornton's design by adding a grand staircase and Corinthian colonnade on the east front (FIG. 30–22). After the British gutted the building in the War of 1812, Latrobe repaired the wings and designed a higher dome. Seeking new symbolic forms for the nation within the traditional classical vocabulary, Latrobe also created for the interior a variation on the Corinthian order by substituting indigenous plants—corn (FIG. 30–23) and tobacco—for the Corinthian order's acanthus leaves

30–23 | Giuseppe Franzoni **CORNCOB CAPITAL**
Sculpted for the U.S. Capitol. 1809.

30–24 | Karl Friedrich Schinkel **ALTES MUSEUM**
Berlin. 1822–30.

30–25 | Charles Barry and Augustus Welby Northmore Pugin **HOUSES OF PARLIAMENT**
London, England. 1836-60. Royal Commission on the Historical Monuments of England, London.

Pugin published two influential books in 1836 and 1841, in which he argued that the Gothic style of Westminster Abbey was the embodiment of true English genius. In his view, the Greek and Roman classical orders were stone replications of earlier wooden forms and therefore fell short of the true principles of stone construction.

(see Introduction, Fig. 3). Latrobe resigned in 1817, and the reconstruction was completed under Charles Bulfinch (1763–1844). A major renovation begun in 1850 brought the building closer to its present form.

Many European capitals in the early nineteenth century erected museums in the Neoclassical style—which, being derived chiefly from Greek and Roman religious architecture, positioned the new buildings as temples of culture. The most influential of these was the **ALTES** ("Old") **MUSEUM** in Berlin, designed in 1822 by Karl Friedrich Schinkel (1781–1841) and built between 1824 and 1830 (**FIG. 30–24**). Commissioned to

display the royal art collection, the Altes Museum was built on an island in the Spree River in the heart of the capital, directly across from the Baroque royal palace. The museum's imposing façade consists of a screen of eighteen Ionic columns, raised on a platform with a central staircase. Attentive to the problem of lighting artworks on both the ground and the upper floors, Schinkel created interior courtyards on either side of a central rotunda, tall windows on the museum's outer walls to provide natural illumination, and partition walls perpendicular to the windows to eliminate glare on the varnished surfaces of the paintings on display.

ing which are not necessary for convenience, construction or propriety; second, that all ornament should consist of enrichment of the essential structure of the building."

In nineteenth-century Europe and the United States, many architects used the Gothic style because of its religious associations, especially for Roman Catholic, Anglican, and Episcopalian churches. The British-born American architect Richard Upjohn (1802–78) designed many of the most important Gothic revival churches in the United States, including **TRINITY CHURCH** in New York (**FIG. 30–26**). With its tall spire, long nave, and squared-off chancel, Trinity quotes the early fourteenth-century British Gothic style particularly dear to Anglicans and Episcopalians. Every detail is historically accurate, although the vaults are of plaster, not masonry. The stained-glass windows above the altar were among the earliest in the United States.

ART IN THE SECOND HALF OF THE NINETEENTH CENTURY

The second half of the nineteenth century has been called the positivist age, an age of faith in the positive consequences of close observation of the natural and human realms. The term *positivism* was used by the French philosopher Auguste Comte (1798–1857) during the 1830s to describe what he saw as the final stage in the development of philosophy, in which all knowledge would derive from the objectivity of science and scientific methods. Just as scientists had determined through observation the laws of motion and gravity, so might *social scientists*—Comte invented this term—deduce the laws underlying human culture. Metaphysical and theological speculation were practically useless in this new era, he wrote in *The Nature and Importance of Positive Philosophy.* "The mind has given up the vain search after Absolute notions, the origin and destination of the universe, and the causes of phenomena, and applies itself to the study of their laws. . . . Reason and observation, duly combined are the means of this knowledge." In the second half of the century, the term *positivism* came to be applied widely to any expression of the new emphasis on objectivity.

In the visual arts, the positivist spirit is most obvious in the decline of Romanticism in favor of the accurate and apparently objective description of the ordinary, observable world. Positivist thinking is evident in the new movement of Realism in painting, and in many other artistic developments of the period after 1850—from the development of photography, capable of recording nature with unprecedented accuracy, to the highly descriptive style of academic art, to Impressionism's almost scientific emphasis on the optical properties of light and color. In architecture, the application of new technologies also led at the century's end to the abandonment of historical styles and ornamentation in favor of a more direct or "realistic" expression of structure and materials.

30–26 | Richard Upjohn **TRINITY CHURCH**
New York City. 1839–46.

GOTHIC PRIDE. Schinkel also created numerous Gothic architectural designs, which many Germans considered an expression of national genius. Meanwhile, the British claimed the Gothic as part of *their* patrimony and erected a plethora of Gothic revival buildings in the nineteenth century, the most famous being the **HOUSES OF PARLIAMENT** (**FIG. 30–25**). After Parliament's Westminster Palace burned in 1834 in the fire so memorably painted by Turner, the government opened a competition for a new building designed in the English Perpendicular Gothic style, to be consistent with the neighboring Westminster Abbey, the thirteenth-century church where English monarchs are crowned.

Charles Barry (1795–1860) and Augustus Welby Northmore Pugin (1812–52) won the commission. Barry was responsible for the basic plan, whose symmetry suggests the balance of powers of the British system; Pugin provided the intricate Gothic decoration laid over Barry's essentially classical plan. The leading advocate of Gothic architecture in his era, Pugin in 1836 published *Contrasts,* which unfavorably compared the troubled modern era of materialism and mechanization with the Middle Ages, which he represented as an idyllic epoch of deep spirituality and satisfying handcraft. For Pugin, Gothic was not a style but a principle, like classicism. The Gothic, he insisted, embodied two "great rules" of architecture: "first that there should be no features about a build-

Early Photography in Europe

A prime expression of the new, positivist interest in descriptive accuracy spurred by Comte's philosophy was the development of photography. Photography as we know it emerged around 1840, but since the late Renaissance, artists and others had been seeking a mechanical method for exactly recording or rendering a scene. One early device was the **camera obscura** (Latin, meaning "dark chamber"), which consists of a darkened room or box with a lens through which light passes, projecting onto the opposite wall or box side an upside-down image of the scene, which an artist can trace. By the seventeenth century a small, portable camera obscura, or camera, had become standard equipment for many landscape painters. Photography developed essentially as a way to fix—that is, to make permanent—the images produced by a camera obscura on light-sensitive material.

30–27 | Louis-Jacques-Mandé Daguerre **THE ARTIST'S STUDIO** 1837. Daguerreotype, 6½ × 8½" (16.5 × 21.6 cm). Société Française de Photographie, Paris.

STILL LIFE AND ALLEGORY. The first person to "fix" a photographic image was the painter Louis-Jacques-Mandé Daguerre (1787–1851), who guarded his patents so jealously that the earliest photographs are still called **daguerreotypes**. Using the most advanced lenses to project a scene onto a treated metal plate for twenty to thirty minutes yielded what seemed a perfect reproduction of the visible world. Daguerre's photograph of his studio tabletop (FIG. 30–27) retains the conventions of the still life that Daguerre practiced in his own painting, but the camera accurately captured the look of the drawing, the plaster cast, the curtain, and the wicker-covered bottle. Improvements in photography over the next twenty years gave better lenses, smaller cameras, and shorter exposure times, so that by the mid-nineteenth century portrait photography was widely practiced in many cities.

The acceptance of photography as an art form alongside painting or sculpture took much longer, however. Among the first photographers to argue for its artistic legitimacy was Oscar Rejlander (1813–75) of Sweden, who had studied painting in Rome before settling in England. He first took up photography in the early 1850s as an aid for painting but was soon attempting to create photographic equivalents of the painted and engraved moral allegories so popular in Britain since the time of Hogarth (SEE FIG. 29–26). In 1857 he produced his most famous work, **THE TWO PATHS OF LIFE** (FIG. 30–28), by combining thirty negatives. This allegory of Good and Evil, work and idleness, was loosely based on Raphael's *School of Athens* (SEE FIG. 20–6). At the center, an old sage ushers two young men into life. The serene youth on the right turns toward personifications of Religion, Charity, Industry, and other virtues, while his counterpart eagerly responds to the enticements of pleasure. The figures on the left Rejlander described as personifications of "Gambling, Wine, Licentiousness and other Vices, ending in Suicide, Insanity, and Death." In the lower center, with a drapery over her head, is the hopeful figure of "Repentance." Although Queen Victoria

30–28 | Oscar Rejlander **THE TWO PATHS OF LIFE** 1857. Combination albumen print, 16 × 31" (41 × 79.5 cm). George Eastman House, Rochester, New York.

30–29 │ Julia Margaret Cameron **PORTRAIT OF THOMAS CARLYLE**
1867. Silver print, 10 × 8″ (25.4 × 20.3 cm). The Royal Photographic Society, Collection at National Museum of Photography, Film, and Television, England.

purchased a copy of *The Two Paths of Life* for her husband, it was not generally well received as art. One typical response was that "mechanical contrivances" could not produce works of "high art," a persistent criticism of photography.

PORTRAITURE. The most creative early portrait photographer was Julia Margaret Cameron (1815–79), who received her first camera as a gift from her daughters when she was forty-nine. Cameron's principal subjects were the great men and women of British arts, letters, and sciences, many of whom had long been family friends. Cameron's work was more personal and less dependent on existing forms than Rejlander's. Like many of Cameron's portraits, that of the famous British historian Thomas Carlyle is deliberately slightly out of focus (FIG. 30–29). Cameron was consciously rejecting the sharp stylistic precision of popular portrait photography, which she felt accentuated the merely physical attributes and neglected a subject's inner character. By blurring the details she sought to call attention to the light that suffused her subjects—a metaphor for creative genius—and to their thoughtful, often inspired expressions. In her autobiography Cameron said: "When I have had such men before my camera my whole soul has endeavored to do its duty towards them in recording faithfully the greatness of the inner as well as the features of the outer man."

The Frenchman Gaspard-Félix Tournachon, known as Nadar (1820–1910), applied photography to an even more ambitious goal, initially adopting the medium in 1849 as an aid in realizing the "Panthéon-Nadar," a series of lithographs intended to include the faces of all the well-known Parisians of the day. Nadar quickly saw both the documentary and the commercial potential of the photograph, and in 1853 opened a portrait studio that became a meeting place for many of the great intellectuals and artists of the period. The first exhibition of Impressionist art was held there in 1874.

A realist in the tradition inaugurated by Daguerre, Nadar embraced photography because of its ability to capture people and their surroundings exactly: He took the first aerial photographs of Paris (from a hot-air balloon equipped with a darkroom), photographed the city's catacombs and sewers, produced a series on typical Parisians, and attempted to record all the leading figures of French culture. As we see in his portrait of the poet Charles Baudelaire (FIG. 30–30), Nadar avoided props and formal poses in favor of informal

30–30 │ Nadar (Gaspard-Félix Tournachon)
PORTRAIT OF CHARLES BAUDELAIRE
1863. Silver print. Caisse Nationale des Monuments Historiques et des Sites, Paris.

The year this photograph was taken, Baudelaire published "The Painter of Modern Life," a newspaper article in which he called on artists to provide an accurate and insightful portrait of the times. The idea may have come from Nadar, who had been trying to do just that for some time. Although Baudelaire never wrote about the photographic work of his friend Nadar, he was highly critical of the vogue for photography and of its influence on the visual arts. In his Salon review of 1859 he said: "The exclusive taste for the True . . . oppresses and stifles the taste of the Beautiful. . . . In matters of painting and sculpture, the present-day *Credo* of the sophisticated is this: 'I believe in Nature . . . I believe that Art is, and cannot be other than, the exact reproduction of Nature. . . .' A vengeful God has given ear to the prayers of this multitude. Daguerre is his Messiah."

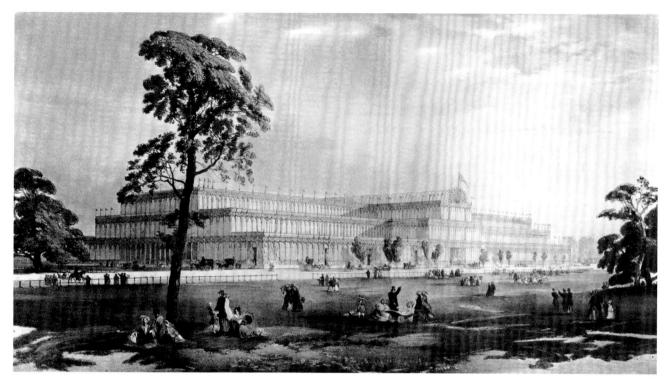

30–31 | Joseph Paxton **CRYSTAL PALACE**
London. 1850–51. Iron, glass, and wood.

ones determined by the sitters themselves. His goal was not so much an interpretation as a factual record of a sitter's characteristic appearance and demeanor.

New Materials and Technology in Architecture at Midcentury

The positivist faith in technological progress as the key to human progress spawned world's fairs that celebrated advances in industry and technology. The first of these fairs, the London Great Exhibition of 1851, introduced new building techniques that would eventually lead to the development of Modern architecture.

The revolutionary construction of the **CRYSTAL PALACE** (FIG. 30–31), created for the London Great Exhibition by Joseph Paxton (1803–65), featured a structural skeleton of cast iron that held iron-framed glass panes measuring 49 by 30 inches, the largest size that could then be mass-produced. Prefabricated wooden ribs and bars supported the panes. The triple-tiered edifice was the largest space ever enclosed up to that time—1,851 feet long, covering more than 18 acres, and providing for almost a million square feet of exhibition space. The central vaulted transept—based on the new cast-iron railway stations—rose 108 feet to accommodate a row of elms dear to Prince Albert, the husband of Queen Victoria. Although everyone agreed that the Crystal Palace was a technological marvel, most architects and critics, still wedded to Neoclassicism and Romanticism, considered it a work of engineering rather than legitimate architecture because it

made no clear allusion to any past style. Some observers, however, were more forward-looking. One visitor called it a revolution in architecture from which a new style would emerge.

We see a less reverent attitude toward technological progress in the first attempt to incorporate structural iron into architecture proper: the **BIBLIOTHÈQUE SAINTE-GENEVIÈVE** (FIG. 30–32), a library in Paris designed by Henri Labrouste (1801–75). Conventionally trained at the École des Beaux-Arts and employed as one of its professors, Labrouste was something of a radical in his desire to reconcile the École's conservative design principles with the technological innovations of industrial engineers. Although reluctant to promote this goal in his teaching, he clearly pursued it in his practice.

Because of the Bibliothèque Sainte-Geneviève's educational function, Labrouste wanted the building to suggest the course of both learning and technology. The window arches on the exterior have panels with the names of 810 important contributors to Western thought from its religious origins to the positivist present, arranged chronologically from Moses to the Swedish chemist Jöns Jakob Berzelius. The exterior's stripped-down Renaissance style reflects the belief that the modern era of learning dates from that period. The move from outside to inside subtly outlines the general evolution of architectural techniques. The exterior of the library features the most ancient of permanent building materials, cut stone, which was considered the only construction material "noble" enough for a serious building. The columns in the entrance

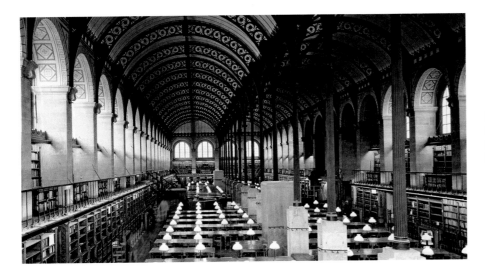

30–32 | Henri Labrouste
READING ROOM, BIBLIOTHÈQUE SAINTE-GENEVIÈVE
Paris. 1843–50.

hall are solid masonry with cast-iron decorative elements. In the main reading room, however, cast iron plays an undisguised structural role. Slender iron columns—cast to resemble the most ornamental Roman order, the Corinthian—support two parallel barrel vaults. The columns stand on tall concrete pedestals, a reminder that modern construction technology rests on the accomplishments of the Romans, who perfected the use of concrete. The design of the delicate floral cast-iron ribs in the vaults is borrowed from the Renaissance architectural vocabulary.

French Academic Art and Architecture

The Académie des Beaux-Arts and its official art school, the École des Beaux-Arts, exerted a powerful influence over the visual arts in France throughout the nineteenth century. Academic artists controlled the Salon juries, and major public commissions routinely went to academic architects, painters, and sculptors.

GARNIER: THE OPÉRA. Unlike Labrouste in the Bibliothèque Sainte-Geneviève, most later nineteenth-century architects trained at the École des Beaux-Arts worked in a style known as **historicism**, an elaboration on earlier Neoclassical and Romantic revivals. Historicists were expected to be aware of the whole sweep of architectural history. They often combined historical allusions to different periods in a single building. They typically used iron only as an internal support for conventional materials, as in the case of the **OPÉRA**, the Paris opera house (**FIG. 30–33**) designed by Charles Garnier (1825–98). The Opéra was a focal point of a thorough urban redevelopment plan begun under Napoleon III by Georges-Eugène Haussmann (1809–91) in the 1850s. After riots in 1848 devastated some of the city's central neighborhoods, the city leaders engaged Haussmann to rebuild the city and redraw the street map. Haussmann's project swept away the narrow, winding, medieval streets with their historic buildings, replacing them with new buildings

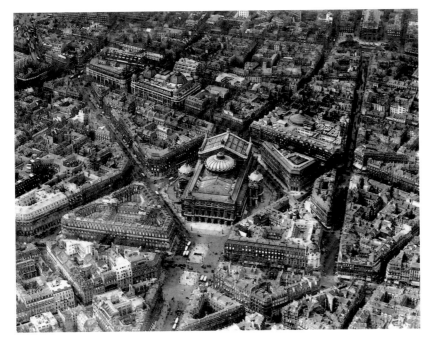

30–33 | Charles Garnier
THE OPÉRA
Paris. 1861–74.

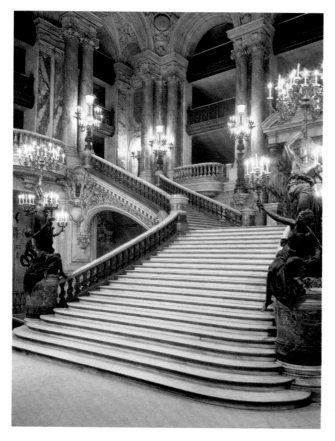

30–34 | GRAND STAIRCASE, THE OPÉRA

The bronze figures holding the lights on the staircase are by Marcello, the pseudonym used by Adèle d'Affry (1836–79), the duchess Castiglione Colonna, as a precaution against the male chauvinism of the contemporary art world.

one on the great, sweeping Baroque staircase, where various members of the Paris elite—from old nobility to newly wealthy industrialists—could display themselves, the men in tailcoats accompanying women in bustles and long trains. As Garnier himself said, the purpose of the Opéra was to fulfill the most basic of human desires: to hear, to see, and to be seen.

CARPEAUX. Jean-Baptiste Carpeaux (1827–75), who had studied at the École des Beaux-Arts under the Romantic sculptor François Rude (SEE FIG. 30–9), was commissioned to carve one of the large sculptural groups for the façade of Garnier's Opéra (illustrated here in a plaster version). In this work, **THE DANCE** (FIG. 30–35), a winged personification of Dance, a slender male carrying a tambourine, leaps up joyfully in the midst of a compact, entwined group of mostly nude female dancers, embodying the theme of uninhibited Dionysian revelry. The erotic implication of this wild dance is revealed by the presence in the background of a satyr, a mythological creature known for its lascivious appetites.

Carpeaux's group upset many Parisians because he had not smoothed and generalized the bodies as Neoclassical

along wide, straight, tree-lined avenues that were more propitious for horse-drawn carriages, for strollers, and for suppressing future riots.

Set in one of these new intersections and carefully hiding its cast-iron frame, Garnier's design is a masterpiece of historicism based mostly on the Baroque style, here revived in order to recall that earlier period of France's greatness. The massive façade, featuring a row of paired columns above an arcade, is essentially a heavily ornamented, Baroque version of the seventeenth-century wing of the Louvre, an association meant to suggest the continuity of the French nation and to flatter Emperor Napoleon III by comparing him favorably with King Louis XIV. The luxuriant treatment of form, in conjunction with the building's primary function as a place of entertainment, was intended to celebrate the devotion to wealth and pleasure that characterized the period. The ornate architectural style was also appropriate for the home of that most flamboyant musical form, the opera.

The inside of what some critics called the "temple of pleasure" (FIG. 30–34) was even more opulent, with neo-Baroque sculptural groupings; heavy, gilded decoration; and a lavish mix of expensive, polychromed materials. The highlight of the interior was not the spectacle onstage so much as the

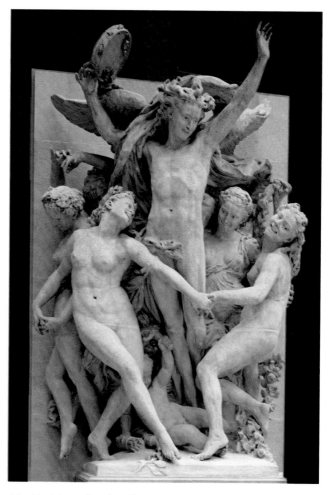

30–35 | Jean-Baptiste Carpeaux **THE DANCE**
1867-68. Plaster, height approx. 15′ (4.6 m).
Musée de l'Opéra, Paris.

30–37 | Gustave Courbet **THE STONE BREAKERS**
1849. Oil on canvas, 5'3" × 8'6" (1.6 × 2.59 m). Formerly Gemäldegalerie, Dresden.
Destroyed in World War II.

enjoyed successful careers during their day, creating works based on history, mythology, or picturesque genre, but they are mostly forgotten now because most of their work was simply not innovative. Rather, their art catered to the taste of most Salon visitors, who during the rapid social changes that transformed modern society looked to art for the reassurance of a comforting subject well painted.

In the middle nineteenth century, however, some artists rejected the precepts of the Salon in favor of a belief that art should faithfully record ordinary life. Most had not read Auguste Comte, but they joined in the new spirit of objectivity. In the years after 1850, some of the work produced by these independent-minded landscape and figure painters was labeled **Realism**, reflecting their positivist belief that art should show the "unvarnished truth." Some of these realists took up subjects that were generally regarded as not important enough for a serious work of art, and as a result they tended to get bad reviews in the press. But as we look back at the decades surrounding the middle of that century, we see that the realists were creating the most innovative and challenging work.

The political backdrop of the rise of Realism was defined by the Revolution of 1848 in France, when an uneasy coalition of socialists, anarchists, and workers overthrew the July Monarchy. The revolts began in February of that year, initially over government corruption and narrow voting rights, but they soon spread to a dozen major cities across Europe. The revolts led in France to the installation of Napoleon III (nephew of Bonaparte) as emperor under a new constitution with broadened suffrage rights, but still much social unease. Napoleon III soon acted to redraw the Paris street maps, as we have seen, to help prevent future revolts.

The Realist movement had a close parallel in literature of the time. Emile Zola, Charles Dickens, Honoré de Balzac, and others wrote novels that focused close attention on the urban lower classes. Zola, in particular, seemed to adhere to positivist beliefs in social science, as he said that he envisioned his novels as scientific experiments: He set his characters loose in an environment to see how they might interact with each other.

REALIST PAINTING IN FRANCE. The social radical Gustave Courbet (1819–77) was inspired by the events of 1848 to turn his attention to poor and ordinary people. Born and raised in Ornans near the Swiss border and largely self-taught as an artist, he moved to Paris in 1839. The street fighting of 1848 seems to have radicalized him. He told one newspaper in 1851 that he was "not only a Socialist but a democrat and a Republican: in a word, a supporter of the whole Revolution." Courbet proclaimed his new political commitment in three large paintings he submitted to the Salon of 1850–51.

One of these, **THE STONE BREAKERS** (FIG. 30–37), is a large painting showing two haggard men laboring to produce gravel used for roadbeds. In a letter he wrote while working on the painting, Courbet described its origins and considered its message:

> [N]ear Maisières [in the vicinity of Ornans], I stopped to consider two men breaking stones on the highway. It's rare to meet the most complete expression of poverty, so an idea for a picture came to me on the spot. I made an appointment with them at my studio for the next day.... On the one side is an old man, seventy.... On the other side is a young fellow . . . in his filthy tattered shirt. . . . Alas, in labor such as this, one's life begins that way, and it ends the same way.

To contemporary viewers, this large painting of workers on the lowest social level seemed to dignify the revolutionaries of 1848. Courbet's friend, the anarchist philosopher Pierre-Joseph Proudhon, in 1865 called *The Stone Breakers* the first socialist picture ever painted, "a satire on our industrial civilization, which continually invents wonderful machines to perform all kinds of labor ... yet is unable to liberate man from the most backbreaking toil." And Courbet himself, in a letter of the following year, referred to the painting as a depiction of "injustice."

Courbet's representation of *The Stone Breakers* on an 8½-foot-wide canvas testified in a provocative way to the painter's respect for ordinary people. In French art before 1848, such people usually had been shown only in modestly scaled paintings, while monumental canvases had been reserved for heroic subjects and pictures of the powerful. Immediately after completing *The Stone Breakers*, Courbet began work on an even larger canvas, roughly 10 by 21 feet, focusing on another scene of ordinary life: the funeral of an unnamed bourgeois citizen of Ornans. **A BURIAL AT ORNANS** (FIG. 30–38), also exhibited at the Salon of 1850–51, was attacked by conservative critics, who objected to its presentation of a mundane provincial funeral on a scale normally reserved for the depiction of a major historical event. They also faulted its disrespect for conventional compositional standards: Instead of arranging figures in a pyramid that would indicate a hierarchy of importance, Courbet lined them up in rows across the picture plane—an arrangement he considered more democratic. Critics also noted that the work contains no suggestion of an afterlife; rather it presents death and burial as mere physical facts, as a positivist might regard them. The painter's political convictions are especially evident in the individual attention and sympathetic treatment he accords the ordinary citizens of Ornans, many of them the artist's friends and family members. Courbet seems to have enjoyed the controversy: When some of his works were refused by the jury for a special Salon at the International Exposition of 1855, he rented a building near the fair's Pavilion of Art and installed a show of his own works which he called the Pavilion of Realism.

Similar accusations of political radicalism were made against Jean-François Millet (1814–75), though with less justification. The artist grew up on a farm and, despite living in Paris between 1837 and 1848, never felt comfortable in the city. The 1848 Revolution's preoccupation with ordinary people led Millet to focus on peasant life, only a marginal concern in his early work, and his support of the revolution earned him a state commission that allowed him to move from Paris to the village of Barbizon. After settling there in 1849, he devoted his art almost exclusively to the difficulties and simple pleasures of rural existence.

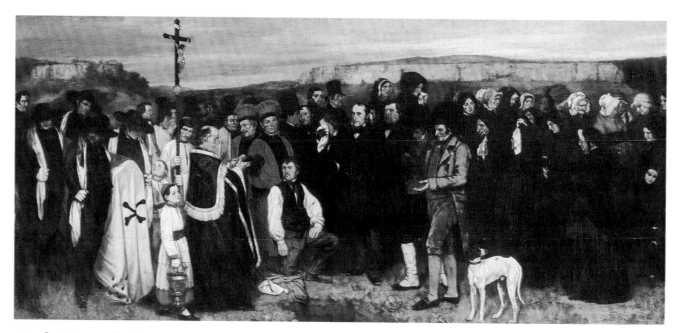

30–38 | Gustave Courbet **A BURIAL AT ORNANS**
1849. Oil on canvas, 10'3½" × 21'9" (3.1 × 6.6 m). Musée d'Orsay, Paris.

A Burial at Ornans was inspired by the 1848 funeral of Courbet's maternal grandfather, Jean-Antoine Oudot, a veteran of the Revolution of 1793. The painting is not meant as a record of that particular funeral, however, since Oudot is shown alive in profile at the extreme left of the canvas, his image adapted by Courbet from an earlier portrait. The two men to the right of the open grave, dressed not in contemporary but in late eighteenth-century clothing, are also revolutionaries of Oudot's generation, and their proximity to the grave suggests that one of their peers is being buried. Courbet's picture may be interpreted as linking the revolutions of 1793 and 1848, both of which sought to advance the cause of democracy in France.

30–39 | Jean-François Millet **THE GLEANERS**
1857. Oil on canvas, 33 × 44″ (83.8 × 111.8 cm).
Musée d'Orsay, Paris.

Among the best known of Millet's mature works is **THE GLEANERS** (FIG. 30–39), which shows three women gathering grain at harvest time. The warm colors and slightly hazy atmosphere are soothing, but the scene is one of extreme poverty. Gleaning, or the gathering of the grains left over after the harvest, was a form of relief offered to the rural poor. It required hours of backbreaking work to gather enough wheat to produce a single loaf of bread. When the painting was shown in 1857, a number of critics thought Millet was attempting to rekindle the sympathies and passions of 1848, and he was therefore labeled a realist and even a socialist. Although Millet did not harbor such beliefs, his works aroused suspicion and controversy.

The kind of work produced in the 1830s and 1840s by the Barbizon School (SEE FIG. 30–18) became increasingly popular with Parisian critics and collectors after 1850, largely because of the radically changed conditions of Parisian life. Between 1831 and 1851 the city's population doubled, then the massive renovations of the entire city led by Haussmann transformed Paris from a collection of small neighborhoods to a modern, crowded, noisy, and fast-paced metropolis. Another factor in the appeal of images of peaceful country life was the widespread uneasiness over the political and social effects of the Revolution of 1848, and fear of further disruptions.

Soothing images of the rural landscape became a specialty of Jean-Baptiste-Camille Corot (1796–1875), who during the early decades of his career had painted not only historical landscapes with subjects drawn from the Bible and classical history, but also ordinary country scenes similar to those depicted by the Barbizon School. Ironically, just as popular taste was beginning to favor the latter kind of work, Corot around 1850 moved on to a new kind of landscape painting that mixed naturalistic subject matter with Romantic, poetic effects. A fine example is **FIRST LEAVES, NEAR MANTES** (FIG. 30–40), an idyllic image of budding green foliage in a warm, misty wood.

30–40 | Jean-Baptiste-Camille Corot **FIRST LEAVES, NEAR MANTES**
c. 1855. Oil on canvas, 13⅜ × 18⅛″ (34 × 36 cm). The Carnegie Museum of Art, Pittsburgh,
Pennsylvania.

30–41 | Rosa Bonheur **PLOWING IN THE NIVERNAIS: THE DRESSING OF THE VINES**
1849. Oil on canvas, 5'9″ × 8'8″ (1.8 × 2.6 m). Musée d'Orsay, Paris.

Bonheur was often compared with George Sand, a contemporary woman writer who adopted a male name as well as male dress. Sand devoted several of her novels to the humble life of farmers and peasants. Critics at the time noted that *Plowing in the Nivernais* may have been inspired by a passage in Sand's *The Devil's Pond* (1846) that begins: "But what caught my attention was a truly beautiful sight, a noble subject for a painter. At the far end of the flat ploughland, a handsome young man was driving a magnificent team [of] oxen."

The feathery brushwork in the grasses and leaves infuses the painting with a soft, dreamy atmosphere that is counterbalanced by the solidly modeled tree trunks in the foreground, which create a firm sense of structure. Beyond the trees, a dirt road meanders toward the village in the background. Two rustic figures travel along the road at the lower center, while another figure labors in the woods at the lower right. Corot invites us to identify with these figures and to share imaginatively in their simple and unhurried rural existence.

Among the period's most popular painters of farm life was Rosa Bonheur (1822–99), whose commitment to rural subjects was partly the result of her aversion to Paris, where she had been raised. Bonheur's success in what was then a male domain owed much to the socialist convictions of her parents, who belonged to a radical utopian sect founded by the Comte de Saint-Simon (1760–1825), which believed not only in the equality of women but also in a future female Messiah. Bonheur's father, a drawing teacher, provided most of her artistic training.

Bonheur devoted herself to painting her beloved farm animals with complete accuracy, increasing her knowledge by reading zoology books and making detailed studies in stockyards and slaughterhouses. (To gain access to these all-male preserves, Bonheur got police permission to dress in men's clothing.) Her professional breakthrough came at the Salon of 1848, where she showed eight paintings and won a first-class medal. Shortly after, she received a government commission to paint **PLOWING IN THE NIVERNAIS: THE DRESSING OF THE VINES (FIG. 30–41)**, a monumental composition featuring one of her favorite animals, the ox. The powerful beasts, anonymous workers, and fertile soil offer a reassuring image of the continuity of agrarian life. The stately movement of people and animals reflects the kind of carefully balanced compositional schemes taught in the academy and echoes scenes of processions found in classical art. The painting's compositional harmony—the shape of the hill is answered by and continued in the general profile of the oxen and their handler on the right—as well as its smooth illusionism and conservative theme were very appealing to the taste of the times. Her workers are far less pathetic than those of Courbet or Millet. Bonheur became so famous that in 1865 she received France's highest award, membership in the Legion of Honor, becoming the first woman to be awarded its Grand Cross.

Millet, Courbet, Bonheur, and the other Realists who emerged in the 1850s are sometimes referred to as the "Generation of 1848." Because of his sympathy with working-class people, Honoré Daumier (1808–79) is also grouped with this generation. Unlike Courbet and the others, however, Daumier often depicted urban scenes, as in his famous early lith-

30–42 | Honoré Daumier **THE THIRD-CLASS CARRIAGE**
c. 1862. Oil on canvas, 25¼ × 35½" (65.4 × 90.2 cm).
The National Gallery of Canada, Ottawa.
Purchase, 1946

Although he devoted himself seriously to oil painting during the later decades of his life, Daumier was known to the Parisian public primarily as a lithographer whose cartoons and caricatures appeared regularly in the press. Early in his career he drew anti-monarchist caricatures critical of King Louis-Philippe, but censorship laws imposed in 1835 obliged him to focus on social and cultural themes of a nonpolitical nature.

ograph *Rue Transnonain, Le 15 Avril 1834* (see Introduction, FIG. 13) and his later oil painting **THE THIRD-CLASS CARRIAGE** (FIG. 30–42). The painting depicts the interior of one of the large, horse-drawn buses that transported Parisians along one of the new boulevards Haussmann had introduced as part of the city's redevelopment. Daumier places the viewer in the poor section of the bus, opposite a serene grandmother, her daughter, and her two grandchildren. Although there is a great sense of intimacy and unity among these people, they are physically and mentally separated from the upper- and middle-class passengers, whose heads appear behind them. By portraying the lower classes as hardworking and earnest, the work humanizes them in a way similar to that of the novels of Charles Dickens.

REALISM OUTSIDE FRANCE. Following the French lead, artists of other nations also embraced Realism in the period after 1850 as the social effects of urbanization and industrialization began to take hold in their countries. In Russia, Realism developed in relation to a new concern for the peasantry. In 1861 the czar abolished serfdom, emancipating Russia's peasants from the virtual slavery they had endured on the large estates of the aristocracy. Two years later a group of painters inspired by the emancipation declared allegiance both to the peasant cause and to freedom from the St. Petersburg Academy of Art, which had controlled Russian art since 1754. Rejecting what they considered the escapist, "art for art's sake" aesthetics of the Academy, the members of the group dedicated themselves to a socially useful Realism. Committed to bringing art to the people in traveling exhibitions, they called themselves the Wanderers. By the late 1870s members of the group, like their counterparts in music and literature, had also joined a nationalistic movement to reassert what they considered to be an authentic Russian culture rooted in the traditions of the peasantry, rejecting the Western European customs that had long predominated among the Russian aristocracy.

Ilya Repin (1844–1930), who attended the St. Petersburg Academy and won a scholarship to study in Paris, joined the Wanderers in 1878 after his return to Russia. Repin painted a series of works illustrating the social injustices then prevailing in his homeland, including **BARGEHAULERS ON THE VOLGA** (FIG. 30–43). The painting features a group of wretchedly dressed peasants condemned to the brutal work

30–43 | Ilya Repin **BARGEHAULERS ON THE VOLGA**
1870-73. Oil on canvas, 4'3¾" × 9'3" (1.3 × 2.81 m). State Russian Museum, St. Petersburg.

of pulling ships up the Volga River. To heighten our sympathy for these workers, Repin placed a youth in the center of the group, a young man who will soon look as old and tired as his companions unless something is done to rescue him. In this way, the painting is a cry for action.

The most uncompromising American Realist of the era, Thomas Eakins (1844–1916), was also criticized for selecting controversial subjects. Born in Philadelphia, Eakins trained at the Pennsylvania Academy of the Fine Arts, but since he regarded the training in anatomy as not rigorous enough—lacking realism, as he might have put it—he supplemented his training at the Jefferson Medical College nearby. He later studied at the École des Beaux-Arts in Paris, then spent six months in Spain, where he encountered the profound realism of Jusepe de Ribera and Diego Velázquez (SEE FIGS. 22–25, 22–27). After he returned to Philadelphia in 1870, he specialized in frank portraits and scenes of everyday life whose lack of conventional charm generated little popular interest. But he was a charismatic and influential teacher, and was soon appointed director of the Pennsylvania Academy.

One work of his did attract attention of a negative kind: THE GROSS CLINIC (FIG. 30–44) was severely criticized and was refused exhibition space at the 1876 Philadelphia Centennial because the jury apparently did not regard surgery as a fit subject for art. The painting shows Dr. Samuel David Gross performing an operation with young medical students looking on. The representatives of science—a young medical student, the doctor, and his assistants—are all highlighted. This dramatic use of light, inspired by Rembrandt and the Spanish Baroque masters Eakins admired, is not meant to stir emotions but to make a point: Amid the darkness of ignorance and fear, modern science shines the light of knowledge. The light in the center falls not on the doctor's face but on his forehead—on his mind. The French poet and art critic Charles Baudelaire had called as far back as 1846 for artists to depict "The Heroism of Modern Life," and turn away from the historical or the imaginary. He wrote, "There *are* such things as modern beauty and modern heroism." Though Eakins most likely had not read Baudelaire's call, he did see Dr. Gross as a hero and depicted him memorably. For many years the painting hung not in an art gallery but at the Jefferson Medical College.

A few years later, Eakins's commitment to the unvarnished truth proved costly in his career. When he removed the loincloth from a male nude model in a mixed life-drawing class, the scandalized Academy board gave him the choice of changing his teaching methods or resigning. He resigned. This step did not remove Realism from the Academy curriculum, however, as we shall see in the next chapter.

His compatriot Winslow Homer (1836–1910) believed that unadorned realism was the most appropriate style for American-type democratic values. The Boston-born Homer began his career in 1857 as a freelance illustrator for popular

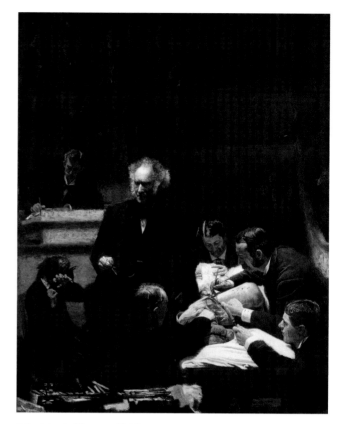

30–44 Thomas Eakins **THE GROSS CLINIC**
1875. Oil on canvas, 8′ × 6′5″ (2.44 × 1.98 m). Jefferson Medical College of Thomas Jefferson University, Philadelphia.

Eakins, who taught anatomy and figure drawing at the Pennsylvania Academy of the Fine Arts, disapproved of the academic technique of drawing from plaster casts. In 1879 he said, "At best, they are only imitations, and an imitation of an imitation cannot have so much life as an imitation of nature itself." He added, "The Greeks did not study the antique . . . the draped figures in the Parthenon pediment were modeled from life, undoubtedly."

periodicals such as *Harper's Weekly*, which sent him to cover the Civil War in 1862. In 1866–67 Homer spent ten months in France, where the Realist art he saw may have inspired the rural subjects he painted when he returned. His commitment to depicting common people deepened after he spent 1881–82 in a tiny English fishing village on the rugged North Sea coast. The strength of character of the people there so inspired him that he turned from idyllic subjects to more dramatic themes involving the heroic human struggle against natural adversity. In England, he was particularly impressed with the breeches buoy, a mechanical apparatus used to rescue those aboard foundering ships. During the summer of 1883 Homer made sketches of a breeches buoy imported by the lifesaving crew in Atlantic City, New Jersey. The following year Homer painted **THE LIFE LINE** (FIG. 30–45), which depicts a coast guardsman using the breeches buoy to rescue an unconscious woman and is a testament not simply to human bravery but also to ingenuity.

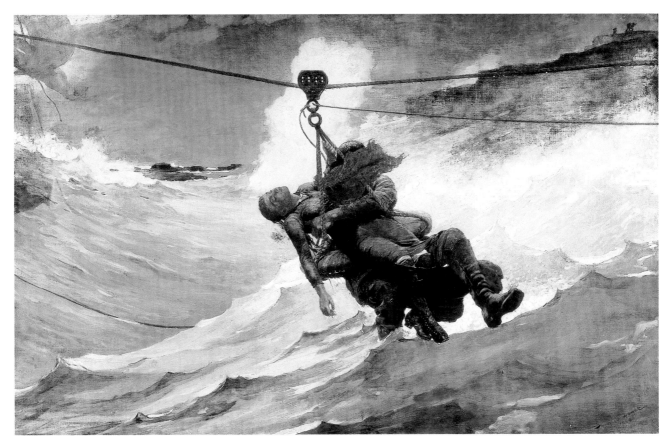

30–45 | Winslow Homer **THE LIFE LINE**
1884. Oil on canvas, 28 ¾ × 44 ⅜″ (73 × 113.3 cm). Philadelphia Museum of Art.
The George W. Elkins Collection.

In the early sketches for this work, the man's face was visible. The decision to cover it focuses more attention not only on the victim but also on the true hero, the mechanical apparatus known as the breeches buoy.

Late Nineteenth-Century Art in Britain

The parliamentary reforms of the 1830s made England a more flexible society, better able to deal with the social pressures that industrialization and urbanization caused. Though it had its share of political agitation, the country was spared the worst violence of the 1848 revolts. Likewise, Realist currents were few, and they were tied to an effort to reform English art that looked back to the social concern of Hogarth. In 1848 seven young London artists formed the Pre-Raphaelite Brotherhood in response to what they considered the misguided practices of contemporary British art. Instead of the Raphaelesque conventions taught at the Royal Academy, the Pre-Raphaelites advocated the naturalistic approach of certain early Renaissance masters, especially those of northern Europe. They advocated as well a moral approach to art, in keeping with what they saw as a long tradition in Britain.

HUNT. The combination of didacticism and naturalism that characterized the first phase of the movement is best represented in the work of one of its leaders, William Holman Hunt (1827–1910), for whom moral truth and visual accuracy were synonymous. A well-known painting by this academically trained artist is **THE HIRELING SHEPHERD**

(FIG. 30–46). Hunt painted the landscape portions of the composition outdoors, an innovative approach at the time, leaving space for the figures, which he painted in his London studio. The work depicts a farmhand neglecting his duties to flirt with a woman while pretending to discuss a death's-head moth that he holds in his hand. Meanwhile, some of his

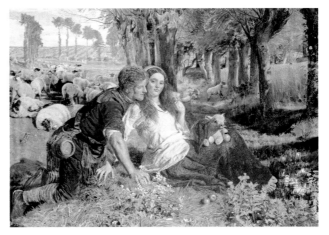

30–46 | William Holman Hunt **THE HIRELING SHEPHERD**
1851. Oil on canvas, 30 ⅛ × 43 ⅛″ (76.4 × 109.5 cm).
Manchester City Art Gallery, England.

employer's sheep are wandering into an adjacent field, where they may become sick or die from eating green corn. Hunt later explained that he meant to satirize pastors who instead of tending their flock waste time discussing what he considered irrelevant theological questions. The work is certainly an allegory fashioned after one of the parables of Jesus about good and bad shepherds (John 10:11-13). The painting can also be seen as a moral lesson on the perils of temptation. The woman is cast as a latter-day Eve, as she feeds an apple—a reference to humankind's fall from grace—to the lamb on her lap and distracts the shepherd from his duty.

MORRIS AND THE ARTS AND CRAFTS MOVEMENT. The socialist values of the Revolution of 1848 had their strongest impact on English arts in the field of interior design. William Morris (1834–1896) worked briefly as a painter under the influence of the Pre-Raphaelites before turning his attention to interior design and decoration. Morris's interest in handcrafts developed in the context of a widespread reaction against the gaudy design of industrially produced goods that began with the Crystal Palace exhibition of 1851. Unable to find satisfactory furnishings for his new home after his marriage in 1859, Morris designed and made them himself with the help of friends. He then founded a decorating firm to produce a full range of medieval-inspired objects. Although many of the furnishings offered by Morris & Company were expensive, one-of-a-kind items, others, such as the rush-seated chair illustrated here (**FIG. 30–47**), were cheap and simple, intended to provide a handcrafted alternative to the vulgar excess characteristic of industrial furniture. Concerned with creating a "total" environment, Morris and his colleagues designed not only furniture but also stained glass, tiles, wallpaper, and fabrics, such as the **PEACOCK AND DRAGON CURTAIN** seen in the background of FIGURE 30–47.

Morris inspired what became known as the Arts and Crafts movement. His aim was to benefit not just a wealthy few but society as a whole. He rebelled against the common Western notion, in effect since the Renaissance, that art was a highly specialized product made by a uniquely gifted person for sale at a high price to a wealthy individual for a private possession. Rather, he hoped to usher in a new era of art by the people and for the people. As he said in the hundreds of lectures he began delivering in 1877, "I do not want art for a few, any more than education for a few, or freedom for a few." A socialist, Morris had serious doubts about mass production not only because he found its products ugly but also because of its deadening influence on the industrial worker, forced to work ten- to twelve-hour days at repetitive tasks. With craft-work, he maintained, the laborer retains the satisfaction of seeing a project through to completion. He was inspired by the popular and mostly anonymous artists of the Middle Ages, but he also dreamed of a Utopian future without class

30–47 | **FOREGROUND:** Philip Webb **SINGLE CHAIR FROM THE SUSSEX RANGE**
In production from c. 1865. Ebonized wood with rush seat, 33 × 16½ × 14″ (83.8 × 42 × 35.6 cm). Manufactured by Morris & Company. William Morris Gallery (London Borough of Waltham Forest).

BACKGROUND: William Morris **PEACOCK AND DRAGON CURTAIN**
1878. Handloomed jacquard-woven woolen twill, 12′10 ½″ × 11′5 ⅜″ (3.96 × 3.53 m). Manufactured at Queen Square and later at Merton Abbey. Victoria & Albert Museum, London.

Morris and his principal furniture designer, Philip Webb (1831-1915), adapted the Sussex Range from traditional rush-seated chairs of the Sussex region. The handwoven curtain in the background is typical of Morris's fabric design in its use of flat patterning that affirms the two-dimensional character of the textile medium. The pattern's prolific organic motifs and soothing blue and green hues—the decorative counterpart to those of naturalistic landscape painting—were meant to provide relief from the stresses of modern urban existence.

envy and where everyone embellished their lives with some form of art.

WHISTLER. Not all of those who participated in the revival of the decorative arts were committed to improving the conditions of modern life. Many saw in the Arts and Crafts revival simply another way to satisfy an elitist taste for beauty. Among these was the American expatriate James Abbott McNeill Whistler (1834–1903), who not only devoted attention to the rooms and walls where art is hung, but also participated in

controversies that laid important groundwork for the art of the next century. After flunking out of West Point in the early 1850s, Whistler studied art in Paris, where he came under the influence of the Realists, and painted seascapes with Courbet. After settling in London in 1859, his thought evolved away from Realism, and he began to conceive of aesthetic values as independent of any other social fact. That is, he believed that the mere arrangement of a room or a painting can be aesthetically pleasing in itself, no matter what it contains or depicts. He was among the first to hang his works in a gallery in a single row, rebelling against the "stacked" array of most art exhibitions since the seventeenth century. He also occasionally designed rooms to hold his works, mindful of the total harmony of a space.

His ideas about what makes a successful work of art proved equally revolutionary. He was among the first to collect Japanese art, finding there fascinating patterns of pure decoration that delighted his eye although he understood nothing of the subject matter. By the middle of the 1860s he was titling his works "Symphony" and "Arrangement," hinting that just as a symphony can be a pleasing composition of sound, so a painting can be a pleasing arrangement of form, regardless of its subject. He made several landscapes with the musical title "Nocturne," and when he exhibited some of these in 1877, he drew a negative review from England's leading art critic John Ruskin, a supporter of the Pre-Raphaelites who defended the moral intentions of those artists. Whistler's work seemed to have no such purpose, so Ruskin wondered in print how an artist could "demand 200 guineas for flinging a pot of paint in the public's face."

The most controversial painting in Whistler's show was NOCTURNE IN BLACK AND GOLD, THE FALLING ROCKET (FIG. 30–48), and it precipitated one of the most important court cases in Western art history. The work is a night scene painted in restricted tonalities that looks at first like a completely abstract painting, meaning that it does not represent observable aspects of nature. In fact, Whistler depicted a fireworks show over a lake at nearby Cremorne Gardens, with viewers dimly recognizable in the foreground. Calling the work a "Nocturne" recalled the piano pieces of Romantic composer Frederic Chopin, though Whistler was less interested in Romantic feeling than in pursuing the parallel between art and music. After reading Ruskin's review, Whistler sued the critic for libel and the case went to trial (see "Art on Trial in 1877"). On the witness stand, the artist defended his view that art has no higher purpose than creating visual delight; he further claimed that art need not have a subject matter at all in order to be successful. While Whistler never made a completely abstract painting, his theories became an important part of the justification for abstract art in the next century.

Defining Art
ART ON TRIAL IN 1877

This is a partial transcript of Whistler's testimony at the libel trial that he initiated against the art critic John Ruskin. Whistler's responses often provoked laughter, and the judge at one point threatened to clear the courtroom.

Q: What is your definition of a Nocturne?

A: I have, perhaps, meant rather to indicate an artistic interest alone in the work, divesting the picture from any outside sort of interest which might have been otherwise attached to it. It is an arrangement of line, form, and color first . . . The *Nocturne in Black and Gold* [SEE FIG. 30-48] is a night piece, and represents the fireworks at Cremorne.

Q: Not a view of Cremorne?

A: If it were called a view of Cremorne, it would certainly bring about nothing but disappointment on the part of beholders. It is an artistic arrangement. It was marked 200 guineas . . .

Q: I suppose you are willing to admit that your pictures exhibit some eccentricities; you have been told that over and over again?

A: Yes, very often.

Q: You send them to the gallery to invite the admiration of the public?

A: That would be such a vast absurdity on my part that I don't think I could.

Q: Did it take you much time to paint the *Nocturne in Black and Gold?* How soon did you knock it off?

A: I knocked it off in possibly a couple of days; one day to do the work, and another to finish it.

Q: And that was the labor for which you asked 200 guineas?

A: No, it was for the knowledge gained through a lifetime.

The judge ruled in Whistler's favor; Ruskin had indeed libeled him. But he awarded Whistler damages of only one half of one cent. Since in those days the person who brought the suit had to pay all the court costs, the case ended up bankrupting the artist.

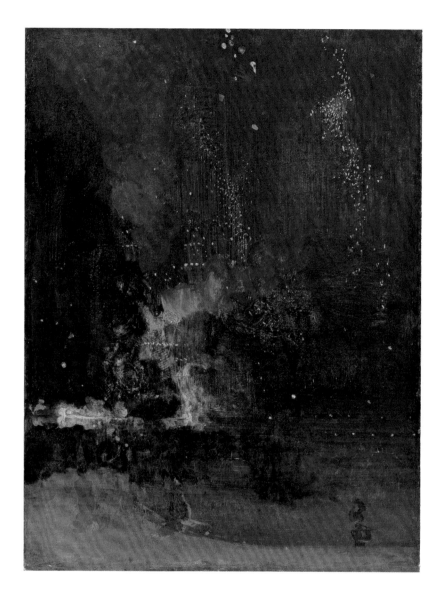

30–48 | James Abbott McNeill Whistler
NOCTURNE IN BLACK AND GOLD, THE FALLING ROCKET
1875. Oil on panel, 23¾ × 18⅜″ (60.2 × 46.7 cm). Detroit Institute of Arts, Detroit, Michigan.
46.309

Impressionism

While the leading British artists were moving away from the naturalism advocated by the original Pre-Raphaelite Brotherhood, their French counterparts were pushing the French Realist tradition into new territory. The generation that matured around 1870 began as followers of Realism or the Barbizon School but soon moved to more modern subjects: leisure, the upper middle class, and the city. Although many of these artists specialized in paintings of the countryside, their point of view was usually that of a city person on holiday.

In April 1874, a number of these artists, including Paul Cézanne, Edgar Degas, Claude Monet, Berthe Morisot, Camille Pissarro, and Pierre-Auguste Renoir, exhibited together in Paris as the *Société Anonyme des Artistes Peintres, Sculpteurs, Graveurs, etc.* (Corporation of Artists Painters, Sculptors, Engravers, etc.). The mastermind of this arrangement was Pissarro, a devotee of anarchist philosophies. Anarchists such as Proudhon urged citizens to band together into

voluntary associations for mutual aid instead of relying on the state for such functions as banking and policing. Pissarro envisioned the *Société* as such a mutual aid group in opposition to the state-funded Salons. While the Impressionists became the best-known members that are remembered today, at the time the group consisted of artists who worked in various styles. All thirty participants agreed not to submit anything that year to the Salon, which had in the past often rejected their works; hence, their exhibition was a declaration of independence from the Academy and a bid to gain the attention of the public without the intervention of a jury. While the exhibition received some positive reviews, it was attacked by most critics. Louis Leroy, writing in the comic journal *Charivari*, seized on the title of a painting by Monet, *Impression, Sunrise* (1873), and dubbed the entire exhibition "impressionist." While Leroy used the word to attack the seemingly haphazard technique and unfinished look of some of the paintings, Monet and many of his colleagues were

pleased to accept the label, which spoke to their concern for capturing an instantaneous impression of a scene in nature. Seven more Impressionist exhibitions followed between 1876 and 1886, with the membership of the group varying slightly on each occasion; only Pissarro participated in all eight shows. The exhibitions of the Impressionists inspired other artists to organize alternatives to the Salon, a development that by the end of the century ended the French Academy's centuries-old stranglehold on the display of art and thus on artistic standards.

MANET. Frustration among progressive artists with the exclusionary practices of the Salon jury had been mounting in the decades preceding the first Impressionist exhibition. Such discontent reached a fever pitch in 1863 when the jury turned down nearly 3,000 works submitted to the Salon, leading to a storm of protest. In response, Napoleon III tried to mediate in the dispute by ordering an exhibition of the refused work called the *Salon des Refusés* ("Salon of the Rejected Ones").

Featured in it was a painting by Édouard Manet (1832–83), **LE DÉJEUNER SUR L'HERBE** or **THE LUNCHEON ON THE GRASS** (FIG. 30–49), which scandalized contemporary viewers and helped to establish Manet as a radical artist. Within a few years, many of the future Impressionists would gather around Manet and follow his lead in challenging academic conventions.

A well-born Parisian who had studied in the early 1850s with the progressive academician Thomas Couture (1815–79), Manet had by the early 1860s developed a strong commitment to Realism, largely as a result of his friendship with the poet Baudelaire (SEE FIG. 30–30). In his article "The Painter of Modern Life," Baudelaire called for an artist who would be the painter of contemporary manners, "the painter of the passing moment and all the suggestions of eternity that it contains." Manet seems to have responded to Baudelaire's call in painting *Le Déjeuner sur l'Herbe*, which proved deeply offensive to both the academic establishment and the average Salon-goer. Most disturbing to contemporary viewers was the "immorality" of Manet's theme: a suburban picnic

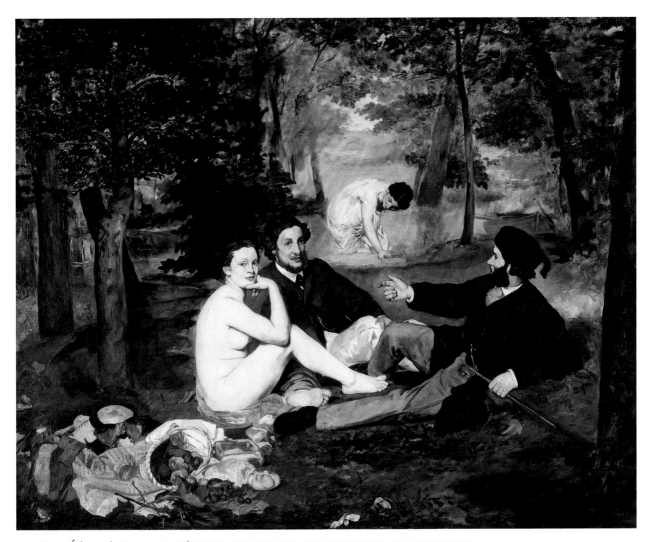

30–49 | Édouard Manet **LE DÉJEUNER SUR L'HERBE (THE LUNCHEON ON THE GRASS)**
1863. Oil on canvas, 7′ × 8′8″ (2.13 × 2.64 m). Musée d'Orsay, Paris.

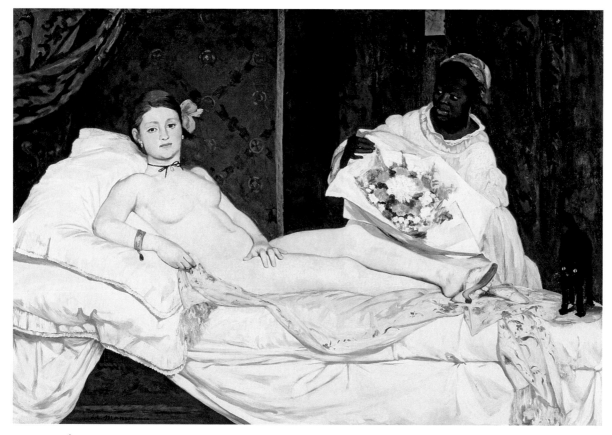

30–50 | Édouard Manet OLYMPIA
1863. Oil on canvas, 4′3″ × 6′2¼″ (1.31 × 1.91 m). Musée du Louvre, Paris.

featuring a scantily clad bathing woman in the background and, in the foreground, a completely naked woman, seated alongside two fully clothed, upper-class men. Manet's scandalized audience assumed that these women were prostitutes and that the well-dressed men were their clients. What was most shocking about this work was its modernity, presenting nudity in the context of contemporary life. In contrast, one of the paintings that gathered most renown at the official Salon in that year was Alexandre Cabanel's *Birth of Venus* (SEE FIG. 30–36), which, because it presented nudity in a more acceptable classical environment, was favorably reviewed and quickly entered the collection of Napoleon III.

Manet apparently conceived of *Le Déjeuner sur l'Herbe* as a modern version of a famous Venetian Renaissance painting in the Louvre, the *Pastoral Concert*, then believed to be by Giorgione but now attributed to both Titian and Giorgione (SEE FIG. 20–24). Manet also adapted for his composition a group of river gods and a nymph from an engraving by Marcantonio Raimondi based on Raphael's *The Judgment of Paris*—an image that, in turn, looked back to classical reliefs. With its deliberate allusions to Renaissance artworks, Manet's painting addresses the history of art and Manet's relationship to it. To a viewer who has in mind the traditional perspective and the rounded modeling of forms of the two Renaissance works,

the stark lighting of Manet's nude and the flat, cutout quality of his figures become all the more shocking. In this way, Manet emphasized his own radical innovations.

The intended meaning of *Le Déjeuner* remains a matter of considerable debate. Some see it as a portrayal of modern alienation, for the figures in Manet's painting fail to connect with one another psychologically. Although the man on the right seems to gesture toward his companions, the other man gazes off absently, while the nude turns her attention away from them and to the viewer. Moreover, her gaze makes us conscious of our role as outside observers; we, too, are estranged. Manet's rejection of warm colors for a scheme of cool blues and greens plays an important role, as do his flat, sharply outlined figures, which seem starkly lit because of the near absence of modeling. The figures are not integrated with their natural surroundings, as in the *Pastoral Concert*, but seem to stand out sharply against them, as if seated before a painted backdrop.

Shortly after completing *Le Déjeuner sur l'Herbe*, Manet painted **OLYMPIA** (FIG. 30–50), whose title alluded to a socially ambitious prostitute of the same name in a novel and play by Alexandre Dumas *fils* (the younger). Like *Le Déjeuner sur l'Herbe*, Manet's *Olympia* was based on a Venetian Renaissance source, Titian's *Venus of Urbino* (SEE FIG. 20–26), which Manet had earlier copied in Florence. At first, Manet's paint-

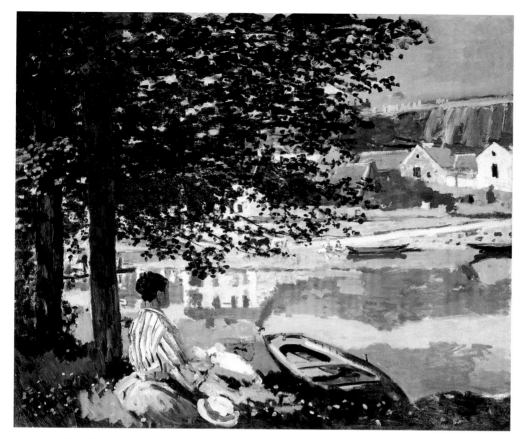

30–51 | Claude Monet **ON THE BANK OF THE SEINE, BENNECOURT**
1868. Oil on canvas, 32 × 39⅔″ (81.5 × 100.7 cm). Art Institute of Chicago.
Potter Palmer Collection, 1922.427

ing appears to pay homage to Titian's in its subject matter (the Titian painting was then believed to be the portrait of a Venetian courtesan) and composition. However, Manet made his modern counterpart the very antithesis of the Titian. Whereas Titian's female is curvaceous and softly rounded, Manet's is angular and flattened. Whereas Titian's looks lovingly at the male spectator, Manet's appears coldly indifferent. Our relationship with Olympia is underscored by the reaction of her cat, who—unlike the sleeping dog in the Titian—arches its back at us. Finally, instead of looking up at us, Olympia stares down on us, indicating that she is in the position of power and that we are subordinate, akin to the black servant at the foot of the bed who brings her a bouquet of flowers. In reversing the Titian, Manet in effect subverted the entire tradition of the accommodating female nude. Not surprisingly, conservative critics vilified the *Olympia* when it was displayed at the Salon of 1865.

Manet generally submitted his work to every Salon, but when he had a number of rejections in 1867, he did as Courbet had done in 1855: He rented a hall nearby and staged a solo exhibition. This made Manet the unofficial leader of a group of progressive artists and writers who gathered at the Café Guerbois in the Montmartre district of Paris. Among the artists who frequented the café were Degas,

Monet, Pissarro, and Renoir, who would soon exhibit together as the Impressionists. With the exception of Degas, who, like Manet, remained a studio painter, these artists began to paint outdoors, *en plein air* ("in the open air"), in an effort to record directly the fleeting effects of light and atmosphere. (*Plein air* painting was greatly facilitated by the invention in 1841 of tin tubes for oil paint.)

MONET. Claude Monet (1840–1926) was probably the purest exponent of Impressionism. Born in Paris but raised in the port city of Le Havre, Monet trained briefly with an academic teacher but soon forsook the studio to paint outdoors. He befriended the Barbizon School artist Daubigny (SEE FIG. 30–18), who urged him to "be faithful to his impression," and guided the younger artist to create his own floating studio on a boat. Many of Monet's early works include expanses of water, such as **ON THE BANK OF THE SEINE, BENNECOURT** (FIG. 30–51). Monet's effort to capture the intense brightness of the sunlight led to the creation of this work, which one critic complained made his eyes hurt. Monet applied the flat expanses of pure color to the canvas unmixed, directly out of the tube, and he avoided underpainting his canvases in brown, as the academics taught. This is a solitary figure in a landscape, but it is not a Romantic vision. Monet visited

England in 1870 and saw the extremely painterly works by Turner, such as *The Burning of the Houses of Lords and Commons* (SEE FIG. 30–16). While Turner's brushwork may have influenced some of Monet's later landscapes, Monet did not share the older artist's commitment to feeling or to narrative. He said simply, "The Romantics have had their day." Instead he painted simple moments, capturing the play of light quickly before it changed.

In the 1870s, Monet moved further away from his Barbizon sources and began painting more urban subjects, such as the St. Lazare railway station (FIG. 30–52). This was a new structure, made of steel and glass, and Monet was fascinated by the way light descended through the glass ceiling and filtered through the steam from the trains parked beneath. He set up his easel in the station (to the consternation of the station manager), and painted twelve different views of the canopy under differing light conditions. The railroad was at that time a modern conveyance, bringing hordes of people from the countryside into the center of Paris. Monet had no interest in the human drama of the arrivals and departures, but rather he focused on the evanescent qualities of the light in the context of modern urban haste.

Monet carried out his quest to record the shifting play of light on the surface of objects and the effect of that light on the eye without concern for the physical character or any symbolic importance of the objects he represented. The American painter Lilla Cabot Perry, who befriended Monet in his later years, recalled him telling her:

> When you go out to paint, try to forget what objects you have before you—a tree, a house, a field, or whatever. Merely think, Here is a little square of blue, here an oblong of pink, here a streak of yellow, and paint it just as it looks to you, the exact color and shape, until it gives your own naive impression of the scene before you.

Perry also reported that Monet

> said he wished he had been born blind and then had suddenly gained his sight so that he could have begun to paint in this way without knowing what the objects were that he saw before him. He held that the first real look at the motif was likely to be the truest and most unprejudiced one. . . .

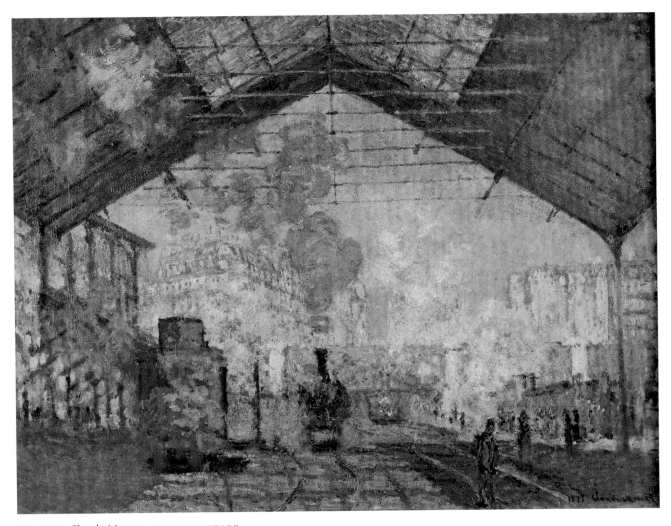

30–52 | Claude Monet **GARE ST-LAZARE**
1877. Oil on canvas, 29¾ × 50" (75.5 × 104 cm). Musée d'Orsay, Paris.
Photo: Erich Lessing/Art Resource, NY

Two important ideas are expressed here. One is that a quickly painted oil sketch most accurately records a landscape's general appearance. This view had been a part of academic training since the late eighteenth century, but such sketches were considered merely part of the preparation for a finished work. In essence Monet attempted to raise these traditional "sketch aesthetics" to the same level as a completed painting. As a result, the major criticism at the time was that his paintings were not "finished." The second idea is a more modern one, that an artist can see a subject freshly, without preconceptions or traditional filters. This was an inheritance of the Barbizon painters, and it led the Impressionists to paint subjects that had not been painted before. They sought subject matter that lacked the traditional markers of appropriateness: symbolic content, historical allusion, or narrative meanings. Instead they painted modern urban and suburban life in a way that captured its fast-changing character.

In the 1880s and 1890s, Monet focused his vision yet more intently, taking the idea of a series of works to other outdoor subjects: grain stacks, rows of poplar trees against the sky, and the cathedral at Rouen (FIG. 30–53). He painted the cathedral not because he suddenly discovered religion late in life, but because he found the church's undulating stone surface a laboratory of natural light effects, which he could paint without worrying much about perspective. He especially focused on the content of the shadows in the façade's deep niches, where he sometimes found iridescent overtones created by afterimages on his retina.

COUNTRY AND CITY IN *PLEIN AIR*. Although he painted during the 1870s in a style similar to Monet's, Camille Pissarro (1830–1903) identified more strongly with peasants and rural laborers. Born in the Danish West Indies to a French family and raised near Paris, Pissarro studied art in that city during the 1850s and early 1860s. After assimilating the influences of both Corot and Courbet, Pissarro embraced Impressionism in 1870, when both he and Monet were living in London to escape the Franco-Prussian War. There, they worked closely together, dedicating themselves, as Pissarro later recalled, to "*plein air* light and fugitive effects." The result, for both painters, was a lightening of color and a loosening of the way they handled paint.

Following his return to France, Pissarro settled in Pontoise, a small, hilly village northwest of Paris that retained a thoroughly rural character. There he worked for much of the 1870s in a style close to that of Monet, using high-keyed color and short brushstrokes to capture fleeting qualities of light and atmosphere. Rather than the vacationer's landscapes that Monet favored, however, Pissarro chose agrarian themes such as orchards and tilled fields. In the late 1870s his painting tended toward greater visual and material complexity.

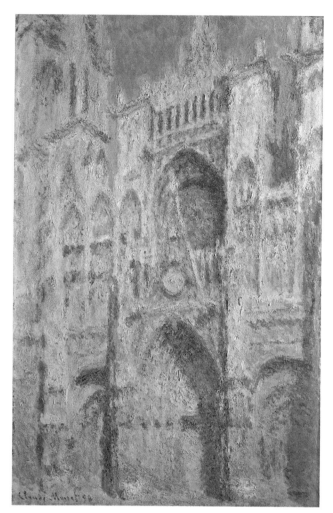

30–53 | Claude Monet
ROUEN CATHEDRAL: THE PORTAL (IN SUN)
1894. Oil on canvas, 39¼ × 26" (99.7 × 66 cm).
The Metropolitan Museum of Art, New York.
Theodore M. Davis Collection, Bequest of Theodore M. Davis, 1915
(30.95.250)

Monet painted more than thirty views of the façade of Rouen Cathedral. He probably began each canvas during two stays in Rouen in early 1892 and early 1893, observing his subject from a second-story window across the street. He then finished the whole series in his studio at Giverny. In these paintings Monet continued to pursue his Impressionist aim of capturing fleeting effects of light and atmosphere, but his extensive reworking of them in the studio produced pictures far more carefully orchestrated and laboriously executed than his earlier, more spontaneously painted *plein air* canvases.

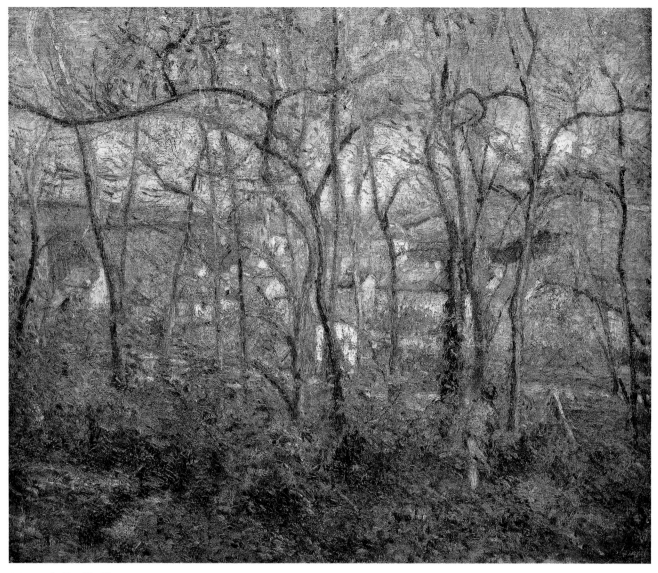

30–54 | Camille Pissarro **WOODED LANDSCAPE AT L'HERMITAGE, PONTOISE**
1878. Oil on canvas, 18⅜ × 22⅛″ (46.5 × 56 cm). The Nelson-Atkins Museum of Art, Kansas City, Missouri.
Gift of Dr. and Mrs. Nicholas S. Pickard

WOODED LANDSCAPE AT L'HERMITAGE, PONTOISE (FIG. 30–54) reflects the continuing influence of Corot (SEE FIG. 30–40) in its composition of foreground trees that screen the view of a rural path and village and in its inclusion of a rustic figure at the lower right. Pissarro uses a brighter and more variegated palette than Corot, however, and he applies his paint more thickly, through a multitude of dabs, flecks, and short brushstrokes. One hostile critic remarked, accurately but painfully, "Corot, Corot, what crimes are committed in your name!"

More typical of the Impressionists in his proclivity for painting scenes of upper-middle-class recreation was Pierre-Auguste Renoir (1841–1919), who met Monet at the École des Beaux-Arts in 1862. Despite his early predilection for figure painting in a softened, Courbet-like mode, Renoir was encouraged by his more forceful friend Monet to create pleasant, light-filled landscapes, which were painted outdoors. By

the mid-1870s Renoir was combining Monet's style in the rendering of natural light with his own taste for the figure.

MOULIN DE LA GALETTE (FIG. 30–55), for example, features dancers dappled in bright afternoon sunlight. The Moulin de la Galette (the "Pancake Mill"), in the Montmartre section of Paris, was an old-fashioned Sunday afternoon dance hall, which during good weather made use of its open courtyard. Renoir has glamorized its working-class clientele by replacing them with his young artist friends and their models. Frequently seen in Renoir's work of the period, these attractive people are shown in attitudes of relaxed congeniality, smiling, dancing, and chatting. The innocence of their flirtations is underscored by the children in the lower left, while the ease of their relations is emphasized by the relaxed informality of the composition itself. The painting is knit together not by figural arrangement but by the overall mood, the sunlight falling through the

trees, and the way Renoir's soft brushwork weaves his blues and purples through the crowd and across the canvas. This idyllic image of a carefree age of innocence, a kind of paradise, nicely encapsulates Renoir's essential notion of art: "For me a picture should be a pleasant thing, joyful and pretty—yes pretty! There are quite enough unpleasant things in life without the need for us to manufacture more."

URBAN ANGLES. Subjects of urban leisure also attracted Edgar Degas (1834–1917), but he did not share the *plein air* Impressionists' interest in outdoor light effects. Instead, Degas composed his pictures in the studio from working drawings—a traditional academic procedure. Degas had in fact received rigorous academic training at the École des Beaux-Arts in the mid-1850s and subsequently spent three years in Italy studying the Old Masters. Firm drawing and careful composition remained central features of his art for the duration of his career, setting it apart from the more spontaneously executed pictures of the *plein air* painters.

The son of a Parisian banker, Degas was closer to Manet than to other Impressionists in age and social background. He was also the most well trained in a traditional sense, having studied with a pupil of Ingres and having made numerous copies of masterworks in museums (a typical way for students to learn in those days). After a period of painting psychologically probing portraits of friends and relatives, Degas became convinced that traditional painting had no future, so he turned in the 1870s to more modern subjects such as the racetrack, music hall, opera, and ballet. Composing his ballet scenes from carefully observed studies of rehearsals and performances, Degas, in effect, arranged his own visual choreography. **THE REHEARSAL ON STAGE** (FIG. 30–56), for example, is not a factual record of something seen but a careful contrivance, intended to delight the eye. The rehearsal is viewed from an opera box close to the stage, creating an abrupt foreshortening of the scene emphasized by the dark scrolls of the bass viols that jut up from the lower left. His work shows two new important influences: The angular viewpoint in this and many other works shows his knowledge of Japanese prints, which he collected, and the seemingly arbitrary cropping of figures (seen here at the left) shows the influence of photography, which he also practiced. His work diverges significantly

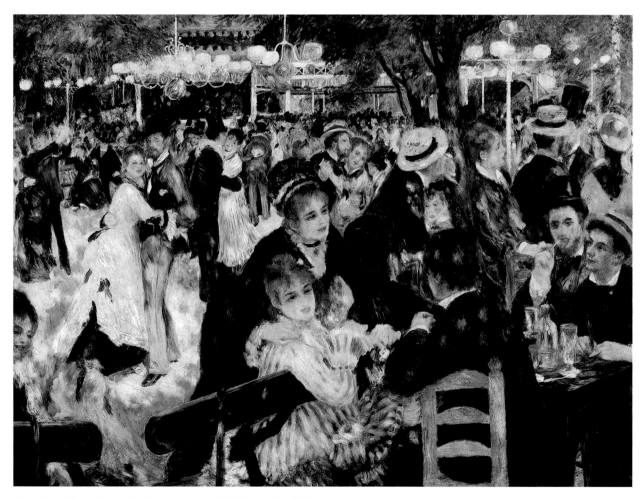

30–55 | Pierre-Auguste Renoir **MOULIN DE LA GALETTE**
1876. Oil on canvas, 4'3½" × 5'9" (1.31 × 1.75 m). Musée d'Orsay, Paris.

30–56 | Edgar Degas **THE REHEARSAL ON STAGE**
c. 1874. Pastel over brush-and-ink drawing on thin, cream-colored wove paper, laid on bristol board, mounted on canvas, 21⅜ × 28¾" (54.3 × 73 cm). The Metropolitan Museum of Art, New York.
Bequest of Mrs. H. O. Havemeyer Collection, Gift of Horace Havemeyer, 1929 (29.160.26)

In the right background of Degas's picture sit two well-dressed, middle-aged men, each probably a "protector" (lover) of one of the dancers. Because ballerinas generally came from lower-class families and exhibited their scantily clad bodies in public—something that "respectable" bourgeois women did not do—they were widely assumed to be sexually available, and they often attracted the attentions of wealthy men willing to support them in exchange for sexual favors. Several of Degas's ballet pictures also include one or more of the dancers' mothers, who would accompany their daughters to rehearsals and performances in order to safeguard their virtue.

from that of the other Impressionists in these compositional techniques and also in his subjects, which are mostly indoors under artificial light. But the Realist novelist Edmond de Goncourt, a friend of most of the Impressionists, said that Degas was most able to capture "the soul of modern life."

We see similarly jarring angles in contemporary urban views in the art of Gustave Caillebotte (1848–1894), a friend of Degas who helped organize some of the Impressionist exhibitions and bought works from them when they needed financial assistance. Private study with an academic teacher qualified him for the École des Beaux-Arts, but he never attended. Rather, Caillebotte was fascinated by the new urban geometry that modern construction and Haussmann's new street grid produced. His **PARIS STREET, RAINY DAY** (FIG. **30–57**) shows an unconventional and offhand composition similar to those of Degas, but with a gaping hole in the center where the street rushes away into seeming infinity. This is a typically open intersection that Haussmann's carving-up of Paris produced, here portrayed in somewhat exaggerated perspective. The figure at the right is cropped and crowded in

with two others in one half of the canvas, delineated by a lamppost; the other half is mostly building façades and a rain-soaked stone street. Caillebotte's painting technique owed little to Monet's pure colors, but his subjects and compositions remain jarringly modern.

UPPER-CLASS LIVES. Another artist who showed with the Impressionists was the American expatriate Mary Cassatt (1844–1926). Born near Pittsburgh to a well-to-do family, Cassatt studied at the Pennsylvania Academy of the Fine Arts in Philadelphia between 1861 and 1865 and then moved to Paris for further academic training. She lived in France for most of the rest of her life. The realism of the figure paintings she exhibited at the Salons of the early and middle 1870s attracted the attention of Degas, who invited her to participate in the fourth Impressionist exhibition, in 1879. Although she, like Degas, remained a studio painter, disinterested in *plein air* painting, her distaste for what she called the tyranny of the Salon jury system made her one of the group's staunchest supporters.

30–57 Gustave Caillebotte **PARIS STREET, RAINY DAY**
1877. Oil on canvas, 83½ × 108¾″ (212.2 × 276.2 cm). The Art Institute of Chicago.
Part of the Charles H. and Mary F. S. Worcester Fund

Cassatt focused her work on the world to which she had access: the domestic and social life of well-off women. One of the paintings she exhibited in 1879 was **WOMAN IN A LOGE** **(FIG. 30–58).** The painting's bright and luminous color, fluent brushwork, and urban subject were no doubt chosen partly to demonstrate her solidarity with her new associates. (Renoir had exhibited a very similar image of a woman at the opera in 1874.) Reflected in the mirror behind the smiling woman are other operagoers, some with opera glasses trained not on the stage but on the crowd around them, scanning it for other elegant socialites. As Charles Garnier had noted, his new Opéra (SEE FIG. 30–34) made an ideal backdrop for just this kind of display.

30–58 Mary Cassatt **WOMAN IN A LOGE**
1879. Oil on canvas, 31⅝ × 23″ (80.3 × 58.4 cm).
Philadelphia Museum of Art.
Bequest of Charlotte Dorrance Wright

Long known as *Lydia in a Loge, Wearing a Pearl Necklace*, this painting was believed to portray Cassatt's sister, Lydia, who came to live with her in 1877 and posed for many of her works. The young, red-haired sitter does not resemble the older, dark-haired Lydia, how-ever, and was probably a professional model whose name has not been recorded. The painting is now known by the title it had when shown at the fourth Impressionist exhibition in 1879.

30–59 | Mary Cassatt **MATERNAL CARESS**
1891. Drypoint, soft-ground etching, and aquatint on paper,
14¾ × 10¾" (37.5 × 27.3 cm). National Gallery of Art,
Washington, D.C.
Chester Dale Collection (1963.10.255)

Her later work shows the influence of Japanese prints, as the artist began endowing her compositions with more solid forms in off-balance compositions (FIG. 30–59). The clashing patterns in the mother's dress and the chair, with the tipped "horizon" line from the bed seen at an angle, testify to this influence. Though she lived as an expatriate, Cassatt retained her connections with upper-class society back in the United States, and when her friends and relatives came to visit she encouraged them to buy works by the Impressionists, thus creating a market for their work in the United States before one developed in France itself.

Cassatt decided early to have a career as a professional artist, but Berthe Morisot (1841–95) came to that decision only after years in the amateur role then conventional for women. Morisot and her sister, Edma, copied paintings in the Louvre and studied under several different teachers, including Corot, in the late 1850s and early 1860s. The sisters showed in the five Salons between 1864 and 1868, the year they met Manet. In 1869 Edma married and, following the traditional course, gave up painting to devote herself to domestic duties. Berthe, on the other hand, continued painting, even after her 1874 marriage to Manet's brother, Eugène, and the birth of

their daughter in 1879. Morisot sent nine works to the first exhibition of the Impressionists in 1874 and showed in all but one of their subsequent exhibitions.

Like Cassatt, Morisot dedicated her art to the lives of bourgeois women, which she depicted in a style that became increasingly loose and painterly over the course of the 1870s. In works such as **SUMMER'S DAY** (FIG. 30–60), Morisot pushed the "sketch aesthetics" of Impressionism almost to their limit, dissolving her forms into a flurry of feathery brushstrokes. Originally exhibited in the fifth Impressionist exhibition in 1880 under the title *The Lake of the Bois du Boulogne*, Morisot's picture is typically Impressionist in its depiction of modern urban leisure in a large park on the fashionable west side of Paris. As the women apparently ride in a ferry between tiny islands in the largest of the park's lakes, the viewer occupies a seat opposite them and is invited to share their enjoyment of the delicious weather and pleasant surroundings.

LATER MANET. Although he never exhibited with the Impressionists, preferring to submit his pictures to the official Salons where he had only limited success, Édouard Manet nevertheless in the 1870s followed their lead by lightening his palette, loosening his brushwork, and confronting modern life in a more direct manner than he had in *Le Déjeuner sur l'Herbe* and *Olympia,* both of which maintained a dialogue with the art of the past. But complicating Manet's apparent acceptance of the Impressionist viewpoint was his commitment, conscious or not, to counter Impressionism's essentially optimistic interpretation of modern life with a more pessimistic (we might say Realist) one.

Manet's last major painting, **A BAR AT THE FOLIES-BERGÈRE** (FIG. 30–61), for example, contradicts the happy aura of works such as *Moulin de la Galette* (SEE FIG. 30–55) and *Woman in a Loge* (SEE FIG. 30–58). In the center of the painting stands one of the barmaids at the Folies-Bergère, a large nightclub with bars arranged around a theater that offered circus, musical, and vaudeville acts. Reflected in the mirror behind her is some of the elegant crowd, who are entertained by a trapeze act. (The legs of one of the performers can be seen in the upper left.) On the marble bartop Manet has spread a glorious still life of liquor bottles, tangerines, and flowers, associated not only with the pleasures for which the Folies-Bergère was famous but also with the barmaid herself, whose wide hips, strong neck, and closely combed golden hair are echoed in the champagne bottles. The barmaid's demeanor, however, refutes these associations. Manet puts the viewer directly in front of her, in the position of her customer. She neither smiles at this customer, as her male patrons and employers expected her to do, nor gives the slightest hint of recognition. She appears instead to be self-absorbed and slightly depressed, perfunctory in the manner of the many shallow interactions that urban life enables. But in the mirror

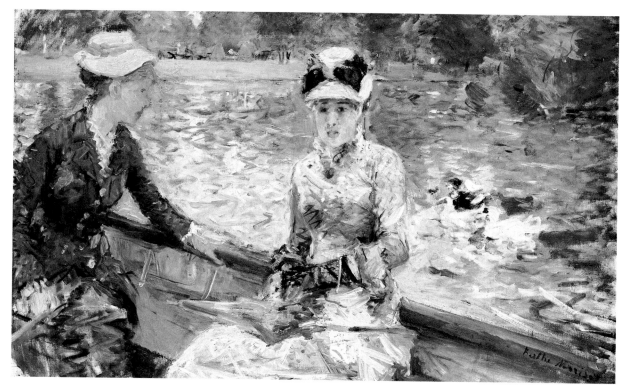

30–60 | Berthe Morisot **SUMMER'S DAY**
1879. Oil on canvas, 17 ¹³⁄₁₆ × 29 ⁵⁄₁₆″ (45.7 × 75.2 cm). The National Gallery, London.
Lane Bequest, 1917

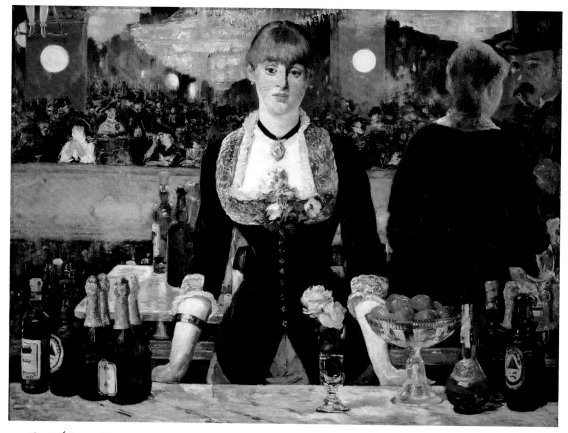

30–61 | Édouard Manet **A BAR AT THE FOLIES-BERGÈRE**
1881–82. Oil on canvas, 37 ¾ × 51 ¼″ (95.9 × 130 cm). Courtauld Institute of Art Gallery, London.
(P.1934.SC.234)

behind her, her reflection and that of her customer tell a different story. In this reflection, which Manet has curiously shifted to the right as if the mirror were placed at an angle, the barmaid leans toward the patron, whose intent gaze she appears to meet; the physical and psychological distance between them has vanished. Exactly what Manet meant to suggest by this juxtaposition has been much debated. One possibility is that he wanted to contrast the longing for happiness and intimacy, reflected miragelike in the mirror, with the disappointing reality of ordinary existence that directly confronts the viewer of the painting.

THE BIRTH OF MODERN ART

Manet and the Impressionists are generally regarded as the initiators of Modern art, a many-faceted movement that began probably in the 1860s and lasted for just over a hundred years. Rather than a cohesive movement with specific stylistic characteristics (such as the Rococo, for example), Modern art is distinguished primarily by a rejection of the traditions of art that had been handed down since the Renaissance. This traditional legacy came to artists in the form of customs, techniques, conventions, and rules. *Custom* dictated, for example, that artists paint with oil on canvas, using their brushes in certain ways, or that they cast public monuments in bronze. *Techniques* formed the principal subject of art instruction, such as one-point perspective and figure drawing from the nude. *Conventions* are the often unspoken agreements between artists and viewers, which, for example, lead Western viewers to see three-dimensional space in a painting's flat surface or to regard large works as more important than small ones. *Rules* are more stringent prohibitions, such as obscenity laws, which can invoke penalties. Far from being restrictive, this network of traditions defined Western art for about 400 years, giving artists a scope in which to operate and a set of values by which viewers could judge their products. Before Modern art, most innovation took place within the tradition.

Yet in the second half of the nineteenth century, artists began seriously and systematically to question that traditional legacy. They did this for various reasons, which some artists spoke about and others acted on unconsciously. Some thought that the tradition was simply used up and that nothing more could be said with it. Others regarded the tradition as irrelevant to the fast-changing world of urbanization and industrialization of that period. Claude Monet, for example, disregarded his academic teacher when he urged the class to think of Greek sculpture every time they saw a nude. Monet had serious doubts about the relevance of Greek sculpture to modern life. Some artists (probably a minority) were natural rebels who generally believed in opposing authority. The rise of photography was another important impetus to experimentation in art: Why perfect ancient methods of rendering

a subject when a machine could do it almost as well? Whatever the reason, Modern artists rejected not only the tradition but also the superstructure that came with it in the form of academic training, Salon exhibitions, and the taste of most of the art-viewing public. This choice was a costly one for many of them, who could have had much more lucrative careers if they had created their art in more acceptable modes.

A deeper cause of Modern art was the modernization of society. The Industrial Revolution created a new public for art in the urban middle classes who flocked to the Salons in search of culture. As we have seen, their taste was cautious and conservative, favoring Academic artists such as Bouguereau, Carpeaux, and Cabanel. Modern artists had little interest in catering to this clientele, and preferred to carry out and exhibit their experiments in realms outside the norm.

In place of the "official" art culture, Modern artists created what has been called an **avant-garde**. The term was initially used in a military context, designating the forward units of an advancing army that scouted territory which the rest of the troops would soon occupy. This term thus captures the forward-looking aspect of Modern art, and the belief that Modernists are working ahead of the public's ability to comprehend. As an art-world social group, the avant-garde consisted of Modern artists, along with a few collectors, art critics, and art dealers who followed the latest developments and found them stimulating. These two concepts, the rejection of tradition and the avant-garde, are most important for understanding Modern art.

Despite the angry protestations of conservative critics, the rejection of tradition did not happen all at once. In fact, the Modern art movement unfolded in a gradual and even logical way, as artists questioned and threw out one rule after another in succeeding decades. Modernism was not revolutionary but rather evolutionary. The Realists shunned traditional narrative content and properly "dignified" subject matter. The Impressionists also did that, and in addition they broke the convention that separated sketch from finished work. Although they seemed radical to some at the time, both of these movements left large parts of the tradition perfectly intact. After Impressionism began to run its course in the middle 1880s, other movements came along to challenge other aspects of the tradition. To these artists and movements we turn next.

Post-Impressionism

The English critic Roger Fry coined the term *Post-Impressionism* in 1910 to identify a broad reaction against Impressionism in avant-garde painting of the late nineteenth and early twentieth centuries. Art historians recognize Paul Cézanne (1839–1906), Georges Seurat (1859–1891), Vincent van Gogh (1853–1890), and Paul Gauguin (1848–1903) as the principal Post-Impressionist artists. Each of these painters moved through an Impressionist phase, and each continued to use in his mature work the bright Impressionist palette. But each came also to reject

Impressionism's emphasis on the spontaneous recording of light and color. Some sought to create art with a greater degree of formal order and structure; others moved further from Impressionism and developed more abstract styles that would prove highly influential for the development of Modern painting in the early twentieth century.

CÉZANNE. No artist had a greater impact on the next generation of Modern painters than Cézanne, who enjoyed little professional success until the last few years of his life, when younger artists and critics began to recognize the innovative qualities of his art. The son of a prosperous banker in the southern French city of Aix-en-Provence, Cézanne studied art first in Aix and then in Paris, where he participated in the circle of Realist artists around Manet. Cézanne's early pictures, somber in color and coarsely painted, often depicted Romantic themes of drama and violence, and were consistently rejected by the Salon.

In the early 1870s Cézanne changed his style under the influence of Pissarro and adopted the bright palette, broken brushwork, and everyday subject matter of Impressionism. Like the Impressionists, with whom he exhibited in 1874 and 1877, Cézanne now dedicated himself to the objective transcription of what he called his "sensations" of nature. Unlike the Impressionists, however, he did not seek to capture transi-

tory effects of light and atmosphere but rather to create a sense of order in nature through a methodical application of color that merged drawing and modeling into a single process. His professed aim was to "make of Impressionism something solid and durable, like the art of the museums."

Cézanne's tireless pursuit of this goal is exemplified in his paintings of Mont Sainte-Victoire, a prominent mountain near his home in Aix that he depicted about thirty times in oil from the mid-1880s to his death. The version here (FIG. 30–62) shows the mountain rising above the Arc Valley, which is dotted with houses and trees and is traversed at the far right by an aqueduct. Framing the scene at the left is an

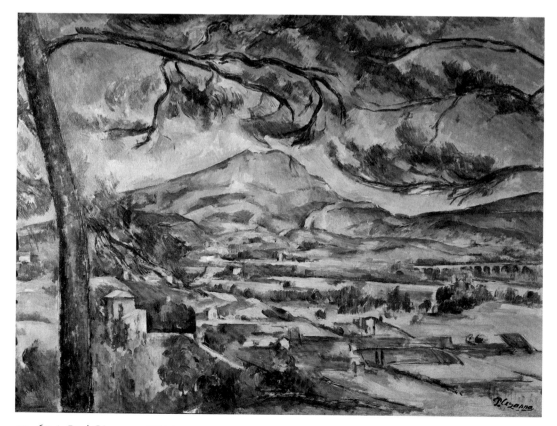

30–62 | Paul Cézanne **MONT SAINTE-VICTOIRE**
c. 1885–87. Oil on canvas, 25½ × 32″ (64.8 × 92.3 cm). Courtauld Institute of Art Gallery, London.
(P.1934.SC.55)

evergreen tree, which echoes the contours of the mountains, creating visual harmony between the two principal elements of the composition. The even lighting, still atmosphere, and absence of human activity in the landscape communicate a sense of timeless endurance, at odds with the Impressionists' interest in capturing a momentary aspect of the ever-changing world.

Cézanne's paint handling is more deliberate and constructive than the Impressionists' spontaneous and comparatively random brushwork. His strokes, which vary from short, parallel hatchings to sketchy lines to broader swaths of flat color, not only record his "sensations" of nature but also weave every element of the landscape together into a unified surface design. That surface design coexists with the effect of spatial recession that the composition simultaneously creates, generating a fruitful tension between the illusion of three dimensions "behind" the picture plane and the physical reality of its two-dimensional surface. On the one hand, recession into depth is suggested by elements such as the foreground tree, a **repoussoir** (French for "something that pushes back") that helps draw the eye into the valley and toward the distant mountain range, and by the gradual transition from the saturated greens and orange-yellows of the foreground to the softer blues and pinks in the mountain, which create an effect of atmospheric perspective. On the other hand, this illusion of consistent recession into depth is challenged by the inclusion of blues, pinks, and reds in the foreground foliage, which relate the foreground forms to the background mountain and sky, and by the tree branches in the sky, which follow the contours of the mountain, making the peak appear nearer and binding it to the foreground plane. Contemporary photographs of this same location reveal that Cézanne composed his paintings not according to how the scene looked. Nor did he alter the fact to fit his feeling, as a Romantic might. Rather, he depicted the scene in accordance with the harmony that the composition of the painting itself demanded. This proved a tremendously fruitful idea for future artists.

Spatial ambiguities of a different sort appear in Cézanne's late still lifes, in which many of the objects seem incorrectly drawn. In **STILL LIFE WITH BASKET OF APPLES** (FIG. 30–63), for example, the right side of the table is higher than the left, the wine bottle has two different silhouettes, and the pastries on the plate next to it are tilted upward while the apples below seem to be viewed head-on. Such apparent inaccuracies are not evidence of Cézanne's incompetence, however, but of his willful disregard for the rules of traditional scientific perspective. Although scientific perspective mandates that the eye of the artist (and hence the viewer) occupy a fixed point relative to the scene being observed (see "Brunelleschi, Alberti and Renaissance Perspective," page 622), Cézanne studies different objects in a painting from slightly different positions. Most of us, after all, when examining a scene, turn our head or move our bodies in order to take it all in. This composition as a whole, assembled from multiple sightings of its various elements, is complex and dynamic and even seems on the verge of collapse. The pastries look as if they could levitate, the bottle tilts precariously, the fruit basket appears ready to spill its contents, and only the folds and small tucks in the white cloth seem to prevent the apples from cascading to the floor. All of these physical improbabilities are designed, however, to serve the larger visual logic of the painting as a work of art, characterized by Cézanne as "something other than reality"—not a direct representation of nature but "a construction after nature." As with his landscapes, the distinction is a crucial one that later artists would exploit.

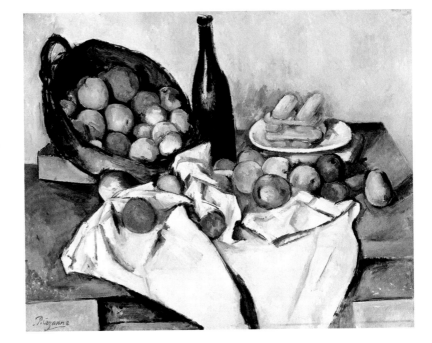

30–63 | Paul Cézanne
STILL LIFE WITH BASKET OF APPLES
1890-94. Oil on canvas, 24⅜ × 31"
(62.5 × 79.5 cm). The Art Institute of Chicago.
Helen Birch Bartlett Memorial Collection

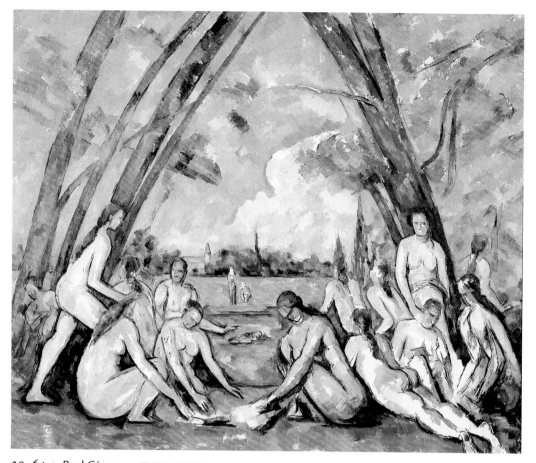

30–64 | Paul Cézanne **THE LARGE BATHERS**
1906. Oil on canvas, 6'10" × 8'2" (2.08 × 2.49 m). Philadelphia Museum of Art.
The W. P. Wilstach Collection

Toward the end of his life, Cézanne's constructions after nature became increasingly abstract, as we see in the monumental **THE LARGE BATHERS** (FIG. 30–64), probably begun in the last year of his life, and left unfinished. This canvas, the largest Cézanne ever painted, culminated his involvement with the subject of nude bathers in nature, a theme he had admired in the Old Masters and had depicted on numerous earlier occasions. Unlike his predecessors, however, Cézanne did not usually paint directly from models but instead worked from earlier drawings, photographs, and memory. As a result, his bathers do not appear lifelike but have simplified, schematic forms. In *The Large Bathers*, the bodies cluster in two pyramidal groups at the left and right sides of the painting, beneath a canopy of trees that opens in the middle onto a triangular expanse of water, landscape, and sky. The figures assume motionless, statuesque poses (the crouching figure at the left quotes the Hellenistic *Crouching Venus* that Cézanne had copied in the Louvre) and seem to exist in a timeless realm, unlike the bathers of Manet (SEE FIG. 30–49), who clearly inhabit the modern world. Emphasizing the scene's serene remoteness from everyday life, the simplified yet resonant palette of blues and greens, ochers and roses, laid down in large patches over a white ground, suffuses the picture with light. Despite its unfinished state, *The Large Bathers* stands as a

grand summation of Cézanne's art. His conception of the canvas as a separate realm from reality, requiring its own rules of composition, is his chief legacy to Modern art.

SEURAT. Georges Seurat was another artist who, like Cézanne, adapted Impressionist discoveries to the creation of an art of greater structure and monumentality. Born in Paris and trained at the École des Beaux-Arts, Seurat became devoted to classical aesthetics, which he combined with a rigorous study of optics and color theory, especially the "law of the simultaneous contrast of colors," first formulated by Michel-Eugène Chevreul in the 1820s. Chevreul's law holds that adjacent objects not only cast reflections of their own color onto their neighbors but also create in them the effect of their **complementary color**. Thus, when a blue object is set next to a yellow one, the eye will detect a trace of purple, the complement of yellow, and in the yellow object a trace of orange, the complement of blue.

The Impressionists knew of Chevreul's law but had not applied it systematically. Seurat, however, approached color as a scientist might. He calculated exactly which hues should be combined, in what proportion, to produce the effect of a particular color. He then set these hues down in dots of pure color, next to one another, in what came to be known by the

various names of *divisionism* (the term preferred by Seurat), *pointillism*, and *Neo-Impressionism*. In theory, these juxtaposed dots would merge in the viewer's eye to produce the impression of other colors, which would be perceived as more luminous and intense than the same hues mixed on the palette. In Seurat's work, however, this optical mixture is never complete, for his dots of color are large enough to remain separate in the eye, giving his pictures a grainy appearance the artist liked because it better showed the underlying order of his work.

Seurat's best-known work is **A SUNDAY AFTERNOON ON THE ISLAND OF LA GRANDE JATTE** (FIG. 30–65), which he first exhibited at the eighth and final Impressionist exhibition in 1886. The theme of weekend leisure is typically Impressionist, but the rigorous divisionist technique, the stiff formality of the figures, and the highly calculated geometry of the composition produce a solemn, abstract effect quite at odds with the casual naturalism of earlier Impressionism. Seurat's picture in fact depicts a contemporary subject in a highly formal style recalling much older art, such as that of the ancient Egyptians.

From its first appearance, *A Sunday Afternoon on the Island of La Grande Jatte* has generated conflicting interpretations. Contemporary accounts of the island indicate that on Sundays it was noisy, littered, and chaotic. By painting it the way he did, Seurat may have intended to show how tranquil it *should* be. It is more likely that he was satirizing the Parisian middle class, since like Pissarro he was a devotee of anarchist beliefs and made cartoons for anarchist magazines at that time.

VAN GOGH. Among the many artists to experiment with divisionism was the Dutch painter Vincent van Gogh, who took divisionism and Impressionism and made of them a highly expressive personal style. The oldest son of a Protestant minister, van Gogh worked as an art dealer, teacher, and evangelist before deciding in 1880 to become an artist. After brief periods of study in Brussels, The Hague, and Antwerp, he moved in 1886 to Paris, where he discovered the work of the Impressionists and Post-Impressionists. Van Gogh quickly adapted Seurat's divisionism, but rather than laying his paint

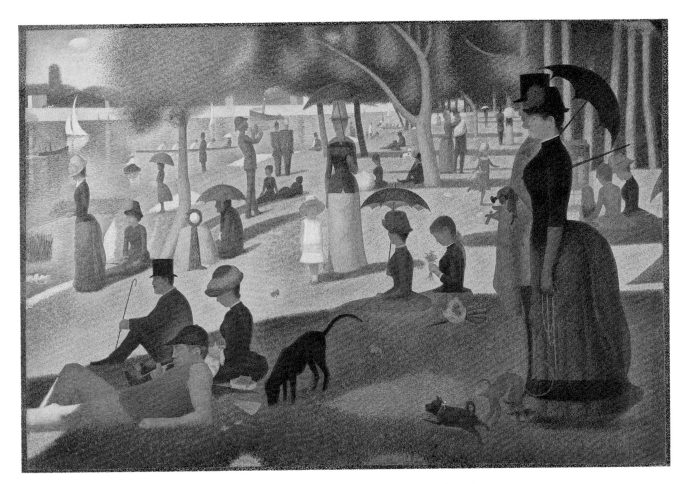

30–65 | Georges Seurat **A SUNDAY AFTERNOON ON THE ISLAND OF LA GRANDE JATTE**
1884–86. Oil on canvas, 6'9½" × 10'1¼" (2.07 × 3.08 m). The Art Institute of Chicago.
Helen Birch Bartlett Memorial Collection

Although the painting is highly stylized and carefully composed, it has a strong basis in factual observation. Seurat spent months visiting the island, making small studies, drawings, and oil paintings of the light and the people he found there. All of the characters in the final painting, including the woman with the monkey, were based on his observations at the site.

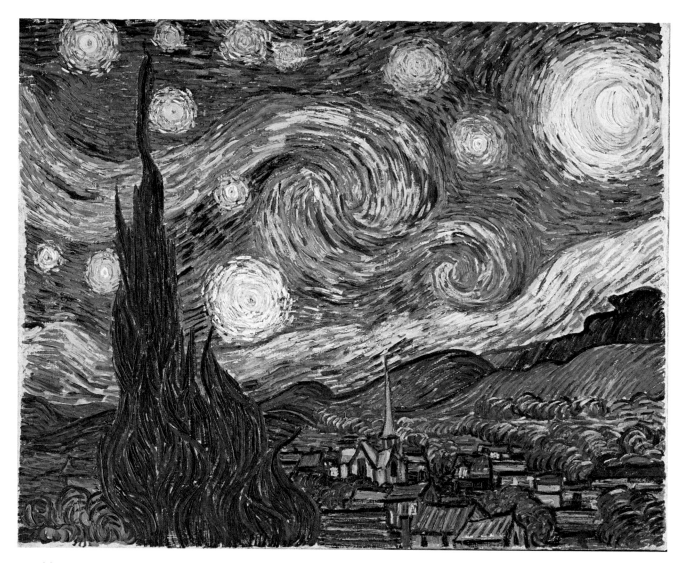

30–66 | Vincent van Gogh **THE STARRY NIGHT**
1889. Oil on canvas, 28 ¾ × 36 ¼″ (73 × 93 cm). The Museum of Modern Art, New York.
Acquired through the Lillie P. Bliss Bequest (472.1941)

down regularly in dots, he typically applied it freely in multi-directional dashes of impasto (thick applications of pigment), which gave his pictures a greater sense of physical energy and a palpable surface texture.

Van Gogh was a socialist who believed that modern life, with its constant social change and focus on progress and success, alienated people from each other and themselves (see "Modern Artists and World Cultures," page 1042). His own paintings are efforts to establish empathy between artist and viewer, thereby overcoming some of the emotional barrenness that he felt modern society created. In a steady and prolific output over ten years, he communicated his emotional state in paintings that contributed significantly to the emergence of the **Expressionistic** tradition, in which the intensity of an artist's feelings overrides fidelity to the actual appearance of things. For example, he once described his working method in a letter to his brother:

I should like to paint the portrait of an artist friend who dreams great dreams, who works as the nightingale sings, because it is his nature. This man will be fair-haired. I should like to put my appreciation, the love I have for him, into the picture. So I will paint him as he is, as faithfully as I can—to begin with. But that is not the end of the picture. To finish it, I shall be an obstinate colorist. I shall exaggerate the fairness of the hair, arrive at tones of orange, chrome, pale yellow. Behind the head—instead of painting the ordinary wall of the shabby apartment, I shall paint infinity, I shall do a simple background of the richest, most intense blue that I can contrive, and by this simple combination, the shining fair head against this rich blue background, I shall obtain a mysterious effect, like a star in the deep blue sky.

One of the earliest and most famous examples of Expressionism is **THE STARRY NIGHT** (FIG. 30–66), which van Gogh painted from imagination and memory as well as

MODERN ARTISTS AND WORLD CULTURES

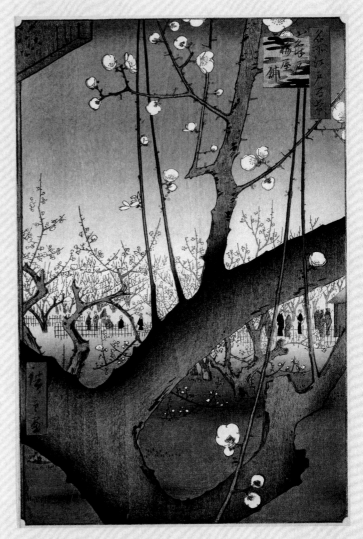

Hiroshige **PLUM ORCHARD, KAMEIDO**
1857. From *One Hundred Famous Views of Edo*. Woodblock print,
13¼ × 8⅝ " (33.6 × 47 cm). The Brooklyn Museum,
New York.

Non-Western art has been a constant influence on a great deal of Modern art. In some respects this is logical, because if artists regard their own tradition as outmoded or in need of reform, they may naturally look to other cultures for inspiration. Artistic interest in foreign cultures is certainly not new—the Orientalists, for example, visited many countries—but unlike previous cultural interactions, Modern artists were open to stylistic influence from nearly every inhabited continent.

The first wave of such influence was from Japan, beginning shortly after the U.S. Navy forcibly opened that country to Western trade and diplomacy in 1853.

Two years later, France, England, Russia, and the United States signed trade agreements that permitted regular exchange of goods. The first Japanese art to engage the attention of Modern artists was a sketchbook called *Manga* by Hokusai (1760–1849), which several Parisian artists eagerly passed around. Soon it became fashionable for people connected to the art world to collect Japanese objects for their homes. Édouard Manet, for example, painted a portrait of Emile Zola at his desk along with a Japanese screen and some prints that he owned. The Paris International Exposition of 1867 hosted the first exhibit of Japanese prints on the continent.

Soon, Japanese lacquers, fans, bronzes, hanging scrolls, kimonos, ceramics, illustrated books, and *ukiyo-e* (prints of the "floating world," the realm of geishas and popular entertainment) began to appear in Western European specialty shops, art galleries, and even some department stores. French interest in Japan and its arts reached such proportions by 1872 that the art critic Philippe Burty gave it a name: *japonisme*.

Japanese art profoundly influenced Western painting, printmaking, applied arts, and eventually architecture. The tendency toward simplicity, flatness, and the decorative evident in much painting and graphic art in the West between roughly 1860 and 1900 is probably the most characteristic result of that influence. Nevertheless, its impact was extraordinarily diverse. What individual artists took from the Japanese depended on their own interests. Thus, Whistler found encouragement for his decorative conception of art, while Edgar Degas discovered both realistic subjects and interesting compositional arrangements, and those interested in the reform of late nineteenth-century industrial design found in Japanese objects both fine craft and a smooth elegance lacking in the West. Vincent van Gogh enjoyed the bold design and handcrafted quality of Japanese prints. He both owned and copied Japanese prints, as the accompanying illustrations show.

Other artists saw in non-Western cultures not only new art styles, but also alternatives to Western civilization. Many Modern artists embraced preindustrial cultures, often naively, in a search for what was "primitive" and hence purer. Paul Gauguin's attitude was among the most enthusiastic of these, but primitivism remained an important influence on Modern art well into the twentieth century.

Vincent van Gogh **JAPONAISERIE: FLOWERING PLUM TREE**
1887. Oil on canvas, 21½ × 18″ (54.6 × 45.7 cm). Vincent van Gogh Museum, Amsterdam.

observation. Above the quiet town the sky pulsates with celestial rhythms and blazes with exploding stars. Van Gogh may have subscribed to the then-popular theory that after death people journey to a star, where they continue their lives. Contemplating immortality in a letter, van Gogh wrote: "Just as we take the train to get to Tarascon or Rouen, we take death to reach a star." The idea is given visible form in this painting by the cypress tree, a traditional symbol of both death and eternal life, which dramatically rises to link the terrestrial and celestial realms. The brightest star in the sky is actually a planet, Venus, which is associated with love. It is possible that the picture's extraordinary excitement also expresses van Gogh's euphoric hope of gaining the companionship that had eluded him on earth. The painting is a riot of brushwork, as rail-like strokes of intense color writhe across its surface. If the traditional function of brushwork is to describe a subject, van Gogh surpassed this and made brushwork more immediately expressive of the artist's feelings than any previous painter in the Western tradition. During the last year and a half of his life he experienced repeated psychological crises that lasted for days or weeks. While they were raging, he wanted to hurt himself and he heard loud noises in his head, but he could not paint. The stress and burden of these attacks led him into a mental asylum and eventually to his suicide in July 1890.

GAUGUIN. In painting from his imagination rather than from nature in *The Starry Night*, van Gogh was perhaps following the advice of his friend Gauguin, who had once counseled another colleague, "Don't paint from nature too much. Art is an abstraction. Derive this abstraction from nature while dreaming before it, and think more of the creation that will result." Gauguin's own mature work was even more abstract than van Gogh's, and, like Cézanne's, it laid important foundations for the development of nonrepresentational art in the twentieth century. Born in Paris to a Peruvian mother and a radical French journalist father, Gauguin lived in Peru from infancy until the age of seven; this experience, together with his service in the Merchant Marine in his youth, may have awakened in him the wanderlust that marked his artistic life. During the 1870s and early 1880s Gauguin enjoyed a comfortable bourgeois life as a stockbroker and painted in his spare time under the tutelage of Pissarro. Between 1880 and 1886, he exhibited in the final four Impressionist exhibitions. In 1883, Gauguin lost his job during a stock market crash; three years later he abandoned his wife and five children to pursue a full-time painting career. Gauguin knew firsthand the business-oriented culture of the day, and he came to despise it, at one point dismissing capitalism in a letter to a friend as "the European struggle for money." Disgusted by what he considered the corruption of urban civilization and seeking a more "primitive" existence,

Gauguin lived for extended periods in the French province of Brittany between 1886 and 1891, traveled to Panama and Martinique in 1887, spent two months in Arles with van Gogh in 1888, and then in 1891 sailed for Tahiti, a French colony in the South Pacific. After a final sojourn in France in 1893–95, Gauguin returned to the Pacific, where he died in 1903.

Gauguin's mature style was inspired by such nonacademic sources as medieval stained glass, folk art, and Japanese prints, and it featured simplified drawing, flattened space, and antinaturalistic color. Gauguin rejected Impressionism because it neglected subjective feelings and "the mysterious centers of thought." Gauguin called his anti-Impressionist style *synthetism*, because it synthesized observation of the subject in nature with the artist's feelings about that subject, expressed through abstracted line, shape, space, and color. Very much a product of such synthesis is **MAHANA NO ATUA (DAY OF THE GOD) (FIG. 30–67)**, which, despite its Tahitian subject, was painted in France during one of his return trips home from the South Pacific. Gauguin had gone to Tahiti hoping to find an unspoiled paradise where he could live and work cheaply and "naturally." What he discovered, instead, was a thoroughly colonized country whose native culture was rapidly disappearing under the pressures of Westernization. In his paintings, Gauguin ignored this reality and depicted the Edenic ideal in his imagination, as seen in *Mahana no atua*, with its bright colors, stable composition, and appealing subject matter.

Gauguin divided *Mahana no atua* into three horizontal zones in styles of increasing abstraction. The upper zone, painted in the most realistic manner, centers around the statue of a god, behind which extends a beach landscape populated by Tahitians. This god was not local to Tahiti; it is Gauguin's version of a Javanese figure that he saw illustrated in a magazine. In the middle zone, directly beneath the statue, three figures occupy a beach divided into several bands of antinaturalistic color. The central female bather dips her feet in the water and looks out at the viewer, while on either side of her two figures recline in fetuslike postures—perhaps symbolizing birth, life, and death. Filling the bottom zone of the canvas is a strikingly abstract pool whose surface does not reflect what is above it but instead offers a dazzling array of bright colors, arranged in a puzzlelike pattern of flat, curvilinear shapes. By reflecting a strange and unexpected reality exactly where we expect to see a mirror image of the familiar world, this magic pool seems the perfect symbol of Gauguin's desire to evoke "the mysterious centers of thought." Gauguin's chief groundbreaking innovation was his use of color not to describe a subject, but to express his feelings. Like many of Gauguin's works, *Mahana no atua* is enigmatic and suggestive of unstated meanings that cannot be literally represented but only evoked indirectly through abstract pictorial means.

30–67 | Paul Gauguin **MAHANA NO ATUA (DAY OF THE GOD)**
1894. Oil on canvas, 27 ⅜ × 35 ⅝" (69.5 × 90.5 cm). The Art Institute of Chicago.
Helen Birch Bartlett Memorial Collection (1926.198)

Symbolism in Painting

Gauguin's suggestiveness is characteristic of *Symbolism*, an international movement in late nineteenth-century art and literature of which he was a recognized leader. Like the Romantics before them, the Symbolists opposed the values of rationalism and material progress that dominated modern Western culture and instead explored the nonmaterial realms of emotion, imagination, and spirituality. Ultimately the Symbolists sought a deeper and more mysterious reality than the one we encounter in everyday life, which they conveyed not through traditional iconography but through ambiguous subject matter and formal stylization suggestive of hidden and elusive meanings. Instead of objectively representing the world, they transformed appearances in order to give pictorial form to psychic experience, and they often compared their works to dreams. It seems hardly coincidental that Sigmund Freud, who compared artistic creation to the process of dreaming, wrote his pioneering *The Interpretation of Dreams* (1900) during the Symbolist period.

The Symbolist movement in painting closely parallels a similar one in literature, led by poets and art critics such as Maurice Maeterlinck, Jean Moréas, Joris-Karl Huysmans, and Paul Verlaine. Pronouncing themselves disgusted with the alleged materialism of contemporary society, they too retreated into fantasy worlds that they conjured from their imaginations. The purpose of a work of art, they wrote, was to serve as an evacuation hoist, lifting us out of our grimy present reality into a world of dreams and hallucinations. Maeterlinck wrote an extended poem about a forbidden medieval love affair, *Pelleas and Melisande*, in which the action takes place mostly at night, and Melisande's long yellow hair both illuminates some scenes and symbolizes her sexuality (composer Claude Debussy would turn this poem into a Symbolist opera in 1901). Huysmans' short novel *Against the Grain (A Rebours)* has a single character, an aristocrat named Des Esseintes, who locks himself away from the world because "Imagination could easily be substituted for the vulgar realities of things." Even nature was boring to the

Symbolists. Reversing Monet's criticism of the Romantics, Des Esseintes mused: "Nature had had her day, as he put it. By the disgusting sameness of her landscapes and skies, she had once and for all wearied the considerate patience of aesthetes." Instead, the truly sensitive person must take refuge in artworks "steeped in ancient dreams or antique corruptions, far removed from the manner of our present day."

EUROPEAN SYMBOLISTS. A dreamlike atmosphere pervades the later work of Gustave Moreau (1826–98), an older academic artist whom the Symbolists recognized as a precursor. The Symbolists particularly admired Moreau's renditions of the biblical Salome, the young Judaean princess who, at the instigation of her mother, Herodias, performed an erotic dance before her stepfather, Herod, and demanded in return the head of John the Baptist (Mark 6:21–28). In **THE APPARI-**

TION (FIG. 30–68), exhibited at the Salon of 1876, the seductive Salome confronts a vision of the saint's severed head, which hovers open-eyed in midair, simultaneously dripping blood and radiating holy light. Moreau depicted this macabre subject and its exotic architectural setting in elaborate linear detail with touches of jewel-like color. His style creates an atmosphere of voluptuous decadence that amplifies Salome's role as the archetypal *femme fatale*, the "fatal woman" who tempts and destroys her male victim—a fantasy that haunted the imagination of countless male Symbolists, perhaps partly in response to late nineteenth-century feminism.

A younger artist who embraced Symbolism was Odilon Redon (1840–1916). Although he exhibited with the Impressionists in 1886, he diverged from their artistic goals by using nature as a point of departure for fantastic visions tinged with loneliness and melancholy. For the first twenty-

30–68 | Gustave Moreau **THE APPARITION**
1874-76. Watercolor on paper, 41⁵⁄₁₆ × 28³⁄₁₆"
(106 × 72.2 cm). Musée du Louvre, Paris.

30–69 | Odilon Redon **THE MARSH FLOWER, A SAD AND HUMAN FACE**
Plate 2 from *Homage to Goya*. 1885. Lithograph,
10⅞ × 8" (27.5 × 20.3 cm).
The Museum of Modern Art, New York.
Abby Aldrich Rockefeller Purchase Fund

Fascinated by the science of biology, Redon based his strange hybrid creatures on the close study of living organisms. His aim, as he wrote in his journal, was "to make improbable beings live, like human beings, according to the laws of probability by putting . . . the logic of the visible at the service of the invisible."

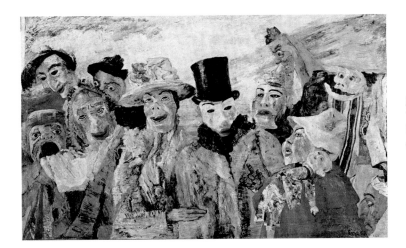

30–70 | James Ensor **THE INTRIGUE**
1890. Oil on canvas, 35½ × 59″ (90.3 × 150 cm).
Koninklijk Museum voor Schone Kunsten, Antwerp.
© Ensor / Licensed by VAGA, New York, New York

five years of his career, Redon created moody images in black-and-white charcoal drawings that he referred to as *Noirs* ("Blacks"). He also made highly imaginative etchings and lithographs, such as **THE MARSH FLOWER, A SAD AND HUMAN FACE** (FIG. 30–69), one of many bizarre human-vegetal hybrids Redon invented. It should hardly surprise us that the fictional character Des Esseintes loved Redon, and in Huysmans' *Against the Grain* he spent an entire day looking at Redon's prints and dark charcoal drawings: "These designs were beyond anything imaginable; they leaped, for the most part, beyond the limits of painting and introduced a fantasy that was unique, the fantasy of a diseased and delirious mind."

Like the Impressionists, the Symbolists staged art exhibitions outside the normal venues of the day, but they cared less about attracting the general public. Instead of hiring a hall, printing a program, and charging a small admission fee as the Impressionists had done, the Symbolists showed modest exhibitions in more out-of-the-way places. For example, during the 1889 Universal Exposition, which marked the debut of the Eiffel Tower (SEE FIG. 30–1), they hung some works in a café a few blocks away from the grounds; the show passed almost unnoticed in the press.

Symbolism originated in France but had a profound impact on the avant-garde in other countries, where it often merged with Expressionist tendencies. Such a melding of Symbolism and Expressionism is evident in the work of the Belgian painter and printmaker James Ensor (1860–1949), who, except for four years of study at the Brussels Academy, spent his life in the coastal resort town of Ostend. Like Redon, Ensor derived his weird and anxious visions from the observation of the real world—often from the grotesque papier-mâché masks that his family sold during the annual pre-Lenten carnival, one of Ostend's main holidays. In paintings such as **THE INTRIGUE** (FIG. 30–70), these disturbing masks seem to come to life and reveal rather than hide the character of the people wearing them—comical, stupid, and hideous. The acidic colors increase the sense of caricature, as does the crude handling of form. The rough paint is both

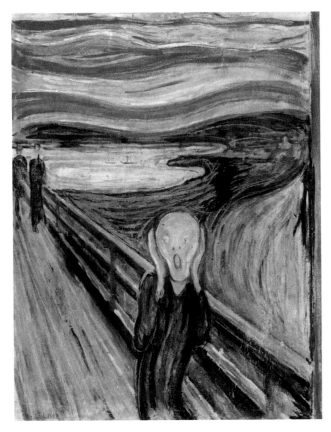

30–71 | Edvard Munch **THE SCREAM**
1893. Tempera and casein on cardboard, 36 × 29″ (91.3 × 73.7 cm). Nasjonalgalleriet, Oslo, Norway.

expressive and Expressionistic: Its lack of subtlety well characterizes the subjects, while its almost violent application directly records Ensor's feelings toward them.

The sense of powerful emotion that pervades Ensor's work is even more evident in that of his Norwegian contemporary Edvard Munch (1863–1944). Munch's most famous work, **THE SCREAM** (FIG. 30–71), is an unforgettable image of modern alienation that merges Symbolist suggestiveness with

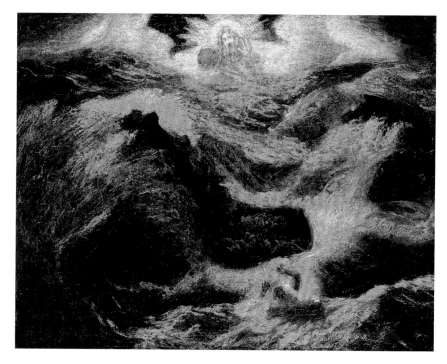

30–72 | Albert Pinkham Ryder
JONAH
c. 1885. Oil on canvas, mounted on fiber-
board, 27¼ × 34⅜" (69.2 × 87.3 cm).
Smithsonian American Art Museum,
Smithsonian Institution, Washington, D.C.
Gift of John Gellatly, (1929.6.98)

Expressionist intensity of feeling. Munch recorded the paint-
ing's genesis in his diary: "One evening I was walking along a
path; the city was on one side, and the fjord below. I was tired
and ill. . . . I sensed a shriek passing through nature. . . . I
painted this picture, painted the clouds as actual blood." In
the painting itself, however, the figure is on a bridge and the
scream emanates from him. Although he vainly attempts to
shut out its sound by covering his ears, the scream fills the
landscape with clouds of "actual blood." The overwhelming
anxiety that sought release in this primal scream was chiefly a
dread of death, as the sky and the figure's skull-like head sug-
gest, but the setting of the picture also suggests a fear of open
spaces. The expressive abstraction of form and color in the
painting reflects the influence of Gauguin and his Scandina-
vian followers, whose work Munch had encountered shortly
before he painted *The Scream*.

AMERICAN SYMBOLISTS. Some American artists of the late
nineteenth century turned their backs on modern reality and,
like their European Symbolist counterparts, escaped into the
realms of myth, fantasy, and imagination. Some were also
attracted to traditional literary, historical, and religious sub-
jects, which they treated in unconventional ways to give them
new meaning, as Albert Pinkham Ryder (1847–1917) did in
his highly expressive interpretation of **JONAH** (FIG. 30–72).

Ryder moved from Massachusetts to New York City
around 1870 and studied at the National Academy of Design.
Although he traveled to Europe four times between 1877
and 1896, he seems to have been mostly unaffected by both
the old and modern works he saw there. His mature painting
style was an extremely personal one, as were his working

methods. Ryder would paint and repaint the same canvas
over a period of several years, loading glazes one on top of
another to a depth of a quarter inch or more, mixing in with
his oils such substances as varnish, bitumen, and candle wax.
Due to chemical reactions between his materials and the
uneven drying times of the layers of paint, most of Ryder's
pictures have become darkened and severely cracked.

In *Jonah*, Ryder depicted the moment when the terrified
Old Testament prophet, thrown overboard by his shipmates,
was about to be consumed by a great fish. Appearing above in
a blaze of holy light is God, shown as a bearded old man who
holds the orb of divine power and makes a gesture of blessing,
as if promising Jonah's eventual redemption. Both the sub-
ject—being overwhelmed by hostile nature—and its dramatic
treatment through dynamic curves and sharp contrasts of light
and dark are characteristically Romantic. The broad, general-
ized handling of the violent sea is particularly reminiscent of
Turner (SEE FIGS. 30–15, 30–16), one of the few European
artists whose work Ryder is known to have admired.

Vividly imagined biblical subjects became a specialty of
Henry Ossawa Tanner (1859–1937), the most successful
African American painter of the late nineteenth and early
twentieth centuries. The son of a bishop in the African
Methodist Episcopal Church, Tanner grew up in Philadel-
phia, sporadically studied art under Thomas Eakins at the
Pennsylvania Academy of the Fine Arts between 1879 and
1885, then worked as a photographer and drawing teacher in
Atlanta. In 1891 he moved to Paris for further academic
training. In the early 1890s Tanner painted a few African
American genre subjects but ultimately turned to biblical
painting in order to make his art serve religion.

Tanner's **THE RESURRECTION OF LAZARUS** (FIG. 30–73) received a favorable critical reception at the Paris Salon of 1897 and was purchased by the Musée du Luxembourg, the museum for living artists. The subject is the biblical story in which Jesus went to the tomb of his friend Lazarus, who had been dead for four days, and revived him with the words "Lazarus, come forth" (John 11:1–44). Tanner shows the moment following the miracle, as Jesus stands before the amazed onlookers and gestures toward Lazarus, who begins to rise from his tomb. The limited palette of browns and golds, reminiscent of Rembrandt but more intense, is appropriate for the somber burial cave. It also has the expressive effect of unifying the astonished witnesses in their recognition that a miracle has indeed occurred.

Late Nineteenth-Century French Sculpture

RODIN. The most successful and influential European sculptor of the late nineteenth century was Auguste Rodin (1840–1917), whose work embodies some of the contemporary Symbolist and Expressionist currents. The public was much more prepared to accept his style, however, than that of the Symbolists. Born in Paris and trained as a decorative craftworker, Rodin failed on three occasions to gain entrance to the École des Beaux-Arts and consequently spent the first twenty years of his career as an assistant to other sculptors and

decorators. After an 1875 trip to Italy, where he saw the sculpture of Donatello and Michelangelo, Rodin developed his mature style of vigorously modeled figures in unconventional poses, which were simultaneously scorned by academic critics and admired by the general public.

Rodin's status as a major sculptor was confirmed in 1884, when he won a competition for the **BURGHERS OF CALAIS** (FIG. 30–74), commissioned to commemorate an event from the Hundred Years' War. In 1347 Edward III of England had offered to spare the besieged city of Calais if six leading citizens (or *burghers*)—dressed only in sackcloth with rope halters and carrying the keys to the city—would surrender to him for execution. Rodin shows the six volunteers preparing to give themselves over to what they assume will be their deaths. The Calais commissioners were not pleased with Rodin's conception of the event. Instead of calm, idealized heroes, Rodin presented ordinary-looking men in various attitudes of resignation and despair. He exaggerated their facial expressions, expressively lengthened their arms, greatly enlarged their hands and feet, and swathed them in heavy fabric, showing not only how they may have looked but how they must have felt as they forced themselves to take one difficult step after another. Rodin's willingness to stylize the human body for expressive purposes was a revolutionary move that opened the way for the more radical innovations of later sculptors.

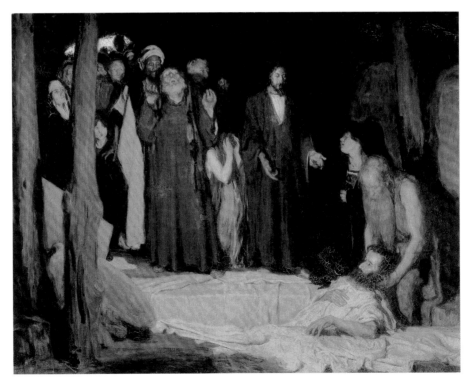

30–73 | Henry Ossawa Tanner **THE RESURRECTION OF LAZARUS**
1896. Oil on canvas, 37⅜ × 47¹³/₁₆″ (94.9 × 121.4 cm). Musée d'Orsay, Paris.

Tanner believed that biblical stories could illustrate the struggles and hopes of contemporary African Americans. He may have depicted the resurrection of Lazarus because many black preachers made a connection between the story's themes of redemption and rebirth and the Emancipation Proclamation of 1863, which freed black slaves and gave them a new life.

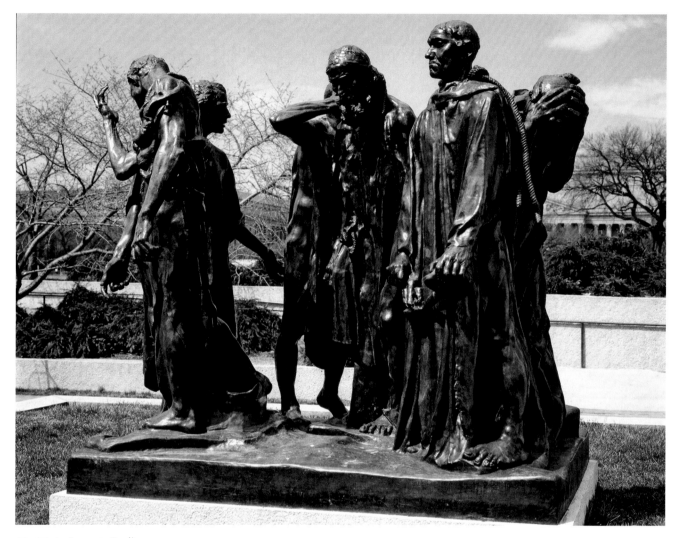

30–74 | Auguste Rodin **BURGHERS OF CALAIS**
1884–89. Bronze, 6'10½" × 7'11" × 6'6" (2.1 × 2.4 × 2 m). Hirshhorn Museum and Sculpture Garden,
Smithsonian Institution, Washington, D.C.
Gift of Joseph H. Hirshhorn, 1966

Nor were the commissioners pleased with Rodin's plan to display the group on a low pedestal. Rodin felt that the usual placement of such figures on an elevated pedestal suggested that only higher, superior humans are capable of heroic action. By placing the figures nearly at street level, Rodin hoped to convey to viewers that ordinary people, too, are capable of noble acts. Rodin's removal of public sculpture from a high to a low pedestal would lead, in the twentieth century, to the elimination of the pedestal itself and to the presentation of sculpture in the "real" space of the viewer.

CLAUDEL. An assistant in Rodin's studio who worked on the *Burghers of Calais* was Camille Claudel (1864–1943), whose accomplishments as a sculptor were long overshadowed by the dramatic story of her life. Claudel began to study

sculpture in 1879 and became Rodin's pupil four years later. After she started working in his studio, she also became his mistress, and their often stormy relationship lasted fifteen years. Both during and after her association with Rodin, Claudel enjoyed independent professional success, but she also suffered from psychological problems that eventually overtook her, and she spent the last thirty years of her life in a mental asylum.

Among Claudel's most celebrated works is **THE WALTZ** (**FIG. 30–75**), which exists in several versions made between 1892 and 1905. The sculpture depicts a dancing couple, the man unclothed and the woman seminude, her lower body enveloped in a long, flowing gown. In Claudel's original conception, both figures were entirely nude, but she had to add drapery to the female figure after an inspector from the Ministry of the Beaux-Arts found the pairing of the nude

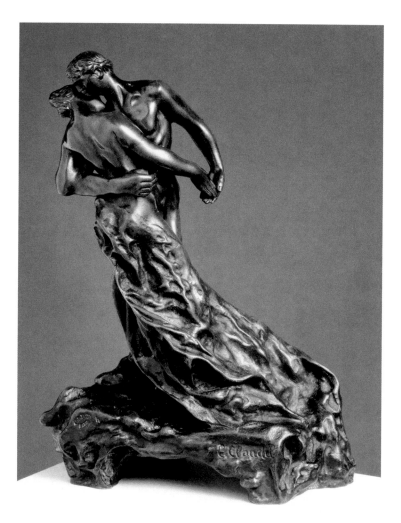

30–75 | Camille Claudel **THE WALTZ**
1892–1905. Bronze, 9⅞" (25 cm). Neue Pinakothek, Munich.

French composer Claude Debussy, a close friend of Claudel, displayed a cast of this sculpture on his piano. Debussy acknowledged the influence of art and literature on his musical innovations.

bodies indecent and recommended against a state commission for a marble version of the work. After Claudel added drapery, the same inspector endorsed the commission, but it was never carried out. Instead, Claudel modified *The Waltz* further and had it cast in bronze.

In this work, Claudel succeeded in conveying an illusion of fluent motion as the dancing partners whirl in space, propelled by the rhythm of the music. The spiraling motion of the couple, enhanced by the woman's flowing gown, encourages the observer to view the piece from all sides, increasing its dynamic effect. Despite the physical closeness of the dancers there is little actual physical contact between them, and their facial expressions reveal no passion or sexual desire. After violating decency standards with her first version of *The Waltz*, Claudel perhaps sought in this new rendition to portray love as a union more spiritual than physical.

Art Nouveau

The swirling mass of drapery in Claudel's *Waltz* has a stylistic affinity with Art Nouveau (French for "new art"), a movement launched in the early 1890s that for more than a decade permeated all aspects of European art, architecture, and design. Like the contemporary Symbolists, the practitioners of Art Nouveau largely rejected the values of modern industrial society and sought new aesthetic forms that would retain a preindustrial sense of beauty while also appearing fresh and innovative. They drew particular inspiration from nature, especially from organisms such as vines, snakes, flowers, and winged insects, whose delicate and sinuous forms were the basis of their graceful and attenuated linear designs. Following from this commitment to organic principles, they also sought to harmonize all aspects of design into a beautiful whole, as found in nature itself.

of William Morris's socialist theories of art (see page 1022) convinced him that he should devote his creative energies toward art that everyone can see. From that moment he focused his efforts on useful objects. After designing a house for his family in 1895, he proceeded to create the rugs, furniture, utensils, wallpaper, and even his wife's dresses. He wrote in an exhibition catalogue near the same time, "The hope of a happy and egalitarian future lies behind these new decorative works." His design office in Brussels became a beehive of activity, and he argued against historicism in architecture and in favor of art for all. When the grocery firm Tropon approached him with a commission for a new advertising campaign, van de Velde created the first integrated marketing program in the history of design (**FIG. 30–77**). The abstract ovoid module that forms the center of this poster became the company's logo, and was featured on all of its products, as well as its stationery, advertising, and delivery vehicles.

GAUDÍ AND KLIMT. The application of graceful linear arabesques to all aspects of design, evident in the entry hall of the Tassel House, began a vogue that spread across Europe. In Spain, where the style was called *Modernismo*, the major practitioner was the Catalan architect Antonio Gaudí i Cornet

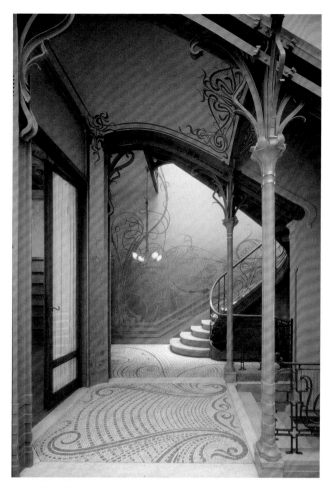

30–76 | Victor Horta **STAIRWAY, TASSEL HOUSE**
Brussels. 1892–93.

HORTA AND VAN DE VELDE. The artist most responsible for introducing the Art Nouveau style in architecture was the Belgian, Victor Horta (1861–1947). Trained at the academies in Ghent and Brussels, Horta worked in the office of a Neoclassical architect in Brussels for six years before opening his own practice in 1890. In 1892 he received his first important commission, a private residence in Brussels for a Professor Tassel. The result, especially the house's entry hall and staircase (**FIG. 30–76**), was strikingly original. The ironwork, wall decoration, and floor tile were all designed in an intricate series of long, graceful curves. Although Horta's sources are still a matter of debate, he apparently was much impressed with the stylized linear graphics of the English Arts and Crafts movement of the 1880s. Horta's concern for integrating the various arts into a more unified whole, like his reliance on a refined decorative line, derived largely from English reformers.

Horta's contemporary and compatriot Henry van de Velde (1863–1957) brought the Art Nouveau style into nearly all of the decorative arts. He studied at the Belgian National Academy in Antwerp, then went to Paris where he saw the Post-Impressionist art of Seurat and others. After a period making divisionist works in the late 1880s, his reading

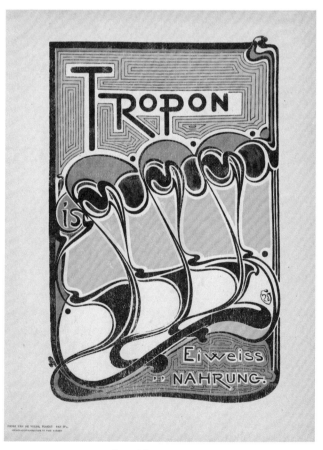

30–77 | Henry van de Velde **TROPON**
1898. Color lithograph, 12¼ × 8″ (31 × 20 cm). Fine Arts Museums of San Francisco.
Achenbach Foundation for the Graphic Arts Purchase, 1976.1.361

30–78 | Antonio Gaudí **SERPENTINE BENCH, GÜELL PARK**
Barcelona. 1900–14.

(1852–1926). Gaudí attempted to integrate natural forms into his buildings and into daily life. For a public plaza on the outskirts of Barcelona, he combined architecture and sculpture in a continuous, serpentine bench that also is a boundary wall (FIG. 30–78). Its surface is a glittering mosaic of broken pottery and tiles in homage to the long tradition of ceramic work in Spain.

In Austria, Art Nouveau was referred to as *Sezessionstil* because of its association with the Vienna Secession, one of several such groups formed in the late nineteenth century by progressive artists who seceded from conservative academic associations to form more liberal exhibiting bodies. The Vienna Secession's first president, Gustav Klimt (1862–1918), led a faction within the group dedicated to a richly decorative art and architecture that would offer an escape from the drab, ordinary world.

Between 1907 and 1908 Klimt perfected what is called his golden style, seen in **THE KISS** (FIG. 30–79), where a couple embrace in a golden aura. The representational elements here are subservient to the decorative ones, which are characteristically Art Nouveau in their intricate, ornamental quality. Not evident at first glance is the tension in the couple's physical relationship, most noticeable in the way that the woman's head is forced uncomfortably against her shoulder. That they kneel dangerously close to the edge of a precipice further unsettles the initial impression for those willing to look further into the beautiful surface.

30–79 | Gustav Klimt
THE KISS
1907-8. Oil on canvas,
5′ 10¾″ × 6′ (1.8 × 1.83 m).
Österreichische
Nationalbibliothek, Vienna.

The Secession was part of a generational revolt expressed in art, politics, literature, and the sciences. The Viennese physician Sigmund Freud, founder of psychoanalysis, may be considered part of this larger cultural movement, one of whose major aims was, according to the architect Otto Wagner, "to show modern man his true face."

30–80 | Hector Guimard **DESK**
c. 1899 (remodeled after 1909).
Olive wood with ash panels,
28¾ × 47¾" (73 × 121 cm). The
Museum of Modern Art, New York.
Gift of Madame Hector Guimard

30–81 | Henri de Toulouse-Lautrec **JANE AVRIL**
1893. Lithograph, 50½ × 37" (129 × 94 cm).
San Diego Museum of Art.
Gift of the Baldwin M. Baldwin Foundation (1987.32)

GUIMARD AND TOULOUSE-LAUTREC. In France, Art Nouveau was also sometimes known as *Style Guimard* after its leading French practitioner, Hector Guimard (1867–1942). Guimard worked in an eclectic manner during the early 1890s, but in 1895 he met and was influenced by Horta. He went on to design the famous Art Nouveau-style entrances for the Paris Métro (subway) and devoted considerable effort to interior design and furnishings, such as the desk he made for himself (FIG. 30–80). Instead of a static and stable object, Guimard handcrafted an asymmetrical, organic entity that seems to undulate and grow.

We see the influence of the Art Nouveau style on the century's best-known poster designer, Henri de Toulouse-Lautrec (1864–1901). Born into an aristocratic family in the south of France, Lautrec suffered from a genetic disorder and childhood accidents that left him physically handicapped and short in height. Extremely gifted artistically, he moved to Paris in 1882 and had private academic training before discovering the work of Degas, which greatly influenced his own development. He also discovered Montmartre, a lower-class entertainment district of Paris, and soon joined its population of bohemian artists. From the late 1880s Lautrec dedicated himself to depicting the social life of the Parisian cafés, theaters, dance halls, and brothels—many of them in Montmartre—that he himself frequented.

Among these images were thirty lithographic posters Lautrec designed between 1891 and 1901 as advertisements for popular night spots and entertainers. His portrayal of the café dancer Jane Avril (FIG. 30–81) demonstrates the remarkable originality that Lautrec brought to an essentially commercial project. The composition juxtaposes the dynamic figure of Avril dancing onstage at the upper left with the cropped image of a bass viol player and the scroll of his instrument at the lower right. The bold foreshortening of the stage and the prominent placement of the bass in the foreground both suggest the influence of Degas, who employed

similar devices (SEE FIG. 30–56). Lautrec departs radically from Degas's naturalism, however, particularly in his imaginative extension of each end of the bass viol's head into a curving frame that encapsulates Avril and connects her visually with her musical accompaniment. Also antinaturalistic are the radical simplification of form, suppression of modeling, flattening of space, and integration of blank paper into the composition, all of which suggest the influence of Japanese woodblock prints. Meanwhile, the emphasis on curving lines and the harmonization of the lettering with the rest of the design are characteristic of Art Nouveau.

Late-Century Photography

Despite the efforts of Rejlander, Cameron, and others to win recognition for photography as an art form (SEE FIGS. 30–28, 30–29), the medium was still generally regarded as a "hand-maiden to the arts," as poet Charles Baudelaire put it. Painters such as Ingres, Delacroix, and Courbet had used photographs in place of posed models for some of their paintings, and photographers were widely accepted as portraitists or journalists, but dominant opinion still held back from accepting them as artists. Their efforts to gain legitimacy led to the rise of an international movement known as *Pictorialism*, in which photographers sought to create images whose aesthetic qualities matched those of Modern painting, drawing, and print-making. The principal debate among Pictorialists was over

the degree of manipulation a photographer could engage in. Some photographers urged combining negatives into a print, as Rejlander had done, while others, who called themselves Naturalists or straight photographers, preferred composing a single negative while standing behind the camera and then printing it with minimal manipulation.

PHOTOGRAPHY AS ART. The leader of the Naturalist faction of Pictorialism was Peter Henry Emerson (1856–1936), though he later recanted some of his early positions. Born in Cuba, he lived there until age 13 when his family moved to London. He originally trained as a doctor and had a small medical practice until the lure of art overtook him in the middle 1880s. His early efforts at photographing the landscape convinced him that photography was an art form "superior to etching, woodcutting, and charcoal drawing," as he put it in his 1886 book *Photography: A Pictorial Art*. His work from this period shows him capturing poetic effects in interestingly off-balance compositions (FIG. 30–82). This work shows both his flair for composition and his devotion to print quality, which he regarded as crucial to photography's acceptance as an art form. He urged photographers to use the platinum process, in which the printing paper is coated with platinum dust, an exceptionally sensitive surface that can faithfully transmit very subtle tonal gradations. (Most art photographers used this process until World War I pushed

30–82 | Peter Emerson **CANTLEY: WHERRIES WAITING FOR THE TURN OF THE TIDE**
1886. Platinum print, 7⅜ × 11³⁄₁₆″ (18.7 × 28.4 cm). George Eastman House, Rochester, New York.
Gift of William C. Emerson. GEH NEG: 5894. Obj no. 79:4338:0001

the price of platinum to impractical levels.) Ironically enough, a meeting with James McNeill Whistler in 1895 caused Emerson to radically alter his belief that photography was an art. After seeing Whistler's Nocturnes (SEE FIG. 30–48) and Japanese prints, Emerson came to believe that photography was only a mechanical process that could not equal the direct inspiration of an artist. However, before his resignation from the Photographic Society he gave a great deal of recognition to photographers, and his aesthetic of straight photography dominated the practice of art photographers until well into the next century.

PHOTOGRAPHY AS ACTIVISM. The urban photographs of Jacob Riis (1849–1914) offer a harsh contrast to the essentially aesthetic views of Emerson. A reformer who aimed to galvanize public concern for the unfortunate poor, Riis saw photography not as an artistic medium but as a means of bringing about social change. Riis immigrated to New York City from Denmark in 1870 and was hired as a police reporter for the *New York Tribune*. He quickly established himself as a maverick among his colleagues by actually investigating slum life himself rather than merely rewriting police reports. Riis's contact with the poor convinced him that crime, poverty, and ignorance were largely environmental problems that resulted from, rather than caused, harsh slum conditions. He believed that if Americans knew the truth about slum life, they would support reforms.

Riis turned to photography in 1887 to document slum conditions, and three years later published his photographs in a groundbreaking study, *How the Other Half Lives*. The illustrations were accompanied by texts that described their circumstances in matter-of-fact terms. Riis said he found the poor, immigrant family shown in **TENEMENT INTERIOR IN POVERTY GAP: AN ENGLISH COAL-HEAVER'S HOME** (FIG. 30–83) when he visited a house where a woman had been killed by her drunken, abusive husband:

> The family in the picture lived above the rooms where the dead woman lay on a bed of straw, overrun by rats. . . . A patched and shaky stairway led up to their one bare and miserable room. . . . A heap of old rags, in which the baby slept serenely, served as the common sleeping-bunk of father, mother, and children—two bright and pretty girls, singularly out of keeping in their clean, if coarse, dresses, with their surroundings. . . . The mother, a pleasant-faced woman, was cheerful, even light-hearted. Her smile seemed the most sadly hopeless of all in the utter wretchedness of the place.

What comes through clearly in the photograph is the family's attempt to maintain a clean, orderly life despite the rats and the chaotic behavior of their neighbors. The broom behind the older girl implies as much, as does the caring way the father holds his youngest daughter. Riis shows that such slum dwellers are decent people who deserve better.

30–83 | Jacob Riis **TENEMENT INTERIOR IN POVERTY GAP: AN ENGLISH COAL-HEAVER'S HOME**
c. 1889. Museum of the City of New York.
The Jacob A. Riis Collection

During the late nineteenth and early twentieth centuries, American social and business life operated under the British sociologist Herbert Spencer's theory of Social Darwinism, which in essence held that only the fittest will survive. Riis saw this theory as merely an excuse for neglecting social problems.

Architecture

The history of late nineteenth-century architecture is a story of the impact of modern conditions and materials on the still-healthy Beaux-Arts historicist tradition. Unlike painting and sculpture, where antiacademic impulses gained force after 1880, in architecture the search for modern styles occurred somewhat later and met with considerably more resistance. As the École des Beaux-Arts in Paris was rapidly losing its leadership in figurative art education, it was becoming the central training ground for both European and American architects. The center of innovation in late-century architecture was in the American Midwest.

WORLD'S COLUMBIAN EXHIBITION, CHICAGO. Richard Morris Hunt (1827–95) in 1846 became the first American to study architecture at the École des Beaux-Arts. Extraordinarily skilled in Beaux-Arts historicism and determined to raise the standards of American architecture, he built in every accepted style, including Gothic, French classicist, and Italian Renaissance. After the Civil War, Hunt built many lavish mansions emulating aristocratic European models for the growing class of wealthy Eastern industrialists and financiers.

Late in his career, Hunt participated in a grand project with more democratic aims: He was head of the board of architects for the 1893 World's Columbian Exposition in Chicago, organized to commemorate the 400th anniversary

Elements of Architecture
THE CITY PARK

Parks originated during the second millennium BCE in China and the Near East as enclosed hunting reserves for kings and the nobility. In Europe from the Middle Ages through the eighteenth century, they remained private recreation grounds for the privileged. The first urban park intended for the public was in Munich, Germany, laid out by Friedrich Ludwig von Sckell in 1789–95 in the picturesque style of an English landscape garden (SEE FIG. 29–20), with irregular lakes, gently sloping hills, broad meadows, and paths meandering through wooded areas.

Increased crowding and pollution during the Industrial Revolution prompted outcries for large public parks whose greenery would help purify the air and whose open spaces would provide city dwellers of all classes with a place for healthful recreation and relaxation. Numerous municipal parks were built in Britain during the 1830s and 1840s and in Paris during the 1850s and 1860s, when Georges-Eugène Haussmann redesigned the former royal hunting forests of the Bois de Boulogne and the Bois de Vincennes in the English style favored by the emperor.

In American cities before 1857, the only outdoor spaces for the public were small squares found between certain intersections, and larger gardens, such as the Boston Public Garden. Neither kind of space filled the growing need for varied recreational facilities. For a time, naturalistically landscaped suburban cemeteries became popular sites for strolling, picnicking, and even horse racing—an incongruous use that strikingly demonstrated the need for urban recreation parks.

The rapid growth of Manhattan spurred civic leaders to set aside parkland while open space still existed. The city purchased an 843-acre tract in the center of the island and in 1857 announced a competition for its design as Central Park. The competition required that designs include a parade ground, playgrounds, a site for an exhibition or concert hall, sites for a fountain and for a viewing tower, a flower garden, a pond for ice skating, and four east–west cross streets so that the park would not interfere with the city's vehicular traffic.

The latter condition was pivotal to the winning design, drawn up by architect Calvert Vaux (1824–95) and park superintendent Frederick Law Olmsted (1822–1903), who sank the crosstown roads in trenches hidden below the surface of the park and designed separate routes for carriages, horseback riders, and pedestrians.

Central Park contains some formal elements, such as the stately tree-lined Mall leading to the classically styled Bethesda Terrace and Fountain, but its designers believed that the "park of any great city [should be] an antithesis to its bustling, paved, rectangular, walled-in streets." Accordingly, Olmsted and Vaux followed the English tradition by designing Central Park in a naturalistic manner based on irregularities in topography and plantings. Where the land was low, they further depressed it, installing drainage tiles and carving out ponds and meadows. They planted clumps of trees to contrast with open spaces, and they emphasized natural outcroppings of schist to provide elements of dramatic, rocky scenery. They arranged walking trails, bridle paths, and carriage drives to provide a series of changing vistas. An existing reservoir divided the park into two sections. Olmsted and Vaux developed the southern half more completely and located most of the sporting facilities and amenities there, while they treated the northern half more as a nature preserve. Substantially completed by the end of the Civil War, Central Park was a tremendous success and launched a movement to build similar parks in cities across the United States and to conserve wilderness areas and establish national parks.

Frederick Law Olmsted and Calvert Vaux **MAP OF CENTRAL PARK, NEW YORK CITY**
1858–1880. Revised and extended park layout as shown in a map of 1873.

The rectangular water tanks in the middle of the park were later removed and replaced by a large, elliptical meadow known as the Great Lawn.

of Columbus's arrival in the Americas. The board abandoned the metal-and-glass architecture of earlier world's fairs (SEE FIG. 30–31) in favor of the appearance of what it called "permanent buildings—a dream city." (The buildings were actually temporary ones composed of staff, a mixture of plaster and fibrous materials.) To create a sense of unity for all the exposition's major buildings, the board designated a single, classical style associated with both the birth of democracy in ancient Greece and the imperial power of ancient Rome, reflecting the United States' pride in its democratic institutions and emergence as a world power. Hunt's design for the Administration Building at the end of the Court of Honor (FIG. 30–84) was in the Renaissance classicist mode used by earlier American architects for civic buildings (SEE FIG. 30–22).

The World's Columbian Exposition also provided a model for the American city of the future—reassurance that it could be clean, spacious, carefully planned, and classically beautiful, in contrast to the ill-planned, sooty, and overcrowded American urban centers rapidly emerging in the late nineteenth century. Frederick Law Olmsted, the designer of New York's Central Park (see "The City Park," page 1059), was principally responsible for the landscape design of the Chicago exposition. He converted the marshy lakefront into lagoons, canals, ponds, and islands, some laid out formally, as in the Court of Honor, others informally, as in the section containing national and state pavilions. After the fair closed and most of its buildings were taken down, Olmsted's landscape art remained for succeeding generations to enjoy.

THE CHICAGO SCHOOL: THE FIRST SKYSCRAPERS. The second American architect to study at the École des Beaux-Arts was Henry Hobson Richardson (1838–86). Born in Louisiana and schooled at Harvard, Richardson returned from Paris in 1865 and settled in New York. Like Hunt, he worked in a variety of styles, but he became famous for a simplified Romanesque style known as Richardsonian Romanesque. His best-known building was probably the **MARSHALL FIELD WHOLESALE STORE** in Chicago (FIG. 30–85). Although it is reminiscent of Renaissance palaces in form and of Romanesque churches in its heavy stonework and arches, it has no precise historical antecedents. Instead, Richardson took a fresh approach to the design of this modern commercial building. Applied ornament is all but eliminated in favor of the intrinsic appeal of the rough stone and the subtle harmony between the dark red granite facing of the base and the red sandstone of the upper stories. The solid corner piers, the vertical structural supports, give way to the regular rhythm of the broad arches of the middle floors, which are doubled in the smaller arches above, then doubled again in the rectangular windows of the attic. The integrated mass of the whole is completed in the crisp line of the simple cornice at the top.

Richardson's plain, sturdy building was a revelation to the young architects of Chicago then engaged in rebuilding the city after the disastrous fire of 1871 and helped shape a distinctly American architecture. About this time, new technology for making inexpensive steel (an alloy of iron, carbon, and other materials) brought architecture entirely new structural possibilities. The first structural use of steel in the internal skeleton of a building was made in Chicago by William Le Baron Jenney (1832–1907), and his example was soon followed by the younger architects who became known as the Chicago School. These architects saw in the stronger, lighter material the answer to both their search for an independent style and their clients' desire for taller buildings. The rapidly rising cost of commercial urban property made tall buildings more efficient; the first electric elevator, dating from 1889, made them possible.

Equipped with steel and with the improved passenger elevators, driven by new economic considerations, and inspired by Richardson's departure from Beaux-Arts historicism, the Chicago School architects produced a new kind of building—the skyscraper—and a new style of architecture. A fine early example of their work, and evidence of its rapid spread throughout the Midwest, is Louis Sullivan's **WAINWRIGHT BUILDING** in St. Louis, Missouri (FIG. 30–86). The Boston-born Sullivan (1856–1924) had studied for a year at the Massachusetts Institute of Technology (MIT), home of the United States' first architecture program, and equally briefly at the École des Beaux-Arts, where he seems to have developed his lifelong distaste for historicism. He settled in Chicago in 1875, partly because of the building boom there that had followed the fire of 1871, and in 1883 he entered into a partnership with the Danish-born engineer Dankmar Adler (1844–1900).

Sullivan's first major skyscraper, the Wainwright Building has a U-shaped plan that provides an interior light well for the illumination of inside offices. The ground floor, designed to house shops, has wide plate-glass windows for the display of merchandise. The second story, or mezzanine, also features large windows for the illumination of the shop offices. Above the mezzanine rise seven identical floors of offices, lit by rectangular windows. An attic story houses the building's mechanical plant and utilities. Forming a crown to the building, this richly decorated attic is wrapped in a foliate frieze of high-relief terra cotta, punctuated by bull's-eye windows, and capped by a thick cornice slab.

The Wainwright Building thus features a clearly articulated, tripartite design in which the different character of each of the building's parts is expressed through its outward appearance. This illustrates Sullivan's philosophy of functionalism, summed up in his famous motto, "Form follows function," which holds that the function of a building should dictate its design. But Sullivan did not design the Wainwright Building along strictly functional lines; he also took expres-

30–84 | **COURT OF HONOR, WORLD'S COLUMBIAN EXPOSITION**
Chicago. 1893. View from the east.

Surrounding the Court of Honor were, from left to right, the Agriculture Building by McKim, Mead, and White; the Adminis-tration Building by Richard Morris Hunt; and the Manufactures and Liberal Arts Building by George B. Post. The architectural ensemble was collectively called The White City, a nickname by which the exposition was also popularly known. The statue in the foreground is *The Republic* by Daniel Chester French.

30–85 | Henry Hobson Richardson **MARSHALL FIELD WHOLESALE STORE**
Chicago. 1885–87. Demolished c. 1935.

30–86 | Louis Sullivan **WAINWRIGHT BUILDING**
St. Louis, Missouri. 1890–91.

sive considerations into account. The thick corner piers, for example, are not structurally necessary since the building is supported by a steel-frame skeleton, but they serve to empha-size its vertical thrust. Likewise, the thinner piers between the office windows, which rise uninterruptedly from the third

story to the attic, echo and reinforce the dominant verticality. Sullivan emphasized verticality in the Wainwright Building not out of functional concerns but rather out of emotional ones. A tall office building, in his words, "must be every inch a proud and soaring thing, rising in sheer exultation."

In the Wainwright Building that exultation culminates in the rich vegetative ornament that swirls around the crown of the building, serving a decorative function very much like that of the foliated capital of a classical column. The tripartite structure of the building itself suggests the classical column with its base, shaft, and capital, reflecting the lingering influence of classical design principles even on an architect as opposed to historicism as Sullivan. It would remain for the Modern architects of the early twentieth century to break free from tradition entirely and pioneer an architectural aesthetic that was entirely new.

IN PERSPECTIVE

As the nineteenth century began, Neoclassicism and Romanticism were principal movements in Western art, with the former dominant in the academies and Salons, while the latter led the way in innovations. Romantics favored landscape, literature, or recent dramatic events as subjects, and rendered them in off-balance compositions that often featured loose, painterly brushwork.

The Realist movement that emerged in the late 1840s baffled most of the public with its deadpan renditions of common subjects such as rural labor. Yet the movement was the most innovative of the time, and its quasi-scientific accuracy led to Impressionism in the 1860s. Building on the Realism of Courbet and the Romantic-Realist landscapes of the Barbizon School, the Impressionists painted the landscape in pure, unmixed colors and loose brushwork as they tried to capture the fleeting play of light over their subjects. Soon the Impressionists also painted the bustling urban life of the newly redesigned Paris streets. Both Realism and Impressionism partook of the spirit of positivism, the intellectual movement begun by Auguste Comte that favored direct observation over philosophical speculation and imaginative flights. The new art of photography also seemed to embody the positivist spirit, with its apparently seamless translation of reality onto a negative.

The Impressionists are generally regarded as the founders of Modern art, which generally rejected traditional rules. This earned them the scorn of much of the public: The Industrial Revolution had created an atmosphere of rapid social change that led the new middle-class art viewers to crave comforting, traditional subjects rendered with polished technique. Modern artists seceded from these demands, and functioned within a narrow social context of critics and collectors called the avant-garde.

As Impressionism reached its limits in the middle 1880s, Modern artists went in several directions. Post-Impressionists built directly on the preceding movement, taking it into greater formal organization or personal expression. Symbolists took refuge from the changing world in the misty realm of imagination, while Art Nouveau reinvested the design disciplines with organic shapes. In architecture, revivalism and historicism early in the century were displaced by technological innovations at midcentury that eventually led to the modern skyscraper.

GOYA
FAMILY OF CHARLES IV
1800

BARRY AND PUGIN
HOUSES OF PARLIAMENT
1836–60

BONHEUR
PLOWING IN THE NIVERNAIS
1849

CAMERON
PORTRAIT OF THOMAS CARLYLE
1867

RODIN
BURGHERS OF CALAIS
1884–89

CASSATT
MATERNAL CARESS
1891

CÉZANNE
STILL LIFE WITH BASKET OF APPLES
1890–94

1800

1820

1840

1860

1880

1900

NINETEENTH-CENTURY ART IN EUROPE AND THE UNITED STATES

◄ Napoleon Crowned Emperor of France 1804

◄ Battle of Waterloo 1815

◄ July Monarchy 1830–48

◄ Beginning of Modern Photography c. 1840

◄ Revolution in France; Marx and Engels Publish *Communist Manifesto*; Women's Right Convention, Seneca Falls, NY 1848

◄ London Great Exhibition 1851

◄ American Civil War 1861–65

◄ Paris Universal Exposition 1889

◄ World's Columbian Exposition, Chicago 1893

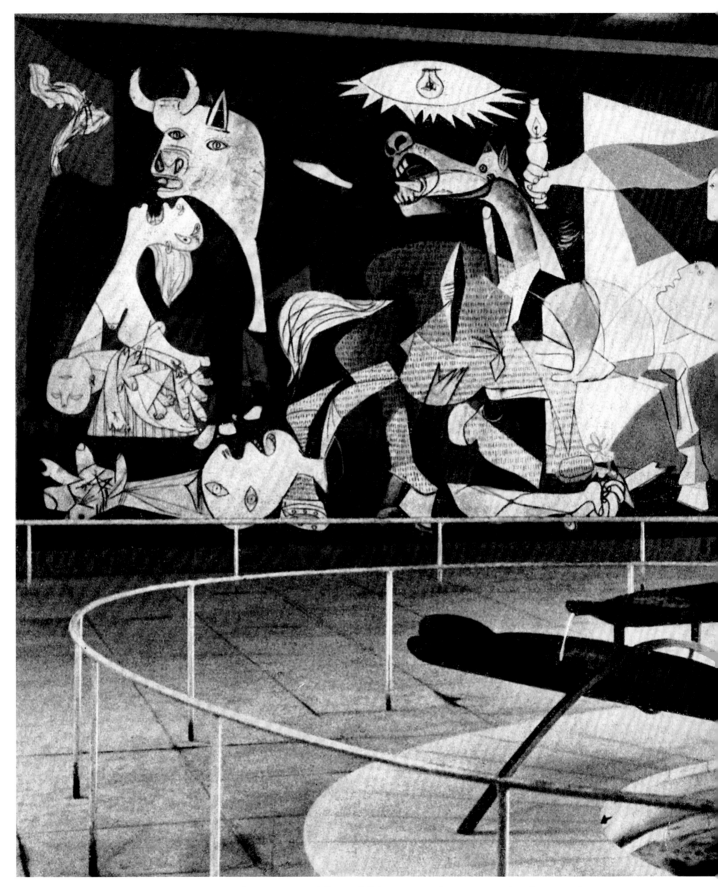

31–1 | Pablo Picasso **GUERNICA** 1937. Oil on canvas, 11′6″ × 25′8″ (3.5 × 7.8 m). Museo Nacional Centro de Arte Reina Sofía, Madrid. On permanent loan from the Museo del Prado, Madrid. Shown installed in the Spanish Pavilion of the Paris Exposition, 1937. In the foreground: Alexander Calder's *Fontaine de Mercure*. 1937. Mercury, sheet metal, wire rod, pitch, and paint, 44 × 115 × 77″ (122 × 292 × 196 cm). Fundacio Joan Miró, Barcelona.

MODERN ART IN EUROPE AND THE AMERICAS, 1900–1945

In April 1937, during the Spanish Civil War, German pilots flying for Spanish fascist leader General Francisco Franco targeted the Basque city of Guernica. This act, the world's first intentional mass bombing of civilians, killed more than 1,600 people and shocked the world. The Spanish artist Pablo Picasso, living in Paris at the time, reacted to the massacre by painting **GUERNICA,** a stark, hallucinatory nightmare that became a powerful symbol of the brutality of war (FIG. 31–1).

Focusing on the victims, Picasso restricted his palette to black, gray, and white—the tones of the newspaper photographs that publicized the atrocity. Expressively distorted women, one holding a dead child and another trapped in a burning house, wail in desolation at the carnage. A screaming horse, an image of betrayed innocence, represents the suffering Spanish Republic, while a bull symbolizes either Franco or Spain. An electric light and a woman holding a lantern suggest Picasso's desire to reveal the event in all its horror.

The work excited widespread admiration when exhibited later that year in the Spanish Pavilion of the International Exposition in Paris because the artist used the language of Modern art to comment in a heartfelt manner on what seemed an international scandal. However, when World War II broke out a few years later, the tactic of bombing civilians became a common strategy that all sides adopted.

EUROPE AND THE AMERICAS IN THE EARLY TWENTIETH CENTURY

Just as we ponder *Guernica* within the context of the Spanish Civil War, so too must we consider the backdrop of politics, war, and technological change to understand other twentieth-century art. As that century dawned, many Europeans and Americans believed optimistically that human society would "advance" through the spread of democracy, capitalism, and technological innovation. By 1906 representative governments existed in the United States and every major European nation (SEE MAP 31–1), and Western power grew through colonialism across Africa, Asia, the Caribbean, and the Pacific. The competitive nature of both colonialism and capitalism created great instability in Europe, however, and countries joined together in rival political alliances. World War I erupted in August 1914, initially pitting Britain, France, and Russia (the Allies) against Germany and Austria (the Central Powers). U.S. troops entered the war in 1917 and contributed to an Allied victory the following year.

World War I significantly transformed European politics and economics, especially in Russia, which became the world's first Communist nation in 1917 when a popular revolution brought the Bolshevik ("Majority") Communist Party of Vladimir Lenin to power. In 1922 the Soviet Union, a Communist state encompassing Russia and neighboring areas, was created. A revolution in Mexico (1910–1917) also overthrew an oppressive government.

The United States emerged from the war as the economic leader of the West, and economic recovery followed in Western Europe, but the 1929 New York stock market crash plunged the West into the Great Depression. In 1933, President Franklin D. Roosevelt responded with the New Deal, an ambitious welfare program meant to provide jobs and stimulate the American economy, and Britain and France also instituted state welfare policies during the 1930s. Elsewhere in Europe, the economic crisis brought to power right-wing totalitarian regimes: Benito Mussolini had already become the fascist dictator of Italy in the mid-1920s; he was followed in Germany in 1933 by the Nazi leader Adolf Hitler. In Spain, General Francisco Franco consolidated his power by 1939 after his victory in the Spanish Civil War. Meanwhile, in the Soviet Union, Joseph Stalin (who had succeeded Lenin in 1924) established his authoritarian rule through the execution or imprisonment of millions of his political opponents.

The Western world of the early twentieth century was rocked by advances in technology, science, and psychology that undercut traditional beliefs and created new ways of seeing and understanding the world. Naming just a few of the technological innovations will help establish their reach: electrification, radio, automobiles, airplanes, movies, radar, and assembly-line production. Technology led both to better medicines for prolonging life and to more efficient warfare, which shortened it.

The stable and orderly Newtonian world of science was replaced with the more dynamic and unpredictable theory of relativity that German physicist Albert Einstein largely pioneered. His great innovation was to discover that matter is not stable at the atomic level. Rather, what we formerly took to be solid matter is only another form of energy, similar to gravity or light but much more powerful than either. He likewise altered our previous conceptions of space and time in a three-dimensional universe. After Einstein, it made more sense to see space and time as relative to each other: What time it is depends on where you are and how fast you are moving.

At the same time, new theories and discoveries in psychology altered how humans viewed themselves. In 1900, Austrian psychiatrist Sigmund Freud published *The Interpretation of Dreams,* which posited that our behavior is often motivated by powerful forces that are below our level of awareness. The human unconscious, as he described it, has strong urges for love and power that we simply cannot act upon if society is to remain peaceful and whole. Our psychic lives are not wholly, or even usually, guided by reason alone, but often by these urges that we may be unaware of. Thus we are always attempting to strike a balance between our rational

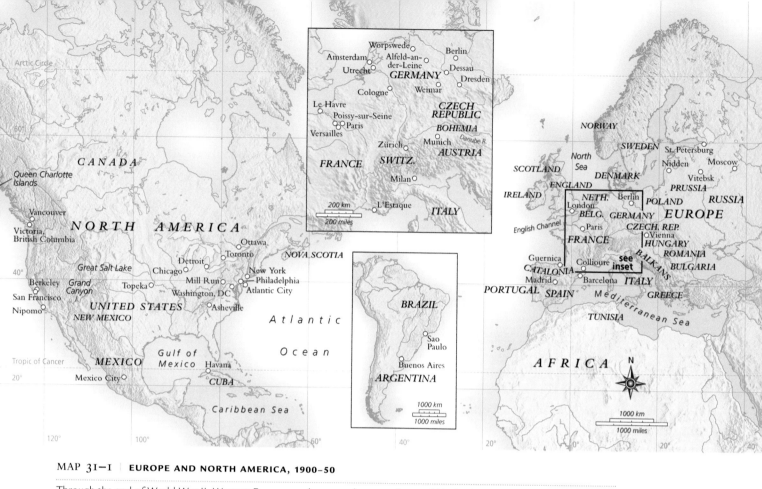

MAP 31–1 | **EUROPE AND NORTH AMERICA, 1900–50**

Through the end of World War II, Western Europe was home to the many forms of Modernism.

and irrational sides, often erring on one side or the other. Also in 1900, Russian scientist Ivan Pavlov began feeding dogs just after ringing a bell. Soon the dogs salivated not at the sight of food but at the sound of the bell. The discovery that these "conditioned reflexes" also exist in humans showed that if we manage the external stimuli we can control people's appetites. Political leaders of all stripes soon took advantage of this fact. As a consequence of all these events and discoveries, the old view that humans were created in the image of God took a severe beating.

EARLY MODERN ART IN EUROPE

Modern artists also invented myriad new ways of seeing our world. Most artists did not read physics or psychology, but they lived in the same world that was being transformed by these two fields. The Modernist urge to question and overthrow tradition was fertilized and encouraged by the constant change in the surrounding society. Modern art in the early twentieth century was still mostly controversial and much criticized for being either a publicity stunt, childish,

untrained, or politically subversive. Most often, none of these criticisms was true. Rather, Modern art is an outgrowth of modern society. Just as modern society valued innovation and invention, so did the art world. The plethora of new products that industry gave us is paralleled in the panoply of new styles of Modern art that we will be examining here.

The Fauves: Wild Beasts of Color

The Salon system still operated in France, but the ranks of artists dissatisfied with its conservative precepts swelled. These malcontents early in the century launched the *Salon d'Automne* ("Autumn Salon") in opposition to the official one that took place in the spring. The Autumn Salons had liberal juries where artists of all stripes exhibited, including Realists, Impressionists, Post-Impressionists, Symbolists, and even bad academic artists. The first Modern movement of the twentieth century made its debut in this salon's disorderly halls. Reviewing the 1905 Salon d'Automne, critic Louis Vauxcelles referred to some young painters as *fauves* ("wild beasts")—a term that captured the explosive colors and impulsive brushwork that characterized their pictures. Their

leaders—André Derain (1880–1954), Maurice de Vlaminck (1876–1958), and Henri Matisse (1869–1954)—advanced the colorist tradition in modern French painting, which they dated from the work of Eugène Delacroix (SEE FIGS. 30–7, 30–8) and which included that of the Impressionists and Post-Impressionists such as Gauguin and van Gogh. The Fauves took further the expressive power of color and brushwork that the latter two especially pioneered.

Among the first major Fauve works were paintings that Derain and Matisse made in 1905 in Collioure, a Mediterranean port. Derain's **MOUNTAINS AT COLLIOURE** (FIG. 31–2) exemplifies so-called mixed-technique Fauvism, in which short strokes of pure color, derived from the work of van Gogh and Seurat (SEE FIG. 30–65), are combined with curvilinear planes of flat color, inspired by Gauguin's paintings and Art Nouveau decorative arts (SEE FIG. 30–77). Derain's assertive colors, which he likened to "sticks of dynamite," do not record what he actually saw in the landscape but rather generate their own purely artistic energy as they express the artist's intense feeling about what he saw. The stark juxtaposi-tions of complementary hues—green leaves next to red tree trunks, red-orange mountainsides against blue-shaded slopes—create what Derain called "deliberate disharmonies." Equally interested in such deliberate disharmonies was Matisse, whose **THE WOMAN WITH THE HAT** (FIG. 31–3) sparked controversy at the 1905 Salon d'Automne—not because of its fairly conventional subject, but because of the way its subject was depicted: with crude drawing, sketchy brushwork, and wildly arbitrary colors that create a harsh and dissonant effect.

Matisse soon settled into a style with less fevered brushwork but color regions just as vivid. **THE JOY OF LIFE** (FIG. 31–4) depicts nudes in attitudes close to traditional studio poses, but the landscape is intensely bright. He defended his aims in a 1908 pamphlet called *Notes of a Painter:* "What I am after, above all, is expression," he wrote. In the past, an artist might express feeling through the figure poses or facial expressions that the characters in the painting had. But now, he wrote, "The whole arrangement of my picture is expressive. The place occupied by figures or objects, the empty spaces around them, the proportions, everything plays a part."

31–2 | André Derain **MOUNTAINS AT COLLIOURE**
1905. Oil on canvas, 32 × 39½″ (81.5 × 100 cm). National Gallery of Art, Washington, D.C.
John Hay Whitney Collection

31–3 | Henri Matisse
THE WOMAN WITH THE HAT
1905. Oil on canvas, 31¾ × 23½"
(80.6 × 59.7 cm). San Francisco Museum of
Modern Art.

Bequest of Elise S. Haas

Both *The Woman with the Hat* and *The Joy of Life*
(FIG. 31-4) were originally owned by the brother
and sister Leo and Gertrude Stein, important
American patrons of European avant-garde art in
the early twentieth century. They hung their col-
lection in their Paris apartment, where they
hosted an informal salon that attracted many
leading literary, musical, and artistic figures,
including Matisse and Picasso. In 1913 Leo
moved to Italy while Gertrude remained in Paris,
pursuing a career as a Modernist writer and con-
tinuing to host a salon with her companion, Alice
B. Toklas.

31–4 | Henri Matisse **LE BONHEUR DE VIVRE (THE JOY OF LIFE)**
1905-6. Oil on canvas, 5'8½" × 7' 9¾" (1.74 × 2.38 m). The Barnes Foundation, Merion, Pennsylvania.
(BF 719)

And the colors that he used? "The chief aim of color should be to serve expression as well as possible." We see in *The Joy of Life* that he also radically simplified the forms, both of the trees and of the bodies. The purpose of this step was to avoid overloading the viewer with excess details. A viewer may become absorbed in the leaves or the clouds, for example, and lose the overall feeling of the work. Matisse wrote, "All that is not useful in the picture is detrimental. A work of art must be harmonious in its entirety; for superfluous details would, in the mind of the beholder, encroach upon the essential elements." Far from the "wild beast" that his detractors saw, Matisse was a thoughtful innovator rather than a radical. The feelings that he communicated were mostly positive and pleasant, making his paintings, as he said, "something like a good armchair in which to rest from physical fatigue."

"The Bridge" and Primitivism

In northern Europe, the Expressionist tradition of artists such as van Gogh and Ensor expanded as younger artists used abstracted forms and colors to communicate more complicated emotional and spiritual states. Prominent in German Expressionist art was *Die Brücke* ("The Bridge"), which formed in Dresden in 1905 when four architecture students—Fritz Bleyl (1880–1966), Erich Heckel (1883–1970), Ernst Ludwig Kirchner (1880–1938), and Karl Schmidt-Rottluff (1884–1976)—decided to devote themselves to painting and to form an exhibiting group. Other German and European artists later joined the group, which endured until 1913. Die Brücke was named for a passage in Friedrich Nietzsche's *Thus Spake Zarathustra* (1883) that spoke of contemporary humanity's potential to be the evolutionary "bridge" to a more perfect being of the future.

The artists hoped that The Bridge would become a gathering place for "all revolutionary and surging elements," in opposition to the dominant culture, which they saw as "pale, overbred, and decadent," according to written testimony from one of the leaders. Among their favorite motifs were nudes in nature, such as we see in Schmidt-Rottluff's **THREE NUDES–DUNE PICTURE FROM NIDDEN** (FIG. 31–5), which shows three simplified female nudes formally integrated with their landscape. The style is purposefully simple and direct, and is a good example of Modernist **Primitivism**, which drew its inspiration from the non-Western arts of Africa, Pre-Columbian America, and Oceania. The bold stylization typical of such art offered a compelling alternative to the sophisticated illusionism that the Modern artists rejected, and it also provided them formal models to adapt. Many Modernists also believed that immersion in non-Western aesthetics gave them access to a more authentic state of being, uncorrupted by civilization and filled with primal spiritual energies. Nudism was also a growing cultural trend in Germany in those years, as city-dwellers forsook the urban environment to frolic outdoors and reconnect with nature.

31–5 | Karl Schmidt-Rottluff
THREE NUDES—DUNE PICTURE FROM NIDDEN
1913. Oil on canvas, 38⅝ × 41¼" (98 × 106 cm). Staatliche Museen zu Berlin, Preussischer Kulturbesitz, Nationalgalerie.

The group member most systematically committed to Primitivism was Emil Nolde (1867–1956), who was invited to join The Bridge in 1906. Originally trained in industrial design, he had studied with a private academic painting teacher in Paris for a few months in 1900, but he never painted as he was taught. Rather, Nolde regularly visited

31–6 | Emil Nolde **MASKS**
1911. Oil on canvas, 28¾ × 30½" (73.03 × 77.47 cm). Nelson-Atkins Museum, Kansas City, Missouri.
Gift of the Friends of Art, 5490. © Artists Rights Society (ARS), New York

intense and often grotesque expression of power and life in very simple forms—that may be why we like these works of native art." Nolde was never exactly a joiner, so he stopped frequenting The Bridge studio in 1907 but remained on good terms with the members thereafter.

Several Bridge members also made their own "primitive" sculpture. Heckel's **CROUCHING WOMAN** (FIG. 31–7) is crudely carved in wood with hacking strokes, rejecting the classical tradition of marble and bronze and suggesting the desire to return to nature depicted in Schmidt-Rottluff's *Three Nudes*.

During the summers, members of The Bridge did return to nature, visiting remote areas of northern Germany, but in 1911 they moved to Berlin—perhaps preferring to imagine the simple life. Ironically, their images of cities, especially Berlin, offer powerful arguments against living there. Particularly critical of urban life are the street scenes of Kirchner, such as **STREET, BERLIN** (FIG. 31–8). Dominating the left half of the painting, two prostitutes—their professions advertised by their large feathered hats and fur-trimmed coats—strut past well-dressed bourgeois men, their potential clients.

31–7 | Erich Heckel **CROUCHING WOMAN**
1912. Painted linden wood, 11⅞ × 6¾ × 3⅞"
(30 × 17 × 10 cm). Estate of Erich Heckel, Hemmenhofen am Bodensee, Germany.

ethnographic museums to study the arts of tribal cultures from Africa and Oceania, and he was greatly stimulated by the radical simplifications and forceful presence of figural arts that he saw there. One result of his research was **MASKS** (FIG. 31–6). Here he used the garish colors and fevered brushwork of Expressionism to depict some of the masks that he sketched in the museum. If a traditional still life is a careful composition of pleasant items on a well-lit tabletop, surely this work is a brisk riposte. The masks hang in an indefinite pictorial space, presenting a lurid and grotesque appearance. On the eve of World War I, Nolde accompanied a German scientific expedition that traveled to New Guinea via Asia and the Palau Islands. In the preface to an unfinished book that he intended to write about his travels, he explained what attracted an artist from the supposedly "advanced" European civilization to the arts of Oceania: "Absolute originality, the

31–8 | Ernst Ludwig Kirchner **STREET, BERLIN**
1913. Oil on canvas, 47½ × 35⅞" (120.6 × 91 cm).
The Museum of Modern Art, New York.
Purchase (274.39)

31–9 Käthe Kollwitz **THE OUTBREAK**
From the *Peasants' War* series. 1903. Etching, 20 × 23 ⅓″
(50.7 × 59.2 cm). Kupferstichkabinett, Staatliche Museen zu
Berlin, Preussischer Kulturbesitz.

The women and men appear as artificial and dehumanized
figures, with masklike faces and stiff gestures. Their bodies
crowd together, but they are psychologically distant from one
another, victims of modern urban alienation. The harsh col-
ors, tilted perspective, and angular lines register Kirchner's
Expressionistic response to the subject.

Independent Expressionists

While the members of The Bridge sought to further their
artistic aims collectively, many Expressionists in German-
speaking countries worked independently. One, Käthe Koll-
witz (1867–1945), was committed to causes of the working
class and pursued social change primarily through printmak-
ing because of its potential to reach a wide audience.
Between 1902 and 1908 she produced the *Peasants' War*
series, seven etchings that depict in an exaggerated and
intense fashion events in a sixteenth-century rebellion. **THE
OUTBREAK** (FIG. 31–9) shows the peasants' built-up fury from

31–10 Paula Modersohn-Becker
**SELF-PORTRAIT WITH AN AMBER
NECKLACE**
1906. Oil on canvas, 24 × 19 ¾″
(61 × 50 cm). Öffentliche Kunst-
sammlung Basel, Kunstmuseum,
Basel, Switzerland.
(1748)

years of mistreatment exploding against their oppressors, a lesson in the power of group action. Kollwitz said that she herself was the model for the leader of the revolt, Black Anna, who raises her hands to signal the attack. Her arms silhouetted against the sky, and the crowded mass of workers with their farm tools, form a jumbled and chaotic picture of a time of upheaval.

Paula Modersohn-Becker (1876–1907), like Kollwitz, studied at the Berlin School of Art for Women, then moved in 1898 to Worpswede, a rustic artists' retreat in northern Germany. Dissatisfied with the Worpswede artists' naturalistic approach to rural life, after 1900 she made four trips to Paris to assimilate recent developments in Post-Impressionist painting. Her **SELF-PORTRAIT WITH AN AMBER NECKLACE** (FIG. 31–10) testifies to the inspiration she found in the work of Paul Gauguin (SEE FIG. 30–67). Her simplified shapes and crude outlines are similar to those in Schmidt-Rottluff's *Three Nudes* (FIG. 31–5), but her muted palette avoided his intense colors. By presenting herself against a screen of flowering plants and tenderly holding a flower that echoes the shape and color of her breasts, she appears as a natural being in tune with her surroundings, as in the nudist paintings by members of The Bridge.

In contrast to Modersohn-Becker's gentle self-portrait, one by Austrian Egon Schiele (1890–1918) conveys physical and psychological torment (FIG. 31–11). Schiele's father had suffered from untreated syphilis and died insane when Egon was fourteen, leaving his son with an abiding link between sex, suffering, and death. In numerous drawings and watercolors, Schiele represented women in sexually explicit poses that emphasize the animal nature of the human body, and his self-portraits reveal deep ambivalence toward the sexual content of both his art and his life. In **SELF-PORTRAIT NUDE**, the artist stares at the viewer with an anguished expression, his emaciated body stretched into an uncomfortable pose. The absent right hand suggests amputation, and the unarticulated genital region, castration. The missing body parts have been interpreted as the artist's symbolic self-punishment for indulgence in masturbation, then commonly believed to lead to insanity.

31–11 | Egon Schiele **SELF-PORTRAIT NUDE**
1911. Gouache and pencil on paper, 20¼ × 13¾"
(51.4 × 35 cm). The Metropolitan Museum of Art, New York.
Bequest of Scofield Thayer, 1982 (1984.433.298)

Spiritualism of the Blue Rider

Members of *Der Blaue Reiter* ("The Blue Rider") harbored more spiritual intentions that led one member to produce some of the first completely abstract paintings. The group was named for a popular image of a blue knight, the Saint George on the city emblem of Moscow, which many believed would be the world's capital during Christ's 1,000-year reign on earth following the Apocalypse prophesied by Saint John. The Blue Rider formed in Munich around the painters Vasily Kandinsky (1866–1944), a Russian from Moscow, and Franz Marc (1880–1916), a native of Munich, who both considered blue the color of spirituality. Its first exhibition, in December 1911, featured fourteen very diverse artists, whose subjects and styles ranged widely, from naive realism to radical abstraction.

During the early years of his career, Franz Marc moved from a Barbizon-inspired landscape style to a colorful form of Expressionism influenced by the Fauves. By 1911 he was painting animals rather than people because he felt that animals enjoyed a purer, more spiritual relationship to nature than did humans; he rendered these animals in bold, near-primary colors. In his **THE LARGE BLUE HORSES** (FIG. 31–12), the animals merge into a homogenous unit, the fluid contours of which reflect the harmony of their collective existence and echo the lines of the hills behind them, suggesting that they are also in harmony with their surroundings. The pure, strong colors reflect their uncomplicated yet intense experience of the world as Marc enviously imagined it.

31–12 | Franz Marc **THE LARGE BLUE HORSES**
1911. Oil on canvas, 3′5⅜″ × 5′11¼″ (1.05 × 1.81 m). Walker Art Center, Minneapolis.
Gift of T. B. Walker Collection, Gilbert M. Walter Fund, 1942

31–13 | Vasily Kandinsky **THE BLUE MOUNTAIN (DER BLAUE BERG)**
1908–09. Oil on canvas, 41¾ × 38″ (106 × 96.6 cm).
Guggenheim Museum, New York.
Gift of Solomon R. Guggenheim, 1941.41.505. Vasily Kandinsky © 2007
© Artists Rights Society (ARS), New York/ADAGP, Paris

The most radical of the Expressionists was also the best read. Born into a wealthy family and trained originally as a lawyer, Kandinsky was headed for a career as a law school professor in Moscow when he began to frequent exhibitions of Modern art during trips to Germany. After procuring private art instruction, he threw over the idea of a conventional career, settled in Munich in 1896, and began painting.

His early works make frequent reference to Russian folk culture, a "primitive" type of society that inspired him. His 1909 work **THE BLUE MOUNTAIN (FIG. 31–13)** shows two horsemen, rendered in the style of Russian folk art, before a looming peak in his favorite color. The flatness of the work and the carefully parallel brushstrokes show influence from Gauguin and Cézanne. Many of his works feature riders; Kandinsky had in mind the horsemen of the Apocalypse who usher in the end of the world before its final transformation at the end of time.

Kandinsky's study of Whistler's work (SEE FIG. 30–48) also led him to see that the arts of painting and music were related: Just as the composer organizes sound, a painter organizes color and form. This insight was the most direct cause of Kandinsky's contribution to the history of Western art. His musical explorations led him to the work of the Austrian composer Arnold Schoenberg, who in the years surrounding 1910 was taking one of the most momentous steps in musical history. All Western music since antiquity was based on the arrangement of notes into scales, or modes (such as today's common major and minor), and composers could choose the scale they wanted for expressive reasons. Particularly since the Baroque period, each of the notes in any given scale had a role to play, and these roles operated in a clear hierarchy that served

to reinforce what became known as the "tonal center," a kind of home base or place of repose in the musical composition. Schoenberg's great departure was to eliminate the tonal center and treat all tones equally, denying the listener any place of repose and instead prolonging the tension (and thus, he felt, the expression) indefinitely. Kandinsky contacted the composer and was delighted to find out that he also painted in an Expressionist style. Kandinsky asked himself: If music can do without a tonal center, can art do without subject matter?

He found it difficult to paint a completely abstract painting, just as it is difficult to sing without a tonal scale. He gave his works musical titles, such as "Composition" and "Improvisation," and he made his paintings respond to his inner state rather than an external stimulus. Sometime in 1910, art historians generally agree, Kandinsky made his first abstract work. A typical work from this period is **IMPROVISATION 28** (**FIG. 31–14**). This work retains a vestige of the landscape; Kandinsky found references to nature the hardest to transcend. But the work takes us into a vortex of color, line, and shape. If we recognize buildings or mountains or faces in the work, then perhaps we are seeing in the old way, looking for correspondences between the painting and the world where none are intended. Rather, the artist would have us look at the painting as if we were hearing a symphony, responding instinctively and spontaneously to this or that passage, and then to the total experience. Kandinsky further explained the musical analogy in a short book about his working methods called *Concerning the Spiritual in Art:* "Color directly influences the soul. Color is the keyboard, the eyes are the hammers, the soul is the piano with many strings. The artist is the hand that plays, touching one key or another purposively, to cause vibrations in the soul."

Kandinsky saw his art as part of a wider political program in opposition to the materialism of Western society. Art's traditional focus on accurate rendering of the physical world is a basically materialistic quest, he thought. Art should not depend so much on mere physical reality. He hoped that his paintings would lead humanity toward a deeper awareness of spirituality and the inner world.

The Swiss-born Paul Klee (1879–1940) participated in the second Blue Rider exhibition of 1912, but his involvement with the group was never more than tangential. A 1914 trip to Tunisia, rather than the Blue Rider, inspired Klee's interest in the expressive potential of color. On his return,

31–14 | Vasily Kandinsky **IMPROVISATION 28 (SECOND VERSION)**
1912. Oil on canvas, 43⅞ × 63⅞". Guggenheim Museum, New York.

Gift, Solomon R. Guggenheim. 37.239. Vasily Kandinsky © 2003 Artists Rights Society (ARS), New York/ADAGP, Paris

31–15 | Paul Klee
HAMMAMET WITH ITS MOSQUE
1914. Watercolor and pencil on two sheets of laid paper mounted on cardboard, 8⅛ × 7⅝″ (20.6 × 19.7 cm). The Metropolitan Museum of Art, New York.
The Berggruen Klee Collection, 1984 (1984.315.4)

Klee painted watercolors based on his memories of North Africa, including **HAMMAMET WITH ITS MOSQUE** (FIG. 31–15). The play between geometric composition and irregular brushstrokes is reminiscent of Cézanne's work, which Klee had recently seen. The luminous colors and delicate **washes**, or applications of dilute watercolor, result in a gently shimmering effect. The subtle modulations of red across the bottom, especially, are positively melodic. Klee, who played the violin and belonged to a musical family, seems to have wanted to use color the way a musician would use sound, not to describe appearances but to evoke subtle nuances of feeling.

Cubism in Europe: Exploding the Still Life

Of all Modern art movements created before World War I, Cubism probably had the most influence on later artists. The joint invention of Pablo Picasso (1881–1973) and Georges Braque (1882–1963), the Cubist style proved a fruitful launching pad for both artists, allowing each to comment on modern life and to investigate how we perceive the world.

PICASSO'S EARLY ART. Born in Málaga, Spain, Picasso was a child prodigy as an artist. During his teenage years at the National Academy in Madrid, he made highly polished works that portended a bright future, had he stayed on a conservative

31–16 | Pablo Picasso **SELF-PORTRAIT**
1901. Oil on canvas, 31⅞ × 23⅝″ (81 × 60 cm). Musée Picasso, Paris.

31–17 | Pablo Picasso
FAMILY OF SALTIMBANQUES
1905. Oil on canvas,
6′11¾″ × 7′6⅜″ (2.1 × 2.3 m).
National Gallery of Art,
Washington, D.C.
Chester Dale Collection

artistic path. But his restless temperament led him to Barcelona in 1899, where he involved himself in avant-garde circles.

During this time Picasso was attracted to the socially conscious nineteenth-century French painting that included Daumier (SEE FIG. 30–42) and Toulouse-Lautrec (SEE FIG. 30–81). In what is known as his Blue Period, he painted the outcasts of Paris and Barcelona in weary poses, using a coldly expressive blue, likely chosen for its associations with melancholy. These paintings seem to have been motivated by Picasso's political sensitivity to those he considered victims of modern capitalist society, which eventually led him to join the Communist Party. They also reflect his own unhappiness, hinted at in his 1901 **SELF-PORTRAIT** (FIG. 31–16), which reveals his familiarity with cold, hunger, and disappointment.

In search of a more vital art environment, Picasso moved to Paris in 1904. There his personal circumstances greatly improved. He gained a circle of supportive friends among the avant-garde, and his work attracted several important collectors. His works from the end of 1904 through 1905, known collectively as the Rose Period because of the introduction of that color into his palette, show the last vestiges of his earlier despair. During the Rose Period, Picasso was preoccupied with the subject of traveling acrobats, *saltimbanques,* whose rootless and insecure existence on the margins of society was

similar to the one he too had known. Picasso rarely depicted them performing but preferred to show them at rest, as in **FAMILY OF SALTIMBANQUES** (FIG. 31–17). In this mysterious composition, six figures inhabit a barren landscape painted in warm tones of beige and rose sketchily brushed over a blue ground. Five of the figures cluster together in the left two-thirds of the picture while the sixth, a seated woman, curiously detached, occupies her own space in the lower right. All of the *saltimbanques* seem psychologically withdrawn and uncommunicative, as silent as the empty landscape they occupy.

Soon his encounters with non-Western art in Paris museums would prove decisive in his career. In 1906 the Louvre installed a newly acquired collection of sixth- and fifth-century BCE sculpture from the Iberian Peninsula (present-day Spain and Portugal). Picasso identified these ancient Iberian figures with the stoic dignity of the villagers in the province of his birth. Even more important, he made repeated visits to the ethnographic museum where African art from France's colonies was displayed. While he never took the time to study the cultures where the art originated, Picasso was greatly stimulated by the expressive power and formal novelty of the African masks that he saw. Since African art was relatively inexpensive, he also bought several pieces and kept them in his studio.

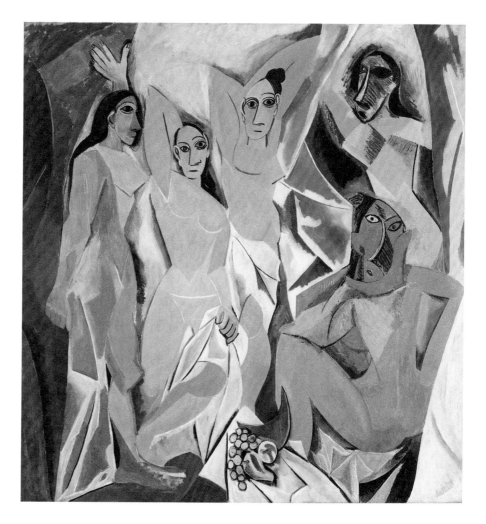

31–18 | Pablo Picasso
**LES DEMOISELLES D'AVIGNON
(THE YOUNG LADIES OF AVIGNON)**
1907. Oil on canvas, 8′ × 7′8″
(2.43 × 2.33 m). The Museum of
Modern Art, New York.
Acquired through the Lillie P. Bliss Bequest,
(333.1939)

The result of these encounters burst into view in Picasso's large 1907 work **LES DEMOISELLES D'AVIGNON (THE YOUNG LADIES OF AVIGNON)** (FIG. 31–18). The Iberian influence is seen specifically in the faces of the three leftmost figures, with their simplified features and wide, almond-shaped eyes. The faces of the two right-hand figures, painted in a radically different style, were inspired by African art. Given the then-dominant condescending attitudes toward such allegedly "primitive" cultures, Picasso's wholesale adoption and adaptation of their styles for a large, multifigured painting—as opposed to a still life or a small genre work—was a culturally rebellious thing to do. Such sympathy with non-Western styles paralleled his political beliefs at the time, as he flirted with anarchist theories. Along with its bold embrace of non-Western art, the controversial subject matter of the work is prostitutes. The term *demoiselles*, meaning "young ladies," is a euphemism for prostitutes, and *Avignon* refers not to the French town but to a narrow street in the red-light district of Barcelona.

We see the African influence not only in their masklike faces, but also in the handling of their forms in space. The women in the painting are flattened and fractured into sharp curves and angles. The space they inhabit is equally fractured and convulsive. The central pair of *demoiselles* raise their arms in a traditional gesture of accessibility but contradict it with their hard, piercing gazes and firm mouths. Even the fruit displayed in the foreground, a symbol of female sexuality, seems hard and dangerous. Women, Picasso suggests, are not the gentle and passive creatures that men would like them to be. With this viewpoint he contradicts practically the entire tradition of erotic imagery since the Renaissance. Likewise, his treatment of space shatters the orderly perspective also inherited from that period.

Most of Picasso's friends were horrified by his new work. Matisse, for example, accused Picasso of making a joke of Modern art and threatened to break off their friendship. But one artist, Georges Braque, responded positively, and he saw in *Les Demoiselles d'Avignon* a potential that Picasso probably had not fully intended. Picasso used broken and distorted forms expressionistically, to convey his view of women, which some feminists have derided as misogynist. But what secured Picasso's place at the forefront of the Parisian avant-garde was the revolution in form that *Les Demoiselles d'Avignon* inaugurated. Braque responded eagerly to Picasso's formal innovations and set out, alongside Picasso, to develop them. The work was the seedbed for the Cubist style, which came in two phases, Analytic and Synthetic.

ANALYTIC CUBISM. Georges Braque was born a year after Picasso, near Le Havre, France, where he trained to become a house decorator like his father and grandfather. In 1900 he moved to Paris. The Fauve paintings in the 1905 Salon d'Automne so impressed him that he began to paint brightly colored landscapes, but it was the 1907 Cézanne retrospective that established his future course. Picasso's *Demoiselles* sharpened his interest in altered form and compressed space and emboldened Braque to make his own advances on Cézanne's late direction.

Braque's 1908 **HOUSES AT L'ESTAQUE** (FIG. 31–19) reveals the emergence of early Cubism. Inspired by Cézanne's example, Braque reduced nature's many colors to its essential browns and greens and eliminated detail to emphasize basic geometric forms. Arranging the buildings into an approximate pyramid, he pushed those in the distance closer to the foreground, so the viewer looks *up* the plane of the canvas more than into it. The painting is less a Cézannesque study of nature than an attempt to translate nature's complexity into an independent, aesthetically satisfying whole.

Braque submitted *Houses at L'Estaque* to the 1908 Autumn Salon, but the jury, which included Matisse, rejected it—Matisse dismissively referring to Braque's "little cubes." Thus, the name *Cubism* was born.

Braque's early Cubist work helped point Picasso in a new artistic direction. By the end of 1908 the two artists had begun an intimate working relationship that lasted until Braque went off to war in 1914. "We were like two mountain climbers roped together," Braque later said. The move toward simplification begun in Braque's landscapes in 1908 continued in the moderately scaled still lifes the two artists produced over the next two and a half years. In Braque's **VIOLIN AND PALETTE** (FIG. 31–20), the gradual abstraction of deep

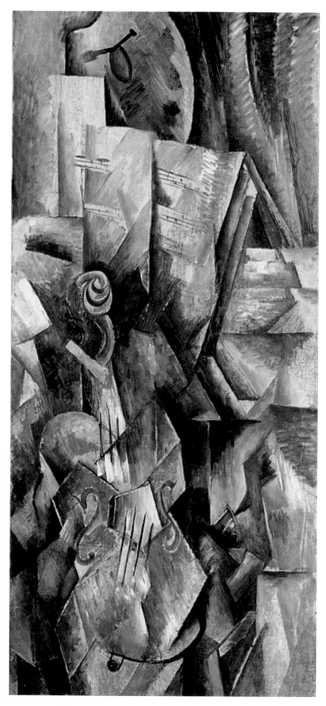

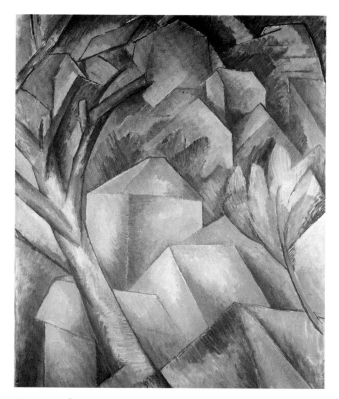

31–19 | Georges Braque **HOUSES AT L'ESTAQUE**
1908. Oil on canvas, 36¼ × 23⅞" (73 × 59.5 cm).
Kunstmuseum, Bern, Switzerland.
Collection Hermann and Magrit Rupf-Stiftung

31–20 | Georges Braque **VIOLIN AND PALETTE**
1909–10. Oil on canvas, 36⅛ × 16⅞" (91.8 × 42.9 cm).
Solomon R. Guggenheim Museum, New York.
(54.1412)

space and recognizable subject matter is well under way. The still-life items are not arranged in illusionistic depth but are pushed close to the picture plane in a shallow space. Braque knit the various elements together into a single shifting surface of forms and colors. In some areas of the painting, these formal elements have lost not only their natural spatial relations but their identities as well. Where representational motifs remain—the violin, for example—Braque fragmented them to facilitate their integration into the whole.

Braque's and Picasso's paintings of 1909 and 1910 initiated what is known as Analytic Cubism because of the way the artists broke objects into parts as if to analyze them. The works of 1911 and early 1912 are also grouped under the *Analytic* label, although they reflect a different approach to the breaking up of forms. Instead of simply fracturing an object, Picasso and Braque picked it apart and rearranged its elements. In this way, Analytic Cubism resembles the actual process of perception. When we look at an object, we are likely to examine it from various angles and then reassemble our glances into a whole in our brain. Picasso and Braque shattered their subjects into jagged forms analogous to momentary, partial glances, but they reassembled the pieces according not to the laws of reality but to those of aesthetic composition. Remnants of the subject Picasso worked from are evident throughout **MA JOLIE** (FIG. 31–21), for example, but any attempt to reconstruct that subject—a woman with a stringed instrument—would be misguided because the subject provided only the raw material for a formal arrangement.

The inscription of the title on the work offers a joke at the expense of baffled viewers (of which there were probably very many). *Ma Jolie* means "My Pretty One," which was also the name of a popular song. Our first impulse might be to wonder what exactly is pictured on the canvas, and to that unspoken question, Picasso provided a sarcastic answer: "It's My Pretty One!"

A subtle tension between order and disorder is maintained throughout this painting. For example, the shifting effect of the surface, a delicately patterned texture of grays and browns, is given regularity through the use of short, horizontal brushstrokes. Similarly, with the linear elements, strict horizontals and verticals dominate, although many irregular curves and angles are also to be found. The combination of horizontal brushwork and right angles firmly establishes a grid that effectively counteracts the surface flux. Moreover, the repetition of certain diagonals and the relative lack of details in the upper left and upper right create a pyramidal shape. Thus, what at first may seem a random assemblage of lines and muted colors turns out to be a well-organized unit. The aesthetic satisfaction of such a work depends on the way chaos seems to resolve itself into order.

SYNTHETIC CUBISM. Works such as *Ma Jolie* brought Picasso and Braque to the brink of total abstraction, but in the spring

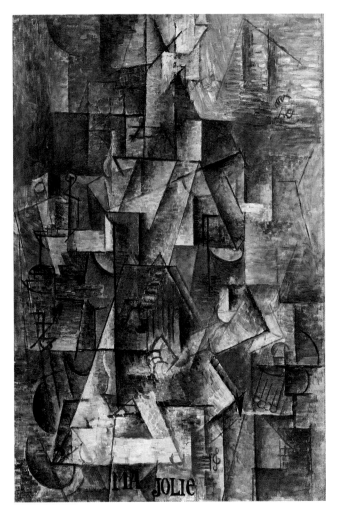

31–21 | Pablo Picasso **MA JOLIE**
1911–12. Oil on canvas, 39⅜ × 25¾" (100 × 65.4 cm). The Museum of Modern Art, New York.
Acquired through the Lillie P. Bliss Bequest (176.1945)

In 1923 Picasso said, "Cubism is no different from any other school of painting. The same principles and the same elements are common to all. The fact that for a long time Cubism has not been understood . . . means nothing. I do not read English, . . . [but] this does not mean that the English language does not exist, and why should I blame anybody . . . but myself if I cannot understand [it]?"

of 1912 they pulled back and began to create works that suggested more clearly discernible subjects. Neither artist wanted to break the link to reality; Picasso once said that there was no such thing as perfectly abstract art, because, he said, "You have to start somewhere." This second major phase of Cubism is known as Synthetic Cubism because of the way the artists created motifs by combining simpler elements, as in a chemical synthesis. Picasso's **GLASS AND BOTTLE OF SUZE** (FIG. 31–22), like many of the works he and Braque created from 1912 to 1914, is a *collage* (from the French *coller*, meaning "to glue"), a work composed of separate elements pasted together. At the center, newsprint and construction paper are assembled to suggest a

tray or round table supporting a glass and a bottle of liquor with an actual label. Around this arrangement Picasso pasted larger pieces of newspaper and wallpaper. The composition of this work is Cubist, as jagged shapes overlap in a shallow space. The elements together evoke not only a place—a bar—but also an activity: the viewer alone with a newspaper, enjoying a quiet drink. However, the newspaper clippings deal with the First Balkan War of 1912–13, which contributed to the outbreak of World War I. Picasso may have wanted to underline the disorder in his art by comparing it with the disorder then building in the world.

Picasso soon extended the principle of collage to produce revolutionary Synthetic Cubist sculpture, such as **MANDOLIN AND CLARINET (FIG. 31–23).** Composed of wood scraps, the sculpture suggests the typical Cubist subject of two musical instruments at right angles to each other. Sculpture has traditionally been either carved, modeled, or cast, but Picasso invented a new method here. In works such as this Picasso introduced the revolutionary technique of **assemblage**, giving sculptors the option not only of carving or modeling but also of constructing their works out of found

objects and unconventional materials. Another innovative feature of assemblage was the introduction of space into the interior of the sculpture. We see how the parts of the sculpture do not fit perfectly together, leaving gaps and holes. Moreover, the white central piece describes a semicircle that juts outward toward the viewer. Thus the sculpture creates volume through contained space rather than mass alone. This innovation reversed the traditional conception of sculpture as a solid surrounded by a void.

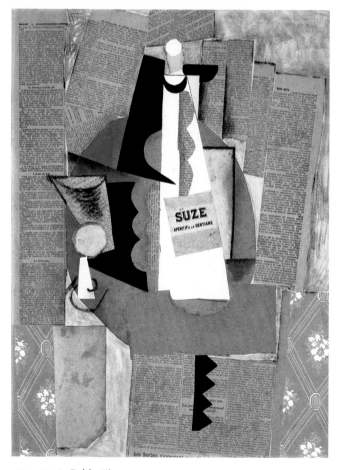

31–22 | Pablo Picasso **GLASS AND BOTTLE OF SUZE**
1912. Pasted paper, gouache, and charcoal, 25¾ × 19¼″ (65.4 × 50.2 cm). Washington University Gallery of Art, St. Louis, Missouri.
University Purchase, Kende Sale Fund, 1946

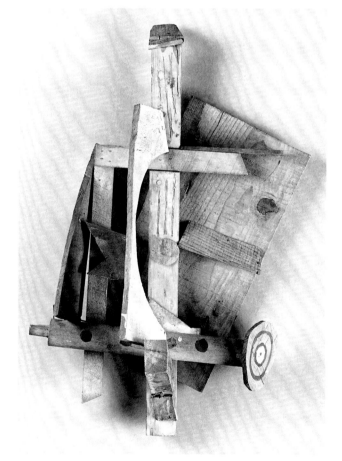

31–23 | Pablo Picasso **MANDOLIN AND CLARINET**
1913. Construction of painted wood with pencil marks, 22⅝ × 14⅛ × 9″ (58 × 36 × 23 cm). Musée Picasso, Paris.

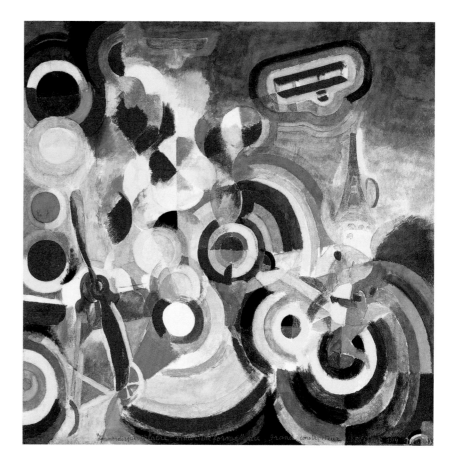

31–24 | Robert Delaunay
HOMAGE TO BLÉRIOT
1914. Tempera on canvas, 8′2½″ × 8′3″
(2.5 × 2.51 m). Öffentliche
Kunstsammlung Basel, Kunstmuseum,
Basel, Switzerland.
Emanuel Hoffman Foundation

Extensions of Cubism

As the various phases of Cubism emerged from the studios of Braque and Picasso, it became clear to the art world that something of great significance was happening. Artists in many countries used various aspects of the Cubist style to create works that significantly broadened the message of Cubism beyond the studio-based aesthetic of its inventors.

FRENCH EXTENSIONS. Robert Delaunay (1885–1941) and his wife, the Ukrainian-born Sonia Delaunay-Terk (b. Sonia Stern, 1885–1979), took monochromatic, static, Analytic Cubism into a new, wholly different direction. Neo-Impressionism and Fauvism influenced Robert's early painting, and his interest in the spirituality of color led him to participate in Blue Rider exhibitions. Beginning in 1910, he fused Fauvist color with Analytic Cubist form in works celebrating the modern city and modern technology. One of these, **HOMAGE TO BLÉRIOT** (FIG. 31–24), pays tribute to the French pilot who in 1909 was the first to fly across the English Channel. One of Blériot's early airplanes, in the upper right, and the Eiffel Tower, below it, symbolized technological and social progress, and the crossing of the Channel expressed the hope of a new, unified world without national antagonisms. The brightly colored circular forms that fill the canvas suggest both the movement of the propeller on the left and the blazing sun,

as well as the great rose windows of Gothic cathedrals. By combining images of progressive science with those of divinity, Delaunay suggested that progress is part of God's divine plan. The ecstatic painting thus synthesizes not only Fauvist color and Cubist form but also religion and modern technology.

The critic Guillaume Apollinaire labeled Sonia and Robert's style Orphism for its affinities with Orpheus, the legendary Greek poet whose lute playing charmed wild beasts, implying an analogy between their painting and music. They preferred to think of their work in terms of "simultaneity," a complicated concept based on Michel-Eugène Chevreul's law of the simultaneous contrast of colors. *Simultaneity* for Sonia and Robert connoted the collapse of spatial distance and temporal sequence into the simultaneous "here and now" and the creation of harmonic unity out of elements normally considered disharmonious. The simultaneity that they envisioned captured the new, faster pace of life made possible by airplanes, telephones, and automobiles.

Sonia produced innovative paintings along with Robert, but she also devoted much of her career to fabric and clothing design. She pioneered new clothing patterns based on Modern painting and used them in garments that she called Simultaneous Dresses. Her greatest critical success came in 1925 at the International Exposition of Modern Decorative and Industrial Arts, for which she decorated a Citroën sports

31–25 | Sonia Delaunay-Terk
**CLOTHES AND CUSTOMIZED CITROËN B-12
(EXPO 1925 MANNEQUINS AVEC AUTO)**
From *Maison de la Mode*, 1925.

Delaunay-Terk's clothing and fabric designs were displayed at the 1925 International Exposition of Modern Decorative and Industrial Arts in Paris. The term *Art Deco* was coined to describe the kind of geometric style influenced by Cubism and abstract art evident in many of the works on display, which included clocks, furniture, and wallpaper.

car to match one of her ensembles (**FIG. 31–25**), suggesting that her bold geometric designs were an expression of the new automobile age. Sonia chose that particular car because it was produced cheaply for a mass market, and she had also recently brought out inexpensive ready-to-wear clothing. Moreover, the small three-seater was specifically designed to appeal to the "new woman," who, like the artist herself, was less tied to home and family and less dependent on men than her predecessors. Regrettably, only black-and-white photos exist of these creations.

Similarly fascinated by technology was Fernand Léger (1881–1955), who developed a version of Cubism based on machine forms. Léger painted in a nearly abstract Cubist style as early as 1911, but his artistic development was redirected by his wartime experience. Drafted into the French army, he was almost killed in a poison gas attack; the experience led him to see more beauty in everyday objects, even machine-made ones. **THREE WOMEN** (**FIG. 31–26**) is a machine-age version of the French odalisque tradition that dates back to Ingres (SEE FIG. 30–4). The picture space is shallow and compressed but less radically shattered than Analytic Cubist works. The women, arranged within a geometric grid, stare out blankly at us, embodying a quality of classical calm. Léger's women have identical faces, and their bodies seem assembled from

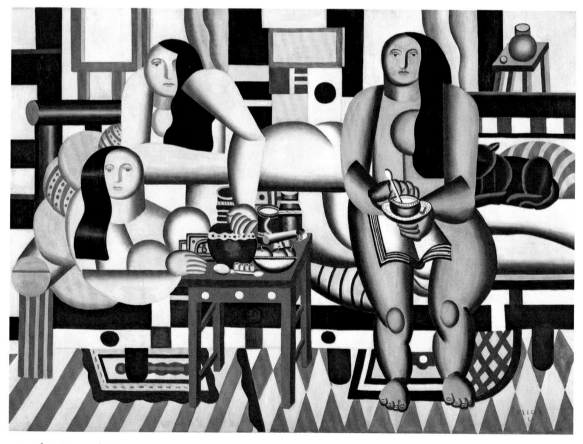

31–26 | Fernand Léger **THREE WOMEN**
1921. Oil on canvas, 6′½″ × 8′3″ (1.84 × 2.52 m). The Museum of Modern Art, New York.
Mrs. Simon Guggenheim Fund

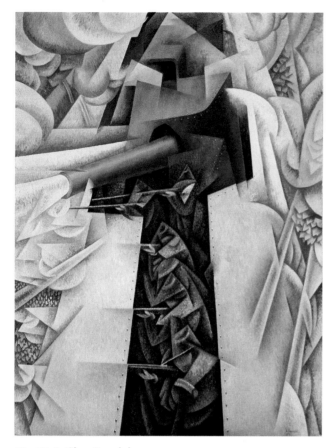

31–27 | Gino Severini **ARMORED TRAIN IN ACTION**
1915. Oil on canvas, 45⅝ × 34⅞" (115.8 × 88.5 cm).
The Museum of Modern Art, New York.
Gift of Richard S. Zeisler. 287.86

Among the signers of the manifesto, Gino Severini (1883–1966) most consistently expressed the radical Futurist idea that war was a cleansing agent for humanity. He lived in Paris from 1906, where he focused special attention on the work of Seurat. Invited to sign the Technical Manifesto while living in Paris, he served as an intermediary between the Futurists based in Italy and the French avant-garde. In his 1915 work **ARMORED TRAIN IN ACTION** (FIG. 31–27), we see the artist's interest in Seurat's Post-Impressionism in the small strokes of bright color that enliven the surface of the work. He also uses the compressed picture space and jagged forms of Cubism to describe a tumultuous scene of smoke, violence, and cannon blasts issuing from the speeding train. The viewpoint in this painting is similarly dizzying, as if we are flying above in an airplane.

In 1912 the Futurist painter Umberto Boccioni (1882–1916) took up sculpture, and his "Technical Manifesto of Futurist Sculpture" called for a "sculpture of environment" in which closed outlines would be broken open and sculptural forms integrated with surrounding space. If traditional sculpture represented things at rest, Futurist sculpture should concern itself with motion. His major sculptural work, **UNIQUE FORMS OF CONTINUITY IN SPACE** (FIG. 31–28), presents an armless nude figure in full, powerful stride. The contours of the muscular body flutter and flow into the surrounding space, expressing the figure's great velocity and vitality as it rushes forward, a stirring symbol of the brave new Futurist world. This brave new world included World War I, which the Futurists enthusiastically supported. Boccioni enlisted immediately, and lost his life in combat.

standardized, interchangeable metal parts. The bright, exuberant colors and patterns that surround them suggest a positive vision of an orderly industrial society.

ITALIAN EXTENSIONS. Italian Futurism emerged on February 20, 1909, when the controversial Milanese poet and literary magazine editor Filippo Marinetti (1876–1944) published his "Foundation and Manifesto of Futurism" in a Paris newspaper. An outspoken attack against everything old, dull, "feminine," and safe, Marinetti's manifesto promoted the exhilarating "masculine" experiences of warfare and reckless speed. Futurism aimed both to free Italy from its past and to promote a new taste for the thrilling speed, energy, and power of modern technology and modern urban life.

In April 1911, five Milanese artists issued the "Technical Manifesto" of Futurist painting, in which they boldly declared that "all subjects previously used must be swept aside in order to express our whirling life of steel, of pride, of fever, and of speed." Some members of the group took a trip to Paris to prepare for a Futurist exhibition in 1912, and when they saw Cubist works there they realized that the style could be harnessed to express their love of machines, speed, and war.

RUSSIAN EXTENSIONS. At the beginning of the century, art societies in St. Petersburg and Moscow began showing works by Impressionist and Post-Impressionist artists. In addition, some important Russian art collectors in both cities bought Modern artworks and opened their homes to artists. These two factors made it possible for Russians to be aware of most of the latest developments in the rest of Europe. By 1912, several Russians were painting in a style they called Cubo-Futurism for its combination of those two movements. Soon Russian artists took Cubism into completely abstract realms.

The leader in this new movement was Kazimir Malevich (1878–1935), who emerged after 1915 as the leading figure in the Moscow avant-garde. According to his later reminiscences, "in the year 1913, in my desperate attempt to free art from the burden of the object, I took refuge in the square form and exhibited a picture which consisted of nothing more than a black square on a white field." He used this large canvas as a backdrop for a performance of Mikhail Matiushin's new opera, *Victory Over the Sun,* in that year. Malevich exhibited thirty-nine works in this radically new vein at the "Last Futurist Exhibition of Paintings: 0.10," held in St. Petersburg in the winter of 1915–16. One work, **SUPREMATIST PAINTING (EIGHT RED RECTANGLES)** (FIG. 31–29), consists simply of

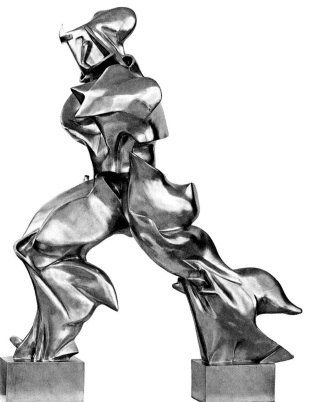

31–28 | Umberto Boccioni
UNIQUE FORMS OF CONTINUITY IN SPACE
1913. Bronze, 43⅞ × 34⅞ × 15¾″ (111 × 89 × 40 cm).
The Museum of Modern Art, New York.
Acquired through the Lillie P. Bliss Bequest, (231.1948)

Boccioni and the Futurist architect Antonio Sant'Elia were both killed in World War I. The Futurists had ardently promoted Italian entry into the war on the side of France and England. After the war Marinetti's movement, still committed to nationalism and militarism, supported the rise of fascism under Benito Mussolini, although a number of the original members of the group rejected this direction.

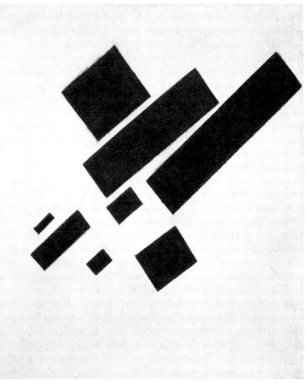

31–29 | Kazimir Malevich
SUPREMATIST PAINTING (EIGHT RED RECTANGLES)
1915. Oil on canvas, 22½ × 18⅞″ (57 × 48 cm).
Stedelijk Museum, Amsterdam.

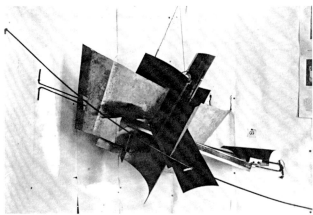

31–30 | Vladimir Tatlin **CORNER COUNTER-RELIEF**
1915. Mixed media, 31½ × 59 × 29½″ (80 × 150 × 75 cm).
Present whereabouts unknown.
© Estate of Vladimir Tatlin/RAO Moscow/Licensed by VAGA, New York, NY

eight red rectangles arranged diagonally on a white painted ground. Malevich called this art Suprematism, short for "the supremacy of pure feeling in creative art" motivated by "a pure feeling for plastic [that is, formal] values." By eliminating objects and focusing entirely on formal issues, Malevich intended to "liberate" the essential beauty of all great art.

While Malevich was launching an art that transcended the present, Vladimir Tatlin (1885–1953) was opening a very different direction for Russian art, inspired by Synthetic Cubism. In April 1914, Tatlin went to Paris specifically to visit Picasso's studio. Tatlin was most impressed by the Synthetic Cubist sculpture he saw there, such as *Mandolin and Clarinet* (SEE FIG. 31–23), and began to produce innovative nonrepresentational relief sculptures constructed of various materials, including metal, glass, plaster, asphalt, wire, and wood. These "Counter-Reliefs," as he called them, were based on the conviction that each material generates its own repertory of forms and colors. Partly because he wanted to place "real

materials in real space" and because he thought the usual placement on the wall tended to flatten his reliefs, Tatlin began at the "0.10" exhibition of 1915–16 to suspend them across the upper corners of rooms (FIG. 31–30)—the usual location for the traditional Russian religious pictures known as icons. In effect, these Counter-Reliefs were intended to replace the old symbol of Russian faith with one dedicated to respect for modern and industrial materials.

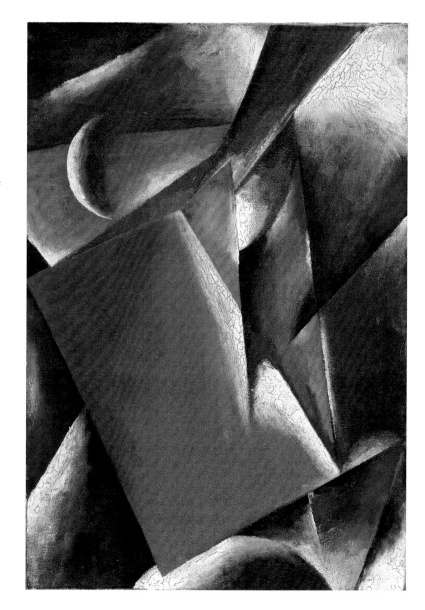

31–31 | Liubov Popova
ARCHITECTONIC PAINTING
1917. Oil on canvas, 29 ¹³⁄₁₆ × 21″
(75.57 × 53.34 cm). Los Angeles County
Museum of Art.

Purchased with funds provided by the Estate of Hans G. M. de
Schulthess and the David E. Bright Bequest. 87.49

The Suprematist movement attracted many women, the most radical of whom was Liubov Popova (1889–1924). Born into a wealthy family, she studied Modern art in Paris in 1912–13. On her return to Russia she gravitated toward the Suprematists, and she made her first completely abstract Cubist works in 1916. She titled all of these works **ARCHITECTONIC PAINTING** (FIG. 31–31). They are more dynamic than those of Malevich, as their forms are modeled and seem to jut into our space. The title alludes to the combination of two- and three-dimensional forms that she attempted to capture in the shallow space of Cubism. The bright colors contribute to the dynamic space that the work creates: Warm colors, such as red and orange, seem to advance toward the viewer, while cool ones (blue and black) recede.

The Russian avant-garde enthusiastically supported the Russian Revolution when it broke out in 1917. They thought that their new form of art was appropriate for the new type of Russian citizen that would emerge from the ashes of the Czarist dictatorship.

Toward Abstraction in Sculpture

Sculpture underwent a revolution as profound as that of painting in the years prior to World War I. Some of the innovations were carried out by artists such as Erich Heckel (SEE FIG. 31–7), who gouged and chopped his sculptures in an Expressionist fashion, and Picasso (FIG. 31–23), who invented constructed sculpture. The sculptor most devoted to making abstract three-dimensional objects was the Romanian Constantin Brancusi (1876–1957). Brancusi settled in Paris in 1904 and was immediately captivated by non-Western art. He admired the simplification of forms that he found in the art of many of those cultures because he thought that the artists who made them were intent on capturing the "essence" of the subject. This search for an essence seemed the opposite of the Western tradition after Michelangelo, which he thought focused too much attention on the superficial appearance. He wrote, "What is real is not the external form but the essence of things. Starting from this truth it is impossible for anyone to express anything essentially real by imitating its exterior surface."

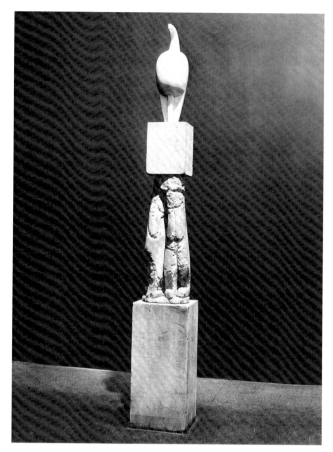

Brancusi's works tend to focus on two subjects, each of profound symbolic significance: the bird and the egg. The bird symbolized for him the human urge to transcend gravity and earthbound existence. We see in **MAGIC BIRD** (FIG. 31–32) that the avian form rises majestically above the figural masses below. The sculpture was inspired by Igor Stravinsky's orchestral piece *The Firebird,* a ballet based on a Russian folk tale that Brancusi saw in 1910. In the ballet, Prince Ivan rescues himself and a princess from an evil sorcerer and his monsters by waving one of the Firebird's feathers. The Firebird then leads Ivan to the hidden egg that holds the evil sorcerer's spirit, and she tells him to break it. When he does, the sorcerer vanishes. The upper part of the sculpture is the Firebird, who in the ballet has bright red plumage. Brancusi made her sleek and abstract. Below are struggling human masses that symbolize the sorcerer's assistants.

For Brancusi, the egg symbolized birth or rebirth and the potential for growth and development. He saw egg shapes as perfect, organic ovals that contain all possible life forms. In **THE NEWBORN** (FIG. 31–33), he charmingly conflated the egg shape with that of a shrieking infant's head. Both infants and eggs, after all, represent a life span in prototype. Perhaps its cry is the primal shout of the baby as it leaves the womb and enters a new (and for Brancusi, more problematic) level of existence.

31–32 | Constantin Brancusi **MAGIC BIRD**
1908–12. White marble, height 22″ (55.8 cm), on three-part limestone pedestal, height 5′10″ (1.78 m), of which the middle part is the *Double Caryatid* (c. 1908);
overall 7′8″ × 12 ¾″ × 10 ⅝″ (237 × 32 × 27 cm).
The Museum of Modern Art, New York.

Katherine S. Dreier Bequest

31–33 | Constantin Brancusi
THE NEWBORN
1915. Marble, 5¾ × 8¼ × 5⅞″
(14.6 × 21 × 14.8 cm). Philadelphia Museum of Art.

Louise and Walter Arensberg Collection.
1950.134.10. Artists Rights Society

Dada

When the Great War broke out in August 1914, most European leaders thought it would be over by Christmas. Each side reassured its population that the efficiency and bravery of its soldiers would ensure a speedy resolution and that Europe could then resume its onward march of progress. Yet these hopes proved illusory in the extreme. World War I was by far the most brutal in human history up to that time, as the allegedly advanced societies hurled themselves at each other. A casualty list provides some indication of the human toll: Germany suffered 850,000 dead; France lost 700,000; Great Britain, 400,000. Large as they are, these numbers cover only the Western front, and only the single year 1916. The conflict, which was supposed to end quickly and gloriously, settled into a vicious stalemate on all fronts, as each side deployed the latest technology for killing: machine guns, flame throwers, fighter aircraft, poison gas. On the home front, governments assumed unheard-of powers over industry and labor in order to manage the war effort. Citizens saw propaganda campaigns, war profiteering masquerading as patriotism, and food rationing. Disgust with the conflict would eventually spring up on many fronts, but the first artistic movement to react against the slaughter and its moral quandaries was Dada. If the goal of Modern art was questioning and overthrowing the traditions of art, the Dadaists went further and questioned art itself.

HUGO BALL AND THE CABARET VOLTAIRE. The movement began with the opening of the Cabaret Voltaire in Zürich, Switzerland, on February 5, 1916. The cabaret's founders, German actor and poet Hugo Ball (1886–1927) and his companion, Emmy Hennings (d.1949), a nightclub singer, had moved to neutral Switzerland after World War I broke out. Their cabaret was inspired by the bohemian artists' cafés they had known in Berlin and Munich, and it attracted avant-garde writers and artists of various nationalities who shared their disgust with contemporary culture, which they blamed for the war.

Ball's performance while reciting one of his sound poems, **"KARAWANE"** (FIG. 31–34), reflects the iconoclastic spirit of the Cabaret Voltaire. His legs and body encased in blue cardboard tubes, his head surmounted by a white-and-blue "witch doctor's hat," as he called it, and his shoulders covered with a huge, gold-painted cardboard collar that flapped when he moved his arms, he slowly and solemnly recited the poem, which consisted of nonsensical sounds. As was typical of Dada, this performance involved two both critical and playful aims. One goal was to retreat into sounds alone and thus renounce "the language devastated and made impossible by journalism." Another end was simply to amuse his audience by introducing the healthy play of children back into what he considered overly restrained adult lives. The flexibility of interpretation inherent in Dada extended to its name, which, according to one account, was chosen at random from a dictionary. In German the term signifies baby talk; in French it means "hobbyhorse"; in Romanian and Russian, "yes, yes"; in the Kru African dialect, "the tail of a sacred cow." The name, and therefore the movement, could be defined as the individual wished.

DUCHAMP. French artist Marcel Duchamp (1887–1968) created the most shocking Dada works. He was also influential in spreading Dada to the United States after he moved to New York to escape the war in Europe. In Paris, Duchamp had experimented successfully with Cubism before abandoning painting, which he came to consider a mindless activity. By the time he arrived in New York, Duchamp believed that art should appeal to the intellect rather than the senses. Duchamp's cerebral approach is exemplified in his **readymades**, which were ordinary manufactured objects transformed into artworks simply through the decision of the artist. The most notorious readymade was **FOUNTAIN** (FIG. 31–35), a porcelain urinal turned 90 degrees and signed with the pseudonym "R. Mutt," a play on the name of the fixture's

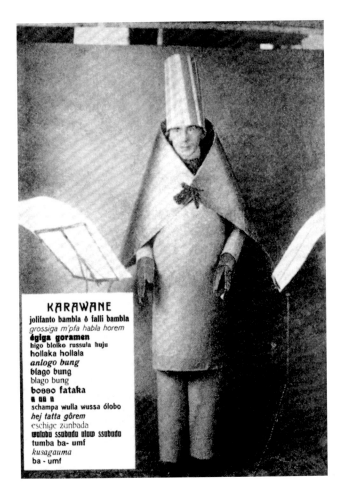

31–34 HUGO BALL RECITING THE SOUND POEM "KARAWANE"

Photographed at the Cabaret Voltaire, Zürich, 1916.

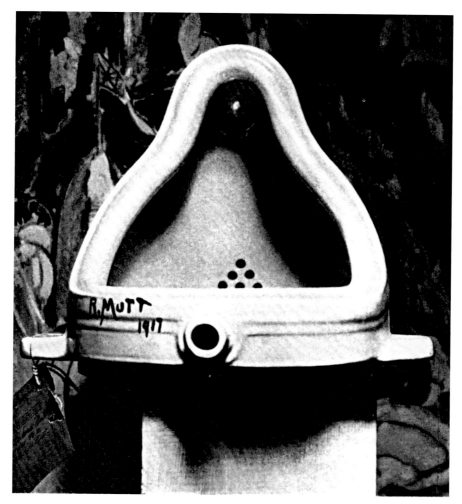

31–35 | Marcel Duchamp **FOUNTAIN**
1917. Porcelain plumbing fixture and enamel paint, height 24⅝" (62.5 cm).
Photograph by Alfred Stieglitz. Philadelphia Museum of Art.
Louise and Walter Arensberg Collection (1998-74-1)

Stieglitz's photograph is the only known image of Duchamp's original *Fountain*, which mysteriously disappeared after it was rejected by the jury of the American Society of Independent Artists exhibition. Duchamp later produced several more versions of *Fountain* by simply buying new urinals and signing them "R. Mutt/1917."

manufacturer, the J. L. Mott Iron Works. Duchamp submitted *Fountain* anonymously in 1917 to the first annual exhibition of the American Society of Independent Artists, which was committed to staging a large, unjuried show, open to any artist who paid a $6 entry fee. Duchamp, a founding member of the society and the head of the show's hanging committee, entered *Fountain* partly to test just how open the society was. A majority of the society's directors declared that *Fountain* was not a work of art, and, moreover, was indecent, so the piece was refused. The decision did not surprise Duchamp, who immediately resigned from the society.

A small journal that Duchamp helped to found published an unsigned editorial on the Mutt case refuting the charge of immorality and wryly noting: "The only works of art America has given are her plumbing and bridges." In a more serious vein, the editorial added: "Whether Mr. Mutt with his own hands made the fountain or not has no importance. He CHOSE it. He took an ordinary article of life, placed it so that its useful significance disappeared under the new title and point of view—created a new thought for that object." *Fountain* is a masterpiece of philosophical investigation, a conundrum on a tabletop that quietly explodes some

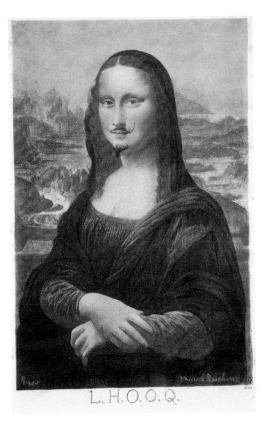

31–36 | Marcel Duchamp **L.H.O.O.Q.**
1919. Pencil on reproduction of Leonardo's *Mona Lisa*.
7¾ × 4¾" (19.7 × 12.1 cm). Philadelphia Museum of Art.
Louise and Walter Arensberg Collection

of our most cherished notions. If a work of art is supposed to be a hand-made product, crafted (and signed) by the creator, this work is neither. If a work of art is supposed to have meaningful form, this work is formed to catch excretions. If a work of art is supposed to show the results of the artist's years of training and study, this work shows only the results of a trip to the hardware store. Duchamp's radical gesture was one of the most important advances of Modern art.

Equally challenging in a slightly different direction is **L.H.O.O.Q.** (FIG. 31–36). Duchamp bought a postcard reproduction of Leonardo's *Mona Lisa* (SEE FIG. 20-4), drew a mustache and beard on the famous face, and signed it with his name. He called this piece not a readymade but an "assisted readymade," in which the artist takes a common object and "assists" it with some alteration. Like *Fountain,* this work challenges preconceived notions with tremendous irreverence. Yet here the target is somewhat different. If one purpose of art is to contribute to civilization by creating objects of beauty, how can artists do this in the face of the unprecedented brutality of the war? Why would an artist want to contribute to the civilization that brought us such carnage? Duchamp's contribution to civilization is to ridicule its hypocrisies. One of the founders of the Dada movement put it succinctly: "Dada was born of disgust." In the face of poison gas attacks that caused thousands of casualties in a single day,

perhaps the most reasonable response is one that scales similar heights of ridiculousness.

Duchamp made only a few readymades. In fact, he created very little art at all after about 1922, when he devoted himself mostly to chess. Asked his occupation, he usually said, "retired artist"; his influence, however, made itself felt in many other Modern art movements for the rest of the century.

BERLIN DADA. Dada soon spread to other countries. Early in 1917 Hugo Ball and the Romanian-born poet Tristan Tzara (1896–1963) organized the Galerie Dada. Tzara also edited the magazine *Dada,* which soon attracted the attention of like-minded men and women in various European capitals. The movement spread farther when members of Ball's circle returned to their respective homelands after the war. Richard Huelsenbeck (1892–1974) brought Dada to Germany, where he helped form the Club Dada in Berlin in April 1918.

One distinctive feature of Berlin Dada was the amount of visual art it produced, while Dada elsewhere tended to be

31–37 | Kurt Schwitters
MERZBILD 5B (PICTURE-RED-HEART-CHURCH)
April 26, 1919. Collage, tempera, and crayon on cardboard,
32⅞" × 23¾" (83.4 × 60.3 cm). Guggenheim Museum.
52.1325. Kurt Schwitters © 2003 Artists Rights Society (ARS), New York/VG Bild-Kunst, Bonn

31–38 | Hannah Höch **DADA DANCE**
1922. Photomontage, 12⅝ × 9⅛″ (32 × 23 cm).
Israel Museum, Jerusalem.
Arturo Schwartz Collection of Dada and Surrealist Art

more literary. Berlin Dada members especially favored collage and **photomontage** (a photograph created from many smaller photographs arranged in a composition), one of whose leading practitioners was Kurt Schwitters (1887–1948). After study at the Dresden academy, Schwitters painted in an Expressionist style until an important 1919 meeting with Huelsenbeck and other Dadaists. Probably the best example of a Dada collage was created in 1918 by Jean Arp, who dropped torn scraps of paper on a canvas and glued them down where they fell; in contrast, Schwitters used pieces of trash that he found in streets and parks to make images of subtle poetry (FIG. 31–37). Schwitters called each of these works *Merzbild,* or *Merz* picture, using an invented term that he claimed meant "garbage" or "rejects." He layered items such as rail tickets, postage stamps, ration coupons, and beer labels together with painted or drawn surfaces, because, he said, refuse deserves equal rights along with paint. The detritus he used was the mass-produced refuse of modern society. In the present work we see several fragments of this type, along with a newspaper page of telling significance. It is a clipping from February 1919 that describes some of the postwar disorder of defeated Germany, as a short-lived socialist republic in Bremen was brutally overthrown by conserva-

tive forces. Schwitters thus took the collage of Synthetic Cubism and broadened its image vocabulary in order to make pointed political statements.

Hannah Höch (1889–1978) was among the best exponents of photomontage. Between 1916 and 1926, Höch worked for Berlin's largest publishing house, producing decorative border patterns and writing articles on crafts for a domestically oriented magazine, and many of her photomontages focus on women's issues. Although the status of women improved in Germany after the war, and the "new woman" was much discussed in the German news media, Höch's contribution to this discussion was largely critical. In works such as DADA DANCE (FIG. 31–38), she seems to ridicule the way changing fashions establish standards of beauty that women, regardless of their natural appearance, must observe. On the right is an odd composite figure, wearing high-fashion shoes and dress, in a ridiculously elegant pose. The taller figure, with a small, black African head, looks down on her with a pained expression. For Höch, as for many in the Modernist era, Africa represented what was natural, so Höch presumably meant to contrast natural elegance with its foolish, overly cultivated counterpart. The work's message is not immediately evident, however; nor is it spelled out clearly by the text, which reads: "The excess of Hell falls into the coffers of Pastor Klatt for innocent children of criminals." Many Dadaists valued such purposeful obscurity, a fact which made them good candidates for the Surrealist movement after it began in the mid-1920s.

EARLY MODERN ART IN THE AMERICAS

Artists in the United States were closest to the European innovations, adapting and adopting many of them within a few years of their appearance, but the penetration of Modern art elsewhere in the Americas was uneven. The reasons varied with each region: Canadians had few artistic contacts with Europe; many Mexicans were ideologically opposed to Modern art; South America was far enough away that a time lag took effect. In each case, Modern art took a form different from what unfolded in Europe. If there is a common thread uniting all these regions, it is self-exploration. That is, in many countries artists put the vocabulary of Modern art into the service of a search for cultural roots; they explored the new styles as they also searched for ways to embody their cultural identity.

Modernist Tendencies in the United States

When Modern art was first exhibited in the United States, it competed with a still-vital American Realist tradition that was fundamentally opposed to the abstract styles of painters such as Kandinsky, Delaunay, and Malevich. In the opening decade of the twentieth century, a vigorous Realist movement coalesced in New York City around the charismatic

31–39 John Sloan **ELECTION NIGHT**
1907. Oil on canvas, 26⅜ × 32¼" (67 × 82 cm). Memorial Art Gallery of the University of Rochester,
Rochester, New York, Marion Stratton Gould Fund. 41.33.

painter and teacher Robert Henri (1865–1929). Speaking out against both the academic conventions of "beautiful" subject matter and the Impressionistic style then dominating American art, Henri told his students: "Paint what you see. Paint what is real to you."

THE ASHCAN SCHOOL. In 1908, Henri organized an exhibition of artists who came to be known as The Eight, four of whom were former newspaper illustrators. The show was a gesture of protest against the conservative exhibition policies of the National Academy of Design, the American counterpart of the French École des Beaux-Arts. Because they depicted scenes of often gritty urban life in New York City, five of The Eight became part of what was later dubbed the Ashcan School.

Several members of the Ashcan School studied at the Pennsylvania Academy, where a Realist tradition that Thomas Eakins established (SEE FIG. 30–44) remained active. Most characteristic of this school is John Sloan (1871–1951), whose **ELECTION NIGHT** (FIG. 31–39) embodies many of the group's concerns. The artist went out into the street during a postelection victory celebration and made a sheaf of quick drawings that he then turned into this painting. The work retains the feel of a spontaneous sketch, with its rough, painterly surface. Members

of the group were criticized, as the Impressionists had been before them, for exhibiting unfinished works. Sloan was an avid socialist who made illustrations for several leftist magazines in those years, but he used his painting for a broader purpose: to record the passing show of humanity in its beautiful as well as grimy aspects. This work seems to record the latter category, as some of the revelers look ridiculous in their false noses as they blow on huge trumpets. In the first decade of the twentieth century, the Ashcan School was the most Modern art movement in the United States.

STIEGLITZ'S GALLERY. The chief proponent of European Modern art in the United States was the photographer Alfred Stieglitz, who in the years before World War I worked to foster the American recognition of European Modernism and to support its independent development by Americans. Like Peter Emerson before him (SEE FIG. 30–82), Stieglitz sought recognition for photography as a creative art form on a par with painting, drawing, and printmaking. Born in New Jersey to a wealthy German immigrant family, Stieglitz was educated in the early 1880s at the Technische Hochschule in Berlin, where he discovered photography and quickly recognized its artistic potential. In 1890 Stieglitz began to photograph New York City street scenes with one of the new high-

speed, handheld cameras (the most popular of which, the Kodak, was invented in 1888), which permitted him to "await the moment when everything is in balance" and capture it. He sent one of his early photos to Emerson, who published it in his magazine. Stieglitz promoted his views through an organization called the Photo-Secession, founded in 1902, and two years later he opened a gallery at 291 Fifth Avenue, soon known simply as "291," which exhibited Modern art as well as photography to help break the barrier between the two. In the years around 1910, Stieglitz's gallery became the American focal point not only for the advancement of photographic art but also for the larger cause of European Modernism. Even more important, Stieglitz also exhibited young American artists beginning to experiment with Modernist expression.

In his own art, Stieglitz used his camera to capture poetic moments in the midst of urban life, as we see in **THE FLAT-IRON BUILDING** (FIG. 31–40). Usually Stieglitz's poetic moments were fascinating formal compositions that he framed, rather than documents of human interaction. The tree trunk in the right finds an echo in the grove farther back, and also in the wedge-shaped building that gave the work its title. An arc of chairs behind a low wall seems to encircle both the building and the trees. The entire scene is bathed in winter's cloudy light, which the artist finely controlled through careful exposure, exacting darkroom treatment, and handcrafted printing. Like Emerson, Stieglitz was a devotee of straight photography. Stieglitz's magazine *Camera Work*, where this image was published in 1903, was among the highest-quality art publications in existence at that time.

THE ARMORY SHOW. The turning point for Modern art in the United States was the 1913 exhibition known as the Armory Show. It was assembled by one of The Eight, Arthur B. Davies (1862–1928), to demonstrate how outmoded were the views of the National Academy of Design. Unhappily for the Ashcan School, the Armory Show also demonstrated how out of fashion their Realistic approach was. Of the more than 1,300 works in the show, only about a quarter were by Europeans, but those works drew all the attention. Critics claimed that Matisse, Kandinsky, Braque, Duchamp, and Brancusi were the agents of "universal anarchy." The academic painter Kenyon Cox called them mere savages. When a selection of works continued on to Chicago, civic leaders there called for a morals commission to investigate the show. Faculty and students at the School of the Art Institute were so enraged they hanged Matisse in effigy.

A number of younger artists, however, responded positively and sought to assimilate the most recent developments from Europe. The issue of Realism versus academicism, so critical before 1913, suddenly seemed inconsequential. For the first time in their history, American artists at home began fighting their provincial status.

31–40 | Alfred Stieglitz **THE FLATIRON BUILDING**
1903. Photogravure, 6¹¹⁄₁₆ × 3⁵⁄₁₆″ (17 × 8.4 cm) mounted. Metropolitan Museum of Art, New York, Gift of J. B. Neumann, 1958 (58.577.37).

Among the pioneers of American Modernism who exhibited at the Armory Show was Marsden Hartley (1877–1943), who was also a regular exhibitor at Stieglitz's 291 gallery. Between 1912 and 1915 Hartley lived mostly abroad, first in Paris, where he discovered Cubism, then in Berlin, where he was drawn to the colorful, spiritually oriented Expressionism of Kandinsky. Around the beginning of World War I, Hartley merged these influences into the powerfully original style seen in his *Portrait of a German Officer* (see *"Portrait of a German Officer,"* page 1094), a tightly arranged composition of boldly colored shapes and patterns, interspersed with numbers, letters, and fragments of German military imagery that refer symbolically to its subject.

THE ⬤BJECT SPEAKS

PORTRAIT OF A GERMAN OFFICER

Marsden Hartley's modernist painting *Portrait of a German Officer* does not literally represent its subject but speaks symbolically of it through the use of numbers, letters, and fragments of German military paraphernalia and insignia. While living in Berlin in 1914, the homosexual Hartley became enamored of a young Prussian lieutenant, Karl von Freyburg, whom he later described in a letter to his dealer, Alfred Stieglitz, as "in every way a perfect being—physically, spiritually and mentally, beautifully balanced—24 years young. . . ." Freyburg's death at the front in October 1914 devastated Hartley, and he mourned the fallen officer through painting.

The black background of *Portrait of a German Officer* serves formally to heighten the intensity of its colors and expressively to create a solemn, funereal mood. The symbolic references to Freyburg include his initials ("Kv.F"), his age ("24"), his regiment number ("4"), epaulettes, lance tips, and the Iron Cross he was awarded the day before he was killed. The cursive "E" may refer to Hartley himself, whose given name was Edmund.

Even the seemingly abstract, geometric patterns have symbolic meaning. The black-and-white checkerboard evokes Freyburg's love of chess. The blue-and-white diamond pattern comes from the flag of Bavaria. The black-and-white stripes are those of the historic flag of Prussia. And the red, white, and black bands constitute the flag of the German Empire, adopted in 1871.

Marsden Hartley **PORTRAIT OF A GERMAN OFFICER**
1914. Oil on canvas, 68¼ × 41⅜″ (1.78 × 1.05 m).
The Metropolitan Museum of Art, New York.
The Alfred Stieglitz Collection, 1949 (49.70.42)

HOME-GROWN MODERNISTS. In some ways the most original of the early Modernists in the United States was Arthur Dove (1880–1946). Dove went to Europe in 1907–09, where he studied the work of the Fauves and exhibited at the Autumn Salon. After returning home, he isolated himself and began making abstract studies from nature around the same time as Vasily Kandinsky, though the two were unaware of each other. His series of works called **NATURE SYMBOLIZED** (**FIG. 31–41**) is a remarkable set of small works in which the artist made visual equivalents for natural phenomena such as rivers, trees, and breezes. While Kandinsky focused on his inner life and tried to shut out the external world, Dove rendered in abstract terms his experience in the landscape. A reader of the American philosopher Ralph Waldo Emerson, Dove liked to say that he had "no background except perhaps the woods, running streams, hunting, fishing, camping, the sky." In 1912 he bought a chicken farm in Connecticut so that he could stay close to nature and not have to depend on art sales for his livelihood. Dove is a minor master, an American-type individualist even in an avant-garde context; he worked outside the mainstream and cared little for how his work was received.

Stieglitz reserved his strongest professional and personal commitment at 291 for Georgia O'Keeffe (1887–1986). Born in rural Wisconsin, O'Keeffe studied and taught art sporadically between 1905 and 1915, when a New York friend showed Stieglitz some of O'Keeffe's abstract charcoal drawings. On seeing them, Stieglitz is reported to have said, "At last, a woman on paper!" Stieglitz included O'Keeffe's work in a small group show at 291 in the spring of 1916 and gave her a solo exhibition the following year. One male critic wrote that O'Keeffe, with her organic abstractions, had "found expression in delicately veiled symbolism for 'what every woman knows' but what women heretofore kept to themselves." This was the beginning of much written criticism that focused on the artist's gender, to which O'Keeffe strongly objected. She wanted to be considered an artist, not a woman artist.

O'Keeffe went to New York in 1918, and she and Stieglitz married in 1924. In 1925 Stieglitz introduced O'Keeffe's innovative, close-up images of flowers, which remain among her best-known subjects (see Fig. 5, Introduction). That same year, O'Keeffe began to paint New York skyscrapers, which artists and critics of the period recognized as an embodiment of American inventiveness and productive energy. O'Keeffe's skyscraper paintings are not unambiguous celebrations of lofty buildings, however. She often depicted them from a low vantage point so that they appear to loom ominously over the viewer, as in **CITY NIGHT** (**FIG. 31–42**), whose dark tonalities, stark forms, and exaggerated perspective may produce a sense of menace or claustrophobia. The painting seems to reflect O'Keeffe's own growing perception of the city as too confining. In 1929, she began to spend her summers in New Mexico and moved there permanently after Stieglitz's death.

31–41 | Arthur Dove **NATURE SYMBOLIZED NO. 2**
c. 1911. Pastel on paper, 18 × 21⅞″ (45.8 × 55 cm).
The Art Institute of Chicago.

31–42 | Georgia O'Keeffe **CITY NIGHT**
1926. Oil on canvas, 48 × 30″ (123 × 76.9 cm).
Minneapolis Institute of Arts.

Modernism Breaks Out in Latin America

Academic values dominated Latin American art during the nineteenth century, as artists and patrons mostly went to Paris in search of training or works to decorate their houses. At the time of World War I, the most radical artists in most countries practiced a pleasant form of Impressionism that focused on the local landscape or traditional customs. After the war, when artists who had studied abroad returned with visions of Cubism or Expressionism, they caused a jolt similar to that of the Armory Show in the United States. Yet Latin American Modernists did not merely imitate Europe-based Modern styles, as they might imitate clothing fashions or technology. Latin American artists put the Modern language to use in exploring ethnic, national, or continental identity.

BRAZIL. The year 1922 marked the centenary of Brazil's independence from Portugal, and the avant-garde in Sao Paulo celebrated with Modern Art Week. It was time for Brazil to declare its artistic independence as well, and so the event gathered avant-garde poets, dancers, and musicians as well as visual artists. The week had an undeniable confrontational character. Poets penned new lines making fun of their elders, and dancers enacted Modern versions of indigenous rituals. Composer Heitor Villa-Lobos (1887–1959) appeared on stage in a bathrobe and slippers to play new music based on Afro-Brazilian rhythms.

Sao Paulo poet Oswald de Andrade, a planner of Modern Art Week, wrote the *Anthropophagic Manifesto* in 1928 that proposed a radical solution to the most urgent problem: What would be Brazil's relationship to European culture? He wrote that Brazilians should do with European culture what the ancient Brazilian natives did to the arriving Portuguese explorers as often as they could: Eat them. The relationship of Brazil to Europe would be one of cannibalism, or *anthropophagia*. Brazilians would gobble up European culture, ingest it, and let it strengthen Brazilianness.

The painter who most closely embodies this irreverent ideal is Tarsila do Amaral (1887–1974), a daughter of the coffee-planting aristocracy who studied in Europe with Fernand Léger, among others (SEE FIG. 31–26). Her work **ABAPORÚ (THE ONE WHO EATS)** shows what might happen if Léger were taken out into the fresh air (FIG. 31–43). The work also shows influence of Brancusi's smooth abstractions (SEE FIG. 31–33), which Tarsila collected. But she purposely inserted "tropical" clichés into this work, in the form of the cactus and the lemon-slice sun. The subject matter is a cannibal who seems to sit and reflect on life. If we Brazilians are cannibals, the work seems to say, well then, let us be cannibals. Or, as Andrade put it in one of his manifestos: "Carnival in Rio is the religious outpouring of our race. Richard Wagner yields to the samba. Barbaric but ours. We have a dual heritage: the jungle and the school."

31–43 | Tarsila do Amaral
ABAPORÚ (THE ONE WHO EATS)
1928. Oil on canvas, 34″ × 29″ (86.4 × 73.7 cm).
Museo de Arte Latinoamericano, Buenos Aires.
Courtesy of Guilherme Augusto do Amaral / Malba-Coleccion Constantini, Buenos Aires

ARGENTINA. In Argentina, the first exhibition of Cubist art in 1924 had a curious reception. On the first day of the show, the country's president came to visit, all by himself, to see the latest novelty. Later that evening at the official opening, a disturbance broke out that forced the gallery to close. These facts are signs of Argentina's "idiosyncratic modernity," wrote Xul Solar, the leading avant-garde artist. Argentina was at that time among the world's wealthiest nations, made rich on exports of beef and grain. It was also among the most cosmopolitan, with over 90 percent of the population of European descent, about half of them born in Europe. Buenos Aires saw itself as an outpost of Paris or Madrid.

Xul Solar (b. Alejandro Schultz Solari, 1887–1963) took the pseudonym in order to name himself after sunlight–Xul is the Latin *lux*, "light," spelled backward. He lived for twelve years in Europe, where he spent as much time studying art as the arcane mysticisms of the Jewish Kabbalah, the Chinese I Ching, tarot cards, and astrology. On his return in 1924, he altered his piano so that it showed colors instead of playing notes, and he invented two new languages that synthesized European and indigenous tongues. His paintings were little-known in his time because they are mostly small watercolors that he rarely exhibited (FIG. 31–44). The style of these works is most indebted to the Expressionist Paul Klee (SEE FIG. 31–15) but with important differences that reflect Xul's mystical proclivities. The central figure has catlike whiskers, lending it a mysterious air that the half-closed green eyes support.

31–44 | **Xul Solar** **JEFA (PATRONESS)**
1923. Watercolor on paper, set on cardboard, 10¼″ × 10¼″
(26 × 26 cm). Museum of Fine Arts, Houston.
Museum purchase with funds provided by the Latin American Experience Gala
and Auction 2005.343

The shallow composition is crisscrossed with lines of varying
thickness which tend to go to or from the head, perhaps indi-
cating directions of thought. An arrow at the top center con-
nects the head to a blue orb symbolizing the universe,
between a sun and crescent moon. Two smaller figures seem
able to walk forward or backward with equal ease. A star of
David at the right sits below a truncated Christian cross in
the upper corner. This female feline is a mysterious but
seemingly all-knowing being, which is now the artist
regarded himself. Xul received the most support for his art
from the literary magazine *Martín Fierro,* where the author
Jorge Luis Borges worked. The magazine promoted avant-
garde nationalism, Borges wrote, "believ[ing] in the impor-
tance of the intellectual contribution of the Americas, after
taking a scissors to each and every umbilical cord."

CUBA. The avant-garde in Cuba in the 1920s was the most
interdisciplinary, consisting of anthropologists, poets, com-
posers, and even a few scientists. They gathered into a group
in Havana that called itself "The Minority." Their 1927
manifesto pronounced itself opposed to government corrup-
tion, "Yankee imperialism," and dictatorships on any conti-
nent. Visual artists were urged to embrace not only new art,
but, more important, popular art: to make Modern art that is
rooted on Cuban soil. The artist who did this the most con-
sistently over the years was Amelia Peláez (1896–1968).
Shortly after the manifesto appeared, she had a seven-year
stay in Paris where she studied with Alexandra Exter, a Russ-

ian artist allied with the Suprematists. On her return home in
1934, she joined the anthropologist Lydia Cabrera in study-
ing Cuban popular and folk arts. Her paintings focus on the
woman's realm of the Cuban domestic interior with a dis-
tinct national orientation (FIG. 31–45). The overall pictorial
organization of this work is Cubist, as the flattened forms
overlap in compressed pictorial space. We recognize in the
work a mirror, a tabletop, and local hibiscus flowers, but these
are embroidered by abstract patterns in pure color with heavy
black outlining. This feature would be recognizable to any
Cuban as a reinterpretation of the fan-shaped stained-glass
windows that decorate a great many Cuban homes.

MEXICO. Art culture in Mexico was decisively shaped by
the revolution of 1910–1917, which overthrew a dictatorship
and established in his place a more democratic regime. Most
postrevolutionary government officials believed that the
more abstract forms of Modern art would not serve the peo-
ple's needs because they are incomprehensible to the public.
The Ministry of Education instead hired artists to paint
murals in public buildings in a readily recognizable style. This
movement of muralism will be discussed later, in the context
of art for social change.

31–45 | **Amelia Peláez** **MARPACÍFICO (HIBISCUS)**
1943. Oil on canvas, 45½ × 35″ (115.6 × 88.9 cm).
Art Museum of the Americas, Washington, D.C.
Gift of IBM

31–46 | Frida Kahlo
THE TWO FRIDAS
1939. Oil on canvas.
5′8½″ × 5′8½″ (1.74 × 1.74 m).
Museo de Arte Moderno, Instituto
Nacional de Bellas Artes, Mexico
City.

Some artists who did not participate in the mural program created highly individual styles with little or no connection to European Modernism. One of these was Frida Kahlo (1907–1954), who based her autobiographical art on traditional Mexican folk painting (FIG. 31–46). **THE TWO FRIDAS** shows a double image of the artist that expresses the split in her identity between European and Mexican (she was born of a German father and a part-indigenous Mexican mother). The European Frida on the left wears a Victorian dress while the Frida on the right wears Mexican peasant clothing. This latter Frida holds in her lap a piece of pre-Columbian sculpture, a small head of an indigenous god connected to a blood vessel that passes through the hearts of both Fridas. This vessel ends in the lap of the European Frida, who holds a forceps to try to stop its bleeding. The artist suffered a broken pelvis in a bus accident when she was 17, and faced a lifetime of surgical operations. The work alludes to that personal pain, as well as to the Aztec custom of human sacrifice by heart removal. The value of Kahlo's art, apart from its memorable self-expression, lies in how it investigates and lays bare larger issues of identity. This work focuses most on the mixed heritage of Latin America; others deal more directly with sexuality, feminine identity, and gender equality, all in the context of Kahlo's own life.

Canada

Canadian artists of the nineteenth century, like their counterparts in the United States, generally worked in styles derived from European art. A number of Canadians studied in Paris during the late nineteenth century, some of them mastering academic realism and painting figurative and genre subjects, others developing tame versions of Impressionism and Post-Impressionism that they applied to landscape painting. Back in Canada, several of the most advanced painters in 1907 formed the Canadian Art Club, an exhibiting society based in Toronto, Ontario.

LANDSCAPE AND IDENTITY. In the early 1910s, a younger group of Toronto artists, many of whom worked for the same commercial art firm, became friends and began to go on weekend sketching trips together. They adopted the rugged landscape of the Canadian north as their principal subject and presented their art as an expression of Canadian national identity, despite its stylistic debt to European Post-Impressionism. A key figure in this development was Tom Thomson (1877–1917), who beginning in 1912 spent the warm months of each year in Algonquin Provincial Park, a large forest reserve 180 miles north of Toronto. There he made numerous small, swiftly painted, oil-on-board sketches that were the basis for full-size paintings he executed in his studio during the winter. A sketch made in the spring of 1916 led to **THE JACK PINE** (FIG. 31–47). The tightly organized composition features a stylized pine tree rising from a rocky foreground and silhouetted against a luminous background of lake and sky, horizontally divided by cold blue hills. The glowing colors and thick brushwork suggest the influence of Post-Impressionism, while the sinuous shapes and overall decorative effect reveal a debt to Art Nouveau. The painting's arresting beauty and reverential mood, suggesting a divine presence in the lonely northern landscape, have made

it an icon of Canadian art and, for many, a symbol of the nation itself.

NATIVE AMERICAN INFLUENCE. Three years after Thomson's tragic 1917 death by drowning in an Algonquin Park lake, several of his former colleagues formed an exhibiting society called the Group of Seven, which regularly invited other like-minded artists to exhibit with them. One was the West Coast artist Emily Carr (1871–1945), who first met members of the group on a trip to Toronto in 1927. Born in Victoria, British Columbia, Carr studied art in San Francisco (1890–93), England (1899–1904), and Paris (1910–11), where she assimilated the lessons of Post-Impressionism and Fauvism. Between 1906 and 1913 she lived in Vancouver, where she became a founding member of the British Columbia Society of Art. On a 1907 trip to Alaska she was taken with the monumental carved poles of Northwest Coast Native Americans and resolved to document these "real art treasures of a passing race." Over the next twenty-three years Carr visited more than thirty native village sites across British Columbia, making drawings and watercolors as the basis for oil paintings. After a commercially unsuccessful exhibition of her Native American subjects in 1913, Carr returned to Victoria and opened a boardinghouse. Running this business left little time for art, and for the next fifteen years she hardly painted. Her life changed dramatically in 1927 when she was invited to participate in an exhibition of West Coast art at the National Gallery of Canada in Ottawa, Ontario. It was on her trip east to attend the show's opening that she met members of the Group of Seven, whose example and encouragement rekindled her interest in painting.

31–47 | Tom Thomson **THE JACK PINE**
1916-17. Oil on canvas, 49⅞ × 54½" (127.9 × 139.8 cm).
National Gallery of Canada, Ottawa, Ontario.
Purchase, 1918.

Under the influence of the Group of Seven, Carr developed a dramatic and powerfully sculptural style full of dark and brooding energy. An impressive example of such work is **BIG RAVEN** (FIG. 31–48), which Carr based on a watercolor she made in 1912 in an abandoned village in the Queen Charlotte Islands. There she discovered a carved raven raised on a pole, the surviving member of a pair that had marked a mortuary house. While in her autobiography Carr described the raven as "old and rotting," in her painting the bird appears strong and majestic, thrusting dynamically above the swirling

31–48 | Emily Carr
BIG RAVEN
1931. Oil on canvas, 34 × 44⅝"
(87.3 × 114.4 cm).
The Vancouver Art Gallery,
Vancouver, B.C.
Emily Carr Trust (VAG 42.3.11)

vegetation, a symbol of enduring spiritual power. Through its focus on a Native American artifact set in a recognizably northwestern Canadian landscape, Carr's *Big Raven* may be interpreted, like the paintings of the Group of Seven, as an assertion of national pride.

EARLY MODERN ARCHITECTURE

New industrial materials and advances in engineering enabled twentieth-century architects to create unprecedented architectural forms that responded to the changing needs of society. Just as Modern artists set aside the traditions of painting and sculpture, Modern architects rejected historical styles and emphasized simple, geometric forms and plain, undecorated surfaces.

European Modernism

In Europe, a stripped-down and severely geometric style of Modern architecture arose, partly in reaction against the ornamental excesses of Art Nouveau. A particularly harsh critic of Art Nouveau (known in Austria as *Sezessionstil*) was the Viennese writer and architect Adolf Loos (1870–1933). In the essay "Ornament and Crime" (1913), he insisted, "The evolution of a culture is synonymous with the removal of ornament from utilitarian objects." For Loos, ornament was a sign of a degenerate culture.

Exemplary of Loos's aesthetic is his **STEINER HOUSE (FIG. 31–49)**, whose stucco-covered, reinforced-concrete construc-

31–49 Adolf Loos **STEINER HOUSE**
Vienna. 1910.

tion lacks embellishment. The plain, rectangular windows are placed only according to interior needs. For Loos, the exterior's only function was to provide protection from the elements. A curved roof behind allows rain and snow to run off but, unlike the traditional pitched roof, creates no wasted space.

The purely functional exteriors of Loos's buildings qualify him as a founder of European Modern architecture. Another was the German Walter Gropius (1883–1969), who

31–50 Walter Gropius
and Adolf Meyer
FAGUS SHOE FACTORY
Alfeld-an-der-Leine,
Germany. 1911–16.

opened an office in 1910 with Adolf Meyer (1881–1929). Gropius's lectures on increasing workers' productivity by improving the workplace drew the attention of an industrialist who in 1911 commissioned him to design a factory for the **FAGUS SHOE COMPANY** (FIG. 31–50). This building represents the evolution of Modern architecture from the engineering advances of the nineteenth century. Unlike the Eiffel Tower or the Crystal Palace (SEE FIGS. 30–1, 30–31), it was conceived not to demonstrate advances or solve a problem but to function as a building. With it Gropius proclaimed that Modern architecture should make intelligent and sensitive use of what the engineer can provide.

To produce a purely functional building, Gropius gave the Fagus Factory façade no elaboration beyond that dictated by its construction methods. The slender brick piers along the outer walls mark the vertical members of the building's steel frame, and the horizontal bands of brickwork at the top and bottom, like the opaque panels between them, mark floors and ceilings. A **curtain wall**—an exterior wall that bears no weight but simply separates the inside from the outside—hangs over the frame, and it consists largely of glass. The corner piers standard in earlier buildings, here rendered unnecessary by the steel-frame skeleton, have been eliminated. The large windows both reveal the building's structure and flood the workplace with light. This building insists that good engineering is good architecture.

The most important French Modern architect was Le Corbusier (b. Charles-Édouard Jeanneret, 1887–1965), who developed several important concepts that influenced architects for the next half-century. His **VILLA SAVOYE** (FIG. 31–51), a private home outside Paris, is an icon of the

31–51 | Le Corbusier **VILLA SAVOYE**
Poissy-sur-Seine, France. 1929–30.

Located 30 miles outside of Paris, near Versailles, the Villa Savoye was designed as a weekend retreat. The owners, arriving from Paris, could drive right under the house, whose ground floor curves to accommodate the turning radius of an automobile and incorporates a three-car garage.

International Style (see "The International Style," page 1109). It is the best expression of his **domino construction system**, first elaborated in 1914, in which slabs of ferroconcrete (concrete reinforced with steel bars) were floated on six freestanding steel posts, placed at the positions of the six dots on a domino playing piece. Over the next decade the architect explored the possibilities of this structure and in 1926 published "The Five Points of a New Architecture," which argued for elevating houses above the ground on *pilotis* (freestanding posts); making roofs flat for use as terraces; using partition walls slotted between supports on the interior and curtain walls on the exterior to provide freedom of design; and using ribbon windows (windows that run the length of the wall). All of these became features of Modern buildings.

Le Corbusier applied these motifs in a distinctive fashion that combined two apparently opposed formal systems: the simplified Doric architecture of classical Greece and the clear precision of machinery. He referred to his Villa Savoye as a "machine for living," meaning that it should be as rationally designed as a car or an appliance. Such houses could be effectively placed in nature, as here, but they were meant to transcend it, as the elevation off the ground and pure white coloring suggest. The building appears to be a cube, but behind the ribbon windows, the façade is hollow on its two south-facing sides, allowing natural light to penetrate throughout.

American Modern Architecture

CONNECTION TO THE LAND. Many consider Frank Lloyd Wright (1867–1959), a pioneer of architectural Modernism, the greatest American architect of the twentieth century. Summers spent working on his uncle's farm in Wisconsin gave him a deep respect for nature, natural materials, and agrarian life. After briefly studying engineering at the University of Wisconsin, Wright apprenticed for a year with a Chicago architect, then spent the next five years with the firm of Dankmar Adler and Louis Sullivan (SEE FIG. 30–86), eventually becoming their chief drafter. In 1893, Wright opened his own office, specializing in domestic architecture. Seeking better ways to integrate house and site, he turned away from the traditional boxlike design and by 1900 was creating "organic" architecture that integrated a building with its natural surroundings.

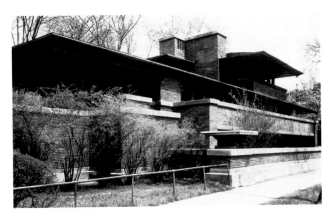

31–52 | Frank Lloyd Wright **FREDERICK C. ROBIE HOUSE**
Chicago. 1906–9.

This distinctive domestic architecture is known as the **Prairie style** because many of Wright's early houses were built in the Prairie States and were inspired by the horizontal character of the prairie itself. Its most famous expression is the **FREDERICK C. ROBIE HOUSE** (FIG. 31–52), which, typical of the style, is organized around a central chimney that marks the hearth as the physical and psychological center of the home. From the chimney mass, dramatically cantilevered (see "Space-Spanning Construction Devices," page xxix, Starter Kit) roofs and terraces radiate outward into the surrounding environment, echoing the horizontality of the prairie even as they provide a powerful sense of shelter for the family within. The windows are arranged in long rows and deeply embedded into the brick walls, adding to the fortresslike quality of the building's central mass.

The horizontal emphasis of the exterior continues inside, especially in the main living level—one long space divided into living and dining areas by a freestanding fireplace. The free flow of interior space that Wright sought was partly inspired by traditional Japanese domestic architecture, which uses screens rather than heavy walls to partition space (see "Shoin Design," page 860). In his quest to achieve organic unity among all parts of the house, Wright integrated lighting and heating into the ceiling and floor and designed built-in bookcases, shelves, and storage drawers. He also incorporated freestanding furniture of his own design, such as the dining room set seen in FIGURE 31–53. The chairs feature a strikingly modern, machine-cut geometric design that harmonizes with the rest of the house. Their high backs were intended to create around the dining table the intimate effect of a room within a room. Wright also designed the table with a view to promoting intimacy: Because he felt that candles and bouquets running down the center of the table formed a barrier between people seated on either side, he integrated lighting features and flower holders into the posts near each of the table's corners.

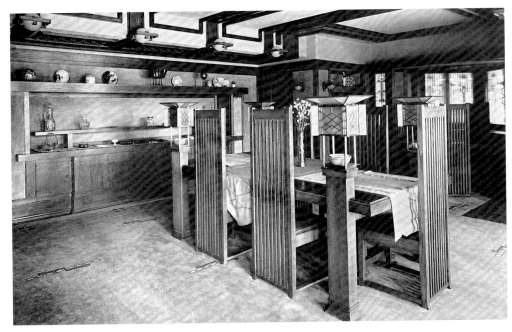

31–53 | Frank Lloyd Wright **DINING ROOM, FREDERICK C. ROBIE HOUSE**

In 1897 Wright helped found the Chicago Arts and Crafts Society, an outgrowth of the movement begun in England by William Morris (Chapter 30). But whereas Morris's English predecessors looked nostalgically back to the Middle Ages and rejected machine production, Wright did not. He detested standardization, but he thought the machine could produce beautiful and affordable objects. The chairs seen here, for example, were built of rectilinear, machine-cut pieces. Wright, a conservationist, favored such rectilinear forms in part because they could be cut with a minimum of wasted lumber.

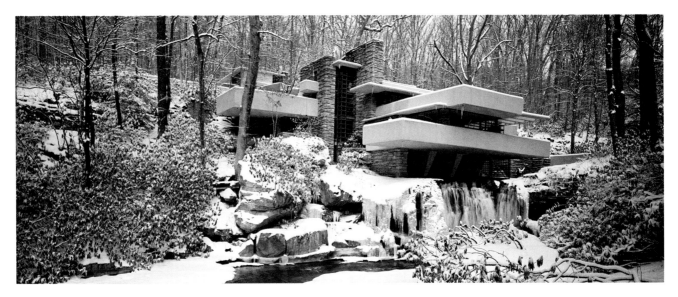

31–54 | Frank Lloyd Wright **EDGAR KAUFMANN HOUSE, FALLINGWATER**
Mill Run, Pennsylvania. 1937.

Wright had an uneasy relationship with Modernism as it developed in Europe. Though he routinely used modern building materials (concrete, glass, steel), he always sought ways to keep his buildings connected to the earth and organic realities. The machine aesthetic of Le Corbusier and Gropius held no interest for him. To keep this organic connection, he often used brick, wood, or local stone, items that more orthodox Modernists shunned because they spoke of the past.

FALLINGWATER (FIG. 31–54), in rural Pennsylvania, is perhaps the best-known expression of Wright's conviction that buildings ought to be not simply on the landscape but *in* it. The house was commissioned by Edgar Kaufmann, a Pittsburgh department store owner, to replace a family summer cottage, on a site that featured a waterfall into a pool where the children played. To Kaufmann's great surprise, Wright decided to build the house into the cliff over the pool, allowing the waterfall to flow around and under the house. A large boulder where the family had sunbathed was built into the house as the hearthstone of the fireplace. In a dramatic move that engineering experts questioned, Wright cantilevered a series of broad concrete terraces out from the cliffside, echoing the great slabs of rock below. The house is further tied to its site through materials. Although the terraces are poured concrete, the wood and stone used elsewhere are either from the site or in harmony with it. Such houses do not simply testify to the ideal of living in harmony with nature but declare war on the modern industrial city. When asked what could be done to improve the city, Wright responded: "Tear it down."

We see a still stronger connection to the land, in combination with a dose of Modernist Primitivism, in the architecture of Mary Colter (1869–1958), which developed separately from that of Wright at about the same time. Born in Pittsburgh and educated at the California School of Design in San Francisco, she spent most of her career as architect and decorator for the Fred Harvey Company, a tourism firm active throughout the Southwest. Colter was an avid student of Native American arts, especially the architecture of the Hopi and Pueblo peoples, and her buildings quoted liberally from those traditions. She designed several visitor facilities at Grand Canyon National Park, of which the most dramatic is the **LOOKOUT STUDIO** (FIG. 31–55). The foundation of this building is natural rock, and most of the walls are built from stones quarried nearby. The building incorporates the edge of the canyon rim and natural rock outcrops into its design,

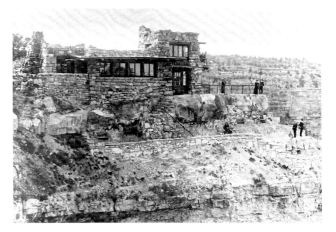

31–55 | Mary Colter **LOOKOUT STUDIO**
Grand Canyon National Park, Arizona. 1914.
Photo Grand Canyon National Park Museum Collection

Elements of Architecture
THE SKYSCRAPER

The evolution of the skyscraper depended on the development of these essentials: metal beams and girders for the structural-support skeleton; the separation of the building-support structure from the enclosing layer (the cladding); fireproofing materials and measures; elevators; and plumbing, central heating, artificial lighting, and ventilation systems. First-generation skyscrapers, built between about 1880 and 1900, were concentrated in the Midwest, especially in Chicago and St. Louis (SEE FIG. 30-86). Second-generation skyscrapers, with more than twenty stories, date from 1895. At first the tall buildings were freestanding towers, sometimes with a base, like the Woolworth Building of 1911–13 (SEE FIG. 31-56). New York City's Building Zone Resolution of 1916 introduced mandatory setbacks—recessions from the ground-level building line—to ensure light and ventilation of adjacent sites. Built in 1931, the 1,250-foot setback form of the Empire State Building, diagrammed here, is thoroughly modern in having a streamlined exterior—its cladding is in Art Deco style (SEE FIG. 31-25, caption)—that conceals the great complexity of the internal structure and mechanisms that make its height possible. The Empire State Building is still one of the tallest buildings in the world.

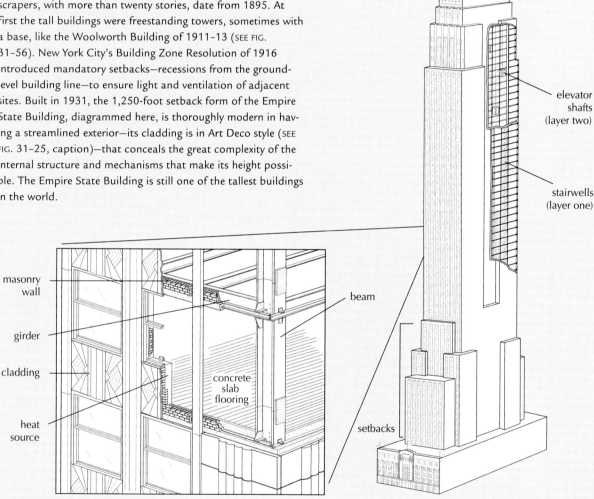

masonry
wall

girder

cladding

heat
source

concrete
slab
flooring

beam

elevator
shafts
(layer two)

stairwells
(layer one)

setbacks

which is intended to facilitate contemplation of the spectacular view across the canyon. The roofline of the structure is also irregular, like the surrounding canyon wall. Inside, she used huge bare logs for most of the structural supports, between raw stone walls. All of these features can also be found in Hopi architecture. The sole concessions to modernity are in the liberal use of glass and a flat cement floor over the stone foundation. Her work on hotels and railroad sta-

tions throughout the Southwest helped to establish a distinctive identity for architecture of that region.

THE AMERICAN SKYSCRAPER. After 1900, New York City assumed leadership in the development of the skyscraper, whose soaring height was made possible by the use of the steel-frame skeleton for structural support and other advances in engineering and technology (see "The Skyscraper," above).

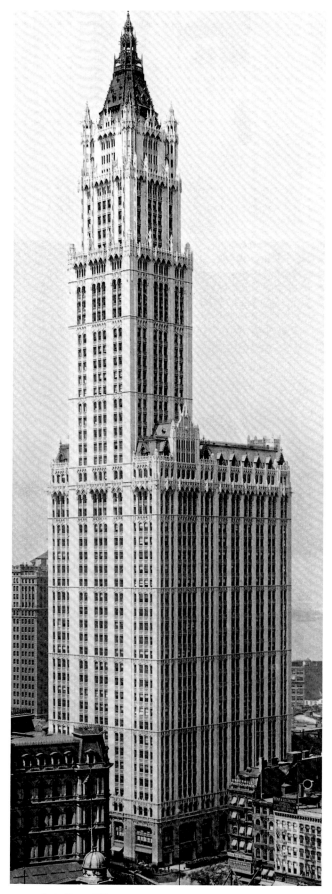

31–56 | Cass Gilbert **WOOLWORTH BUILDING**
New York. 1911–13.
© Collection of the New York Historical Society, New York

New York clients rejected the innovative style of Louis Sullivan and other Chicago architects for the historicist approach still in favor in the East, as seen in the **WOOLWORTH BUILDING** (FIG. 31–56), designed by the Minnesota-based Cass Gilbert (1859–1934). When completed, at 792 feet and 55 floors, it was the world's tallest building. Its Gothic-style external details, inspired by the soaring towers of late-medieval churches, resonated well with the United States' increasing worship of business. Gilbert explained that he wished to make something "spiritual" of what others called his "Cathedral of Commerce."

ART BETWEEN THE WARS

World War I had a profound effect on Europe's artists and architects. While the Dadaists responded sarcastically to the unprecedented destruction, some sought in the war's ashes the basis for a new, more secure civilization. The onset of the Great Depression in 1929 also motivated many artists to try to find ways to serve society. In general, a great deal of art produced between 1919 and 1939 in Europe and North America is connected in some way with the hope for a better and more just world, rather than primarily serving self-expression or the investigation of aesthetics.

Utilitarian Art Forms in Russia

In the 1917 Russian Revolution, the radical socialist Bolsheviks overthrew the czar, took Russia out of the world war, and turned to winning an internal civil war that lasted until 1920. Most of the Russian avant-garde enthusiastically supported the Bolsheviks, who in turn supported them.

CONSTRUCTIVISM. The case of Aleksandr Rodchenko (1891–1956) is fairly representative. An early associate of Malevich and Popova (SEE FIGS. 31–29, 31–31), Rodchenko initially used drafting tools to make abstract drawings. The Suprematist phase of his career culminated in a 1921 exhibition where he showed three large flat, monochromatic panels painted in red, yellow, and blue, which he titled *Last Painting* (they are unfortunately lost). After making this work, he renounced painting as a basically selfish activity and condemned self-expression as socially irresponsible.

In the same year he helped launch a group known as the Constructivists, who were committed to quitting the studio and going "into the factory, where the real body of life is made." In place of artists dedicated to expressing themselves or exploring aesthetic issues, politically committed artists would create useful objects and promote the aims of society. Rodchenko came to believe that painting and sculpture did not contribute enough to practical needs, so after 1921 he began to make photographs, posters, books, textiles, and theater sets that would promote the egalitarian ends of the new Soviet society.

In 1925 Rodchenko designed a model workers' club for the Soviet Pavilion at the Paris International Exposition of Modern Decorative and Industrial Arts (FIG. 31–57). Although Rodchenko said such a club "must be built for amusement and relaxation," the space was essentially a reading room dedicated to the proper training of the Soviet mind. Designed for simplicity of use and ease of construction, the furniture was made of wood because Soviet industry was best equipped for mass production in that material. The design of the chairs is not strictly utilitarian, however. Their high, straight backs were meant to promote a physical and moral posture of uprightness among the workers.

Not all Modernists in Soviet Russia were willing to give up traditional art forms. El Lissitzky (1890–1941), for one, attempted to fit the formalism of Malevich to the new imperative that art be useful to the social order. After the revolution, Lissitzky was invited to teach architecture and graphic arts at the Vitebsk School of Fine Arts and came

31–57 | Aleksandr Rodchenko
VIEW OF THE WORKERS' CLUB
Exhibited at the International Exposition of Modern Decorative and Industrial Arts, Paris. 1925. Rodchenko-Stepanova Archive, Moscow.
Art ©Estate of Aleksandr Rodchenko/RAO, Moscow / VAGA, New York

31–58 | El Lissitzky **PROUN SPACE**
Created for the Great Berlin Art Exhibition. 1923, reconstruction 1965. Stedelijk Van Abbemuseum, Eindhoven, the Netherlands.

under the influence of Malevich, who also taught there. By 1919 he was using Malevich's Suprematist vocabulary for propaganda posters and for the new type of art work he called the Proun (pronounced "pro-oon"), possibly an acronym for the Russian *proekt utverzhdenya novogo* ("project for the affirmation of the new"). Most Prouns were paintings or prints, but a few were spaces (FIG. 31–58) that qualify as early examples of **installation art**—artworks created for a specific site, especially a gallery or outdoor area, that create a total environment. Lissitzky rejected conventional painting tools as too personal and imprecise and produced his Prouns with the aid of mechanical instruments. Their engineered look was meant to encourage precise thinking among the public. Like many other Soviet artists of the late 1920s, Lissitzky grew disillusioned with the power of formalist art to communicate broadly and turned to more utilitarian projects—architectural design and typography, in particular—and he began to produce, along with Rodchenko and others, propaganda photographs and photomontages.

SOCIALIST REALISM. The move away from abstraction was led by a group of Realists, deeply antagonistic to the avant-garde, who banded together in 1922 to form the Association of Artists of Revolutionary Russia (AKhRR) to promote a clear, representational approach to depicting workers, peasants, revolutionary activists, and, in particular, the life and history of the Red Army. Remembering fondly both the Realism and social radicalism of Gustave Courbet (SEE FIG. 30–37), they created huge, dramatic canvases and statues on heroic or inspirational themes in an effort to appeal to the people more directly than they thought Modern art could. By depicting workers and peasants in a heroic manner, they believed they could help build the Soviet state. Their work established the basis for the Socialist Realism instituted by Stalin after he took control of the arts in 1932.

One of the sculptors who worked in this official style was Vera Mukhina (1889–1953), who is best known for her **WORKER AND COLLECTIVE FARM WOMAN** (FIG. 31–59), a colossal stainless-steel sculpture made for the Soviet Pavilion at the Paris Universal Exposition of 1937. The powerfully built male factory worker and female farm laborer hold aloft their respective tools, a hammer and a sickle, to mimic the appearance of these implements on the Soviet flag. The two figures are shown as equal partners striding purposefully into the future, their determined faces looking forward and upward. The dramatic, windblown drapery and the forward propulsion of their diagonal poses enhance the sense of vigorous idealism.

Rationalism in the Netherlands

If Lissitzky's goal was nothing less than reform of human thought through art, a contemporary Dutch movement attempted the same thing using even more simplified means.

31–59 | Vera Mukhina
WORKER AND COLLECTIVE FARM WOMAN
Sculpture for the Soviet Pavilion, Paris Universal Exposition. 1937. Stainless steel, height approx. 78′ (23.8 m).
Art © Estate of Vera Mukhina / RAO, Moscow / VAGA, New York

The Dutch counterpart to Lissitzky's inspirational formalism was a group known as *de Stijl* ("The Style"), whose leading artist was Piet Mondrian (1872–1944). The turning point in Mondrian's life came in 1912, when he went to Paris and encountered Analytic Cubism. After assimilating its influence he gradually moved from radical abstractions of landscape and architecture to a simple, austere form of geometric art inspired by them. In the Netherlands during World War I, he met Theo van Doesburg (1883–1931), another painter who shared his artistic views. In 1917 van Doesburg started a magazine, *De Stijl,* which became the focal point of a Dutch movement of artists, architects, and designers. The title of the magazine is instructive: These artists did not work in a style, they worked in *The Style.*

Animating the de Stijl movement was the conviction that there are two kinds of beauty: a sensual or subjective one and a higher, rational, objective, "universal" kind. In his mature works, Mondrian sought the essence of the second kind, eliminating representational elements because of their subjective associations and curves because of their sensual appeal.

31–60 | Piet Mondrian (1872-1944)
COMPOSITION WITH YELLOW, RED, AND BLUE, 1927.
Oil on canvas, 14⅞ × 13¾" (37.8 × 34.9 cm).
The Menil Collection, Houston. © 2008 Mondrian/Holtzman Trust
c/o HCR International, Warrenton, VA, USA.

Mondrian so disliked the sight of nature, whose irregularities he
held largely accountable for humanity's problems, that when seated
at a restaurant table with a view of the outdoors, he would ask to
be moved.

In this he was following the lead of the theosophist mystic and mathematician M. H. J. Schoenmaekers, who in the 1915 book *New Image of the World* urged thoughtful people "to penetrate nature in such a way that the inner construction of reality is revealed to us." That inner construction, Schoenmaekers wrote, consists of a balance of opposing forces, such as heat and cold, male and female, order and disorder. Moreover, he wrote, artists can help us visualize this inner construction by making completely abstract paintings out of horizontals, verticals, and primary colors only. These words found a ready audience in Mondrian, who had joined the Theosophical Society in 1909 and was already headed toward abstraction in his art. During the war, Mondrian and Schoenmaekers both lived in Amsterdam and shared many visits and conversations.

From about 1920 on, Mondrian's paintings, such as **COMPOSITION WITH YELLOW, RED, AND BLUE** (FIG. 31–60), all employ the same essential formal vocabulary: the three primary hues (red, yellow, and blue), the three neutrals (white, gray, and black), and horizontal and vertical lines. The two linear directions are meant to symbolize the harmony of a series of opposites, including male versus female, individual versus society, and spiritual versus material. For Mondrian the essence of higher beauty was resolved conflict, what he called dynamic equilibrium. Here, in a typical composition, Mondrian achieved this equilibrium through the precise arrangement of color areas of different size, shape, and "weight," asymmetrically grouped around the edges of a canvas whose

31–61 | Gerrit Rietveld **SCHRÖDER HOUSE**
Utrecht, the Netherlands. 1925.

center is dominated by a large area of white. The ultimate purpose of such a painting is to demonstrate a universal style with applications beyond the realm of art. Like Art Nouveau, de Stijl wished to redecorate the world. But Mondrian and his colleagues rejected the organic style of Art Nouveau, believing that nature's example encourages "primitive animal instincts." If, instead, we live in an environment designed according to the rules of "universal beauty," we, like our art, will be balanced, our natural instincts "purified." Mondrian hoped to be the world's last artist: He thought that art had provided humanity with something lacking in daily life and that, if beauty were in every aspect of our lives, we would have no need for art.

The architect and designer Gerrit Rietveld (1888–1964) took de Stijl into the third dimension. His **SCHRÖDER HOUSE** in Utrecht is an important example of the Modern architecture that came to be known as the International Style (see "The International Style," this page). Rietveld applied Mondrian's principle of a dynamic equilibrium to the entire house. The radically asymmetrical exterior (FIG. 31–61) is composed of interlocking gray and white planes of varying sizes, combined with horizontal and vertical accents in primary colors and black. His **"RED-BLUE" CHAIR** is shown here in the interior (FIG. 31–62), where sliding partitions allow modifications in the spaces used for sleeping, working, and entertaining. These innovative wall partitions were the idea of the patron, Truus Schröder-Schräder, a widowed interior designer. Though wealthy, Schröder-Schräder wanted her

31–62 | **INTERIOR, SCHRÖDER HOUSE, WITH "RED-BLUE" CHAIR.** 1925.

Elements of Architecture
THE INTERNATIONAL STYLE

After World War I, increased exchanges between Modern architects led to the development of a common formal language, transcending national boundaries, which came to be known as the International Style. The term gained wide currency as a result of a 1932 exhibition at the Museum of Modern Art in New York, "The International Style: Architecture since 1922," organized by the architectural historian Henry-Russell Hitchcock and the architect and curator Philip Johnson. Hitchcock and Johnson identified three fundamental principles of the style.

The first principle was "the conception of architecture as volume rather than mass." The use of a structural skeleton of steel and ferroconcrete made it possible to eliminate load-bearing walls on both the exterior and interior. The building could now be wrapped in a skin of glass, metal, or masonry, creating an effect of enclosed space (volume) rather than dense material (mass). Interiors could now feature open, free-flowing plans providing maximum flexibility in the use of space.

The second principle was "regularity rather than symmetry as the chief means of ordering design." Regular distribution of structural supports and the use of standard building parts promoted rectangular regularity rather than the balanced axial symmetry of classical architecture. The avoidance of classical balance also encouraged an asymmetrical disposition of the building's components.

The third principle was the rejection of "arbitrary applied decoration." The new architecture depended on the intrinsic elegance of its materials and the formal arrangement of its elements to produce harmonious aesthetic effects.

The style originated in the Netherlands, France, and Germany and by the end of the 1920s had spread to other industrialized countries. Important influences on the International Style included Cubism, the abstract geometry of de Stijl, the work of Frank Lloyd Wright, and the prewar experiments in industrial architecture of Germans such as Walter Gropius. The first concentrated manifestation of the trend came in 1927 at the Deutscher Werkbund's Weissenhofsiedlung exhibition in Stuttgart, Germany, directed by Mies van der Rohe, an architect who, like Gropius, was associated with the Bauhaus in Germany (see p. 1110). This permanent exhibition included modern houses by, among others, Mies, Gropius, and Le Corbusier. Its aim was to present models using new technologies and without reference to historical styles. All of the buildings featured flat roofs, plain walls, and asymmetrical openings, and almost all of them were rectilinear in shape.

The concepts of the International Style remained influential in architecture until the 1970s, particularly in the United States, where numerous European architects, including Mies and Gropius, settled in the 1930s. Even Frank Lloyd Wright, an individualist who professed to disdain the work of his European colleagues, adopted elements of the International Style in his later buildings, such as Fallingwater (SEE FIG. 31–54).

home to suggest not luxury but elegant austerity, with the basic necessities sleekly integrated into a meticulously restrained whole.

Bauhaus Art in Germany

The machine-made look of the buildings and furnishings of de Stijl proved anathema to the designers of the Bauhaus, who wanted to reinvigorate industry through craft. The Bauhaus ("House of Building") was the brainchild of Walter Gropius, an early devotee of the Arts and Crafts movement who believed that mass production destroyed art. He admired the spirit of the medieval building guilds—the *Bauhütten*— that had built the great German cathedrals, and he sought to revive and commit that spirit to the reconciliation of Modern art with industry by synthesizing the efforts of architects, artists, and designers and craft workers. The Bauhaus was formed in 1919, when Gropius convinced the authorities of Weimar, Germany, to allow him to combine the city's schools of art and craft. The Bauhaus moved to Dessau in 1925 and then to Berlin in 1932.

Although Gropius's "Bauhaus Manifesto" of 1919 declared that "the ultimate goal of all artistic activity is the building," the school offered no formal training in architecture until 1927. Gropius thought students would be ready for architecture only after they had completed the required preliminary course and received full training in the crafts taught in the Bauhaus workshops. These included making pottery, metalwork, textiles, stained glass, furniture, wood carvings, and wall paintings. In 1922 Gropius implemented a new emphasis on industrial design, and the next year brought on the Hungarian-born László Moholy-Nagy (1895–1946) to reorient the workshops toward the creation of sleek, func-

31–64 | Anni Albers **WALL HANGING**
1926. Silk, two-ply weave, 5'11 5⁄16" × 3'11 5⁄8" (1.83 × 1.22 m). Busch-Reisinger Museum, Harvard University, Cambridge, Massachusetts
Association Fund.

Following the closure of the Bauhaus in 1933 by the Nazis, Anni Albers and her husband, Josef, immigrated to the United States, where they became influential teachers at the newly founded Black Mountain College in Asheville, North Carolina. Anni Albers exerted a powerful influence on the development of fiber art in the United States through her exhibitions, her teaching, and her many publications, including the books *On Designing* (1959) and *On Weaving* (1965).

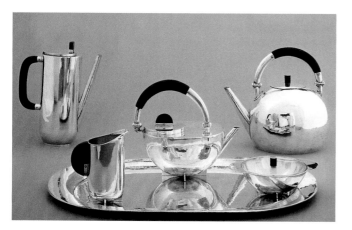

31–63 | Marianne Brandt **COFFEE AND TEA SERVICE**
1924. Silver and ebony, with Plexiglas cover for sugar bowl. Bauhaus Archiv, Berlin.

The lid of Marianne Brandt's sugar bowl is made of Plexiglas, reflecting the Bauhaus's interest in incorporating the latest advances in materials and technology into the manufacture of utilitarian objects.

tional designs suitable for mass production. The elegant tea and coffee service (**FIG. 31–63**) by Marianne Brandt (1893– 1983), for example, though handcrafted in silver, was a prototype for mass production in a cheaper metal such as nickel silver. After the Bauhaus moved to Dessau, Brandt designed several innovative lighting fixtures and table lamps that went into mass production, earning much-needed revenue for the school. After Moholy-Nagy's departure in 1928 (the same year Gropius left), she directed the metal workshop for a year before leaving the Bauhaus herself.

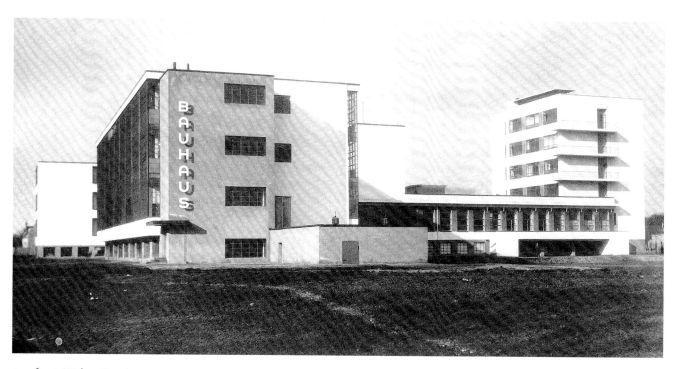

31–65 | Walter Gropius **BAUHAUS BUILDING**
Dessau, Germany. 1925-26. View from northwest.

One of the enduring contributions of the Bauhaus was graphic design. The sans-serif letters of the building's sign not only harmonize with the architecture's clean lines but also communicate the Bauhaus commitment to modernity. Sans-serif typography (that is, a typeface without serifs, the short lines at the end of the strokes of a letter) had been in use only since the early nineteenth century, and a host of new sans-serif typefaces was created in the 1920s.

As a woman holding her own in the otherwise all-male metals workshop, Brandt was an exceptional figure at the Bauhaus. Although women were admitted to the school on an equal basis with men, Gropius opposed their education as architects and channeled them into workshops that he deemed appropriate for their gender, namely pottery and textiles. One of the most talented members of the textile workshop was the Berlin-born Anni Albers (b. Annelise Fleischmann, 1899–1994), who arrived at the school in 1922 and three years later married Josef Albers (1888–1976), a Bauhaus graduate and professor. Obliged to enter the textiles workshop rather than the painting studio, Anni Albers set out to make "pictorial" weavings that would equal paintings as fine (as opposed to applied) art. Albers's wall hangings, such as the one shown in FIGURE 31–64, were intended to aesthetically enhance the interior of a modern building in the same way an abstract painting would. The decentralized, rectilinear design reflects the influence of de Stijl, while acknowledging weaving as a process of structural organization.

Albers's intention was "to let threads be articulate . . . and find a form for themselves to no other end than their own orchestration." Numerous other Bauhaus works reveal a similarly "honest" attitude toward materials, including Gropius's design for the new Dessau Bauhaus, built in 1925–26. The building frankly acknowledges the reinforced concrete, steel,

and glass of which it is built but is not strictly utilitarian. Gropius, influenced by de Stijl, used asymmetrical balancing of the three large, cubical structural elements to convey the dynamic quality of modern life (FIG. 31–65). The expressive glass-panel wall that wraps around two sides of the workshop wing of the building recalls the glass wall of the Fagus Shoe Factory (SEE FIG. 31–50) and sheds natural light on the workshops inside. The raised parapet below the workshop windows demonstrates the ability of modern engineering methods to create light, airy spaces unlike the heavy spaces of past styles.

After the Bauhaus moved to Berlin in 1932, it lasted only one more year before Adolf Hitler forced its closure (see "Suppression of the Avant-Garde in Nazi Germany," page 1112). Hitler objected to Modern art on two grounds: first, that it was cosmopolitan and not nationalistic enough; second, that it was unduly influenced by Jews. Only the first of these has a shred of truth; as grounds for censorship, neither is rational.

Art and Politics

Many art movements of the interwar period had a goal of improving the world somehow, but a few of them were more directly linked to political realities in their respective countries. These more politically oriented movements took a slightly different form in each region, in styles ranging from realism to abstraction.

Defining Art
SUPPRESSION OF THE AVANT-GARDE IN NAZI GERMANY

The 1930s in Germany witnessed a serious political reaction against avant-garde art and, eventually, a concerted effort to suppress it. One of the principal targets was the Bauhaus. Through much of the 1920s, the Bauhaus, where such luminaries as Paul Klee, Vasily Kandinsky, Josef Albers, and Ludwig Mies van der Rohe taught, had struggled against an increasingly hostile and reactionary political climate. As early as 1924 conservatives accused the Bauhaus of being not only educationally unsound but also politically subversive. To avoid having the school shut down by the opposition, Gropius moved it to Dessau in 1925, at the invitation of Dessau's liberal mayor, but he left the school soon after the relocation. His successors faced increasing political pressure, as the school was a prime center of Modernist practice, and the Bauhaus was again forced to move in 1932, this time to Berlin.

After Adolf Hitler came to power in 1933, the Nazi party mounted an aggressive campaign against Modern art. In his youth Hitler himself had been a mediocre landscape painter, and he had developed an intense hatred of the avant-garde. During the first year of his regime, the Bauhaus was forced to close for good. A number of the artists, designers, and architects who had been on its faculty—including Albers, Gropius, and Mies—migrated to the United States.

The Nazis also launched attacks against the German Expressionists, whose often intense depictions of German soldiers defeated in World War I and of the economic depression following the war were considered unpatriotic. Most of all, the treatment of the human form in these works, such as the Expressionistic exaggeration of facial features, was deemed offensive. The works of these and other artists were removed from museums, while the artists themselves were subjected to public ridicule and often forbidden to buy canvas or paint.

As a final move against the avant-garde, the Nazi leadership organized in 1937 a notorious exhibition of banned works. The "Degenerate Art" exhibition was intended to erase Modernism once and for all from the artistic life of the nation. Seeking to brand all the advanced movements of art as sick and degenerate, it presented Modern artworks as specimens of pathology; the organizers printed derisive slogans and comments to that effect on the gallery walls (see illustration). The 650 paintings, sculpture, prints, and books confiscated from German public museums were viewed by 2 million people in the four months the exhibition was on view in Munich and by another million during its subsequent three-year tour of German cities.

By the time World War II broke out, the authorities had confiscated countless works from all over the country. Most were publicly burned, though the Nazi officials sold much of the looted art at public auction in Switzerland to obtain foreign currency.

The blindness of the Nazi regime even kept it from recognizing some of its friends. Expressionist Emil Nolde (SEE FIG. 31–6) joined the Danish section of the Nazi party in 1932, but still his works were confiscated and he was forbidden from painting. Among the other artists crushed by the Nazi suppression was Ernst Ludwig Kirchner, whose *Street, Berlin* (SEE FIG. 31–8) was included in the "Degenerate Art" exhibit. The state's open animosity was a factor in his suicide in 1938.

THE DADA WALL IN ROOM 3 OF THE "DEGENERATE ART" (ENTARTETE KUNST) EXHIBITION
Munich. 1937.

Art © Estate of George Grosz/Licensed by VAGA, New York, N.Y.

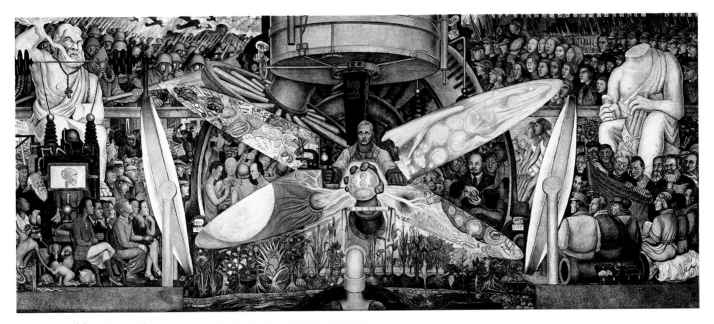

31–66 | Diego Rivera **MAN, CONTROLLER OF THE UNIVERSE**
1934. Fresco, 15'11" × 37'6" (4.85 × 11.45 m). Museo del Palacio de Bellas Artes, Mexico City.

PAINTING FOR THE PEOPLE IN MEXICO. The Mexican Revolution of 1910 overthrew the thirty-five-year-long dictatorship of General Porfirio Díaz and was followed by ten years of political instability. In 1920 the reformist president Álvaro Obregón came to power and restored political order. As part of their revolt against the old regime, the leaders of the new government found ways to put art in the service of the people and the just-completed revolution. Obregón's government commissioned artists to decorate public buildings with murals celebrating the history, life, and work of the Mexican people.

Prominent in the new Mexican mural movement was Diego Rivera (1886–1957), a child prodigy who had enrolled in Mexico City's Academia de San Carlos at age 11. From 1911 to 1919 Rivera lived in Paris, where he befriended Picasso and worked in a Synthetic Cubist style. In 1919 he met David Siqueiros (1896–1974), another future Mexican muralist. They began to discuss Mexico's need for a national and revolutionary art. Siqueiros was violently opposed to Modern art, which he dismissed as "intellectual masturbation." It would be better, Rivera and Siqueiros thought, to make art in public places so that it could not be bought or sold, and to make it in a recognizable style. In this way, art could serve the people. In 1920–21 Rivera traveled in Italy to study its great Renaissance frescoes, then he visited ancient indigenous sites in Mexico that also had large mural paintings. The Mexican mural movement was indebted to both traditions.

One of Rivera's best murals (FIG. 31–66) was originally planned for New York City. Between 1930 and 1934 Rivera worked in the United States, painting murals in San Francisco, Detroit, and New York. In 1933 the Rockefeller family commissioned him to paint a mural for the lobby of the RCA Building in Rockefeller Center, a fresco on the theme "Man at the Crossroads Looking with Hope and High Vision to the Choosing of a New and Better Future." When Rivera, a Communist, proposed including a portrait of Lenin in the mural, the Rockefellers objected. Rivera offered to add heads of Abraham Lincoln and some abolitionists, but the offer was refused. The Rockefellers canceled his commission, paid him his fee, and had the unfinished mural destroyed.

In response to what he called an "act of cultural vandalism," Rivera re-created the mural in the Palacio de Bellas Artes in Mexico City, under the new title **MAN, CONTROLLER OF THE UNIVERSE**. At the center of the mural, the clear-eyed young figure in overalls represents Man, who symbolically controls the universe through the manipulation of technology. Crossing behind him are two great ellipses that represent, respectively, the microcosm of living organisms as seen through the microscope at Man's right hand, and the macrocosm of outer space as viewed through the giant telescope above his head. Below, fruits and vegetables rise from the earth as a result of his agricultural efforts. To Man's left (the viewer's right), Lenin joins the hands of several workers of different races. To Man's right, decadent capitalists debauch themselves in a nightclub, directly beneath the disease-causing cells in the ellipse. (Rivera included in this section a portrait of the bespectacled John D. Rockefeller Jr.) The wings of the mural feature, to Man's left, the workers of the world embracing socialism, and, to Man's right, the capitalist world, which is cursed by militarism and labor

unrest. The work of the muralists on government buildings in Mexico influenced art in the United States, as the Federal government also engaged in a program during the Depression to hire American artists to decorate public buildings with murals (see "Federal Patronage for American Art during the Depression," page 1116).

THE HARLEM RENAISSANCE. Between the two world wars, hundreds of thousands of African Americans migrated from the rural, mostly agricultural South to the urban, industrialized North, fleeing racial and economic oppression and seeking greater social and economic opportunity. This transition gave rise to the so-called New Negro movement, which encouraged African Americans to become politically progressive and racially conscious. The New Negro movement in turn stimulated a flowering of black art and culture known as the Harlem Renaissance, because its capital was in Manhattan's Harlem district, which had the country's largest concentration of African Americans. The cultural flowering encouraged musicians such as Duke Ellington, novelists such as Jean Toomer, and poets such as Langston Hughes. The intellectual leader of the Harlem Renaissance was Alain Locke (1886–1954), a critic and philosophy professor who argued that black artists should seek their artistic roots in the traditional arts of Africa rather than in the art of white America or Europe.

The first black artist to answer Locke's call was Aaron Douglas (1898–1979), a native of Topeka, Kansas, who moved to New York City in 1925 and rapidly developed an abstracted style influenced by African art. In paintings such as **ASPECTS OF NEGRO LIFE: FROM SLAVERY THROUGH RECONSTRUCTION** (FIG. 31–67), Douglas used schematic figures, sil-

houetted in profile with the eye rendered frontally as in ancient Egyptian reliefs and frescoes, and he limited his palette to a few subtle hues, varying in value from light to dark and sometimes organized abstractly into concentric bands that suggest musical rhythms or spiritual emanations. This work, painted for the Harlem branch of the New York Public Library under the sponsorship of the Public Works of Art Project, was intended to awaken in African Americans a sense of their place in history. At the right, Southern black people celebrate the Emancipation Proclamation of 1863, which freed the slaves. Concentric circles issue from the Proclamation, which is read by a figure in the foreground. At the center of the composition, an orator symbolizing black leaders of the Reconstruction era urges black freedmen, some still picking cotton, to cast their ballots in the box before him, while he points to a silhouette of the Capitol on a distant hill. Concentric circles highlight the ballot in his hand. In the left background, Union soldiers depart from the South at the close of Reconstruction, as the fearsome Ku Klux Klan, hooded and on horseback, invades from the left. Despite this negative image, the heroic orator at the center of Douglas's panel remains the focus of the composition, inspiring contemporary viewers to continue the struggle to improve the lot of African Americans.

The career of sculptor Augusta Savage (1892–1962) reflects the difficulties that many African Americans faced. She studied at Cooper Union in New York, but her first application for study in Europe in 1923 was turned down because of her race. Her letter of protest was eloquent but ultimately futile: "Democracy is a strange thing. My brother was good enough to be accepted in one of the regiments that

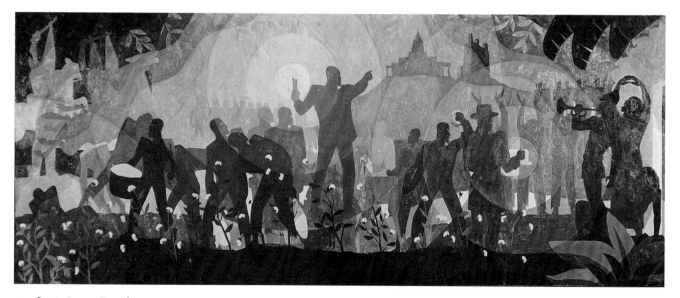

31–67 Aaron Douglas **ASPECTS OF NEGRO LIFE: FROM SLAVERY THROUGH RECONSTRUCTION**
1934. Oil on canvas, 5′ × 11′7″ (1.5 × 3.5 m). Schomburg Center for Research in Black Culture, New York Public Library.

31–68 | Augusta Savage **LA CITADELLE: FREEDOM**
1930. Bronze, 14½ × 7 × 6″ (35.6 × 17.8 × 15.2 cm).
Howard University Art Collection, Washington, D.C.

Sequencing Events
WAR AND REVOLUTION IN THE EARLY 20TH CENTURY

1910–1918	Mexican Revolution
1911	Chinese Revolution; Republic founded under Sun Yat-sen
1914–1918	World War I
1917	Russian Revolution
1922	Soviet Union created
1933	Hitler becomes chancellor of Germany
1936	Outbreak of Spanish Civil War
1939–1945	World War II

The private art school that she established in a basement eventually received Federal funding in 1935 as part of the Works Progress Administration (see "Federal Patronage for American Art during the Depression," page 1116), and it became the Harlem Community Art Center, one of a hundred such centers across the country. Hers was the largest center, and it soon became much more than an art studio: poets, composers, dancers, and historians gathered there to discuss cultural issues and investigate and interpret black history.

The best-known artist to emerge from the Harlem Community Art Center was Jacob Lawrence (1917–2000). He devoted much of his early work to the depiction of black history, which he carefully researched and then recounted through narrative painting series comprising dozens of small panels, each accompanied by a text. He claimed that a single work was insufficient to capture the full import of the stories he researched. The themes of his painting series include the history of Harlem and the lives of abolitionist John Brown and Haitian revolutionary leader Toussaint L'Ouverture. In 1940–41, Lawrence created his most expansive set, **THE MIGRATION OF THE NEGRO**, whose sixty panels chronicle the exodus of African Americans from the rural South to the urban North—an exodus that had brought Lawrence's own parents from South Carolina to Atlantic City, New Jersey, where he was born. The first panel **(FIG. 31–69)**, set in the South, depicts a train station filled with black migrants who stream through portals labeled with the names of Northern and Midwestern cities. The boldly abstracted style, with its simple shapes and bright, flat colors, suggests the influence of Cubism; but a more likely source is Lawrence's own study of the African art that also influenced Cubism. He later also illustrated books by Harlem Renaissance authors.

saw service in France during the war, but it seems his sister is not good enough to be a guest of the country for which he fought." On another occasion she was accepted but was unable to raise the money for passage. Finally in 1930 her efforts paid off, and she studied portraiture at La Grande Chaumière in Paris. On her return she sculpted portraits of many black leaders, such as Marcus Garvey and W. E. B. DuBois. Though she disagreed with Locke about the relevance of the tribal arts of Africa for contemporary artists, she devoted a great deal of time to the study of black history and was particularly stimulated by the story of Haiti, the black republic that achieved independence in 1804 after a slave revolt. One of her sculptures, **LA CITADELLE: FREEDOM**, combines her historical research with her interest in the human form **(FIG. 31–68)**. La Citadelle is a castle that one of Haiti's first leaders erected, in imitation of the executive mansions of other countries. To her its very existence symbolized freedom and equality for blacks. Poised on the toes of one foot, the figure seems to fly through the air.

Art and its Context

FEDERAL PATRONAGE FOR AMERICAN ART DURING THE DEPRESSION

President Franklin D. Roosevelt's New Deal, programs to provide relief for the unemployed and to revive the nation's economy during the Great Depression, included several initiatives to give work to American artists. The Public Works of Art Project (PWAP), set up in late 1933 to employ needy artists, was in existence for only five months but supported the activity of 4,000 artists, who produced more than 15,000 works. The Section of Painting and Sculpture in the Treasury Department, established in October 1934 and lasting until 1943, commissioned murals and sculpture for public buildings but was not a relief program; artists were paid only if their designs were accepted. These programs were influenced by the Mexican government's postrevolutionary mural painting program. The Federal Art Project (FAP) of the Works Progress Administration (WPA), which ran from 1935 to 1943, succeeded the PWAP in providing relief to unemployed artists. The most important work-relief agency of the Depression era, the WPA employed more than 6 million workers by 1943. Its programs to support the arts included the Federal Theater Project and the Federal Writers' Project as well as the Federal Art Project. About 10,000 artists participated in the FAP, producing a staggering amount of art, including about 108,000 paintings, 18,000 works of sculpture, 2,500 murals, and thousands of prints, photographs, and posters. Because it was paid for by the government, all this art became public property. The murals and large works of sculpture, commissioned for public buildings such as train stations, schools, hospitals, and post offices, reached a particularly wide audience.

To build public support for federal assistance to those in need, the government, through the Resettlement Agency (RA) and Farm Security Administration (FSA), hired photographers to document the problems of farmers, then supplied these photographs, with captions, free to newspapers and magazines. A leading RA/FSA photographer between 1935 and 1939 was the San Francisco–based Dorothea Lange (1895-1965). Many of her photographs document the plight of migrant farm laborers who had flooded California looking for work after fleeing the Dust Bowl conditions on the Great Plains. **MIGRANT MOTHER, NIPOMO, CALIFORNIA** pictures Florence Thompson, the 32-year-old mother of seven children, who had gone to a pea-picking camp but found no work because the peas had frozen on the vines. The tired mother, with her knit brow and her hand on her mouth, seems to capture the fears of an entire population of disenfranchised people.

During the Depression, the Federal Art Project paid a generous average salary of about $20 a week (a salesclerk at Woolworth's earned only about $11), allowing painters and sculptors to devote themselves full-time to art and to think of themselves as professionals in a way few had been able to do before 1935. New York City's painters, in particular, began to develop a group identity, largely because they now had time to meet and discuss art in the bars and coffeehouses of Greenwich Village, the city's answer to the cafés that played such an important role in the life of artists in Paris. Finally, the FAP gave New York's art community a sense that high culture was important in the United States. The FAP's monetary support and its professional consequences would prove crucial to the artists later known as the Abstract Expressionists, who made important innovations after 1945.

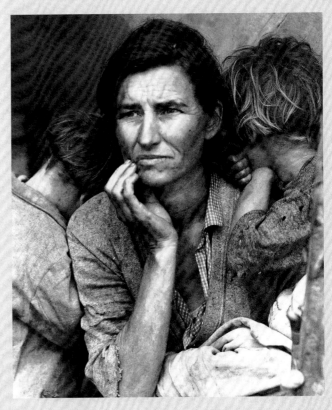

Dorothea Lange **MIGRANT MOTHER, NIPOMO, CALIFORNIA**
February 1936. Gelatin-silver print. Library of Congress, Washington, D.C

SCULPTURE AND FREEDOM. During the 1930s, totalitarian regimes increased pressure on Modern artists. In Russia, the leaders of the Communist Party promoted only Socialist Realism (SEE FIG. 31–59), and it became an official style early in the decade. Party leaders routinely denounced any sort of Modern tendencies in the arts, including music and drama, on the grounds that Modern art was too individualistic and not understandable by the general public. Many of the pioneering Modernists, such as Popova and Rodchenko (SEE FIGS. 31–31, 31–57), were relatively unaffected by this, because they had already moved toward designing posters, furniture, and other useful objects. But Modernists who

31–69 | Jacob Lawrence
**DURING THE WORLD WAR THERE WAS
A GREAT MIGRATION NORTH
BY SOUTHERN NEGROES**
Panel 1 from *The Migration of the Negro*.
1940–41. Tempera on masonite, 12 × 18″
(30.5 × 45.7 cm). The Phillips Collection,
Washington, D.C.

This is the first image in Lawrence's sixty-panel cycle
that tells the story of the migration of Southern
American blacks to the industrialized North in the
decades between the two world wars. The Harlem
writer Alain Locke brought the series to the atten-
tion of Edith Halpert, a white New York art dealer,
who arranged for the publication of several of its
panels in the November 1941 issue of *Fortune* maga-
zine and who showed the entire series the same year
at her Downtown Gallery. Thus, at age 23, Lawrence
became the first African American artist to gain
acclaim from whites in the segregated New York art
world. The next year, the *Migration* series was jointly
acquired by the Phillips Collection in Washington,
D.C., and the Museum of Modern Art in New York,
each of which purchased thirty paintings.

wanted to continue the Suprematist line, despite their contin-
uing support of the Communist revolution, found themselves
without opportunities to exhibit and at times were actively
persecuted. Likewise, when the Nazi party took power in
Germany, energetic suppression of Modernism in the arts fol-
lowed shortly thereafter (see "Suppression of the Avant-Garde
in Nazi Germany," page 1112).

European abstract artists had gathered in 1931 to form
the Abstraction-Creation group, and two years later they
announced opposition to totalitarian control as the central
principle behind their union: "The second issue of *Abstrac-
tion-Creation* appears at a time when, under all regimes, in
some countries more effectively than others, but everywhere,
free thought is fiercely opposed. . . . We place this issue under
the banner of a total opposition to all oppression, of whatever
kind it may be." The group numbered about fifty active
members and a few hundred more associates, working in
many modes of Modern art from Cubism to Neo-Plasticism,
but the most innovative of them were sculptors. These artists
were investigating the allusive power of **biomorphic** forms,
that is, forms based on or resembling forms found in nature.
Picasso too embraced such forms in his anti-Fascist protest
work *Guernica* (SEE FIG. 31–1).

An early leader in biomorphic sculpture was Barbara
Hepworth (1903–1975). After study at the Leeds School of
Art, she joined Abstraction-Creation in 1933, and she later
helped to form Unit One, a similarly oriented group of Eng-
lish artists. Hepworth was among the first to pierce her sculp-
ture with holes, so that air and light pass through (FIG. 31–70).
This strategy differs from that of assemblage, in which the
pieces assembled create spaces and voids (SEE FIG. 31–23).

31–70 | Barbara Hepworth **FORMS IN ECHELON**
1938. Wood, 42½ × 23⅔ × 28″ (108 × 60 × 71 cm).
Tate Gallery, London.
Presented by the artist 1964 © Bowness, Hepworth Estate

FORMS IN ECHELON consists of two pieces whose shape, while not obviously representational, is highly suggestive of organic forms, perhaps weathered stones or fingers or the backs of insects. The artist rarely stated her intentions in creating these shapes, beyond merely saying that they are organic. She hoped that viewers would let their eyes play across them, letting imagination generate associations and meanings. The two parts stand in a relationship to each other that is similarly unstated but potentially full of significance.

Her compatriot Henry Moore (1898–1986) developed the idea of the pierced work in abstractions that were more obviously based on the human form. After serving in World War I, including being gassed at the battle of Cambrai, Moore studied sculpture at the Leeds School of Art and the Royal College of Art. The African, Oceanic, and Pre-Columbian art he saw at the British Museum had a more powerful impact on his developing aesthetic than the tradition-oriented curriculum at the college. In the simplified forms of these non-Western art works he discovered an intense vitality that interested him far more than the refinement of the Renaissance tradition. Moreover, he saw in non-Western art a respect for the inherent qualities of materials such as stone or wood. He

never joined Abstraction-Creation, but he was a founder of Unit One. In most of his own works of the 1920s and 1930s, Moore practiced direct carving in stone and wood and pursued the ideal of truth to material as he created new images of humans.

A central subject in Moore's art is the reclining female figure, such as **RECUMBENT FIGURE** (FIG. 31–71), whose massive, simplified forms recall Pre-Columbian art. Specifically, Moore was inspired by the *chacmool,* a reclining human form that occurs frequently in Toltec and Maya art (SEE FIG. 12–13). The carving reveals Moore's sensitivity to the inherent qualities of the stone, whose natural striations harmonize with the sinuous surfaces of the design. Moore sought out remote quarries and extracted stone from sites that interested him, always insisting that each work he created be labeled with the specific type of stone he used. While certain elements of the body are clearly defined, such as the head and breasts, and the supporting elbow and raised knee, other parts flow together into an undulating mass more suggestive of a hilly landscape than of a human body. An open cavity penetrates the torso, emphasizing the relationship of solid and void fundamental to Moore's art. The sculptor wrote in 1937,

31–71 | Henry Moore **RECUMBENT FIGURE**
1938. Hornton stone, 35 × 52 × 29″ (88.9 × 132.7 × 73.7 cm). Tate Gallery, London.

Originally carved for the garden of the architect Serge Chermayeff in Sussex, Moore's sculpture was situated next to a low-lying Modernist building with an open view of the gently rolling landscape. "My figure looked out across a great sweep of the Downs, and her gaze gathered in the horizon," Moore later recalled. "The sculpture had no specific relationship to the architecture. It had its own identity and did not *need* to be on Chermayeff's terrace, but it so to speak *enjoyed* being there, and I think it introduced a humanizing element; it became a mediator between modern house and ageless land."

31–72 | Alexander Calder **LOBSTER TRAP AND FISH TAIL**
1939. Hanging mobile: painted steel wire and sheet aluminum, approx. 8′6″ × 9′6″ (2.6 × 2.9 m).
The Museum of Modern Art, New York.
Commissioned by the Advisory Committee for the stairwell of the Museum (590.139.a–d)

"A hole can itself have as much shape-meaning as a solid mass." Moore also remarked on "the mystery of the hole—the mysterious fascination of caves in hillsides and cliffs," identifying the landscape as a source of inspiration for his hollowing out of the human body.

If the Italian Futurists suggested motion in their paintings and sculpture, Alexander Calder (1898–1976) made biomorphic works of sculpture that actually move. Calder's **kinetic** works, meaning works containing parts that move, unfix the traditional stability and timelessness of art and invest it with vital qualities of mutability and unpredictability. Born in Philadelphia and trained in both engineering and painting, Calder went to Paris in 1926 and became friendly with several abstract artists, joining Abstraction-Creation in time for the second issue of their journal. On a 1930 visit to Mondrian's studio, he had been impressed by the rectangles of colored paper that the painter had tacked up everywhere on the walls. What would it look like, Calder wondered, if the flat shapes were moving freely in space, interacting in not just

two but three dimensions? The question inspired Calder to begin creating sculpture with moving parts, known as **mobiles**. Calder's **LOBSTER TRAP AND FISH TAIL** (FIG. 31–72) features delicately balanced elements that spin and bob in response to shifting currents of air. At first, the work seems almost completely abstract, but Calder's title works on our imagination, helping us find the oval trap awaiting unwary crustaceans and the delicate wires at the right that suggest the backbone of a fish. The term *mobile,* which in French means "moving body" as well as "motive," or "driving force," came from Calder's friend Marcel Duchamp, who no doubt relished the double meaning of the word.

Surrealists Rearrange Our Minds

The entire history of the interwar period is the appropriate backdrop for the 1924 founding of the Surrealist movement. Led by French writer André Breton (1896–1966), the Surrealists attacked the rational emphasis of Western culture. They were as disillusioned as the Dadaists had been before them,

and indeed, many Surrealists had participated in that earlier movement. The problem, Breton wrote in 1934, is that "We still live under the rule of logic." European civilization emphasizes science, progress, comfort, and success. These values are not wrong in themselves, but in Europe they were pursued with blind fervor, and to the detriment of other values such as fantasy, imagination, and play. The results were obvious to the most casual observer: Europe experienced the unprecedented horrors of World War I, as science was applied to killing. And moreover, Europe was in danger again, they thought, from the rise of fascist regimes in Spain, Germany, and Italy, as those regimes intently snuffed out all opposition.

A participant in the Paris Dada movement, Breton became dissatisfied with the seemingly nonsensical activities of his colleagues and set out to make something more programmatic out of Dada's somewhat unfocused bitterness. In 1924 he published the first "Manifesto of Surrealism," outlining his view of Freud's theory that the human psyche is a battleground where the rational, civilized forces of the conscious mind struggle against the irrational, instinctual urges of the unconscious. The way to improve civilization, Breton argued, does not lie in strengthening the repressive forces of reason, but in freeing the individual to experience and safely express forbidden desires and urges. Artists are uniquely positioned to facilitate these explorations, because, he thought, coming face to face with one's inner demons in an art context may prevent our letting them loose in the real world. The Surrealists developed a number of techniques for liberating the unconscious, including dream analysis, free association, automatic writing, word games, and hypnotic trances. Their aim was to help people discover the more intense reality, or "surreality," that lay beyond the narrow rational notions of what is real.

AUTOMATISM. Surrealist painters employed a variety of manual techniques, known collectively as **automatism,** which were designed to release art from conscious control and thus produce new and surprising forms. Particularly inventive in his use of automatism was Max Ernst (1891–1976), a self-taught German artist who helped organize a Dada movement in Cologne and later moved to Paris, where he joined Breton's circle. In 1925 Ernst discovered the automatist technique of *frottage,* in which the artist rubs a pencil or crayon across a piece of paper placed on a textured surface. The resulting imprints stimulated Ernst's imagination, and he discovered in them fantastic creatures, plants, and landscapes, which he articulated through additional drawing. Ernst adapted the *frottage* technique to painting through *grattage,* creating patterns by scraping off layers of paint from a canvas laid over a textured surface. He then would extract representational forms from the patterns through overpainting. One result of this technique is **THE HORDE** (FIG. 31–73), a nightmarish scene of a group of monsters, seemingly made out of wood, who advance against some unseen opponent. Like

31–73 | Max Ernst **THE HORDE**
1927. Oil on canvas, 44⅞ × 57½" (114 × 146.1 cm). Stedelijk Museum, Amsterdam.

much of Ernst's work of the period, this frightening image seems to resonate with the violence of World War I—which he experienced firsthand in the German army—and also to foretell the coming of another terrible European conflict.

UNEXPECTED JUXTAPOSITIONS. Even more carefully executed are the paintings of Salvador Dalí (1904–89). Trained at the San Fernando Academy of Fine Arts in Madrid, where he mastered the traditional methods of illusionistic representation, Dalí traveled to Paris in 1928 where he met the Surrealists. By the next year Dalí had converted fully to the movement and was welcomed officially into it. Dalí's contribution to Surrealist theory was the "paranoid-critical method," in which the sane person cultivates the ability of the paranoid to misread ordinary appearances and become liberated from the shackles of conventional thought. He hoped that the paranoid-critical method would take an equal place in Western culture along with the scientific method for the analysis of reality.

Dalí's paintings generally deal with sexual urges of various kinds (FIG. 31–74). In the **BIRTH OF LIQUID DESIRES,** we see a woman in a white gown embracing a hermaphroditic figure (one which has both male and female organs). This figure half-kneels on a classical pedestal, its foot in a bowl that a partially hidden figure fills with a liquid, while on its head sits a long loaf of French bread. (Merely describing this piece provides a challenge to logic.) Out of the head a thick black cloud representing a dream emerges below a mysterious cabinet. In one of the recesses of the cloud, the artist inscribed in small print a nonsense phrase: "Consign: to waste the total slate?" The artist said that he arrived at his imagery by carefully writing down his nightmares and merely painting what his fantasy-laden mind conjured up. In this way, the work ful-

31–74 | Salvador Dalí **BIRTH OF LIQUID DESIRES**
1931–32. Oil and collage on canvas, 37⅞ × 44¼"
(96.1 × 112.3 cm). Guggenheim Museum, New York.

Peggy Guggenheim Collection. 76.2553 PG 100. © 2003 Salvador Dalí, Gala-Salvador Dalí Foundation/Artists Rights Society (ARS), New York, N.Y.

morphic form whose shape might suggest a monster facing right, a painter's palette, or a violin (which might in turn suggest a woman's body). A shadow looms over the yellow form, which probably represents the artist's father, with whom Dalí had a tense relationship. There are many other ways to interpret this work, depending on the personality and mental state of the viewer. Others, for example, may see the cave at the left as the most significant motif. The half-shod figure who enters the cave may be regressing toward the womb, a metaphor for incest. Thus, perhaps, the central pair represents an incestuous union. Another line of analysis is to focus on the work's quotations from previous art. Some of these include, besides the classical pedestal and the palette, the pitcher pouring the liquid, a quote from a Dutch genre work by Vermeer (see Chapter 22), and the top of the cloud, which transcribes a portion of a work by the Swiss-German symbolist painter Arnold Böcklin. Dalí's tense relationship with his father is expressed in his uneasy juxtaposition of quotes from his artistic elders.

This absurd yet compelling work typifies the Surrealist interest in unexpected juxtapositions of disparate realities. When created with actual rather than represented objects and materials, the strategy produced disquieting assemblages such as **OBJECT (LE DÉJEUNER EN FOURRURE)** (FIG. 31–75), by Meret Oppenheim (1913–85), a Swiss artist who was one of the few female participants in the Surrealist movement.

fills the Surrealist goal, set out in the first "Manifesto of Surrealism," of expressing "the true process of thought, free from the exercise of reason and from any aesthetic or moral purpose." The composition is dominated by a large yellow bio-

31–75 | Meret Oppenheim **OBJECT (LE DÉJEUNER EN FOURRURE)**
(LUNCHEON IN FUR)
1936. Fur-covered cup, diameter 4⅜" (10.9 cm); fur-covered saucer, diameter 9⅜"
(23.7 cm); fur-covered spoon, length 8" (20.2 cm); overall height, 2⅞" (7.3 cm).
The Museum of Modern Art, New York.

Oppenheim's *Object* was inspired by a café conversation with Picasso about her designs for jewelry made of fur-lined metal tubing. When Picasso remarked that one could cover just about anything with fur, Oppenheim replied, "Even this cup and saucer."

31–76 | Joan Miró **SHOOTING STAR**
1938. Oil on canvas, 25⅝ × 21⅜" (65.2 × 54.4 cm). National
Gallery of Art, Washington D.C.

Gift of Joseph H. Hazen (1970.36.1). Image © 2006 Board of Trustees, National
Gallery of Art, Washington, D.C.

Consisting of a cup, saucer, and spoon covered with the fur of
a Chinese gazelle, Oppenheim's work transforms implements
normally used for drinking tea into a hairy ensemble that
simultaneously attracts and repels the viewer.

BIOMORPHIC ABSTRACTION. The painter who made the
most from biomorphic abstraction was Joan Miró, who
exhibited with the Surrealists from the beginning of the
movement. He arrived at his shapes by doodling, as **SHOOT-
ING STAR** shows (FIG. 31–76). The Surrealists believed that
through the accidents of doodling, we might relax our
rational control and draw something that bubbles up from
our unconscious. Miró usually doodled on the canvas, then
examined his product to see what shapes it suggested, then
applied more lines and colors to bring out what lay hidden.
In an indefinite space influenced by Cubism, the star of the
work's title seems to fly off toward the lower right, though
the central figure could also be a deformed star. Other forms
suggestive of birds' heads or flowers prance across the surface
of this work, which looks improvised. Indeed, Miró painted
in such a way that his forms appear to be taking shape before
our eyes; their identity is in flux just as our thought process is
itself always in flux. Miró was fascinated by the art of chil-
dren, which he regarded as spontaneous and expressive;
though he had been well-trained as an artist, he made it a
goal to forget his learning in order to recover the freshness of
childhood. We see that childlike quality here as well.

If the art world was full of schemes to improve civiliza-
tion during the 1930s, obviously none of them functioned as
the creators hoped; Europe hurtled once again toward war as
the decade closed. A great many artists left Europe for the
Americas, redrawing the map of artistic innovation.

IN PERSPECTIVE

The early twentieth century saw a systematic undermining of
the traditional rules of Western art, as artists overthrew long-
held conventions in a series of movements that flowered
before 1920: Fauvists and Expressionists attacked traditional
notions of pictorial representation through color and brush-
work, culminating in completely abstract paintings by 1910.
Cubists created influential new methods of composition in
both painting and sculpture. Futurists embodied "the beauty
of speed" in new ways, and Suprematists combined Cubist
picture space with complete abstraction. During World War I,
Dada asked the most radical questions about the nature of art
itself. As part of a program of challenging the norms, many
Modern artists looked to non-Western cultures for stylistic
cues. Modern architecture also took definite form in build-
ings that used only the modern materials of concrete, glass,
and steel, without decoration or reference to any past style.

Modern art arrived somewhat later to the Americas, but
artists on those continents also pursued Modernist tech-
niques, often coupling their experiments in form with efforts
to uncover national or cultural identity.

In the period between the wars, many artists gave their
art a deeper social relevance. Some reacted to the slaughter of
World War I, others to social inequalities of various kinds,
while still others combated fascism. Constructivists in Russia
after the Communist Revolution united Modern styles with
practical needs. Socialist Realists and Mexican muralists
retreated from the more radical innovations of Modernism in
order to communicate with the masses, often through art in
public places. Bauhaus artists turned modern mass production
toward a harmonious and beautiful home environment for
consumers. Dutch painters and architects of de Stijl created
art that they hoped would purify the human mind through
use of pure colors and simple forms. Harlem Renaissance
artists raised awareness of African American culture, some
using Modernist techniques, and some looking past them
back to African tribal arts. The Abstraction-Creation group
used organic abstraction as part of a campaign against fascist
regimes, which usually censored Modern art. Surrealists
sought various ways to liberate the unconscious mind, based
on their reading of Freud's psychology, in an effort to reorient
Western culture toward fantasy.

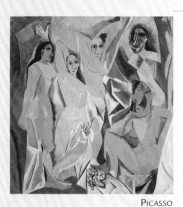

PICASSO
LES DEMOISELLES D'AVIGNON
1907

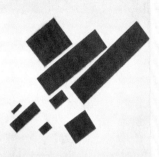

MALEVICH
SUPREMATIST PAINTING
1915

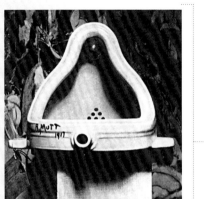

DUCHAMP
FOUNTAIN
1917

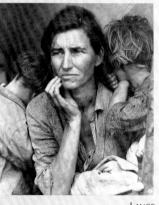

LANGE
**MIGRANT MOTHER,
NIPOMO, CALIFORNIA**
1936

GROPIUS
BAUHAUS
1925–26

LAWRENCE
MIGRATION SERIES
1940–41

PELÁEZ
MARPACÍFICO (HIBISCUS)
1943

MODERN ART IN EUROPE AND THE AMERICAS, 1900–1945

1900

◄ Wright Brothers' First Flight 1903

1910

◄ First Flight Across English Channel 1909
◄ Messican Revolution 1910–17

◄ First Balkan War 1912–13
◄ World War I 1914–18

◄ Russian Revolution 1917

1920

◄ Soviet Union Formed 1922

◄ Stalin Comes to Power 1924

◄ Great Depression Begins 1929

1930

◄ New Deal in U.S.; Hitler Comes to Power in Germany 1933

◄ First Analog Computer 1935

1940

◄ World War II 1939–45
◄ First Digital Computer 1939

◄ Atomic Bomb Dropped on Hiroshima and Nagasaki 1945

1950

32–1 | Jannis Kounellis **UNTITLED (12 HORSES)** 1969. Installation, Galleria L'Attico, Rome.

CHAPTER THIRTY-TWO

THE INTERNATIONAL SCENE SINCE 1945

Visitors to the 1969 Jannis Kounellis exhibition at the Galleria L'Attico in Rome did not see paintings, sculpture, drawings, or any other objects made by the artist. Instead, they encountered twelve live horses of different breeds and colors tethered with halters to the gallery walls (FIG. 32–1). Following the example of Marcel Duchamp (SEE FIG. 31–36), Kounellis did not create a new object but took existing entities (in this case, living ones), placed them in an art context, and designated them a work of art. This particular work existed only as long as the horses remained "installed" in the gallery (three days) and could not be bought or sold. By placing unsalable works in the exhibition space, Kounellis, who harbored leftist political views, challenged "the ideological and economic interests that are the foundations of a gallery."

Kounellis did not intend simply to criticize the capitalist values of the art market; he also wanted to create a memorable work that would generate a rich variety of interpretations. He used horses because they evoke energy and strength and have art-historical associations with equestrian statuary and portraits of mounted heroes and rulers (SEE FIG. 19–14, 19–16, 30–2). One critic wrote that Kounellis's horses "had only to stand in place to confirm their stature as an attribute of Europe personified" and saw them as symbols of "the heritage accumulated over great distances of time, and of the

urgent need for freedom in the present moment." Another felt the installation conveyed "something of the quality of an anxiety dream." Still another suggested that Kounellis was actually mocking art by "treating the exhibition space as if it were a stable," which brought to mind one of the first-century emperor Caligula's "most insulting acts: making a horse a member of the Roman Senate."

However we interpret Kounellis's work, it stimulates our imaginations even as it defies our normal expectations of a work of art and—like much innovative art since World War II—causes us to question the nature of art itself.

THE WORLD SINCE 1945

The United States and the Soviet Union emerged from World War II as the world's most powerful nations and soon were engaged in the "cold war." The Soviets set up communist governments in Eastern Europe and supported the development of communism elsewhere. The United States, through financial aid and political support, sought to contain the spread of communism in Western Europe, Japan, Latin America, and other parts of the developing world. A second huge communist nation emerged in 1949 when Mao Zedong established the People's Republic of China. The United States tried to prevent the spread of communism in Asia by intervening in the Korean War (1950–53) and in the Vietnam War (1965–75).

The United States and the Soviet Union built massive nuclear arsenals aimed at each other, effectively deterring either from attacking for fear of a devastating retaliation. The cold war ended in the late 1980s, when the Soviet leader Mikhail Gorbachev signed a nuclear-arms reduction treaty with the United States and instituted economic and political reforms designed to foster free enterprise and democracy.

The dissolution of the Soviet Union soon followed and gave rise to numerous independent republics.

While the Soviet Union and the United States vied for world leadership, the old European states gave up their empires, often after massive resistance by the colonized peoples. The British led the way by withdrawing from India in 1947. Other European nations gradually granted independence to colonies in Asia and Africa, which entered the United Nations as a Third World bloc not aligned with either side in the cold war. Despite the efforts of the United Nations, deep-seated ethnic and religious hatreds have continued to spark violent conflicts around the world—in countries such as Pakistan, India, South Africa, Somalia, Ethiopia, Rwanda, the former Yugoslavia, and states throughout the Middle East. Escalating the sense of tension around the globe were the devastating terrorist attacks of September 11, 2001, on the World Trade Center and the Pentagon in the United States, and the controversial U.S.–led wars in Afghanistan and Iraq that followed.

A great many Modern artists since 1945 have used their art to comment on the state of the world, and the growth and

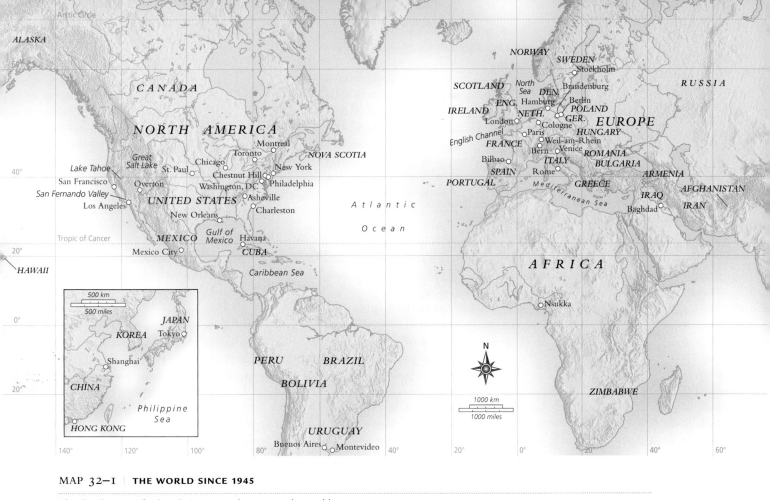

MAP 32–1 | **THE WORLD SINCE 1945**

The distribution of cultural sites expands to cover the world.

proliferation of mass media after World War II made everyone better informed, including artists. In the decade following the war, many artists' reflections on the state of humanity paralleled the Existentialist philosophy developed primarily by Jean-Paul Sartre and Albert Camus. Existentialism started from the position that there was no God, no supreme being, no absolute, no "transpersonal entity." Modern science and the twentieth century's multiple disasters seemed to prove that God must be absent, leaving humans "condemned to be free," as Sartre put it. Existentialists reflected a great deal on the implications of this fact for each person. Since there is no God, the self is not a "soul" or even a stable entity but rather a process in constant evolution as each of us establishes an identity and responds to our world. Sartre's principal philosophical work, *Being and Nothingness,* postulated that human beings are responsible for the world they have created, yet they are also free to decide how to act in it. In this situation, the most valuable art offers sincere individual testimony about life, honest sharing of personal insight about existence.

The assault on tradition that has marked Modern art from its inception continued, but with a slightly different focus. Most Modern artists thought less about questioning Renaissance-based rules because traditional styles of painting and sculpture had receded into the historical distance. Rather, many artists embraced a related quest: investigation of the nature of art. That is, they created works as experiments in form or challenges to the boundaries of art. What arose was a Tradition of the New, as Modern questioning grew more implanted in art institutions such as schools and museums and less controversial among the public.

The most important art-world watershed came sometime in the late 1970s, when the Modern movement seemed to exhaust the search for conventions to attack. The basic conditions and forces that undergirded Modern art also disappeared or evolved, leading to what we call the Postmodern period. Postmodern artists largely gave up the quest for formal novelty, and likewise the avant-garde lost its distinct identity as a social group. Instead there arose a plurality of styles in a more globalized art world, where artists found novel ways of exploring their identity and commenting about issues such as race, gender, the environment, and globalization itself.

POSTWAR EUROPEAN ART

The devastation of Europe in World War II far exceeded the toll of the first conflict: Defeated Germany lost 5 million dead, less than the 6 million Jews that Nazis had murdered in concentration camps, and far less than Russia's 20 million war casualties. Poland lost 20 percent of its population. At war's end, the total number of refugees and displaced persons across the continent amounted to 40 million. Two years after the end of hostilities, French industry was producing only 35 percent of its 1939 total. Looking at the condition of Europe in the same year, Winston Churchill described the extent of the catastrophe: "What is Europe now? A rubble heap, a charnel house, a breeding ground of pestilence and hate."

Most European artists in the immediate postwar period used their art to come to terms in some way with what they had experienced. There were many debates about how best to do this: Some urged figural styles, others proposed abstract art.

Figural Artists

For many artists, figuration was a way to keep one's art close to the human condition, to preserve a connection to humanity, or to express some kinship with the wounded, the displaced, and the dead. Swiss-born Alberto Giacometti (1901–1966) did this most memorably in sculpture (FIG. 32–2). He had worked in an abstract mode related to biomorphic Surrealism in the 1930s, but the war caused a crisis for him. Abstract art was merely "decorator stuff," he said, irrelevant to postwar humanity. So after the war he began sculpting in plaster from live models. The figures he produced were the antithesis of the classical ideal: thin, fragile, and lumpy, their surfaces rough and crude. Jean-Paul Sartre wrote that Giacometti's figures reminded him of "the fleshless martyrs of Buchenwald [concentration camp]." Yet they bravely occupy their limited space, and they even seem to ascend. Their frail nobility offers us a poignant vision of a way of "being in the world," to use a phrase dear to Existentialists. These slight individuals seemed to embody Sartre's view of the human condition. He wrote that Giacometti's figures are "between nothingness and being."

English artist Francis Bacon (1909–92) captured more of the horror and less of the ascent in his figural paintings. While working as an interior decorator, Bacon taught himself to paint in about 1930 but produced few pictures until the early 1940s, when the onset of World War II crystallized his harsh view of the world. He served as an air raid warden during the conflict, seeing that his neighbors got to safety during Nazi bombing attacks. His style draws on the Expressionist work of Vincent van Gogh (SEE FIG. 30–66) and Edvard Munch (SEE FIG. 30–71), as well as on Picasso's figure paintings. His subject matter comes from a wide variety of sources, including post-Renaissance Western art. **HEAD SURROUNDED BY SIDES OF BEEF** (FIG. 32–3), for example, is inspired by Diego

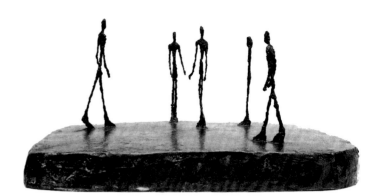

32–2 | Alberto Giacometti **CITY SQUARE**
1948. Bronze, 8½ × 25⅛ × 17¼″ (21.6 × 64.5 × 43.8 cm).
The Museum of Modern Art, New York.
Purchase (337.1949)

32–3 | Francis Bacon **HEAD SURROUNDED BY SIDES OF BEEF**
1954. Oil on canvas, 50¾ × 48″ (129 × 122 cm). The Art Institute of Chicago.
Harriott A. Fox Fund

Velázquez's *Pope Innocent X* (1650), a solid and imperious figure that Bacon transformed into an anguished, insubstantial man howling in a black void. The feeling is also reminiscent of Munch's *The Scream,* but Bacon's pope is enclosed in a claustrophobic box that contains his frightful cries. The figure's terror is magnified by the sides of beef behind him, quoted from a Rembrandt painting. (Bacon said that slaughterhouses and meat brought to his mind the Crucifixion.) Bacon's pope seems to show that humanity's claim to a divine connection is illusory at best. The artist wrote, "I hope to make the best human cry in painting . . . to remake the violence of reality itself."

The French painter Jean Dubuffet (1901–85) developed a distinctive form of Expressionism inspired by what he called *art brut* ("raw art")—the work of children and the insane—which he considered uncontaminated by Western culture. The war provoked a crisis of values, he thought. Certain old beliefs—that humans are fit to be masters of nature, that the world responds to reason and analysis—have been proved wrong. In the 1951 lecture "Anticultural Positions," he expressed deep disillusionment with those traditional notions and urged artists to reject "civilization." In a postwar version of Modernist Primitivism, he embraced art by the insane and funded a society to study and collect it. In his own art, at times he applied paint mixed with tar, sand, and mud, using his fingers and ordinary kitchen utensils, in a deliberately crude and spontaneous style that imitated *art brut*. In the early 1950s, he began to mix oil paint with new, fast-drying industrial enamels, laying them over a preliminary base of still-wet oils. The result was a texture of fissures and crackles that suggests organic surfaces, like those of **COW WITH THE SUBTILE NOSE** (FIG. 32–4). Dubuffet observed that "the sight of that animal affords me an inexhaustible feeling of well-being because of the aura of calm and serenity it gives off." The animal seems completely content and focused on its "subtile" nose, which appears to twitch just slightly, perhaps at the scent of some grassy morsel.

Abstraction and *Art Informel*

Dubuffet's celebration of crude, basic forms of self-expression, including graffiti, contributed to the emergence of the most distinctive postwar European artistic approach: *Art Informel* ("formless art"), which was sometimes also called *tachisme* (*tache* is French for "spot" or "stain"). *Art Informel* was promoted by French critic Michel Tapié (1909-87), who opposed geometric formalism as the proper response to the horrors of World War II. He insisted that Dada and the two world wars had discredited all notions of humanity as reasonable, thus clearing the way for a new and more authentic concept of the species that locates the origins of human expression in the simple, honest mark. Most practitioners of *Art Informel* worked abstractly, in part because the prewar totalitarian regimes despised abstraction. Moreover, many artists favored abstraction because it was cosmopolitan, not rooted in any of the nationalisms that had fueled the century's bloody conflicts.

The principal founder of *Art Informel* was Wolfgang Schulze, called Wols (1913–1951), who lived through some of Europe's dislocations. Born in Germany, the resolutely anti-Nazi artist left his homeland as soon as Hitler took power. He settled in Paris, where he knew many Modern artists, and took up a career as a photographer, with his work featured in international fashion magazines such as *Vogue* and *Harper's Bazaar*. When France was overrun in the Nazi invasion, he

32–4 | Jean Dubuffet **COW WITH THE SUBTILE NOSE**
1954. Oil on enamel on canvas, 35 × 45¾" (89.7 × 117.3). The Museum of Modern Art, New York.
Benjamin Scharps and David Scharps Fund

fled to Spain, where he was arrested and his passport confiscated. Deported from Spain in 1940, he lived the rest of the war as a stateless person in a refugee camp in southern France. When the war ended he settled in Paris and took up art again, painting in an abstract style (FIG. 32–5). He applied paint with whatever was at hand, sometimes allowing it to drip and run. Sometimes he threw paint at the canvas, then scraped the surfaces with a knife. These techniques are his own elaborations of Surrealist automatism. The resulting works often resemble cells or bacterial growths, with a disease-ridden or violent appearance. His experiences convinced him that humanity was no more noble than any other life form, however lowly or lofty. Sartre wrote about Wols and gave him money for his resettlement, but the artist's difficult history and complicated personal temperament led him to live carelessly, and he died of food poisoning in 1951.

If *Art Informel* expanded the range of materials that artists could apply to a canvas, Alberto Burri (1915–1995) used this more ample vocabulary in tellingly symbolic ways. A surgeon in the Italian army during the war, Burri was captured and spent most of the conflict in a POW camp in Texas. There he taught himself to paint with whatever was at hand, a trait that marked the rest of his career. Repatriated in 1945, he began to create works using red paint along with the burlap sacks that held donated foodstuffs that Italy received during its reconstruction (FIG. 32–6). The artist rarely spoke of his work, but the burlap seems to signify the bandages he used as a surgeon, and the red paint, the blood that flowed from unseen injuries. The English art critic Herbert Read, one of Burri's early supporters, wrote of him, "Burri is defiant in the face of chaos. He tries to face the wounds of Europe and heal them."

32–5 | Wols (Wolfgang Schulze) **PAINTING**
1944–45. Oil on canvas, 31⅞ × 32″ (81 × 81.1 cm).
The Museum of Modern Art, New York.
Gift of D. and J. de Menil Fund (29.1956) / Otto Wols © 2007 Artists Rights
Society (ARS), New York

32–6 | Alberto Burri
COMPOSITION (COMPOSIZIONE)
1953. Oil, gold paint, and glue on
burlap and canvas, 33⅞ × 39½″
(86 × 100 cm). Solomon R.
Guggenheim Museum, New York.
FN53.1364

32–7 | Wifredo Lam **ZAMBEZIA, ZAMBEZIA**
1950. Oil on canvas, 49⅛ × 43⅜" (125 × 110 cm).
Solomon R. Guggenheim Museum, New York.
Gift, Mr. Joseph Cantor, 1974.2095. Wifredo Lam © 2007 Artists
Rights Society (ARS), New York / ADAGP, Paris

ABSTRACT EXPRESSIONISM

The rise of fascism and the outbreak of World War II led many leading European artists and writers to move to the United States. By 1941, André Breton, Salvador Dalí, Fernand Léger, Piet Mondrian, and Max Ernst were living in New York, where they had a strong impact on the art scene. American abstract artists were most deeply affected by the ideas of the Surrealists, from which they evolved Abstract Expressionism, a wide variety of work produced in New York between 1940 and roughly 1960. This movement pioneered many innovations, in materials used, methods of application, compositional structures, and the sizes of the resulting works. Abstract Expressionism is also known as the New York School, a more neutral label many art historians prefer.

The Formative Phase

The earliest Abstract Expressionists found inspiration in Cubist formalism and Surrealist automatism, two very different strands of Modernism. But whereas European Surrealists had derived their notion of the unconscious from Sigmund Freud, many of the Americans subscribed to the thinking of Swiss psychoanalyst Carl Jung (1875–1961). Jung's theory of the collective unconscious holds that beneath one's private memories lies a storehouse of feelings and symbolic associations common to all humans. Abstract Expressionists, dissatis-

fied with what they considered the provincialism of American art in the 1930s, sought the universal themes within themselves.

SPIRITUAL HERITAGE. One of the first artists to bring these influences together was Cuban artist Wifredo Lam (1902–1980), who turned them into art that supported the struggle against colonialism. Of mixed Chinese, Spanish, and African descent, he studied at the National Academy in Havana before settling in Paris. There he became friendly with both Picasso and the Surrealists, and his work began to reflect these influences. The Nazi invasion of France forced him to return to his homeland, on the same boat with Surrealist leader André Breton. While Breton continued on to New York, Lam remained in Havana and began investigating his Afro-Cuban heritage in the company of anthropologist Lydia Cabrera and novelist Alejo Carpentier. Lam's work from the late 1940s shows strong influence of Afro-Cuban art forms associated with *santería,* an indigenous form of polytheistic spirituality. Unlike European Primitivists, who adapted art forms foreign to them without necessarily studying their meanings, Lam reconnected with his own heritage and used it in works that often have an anticolonial subtext. **ZAMBEZIA, ZAMBEZIA,** for example (**FIG. 32–7**), shows overlapping planes and shallow spaces reminiscent of Joan Miró

32–8 | Arshile Gorky **GARDEN IN SOCHI**
c. 1943. Oil on canvas, 31 × 39″ (78.7 × 99.1 cm). The Museum of Modern Art, New York.
Acquired through the Lillie P. Bliss Bequest (492.1969)

Born Vosdanig Adoian in Turkish Armenia, Arshile Gorky adopted his new Russian-sounding name (*Gorky* is Russian for "bitter")
after settling in New York in 1925. Insecure about his Armenian origins and hoping to impress his American colleagues, Gorky
often gave his birthplace as Kazan, Russia, and on one occasion claimed to be a cousin of the famous Russian writer Maksim
Gorky—apparently unaware that this was the pen name of Aleksey Peshkov. Related to Gorky's fabrication of a Russian back-
ground is his naming of *Garden in Sochi* for a Russian town rather than the Armenian village of Khorkom that actually inspired it.

(SEE FIG. 31–76), but here the forms are derived from Afro-
Cuban religious implements used in rituals. The central fig-
ure is a composite deity of *santería*. The title is an early colo-
nial name for Zimbabwe in East Africa. At that time this
region was still a colony known as Rhodesia, but it was also a
source for slaves brought to Cuba. Lam said, "I wanted with
all my heart to paint the drama of my country . . . In this way
I could act as a Trojan horse spewing forth hallucinating fig-
ures with the power to surprise, to disturb the dreams of the
exploiters."

Arshile Gorky (1904–48) took the Cubist-Surrealist
style further into spontaneous improvisation. He was born in
Armenia and immigrated to the United States in 1920 fol-
lowing Turkey's brutal eviction of its Armenian population,
which caused the death of Gorky's mother. Converging in
Gorky's mature work were his childhood memories of
Armenia, which provided his primary subject matter; his
interest in Surrealism; and his attraction to Jungian ideas.
These factors came together in the early 1940s in a series of
paintings that Gorky called **GARDEN IN SOCHI** after the Russ-
ian resort on the Black Sea but that were actually inspired by
Gorky's father's garden in his native Khorkom, Armenia (FIG.
32–8). According to Gorky, this garden was known as the
Garden of Wish Fulfillment. It contained a rock upon which
village women, including his mother, rubbed their bare
breasts for the granting of wishes; above the rock stood a

"Holy Tree" to which people tied strips of clothing. Gorky's painting includes the highly abstracted images of a bare-breasted woman at the left, a tree trunk at the upper center, and perhaps pennants of cloth at the upper right. The out-of-scale yellow shoes below the tree may refer to "the beautiful Armenian slippers" that Gorky and his father had worn in Khorkom. Knowledge of such autobiographical details is not necessary, however, to appreciate the painting's expressive effect, for the fluid, biomorphic forms—derived from Miró (SEE FIG. 31–76)—suggest vital life forces and signal Gorky's evocation of not only his own past but also an ancient, universal, unconscious identification with the earth. Despite their improvisational appearance, Gorky's paintings were based on detailed preparatory drawings—he wanted his paintings to touch his viewers deeply and to be formally beautiful, like the drawings of Ingres and Matisse.

PRIMORDIAL IMAGERY. Jackson Pollock (1912–56), the most famous of the Jung-influenced Abstract Expressionists, rejected this European tradition of aesthetic refinement—what he referred to as "French cooking"—for cruder, rougher formal values identified with the Wyoming frontier country of his birth. Pollock went to New York in 1930 and studied at the Art Students League and later with the Mexican muralist David Siqueiros. Self-destructive and alcoholic, Pollock entered Jungian psychotherapy in 1939. Because Pollock was reluctant to talk about his problems, the therapist engaged him through his art, analyzing in terms of Jungian symbolism the drawings Pollock brought in each week.

The therapy had little apparent effect on Pollock's personal problems, but it greatly affected his art. He gained a new vocabulary of symbols and a belief in Jung's notion that artistic images that tap into primordial human consciousness can have a positive psychological effect on viewers, even if they do not understand the imagery. In paintings such as **MALE AND FEMALE** (FIG. 32–9), Pollock covered the surface of the painting with symbols he ostensibly retrieved from his unconscious through automatism. Underneath them is a firm compositional structure of strong vertical elements flanking a central rectangle—evidence, according to Pollock's therapist, of the healthy, stable adult psyche in which male and female elements are integrated. Such elements are balanced throughout the painting and within the forms suggesting two facing figures. Each figure combines soft, curving shapes suggestive of femininity with firmer, angular ones that connote masculinity. The sexual identity of both figures is therefore ambiguous; each seems to be both male and female. The painting and the two figures within it represent not only the union of Jung's *anima* (the female principle in the male) and *animus* (the male principle in the female) but also that of Pollock and his then lover, Lee Krasner (1908–84), a painter (SEE FIG. 32–12) with whom he had an intense relationship and whom he would marry in 1945.

32–9 | Jackson Pollock **MALE AND FEMALE**
1942. Oil on canvas, 6'1¼" × 4'1" (1.86 × 1.24 m).
Philadelphia Museum of Art.
Gift of Mr. and Mrs. Gates Lloyd

The reds and yellows used here, like the diamond shapes featured at the center, were inspired by Southwestern Native American art. Native Americans, like other so-called primitive peoples, were believed to have direct access to the collective unconscious and were therefore much studied by Surrealists and early members of the New York School, including Pollock and his psychiatrist.

Action Painting

In the late 1940s, Pollock liberated his earlier automatism in large canvases that evolved into a completely abstract welter that seemed to capture the controlled disorder of a frenzied dance. This forcefully improvisational style came to be known as *action painting*. The term was coined by art critic Harold Rosenberg (1906–78) in his 1952 essay "The American Action Painters," in which he claimed: "At a certain moment the canvas began to appear to one American painter after another as an arena in which to act—rather than a space in which to reproduce, redesign, analyze, or 'express' an object, actual or imagined. What was to go on the canvas was not a

picture but an event." Although he did not mention them by name, Rosenberg was referring primarily to Pollock and to Pollock's chief rival for leadership of the New York School, Willem de Kooning (1904–97). It was Pollock, said de Kooning, who "broke the ice."

EXPLODING HIERARCHY. Beginning in the fall of 1946, Pollock worked in a renovated barn, where he placed his canvases on the floor so that he could work on them from all four sides. He also began to employ enamel house paints along with conventional oils, dripping them onto his canvases with sticks and brushes, using a variety of fluid arm and wrist movements (FIG. 32–10). As a student, he had experimented with spraying and dripping industrial paints during his studies with Siqueiros. He was also, according to his wife, a "jazz addict" who would spend hours listening to the explosively improvised bebop of Charlie Parker and Dizzy Gillespie. In addition, visits to the Natural History Museum allowed him to witness Navajo sand painting, a healing ritual in which a shaman pours colored sand on the floor in symbolic patterns. All of these sources help us to understand where Pollock's art came from, but they do not explain the power of the works he created from them, which engulf the viewer's entire field of vision (FIG. 32–11). AUTUMN RHYTHM and other works by Pollock from this period innovate in many ways. Besides the novel method of paint application shown in the photo, the works show no trace of the Cubist picture space, Picasso's chief legacy to Modern art. Following from this, the composition lacks hierarchical arrangement, as almost every area of the work is equally energized. In addition, the work shows

32–10 | Hans Namuth **PHOTOGRAPH OF JACKSON POLLOCK PAINTING**
The Springs, New York. 1950.

32–11 | Jackson Pollock **AUTUMN RHYTHM (NUMBER 30)**
1950. Oil on canvas, 8'9" × 17'3" (2.66 × 5.25 m). The Metropolitan Museum of Art, New York.
George A. Hearn Fund, 1957 (57.92)

32–12 | Lee Krasner **THE SEASONS**
1957. Oil on canvas, 7'8¾" × 16'11¼" (2.36 × 5.18 m). Whitney Museum of American Art, New York.
Purchased with funds from Frances and Sydney Lewis (by exchange), the Mrs. Percy Uris Purchase Fund, and the Painting and Sculpture Committee (87.7)

clearly its process of making; we could literally retrace most of the artist's steps around the canvas. Finally, the work embodies a new level of physical involvement of the artist with his product. These paintings rank, along with certain works by Kandinsky (FIG. 31–14), Picasso (FIG. 31–18), and Duchamp (FIG. 31–36), among the most important breakthroughs of Modern art. As innovative as they are in a formal sense, these works also speak for the times. Pollock said in a radio interview that he was creating for "the age of the airplane, the atom bomb, and the radio," and the works do seem to embody something of the tensions of the Cold War period, as each side silently threatened the other with instant annihilation.

PAINTING FROM HARMONY, PAINTING FROM DOUBT. Lee Krasner (1908–84), who had studied in New York with the German expatriate teacher and abstract painter Hans Hofmann (1880–1966), produced fully nonrepresentational work several years before Pollock did. After she began living with him in 1942, however, she virtually stopped painting to devote herself to the conventional role of a supportive wife. Following the couple's move to Long Island in 1945, she set up a small studio in a guest bedroom, where she produced small, tight, gestural paintings similar in composition to Pollock's but lacking their sense of freedom. After Pollock's death in an automobile crash in 1956, Krasner took over his studio and produced large, dazzling gestural paintings, known as the *Earth Green* series, which marked her emergence from her husband's shadow. Works such as **THE SEASONS** (FIG. 32–12) feature bold, sweeping curves

that express not only her new sense of liberation but also her identification with the forces of nature in the bursting, rounded forms and springlike colors. "Painting, for me, when it really 'happens' is as miraculous as any natural phenomenon," said Krasner, suggesting an attitude similar to that of Pollock, who found "pure harmony" in the act of painting.

By contrast, Willem de Kooning insisted that "Art never seems to make me peaceful or pure." An immigrant from the Netherlands, de Kooning in the 1930s became friendly with several Modern painters but resisted the shift to Jungian Surrealism. For him it was more important to record honestly and passionately his sense of the world around him, which was never simple or certain. "I work out of doubt," he once remarked. During the 1940s he expressed his nervous uncertainty in the agitated way he handled paint itself. We see these autobiographical urges in action paintings such as **ASHEVILLE** (FIG. 32–13). De Kooning was less radical than Pollock in that he still used brushes and an easel, but the work shares the sense of urgent improvisation that typifies the style. The dominant rhythm of this work is controlled by the brushstrokes in black (including paint drips) that define jagged blocks. Some passages suggest fleshy body parts or eyes, but they are created by natural arm movements or gestures with the brush. The work's title is the name of the town in North Carolina near where Black Mountain College is located, a small college where de Kooning taught in the summer of 1948. Existentialist-oriented art critics see in these works an artist offering a rich glimpse of his own self, captured in a moment. If Sartre was correct in saying that there are no absolutes anymore,

32–13 Willem de Kooning **ASHEVILLE**
1948. Oil and enamel on cardboard, 25⁹⁄₁₆ × 31⅞″ (64.6 × 80.7 cm). Phillips Collection, Washington, D.C.
© The Willem de Kooning Foundation / Artists Rights Society (ARS), New York

32–14 Jean-Paul Riopelle **KNIGHT WATCH**
1953. Oil on canvas, 38 × 76⅝″ (96.6 × 194.8 cm). The National Gallery of Canada, Ottawa, Ontario.

then all we really have is our selves as a reference point. Sartre held that people create their own identities through the decisions that they make, day by day, rather than through realization of some inner destiny or essence. If so, autobiographical works such as this are valuable because they offer us a condensation of the artist's self, built up in paint through a process of steps and decisions that this work makes obvious. Such was certainly the artist's goal.

ACTION PAINTING EXTENDS ITSELF. Action painting soon influenced artists in Canada and in Europe. One participant in this broad movement was the French Canadian painter Jean-Paul Riopelle (1923–2002), who settled in Paris in 1947. In his native Montreal, Riopelle had participated in the activities of *Les Automatistes* ("The Automatists"), who applied the Surrealist technique of automatism to the creation of abstract paintings. In the early 1950s, he began to squeeze blobs of paint directly onto the canvas and then spread them with a palette knife to create an "all-over" pattern of bright color patches, suggestive of broken shards of stained glass, and often traversed, as in **KNIGHT WATCH** (FIG. 32–14), by a network of spidery lines.

Helen Frankenthaler (b. 1928) visited Pollock's studio in 1951 and went on to create a more lyrical version of action painting that had an important influence on later artists. Like Pollock, she worked on the floor, but rather than flinging paint she poured it out in thin washes (FIG. 32–15). She also used unprimed canvas, so that the paint soaked into the fabric rather than sitting on the surface. She typically began a work with some aesthetic question, but soon the process of creation became a self-expressive act as well. She described her working method in an interview (*Artforum,* October 1965): "I will sometimes start a picture feeling, What will happen if I work with three blues . . . ? And very often midway through the picture I have to change the basis of the experience. Or I add and add to the canvas. . . . When I say gesture, my gesture, I mean what my mark is. I think there is something now that I am still working out in paint; it is a struggle for me to both discard and retain what is gestural and personal." In **MOUNTAINS AND SEA,** she poured several colors, then outlined some of them in charcoal. The result reminded her of the coast of Nova Scotia where she frequently went to sketch, so the title of the work, applied later, alludes to this.

Color Field Painting

New York School artists used abstract means to express various sorts of emotional states, not all of them as urgent or improvisatory as that of the action painters. A group known as Color Field painters also developed out of the biomorphic Surrealism of Gorky and Lam, but they moved in a different direction. Responding in part to what they saw as a spiritual problem in modern society, they created works that use large, flat areas of color to evoke transcendent moods of contemplation.

32–15 | Helen Frankenthaler **MOUNTAINS AND SEA** 1952. Oil and charcoal on canvas, 7'2¾" × 9'8¼" (2.2 × 2.95 m). Collection of the artist on extended loan to the National Gallery of Art, Washington, D.C.

32–16 | Mark Rothko **NO. 61, BROWN, BLUE, BROWN ON BLUE**
1953. Oil on canvas, 9'7¾" × 7'7¼" (2.94 × 2.32 m).
The Museum of Contemporary Art, Los Angeles.
The Panza Collection

THE DIVIDED INDIVIDUAL. Mark Rothko's (1903–1970) mature paintings typically feature two to four soft-edged rectangular blocks of color hovering one above another against a monochrome ground. In works such as **BROWN, BLUE, BROWN ON BLUE** (FIG. 32–16) Rothko sought to bring together the two divergent human tendencies that German philosopher Friedrich Nietzsche called the Dionysian and the Apollonian. The rich color represents the emotional, instinctual, or Dionysian element (after Dionysus, the Greek god of wine, the harvest, and inspiration), whereas the simple compositional structure is its rational, disciplined, or Apollonian counterpart (after Apollo, the Greek god of light, music, and truth). However, Rothko was convinced of Nietzsche's contention that the modern individual was "tragically divided," so his paintings are never completely unified but remain a collection of separate parts. What gives this fragmentation its particular force is that these elements offer an abstraction of the human form. In *Brown, Blue, Brown on Blue*, as elsewhere, the three blocks approximate the human division of head, torso, and legs. The vertical paintings, usually somewhat taller than the adult viewer, thus present the viewer with a kind of amplified mirror image of the divided self. The dark tonalities that Rothko increasingly featured in his work emphasize the tragic implications of this division. The best of his mature paintings maintain a tension between the harmony they seem to seek and the fragmentation they regretfully acknowledge.

THE INDIVIDUAL AND THE SUBLIME. Barnett Newman also developed a distinctive nonrepresentational art to address modern humanity's existential condition, declaring his "subject matter" to be "[t]he self, terrible and constant." Newman specialized in monochrome canvases with one or more vertical lines, or "zips," dividing the surface, as in **VIR HEROICUS SUBLIMIS** (FIG. 32–17), whose Latin title means "Man, Heroic and Sublime." Newman often painted large works that engulf the viewer with color. He hoped to provide a modern experience of the sublime, as artists of the past such as Turner had done (SEE FIG. 30–15), but through abstract means which are not attached to any kind of scenery. Newman wondered whether modern science had demystified the world so much that people had lost the ability to sense the sublime. Jung wrote in *Modern Man in Search of a Soul* that the urge for the sublime was indeed frustrated in the modern era, and this led people to engage in war and slaughter as a perverse, negative substitute. Newman's own study of non-Western mythology convinced him that the sublime feelings are basic to most of the world's religions, yet modern Christianity seemed devoted to worldly goals such as material success and getting along well with others. The most popular minister of that period, the New York-based Dr. Norman Vincent Peale, achieved bestseller status with faith-based books such as *The Power of Positive Thinking*. Newman saw this as superficial. Writing about his art in the third person in an essay called "The Plasmic Image," he said: "The present painter is concerned not with his own feelings or with the mystery of his own personality but with the penetration into the world of mystery. His imagination is therefore attempting to dig into metaphysical secrets. To that extent his art is concerned with the sublime."

Sculpture of the New York School

Most sculptural media resist the spontaneous handling that painters such as Pollock developed, but some sculptors still took the New York School into the third dimension by using abstract means to transmit meanings and emotional states. The most important of these, David Smith (1906–1965) and Louise Nevelson (1899–1988), were first trained as painters, and their work retained important links to that medium.

WORKING WITH METAL. Smith gained metalworking skills at 19 as a welder and riveter at an automobile plant in his native Indiana. He first studied painting but turned to sculpture in the early 1930s after seeing reproductions of welded metal sculptures by Picasso and others. After World War II, Smith defied the traditional values of vertical, monolithic sculpture by welding horizontally formatted,

32–17 | Barnett Newman **VIR HEROICUS SUBLIMIS**
1950-51. Oil on canvas, 7'11⅜" × 17'9¼" (2.42 × 5.41 m). The Museum of Modern Art, New York.
Gift of Mr. and Mrs. Ben Heller

open-form pieces that resemble drawings in space. A fine example is **HUDSON RIVER LANDSCAPE** (FIG. **32–18**), whose fluent metal calligraphy, reminiscent of Pollock's poured lines of paint, was inspired by views from a train window of the rolling topography of upstate New York. Like many of his works from this period, the piece is meant to be seen from the front, like a painting.

During the last five years of his life, Smith turned from nature-based themes to formalism—a shift partly inspired by his discovery of the expressive properties of stainless steel. Smith explored both its relative lightness and the beauty of its polished surfaces in the *Cubi* series, monumental combinations of geometric units inspired by and offering homage to the formalism of Cubism. Like the Analytic Cubist works of

32–18 | David Smith
HUDSON RIVER LANDSCAPE
1951. Welded steel,
49 × 73¾ × 16½"
(127 × 187 × 42.1 cm).
Whitney Museum of American Art,
New York.
Art © Estate of David Smith/Licensed by
VAGA, New York, N.Y.

32–19 | Louise Nevelson **SKY CATHEDRAL**
1958. Assemblage of wood construction, painted black, 11′3½″ × 10′¼″ × 1′6″ (3.44 × 3.05 × 0.46 m).
The Museum of Modern Art, New York.

Gift of Mr. and Mrs. Mildwoff

Braque and Picasso (SEE FIG. 31–21), *Cubi XIX* (see Fig. 6, Introduction) presents a finely tuned balance of elements that, though firmly welded together, seems ready to collapse at the slightest provocation. The viewer's aesthetic pleasure depends on this tension and on the dynamic curvilinear patterns formed by the play of light over the sculpture's burnished surfaces. The *Cubi* works were meant to be seen outdoors, not only because of the effect of sunlight but also because of the way natural shapes and colors complement the inorganic ones.

WORKING WITH WOOD. While many sculptors of the New York School shared Smith's devotion to welded metal, some

continued to work with more traditional materials, such as wood. Wood became the signature medium of Louise Nevelson (1899–1988), a Russian immigrant who gained intimacy with the material as a child in Maine, where her father ran a lumberyard. After studying painting with Hans Hofmann, who introduced her to the formal language of Cubism, Nevelson turned to sculpture around 1940, working first in a biomorphic mode reminiscent of Henry Moore (SEE FIG. 31–71) before discovering her talent for evoking ancient ruins, monuments, and royal personages through assemblage.

Nevelson's most famous works are the wall-scale assemblages she began to produce in the late 1950s out of stacked packing boxes, which she filled with carefully and

sensitively arranged Analytic Cubist-style compositions of chair legs, broom handles, cabinet doors, spindles, and other wooden objects. She painted her assemblages a matte black to obscure the identity of the individual elements, to formally integrate them, and to provide an element of mystery. One of her first wall assemblages was **SKY CATHEDRAL** (FIG. 32–19), which Nevelson believed could transform an ordinary space into another, higher realm—just as the prosaic elements she worked with had themselves been changed. To add a further poetic dimension, Nevelson first displayed *Sky Cathedral* bathed in soft blue light, like moonlight.

EXPERIMENTS WITH FORM IN BUENOS AIRES

Uruguayan and Argentine artists were as innovative as their counterparts from the New York School but in a completely different direction. Starting from the geometric abstraction of Mondrian (SEE FIG. 31–60), they pioneered a range of new techniques in abstract painting and sculpture. They gathered in Buenos Aires immediately after the war, where they formed the groups Arte Concreto-Invención and Madí. Like the Abstraction-Creation group in Europe (see Chapter 31), the South Americans were also motivated by antifascism: Ruling Argentina at that time was Juan Perón, who admired Italian dictator Mussolini and professed a profound dislike of Modern art.

The forerunner of the Latin American experiments was the Uruguayan Joaquín Torres-García (1874–1949), who established what he called a "School of the South" in Montevideo, Uruguay's capital. He had spent forty-three years in Europe and participated in several abstract art groups. His own art was also rooted in Pre-Columbian indigenous art forms of the Inca, especially their masonry buildings (SEE FIG 26–6). He regarded ancient American cultures as a fertile bed of ideas similar to how Europeans might regard ancient Greek art: an important traditional source for later innovation. Torres-García also noticed that the patterns of stone in Inca architecture resembled the abstract paintings of Mondrian and others, a fact that he took as support for the universal validity of abstract art. His paintings (FIG. 32–20) combine ideas gleaned from Mondrian with Pre-Columbian patterns in a style he called Constructive Universalism. A tireless educator, he taught hundreds of students, formed several magazines, and even hosted a radio show.

32–20 | Joaquín Torres-García **ABSTRACT ART IN FIVE TONES AND COMPLEMENTARIES**
1943. Oil on board mounted on panel, 20½ × 26⅝″ (52.1 × 67 cm). Albright Knox Art Gallery, Buffalo, N.Y.
Gift of Mr. and Mrs. Armand J. Castellani, 1979 / Artists Rights Society (ARS), New York

Concrete-Invention

After visiting Torres-García and taking in his polemical materials in the years just after World War II, younger artists in Buenos Aires moved their art even further away from representation. Mondrian, after all, was still representing a cosmic order, and Torres-García owed some of his forms to ancient stone walls. They called their group "Concrete" in order to avoid the term *abstract,* which might mean that their art was abstracted from something else. Rather, they stressed their own "Invention" of new forms. Their first important discovery was the shaped canvas (FIG. 32–21), here in a version by Raúl Lozza (b. 1911). The artist's goal was not to picture or represent anything, nor was it to transcribe or symbolize his emotional state. The work should exist without reference to any other reality. Art with a representational agenda, even a hidden one, is harmful because it "tends to sap the mental strength of viewers, leaving them unaware of their true powers," according to one of the group's manifestos. Representational art makes viewers into passive spec-

tators. Rather, Lozza invented these forms without any preconceived notion so that the viewer could experience the forms merely as forms. Conforming the creations to a rectangular format limits the artist's scope of invention. Moreover, a shaped canvas was necessary because a rectangular or square painting might still be readable as a "picture" of something. Straight edges are necessary because curved ones might remind viewers of some organic shape. The surface is completely smooth because showing brushwork would point the viewer's attention away from the work itself and toward the artist. Lozza, who made leftist political cartoons in the 1930s, hoped that viewers would grasp their "true powers" after seeing these works and be more inclined to invent something in their own lives.

Madí

The next aesthetic question follows logically from Lozza's work, and it led to another important innovation: If the artist's goal is to invent new forms, why limit oneself to paint on a flat surface? Can artists invent in entirely new media? These questions first occurred to Gyula Kosice (b. 1924), and they led him to split from Concrete-Invention and form Madí in 1946. (The name, pronounced "mah-DEE," is a nonsense word.) This group, which included poets and composers as well as painters, rejected many of the previous limitations of their media. Madí poets arranged words on the page in visual patterns rather than verses; composers threw out the Western harmonic system, as Schoenberg had done earlier (see Chapter 31). After painting shaped canvases and experimenting with sculpture that moved, Kosice in 1946 was the first to make a sculpture out of neon lights (FIG. 32–22). As in Lozza's **ANALYTICAL STRUCUTURE**, the shapes are intended to be completely abstract, but here they are also immaterial, since they consist of neon gas agitated to a glow by electricity. Color is not something that the artist applied to the work, but rather it exists in the tube and in the air surrounding it. The artists of Madí and Concrete-Invention exhibited widely over the next two decades, and helped establish a strong current of geometric abstraction in Latin American art, which at times converged with later European and North American developments.

POSTWAR PHOTOGRAPHY

Documentary photography, which flourished under New Deal patronage in the 1930s (see page 1116), went into eclipse following the withdrawal of government support during World War II. Meanwhile, photojournalism, which burgeoned in the 1930s with the appearance of large-format picture magazines such as *Life,* grew in importance during the postwar decades. Fashion periodicals such as *Vogue* and *Harper's Bazaar* also provided work for professional photographers and stimulated the development of color photography.

32–21 | Raul Lozza **ANALYTICAL STRUCUTURE**
1946. Oil and ribbon on wood, 20½ × 11 ⅞"
(52.1 × 32.5 cm). Galerie von Bartha, Basel.
Artists Rights Society (ARS), New York

sensitively arranged Analytic Cubist-style compositions of chair legs, broom handles, cabinet doors, spindles, and other wooden objects. She painted her assemblages a matte black to obscure the identity of the individual elements, to formally integrate them, and to provide an element of mystery. One of her first wall assemblages was **SKY CATHEDRAL** (FIG. 32–19), which Nevelson believed could transform an ordinary space into another, higher realm—just as the prosaic elements she worked with had themselves been changed. To add a further poetic dimension, Nevelson first displayed *Sky Cathedral* bathed in soft blue light, like moonlight.

EXPERIMENTS WITH FORM IN BUENOS AIRES

Uruguayan and Argentine artists were as innovative as their counterparts from the New York School but in a completely different direction. Starting from the geometric abstraction of Mondrian (SEE FIG. 31–60), they pioneered a range of new techniques in abstract painting and sculpture. They gathered in Buenos Aires immediately after the war, where they formed the groups Arte Concreto-Invención and Madí. Like the Abstraction-Creation group in Europe (see Chapter 31), the South Americans were also motivated by antifascism: Ruling Argentina at that time was Juan Perón, who admired Italian dictator Mussolini and professed a profound dislike of Modern art.

The forerunner of the Latin American experiments was the Uruguayan Joaquín Torres-García (1874–1949), who established what he called a "School of the South" in Montevideo, Uruguay's capital. He had spent forty-three years in Europe and participated in several abstract art groups. His own art was also rooted in Pre-Columbian indigenous art forms of the Inca, especially their masonry buildings (SEE FIG 26–6). He regarded ancient American cultures as a fertile bed of ideas similar to how Europeans might regard ancient Greek art: an important traditional source for later innovation. Torres-García also noticed that the patterns of stone in Inca architecture resembled the abstract paintings of Mondrian and others, a fact that he took as support for the universal validity of abstract art. His paintings (FIG. 32–20) combine ideas gleaned from Mondrian with Pre-Columbian patterns in a style he called Constructive Universalism. A tireless educator, he taught hundreds of students, formed several magazines, and even hosted a radio show.

32–20 | Joaquín Torres-García **ABSTRACT ART IN FIVE TONES AND COMPLEMENTARIES** 1943. Oil on board mounted on panel, 20½ × 26⅜" (52.1 × 67 cm). Albright Knox Art Gallery, Buffalo, N.Y.
Gift of Mr. and Mrs. Armand J. Castellani, 1979 / Artists Rights Society (ARS), New York

Concrete-Invention

After visiting Torres-García and taking in his polemical materials in the years just after World War II, younger artists in Buenos Aires moved their art even further away from representation. Mondrian, after all, was still representing a cosmic order, and Torres-García owed some of his forms to ancient stone walls. They called their group "Concrete" in order to avoid the term *abstract*, which might mean that their art was abstracted from something else. Rather, they stressed their own "Invention" of new forms. Their first important discovery was the shaped canvas (FIG. 32–21), here in a version by Raúl Lozza (b. 1911). The artist's goal was not to picture or represent anything, nor was it to transcribe or symbolize his emotional state. The work should exist without reference to any other reality. Art with a representational agenda, even a hidden one, is harmful because it "tends to sap the mental strength of viewers, leaving them unaware of their true powers," according to one of the group's manifestos. Representational art makes viewers into passive spec-

tators. Rather, Lozza invented these forms without any preconceived notion so that the viewer could experience the forms merely as forms. Conforming the creations to a rectangular format limits the artist's scope of invention. Moreover, a shaped canvas was necessary because a rectangular or square painting might still be readable as a "picture" of something. Straight edges are necessary because curved ones might remind viewers of some organic shape. The surface is completely smooth because showing brushwork would point the viewer's attention away from the work itself and toward the artist. Lozza, who made leftist political cartoons in the 1930s, hoped that viewers would grasp their "true powers" after seeing these works and be more inclined to invent something in their own lives.

Madí

The next aesthetic question follows logically from Lozza's work, and it led to another important innovation: If the artist's goal is to invent new forms, why limit oneself to paint on a flat surface? Can artists invent in entirely new media? These questions first occurred to Gyula Kosice (b. 1924), and they led him to split from Concrete-Invention and form Madí in 1946. (The name, pronounced "mah-DEE," is a nonsense word.) This group, which included poets and composers as well as painters, rejected many of the previous limitations of their media. Madí poets arranged words on the page in visual patterns rather than verses; composers threw out the Western harmonic system, as Schoenberg had done earlier (see Chapter 31). After painting shaped canvases and experimenting with sculpture that moved, Kosice in 1946 was the first to make a sculpture out of neon lights (FIG. 32–22). As in Lozza's **ANALYTICAL STRUCUTURE**, the shapes are intended to be completely abstract, but here they are also immaterial, since they consist of neon gas agitated to a glow by electricity. Color is not something that the artist applied to the work, but rather it exists in the tube and in the air surrounding it. The artists of Madí and Concrete-Invention exhibited widely over the next two decades, and helped establish a strong current of geometric abstraction in Latin American art, which at times converged with later European and North American developments.

POSTWAR PHOTOGRAPHY

Documentary photography, which flourished under New Deal patronage in the 1930s (see page 1116), went into eclipse following the withdrawal of government support during World War II. Meanwhile, photojournalism, which burgeoned in the 1930s with the appearance of large-format picture magazines such as *Life*, grew in importance during the postwar decades. Fashion periodicals such as *Vogue* and *Harper's Bazaar* also provided work for professional photographers and stimulated the development of color photography.

32–21 | Raul Lozza **ANALYTICAL STRUCUTURE**
1946. Oil and ribbon on wood, 20½ × 11 ⅞"
(52.1 × 32.5 cm). Galerie von Bartha, Basel.
Artists Rights Society (ARS), New York

32–25 | Minor White **CAPITOL REEF, UTAH**
1962. Gelatin-silver print. The Museum of Modern Art, New York.
Purchase. Courtesy © The Minor White Archive, Princeton, New Jersey

She also usually allowed these subjects to sense the presence of the camera, allowing the subject to look back at us. This memorably broke down the distance between viewer and subject.

The Modernist Heritage

Other postwar photographers remained largely aloof from the social landscape and worked at expanding the Modernist line of Emerson and Stieglitz. A leading practitioner of this mode was Minor White (1908–76), whose aesthetically beautiful photographs were also meant to be forms of mystical expression, vehicles of self-discovery and spiritual enlightenment. Using a large-format camera, White focused sharply on weathered rocks (FIG. 32–25), swirling waves, frosted windowpanes, peeling paint, and similar "found" subjects that, as enigmatic photographic images, could serve as abstract visual equivalents for inner emotional states. In the late 1940s, White began showing his works in numbered sequences rather than as isolated individual images, thereby hoping to build a mood over a series of pictures. He experimented with infrared film in the middle 1950s, photographing light invisible to the naked eye in an effort to make his photos transcend physical reality. He also worked to advance photography as an art form, founding and then editing *Aperture* magazine from 1952 to 1975.

MOVING INTO THE REAL WORLD

The next generation of artists, who reached maturity in the 1950s, looked for new ways to link their art to the real world. One reason for this was a rebellion against their immediate forebears. New York School artists, after all, were studio-based. Despite their innovative techniques and formats, they used traditional media: paint, canvas, metal, wood. Perhaps the next goal should be to move beyond the studio. Moreover, younger artists saw the New York School as very serious, their brows darkened by the war and Existentialism, as they tried to flesh out their deeper selves in their work or heal a crisis of human spirituality. Members of the younger generation did not experience the war as adults, so it had less impact on their consciousness. Rather, as the Western world healed from the war's destruction, they saw growing waves of material prosperity that they grappled with in their creations. Thus, the most innovative European and North American artists in the 1950s and early 1960s reintroduced the real world into art and often worked in a less serious and sometimes even playful mode. The movements that resulted were Assemblage, Happenings, and Pop Art.

Assemblage

The most important early influence on the move toward the real world was the composer John Cage (1912–1992). Along with Dada poet Hugo Ball and Surrealist leader André Breton, Cage is one of the most important nonvisual artists to influence the course of Modern art history. He studied composition during the war years with Arnold Schoenberg, whose rejection of the major and minor musical scales earlier in the century paralleled the rise of completely abstract art (see page 1074). Cage's most important innovation in music was to open his works to the random sounds of noise that we all live with every day. For example, he created a piece for twelve radios, whose score consisted of instructions to twelve operators on how to turn their volume and tuning dials; naturally this piece sounded radically different at each new performance and in each new location. The composer did not express his own feelings in this work; rather, he set up a situation in which unpredictable events can happen. This method of creation was a logical outgrowth of his study of Zen Buddhism, which teaches that enlightenment can come at any time, from any sort of experience. Likewise, Assemblage artists gather seemingly random objects and put them together in unruly compositions, not in order to make a predetermined statement but rather to see what kind of meanings might emerge.

BETWEEN ART AND LIFE. Cage was teaching at Black Mountain College near Asheville, North Carolina, when he met his most precocious student, Robert Rauschenberg (b. 1925). Rauschenberg also studied painting with Willem de Kooning, who was on the faculty that year (see his *Asheville*, Fig. 32–13). Ever the

32–26 | Robert Rauschenberg **CANYON**
1959. Combine painting: oil, pencil, paper, metal, photograph, fabric, wood on canvas, plus buttons, mirror, stuffed eagle, pillow tied with cord, and paint tube, 6′1″ × 5′6″ × 2′¾″ (1.85 × 1.68 × 0.63 m).
Courtesy Sonnabend Gallery, on infinite loan to the Baltimore Museum of Art, Baltimore, Maryland.

Art © Robert Rauschenberg/Licensed by VAGA, New York, NY

irreverent prankster, Rauschenberg asked for a drawing by the action painter and expressed his feeling about the older generation by erasing it (with de Kooning's permission). After a trip to Europe in 1948–49, where he saw work by Alberto Burri, among others (SEE FIG. 32–6), Rauschenberg began finding ways to "work in the gap between art and life," as he put it. In 1951, he exhibited a series of blank white paintings, so that the lights in the room and the shadows cast by viewers became the content of the canvases. This closely parallels a similar work by Cage from the same period, *4' 33"* (four minutes thirty-three seconds), which calls for a player or players to sit silently on the stage at their instruments for that length of time, allowing any random sounds to become the work.

Between 1955 and 1960, Rauschenberg created his most important pieces, which he called *Combines* because they combined painting and sculpture. **CANYON,** for example (**FIG. 32–26),** features an assortment of family photographs, public imagery (such as the Statue of Liberty), fragments of political posters (in the center), and various objects salvaged from trash (the flattened steel drum at upper right) or purchased (the stuffed eagle). This agglomeration shares space with various patches of paint. The rich disorder in this work challenges the viewer to make sense of it. In fact, Rauschenberg meant his work to be open to various readings, so he assembled mate-rial that each viewer might interpret differently. One could, for example, see the Statue of Liberty as a symbolic invitation to interpret the work freely. Or perhaps, covered as it is with paint applied in the manner of action painting, it symbolizes that style. Following Cage's ideas, Rauschenberg created a work of art that was to some extent beyond his control—a work of iconographic as well as formal disarray. Rauschenberg cheerfully accepted the chaos and unpredictability of modern urban experience and tried to find artistic metaphors for it. "I only consider myself successful," he said, "when I do something that resembles the lack of order I sense."

BETWEEN ABSTRACTION AND REPRESENTATION. Jasper Johns (b. 1930) integrated the real world in his work in order to ask more direct questions about the nature of art. He came to New York from South Carolina in 1948 and met Rauschenberg six years later. Unlike Rauschenberg's works, Johns's are controlled, emotionally cool, and highly cerebral. Inspired by the example of Marcel Duchamp (SEE FIG. 31–36), Johns produced conceptually puzzling works that seemed to bear on issues raised in contemporary art. Art critics, for example, had praised the evenly dispersed, "nonhierarchical" quality of so much Abstract Expressionist painting, particularly Pollock's. The target in **TARGET WITH FOUR FACES** (FIG. 32–27), an

32–27 | Jasper Johns **TARGET WITH FOUR FACES**
1955. Assemblage: encaustic on newspaper and cloth over canvas, surmounted by four tinted plaster faces in wood box with hinged front; overall, with box open, 33⅝ × 26 × 3" (85.3 × 66 × 7.6 cm). The Museum of Modern Art, New York.

Gift of Mr. and Mrs. Robert C. Scull, (8.1958) Art © Jasper Johns/Licensed by VAGA, New York, NY

emphatically hierarchical, organized image, can be seen as a critical comment on this discourse. The image also raises thorny questions about the difference between representation and abstraction. The target, although arguably a representation, is flat, whereas two-dimensional representational art usually creates the illusion of three-dimensional space. The target therefore occupies a troubling middle ground between the two kinds of painting then struggling for dominance in American art.

Johns, Cage, and Rauschenberg collaborated on several theatrical events in the late 1950s and early 1960s that may be the most perfect assemblages. Cage provided the music while Johns and Rauschenberg made sets and sometimes performed. Dancers came from the Merce Cunningham Dance Company, which specialized in making dance out of everyday actions such as waiting for a bus or reading a newspaper. Prior to the events, none of them informed the others of what they were going to do, or even for how long, so that the result was a multimedia evening of legendary unpredictability.

Happenings

Happenings resemble Assemblage in their incorporation of the real world, but Happenings are more scripted events that take place over a predetermined period of time. Many creators of Happenings acknowledged a debt to Jackson Pollock and his physical enactment of the work of art (SEE FIG. 32–10). If Pollock used his entire body with paint to create two-dimensional works, Happening artists used their bodies in the real world to create events.

THE GUTAI GROUP. The first Happenings took place in Japan, where recovery from war was closely supervised by American occupation. General Douglas MacArthur personally rewrote the Japanese constitution and directed a peaceful social revolution in order to transform postwar Japan into a Western-style nation. This naturally led to a radical collapse of old values that artists took advantage of. Some painters formed the Gutai group in 1954 to "pursue the possibilities of pure and creative activity with great energy," as their manifesto put it. Gutai organized outdoor installations, theatrical events, and dramatic displays of art making. The name of the movement means "embodiment," and most Gutai Happenings involved the artist performing some radical action. For example, one artist made paintings with his feet before an invited audience. Another made "drawings" by framing huge sheets of paper and walking through them. At the second Gutai Exhibition in 1956, Shozo Shimamoto (b. 1928) dressed in protective clothing and eyewear to produce HURLING COLORS (FIG. 32–28) by smashing bottles of paint on a canvas laid on the floor. This pushed Pollock's drip technique into the realm of a performance. Since there was practically no market for contemporary

32–28 Shozo Shimamoto **HURLING COLORS**
1956. Happening at the second Gutai Exhibition, Tokyo.

art in Japan at that time, the artists often destroyed their works after the Happening was over.

KAPROW. The leading creator of Happenings in the United States was Allan Kaprow (1927–2006), like the Assemblagists a student of John Cage. Kaprow's Happenings usually involved simple scripts that invited guests acted out. A particularly ambitious Kaprow Happening of the early 1960s was **THE COURTYARD** (FIG. 32–29), staged on three consecutive nights in the skylight-covered courtyard of a run-down Greenwich Village hotel. At the center of the courtyard stood a 30-foot-high tar paper–covered "mountain." Spectators were handed brooms by two workers and invited to help clean the courtyard, which was filled with crumpled newspaper and bits of tin foil, the latter dropped from the windows above. The workers ascended ladders to dump the refuse into the top of the mountain, while a man on a bicycle rode through the crowd, ringing his handlebar bell. After a few moments, wild noises were heard from the mountain, which then erupted in an explosion of black crepe-paper balls. This was followed by a shower of dishes that broke on the courtyard floor, while noises and activity were heard from the windows above. Mattresses and cartons were lowered to the courtyard, which the workers carried to the top of the mountain and fashioned into an "altar-bed." A young woman, wearing a nightgown and carrying a transistor radio, then climbed to the top of the mountain and reclined on the mattresses. Two photographers entered, searching for the young woman. They ascended the ladder, took flash pictures of her, thanked her, and left. The Happening concluded with an "inverse mountain" descending to cover the young woman.

Although Kaprow argued that Happenings lacked literary content, *The Courtyard* was for him richly symbolic: The young woman in the nightgown, for example, was the "dream girl," the "embodiment of a number of old, archetypal symbols. She is the nature goddess (Mother Nature) . . . and Aphrodite (Miss America)." Kaprow admitted that "very

32–29 | Allan Kaprow **THE COURTYARD**
1962. Happening at the Mills Hotel, New York.

The French artist Yves Klein (1928–1962) arrived at Happenings after experimenting with both *Art Informel* and monochromatic abstract art. For his Happening **ANTHRO-POMETRIES OF THE BLUE PERIOD** (FIG. 32–30), Klein invited members of the Paris art world to watch him direct three nude female models covered in blue paint to press their bodies against large sheets of paper. The accompaniment consisted of a string orchestra playing one constant note. This was meant, in part, as a satire on the pretentiousness of action painting, especially Pollock's work on the floor of his studio. Klein wrote, "I dislike artists who empty themselves into their paintings. They spit out every rotten complexity as if relieving themselves, putting the burden on their viewers." He offered instead a sensuous and diverting display, leading to a work that he created without actually touching it himself.

The Swiss-born Jean Tinguely (1925–1991) made comical Assemblages out of machinery that amounted to Happenings when activated. He studied art in Switzerland during the war, where he got to know several leading Dadaists, including Kurt Schwitters (SEE FIG. 31–37). Among Tinguely's most ingenious contraptions were his *Metamatics,*

few of the visitors got these implications out of *The Courtyard,*" but he believed that many sensed at some level "there was something like that going on."

HUMOR HAPPENS. Two Happenings by European artists from 1960 captured the movement's more humorous side. In Europe, Happenings were called New Realism, a term coined by art critic Pierre Restany in that year. Restany wrote that after the New York School and *Art Informel,* the art of painting was over; there was nothing left to be done with it (he was neither the first nor the last to say this; painting keeps coming back from the dead, as we shall see). After painting will come real life, Restany wrote: "The passionate adventure of the real, perceived in itself . . . The New Realists consider the world a painting: a large, fundamental work of which they appropriate fragments."

32–30 | Yves Klein **ANTHROPOMÉTRIES OF THE BLUE PERIOD**
1960. Performance at the Galerie Internationale d'Art Contemporain, Paris.

32–31 | Jean Tinguely **HOMAGE TO NEW YORK**
1960. Self-destroying sculpture in the garden of the Museum of Modern Art, New York.

machines with rolls of paper attached that produced abstract paintings by the yard. Viewers could turn on the machine, watch it run, and tear off the artworks it created. The satirical implication is that abstract art, which was supposed to power-fully express an artist's inner self, can be mass produced.

Happenings are generally scripted events, but when his largest machine once got out of control, it led to a Happen-ing that made history. He designed **HOMAGE TO NEW YORK** (FIG. 32–31) for a special one-day exhibition in the sculpture garden of the Museum of Modern Art. He assembled the work from yards of metal tubing, several dozen bicycle and baby-carriage wheels, a washing-machine drum, an upright piano, a radio, several electric fans, a noisy old printing press, a bassinet, numerous small motors, two Metamatics, several bottles of chemical stinks, and various noisemakers—the whole ensemble painted white and topped by an inflated orange meteorological balloon. The machine was designed to destroy itself when activated. On the evening of March 17, 1960, before a distinguished group of guests, including New York governor Nelson A. Rockefeller, the work was plugged in. As smoke poured out of the machinery and covered the crowd, parts of the contraption broke free and scuttled off in

various directions, sometimes frightening the onlookers. The Metamatics blew abstract art in their direction. A device meant to douse the burning piano—which kept playing only three notes—failed to work, and firefighters had to be called in. They extinguished the blaze and finished the work's destruction—to boos from the audience, who, except for the museum officials, had been delighted by the spectacle. The artist said the event was better than any he could have planned.

Pop Art

Between about 1955 and 1965, some artists made the move into the real world by borrowing mass-produced imagery, or using mass-production techniques in their art, in response to the growing presence of mass media in the prosperous postwar culture. The movement was almost immediately given the name Pop Art to distinguish it from Assemblage, in which artists also used real objects, only some of them mass produced. The exclusive use of mass-produced imagery or techniques gives Pop Art a slicker look than the other contemporary movements. The emotional tone of Pop Art tends to show a more ironic, cynical, or detached attitude, compared with the irreverence or humor of Assemblage and Happenings.

Pop Art had its widest flowering in the United States after about 1962, but the movement originated in England years earlier. The immediate backdrop for Pop Art is wildly increasing prosperity brought on by a postwar economic boom. The Marshall Plan funneled $9.4 billion to Europe for reconstruction, and the infusion brought about an industrial rebound. By 1950, industrial output for Europe as a whole was one-third higher than it had been in 1939. In 1955, European unemployment was only 2 percent. In most Euro-pean countries, the average citizen benefited from an unprecedented level of government benefits, including social security, national health insurance, unemployment benefits, and company pensions. In 1958, for the first time, more peo-ple crossed the Atlantic by air than by sea. When English Prime Minister Harold Macmillan ran for reelection in 1959, his slogan was "You never had it so good!" In such an environ-ment, lonely Existentialism seemed completely discredited.

HAMILTON. In this setting, younger artists wondered what they should do. Some Londoners formed the Independent Group to discuss the function of art in a comfortable indus-trial society which seemed to lack nothing. The group con-sisted of a critic, two architects, two artists, a photographer, and a writer, and they periodically staged exhibitions at Lon-don's Institute of Contemporary Arts. The artist-member generally credited with pioneering the Pop Art style was Richard Hamilton (b. 1922). An apprentice industrial designer during the war, he was thrown out of the Royal Academy for having "low standards." He reasoned, penetrat-ingly and correctly, that the modern mass culture of televi-

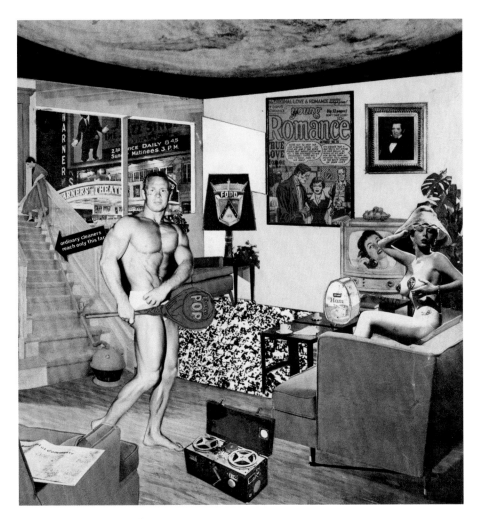

32–32 | Richard Hamilton **JUST WHAT IS IT THAT MAKES TODAY'S HOMES SO DIFFERENT, SO APPEALING?**
1955. Collage, 10¼ × 9¾″ (26 × 24.7 cm). Kunsthalle Tübingen, Germany.
ARS/DACS

sion, movies, and media had taken over many of the previous functions of traditional art. For example, if in the past art showed us ideal beauty, today people see such things in advertising and pin-up photographs. If another function of art is to comment on society, then television news programs do that more vividly. If art has traditionally given us heroic narratives of larger-than-life figures, people today can see this at the movies. Finally, if art somehow symbolizes the times by its style, then car bodies and the latest consumer goods do this just as well.

Hamilton's answer was to make art that ironically used the same strategies as mass media. His 1955 collage has a long title borrowed from advertising slogans: **JUST WHAT IS IT THAT MAKES TODAY'S HOMES SO DIFFERENT, SO APPEALING?** (**FIG. 32–32**). Here we see a man and a woman—Hamilton called them Adam and Eve—in their domestic setting. To point out just a few of the details in this iconographically rich work: The home is populated with brand-name goods, most of them of American origin. Out the window is a movie theater showing *The Jazz Singer,* the 1927 film that was the first to integrate a spoken sound track. On the wall, occupying the

favored place above the TV set, is a portrait of John Ruskin, the moralistic art critic who had libeled James Whistler seventy years before (see "Art on Trial in 1877," page 1025). The central male figure holds the huge sucker that gave the style its name: Art critic Lawrence Alloway referred to that Tootsie Pop when he called Hamilton's collage a work of Pop Art. The work illustrates modern comfort, progress, and success, using the imagery of the mass media themselves. The historical antecedents for this work are the Dada collages of Hannah Höch and others (SEE FIG. 31–38), but Hamilton's work uses later imagery and is less bitter. Like other British Pop artists, Hamilton was not alienated from popular culture; he respected it and worked with it. He later designed an album cover for The Beatles ("White Album," 1968), as did his fellow Pop artist Peter Blake ("Sgt. Pepper's Lonely Hearts Club Band," 1967).

WARHOL. American artists soon found their way to a yet slicker and simpler Pop Art style that uses more layers of irony. Andy Warhol (1928–1987) is a giant of Pop Art if only because he created memorably in many media. Moreover, his

best works conceal important insights behind their mass-produced surfaces. Trained initially as a commercial artist, he decided in 1960 to pursue a career as an artist along the general lines suggested by the work of Johns and Rauschenberg. He took as subjects the iconic images of American mass culture, such as film star Marilyn Monroe (FIG. 32–33). **MARILYN DIPTYCH** is one of the first in which Warhol turned from conventional painting to the assembly-line technique of silkscreening photographic images onto canvas. The method was quicker than painting by hand and thus more profitable, and Warhol could also produce many versions of the subject—all of which he considered good business. He established a workshop in 1965 to make his pieces, and called it ironically The Factory.

The subject of this work is also telling. Like many Americans, Warhol was fascinated by movie stars such as Marilyn Monroe, whose persona became even more compelling after her apparent suicide in 1962, the event that prompted Warhol to begin painting her. The strip of pictures in this work suggests the sequential images of film, the medium that made Monroe famous. Some of these are in black-and-white and some in color, like her movies. The face Warhol portrays, taken from a publicity photograph, is not that of Monroe the person but of Monroe the star, since Warhol was interested in her public mask, not in her personality or character. He borrowed the diptych format from the icons of Christian saints he recalled from the Byzantine Catholic church he had attended as a youth. By symbolically treating the famous actress as a saint, Warhol shed light on his own fascination with fame.

Warhol's most penetrating works take the mass media themselves as subject (FIG. 32–34). **BIRMINGHAM RACE RIOT** deals with the civil rights protests that characterized that period, but Warhol is typically noncommittal in this work. He

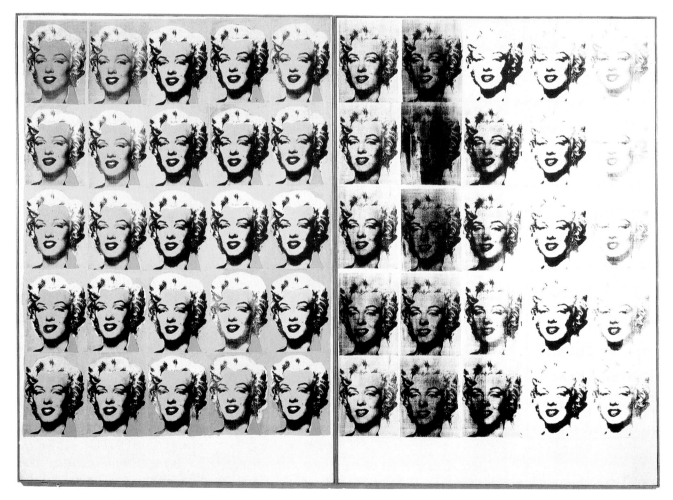

32–33 | Andy Warhol **MARILYN DIPTYCH**
1962. Oil, acrylic, and silkscreen on enamel on canvas, two panels, each 6′10″ × 4′9″ (2.05 × 1.44 m).
Tate Gallery, London.

Warhol assumed that all Pop artists shared his affirmative view of ordinary culture. In his account of the beginnings of the Pop movement, he wrote: "The Pop artists did images that anybody walking down Broadway could recognize in a split second—comics, picnic tables, men's trousers, celebrities, shower curtains, refrigerators, Coke bottles—all the great modern things that the Abstract Expressionists tried so hard not to notice at all."

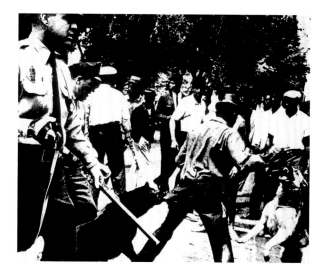

32–34 Andy Warhol **BIRMINGHAM RACE RIOT**
1964. Serigraph on Bristol board, with Japan paper borders,
20 × 24" (50.9 × 60.8 cm). National Gallery of Canada, Ottawa.
(No. 17242) Purchased 1973 / © 2007 Andy Warhol Foundation for the Visual
Arts / SODRAC, Montreal / Artists Rights Society (ARS), New York, NY

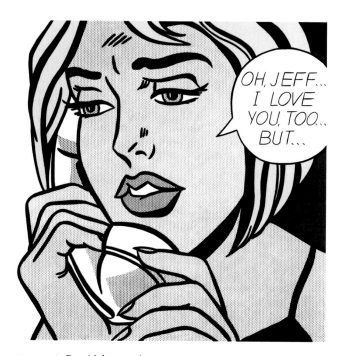

32–35 Roy Lichtenstein **OH, JEFF . . . I LOVE YOU,
TOO . . . BUT . . .**
1964. Oil and Magna on canvas, 48 × 48" (122 × 122 cm).
Private collection.

took no position on the civil rights question but merely tran-
scribed a media image from a popular magazine. Later ver-
sions of this work reproduced the photo dozens of times, as in
the *Marilyn Diptych*. Warhol was among the first to notice that
the mass media bring the whole world much closer to us, but
they also enable us to observe the world in a detached fash-
ion. Tragedies and disasters enter our living rooms every day,

but they come in a small box that we can turn on or off at
will, making us voyeurs rather than participants. Moreover,
the media repeat stories so often that we become desensitized
to their impact. Warhol's works, through deadpan presenta-
tion and seemingly mindless repetition, make both of these
points cogently. He also had a gift for aphorism that by itself
might have guaranteed his fame. Nearly everyone has heard
of his assertion that "In the future everybody will be world-
famous for fifteen minutes." He made a telling comment that
speaks to a central dilemma of modern life: "All of my films
are artificial, but then everything is sort of artificial. I don't
know where the artificial stops and the real starts." Besides his
art pieces and his films, Warhol also founded a magazine
(Interview) and managed a highly influential rock band (The
Velvet Underground). His influence outlasted Modern art
itself, as we shall see.

LICHTENSTEIN. Roy Lichtenstein (1923–97) was among the
first American artists to make art from the *look* as well as the
subjects of popular culture. In 1961, while teaching at Rutgers
University with Allan Kaprow, Lichtenstein began producing
paintings whose imagery and style—featuring heavy black
outlines, flat primary colors, and the **Benday dots** used to add
tone in printing—were drawn from advertisements and car-
toons. The most famous of these early works were based on
panels from war and romance comic books, which Lichten-
stein said he turned to for formal reasons. Although many
assume that he merely copied from the comics, in fact he
made numerous subtle yet important formal adjustments that
tightened, clarified, and strengthened the final image. Never-
theless, most of the paintings retain a sense of the cartoon
plots they draw on. **OH, JEFF . . . I LOVE YOU, TOO . . . BUT . . .**
(FIG. 32–35), for example, compresses into a single frame the
generic romance-comic story line, in which two people fall
in love, face some sort of crisis that temporarily threatens
their relationship, then live happily ever after. Lichtenstein's
work plays an elaborate game with illusion and reality: We
know that comic-book emotions are melodramatic and thus
unreal, and yet he presents them vividly and almost rever-
ently. He actually used a stencil to make sure that he got the
Benday dots right. The issue of what is real and unreal in our
media-saturated culture was just coming to awareness in the
early 1960s; its increasing urgency since then has kept Pop
Art relevant.

OLDENBURG. Swedish-born Claes Oldenburg (b. 1929)
took both a more critical and a more humorous attitude
toward his popular subjects than did Warhol and Lichtenstein.
Oldenburg's humor is most evident in such large-scale public
projects as his Lipstick Monument for his alma mater, Yale
University **(FIG. 32–36).** Oldenburg created this work at the
invitation of a group of graduate students in Yale's School of
Architecture, who requested a monument to the "Second

32–36 | Claes Oldenburg
LIPSTICK (ASCENDING) ON CATERPILLAR TRACKS
1969, reworked 1974. Painted steel body, aluminum tube, and fiberglass tip, 21′ × 19′ 5½″ × 10′11″
(6.70 × 5.94 × 3.33 m). Yale University Art Gallery, New Haven, Connecticut.

Gift of Colossal Keepsake Corporation

American Revolution" of the late 1960s, which was marked by student demonstrations against the Vietnam War. By mounting a giant lipstick tube on tracks from a Caterpillar tractor, Oldenburg suggested a missile grounded in a tank, simultaneously subverting the warlike reference by casting the missile in the form of a feminine cosmetic with erotic overtones. Oldenburg thus urged his audience, in the vocabulary of the time, to "make love, not war." He also addressed the issue of "potency," both sexual and military, by giving the lipstick a balloonlike vinyl tip, which, after being pumped up with air, was meant to deflate slowly. (In fact, the pump was never installed and the drooping tip, vulnerable to vandalism, was soon replaced with a metal one.) Oldenburg and the students provocatively installed the monument on a plaza fronted by the Yale War Memorial and the president's office. The university, offended by the work's irreverent humor, had Oldenburg remove it the next year. In 1974 he reworked **LIP-**

STICK (ASCENDING) ON CATERPILLAR TRACKS in the more permanent materials of fiberglass, aluminum, and steel and donated it to the university, which this time accepted it for the courtyard of Morse College.

THE FINAL ASSAULT ON CONVENTION, 1960–1975

If Pop artists happily engaged with the world of mass culture, other artists saw that movement as a distraction from the basic quest of Modern art: questioning and overthrowing the conventions of art itself. The era of 1960s and early 1970s was another period of intense experimentation, similar to the early twentieth century, when movements and styles proliferated and overlapped with each other. Various groups of artists on different continents attacked the rules from different angles. Though most of this art has no overt political dimension, the restless questioning by artists parallels the social upheavals that also marked that period. The years that saw the civil rights movement, massive rallies against the draft and the Vietnam War, and organized movements of environmentalism, feminism, and the Paris revolts of 1968, also saw artists making works that outdid the radicalism of even the Dadaists.

Op Art and Minimal Art

MATTER AS WAVE. Building on the Latin American tradition of geometric abstraction (SEE FIG. 32–21), some Venezuelan artists experimented with a new kind of motion in their art. We have already seen art that moves by Alexander Calder (SEE FIG. 31–72); Gyula Kosice in Argentina also made mobiles in the 1940s. Is it possible, some wondered, to have art that depends on motion by the *spectator?* In society, people are moving all the time, why not in the art gallery as well? Jesús Rafael Soto (1923–2005) created such works as far back as the 1950s (FIG. 32–37). **TRANSFORMABLE HARMONY** is a series of painted planes a few inches apart, attached together parallel to the wall. When a viewer passes by, the clashing lines set up patterns that seem to vibrate. Soto hoped that these vibrations generate enough interest on optical grounds alone, apart from any personal expression or symbolic meaning, to hold the viewer's contemplative attention. The moving patterns do not exist in the painted planes themselves but only on the viewer's retina; Soto said in 1965 that the form of his art is thus "dematerialized." Viewers passing by at different speeds, at different heights, will see somewhat different patterns. Every viewer with good enough eyesight will see the patterns, though, and their motion does not depend on the viewer's culture or level of education. Soto, a socialist, took pleasure in this egalitarian aspect of his art. Since the work depends primarily on optical phenomena, his art was dubbed (half in jest by a fan of Pop Art) "Op Art."

32-37 | Jesús Rafael Soto **ARMONÍA TRANSFORMABLE (TRANSFORMABLE HARMONY)**
1956. Plexiglass and acrylic on wood, 39⅖ × 15¾ × 39⅖″ (100 × 40 × 100 cm). Art Museum of the Americas, Washington, D.C.
© Jesús Rafael Soto / Artists Rights Society (ARS), New York / ADAGP, Paris

English artist Bridget Riley (b. 1931) worked along a similar path in two-dimensional works (FIG. 32–38). **CURRENT** plays with the viewer's depth perception, as the narrow lines seem to describe wave patterns. Riley's art is based more on natural rhythms than that of Soto, and it also presumes a stationary viewer, but we soon discover as we look at this work that it is impossible to keep our eyes perfectly still. The lines seem to undulate, and the afterimages that develop in our retina create extraneous patterns. These optical phenomena create a new kind of visual immersion, perhaps admirably suited to a fast-paced existence.

MATTER AS MATTER. In its emphasis on hard-edged geometry, Op Art held a formal relationship to Minimalism, which emerged in the mid-1960s as the dominant mode of abstraction in New York. The Minimalists had no knowledge of the earlier Concrete-Invention group in Argentina, but they worked along a similar path. Minimalists sought to purge their art of everything that was not essential to art. They banished subjective gestures and personal feelings; negated representation, narrative, and metaphor; and focused exclusively on the artwork as a physical fact. They employed simple geometric forms with plain, unadorned surfaces and often used industrial techniques and materials to achieve an effect of complete impersonality. Canadian artist Jack Bush (1909–1977) once

said that his paintings are "something to look at, just with the eye, and react." This statement accurately describes part of the Minimalist program, but Bush retained something of a hand-made look in his abstractions. Influenced by Helen Frankenthaler (SEE FIG. 32–15), he worked with thinned-down oils during the first half of the 1960s. Bush switched to acrylics in 1966, the year he painted **TALL SPREAD** (FIG. 32–39). In this large painting from Bush's *Ladder* series, a stack of color bars fills the right side of the canvas, held in place by a single green vertical stripe at the left. While the bands of the ladder alternate in value between dark and light, Bush chose their hues not according to any systematic logic but rather intuitively. Similarly, he avoided geometric regularity by varying the width of each band and leaning its top and bottom edges slightly off the horizontal. Bush's art retains the human touch in ways that American Minimalists worked hard to avoid.

32-38 | Bridget Riley **CURRENT**
1964. Synthetic polymer on board, 58⅛″ × 58⅞″ (148 × 149 cm). The Museum of Modern Art, New York.
Philip Johnson Fund (576.1964)

While the American popular media loved Op Art, most avant-garde critics detested it. Lucy Lippard, for example, called it "an art of little substance," depending "on purely technical knowledge of color and design theory which, when combined with a conventional geometric . . . framework, results in jazzily respectable jumping surfaces, and nothing more." For Lippard and like-minded New York critics, Op Art was too involved with investigating the processes of perception to qualify as serious art.

32–39 | Jack Bush **TALL SPREAD**
1966. Acrylic on canvas, 106 × 50" (271 × 127 cm).
The National Gallery of Canada, Ottawa, Ontario.
Purchase, 1966

32–40 | Frank Stella **AVICENNA**
1960. Aluminum paint on canvas, 6'2½" × 6' (1.91 × 1.85 m).
The Menil Collection, Houston, Texas.

32–41 | Judd Foundation **UNTITLED**
1969. Anodized aluminum and blue Plexiglas,
each 47½ × 59⅞ × 59⅞" (1.2 × 1.5 × 1.5 m);
overall 47½ × 59⅞ × 278½" (1.2 × 1.5 × 7.7 m).
The St. Louis Art Museum, St. Louis, Missouri.
Purchase funds given by the Shoenberg Foundation, Inc. Art © Judd
Foundation / Licensed by VAGA, New York, NY

The painter Frank Stella (b. 1936) inaugurated the Minimalist movement in the late 1950s through a series of large "Black Paintings," whose flat, symmetrical black enamel stripes, laid down on bare canvas with a house painter's brush, rejected the varied colors, spatial depth, asymmetrical compositions, and impulsive brushwork of action painters such as de Kooning. In 1960 Stella created a series of "Aluminum Paintings," using a metallic paint normally applied to radiators. He chose this paint because it "had a quality of repelling the eye," and it created an even flatter, more abstract effect than had the "soft" black enamel. While the "Black Paintings" featured straight bands that either echoed the edges of the rectangular canvas or cut across them on the diagonal, in "Aluminum Paintings" such as **AVICENNA** (FIG. 32–40) Stella arrived at a more consistent fit between the shape of the support and the stripes painted on it by cutting notches out of the corners and the center of the canvas and making the stripes "jog" in response to these irregularities.

In these and subsequent series, Stella continually developed the possibilities of the shaped canvas that Argentine artists had pioneered. He used thick stretchers (the pieces of wood on which canvas is stretched) to give his works the appearance of slablike objects, which his friend Donald Judd (1928–94) recognized as suggesting sculpture. By the mid-1960s, Judd, trained as a painter, had decided that sculpture offered a better medium for creating the kind of pure, matter-of-fact art that he and Stella both sought. Rather than *depicting* shapes, as Stella did—which Judd thought still smacked of representation—Judd created *actual* shapes. In search of maximum simplicity and clarity, he evolved a formal vocabulary featuring identical rectangular units arranged in rows and constructed of industrial materials, especially galvanized iron, anodized aluminum, stainless steel, and Plexiglas. **UNTITLED** (FIG. 32–41) is a typical example of his mature work, which the artist did not make by hand but had fabricated according to his specifications. He faced the boxes with transparent Plexiglas to avoid any uncertainty about what might be inside. He arranged them in evenly spaced rows—the most impersonal way to integrate them—and generally avoided sets of two or three because of their potential to be read as representative of something other than a row of boxes. Judd provided the viewer with a set of clear, self-contained

facts, setting the conceptual clarity and physical perfection of his art against the messy complexity of the real world.

Judd participated in protests against the Vietnam War and bought advertising space in newspapers to publicize that cause, but he felt that art should deal with aesthetic issues only. Some Minimalists struggled with the idea of banishing all personal meaning from their work, and in grappling with it they created innovative pieces. One of these is Eva Hesse (1936–1970), whose personal history kept influencing her creations. Born in Hamburg to German Jewish parents, Hesse narrowly escaped the Nazi Holocaust by immigrating with her family to New York City in 1939. After graduating from the Yale School of Art in 1959, she painted darkly Expressionistic self-portraits that reflected the emotional turbulence of her life. In 1964 she began to make completely abstract sculpture that adapted the vocabulary of Minimalism to a similarly self-expressive purpose. "For me . . . ," said Hesse, "art and life are inseparable. If I can name the content . . . it's the total absurdity of life." The "absurdity" that Hesse pursued in her last works was the complete denial of fixed form and scale, so vital to Minimalists such as Judd. Her **ROPE PIECE** (FIG. 32–42), for example, takes on a different shape and different dimensions each time it is installed. The work consists of several sections of rope, which Hesse and her assistant dipped in

32–42 | Eva Hesse **ROPE PIECE**
1969–70. Latex over rope, string, and wire; two strands, dimensions variable. Whitney Museum of American Art, New York.

Purchase, with funds from Eli and Edythe L. Broad, the Mrs. Percy Uris Purchase Fund, and the Painting and Sculpture Committee (88.17 a-b)

32–43 | Lygia Clark **BICHO LC3 (PAN-CUBISME)**
1970. Aluminum and metal, 9 × 17¾ × 15¼"
(23 × 45 × 40 cm). Daros-Latinamerica, Zurich, Switzerland.
Artists Rights Society (ARS), New York

latex, knotted and tangled, and then hung from wires attached to the ceiling. The resulting linear web extends into new territory the tradition of "drawing in space" practiced by David Smith and others (SEE FIG. 32–18). Much more than a welded sculpture, Hesse's *Rope Piece* resembles a three-dimensional version of a poured painting by Jackson Pollock, and, like Pollock's work, it achieves a sense of structure despite its chaotic appearance. If the Minimal art of Judd and Stella is rigorously shaped by the artist, Hesse allowed the natural force of gravity a much larger role.

Brazilian artists also explored the physical properties of materials, but in ways that brought viewers into the creative process. Lygia Clark (1920–1988) began as an abstract painter, but under the influence of the Madí group (SEE FIG. 32–22), she wondered how she could change the relationship of artist to viewer so that the viewer is not the mere recipient of the artist's invention. She hoped to create work that empowered viewers to cooperate in actually shaping her artworks. In the 1960s she made a series of works called **BICHOS** ("Beasts") from irregular flanges of metal, attached together with hinges in asymmetrical ways (FIG. 32–43). The *Bichos* have no inside or outside, no upside down or right side up. At first they appear to be endlessly manipulable, but it soon becomes clear that the complex system of hinges that she installed limits the possibilities, as if the *Bicho* itself has desires that no one foresaw. The construction of the piece combines with gravity and the intent of the viewer to determine its shape. When a spectator asked her once how and in what ways she could move a *Bicho*, Clark replied, "I don't know, neither do you, but he does."

Arte Povera: Impoverished Art

Many artists in the late 1960s used natural processes in their work in an effort to expand art's vocabulary beyond tradi-

tional materials and reconnect viewers with organic realities. The most cohesive movement in this direction was Arte Povera, formed in Italy in 1967 by several artists who had been reading the American philosopher John Dewey. His 1934 book *Art as Experience* made several claims that later artists would adapt to their own ends. Dewey's principal insight was that the aesthetic experience of a work of art is not so very different from any experience of any object: Viewers select aspects of an object to look at, and they compare what they see with their own mental directory of experiences formed over their lifetimes. Thus the "aesthetic moment" that artists hope for is built in the viewer's mind by the viewer and not, strictly speaking, by the artist. Moreover, everyone's aesthetic experience will be different because the receiving minds are all different. The Italian artists who read this book (in a 1962 translation by Umberto Eco) wondered if viewers might respond aesthetically to visual stimuli that the artist did not exactly create, but merely set into motion. They were most interested in natural processes because they thought that modern life was becoming too prepackaged and mediated, and they also hoped to rebel against the art market by making items (or starting processes) that would be difficult to buy and sell.

The Greek-born Jannis Kounellis (b. 1933) made this approach gloriously visible in his **UNTITLED (12 HORSES)** that began this chapter (FIG. 32–1). Viewers to the gallery got a multisensory experience whose "richness" depended in part on how often the horses were washed and the floor was cleaned. Their experience could also include some of the many symbolic meanings that people attach to horses, and the artist need not specify or discourage any of them. The possibilities of such encounters could prove liberating for artist and viewer alike. The term *Arte Povera* was coined by art critic Germano Celant, who said that these artists are trying to "abolish their function as artists" and "discover the magic and the marvelous in natural elements." Works by Arte Povera artists are "impoverished" in at least two ways: first, the use of natural processes reduces the presence of the artist's ego or personality; second, employing everyday materials removes some of the specialness that artworks have enjoyed for centuries.

Gilberto Zorio (b. 1944) worked a more subtle way when he bought a piece of industrial pipe over nine feet long, sliced it in half, and filled it with cobalt chloride (FIG. 32–44). The compound is highly sensitive to humidity, changing from pink to blue and back again. In a gallery setting, the color changes over the course of a day. In addition, the segment was long enough so that the humidity (and thus the color) might even vary along the length of the pipe. Thus the piece looks different depending on atmospheric conditions, and perhaps it helps make viewers more aware of their sensory surroundings. Other pieces by Zorio involved slowly evaporating salt water during a month-long exhibition; as the pool shrank, a field of crystals grew.

32-44 | Gilberto Zorio **PINK-BLUE-PINK**
1967. Semicylinder filled with cobalt chloride,
11⅞ × 112¼ × 6" (30 × 285 × 15 cm). Galleria Civica d'Arte
Moderna e Contemporanea, Torino, Italy.
Purchased by the Fondazione Guido ed Ettore De Fornaris from Pier Luigi Pero,
Turin, 1985 / Artists Rights Society (ARS), New York / ADAGP, Paris

Mario Merz (1925–2003) was old enough to have experienced and rejected the expressive tendencies of *Art Informel*. He had participated in several shows as a painter, but his career as an abstract artist ended in 1962 when he bought every tube of paint at his local art store and applied them all to one canvas in a single day. His search for a more organic statement led him to the igloo, one of humanity's most primitive structures. He made simple hemispheric frames out of metal, then covered them with what he called "shapeless" materials that lack substance: soil, glass, blobs of clay, or netting (FIG. 32-45). THE IGLOO symbolizes the human need for shelter and recalls how Eskimos live close to the earth. Merz also generally pierced his pieces with neon, in order, he said, to "energize them." The neon tubes might spell out political slogans of the day, or display simple mathematical facts such as $1 + 1 = 2$. By such regressions, he hoped to arrive back at some originating point of thought, a degree zero of aesthetics. The Arte Povera artists were naturally accused of not making art; Merz's reply to this accusation was the most cogent and revealed their broader goal in terms derived from Dewey and Eco: "It is absurd to ask ourselves whether these forms are art or not: What we have to ask ourselves instead is whether they have some organic meaning or not."

32-45 | Mario Merz **IGLOO**
1971. Steel tubes, neon tubing,
wire mesh, transformer,
C-clamps, 39⅜ × 78¾ × 78¾"
(100 × 200 × 200 cm).
Walker Art Center, Minneapolis
T. B. Walker Acquisition Fund, 2001.
(2001.64.1.19) / Artists Rights Society
(ARS), New York

Conceptual and Performance Art

If the Minimalists and Arte Povera artists seemed radical, they were still at least making things: The artists who came to be known as Conceptualists pushed Minimalism to its logical extreme by eliminating the art object itself. Although the Conceptualists always produced something to look at, it was often only a printed statement, a set of directions, or a documentary photograph. The ultimate root of Conceptual art is Marcel Duchamp and his assertion that making art should be a mental, not a physical, activity. That is, every art object begins as an idea; carrying out the idea is a perfunctory affair. Conceptual art is based on the premise that if the idea is good, the art piece will also be good. This standard could apply to a great deal of art. For example, Michelangelo's work on the Sistine ceiling was very creative in envisioning the relationship between God and people in a new way. The *idea* of God reaching out to Adam was the masterpiece, and all he had to do was paint his idea. Many artists had a similar skill level at that time, but no one thought as creatively as Michelangelo did. By that reasoning, Michelangelo is a good Conceptual artist. In the 1960s, the Conceptual artist's quest was to do away with the valuable art object (to "dematerialize" it) while still exposing the artist's thought.

Deemphasizing the art object kept art from becoming simply another luxury item, a concern raised by the booming market for contemporary art that arose during the 1960s. Some artists did not want to make works that would sell in elite galleries and then decorate the homes of the wealthy. Others noticed that the governing boards of many museums consisted of corporate executives from companies that practiced discrimination or earned their money from warfare or exploiting natural resources. Artist groups picketed and protested outside most major museums in the late 1960s at one time or another. Making art that avoided the system became a priority for many.

The most prominent American Conceptual artist, Joseph Kosuth (b. 1945), abandoned painting in 1965 and began to work with language, under the influence of Duchamp and the linguistic philosopher Ludwig Wittgenstein (1889–1951). Kosuth believed that the use of language would direct art away from aesthetic concerns and toward philosophical speculation. His **ONE AND THREE CHAIRS** (FIG. 32–46) invites such speculation by presenting an actual chair, a full-scale black-and-white photograph of the same chair, and a dictionary definition of the word *chair*. The work thus leads the viewer from the physical chair to the purely linguistic ideal of "chairness" and invites the question of which is the most "real."

Many Conceptual artists used their bodies as an artistic medium and engaged in simple activities or performances that they considered works of art. Use of the body offered another alternative to object-oriented mediums like painting and sculpture, and it produced no salable artwork unless the artist's activity was recorded on film or video. One artist who

32–46 | Joseph Kosuth **ONE AND THREE CHAIRS**
1965. Wood folding chair, photograph of chair, and photographic enlargement of dictionary definition of chair; chair, 32⅜ × 14⅞ × 20⅞" (82.2 × 37.8 × 53 cm); photo panel, 36 × 24⅛" (91.4 × 61.3 cm); text panel 24⅛ × 24½" (61.3 × 62.2 cm). The Museum of Modern Art, New York.
Larry Aldrich Foundation Fund (383.1970 a–c)

used his body as an artistic medium in the late 1960s was the California-based Bruce Nauman (b. 1941). In 1966-67 he made a series of eleven color photographs based on wordplay and visual puns. In **SELF-PORTRAIT AS A FOUNTAIN** (FIG. 32–47), for example, the bare-chested artist tips his head back, spurts water into the air, and, in the spirit of Duchamp, designates himself a work of art. He is even a *Fountain,* naming himself after Duchamp's famous urinal.

Some of the most radical Conceptual and Performance art came out of Europe. As far back as 1960, Yves Klein helped initiate Performance art in his *Anthropometries of the Blue Period* (SEE FIG. 32–30). In the same year, Klein staged a more Conceptual show by leaving the gallery completely empty. He called this exhibition *The Void,* and art collectors could buy portions of the emptiness, parceled out in square meters. They had to pay with gold dust, which the artist threw into the Seine River. (There were several takers.)

Similarly subversive was the German artist Joseph Beuys, whose Performances had a ritualistic aspect and, often, a political message as well. Beuys met Happening artist Allan Kaprow in 1963 (SEE FIG. 32–29) and later testified to the importance of the encounter. Like a Happening, a Performance work is an event rather than an object, but Performance artists usually enact their pieces all alone. In 1965 Beuys swathed his head in honey and gold leaf, handicapped himself by attaching a large metal flange to one shoe, and hobbled around a gallery cradling a dead rabbit in his arms (FIG. 32–48). He stopped in front of each work in the gallery

32–47 Bruce Nauman **SELF-PORTRAIT AS A FOUNTAIN**
1966–67. Color photograph, 19¾ × 23¾″ (50.1 × 60.3 cm).
Courtesy Leo Castelli Gallery, New York

Regarding his works of the later 1960s, Nauman observed, "I was using my body as a piece of material and manipulating it. I think of it as going into the studio and being involved in some activity. Sometimes it works out that the activity involves making something, and sometimes the activity itself is the piece."

32–48 Joseph Beuys **HOW TO EXPLAIN PICTURES TO A DEAD HARE** 1965. Photograph of performance.
Photo: Ronald Feldman Gallery, New York.
Estate of Joseph Beuys, Artists Rights Society, New York

and whispered to the animal the meaning of each, then touched its lifeless paw to the glass-coated surface. His radiant head was intended to make him seem a magical figure or a wizard, while the metal flange made him frail at the same time. **HOW TO EXPLAIN PICTURES TO A DEAD HARE** targets endless attempts to explain art (including perhaps this book!). Beuys said, "Even a dead animal preserves more powers of intuition than some human beings." Beuys's later work was more political: Invited to show at the prestigious Documenta show of European contemporary art in 1972, he set up a table and passed out literature from a political party that he founded, the Organization for Direct Democracy Through Referendum. He was fired from his teaching position at the Düsseldorf Academy that year for admitting 172 students to his classes, because, he said, everyone is an artist. One of his 1976 performances was to run for the German Senate (he lost). His expression of mythic meanings combined with political activism made him hugely influential on later European art.

Earthworks and Site-Specific Sculpture

Conceptual and Performance artists seemed to take art to its limits, but most of their events happened in a gallery or

32–49 | Michael Heizer **DOUBLE NEGATIVE**
1969–70. 240,000-ton displacement at Mormon Mesa,
Overton, Nevada. 1,500 × 50 × 30' (457.2 × 15.2 × 9.1 m).
Museum of Contemporary Art, Los Angeles.

Gift of Virginia Dwan. Photograph courtesy the artist

shape a site or do something on it. Acting partly on the political impulse of getting away from the art market and partly on the Modern impulse to throw out conventions, a number of sculptors began to work outdoors, using raw materials found at the site to fashion **Earthworks.** They also pioneered a new category of art making called **site-specific sculpture,** which is designed for a particular location, often outdoors.

LARGE-SCALE EARTHWORKS. One of the leaders of the Earthworks movement was Michael Heizer (b. 1944), the California-born son of a specialist in Native American archaeology. Heizer moved to New York in 1966 but, disgusted by the growing emphasis on art as an investment, began to spend time in the Nevada desert and to create works there that could not easily be bought and sold and that required a considerable commitment of time from viewers. There, in 1969–70, Heizer hired bulldozers to produce his most famous work, **DOUBLE NEGATIVE** (FIG. 32–49). Using a simple Minimalist formal vocabulary, he made two gigantic cuts on opposite sides of a canyon wall at a remote location. To fully experience the work, the viewer needs to travel to Overton, Nevada, to walk into the 50-foot-deep channels and experience their huge scale, and to fly overhead to see the work from above.

museum. Some artists in the early 1970s wondered if art could do without those traditional settings entirely. Certainly art has been made in public places before, in ways that cannot be bought or sold, such as Mexican murals (SEE FIG. 31–66). But perhaps an artist could take the earth itself as a medium, and

32–50 | Robert Smithson **SPIRAL JETTY**
1969–70. Black rock, salt crystal, and earth spiral, length 1,500' (457 m). Great Salt Lake, Utah.

Courtesy James Cohan Gallery, New York Art © Estate of Robert Smithson/Licensed by VAGA, New York, NY

More symbolic in intention was the work of another major Earthworks artist, Robert Smithson (1938–73), a New Jersey native who first traveled to the Nevada desert with Heizer in 1968. In his mature work, Smithson sought to illustrate the "ongoing dialectic" in nature between constructive forces—those that build and shape form—and destructive forces—those that destroy it. **SPIRAL JETTY** (FIG. 32–50), a 1,500-foot spiraling stone and earth platform extending into the Great Salt Lake in Utah, expresses these ideas. Smithson chose the lake because it recalls both the origins of life in the salty waters of the primordial ocean and also the end of life. One of the few organisms that live in the otherwise dead lake is an alga that sometimes gives it a red tinge, suggestive of blood. Smithson also liked the way the abandoned oil rigs that dot the lake's shores suggested both prehistoric dinosaurs and some vanished civilization. He used the spiral because it is the most fundamental shape in nature, appearing, for example, in galaxies, seashells, DNA molecules, and even salt crystals. Smithson also chose the spiral because, unlike Modernist squares, circles, and straight lines, it is a "dialectical" shape, one that opens and closes, curls and uncurls endlessly. It is an organic shape that also appears in rock art by various ancient peoples, where it transmits symbolic meanings unknown to us. More than any other shape, it suggested to him the perpetual coming and going of things. To allow the "ongoing dialectic" of construction and destruction to proceed, Smithson ordered that no maintenance be done on the work. Since he created it, the surrounding lake water has turned red and back to blue, risen up to drown the work, and revealed it again, covered with salt.

IMPERMANENT SITES. Strongly committed to the realization of temporary, site-specific artworks in both rural and urban settings are Christo and Jeanne-Claude, both born on June 13, 1935. Christo Javacheff (who uses only his first name) emigrated from his native Bulgaria to Paris in 1958, where he met Jeanne-Claude de Guillebon. His interest in "wrapping" (or otherwise defining) places or things in swaths of fabric soon became an obsession, and he began wrapping progressively larger items. Their first collaborative work, in 1961, was *Stacked Oil Barrels* and *Dockside Packages* at the port of Cologne, Germany. The pair moved to New York City in 1964. Four years later, Christo and Jeanne-Claude wrapped the Kunsthalle museum in Bern, Switzerland, and the following year they wrapped 1 million square feet of the Australian coastline. The artists pay all their own expenses, never accepting sponsors but rather raising funds through the sale of preparatory drawings of the intended project.

Their best-known work, **RUNNING FENCE** (FIG. 32–51), was a 24½-mile-long, 18-foot-high nylon fence that crossed two counties in northern California and extended into the Pacific Ocean. The artists chose the location in Sonoma and Marin counties for aesthetic reasons, as well as to call atten-

32–51 | Christo and Jeanne-Claude **RUNNING FENCE**
1972-76. Nylon fence, height 18′ (5.50 m), length 24½ miles (40 km). Sonoma and Marin counties, California.

tion to the link between urban, suburban, and rural spaces. This concern with aesthetics is common to all their work, in which they reveal the beauty in various spaces. At the same time, the conflict and collaboration between the artists and various social groups open the workings of the political system to scrutiny and invest their work with a sense of social space. For example, Christo and Jeanne-Claude spent forty-two months overcoming the resistance of county commissioners, half of whom were in favor of the project from the outset, as well as social and environmental organizations, before they could create *Running Fence*. Meanwhile, the project forged a community of supporters drawn from groups as diverse as college students, ranchers, lawyers, and artists. In a way, the fence broke down the social barriers among those people. The work remained in place for two weeks and then was taken down. Property owners whose land the work traversed could keep the materials.

Feminist Art

Feminist art emerged in the context of the Women's Liberation movement of the late 1960s and early 1970s, and it challenged one of the major unspoken conventions of the history of Western art including Modern art: the dominance of men. A major aim of feminist artists and their allies was increased recognition for the accomplishment of women artists, both past and present. As feminists examined the history of art, they found that women had contributed to most of the movements of Western art but were almost never mentioned in histories of art. Feminists also attacked the traditional Western hierarchy that placed "the arts" (painting, sculpture, architecture) at a level of achievement higher than "the crafts" (ceramics, textiles, jewelry-making). Since most craft media have been historically dominated by women, favoring art

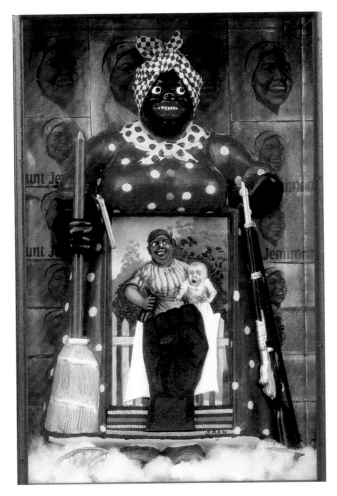

32–52 | Betye Saar **THE LIBERATION OF AUNT JEMIMA**
1972. Mixed media, 11¾ × 11⅞ × 2¾″ (29.8 × 30.3 × 7),
Berkeley Art Museum, University of California.
Purchased with the aid of funds from the National Endowment for the Arts
(selected by The Committee for the Acquisition of Afro-American Art)

lected talent, such as the Los Angeles-based African American sculptor Betye Saar (b. 1926). She had been making assemblages for years that showed a political militancy rare in postwar American art. Several of her works in this medium reflect both feminist interests and the aims of the civil rights movement. Saar's best-known work, **THE LIBERATION OF AUNT JEMIMA** (FIG. 32–52), appropriates (borrows for Saar's own purposes) the derogatory stereotype of the cheerfully servile "mammy" and transforms it into an icon of militant black feminist power. Set against a background papered with the smiling advertising image of Aunt Jemima stands a note pad holder in the form of an Aunt Jemima. She holds a broom (whose handle is actually the pencil for the note pad) and pistol in one hand and a rifle in the other. In the place of the note pad is a picture of another jolly mammy holding a crying child identified by the artist as a mulatto, or person of mixed black and white ancestry. In front of this pair is a large clenched fist—a symbol of Black Power signaling African Americans' willingness to use force to achieve their aims. Saar's armed Jemima liberates herself not only from racial oppression but also from traditional gender roles that had long relegated black women to such subservient positions as domestic servant or mammy.

COLLABORATION. A younger artist who assumed a leading role in the feminist movement of the 1970s was Judy Chicago (b. 1939), whose *The Dinner Party* is perhaps the best-known work of feminist art created in that decade (see "The Dinner Party," page 1168). Born Judy Cohen, she became Judy Gerowitz after her marriage and then in 1970 adopted the surname Chicago (from the city of her birth) to free herself from "all names imposed upon her through male social dominance." Originally a Minimalist sculptor, Chicago in the late 1960s began to make abstracted images of female genitalia designed to challenge the aesthetic standards of the male-dominated art world and to validate female experience. In 1970 she established the first feminist studio art course at Fresno State College (now California State University, Fresno). The next year, she moved to Los Angeles and joined with the painter Miriam Schapiro (b. 1923) to establish at the new California Institute of the Arts (CalArts) the Feminist Art Program, dedicated to training women artists.

During the first year of the program, Chicago and Schapiro led a team of twenty-one female students in the creation of *Womanhouse* (1971–72), a collaborative art environment set in a run-down Hollywood mansion, which the artists renovated and filled with installations that addressed women's issues. Schapiro's work for *Womanhouse,* created in collaboration with Sherry Brody, was *The Dollhouse,* a mixed-media construction featuring several miniature rooms adorned with richly patterned fabrics. Schapiro soon began to incorporate pieces of fabric into her acrylic paintings,

over craft tends to relegate women's achievements to second-class status. Thus early feminist art tended to elevate craft media.

Women artists faced considerable discrimination at that time (and they still do). A 1970 survey revealed that although women constituted half of the nation's practicing artists, only 18 percent of commercial New York galleries carried works by women. Of the 143 artists in the 1969 Whitney Annual (now the Whitney Biennial), one of the country's most prominent exhibitions of the work of living artists, only eight were women. The next year, the newly formed Ad Hoc Committee of Women Artists, disappointed by the lukewarm response of the Whitney's director to their concerns, staged a protest at the opening of the 1970 Annual. To focus more attention on women in the arts, feminist artists began organizing women's cooperative galleries.

ATTACKING STEREOTYPES. As feminist art critics scanned the horizon for contemporary women who were creating with insufficient recognition, they found a wealth of neg-

developing a type of work she called *femmage* (from *female* and *collage*). Schapiro's femmages, such as the exuberant **PERSONAL APPEARANCE #3** (FIG. 32–53), celebrate traditional women's craftwork. After returning to New York from California in 1975, Schapiro became a leading figure in the Pattern and Decoration movement. Composed of both female and male artists, this movement sought to merge Modernist abstraction with ornamental motifs derived from women's craft, folk art, and a variety of non-Western sources in order to break down hierarchical distinctions among them.

RINGGOLD'S STORY QUILTS. African American artist Faith Ringgold (b. 1930) drew on the traditional American craft of quilt making and combined it with the rich heritage of African textiles to create memorable statements about American race relations. She began in the early 1970s to paint on soft fabrics rather than stretched canvases, and to frame her images with decorative quilted borders. Ringgold's mother, Willi Posey, a fashion designer and dressmaker, made these quilted borders until her death in 1981, after which Ringgold took responsibility for both the quilting and the painting. In 1977 Ringgold began writing her autobiography (*We Flew Over the Bridge: The Memoirs of Faith Ringgold,* 1995). Not immediately finding a publisher, she decided to write her stories on her quilts, and in the early 1980s inaugurated what became her signature medium: the story quilt.

Animated by a powerful feminist sensibility, Ringgold's story quilts are always narrated by women and usually address themes related to women's lives. A splendid example is **TAR BEACH** (FIG. 32–54), whose fictional narrator, 8-year-old Cassie Louise Lightfoot, is based on the artist's childhood memories of growing up in Harlem. The "Tar Beach" of the title is the roof of the apartment building on which Ringgold's family, lacking air conditioning, would sleep on hot summer nights. Cassie describes sleeping on Tar Beach as a magical experience. As she lies on a blanket with her brother, she dreams that she can fly and possess everything over which she passes. Cassie can fly over the George Washington Bridge and make it hers; she can fly over the new union building and claim it for her father—a half-black, half–Native American man who helps construct skyscrapers but is prevented by his race from joining the union; she can fly over an ice cream factory to guarantee her mother "ice cream every night for dessert." Ringgold's colorful painting in the center of the quilt shows Cassie and her brother lying on a blanket at the lower right while their parents and two neighbors play cards at a table at center. Directly above the adults appears a second Cassie, magically flying over the George Washington Bridge against a star-dotted sky. Cassie's fantasy of achieving the impossible is charming but also delivers a serious message by remind-

32–53 | Miriam Schapiro **PERSONAL APPEARANCE #3**
1973. Acrylic and fabric on canvas, 60 × 50″ (152.4 × 127 cm). Private collection.

Schapiro championed the theory that women have a distinct artistic sensibility that can be distinguished from that of men and hence a specifically feminine aesthetic. During the late 1950s and 1960s she made explicitly female versions of the dominant Modernist styles, including reductive, hard-edged abstractions of the female form: large X-shapes with openings at their centers. In 1973 she created *Personal Appearance #3*, using underlying hard-edge rectangles and overlaying them with a collage of fabric and paper—materials associated with women's craftwork—the formal and emotional richness of which were meant to counter the Minimalist aesthetic of the 1960s, which Schapiro and other feminists considered typically male.

ing the viewer of the real social and economic limitations that African Americans have faced throughout American history.

IDENTIFICATION WITH NATURE. Many feminists, including Cuban-born Ana Mendieta (1948–85), celebrated the notion that women have a deeper identification with nature than do men. By 1972, Mendieta had rejected painting for Performance and body art. Influenced by Joseph Beuys but inspired by *santería*, the Afro-Cuban religion that Wifredo Lam had dealt with earlier (SEE FIG. 32–7), she produced ritualistic performances on film, as well as about 200 earth-and-body works, called *Silhouettes,* which she recorded in color photographs. Some were done in Mexico, and others, like the **TREE OF LIFE** series (FIG. 32–55), were set in Iowa, where she lived

32–54 | Faith Ringgold **TAR BEACH (PART I FROM THE WOMAN ON A BRIDGE SERIES)**
1988. Acrylic on canvas, bordered with printed, painted, quilted, and pieced cloth, 74⅝ × 68½"
(190.5 × 174 cm). Guggenheim Museum, New York.
Gift, Mr. and Mrs. Gus and Judith Lieber, 1988 (88.362)

after completing graduate study. In this work, Mendieta stands covered with mud, her arms upraised like a prehistoric goddess, appearing at one with nature, her "maternal source." Reconnecting with the maternal source in this and other works was a compensation for a major disruption of her childhood: Along with 14,000 other unaccompanied chil-

dren, Mendieta was sent away from her native country by her parents in 1961 as part of Operation Peter Pan, a cold war mission to rescue Cuban children from communism after the 1959 revolution. The feeling of personal dislocation that this caused would always haunt her art, leading her to imprint her body by various means in several locations.

buildings are to be found in their details. Because he had a large budget for the **SEAGRAM BUILDING** in New York City (FIG. 32–56), for instance, he used custom-made bronze (instead of standardized steel) beams on the exterior, an example of his love of elegant materials. Mies would have preferred to leave the internal steel structural supports visible, but building codes required him to encase them in concrete. The ornamental beams on the outside thus stand in for the functional beams inside, much as the shapes on the surface of a Stella painting refer to the structural frame that holds the canvas (SEE FIG. 32–40).

The dark glass and bronze were meant to give the Seagram Company a discreet and dignified image. The building's clean lines and crisp design seemed to epitomize the efficiency, standardization, and impersonality that had become synonymous with the modern corporation itself—which, in part, is why this particular style dominated corporate architecture after World War II. Such buildings were also economical to build. Mies believed that the industrial preoccupation with streamlined efficiency was the dominant value of the day and that the only legitimate architecture was one that expressed this modern spirit. Criticized for building glass boxes, Mies pointed out the subtle mathematical relations that exist between the various rectangles on his buildings, and retorted, "Less is more."

32–55 | Ana Mendieta
UNTITLED WORK FROM THE TREE OF LIFE SERIES
1977. Color photograph, 20 × 13¼″ (50.8 × 33.7 cm).
Courtesy of Galerie Lelong, New York and the Estate of Ana Mendieta

ARCHITECTURE: FROM MODERN TO POSTMODERN

As in painting and sculpture, Modernism endured in architecture until the 1970s. The International Style, with its plainly visible structure and rejection of historicism, dominated new urban construction in much of the world after World War II. Several important International Style architects, such as Walter Gropius (SEE FIG. 31–65), migrated to the United States and assumed important positions in architecture schools where they trained a generation of like-minded designers.

Midcentury Modernist Architecture

The best examples of postwar International Style buildings were designed by Ludwig Mies van der Rohe (1886–1969), a former Bauhaus staff member and refugee from Nazi Germany (see Chapter 31). Whether designing schools, houses, or office buildings, Mies used the same simple, rectilinear vocabulary that for many came to personify the modern, efficient culture of postwar capitalism. The differences among his

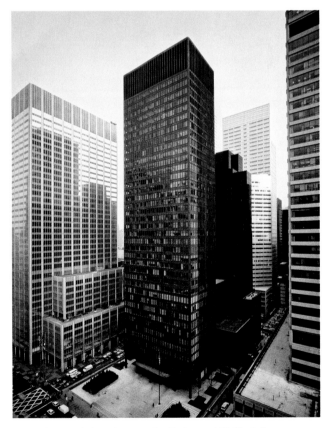

32–56 | Ludwig Mies van der Rohe and Philip Johnson
SEAGRAM BUILDING
New York. 1954-58.

THE OBJECT SPEAKS

THE DINNER PARTY

A complex, mixed-medium installation that fills an entire room, Judy Chicago's **THE DINNER PARTY** takes advantage of feminist art research and speaks powerfully of the accomplishments of women throughout history. Five years of collaborative effort went into the creation of the work, involving hundreds of women and several men who volunteered their talents as ceramists, needleworkers, and china painters to realize Chicago's designs. *The Dinner Party* is composed of a large, triangular table, each side stretching 48 feet, which rests on a triangular platform covered with 2,300 triangular porcelain tiles. Chicago saw the equilateral triangle as a symbol of the equalized world sought by feminism, and she also identified it as one of the earliest symbols of the feminine. The porcelain "Heritage Floor" bears the names of 999 notable women from myth, legend, and history. Along each side of the triangular table, thirteen place settings each represent a famous woman. Chicago chose the number thirteen because it is the number of men who were present at the Last Supper

and also the number of witches in a coven, and therefore a symbol of occult female power. The thirty-nine women honored through the place settings include mythical ancient goddesses such as Ishtar, legendary figures such as the Amazon, and historical personages such as the Egyptian queen Hatshepsut, the Roman scholar Hypatia, the medieval French queen Eleanor of Aquitaine, the medieval French author Christine de Pisan (SEE FIG. 21, Introduction), the Italian Renaissance noblewoman Isabella d'Este (see page 688), the Italian Baroque painter Artemesia Gentileschi (SEE FIG. 22-19), the eighteenth-century English feminist writer Mary Wollstonecraft (shown here), the nineteenth-century American abolitionist Sojourner Truth, and the twentieth-century American painter Georgia O'Keeffe (SEE FIG 31–42).

Each place setting features a 14-inch-wide painted porcelain plate, ceramic flatware, a ceramic chalice with a gold interior, and an embroidered napkin, all set upon an elaborately decorated runner. The runners incorporate decorative

motifs and techniques of stitching and weaving appropriate to the period with which each woman was associated. Most of the plates feature abstract designs based on female genitalia because, Chicago said, "that is all [the women at the table] had in common. . . . They were from different periods, classes, ethnicities, geographies, experiences, but what kept them within the same confined historical space" was the fact of their biological sex. Chicago thought it appropriate to represent the women through plates because they "had been swallowed up and obscured by history instead of being recognized and honored."

Chicago emphasized china painting and needlework in *The Dinner Party* to celebrate craft mediums traditionally practiced by women and to argue that they should be considered "high" art forms on a par with painting and sculpture. This argument complemented her larger aim of raising awareness of the many contributions women have made to history, thereby fostering women's empowerment in the present.

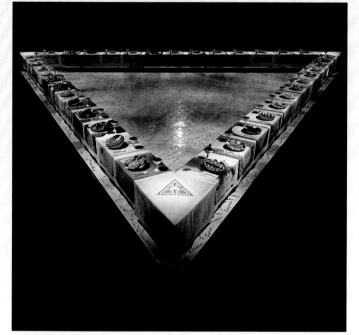

Judy Chicago **THE DINNER PARTY**
1974–79. Overall installation view. White tile floor inscribed in gold with 999 women's names; triangular table with painted porcelain, sculpted porcelain plates, and needlework, each side 48 × 42 × 3' (14.6 × 12.8 × 1 m). The Brooklyn Museum of Art.

Gift of the Elizabeth A. Sackler Foundation (2002.10)

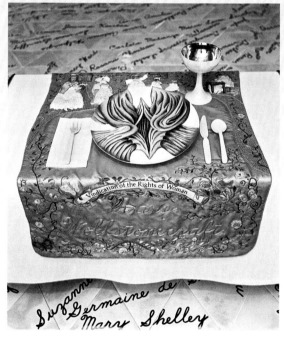

MARY WOLLSTONECRAFT
Place setting, detail of *The Dinner Party*

While Mies's pared-down, rectilinear idiom dominated skyscraper architecture into the 1970s, other building types invited more adventuresome Modernist designs that departed from the rational and impersonal principles of the International Style. A trend toward powerfully expressive, organic forms characterized the architecture of numerous buildings dedicated to religious or cultural functions. Such buildings remained Modernist in their unabashed use of mass-produced materials and lack of historical references, but they showed a new exuberance in design. Expressive designs sometimes appeared also in commercial architecture, as in the remarkable **TRANS WORLD AIRLINES (TWA) TERMINAL** at John F. Kennedy Airport in New York City, by the Finnish-born American architect Eero Saarinen (1910-61). Seeking to evoke the excitement of air travel, Saarinen gave his building dynamically flowing interior spaces and covered it with two broad, winglike canopies of reinforced concrete that suggest a huge bird about to take flight (**FIG. 32–57**). Saarinen also designed all of the building's interior details—from ticket counters to telephone booths—to complement the gull-winged shell.

Modern architects of the post–World War II decades also sought fresh solutions to the persistent challenge of urban housing, which had engaged pioneers of the International Style such as Le Corbusier. The desire for economy led to an interest in the use of standard, prefabricated elements for the construction of both individual houses and larger residential complexes. An innovative example of the latter is **HABITAT '67** (**FIG. 32–58**) by the Israeli-born Moshe Safdie (b. 1938). Built as a permanent exhibit for the 1967 World Exposition in Montreal, the complex consists of three stepped clusters of prefabricated concrete units attached to a zigzagging concrete frame that provides a series of elevated streets and shel-

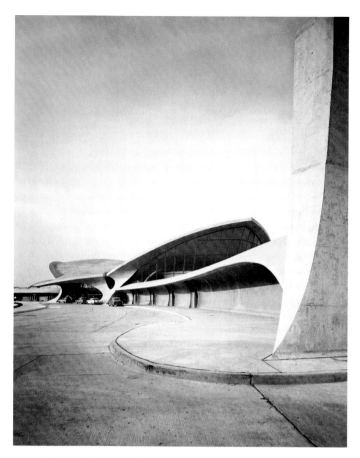

32–57 | Eero Saarinen **TRANS WORLD AIRLINES TERMINAL, JOHN F. KENNEDY AIRPORT**
New York. 1956–62

In 2003 the National Trust for Historic Preservation added the TWA Terminal to its list of America's Eleven Most Endangered Historic Places due to plans by the building's owners, the Port Authority of New York and New Jersey, to demolish portions of the terminal and construct a large new terminal behind it, violating the integrity of Saarinen's design and rendering it useless as an aviation structure.

32–58 | Moshe Safdie
HABITAT '67
Montreal, Quebec, Canada. 1967
World Exposition.

Growing up in Israel, Safdie spent his summers on a kibbutz, or collective farm. This experience partly inspired his plans for Habitat, which adapts aspects of traditional communal living to the social, economic, and technological realities of industrial society.

tered courtyards. By stacking units that contained their own support system, Safdie eliminated the need for an external skeletal frame and allowed for expansion of the complex simply through the addition of more units. An inspired alternative to the conventional high-rise apartment block, Habitat '67 offers greater visual and spatial variety, increased light and air to individual apartments, and a sense of community not often found in a big city housing project.

Postmodern Architecture

Historians trace the origin of Postmodernism in architecture to the work of the Philadelphian Robert Venturi (b. 1925) and his associates, who rejected the abstract purity of the International Style by incorporating into their designs elements drawn from vernacular (meaning popular, common, or ordinary) sources. Parodying Mies van der Rohe's famous aphorism "Less is more," Venturi claimed "Less is a bore" in his pioneering 1966 book *Complexity and Contradiction in Architecture*. The problem with Mies and the other Modernists, he argued, was their impractical unwillingness to accept the modern city for what it is: a complex, contradictory, and heterogeneous collection of "high" and "low" architectural forms. Acting on these impulses, Venturi engaged in practices that Modernists thought heretical: He layered his buildings with references to past styles and at times even applied decoration to them. Such moves were controversial at first, but they pointed a way to innovation that many would follow.

While writing *Complexity and Contradiction in Architecture*, Venturi designed a house for his mother (FIG. 32–59) that illustrated many of his new ideas. The building is both simple and complex. The shape of the façade returns to the archetypal "house" shape—evident in children's drawings—that Modernists from Rietveld (SEE FIG. 31–61) to Safdie had rejected because of its historical associations. Its vocabulary of triangles, squares, and circles is also elementary, although the shapes are arranged in a complex asym-

metry that skews the restful harmonies of Modernist design. The round molding over the door has no structural function, and is thus—gasp!—a decoration. The most disruptive element of the façade is the deep cleavage over the door, which opens to reveal a mysterious upper wall (which turns out to be a penthouse) and chimney top. On the inside, too, complexity and contradiction reign. The irregular floor plan (FIG. 32–60), especially evident in the odd stairway leading to the second floor, is further complicated by the unusual ceilings, some of which are partially covered by a barrel vault.

The Vanna Venturi House makes reference to a number of older buildings, from Michelangelo's Porta Pia in Rome to a nearby house designed by Venturi's mentor, Louis Kahn (1901–74). Although such allusions to architectural history were lost on the general public, they provided many architects, including Philip Johnson (1906–2005), with a path out of Modernism. Johnson's major contribution to Postmodernism is the **AT&T CORPORATE HEADQUARTERS** (now the Sony Building) in New York City (FIG. 32–61), an elegant, granite-clad skyscraper whose thirty-six oversized floors reach the height of an ordinary sixty-story building. The skyscraper makes gestures of accommodation to its surroundings: Its smooth, uncluttered surfaces match those of its International Style neighbors, while the classically symmetrical window groupings between vertical piers echo those in more conservative Manhattan skyscrapers built in the early to mid-1900s. What critics focused on, however, was the building's resemblance to a type of eighteenth-century furniture: the Chippendale highboy, a chest of drawers with a long-legged base. Johnson seems to have intended a pun on the terms *highboy* and *high-rise*. In addition, the round notch at the top of the building and the arched entryway at the base recall the coin slot and coin return of old pay telephones. Many critics were not amused by Johnson's effort to add a touch of humor to high architecture. His purpose, however, was less to poke fun at his client or his profession than to create an architecture that would appeal to the public and at the same time, like a fine piece of furniture, meet its deeper aesthetic needs with a formal, decorative elegance.

32–59 | Robert Venturi **VANNA VENTURI HOUSE**
Chestnut Hill, Pennsylvania. 1961-64.

32–60 | **GROUND-FLOOR PLAN OF THE VANNA VENTURI HOUSE**

32–61 | Philip Johnson and John Burgee
MODEL, AT&T CORPORATE HEADQUARTERS
New York. 1978–83.

After collaborating on the Seagram Building (SEE FIG. 32-56) with Mies, who had long been his architectural idol, Johnson grew tired of the limited Modernist vocabulary. During the 1960s he experimented with a number of alternatives, especially a weighty, monumental style that looked back to nineteenth-century Neoclassicism. At the end of the 1970s he became fascinated with the new possibilities opened by Venturi's Postmodernism, which he found "absolutely delightful."

POSTMODERN ART

Observers disagree about the exact date, but most agree that sometime during the 1970s, the impulses that created Modern art exhausted themselves. If we think back to the key concepts that defined Modern art (see p. 1038), we will see that they had evolved out of existence by the late 1970s. Moreover, the underlying social environment had evolved as well.

The quest to set aside conventions died a natural death when it seemed that all the rules had been broken. The radicalism of some Conceptual and site-specific works of the 1970s seemed to signal the end of an era. For example, an artist once announced a site-specific piece for a public park and unleashed tanks of colorless and odorless gases there; his piece was completely invisible. Another declared Lake Tahoe a work of art. Yet a third declared his own body a work of art and willed it to the Museum of Modern Art when he passes away (he is still alive). The Modernist questioning of conventions reached a point in the 1970s when there were no more conventions to question.

Likewise, the avant-garde has lost its distinctiveness as a source of innovation. In the past, it was a small group that cared about the innovations of a few artists, and it served as a support group for Modern artists such as Monet, Gauguin, Picasso, and Mondrian. As late as the 1950s, this group was still functioning much as it had in the 1880s. Helen Frankenthaler, in the same interview quoted earlier, described the scene in her day: "When we were all showing at Tibor de Nagy [Gallery] in the early fifties, none of us expected to sell pictures. A few people knew your work. There was a handful of people you could talk to in your studio, a small orbit." With the advent of Pop Art in the 1960s, the avant-garde came much more into the public eye. Andy Warhol was a celebrity (and he loved being one). Magazine coverage of contemporary art proliferated. Art schools began teaching Modern techniques instead of traditional ones. The spread of higher education (and the proliferation of art history courses) made the public for contemporary art much larger. All of these factors mean that innovation in the arts is not now confined to a small, select group; rather, a creative idea can now spring up almost anywhere.

Underlying the decline of the avant-garde is a larger social change: Just as Modern art arrived with the transition to an industrial society, Postmodern art is heralded by postindustrial society. Advanced capitalist societies today are based on information and services rather than industry, and these demand a relatively educated population that is flexible and tolerant. The values of Modern art (innovation, questioning of tradition, individual expression) have permeated this society. Most of us embrace the constant changes of our world. The media encourage this by treating each new consumer product as a revolution and rule-breaking as the norm. A telling moment came when a national chain of hamburger

stands adopted this slogan in the 1990s: "Sometimes you just gotta break the rules." In addition, Modern art itself is no longer controversial. The former rebels Gauguin, van Gogh, and Picasso are now the most expensive artists at auction. While the public still resists obscenity in art, most people tolerate what artists do, even when they do not understand it. Postmodern society has made the avant-garde a spent force by absorbing many of its values.

If the dominant tendency of Modern art was the questioning and rejection of tradition, finding a similar unifying concept for Postmodern art is difficult. In that sense, Postmodern art reflects our pluralistic and globalized society, in which innovation can happen anyplace. Since the demise of Modernism, the art world seems to be characterized much more by **pluralism,** in which a number of styles and trends coexist simultaneously. Postmodern artists generally avoid the Modernist goals of researching the qualities of their media or exploring aesthetic issues; first and foremost, they use art to comment on their world. Likewise, if Modern art was characterized by constant creation of new styles, Postmodern artists tend to revive previous styles and media, because they have discovered that referring to past art in a knowing fashion can add meaning to an artistic statement. Indeed, quotation of the past not only characterizes much Postmodern art and architecture; many of today's cultural products, such as movies, advertisements, and even political campaigns, make reference to past versions or even re-create them. We live in the age of the sequel, the knock-off, and the recycled character. In that sense, Andy Warhol's original insight ("I don't know where the artificial stops and the real starts") has become even more cogent. Though the definition of Postmodernism is still in dispute, we can point to a few trends that have motivated artists in this new period.

The Critique of Originality

Some of the first art to be called Postmodern questioned one of Modernism's basic notions, that an individual can create something totally original. If part of the heritage of Modern art is based on originality, Postmodern artists who criticize this notion ironically use the medium best known for truth and accuracy: the camera.

RECEIVED IDENTITY. Cindy Sherman (b. 1954), for example, made a series of works beginning in the late 1970s in which she posed her made-up self in settings that quote well-known plots of old movies (FIG. 32–62). In **UNTITLED FILM STILL #21,** she is the young girl who leaves the small town to find work in the big city. Other photos from the same series show her as the glamorous Southern belle, the hardworking housewife, or the teenager who waits by the phone for a call. All of these works examine the roles that our popular culture assigns to women, and Sherman shows that she understands them all very well and she plays them willingly. She seems to be saying

32–62 | Cindy Sherman **UNTITLED FILM STILL #21**
1978. Black-and-white photograph, 8 × 10″ (20.3 × 25.4 cm).
Courtesy of the artist and Metro Pictures, New York

32–63 | Barbara Kruger
WE WON'T PLAY NATURE TO YOUR CULTURE
1983. Photostat 6′1″ × 4′1″ (1.85 × 1.24 m).
Courtesy Mary Boone Gallery, New York

32–64 | Jeff Wall **AFTER "INVISIBLE MAN" BY RALPH ELLISON, THE PREFACE**
1999-2001. Edition of 2. Cibachrome transparency, aluminum light box, and fluorescent bulbs.

that her personality is the sum of all the movies that she has seen, and she does not know where the real Cindy Sherman starts and the one derived from movies stops. If this statement reminds us of Andy Warhol's confession about the real and the artificial, so much the better. The influence of popular culture on all of our identities has only intensified since he said it.

Barbara Kruger (b. 1945) makes a more militant point with slightly different media (FIG. 32–63). Her work quotes magazine advertising layouts, with a catchy photograph and a slogan inscribed, but the slogan talks back to the viewer with a confrontational sentence that sounds feminist. Women's curves have traditionally been seen as symbols for nature, but this work articulates a revolt against that role. This work is not an "original," but rather a piece of graphic design that can be reproduced. Kruger has worked in many other public media, including billboards and bus shelter posters, implanting her subversive messages directly in the flow of media and advertising.

CONSTRUCTED IDENTITY. If photography was traditionally a medium for the straightforward recording of reality ("The camera never lies"), many Postmodern photographers attack this notion by using the camera to photograph obviously set-up situations. They show us that the camera can indeed be made to lie. Canadian artist Jeff Wall (b. 1946) creates detailed illusions that feel as if they could easily be documentary photographs, even as they seek to rival in visual impact large-scale history paintings from the past as well as glossy advertisements of the present. As an art history student in the 1970s, Wall was impressed by the way nineteenth-century artists such as Delacroix and Manet (see Chapter 30) adapted the conventions of history painting to the depiction of contemporary life. Since the late 1970s his own project has been to fashion a comparable grand-scale representation of the history of his own times, presented in the form of color transparencies mounted in large light boxes—a format borrowed from modern advertising and meant to give his art the same persuasive power.

Like a stage or movie director, Wall carefully designs the settings of his scenes and directs actors to play roles within them. He then shoots multiple photographs and combines them digitally to create the final transparency. To make **AFTER "INVISIBLE MAN" BY RALPH ELLISON, THE PREFACE** (FIG. 32–64), an especially elaborate composition, Wall spent eighteen months constructing the set and another three weeks shooting the single actor within it. The image vividly illustrates a well-known

passage from the classic 1952 novel by Ralph Ellison about a black man's search for fulfillment in modern America, which ends in disillusionment and retreat. Wall shows us the cellar room "warm and full of light," in which Ellison's narrator lives beneath 1,369 light bulbs. Powered by electricity stolen from the power company, these lights illuminate the truth of the character's existence: "Light confirms my reality, gives birth to my form. . . . Without light I am not only invisible but formless as well; and to be unaware of one's form is to live a death. . . . The truth is the light and the light is the truth." The artist mounts his work in large-scale light boxes the size of movie screens, to add yet another layer of quotation.

More recent photographers have continued the critique of originality by showing that photography is not merely a recorder of reality, but it also helps us construct our reality. There is no other way except through photography to establish the historical importance of Performance art or Earthworks, which are more remote for most viewers than famous museums. Likewise, photographs of artists at work also create mythology about them. The photographs of Jackson Pollock at work, for example, helped cement his reputation as a major

32–65 | Vik Muniz **ACTION PHOTO I (FROM "PICTURES OF CHOCOLATE")**
1997. Dye destruction print, 59⅞ × 46⅞" (152 × 121 cm). Victoria & Albert Museum, London.
Art © Vik Muniz / Licensed by VAGA, New York, NY

Modern artist (SEE FIG. 32–10). Vik Muniz (b. 1961) re-creates famous photographs in surprising media and then photographs the result (FIG. 32–65). In **ACTION PHOTO I,** Muniz splashed enough chocolate around so that he was able to make a passable copy of Hans Namuth's famous photo of Pollock at work. In order to make his version, Muniz had to develop the ability to match Pollock's famous drip technique of action painting (differing scales of the respective works complicated the task). After photographing his chocolate panel, he destroyed it, leaving the photograph as the completed work. The layers of reference in this work are numerous: It alludes to Muniz's skillful handling of the chocolate, the photo of Pollock, and to Pollock's actual painting. The latter is arguably the only "original" object in this work.

Andreas Gursky (b. 1955) photographs the spaces of contemporary society: stock exchanges, libraries, airports, designer stores, and, in the present example, a discount store (FIG. 32–66). This work may seem like a straight photograph, but in fact the artist shot several views and combined them with a digital photo editing program; he also altered the color scheme to give it more order. The store tried to create a perfect environment for shopping, and Gursky heightened the effect by smoothing out the dissonant shades, limiting the number of customers, and widening the perspective. He even placed the viewpoint high, as if we are "above the action," and added a reflective ceiling. All of these techniques are common in advertising photographs, which Gursky appropriates. An ironic fact about this particular work is that it belongs in the collection of a financial services company that invests in retail stores. A Postmodern method of discussing this work would be for the author to renounce originality and allow the owner of the work to speak in his place. Thus, let us invite the UBS publicity department to complete the story, from the company website: "Gursky's photographs refer to the structures and aesthetics of the consumerist world, in which context his series on the shop interior of the luxury brand Prada are, in their abstraction, as equally striking as the view into the interior of a 99 Cent store, one of Gursky's works in the UBS Art Collection. Whilst the Prada series could be linked to Color Field paintings, *99 Cent* reminds one of pointillist or impressionist paintings, representing reality while melting light and color."

Telling Stories with Paint

Many in the art world thought that the art of painting was moribund in the last years of the Modern movement. Most innovations seemed to come from Performance, Conceptual, or feminist art, perhaps leaving painting as a historical relic. Such talk has proved completely untrue in the Postmodern period, as artists in many countries have gone back to the studio. There they have rediscovered the pleasures of storytelling through art. Principal influences include Joseph Beuys's political rituals and the self-examination that feminists practiced.

32–66 | Andreas Gursky **99 CENT**
1999. C-print, 81½ × 132⅜″ (207 × 336.7 cm). GURA.PH.9529. Courtesy Matthew Marks Gallery, New York.
© 2001 Andreas Gursky / Artists Rights Society (ARS), New York, NY

NEO-EXPRESSIONISM. One of the first Postmodern movements to arise in the late 1970s was Neo-Expressionism, a return to the Expressionist styles in which the artist tries to render his or her inner self more than the outward appearance of the subject matter at hand. In Germany, the revival of Expressionism took on political connotations because the work of the original Expressionists had been labeled degenerate and banned by the Nazis during the 1930s (see "The Suppression of the Avant-Garde in Nazi Germany," page 1112). The German Neo-Expressionist Anselm Kiefer (b. 1945) was born in the final weeks of World War II, and in his work he has sought to come to grips with his country's Nazi past—"to understand the madness." The burned and barren landscape in his **HEATH OF THE BRANDENBURG MARCH** (**FIG. 32–67**) evokes the ravages of war that the Brandenburg area, near Berlin, has frequently experienced, most recently in

32–67 | Anselm Kiefer **HEATH OF THE BRANDENBURG MARCH**
1974. Oil, acrylic, and shellac on burlap, 3′10½″ × 8′4″ (1.18 × 2.54 m). Stedelijk Van Abbemuseum, Eindhoven, the Netherlands.

Kiefer often incorporates words and phrases into his paintings that amplify their meaning. Here, the words *märkische Heide* ("March Heath") evoke an old patriotic tune of the Brandenburg region, "Märkische Heide, märkische Sand," which Hitler's army adopted as a marching song.

32–68 | Sigmar Polke **RAISED CHAIR WITH GEESE**
1987-88. Artificial resin and acrylic on various fabrics,
9'5⅛" × 9' 5⅛" (2.9 × 2.9 m). The Art Institute of Chicago.
Restricted gift in memory of Marshall Frankel; Wilson L. Mead Endowment
(1990.81)

evocative of the beach, however, the tower also evokes the more pleasurable image of a raised lifeguard chair. Such lighter touches distinguish Polke's work in general from the unrelievedly serious efforts of Kiefer.

An American painter associated with the Neo-Expressionist movement was the tragically short-lived Jean-Michel Basquiat (1960–88), whose meteoric career ended with his death from a heroin overdose at age 27. The Brooklyn-born son of a Haitian father and a Puerto Rican mother, Basquiat was raised in middle-class comfort, against which he rebelled as a teenager. After quitting high school at 17, he left home to become a street artist, covering the walls of lower Manhattan with short and witty philosophical texts signed with the tag SAMO©. In 1980 Basquiat participated in the highly publicized "Times Square Show," which showcased the raw and aggressive styles of subway graffiti artists. The response to Basquiat's work encouraged him to begin painting professionally. Although he was untrained and wanted to make "paintings that look as if they were made by a child," Basquiat was a sophisticated artist. He carefully studied the Abstract

World War II. The road that lures us into the landscape, a standard device in nineteenth-century landscape paintings, here invites us into the region's dark past.

Kiefer's determination to deal with his country's troubled past was shaped in part by his study under Joseph Beuys (SEE FIG. 32–48) in the early 1970s. Another prominent Beuys student was Sigmar Polke (b. 1941), who grew up in Communist-controlled East Germany before moving at age 12 to West Germany. During the 1960s Polke made crude "capitalist realist" paintings that expressed a more critical view of consumer culture than did the generally celebratory work of the British and American Pop artists. Like them, Polke appropriated his images from the mass media. Polke later began to mix diverse images from different sources and paint them on unusual supports, such as printed fabrics, creating a complex, layered effect. **RAISED CHAIR WITH GEESE** (FIG. 32–68), for example, juxtaposes the silhouette of a watchtower with outlined figures of geese and a printed pattern of sunglasses, umbrellas, and folding chairs. The motif of the elevated hut generates many dark associations, ranging from the raised chair used by German fowl hunters (reinforced by the presence of the geese), to a sentry post for soldiers monitoring the border between East and West Germany, to a concentration camp watchtower. Set next to the decorative fabric

32–69 | Jean-Michel Basquiat **HORN PLAYERS**
1983. Acrylic and oil paintstick on canvas, three panels, overall
8' × 6'5" (2.44 × 1.91 m). Broad Art Foundation, Santa
Monica, California

Expressionists, the late paintings of Picasso, and Dubuffet (SEE FIG. 32–4), among others.

Basquiat's **HORN PLAYERS** (FIG. 32–69) portrays jazz musicians Charlie Parker (at the upper left) and Dizzy Gillespie (at center right) and includes numerous verbal references to their lives and music. The urgent paint handling and scrawled lettering seem genuinely Expressionist, conveying Basquiat's strong emotional connection to his subject (he avidly collected jazz records and considered Parker one of his personal heroes), as well as his passionate determination to make African American subject matter visible to his predominantly white audience. "Black people," said Basquiat, "are never portrayed realistically, not even portrayed, in Modern art, and I'm glad to do that."

NEW USES FOR OLD STYLES. In the Postmodern period, nearly every historical style is equally available for recycling by artists; Judith F. Baca (b. 1946) looked back to the Mexican mural movement (SEE FIG. 31–66) to recount from a new perspective the history of California (FIG. 32–70). Painted on a site controlled by the U.S. Army Corps of Engineers, Baca's **GREAT WALL OF LOS ANGELES** extends almost 2,500 feet along the wall of a drainage canal, making it the longest mural in the world. Its subject is the history of California,

with an emphasis on the role of ethnic minorities. The twentieth-century scenes include the deportation of Mexican American citizens during the Great Depression, the internment of Japanese American citizens during World War II, and residents' futile protests over the division of a Mexican American neighborhood by a new freeway. The mural concludes with more positive images of the opportunities minorities gained in the 1960s. Typical of Baca's public work, *The Great Wall of Los Angeles* was a group effort, involving professional artists and hundreds of young people who painted the mural under her direction.

32–70 | Judith F. Baca **THE DIVISION OF THE BARRIOS**
Detail from *The Great Wall of Los Angeles*. 1976-83. Height 13′ (4 m), overall length approx. 2,500′ (762 m).
Tujunga Wash Flood Control Channel, Van Nuys, California.

32–71 | Jaune Quick-to-See Smith **THE RED MEAN: SELF PORTRAIT**
1992. Acrylic, newspaper collage, and mixed media on canvas, 90 × 60″ (228.6 × 154.4 cm). Smith College Museum of Art, Northhampton, Massachusetts.
Part gift from Janet Wright Ketcham, class of 1953, and part purchase from the Janet Wright Ketcham, class of 1953, Fund © Jaune Quick-to-See Smith

Native American artist Jaune Quick-to-See Smith (b. 1940) borrowed a well-known image by Leonardo da Vinci for her work **THE RED MEAN** (FIG. 32–71). She describes the work as a self-portrait, and indeed the center of the work has

32–72 | Kerry James Marshall **MANY MANSIONS**
1994. Acrylic on paper mounted on canvas, 114¼ × 135⅛″ (290 × 343 cm). Art Institute of Chicago.
Max V. Kohnstamm Fund, 1995.147 / Artists Rights Society (ARS), New York

a bumper sticker that reads "Made in the U.S.A." above an identification number. The central figure quotes Leonardo's *Vitruvian Man* (see "Vitruvian Man," page 665), but the message here is autobiographical. Leonardo inscribed the human form within perfect geometric shapes to emphasize the perfection of the human body, while Smith put her silhouette inside the red X that signifies nuclear radiation. This image alludes both to the uranium mines found on some Indian reservations and also to the fact that many have become temporary repositories for nuclear waste. The background of the work is a collage of Native American tribal newspapers. Her self-portrait thus includes her ethnic identity and life on the reservation as well as the history of Western art.

African American painter Kerry James Marshall (b. 1955) updates the pre-Modern genre of history paintings for the contemporary era. He grew up in public housing projects in Alabama and California, and in **MANY MANSIONS** (FIG. 32–72) he painted a visual essay on life in housing projects. In the background we see the huge buildings of Stateway Gardens, one of America's largest housing projects, located in Chicago. Many housing projects have the word "Gardens" in their names, and Marshall poses three well-dressed black men in the foreground, planting a garden in order to help create a sense of community. The three are arrayed in an off-center triangle that is based on Théodore Géricault's *Raft of the "Medusa,"* a narrative work that Marshall admires (see "*Raft of the 'Medusa,'*" page 992). He told an interviewer from the PBS television network, "That whole genre of history painting, that grand narrative style of painting, was something that I really wanted to position my work in relation to." Thus he uses a reference to a past style to enrich his art. The work presents many sentimental touches as well, such as the red ribbon across the top with the altered quote from the Bible: "In my mother's house there are many mansions." Two blue-birds fly along at the left bearing another ribbon in their beaks. The overt cuteness of these features, together with the impossibly florid garden, lend the work an ironic touch. The inscription "IL2-22" is like an illustration number, reminding us that this work is only a version of its subject.

The paintings of Takashi Murakami (b. 1962) tie in closely with the popular culture of the artist's native Japan, but they are only one aspect of his voluminous output. **EYE LOVE SUPERFLAT** (FIG. 32–73) resembles at first glance a corporate logo. Four stylized eyes frame a monogram that symbolizes love on a field of stenciled floral patterns, all in garish colors. The eyes are rendered in a cute style that quotes the Japanese popular culture of *manga* (comics) and animated films. The *Superflat* of the title describes not only the lack of depth in this work but also Japanese culture as a whole, the artist says. Woodblock prints of the nineteenth century used flat patterns, as does much traditional Japanese art by painters such as Sesshu and Sotatsu (see Chapter 25). Murakami was trained in the traditional Japanese art techniques at Tokyo

32–73 | Takashi Murakami **EYE LOVE SUPERFLAT**
2003. Acrylic on canvas mounted on wood, 23½ × 23½"
(59.7 × 59.7 cm). Marianne Boesky Gallery, New York.
© 2003 Takashi Murakami / Kaikai Kiki Co., Ltd. All rights reserved.

National University, where he earned a doctoral degree. He claims that Japanese culture today is still characterized by flatness, now of PDAs, flat-screen televisions, and digital billboards. *Eye Love Superflat* looks reproducible because it is. The artist, whom *Wired* magazine referred to in 2003 as "the next Andy Warhol," leads a workshop called the Hiropon Factory that employs 25 assistants who craft his images into videos,

T-shirts, handbags, and dolls. His career is an excellent example of how the paradigm for artistic success in the Postmodern era has evolved away from the archetypal solitary genius of Modernism.

Finding New Meanings in Shapes

Sculpture reached its limits under the impact of the Minimalist movement, as artists such as Judd and others (SEE FIG. 32–41) used the most elementary structures to see if they could remove all symbolic or personal meanings. Postmodern sculptors have gradually reinvested their work with some of these resonances, and thus the last twenty years have witnessed a flowering of three-dimensional art.

Martin Puryear (b. 1941) had an early interest in biology that would shape his mature aesthetic. As a Peace Corps volunteer in Sierra Leone on the west coast of Africa, Puryear studied the traditional, preindustrial woodworking methods of local carpenters and artisans. In 1966 he moved to Stockholm, Sweden, to study printmaking and learn the techniques of Scandinavian cabinetmakers. Two years later he began graduate studies in sculpture at Yale, where he encountered the work of a number of visiting Minimalist sculptors. By the middle of the 1970s he had combined these formative influences into a distinctive personal style reminiscent, in its organic simplicity, of Constantin Brancusi (SEE FIG. 31–33). Puryear's **PLENTY'S BOAST** (FIG. 32–74) does not represent anything in particular but suggests any number of things, including a strange sea creature or a fantastic musical instrument. Perhaps the most obvious reference is to the horn of plenty evoked in the sculpture's title. But the cone is empty, implying an "empty boast"—another phrase suggested by the

32–74 | Martin Puryear
PLENTY'S BOAST
1994-95. Red cedar and pine,
68 × 83 × 118"
(172.7 × 210.8 × 299.7 cm).
The Nelson-Atkins Museum of
Art, Kansas City, Missouri.
Purchase of the Renee C. Crowell Trust
(F95-16 A-C)

title. Whatever associations one prefers, the beauty of the sculpture lies in its superb craft and its idiosyncratic yet elegant organic forms. Sounding like an early twentieth-century Modernist, Puryear said, "The task of any artist is to discover his own individuality at its deepest."

If Puryear explores the territory of the self, Bombay-born Anish Kapoor (b. 1954) makes reference to the culture of his native India (FIG. 32–75). His pieces refer to the fleshy curves of traditional Indian sculpture and the tall shapes of Hindu temples (SEE FIGS. 23-4, 23–5), without exactly quoting either. He later sprinkles pigment powder on most of his works for two reasons: first, because such powders are the purest colors available since they are not mixed with binders as paint is; second, because such sprinkling has a ritualistic overtone, as if sanctifying the object. This work's long title has a diaristic quality that also suggests enlightenment.

In contrast to Kapoor's contemporary spirituality, Rachel Whiteread (b. 1963) urges us to take a fresh look at everyday things by making casts of them. She has cast the insides of a closet, the rectangle of space under a chair, and the contents of a water tower, turning all of these barely noticed negative spaces into solid blocks. Her aesthetic is based in part on the Arte Povera movement (SEE FIGS. 32–44, 32–45), which similarly found meaning in everyday things. For an exhibition in Venice she made a cast of the space behind the books on her library shelf. Over the years these castings have grown more ambitious, culminating in the 1993 work **HOUSE** (FIG. 32–76), in which she cast the entire inside of a three-story townhouse in concrete. The work took on a political dimension, because it was the last home remaining from a Victorian-era terrace that was being removed to create a new green space. Whiteread intended the work both as a monument to the idea of home and as a political statement about "the state of housing in England; the ludicrous policy of knocking down homes like this and building badly designed tower blocks which themselves have to be knocked down after 20 years." Immediately upon its completion, *House* became the focus of public debate over not just its

32–75 | Anish Kapoor **AS IF TO CELEBRATE, I DISCOVERED A MOUNTAIN BLOOMING WITH RED FLOWERS**
1981. Three drawings and sculpture with wood and various materials, height of tallest element, 38⅛" (97 cm).
Tate Gallery, London.
© Anish Kapoor

32–76 | Rachel Whiteread **HOUSE**
1993. Sprayed concrete. Corner of Grove and Roman roads, London; destroyed in 1994.
Commissioned by Artangel Trust and Beck's

artistic merits but also social issues such as housing, neighborhood life, and the authority of local planners. Intended to be temporary, Whiteread's work stood for less than three months before it, too, was demolished.

Modern sculpture since 1945 has generally neglected the human body, but many Postmodern sculptors have revived it because of its rich narrative possibilities. An important impetus for this renewed interest in the human form came with the AIDS crisis, which hit in the 1980s. The social agitation and medical controversy surrounding this disease gave many artists a new feeling that the human body is not only a means of storytelling but also a site of political struggle. The American sculptor Kiki Smith (b. 1954), who lost a sister to AIDS, has explored this territory in works such as **UNTITLED** (FIG. 32–77). This disturbing sculpture, made of red-stained, tissue-thin gampi paper, represents the flayed, bloodied, and crumpled skin of a male figure, torn into three pieces that hang limply from the wall. The body, once massive and vigorous, is now hollow and lifeless. This shattered, blood-red figure suggests a narrative too gruesome to contemplate but unfortunately not uncommon in present-day wars and terrorist attacks.

Postmodern sculptors may work in almost any medium that can be shaped in three dimensions. Ghana-born sculptor El Anatsui (b. 1944) was making wood carvings with a chainsaw when he began to notice the large quantities of liquor bottles in the trash in Nsukka, Nigeria, where he lives. He gathered several thousand of the aluminum tops, flattened

32–77 | Kiki Smith **UNTITLED**
1988. Ink on gampi paper, 48 × 38 × 7″
(121.9 × 96.5 × 17.8 cm). The Art Institute of Chicago.
Gift of Lannon Foundation (1997.121)

32–78 | El Anatsui **AFTER KINGS**
2005. Aluminum (liquor bottle tops) and copper wire, 88 × 70″ (224 × 178 cm).
Private Collection, Washington, D.C. Courtesy Skoto Gallery, New York.

Artists Rights Society (ARS), New York

them, and stitched them together with copper wire to form large wall pieces such as **AFTER KINGS** (FIG. 32–78). The tops were chosen not only because they were plentiful but also because of symbolic meanings. He said, "To me, the bottle tops encapsulate the essence of the alcoholic drinks which were brought to Africa by Europeans as trade items at the time of the earliest contact between the two peoples. Almost all the brands I use are locally distilled. I now source the caps from around Nsukka, where I live and work. I don't see what I do as recycling. I transform the caps into something else." *After Kings* changes garbage into a form that resembles a traditional kente cloth from the Ashanti culture of Ghana (SEE FIG. 28–12). The kente cloth art form was originally for the nobility only, which helps to explain the title of the work.

The African tradition of making art from whatever is at hand also motivated the British-born Nigerian Chris Ofili (b. 1968) to attach elephant dung to the surface of a painting about Mary, the mother of Jesus. This work became highly controversial when the mayor of New York City tried to close a museum that exhibited it in 1999 (see "Recent Controversies Over Public Funding for the Arts," facing page).

High Tech and Deconstructive Architecture

Architecture has gone through a rebirth almost as dramatic as that of sculpture since the end of Modernism, as architects search restlessly for new support systems beyond the "glass box" of late Modernism (SEE FIG. 32–56). New three-dimensional digital graphics programs allow architects to visualize these new ideas quickly and easily, making possible many innovative building shapes.

HIGH TECH ARCHITECTURE. Even as Postmodernism flourished in the late 1970s and 1980s, High Tech challenged it as the dominant successor to an exhausted Modernism. Characterized by the use of advanced building technology and industrial materials, equipment, and components, High Tech architects experiment with new, more expressive ways of composing a building's mass and of incorporating service modules such as heating and electricity. Among the most spectacular examples of High Tech architecture is the **HONG KONG & SHANGHAI BANK** (FIG. 32–79) by Norman Foster (b. 1935). Invited by his client to design the most beautiful bank in the world, Foster spared no expense in the creation of this futuristic forty-seven–story skyscraper. The rectangular plan features service towers at the east and west ends, eliminating the central service core typical of earlier skyscrapers such as the Seagram Building. The load-bearing steel skeleton, composed of giant masts and girders, is on the exterior. The individual stories hang from this structure, allowing for uninterrupted façades and open working areas filled with natural

Defining Art
RECENT CONTROVERSIES OVER PUBLIC FUNDING FOR THE ARTS

Should public money support the creation or exhibition of art that some taxpayers might find indecent or offensive? This question became an issue of heated debate in 1989–90, when controversies arose around the work of the American photographers Robert Mapplethorpe and Andres Serrano (b. 1950), who had both received funding, directly or indirectly, from the National Endowment for the Arts (NEA). Serrano became notorious for a large color photograph, *Piss Christ* (1987), that shows a plastic crucifix immersed in the artist's urine. Although Serrano did not create that work using public money, he did receive a $15,000 NEA grant in 1989 through the Southeastern Center for Contemporary Art (SECCA), which included *Piss Christ* in a group exhibition. *Piss Christ* came to the attention of the Reverend Donald Wildmon, leader of the American Family Association, who railed against it as "hate-filled, bigoted, anti-Christian, and obscene." Wildmon exhorted his followers to flood Congress and the NEA with letters of protest, and the attack on the NEA was quickly joined by conservative Republican politicians.

Amid the Serrano controversy, the Corcoran Gallery of Art in Washington, D.C., decided to cancel its showing of the NEA-funded Robert Mapplethorpe retrospective (organized by the Institute of Contemporary Art [ICA] in Philadelphia) because it included homoerotic and sadomasochistic images. Congress proceeded to cut NEA funding by $45,000, equaling the $15,000 SECCA grant to Serrano and the $30,000 given to the ICA for the Mapplethorpe retrospective. It also added to the NEA guidelines a clause requiring that award decisions take into consideration "general standards of decency and respect for the diverse beliefs and values of the American public."

During the years of legal battle, the NEA underwent major restructuring under pressure from the Republican-controlled House of Representatives, some of whose members sought to eliminate the agency altogether. In 1996 Congress cut the NEA's budget by 40 percent, cut its staff in half, and replaced its seventeen discipline-based grant programs with four interdisciplinary funding categories. It also prohibited grants to individual artists in all areas except literature, making it impossible for visual artists in any medium to receive grants.

Another major controversy over the use of taxpayer money to support the display of provocative art erupted in the fall of 1999, when the Brooklyn Museum of Art opened the exhibition "Sensation: Young British Artists from the Saatchi Collection" in defiance of a threat from New York City mayor Rudolph Giuliani to eliminate city funding and evict the museum from its city-owned building if it persisted in showing work that he called "sick" and "disgusting." Giuliani and Catholic leaders took particular offense at Chris Ofili's **THE HOLY VIRGIN MARY,** a glittering painting of a stylized African Madonna with a breast made out of elephant dung, set against a background dotted with small photographic images of women's buttocks and genitalia. Ofili, a British-born black of Nigerian parentage who is himself Catholic, explained that he meant the painting to be a contemporary reworking of the traditional image of the Madonna surrounded by naked *putti,* and that the elephant dung, used for numerous practical purposes by African cultures, represents fertility. Giuliani and his allies, however, considered the picture sacrilegious.

When in late September the Brooklyn Museum of Art refused to cancel the show, Giuliani withheld the city's monthly maintenance payment to the museum of $497,554 and filed a suit in state court to revoke its lease. The museum responded with a federal lawsuit seeking an injunction against Giuliani's actions on the grounds that they violated the First Amendment. On November 1, the U.S. District Court for the Eastern District of New York barred Giuliani and the city from punishing or retaliating against the museum in any way for mounting the exhibition. While the mayor had argued that the city should not have to subsidize art that fosters religious intolerance, the court ruled that the government has "no legitimate interest in protecting any or all religions from views distasteful to them." Taxpayers, said the court, "subsidize all manner of views with which they do not agree," even those "they abhor."

Chris Ofili **THE HOLY VIRGIN MARY**
1996. Paper collage, oil paint, glitter, polyester resin, map pins, and elephant dung on linen, 7'11" × 5'11 7/16" (2.44 × 1.83 cm). The Saatchi Gallery, London.

32–79 | Norman Foster **HONG KONG & SHANGHAI BANK**
Hong Kong. 1986.

light. The main banking hall, the lowest segment of the building, features a ten-story atrium space flooded by daylight refracted from motorized "sunscoops" at its apex, computer-programmed to track the sun and channel its rays into the building. The sole concession Foster's High Tech building makes to tradition are the two bronze lions that guard its public entrance—the only surviving elements from the bank's previous headquarters. A popular belief holds that touching the lions before entering the bank brings good luck.

DECONSTRUCTIVIST ARCHITECTURE. Deconstructivist architecture is a new tendency to disturb the traditional architectural values of harmony, unity, and stability through the use of skewed, distorted, and impure geometry. The principal influences on this movement are Suprematism and Constructivism, both Russian Modernist movements (SEE FIGS. 31–30, 31–58). Many architects since the 1980s have combined an awareness of these Russian sources with an interest in the theory of Deconstruction developed by French philosopher Jacques Derrida (1930–2004). Concerned mostly with the analysis of verbal texts, Derridean Deconstruction holds that no text possesses a single, intrinsic meaning. Rather, its meaning is always "intertextual"—a product of its relationship to other texts—and is always "decentered," or "dispersed" along

an infinite chain of linguistic signs, the meanings of which are themselves unstable. Deconstructivist architecture is, consequently, often "intertextual" in its use of design elements from other traditions, including Modernism, and "decentered" in its denial of a unified and stable form.

A prime example of Deconstructivist architecture is the **VITRA FIRE STATION** in Weil-am-Rhein, Germany (FIG. 32–80), by the Baghdad-born Zaha Hadid (b. 1950), who studied architecture in London and established her practice there in 1979. Stylistically influenced by the Suprematist paintings of Kasimir Malevich (SEE FIG. 31–29), the Vitra Fire Station features leaning, reinforced concrete walls that meet at unexpected angles and jut dramatically into space, denying any sense of unity while creating a feeling of dynamism appropriate to the building's function.

The Toronto-born, California-based Frank O. Gehry (b. 1929) creates unstable and Deconstructivist building masses using curved shapes far more exuberant than those of Modern architecture. He achieved his initial fame in the late 1970s with his inventive use of vernacular forms and cheap materials set into unstable and conflicted arrangements. After working during the 1980s in a more classically geometrical mode, in the 1990s Gehry developed a powerfully organic, sculptural style, most famously exemplified in his enormous **GUGGENHEIM MUSEUM** in Bilbao, Spain (FIG. 32–81). The building's complex steel skeleton is covered with a thin skin of silvery titanium that shimmers gold or silver depending on the light. Gehry's building resembles a living organism from most vantage points except the north, from which it resembles a giant ship, a reference to the shipbuilding so important to Bilbao. This building started a trend of adventurous design in art museums that continues today.

New Statements in New Media

The art of our own times is the most difficult to classify and analyze; we are still too close to the Postmodern trees to allow us to see the forest. Having pointed out in general terms a few trends that have developed in the last generation, we will close this book with a brief look at more recent art that is difficult to put into stylistic categories. The artists who created these seven works come from various continents and ethnic groups, reflecting today's globalized art world. Some of the creators focus on political issues; some are autobiographical or symbolic; some explore the new media that technology has given us.

SOCIAL CHANGE. A socially minded artist strongly committed to working in public is David Hammons (b. 1943), an outspoken critic of the gallery system. Lamenting the lack of challenging content in art shows, he says that the art world is "like Novocaine. It used to wake you up but now it puts you to sleep." Only street art, uncontaminated by commerce, he maintains,

32–80 | Zaha Hadid **VITRA FIRE STATION**
Weil-am-Rhein, Germany. 1989–93.

32–81 | Frank O. Gehry **GUGGENHEIM MUSEUM**
Bilbao, Spain. 1993–97.

32–82 | David Hammons **HIGHER GOALS**
1982; shown installed in Brooklyn, New York, 1986. Five poles of mixed media, including basketball hoops and bottle caps, height of tallest pole 40' (11 m).
Courtesy of Artemis Greenberg Van Doren Gallery, New York

park, has backboards and baskets set on telephone poles—a reference to communication—that rise as high as 35 feet. The poles are decorated with bottle caps, a substitute for the cowrie shells used not only in African design but also in some African cultures as money. Although the series may appear to honor the game of basketball, Hammons said it is "anti-basketball sculpture." "Basketball has become a problem in the black community because kids aren't getting an education. . . . It means you should have higher goals in life than basketball."

In their drive to bring about positive social change, some artists have created public works meant to provoke not only discussion but also tangible improvements. Notable examples are the **REVIVAL FIELDS** of Mel Chin (b. 1951), which are designed to restore the ecological health of contaminated land through the action of "hyperaccumulating" plants that absorb heavy metals from the soil. Chin created his first *Revival Field* near St. Paul, Minnesota, in the dangerously contaminated Pig's Eye Landfill (FIG. 32–83). He gave the work the cosmological form of a circle in a square (representing heaven and earth in Chinese iconography), divided into quarters by intersecting walkways. He seeded the inside of the circle with hyperaccumulating plants and the outside with nonaccumulating plants as a control. For three years the plants were harvested and replanted and toxic metals removed from the soil. Chin went on to create other *Revival Fields* elsewhere in the United States and Europe. "Rather than making a metaphorical work to express a problem," said Chin, "a work can . . . tackle a problem head-on. As an art form it extends the notion of art beyond a familiar object-commodity status into the realm of process and public service." He has created a new kind of Earthwork (SEE FIGS. 32–49 TO 32–51) that moves the focus away from aesthetic contemplation in favor of environmental activism.

can still serve the function of jolting people awake. Hammons for the most part aims his work at his own African American community. His best-known creation is probably **HIGHER GOALS** (FIG. 32–82), which he produced in several versions between 1982 and 1986. This one, temporarily set up in a Brooklyn

32–83 | Mel Chin **REVIVAL FIELD: PIG'S EYE LANDFILL**
1991–93. St. Paul, Minnesota.

Although the *Revival Field* series serves the practical purpose of reclaiming a hazardous waste site through the use of plants that absorb toxic metals from the soil, Chin sought funding for his series not from the Environmental Protection Agency but from the National Endowment for the Arts. In 1990 his grant application, which had been approved by an NEA panel, was vetoed by NEA chair John E. Frohnmayer, who questioned the project's status as art. Frohnmayer reversed his decision after Chin eloquently compared *Revival Field* to a work of sculpture: "Soil is my marble. Plants are my chisel. Revived nature is my product. . . . This is responsibility and poetry."

32–84 | Ann Hamilton **INDIGO BLUE**
1991. Installation for "Places with a Past," Spoleto Festival U.S.A., Charleston, South Carolina.

SOCIAL OBSERVATION. Visitors to the installation by Ann Hamilton (b. 1956) at the 1991 Spoleto Festival in Charleston, South Carolina, found an abandoned auto repair shop with a worker sitting at a table laboriously erasing pages from a book, before a huge pile of carefully folded blue clothing (FIG. 32–84). Taking a cue from the everyday aesthetics of John Dewey and Arte Povera, her installation allows historically specific readings that have a political subtext about aspects of American life neglected by most historians. The street outside was named for Eliza Lucas Pinckney, who in 1744 introduced to the American colonies the cultivation of indigo, the source of a blue dye used for blue-collar work clothes, among other things. The focal point of Hamilton's **INDIGO BLUE** was a pile of about 48,000 neatly folded work pants and shirts. However, *Indigo Blue* was more a tribute to the women who washed, ironed, and folded such clothes—in this case, Hamilton and a few women helpers, including her mother—than to the men who wore them. In front of the great mound of shirts and pants sat a performer erasing the contents of old history books—creating page space, Hamilton said, for the ordinary, working-class people usually omitted from conventional histories.

Landscape design has entered its Postmodern phase in the work of Ken Smith (b. 1953). When New York's Museum of Modern Art underwent an expansion in 2005, the curators decided to decorate some of the new roof space with landscape gardens. These spaces would not be accessible from inside the building, and hence the garden had to be maintenance-free. The concept was to decorate the roof so that the building would be less unsightly to the apartment dwellers living nearby. Smith created a humorously understated design using plastic rocks, trees, and bushes set on gravel of various colors, all arranged in a camouflage pattern to "hide" the roof (FIG. 32–85). The curving plots also resemble the winding paths of New York's Central Park (see "The City Park," page 1059), but on a smaller scale responding to the needs of the site. When some neighbors objected that the garden was completely fake, Smith responded that Central Park is fake also, since Olmsted leveled the area before planting anything. The way this work alludes to the past, and makes a joke out of the confusion of the real and unreal, mark it as a highly original piece of garden design, creative in a Postmodern sense.

A number of contemporary artists create installations with video, either using the video monitor itself as a visible part of their work or projecting video imagery onto walls, screens, or other surfaces. The pioneer of video as an artistic medium was the Korean-born Nam June Paik (1931–2006), who proclaimed that just "as collage technique replaced oil paint, the cathode ray [television] tube will replace the canvas." Strongly influenced by John Cage, Paik made experimental music in the late 1950s and early 1960s. He began working with modified television sets in 1963 and bought his first video camera in 1965. Paik worked with live, recorded, and computer-generated images displayed on video monitors of varying sizes, which he often combined into sculptural

32–85 | Ken Smith, Landscape Architect **MOMA ROOF GARDEN**
2005. Outdoor garden at the Museum of Modern Art, New York.
Photograph © Peter Mauss / ESTO / Artists Rights Society (ARS), New York

32–86 | Nam June Paik **ELECTRONIC SUPERHIGHWAY:
CONTINENTAL U.S.**
1995. Forty-seven-channel closed-circuit video installation
with 313 monitors, neon, steel structure, color, and sound;
approx. 15 × 32 × 4' (4.57 × 9.75 × 1.2 m).
Courtesy Holly Solomon Gallery, New York

ensembles such as **ELECTRONIC SUPERHIGHWAY: CONTINEN-
TAL U.S.** (FIG. 32–86), a site-specific installation created for
the Holly Solomon Gallery in New York. Stretching across an
entire wall, the work featured a map of the continental
United States outlined in neon and backed by video moni-
tors perpetually flashing with color and movement and
accompanied by sound. (Side walls featured Alaska and
Hawaii.) The monitors within the borders of each state dis-
played images reflecting that state's culture and history, both
past and recent. The only exception was New York State,
whose monitors displayed live, closed-circuit images of the
gallery visitors, placing them in the artwork and transforming
them from passive spectators into active participants.

DIVISIONS, COMMONALITIES. The videos of Shirin Neshat
(b. 1957) address universal themes within the specific context
of present-day Islamic society. Neshat was studying art in
California when revolution shook her native Iran in 1979.
Returning to Iran in 1990 for the first time in twelve years,
Neshat was shocked by the extent to which fundamentalist
Islamic rule had transformed her homeland, particularly
through the requirement that women appear in public veiled
from head to foot in a *chador,* a square of fabric. Upon her
return to the United States, Neshat began using the black
chador as the central motif of her work.

In the late 1990s Neshat began to make visually arresting
and poetically structured films and videos that offer subtle
critiques of Islamic society. **FERVOR** (FIG. 32–87), in Neshat's
words, "focuses on taboos regarding sexuality and desire" in
Islamic society that "inhibit the contact between the sexes in

public. A simple gaze, for instance, is considered a sin. . . ." Com-
posed of two separate video channels projected simultaneously
on two large, adjoining screens, *Fervor* presents a simple narrative.
In the opening scene, a black-veiled woman and jacket-wearing
man, viewed from above, cross paths in an open landscape. The
viewer senses a sexual attraction between them, but they make
no contact and go their separate ways. Later, they meet again
while entering a public ceremony where men and women are
divided by a large curtain. On a stage before the audience, a
bearded man fervently recounts (in Farsi, without subtitles) a
story adapted from the Koran about Yusuf (the biblical Joseph)
and Zolikha. Zolikha attempts to seduce Yusuf (her husband's
slave) and then, when he resists her advances, falsely accuses him
of having seduced her. The speaker passionately urges his listen-
ers to resist such sinful desires with all their might. As his tone
intensifies and the audience begins to chant in response to his
exhortations, the male and female protagonists grow increasingly
anxious, and the woman eventually rises and exits hurriedly. *Fer-
vor* ends with the man and woman passing each other in an alley,
again without verbal or physical contact.

32–87 | Shirin Neshat **PRODUCTION STILLS
FROM "FERVOR"**
2000. Video/sound installation with two channels of black-
and-white video projected onto two screens, 10 minutes.
Courtesy Barbara Gladstone Gallery, New York

32–88 | Wenda Gu **UNITED NATIONS–BABEL OF THE MILLENNIUM**
1999. Site-specific installation made of human hair, height 75' (22.9 m); diameter 34' (10.4 m).
San Francisco Museum of Modern Art.
Fractional and promised gift of Viki and Kent Logan

While Neshat concentrates on dualisms and divisions—between East and West, male and female, individual desire and collective law—the Shanghai-born artist Wenda Gu (b. 1955) dedicates his art to bringing people together. Trained in traditional ink painting at China's National Academy of Fine Arts, Gu in the 1980s began to paint pseudo-characters—fake, Chinese-looking ideograms of his own invention. Although he later claimed that his intent was simply to "break through the control of tradition," the Chinese authorities feared that his work contained hidden political messages and did not permit his first solo exhibition to open in 1986. The next year Gu emigrated to the United States and in 1992 began his *United Nations* series, which he describes as an ongoing worldwide art project. The series consists of site-specific installations or "monuments" made of human hair, which Gu collects from barbershops across the globe and presses or weaves into bricks, carpets, and curtains. Gu's "national" monuments—installed in such countries as Poland, Israel, and Taiwan—use hair collected within that country, addressing issues specific to that country. His "transnational" monuments address larger themes and blend hair collected from different countries as a metaphor for the mixture of races that the artist predicts will eventually unite humanity into "a brave new racial identity." Many of Gu's installations, such as **UNITED NATIONS–BABEL OF THE MILLENNIUM** (FIG. 32–88), also incorporate invented scripts based on Chinese, English, Hindi, and Arabic characters

that, by frustrating viewers' ability to read them, "evoke the limitations of human knowledge" and help prepare them for entry into an "unknown world."

In its ambitious attempt to address in artistic terms the issue of globalism that dominates discussions of contemporary economics, society, and culture, Gu's work is remarkably timely. Yet, like all important art, it is meant to speak not only to the present but also to the future, which will recognize it as part of the fundamental quest of artists throughout history to extend the boundaries of human perception, feeling, and thought and to express humanity's deepest wishes and most powerful dreams. "A great 'Utopia' of the unification of mankind probably can never exist in our reality," admits Gu, "but it is going to be fully realized in the art world."

IN PERSPECTIVE

Shortly after the end of the World War II in 1945, artistic innovation in the Western world was centered in Paris, New York, and Buenos Aires. The Paris artists reacted to the meltdown of European civilization that witnessed millions of deaths. The New York School pioneered Abstract Expressionism and Color Field painting, while the Buenos Aires groups worked abstractly with shaped canvases and neon.

From about 1955 to 1965, artists experimented with new ways of bringing their art into contact with the real world. Some created Assemblages of real objects in chaotic compositions; others carried out Happenings that involved staging events. The third and most important outgrowth of this trend was Pop Art, in which artists borrowed the techniques of mass media to comment on popular culture.

In the 1960s and early 1970s, artists made the final assault on traditions that date from the Renaissance. As in the early twentieth century, movements followed each other in quick succession, each claiming to be more radical than the last. Minimal artists eliminated personal feeling and all social reference from their work. Conceptual artists eliminated the art object itself in favor of informational documentation of their ideas. Performance artists refused to produce anything permanent at all. Arte Povera artists made works that depended on natural processes rather than the artist's decision to determine their form. Earthwork artists worked in remote locations directly on the surface of the land. Feminists assaulted the mostly unspoken tradition of male dominance. Some of these movements were influenced by the activism of the 1960s, while others shared in the widespread questioning of social norms that marked the period.

By the mid- to late 1970s, there seemed to be no traditional rules of art left to break. In addition, the avant-garde had all but ceased to exist as a group separate from society at large. As a result, most art produced since then has been called Postmodern, as artists ceased focusing on formal innovation and devoted more energy to reflection on our world. Architecture underwent a similar transition as Postmodern architects began to use decoration and historical reference once again.

And the history of art still unfolds. As Modern art restlessly investigated the boundaries of art, the Postmodern period has opened new possibilities for interaction with the audience. If we viewers are aware of art of the past, we will be able to appreciate the many varieties of creativity that await us in the future.

Johns
TARGET WITH FOUR FACES
1955

Krasner
THE SEASONS
1957

Riley
CURRENT
1964

Christo and Jeanne-Claude
RUNNING FENCE
1972–76

Foster
HONG KONG & SHANGHAI BANK
1986

Neshat
**PRODUCTION STILLS
FROM "FERVOR"**
2000

1940

1950

1960

1970

1980

1990

2000

◄ World War II Ends 1945
◄ Britain Withdraws from India 1947

◄ People's Republic of China
 Established 1949
◄ Korean War 1950–53

◄ Civil Rights Movement Begins in U.S
 1954
◄ USSR Launches First Satellite 1957

◄ Human First Orbits Earth 1961
◄ President John F. Kennedy Killed
 1963
◄ U.S. Enters Vietnam War 1965
◄ Montreal World Exposition 1967
◄ Robert F. Kennedy and Martin Luther
 King, Jr., Killed 1968
◄ First Moon Landing 1969

◄ Stephen Hawkings Proposes Black
 Hole Theory 1974

◄ Chernobyl Nuclear Power Plant
 Disaster 1986

◄ Germany Reunited 1990
◄ USSR Disssolved 1991

◄ Advent of World Wide Web 1994

◄ Human Genome Sequence Decoded
 2000
◄ World Trade Center Attack 2001
◄ U.S. War in Iraq 2003

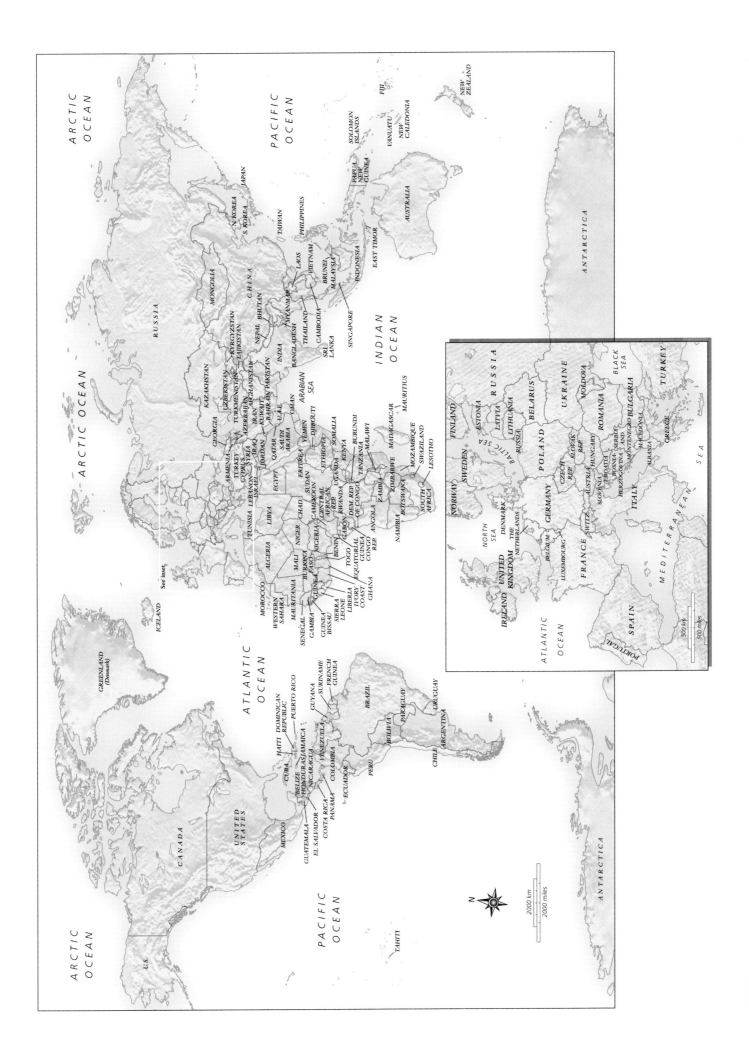

GLOSSARY

abacus The flat slab at the top of a **capital**, directly under the **entablature**.

absolute dating A method of assigning a precise historical date to periods and objects based on known and recorded events in the region as well as technically extracted physical evidence (such as carbon-14 disintegration). See also **radiometric dating, relative dating**.

abstract, abstraction Any art that does not represent observable aspects of nature or transforms visible forms into a stylized image. Also: the formal qualities of this process.

acropolis The **citadel** of an ancient Greek city, located at its highest point and housing temples, a treasury, and sometimes a royal palace. The most famous is the Acropolis in Athens.

acroterion (acroteria) An ornament at the corner or peak of a roof.

adobe Sun-baked blocks made of clay mixed with straw. Also: the buildings made with this material.

adyton The back room of a Greek temple. At Delphi, the place where the **oracles** were delivered. More generally, a very private space or room.

aedicula (aediculae) A decorative architectural frame, usually found around a niche, door, or window. An aedicula is made up of a **pediment** and **entablature** supported by **columns** or **pilasters**.

agora An open space in a Greek town used as a central gathering place or market. See also **forum**.

aisle Passage or open corridor of a church, hall, or other building that parallels the main space, usually on both sides, and is delineated by a row, or **arcade**, of **columns** or piers. Called side aisles when they flank the **nave** of a church.

album A book consisting of a series of painting or prints (album leaves) mounted into book form.

all'antica Meaning, "in the ancient manner."

allegory In a work of art, an image (or images) that symbolically illustrates an idea, concept, or principle, often moral or religious.

alloy A mixture of metals; different metals melted together.

amalaka In Hindu architecture, the circular or square-shaped element on top of a spire (*shikhara*), often crowned with a **finial**, symbolizing the cosmos.

ambulatory The passage (walkway) around the **apse** in a basilican church or around the **central space in a central-plan building**.

amphiprostyle Term describing a building, usually a temple, with **porticoes** at each end but without **columns** along the other two sides.

amphora An ancient Greek jar for storing oil or wine, with an egg-shaped body and two curved handles.

aniconic A symbolic representation without images of human figures, very often found in Islamic art.

animal interlace Decoration made of interwoven animals or serpents, often found in Celtic and early medieval Northern European art.

ankh A looped cross signifying life, used by ancient Egyptians.

appropriation Term used to describe an artist's practice of borrowing from another source for a new work of art. While in previous centuries artists often copied one another's figures, motifs, or compositions, in modern times the sources for appropriation extend from material culture to works of art.

apse, apsidal A large semicircular or polygonal (and usually vaulted) niche protruding from the end wall of a building. In the Christian church, it contains the altar. Apsidal is an adjective describing the condition of having such a space.

arabesque A type of linear surface decoration based on foliage and **calligraphic** forms, usually characterized by flowing lines and swirling shapes.

arcade A series of **arches**, carried by **columns** or **piers** and supporting a common wall or lintel. In a blind arcade, the arches and supports are engaged (attached to the wall) and have a decorative function.

arch In architecture, a curved structural element that spans an open space. Built from wedge-shaped stone blocks called **voussoirs**, which, when placed together and held at the top by a trapezoidal **keystone**, form an effective space-spanning and weight-bearing unit. Requires buttresses at each side to contain the outward thrust caused by the weight of the structure. **Corbel** arch: arch or **vault** formed by **courses** of stones, each of which projects beyond the lower course until the space is enclosed; usually finished with a **capstone**. Horseshoe arch: an arch of more than a half-circle; typical of western Islamic architecture. Ogival arch: a pointed arch created by S curves. Relieving arch: an arch built into a heavy wall just above a post-and-lintel structure (such as a gate, door, or window) to help support the wall above by transferring the load to the side walls.

archaic smile The curved lips of an ancient Greek statue, usually interpreted as an attempt to animate the features.

architrave The bottom element in an **entablature**, beneath the **frieze** and the **cornice**.

art brut French for "raw art." Term introduced by Jean Dubuffet to denote the often vividly **expressionistic** art of children and the insane, which he considered uncontaminated by culture.

articulated Joined; divided into units; in architecture, divided into parts to make spatial organization intelligible.

ashlar A highly finished, precisely cut block of stone. When laid in even **courses**, ashlar masonry creates a uniform face with fine joints. Often used as a facing on the visible exterior of a building, especially as a veneer for the **façade**. Also called **dressed stone**.

assemblage Artwork created by gathering and manipulating two and/or three-dimensional found objects.

astragal A thin convex decorative **molding**, often found on classical **entablatures**, and usually decorated with a continuous row of beadlike circles.

atelier The studio or workshop of a master artist or craftsperson, often including junior associates and apprentices.

atmospheric perspective See **perspective**.

atrial cross The cross placed in the atrium of a church. In Colonial America, used to mark a gathering and teaching place.

atrium An unroofed interior courtyard or room in a Roman house, sometimes having a pool or garden, sometimes surrounded by columns. Also: the open courtyard in front of a Christian church; or an entrance area in modern architecture.

automatism A technique whereby the usual intellectual control of the artist over his or her brush or pencil is foregone. The artist's aim is to allow the subconscious to create the artwork without rational interference.

avant-garde Term derived from the French military word meaning "before the group," or "vanguard." Avant-garde denotes those artists or concepts of a strikingly new, experimental, or radical nature for the time.

axis mundi A concept of an "axis of the world," which marks sacred sites and denotes a link between the human and celestial realms. For example, in Buddhist art, the axis mundi can be marked by monumental freestanding decorative pillars.

baldachin A canopy (whether suspended from the ceiling, projecting from a wall, or supported by columns) placed over an honorific or sacred space such as a throne or church altar.

bargeboards Boards covering the rafters at the gable end of a building; bargeboards are often carved or painted.

barrel vault See **vault**.

bar tracery See **tracery**.

bas-de-page French: bottom of the page; a term used in manuscript studies to indicate pictures below the text, literally at the bottom of the page.

base Any support. Also: masonry supporting a statue or the **shaft** of a **column**.

basilica A large rectangular building. Often built with a **clerestory**, side **aisles** separated from the center **nave** by **colonnades**, and an **apse** at one or both ends. Roman centers for administration, later adapted to Christian church use. Constantine's architects added a transverse aisle at the end of the nave called a **transept**.

bay A unit of space defined by architectural elements such as **columns, piers**, and walls.

beehive tomb A **corbel-vaulted** tomb, conical in shape like a beehive, and covered by an earthen mound.

Benday dots In modern printing and typesetting, the individual dots that, together with many others, make up lettering and images. Often machine- or computer-generated, the dots are very small and closely spaced to give the effect of density and richness of tone.

bestiary A book describing characteristics, uses, and meaning illustrated by moralizing tales about real and imaginary animals, especially popular during the Middle Ages in western Europe.

bi A jade disk with a hole in the center.

biomorphic Adjective used to describe forms that resemble or suggest shapes found in nature.

black-figure A style or technique of ancient Greek pottery in which black figures are painted on a red clay ground. See also **red-figure**.

bodhisattva In Buddhism, a being who has attained enlightenment but chooses to remain in this world in order to help others advance spiritually. Also defined as a potential Buddha.

boss A decorative knoblike element. Bosses can be found in many places, such as at the intersection of a Gothic vault rib. Also buttonlike projections in decorations and metalwork.

bracket, bracketing An architectural element that projects from a wall to support a horizontal part of a building, such as beams or the eaves of a roof.

brandea An object, such as a linen strip, having contact with a relic and taking on the power of the relic.

buon fresco *See* **fresco**.

cairn A pile of stones or earth and stones that served both as a prehistoric burial site and as a marker of underground tombs.

calligraphy Handwriting as an art form.

calyx krater *See* **krater**.

came (cames) A lead strip used in the making of leaded or **stained-glass** windows. Cames have an indented vertical groove on the sides into which the separate pieces of glass are fitted to hold the design together.

cameo Gemstone, clay, glass, or shell having layers of color, carved in **low relief** to create an image and ground of different colors.

camera obscura An early cameralike device used in the Renaissance and later for recording images of nature. Made from a dark box (or room) with a hole in one side (sometimes fitted with a lens), the camera obscura operates when bright light shines through the hole, casting an upside-down image of an object outside onto the inside wall of the box.

canon of proportions A set of ideal mathematical ratios in art based on measurements of the human body.

capital The sculpted block that tops a **column**. According to the conventions of the orders, capitals include different decorative elements. See **order**. Also: a historiated capital is one displaying a narrative.

capriccio A painting or print of a fantastic, imaginary landscape, usually with architecture.

capstone The final, topmost stone in a **corbel arch** or vault, which joins the sides and completes the structure.

cartoon A full-scale drawing used to transfer the outline of a design onto a surface (such as a wall, canvas, panel, or tapestry) to be painted, carved, or woven.

cartouche A frame for a **hieroglyphic** inscription formed by a rope design surrounding an oval space. Used to signify a sacred or honored name. Also: in architecture, a decorative device or plaque, usually with a plain center used for inscriptions or epitaphs.

caryatid A sculpture of a draped female figure acting as a column supporting an **entablature**.

catacomb A subterranean burial ground consisting of tunnels on different levels, having niches for urns and **sarcophagi** and often incorporating rooms (cubiculae).

celadon A high-fired, transparent **glaze** of pale bluish-green hue whose principal coloring agent is an oxide of iron. In China and Korea, such glazes typically were applied over a pale gray **stoneware** body, though Chinese potters some-

times applied them over **porcelain** bodies during the Ming (1368-1644) and Qing (1644-1911) dynasties. Chinese potters invented celadon glazes and initiated the continuous production of celadon-glazed wares as early as the third century CE.

cella The principal interior room at the center of a Greek or Roman temple within which the cult statue was usually housed. Also called the **naos**.

cenotaph A funerary monument commemorating an individual or group buried elsewhere.

centering A temporary structure that supports a masonry **arch** and **vault** or **dome** during construction until the mortar is fully dried and the masonry is self-sustaining.

centrally planned building Any structure designed with a primary central space surrounded by symmetrical areas on each side. For example, **Greek-cross plan** (equal-armed cross).

ceramics A general term covering all types of wares made from fired clay, including **porcelain** and **terra cotta**.

chaitya A type of Buddhist temple found in India. Built in the form of a hall or **basilica**, a chaitya hall is highly decorated with sculpture and usually is carved from a cave or natural rock location. It houses a sacred shrine or stupa for worship.

chamfer The slanted surface produced when an angle is trimmed or beveled, common in building and metalwork.

chasing Ornamentation made on metal by incising or hammering the surface.

***chattri* (*chattris*)** A decorative pavilion with an umbrella-shaped **dome** in Indian architecture.

chevron A decorative or heraldic motif of repeated Vs; a zigzag pattern.

chiaroscuro An Italian word designating the contrast of dark and light in a painting, drawing, or print. Chiaroscuro creates spatial depth and volumetric forms through gradations in the intensity of light and shadow.

chiton A thin sleeveless garment, fastened at waist and shoulders, worn by men and women in ancient Greece.

citadel A fortress or defended city, if possible placed in a high, commanding location.

clapboard Horizontal overlapping planks used as protective siding for buildings, particularly houses in North America.

clerestory The topmost zone of a wall with windows in a **basilica** extending above the **aisle** roofs. Provides direct light into the central interior space (the **nave**).

cloisonné An enamel technique in which metal wire or strips are affixed to the surface to form the design. The resulting areas (cloisons) are filled with enamel (colored glass).

cloister An open space, part of a monastery, surrounded by an **arcaded** or **colonnaded** walkway, often having a fountain and garden, and dedicated to nonliturgical activities and the secular life of the religious. Members of a cloistered order do not leave the monastery or interact with outsiders.

codex (codices) A book, or a group of **manuscript** pages (folios), held together by stitching or other binding on one side.

coffer A recessed decorative panel that is used to reduce the weight of and to decorate ceilings or **vaults**. The use of coffers is called coffering.

colonnade A row of **columns**, supporting a straight lintel (as in a **porch** or **portico**) or a series of arches (an **arcade**).

colophon The data placed at the end of a book listing the book's author, publisher, illuminator, and other information related to its production. Also, in East Asian handscrolls, the inscriptions which follow the painting are called colophons.

column An architectural element used for support and/or decoration. Consists of a rounded or polygonal vertical **shaft** placed on a **base** and topped by a decorative **capital**. In classical architecture, built in accordance with the rules of one of the architectural **orders**. Columns can be freestanding or attached to a background wall (**engaged**).

complementary color The primary and secondary colors across from each other on the color wheel (red and green, blue and orange, yellow and purple). When juxtaposed, the intensity of both colors increases. When mixed together, they negate each other to make a neutral graybrown.

Composite order *See* **order**.

cong A square or octagonal jade tube with a cylindrical hole in the center. A symbol of the earth, it was used for ritual worship and astronomical observations in ancient China.

connoisseurship A term derived from the French word connoisseur, meaning "an expert," and signifying the study and evaluation of art based primarily on formal, visual, and stylistic analysis. A connoisseur studies the style and technique of an object to deduce its relative quality and possible maker. This is done through visual association with other, similar objects and styles. See also **contextualism**; **formalism**.

contextualism An interpretive approach in art history that focuses on the culture surrounding an art object. Unlike **connoisseurship**, contextualism utilizes the literature, history, economics, and social developments (among other things) of a period, as well as the object itself, to explain the meaning of an artwork. See *also* **connoisseurship**.

contrapposto An Italian term meaning "set against," used to describe the twisted pose resulting from parts of the body set in opposition to each other around a central axis.

corbel, corbeling An early roofing and **arching** technique in which each course of stone projects slightly beyond the previous layer (a corbel) until the uppermost corbels meet. Results in a high, almost pointed **arch** or **vault**. A corbel table is a ledge supported by corbels.

corbeled vault *See* **vault**.

Corinthian order *See* **order**.

cornice The uppermost section of a Classical **entablature**. More generally, a horizontally projecting element found at the top of a building wall or **pedestal**. A raking cornice is formed by the junction of two slanted cornices, most often found in **pediments**.

course A horizontal layer of stone used in building.

crenellation Alternating high and low sections of a wall, giving a notched appearance and creating permanent defensive shields in the walls of fortified buildings.

crockets A stylized leaf used as decoration along the outer angle of spins, pinnacles, gables, and around **capitals** in Gothic architecture.

cuneiform An early form of writing with wedge-shaped marks impressed into wet clay with a stylus, primarily used by ancient Mesopotamians.

curtain wall A wall in a building that does not support any of the weight of the structure. Also: the freestanding outer wall of a castle, usually encircling the inner bailey (yard) and keep (primary defensive tower).

cyclopean construction or **masonry** A method of building using huge blocks of rough-hewn stone. Any large-scale, monumental building project that impresses by sheer size. Named after the Cyclopes (sing. Cyclops) one-eyed giants of legendary strength in Greek myths.

cylinder seal A small cylindrical stone decorated with incised patterns. When rolled across soft clay or wax, the resulting raised pattern or design (**relief**) served in Mesopotamian and Indus Valley cultures as an identifying signature.

dado (dadoes) The lower part of a wall, differentiated in some way (by a **molding** or different coloring or paneling) from the upper section.

daguerreotype An early photographic process that makes a positive print on a light-sensitized copperplate; invented and marketed in 1839 by Louis-Jacques-Mandé Daguerre.

demotic writing The simplified form of ancient Egyptian hieratic writing, used primarily for administrative and private texts.

dharmachakra Sanskrit for "wheel" (*chakra*) and "law" or "doctrine" (*dharma*); often used in Buddhist iconography to signify the "wheel of the law."

diptych Two panels of equal size (usually decorated with paintings or reliefs) hinged together.

dogu Small human figurines made in Japan during the Jomon period. Shaped from clay, the figures have exaggerated expressions and are in contorted poses. They were probably used in religious rituals.

dolmen A prehistoric structure made up of two or more large upright stones supporting a large, flat, horizontal slab or slabs.

dome A round **vault**, usually over a circular space. Consists of a curved masonry vault of shapes and cross sections that can vary from hemispherical to bulbous to ovoidal. May use a supporting vertical wall (**drum**), from which the vault springs, and may be crowned by an open space (**oculus**) and/or an exterior **lantern**. When a dome is built over a square space, an intermediate element is required to make the transition to a circular drum. There are two types: A dome on **pendentives** (spherical triangles) incorporates **arched**, sloping intermediate sections of wall that carry the weight and thrust of the dome to heavily buttressed supporting **piers**. A dome on **squinches** uses an arch built into the wall (squinch) in the upper corners of the space to carry the weight of the dome across the corners of the square space below. A half-dome or conch may cover a semicircular space.

domino construction System of building construction introduced by the architect Le Corbusier in which reinforced concrete floor slabs are floated on six freestanding posts placed as if at the positions of the six dots on a domino playing piece.

Doric order See **order**.

dressed stone See **ashlar**.

drum The wall that supports a **dome**. Also: a segment of the circular **shaft** of a **column**.

drypoint An **intaglio** printmaking process by which a metal (usually copper) plate is directly inscribed with a pointed instrument (**stylus**). The resulting design of scratched lines is inked, wiped, and printed. Also: the print made by this process.

earthenware A low-fired, opaque **ceramic** ware that is fired in the range of 800 to 900 degrees Celsius. Earthenware employs humble clays that are naturally heat resistant; the finished wares remain porous after firing unless **glazed**. Earthenware occurs in a range of earth-toned colors, from white and tan to gray and black, with tan predominating.

echinus A cushionlike circular element found below the **abacus** of a Doric **capital**. Also: a similarly shaped **molding** (usually with egg-and-dart motifs) underneath the **volutes** of an Ionic **capital**.

electron spin resonance techniques Method that uses magnetic field and microwave irradiation to date material such as tooth enamel and its surrounding soil.

emblema (emblemata) In a mosaic, the elaborate central motif on a floor, usually a self-contained unit done in a more refined manner, with smaller **tesserae** of both marble and semiprecious stones.

encaustic A painting technique using pigments mixed with hot wax as a medium.

engaged column A **column** attached to a wall. See also column.

engraving An intaglio printmaking process of inscribing an image, design, or letters onto a metal or wood surface from which a print is made. An engraving is usually drawn with a sharp implement (burin) directly onto the surface of the plate. Also: the print made from this process.

entablature In the **Classical orders**, the horizontal elements above the **columns** and **capitals**. The entablature consists of, from bottom to top, an **architrave**, a **frieze**, and a **cornice**.

entasis A slight swelling of the **shaft** of a Greek column. The optical illusion of entasis makes the column appear from afar to be straight.

exedra (exedrae) In architecture, a semicircular niche. On a small scale, often used as decoration, whereas larger exedrae can form interior spaces (such as an **apse**).

expressionism, expressionistic Terms describing a work of art in which forms are created primarily to evoke subjective emotions rather than to portray objective reality.

façade The face or front wall of a building.

faience Type of **ceramic** covered with colorful, opaque glazes that form a smooth, impermeable surface. First developed in ancient Egypt.

fang ding A square or rectangular bronze vessel with four legs. The fang ding was used for ritual offerings in ancient China during the Shang dynasty.

fête galante A subject in painting depicting well-dressed people at leisure in a park or country setting. It is most often associated with eighteenth-century French Rococo painting.

filigree Delicate, lacelike ornamental work.

fillet The flat ridge between the carved out flutes of a **column shaft**. See also **fluting**.

finial A knoblike architectural decoration usually found at the top point of a spire, pinnacle, canopy, or gable. Also found on furniture; also the ornamental top of a staff.

fluting In architecture, evenly spaced, rounded parallel vertical grooves **incised** on **shafts** of **columns** or columnar elements (such as **pilasters**).

foreshortening The illusion created on a flat surface in which figures and objects appear to recede or project sharply into space. Accomplished according to the rules of **perspective**.

formal analysis See **formalism**.

formalism, formalist An approach to the understanding, appreciation, and valuation of art based almost solely on considerations of form. This approach tends to regard an artwork as independent of its time and place of making. See also **connoisseurship**.

four-iwan mosque See **iwan** and **mosque**.

fresco A painting technique in which waterbased pigments are applied to a surface of wet plaster (called **buon fresco**). The color is absorbed by the plaster, becoming a permanent part of the wall. **Fresco secco** is created by painting on dried plaster, and the color may flake off. Murals made by both these techniques are called frescoes.

fresco secco See **fresco**.

frieze The middle element of an **entablature**, between the **architrave** and the **cornice**. Usually decorated with sculpture, painting, or **moldings**. Also: any continuous flat band with **relief sculpture** or painted decorations.

frottage A design produced by laying a piece of paper over a textured surface and rubbing with charcoal or other soft medium.

fusuma Sliding doors covered with paper, used in traditional Japanese construction. Fusuma are often highly decorated with paintings and colored backgrounds.

galleria See **gallery**.

gallery In church architecture, the story found above the side **aisles** of a church, usually open to and overlooking the nave. Also: in secular architecture, a long room, usually above the ground floor in a private house or a public building used for entertaining, exhibiting pictures, or promenading. *Also*: a building or hall in which art is displayed or sold. Also: *galleria*.

garbhagriha From the Sanskrit word meaning "womb chamber," a small room or shrine in a Hindu temple containing a holy image.

genre A type or category of artistic form, subject, technique, style, or medium. See also genre painting.

gesso A ground made from glue, gypsum, and/or chalk forming the ground of a wood panel or the priming layer of a canvas. Provides a smooth surface for painting.

gilding The application of paper-thin **gold leaf** or gold pigment to an object made from another medium (for example, a sculpture or painting). Usually used as a decorative finishing detail.

giornata (giornate) Adopted from the Italian term meaning "a day's work," a giornata is the section of a **fresco** plastered and painted in a single day.

glaze See **glazing**.

glazing An outermost layer of vitreous liquid (**glaze**) that, upon firing, renders **ceramics** waterproof and forms a decorative surface. In painting, a technique particularly used with oil mediums in which a transparent layer of paint (**glaze**) is laid over another, usually lighter, painted or glazed area.

gloss A type of clay **slip** used in **ceramics** by ancient Greeks and Romans that, when fired, imparts a colorful sheen to the surface.

golf foil A thin sheet of gold.

gold leaf Paper-thin sheets of hammered gold that are used in **gilding**. In some cases (such as Byzantine **icons**), also used as a ground for paintings.

gopura The towering gateway to an Indian Hindu temple complex. A temple complex can have several different gopuras.

Grand Manner An elevated style of painting popular in the eighteenth century in which the artist looked to the ancients and to the Renaissance for inspiration; for portraits as well as history painting, the artist would adopt the poses, compositions, and attitudes of Renaissance and antique models.

Grand Tour Popular during the eighteenth and nineteenth centuries, an extended tour of cultural sites in southern Europe intended to finish the education of a young upper-class person from Britain or North America.

grattage A pattern created by scraping off layers of paint from a canvas laid over a textured surface. See also *frottage*.

Greek-cross plan See **centrally planned building**.

Greek-key pattern A continuous rectangular scroll often used as a decorative border. Also called a **meander pattern**.

grid A system of regularly spaced horizontally and vertically crossed lines that gives regularity to an architectural plan. Also: in painting, a grid enables designs to be enlarged or transferred easily.

grisaille A style of monochromatic painting in shades of gray. Also: a painting made in this style.

groin vault See **vault**.

guild An association of craftspeople. The medieval guild had great economic power, as it set standards and controlled the selling and marketing of its members' products, and as it provided economic protection, group solidarity, and training in the craft to its members.

hall church A church with a **nave** and **aisles** of the same height, giving the impression of a large, open hall.

handscroll A long, narrow, horizontal painting or text (or combination thereof) common in Chinese and Japanese art and of a size intended for individual use. A handscroll is stored wrapped tightly around a wooden pin and is unrolled for viewing or reading.

hanging scroll In Chinese and Japanese art, a vertical painting or text mounted within sections of silk. At the top is a semicircular rod; at the bottom is a round dowel. Hanging scrolls are kept rolled and tied except for special occasions, when they are hung for display, contemplation, or commemoration.

haniwa Pottery forms, including cylinders, buildings, and human figures, that were placed on top of Japanese tombs or burial mounds.

hemicycle A semicircular interior space or structure.

henge A circular area enclosed by stones or wood posts set up by Neolithic peoples. It is usually bounded by a ditch and raised embankment.

hieratic In painting and sculpture, a formalized style for representing rulers or sacred or priestly figures.

hieratic scale The use of different sizes for significant or holy figures and those of the everyday world to indicate importance. The larger the figure, the greater the importance.

high relief Relief sculpture in which the image projects strongly from the background. See also **relief sculpture**.

himation In ancient Greece, a long loose outer garment.

historicism The strong consciousness of and attention to the institutions, themes, styles, and forms of the past, made accessible by historical research, textual study, and archaeology.

history painting Paintings based on historical, mythological, or biblical narratives. Once considered the noblest form of art, history paintings generally convey a high moral or intellectual idea and are often painted in a grand pictorial style.

hollow-casting See **lost-wax casting**.

hypostyle hall A large interior room characterized by many closely spaced **columns** that support its roof.

icon An image in any material representing a sacred figure or event in the Byzantine, and later in the Orthodox, Church. Icons were venerated by the faithful, who believed them to have miraculous powers to transmit messages to God.

iconoclasm The banning or destruction of images, especially icons and religious art. Iconoclasm in eighth- and ninth-century Byzantium and sixteenth- and seventeenth-century Protestant territories arose from differing beliefs about the power, meaning, function, and purpose of imagery in religion.

iconographic See **iconography**.

iconography The study of the significance and interpretation of the subject matter of art.

iconostasis The partition screen in a Byzantine or Orthodox church between the **sanctuary** (where the Mass is performed) and the body of the church (where the congregation assembles). The iconostasis displays **icons**.

idealism *See* idealization.

idealization A process in art through which artists strive to make their forms and figures attain perfection, based on pervading cultural values and/or their own mental image of beauty.

ideograph A written character or symbol representing an idea or object. Many Chinese characters are ideographs.

ignudi Heroic figures of nude young men.

illumination A painting on paper or **parchment** used as illustration and/or decoration for **manuscripts** or **albums**. Usually done in rich colors, often supplemented by gold and other precious materials. The illustrators are referred to as illuminators. Also: the technique of decorating manuscripts with such paintings.

impasto Thick applications of pigment that give a painting a palpable surface texture.

impost, impost block A block, serving to concentrate the weight above, imposed between the **capital** of a **column** and the springing of an arch above.

in antis Term used to describe the position of columns set between two walls, as in a **portico** or a **cella**.

incising A technique in which a design or inscription is cut into a hard surface with a sharp instrument. Such a surface is said to be incised.

ink painting A monochromatic style of painting developed in China using black ink with gray **washes**.

inlay To set pieces of a material or materials into a surface to form a design. *Also:* material used in or decoration formed by this technique.

installation art Artworks created for a specific site, especially a gallery or outdoor area, that create a total environment.

intaglio Term used for a technique in which the design is carved out of the surface of an object, such as an engraved seal stone. In the graphic arts, intaglio includes **engraving**, etching, and **drypoint**—all processes in which ink transfers to paper from incised, ink-filled lines cut into a metal plate.

intarsia Decoration formed through wood **inlay**.

intuitive perspective See **perspective**.

Ionic order See **order**.

iwan A large, **vaulted** chamber in a **mosque** with a monumental arched opening on one side.

jamb In architecture, the vertical element found on both sides of an opening in a wall, and supporting an **arch** or lintel.

japonisme A style in French and American nineteenth-century art that was highly influenced by Japanese art, especially prints.

jasperware A fine-grained, unglazed, white **ceramic** developed by Josiah Wedgwood, often colored by metallic oxides with the raised designs ramaining white.

jataka tales In Buddhism, stories associated with the previous lives of Shakyamuni, the historical Buddha.

joined-wood sculpture A method of constructing large-scale wooden sculpture developed in Japan. The entire work is constructed from smaller hollow blocks, each individually carved, and assembled when complete. The joined-wood technique allowed the production of larger sculpture, as the multiple joints alleviate the problems of drying and cracking found with sculpture carved from a single block.

joggled voussoirs Interlocking voussoirs in an arch or lintel, often of contrasting materials for colorful effect.

kantharos A type of Greek vase or goblet with two large handles and a wide mouth.

key block A key block is the master block in the production of a colored **woodblock print**, which requires different blocks for each color. The key block is a flat piece of wood with the entire design carved or drawn on its surface. From this, other blocks with partial drawings are made for printing the areas of different colors.

keystone The topmost **voussoir** at the center of an **arch**, and the last block to be placed. The pressure of this block holds the arch together. Often of a larger size and/or decorated.

kiln An oven designed to produce enough heat for the baking, or firing, of clay.

kinetic art Artwork that contains parts that can be moved either by hand, air, or motor.

kondo The main hall inside a Japanese Buddhist temple where the images of Buddha are housed.

kore (korai) An Archaic Greek statue of a young woman.

kouros (kouroi) An Archaic Greek statue of a young man or boy.

krater An ancient Greek vessel for mixing wine and water, with many subtypes that each have a distinctive shape. **Calyx krater:** a bell-shaped vessel with handles near the base that resemble a flower calyx. Volute krater: a type of krater with handles shaped like scrolls.

kufic An ornamental, angular Arabic script.

kylix A shallow Greek vessel or cup, used for drinking, with a wide mouth and small handles near the rim.

lacquer A type of hard, glossy surface varnish used on objects in East Asian cultures, made from the sap of the Asian sumac or from shellac, a resinous secretion from the lac insect. Lacquer can be layered and manipulated or combined with pigments and other materials for various decorative effects.

lakshana Term used to designate the thirtytwo marks of the historical Buddha. The lakshana include, among others, the Buddha's golden body, his long arms, the wheel impressed on his palms and the soles of his feet, and his elongated earlobes.

lamassu Supernatural guardian-protector of ancient Near Eastern palaces and throne rooms, often represented sculpturally as a combination of the bearded head of a man, powerful body of a lion or bull, wings of an eagle, and the horned headdress of a god, and usually possessing five legs.

lancet A tall narrow window crowned by a sharply pointed **arch**, typically found in Gothic architecture.

lantern A turretlike structure situated on a roof, **vault**, or **dome**, with windows that allow light into the space below.

lekythos (lekythoi) A slim Greek oil vase with one handle and a narrow mouth.

limner An artist, particularly a portrait painter, in England during the sixteenth and seventeenth centuries and in New England during the seventeenth and eighteenth centuries.

lingam **shrine** A place of worship centered on an object or representation in the form of a phallus (the lingam), which symbolizes the power of the Hindu god Shiva.

literati The English word used for the Chinese wenren or the Japanese bunjin, referring to well-educated artists who enjoyed literature, **calligraphy**, and painting as a pastime. Their painting are termed **literati painting**.

literati painting A style of painting that reflects the taste of the educated class of East Asian intellectuals and scholars. Aspects include an appreciation for the antique, small scale, and an intimate connection between maker and audience.

lithograph See **lithography**.

lithography Process of making a print (**lithograph**) from a design drawn on a flat stone block with greasy crayon. Ink is applied to the wet stone and adheres only to the greasy areas of the design.

loggia Italian term for a covered open-air. **gallery**. Often used as a corridor between buildings or around a courtyard, loggias usually have **arcades** or **colonnades**.

lost-wax casting A method of casting metal, such as bronze, by a process in which a wax mold is covered with clay and plaster, then fired, melting the wax and leaving a hollow form. Molten metal is then poured into the hollow space and slowly cooled. When the hardened clay and plaster exterior shell is removed, a solid metal form remains to be smoothed and polished.

low relief Relief sculpture whose figures project slightly from the background. See also **relief sculpture**.

lunette A semicircular wall area, framed by an arch over a door or window. Can be either plain or decorated.

lusterware Ceramic pottery decorated with metallic **glazes**.

madrasa An Islamic institution of higher learning, where teaching is focused on theology and law.

maenad In ancient Greece, a female devotee of the wine god Dionysos who participated in orgiastic rituals. She is often depicted with swirling drapery to indicate wild movement or dance. (Also called a Bacchante, after Bacchus, the Roman name of Dionysos.)

majolica Pottery painted with a tin glaze that, when fired, gives a lustrous and colorful surface.

mandala An image of the cosmos represented by an arrangement of circles or concentric geometric shapes containing diagrams or images. Used for meditation and contemplation by Buddhists.

mandapa In a Hindu temple, an open hall dedicated to ritual worship.

mandorla Light encircling, or emanating from, the entire figure of a sacred person.

manuscript A handwritten book or document.

maqsura An enclosure in a Muslim mosque, near the mihrab, designated for dignitaries.

martyrium (martyria) In Christian architecture, a church, chapel, or shrine built over the grave of a martyr or the site of a great miracle.

mastaba A flat-topped, one-story structure with slanted walls over an ancient Egyptian underground tomb.

matte Term describing a smooth surface that is without shine or luster.

mausoleum A monumental building used as a tomb. Named after the tomb of Mausolos erected at Halikarnassos around 350 BCE.

meander See **Greek-key pattern**.

medallion Any round ornament or decoration. Also: a large medal.

megalith A large stone used in prehistoric building. Megalithic architecture employs such stones.

megaron The main hall of a Mycenaean palace or grand house, having a columnar **porch** and a room with a central fireplace surrounded by four **columns**.

memento mori From Latin for "remember that you must die." An object, such as a skull or extinguished candle, typically found in a *vanitas* image, symbolizing the transience of life.

memory image An image that relies on the generic shapes and relationships that readily spring to mind at the mention of an object.

menorah A Jewish lamp-stand with seven or nine branches; the nine-branched menorah is used during the celebration of Hanukkah. Representations of the seven-branched menorah, once used in the Temple of Jerusalem, became a symbol of Judaism.

metope The carved or painted rectangular panel between the **triglyphs** of a **Doric frieze**.

mihrab A recess or niche that distinguishes the wall oriented toward Mecca (*qibla*) in a **mosque**.

minaret A tall slender tower on the exterior of a mosque from which believers are called to prayer.

minbar A high platform or pulpit in a **mosque**.

miniature Anything small. In painting, miniatures may be illustrations within **albums** or **manuscripts** or intimate portraits.

mirador In Spanish and Islamic palace architecture, a very large window or room with windows, and sometimes balconies, providing views to interior courtyards or the exterior landscape.

mithuna The amorous male and female couples in Buddhist sculpture, usually found at the entrance to a sacred building. The mithuna symbolize the harmony and fertility of life.

moat A large ditch or canal dug around a castle or fortress for military defense. When filled with water, the moat protects the walls of the building from direct attack.

mobile A sculpture made with parts suspended in such a way that they move in a current of air.

modeling In painting, the process of creating the illusion of three-dimensionality on a two-dimensional surface by use of light and shade. In sculpture, the process of molding a three-dimensional form out of a malleable substance.

module A segment or portion of a repeated design. Also: a basic building block.

molding A shaped or sculpted strip with varying contours and patterns. Used as decoration on architecture, furniture, frames, and other objects.

monolith A single stone, often very large.

mortise-and-tenon joint A method of joining two elements. A projecting pin (tenon) on one element fits snugly into a hole designed for it (mortise) on the other. Such joints are very strong and flexible.

mosaic Images formed by small colored stone or glass pieces (tesserae), affixed to a hard, stable surface.

mosque An edifice used for communal Muslim worship.

mudra A symbolic hand gesture in Buddhist art that denotes certain behaviors, actions, or feelings.

mullion A slender vertical element or **colonnette** that divides a window into subsidiary sections.

muqarnas Small nichelike components stacked in tiers to fill the transition between differing vertical and horizontal planes.

naos The principal room in a temple or church. In ancient architecture, the **cella**. In a Byzantine church, the **nave** and **sanctuary**.

narthex The vestibule or entrance porch of a church.

naturalism, naturalistic A style of depiction that seeks to imitate the appearance of nature. A naturalistic work appears to record the visible world.

nave The central space of a **basilica**, two or three stories high and usually flanked by **aisles**.

necking The molding at the top of the **shaft** of the **column**.

necropolis A large cemetery or burial area; literally a "city of the dead."

nemes headdress The royal headdress of Egypt.

niello A metal technique in which a black sulfur alloy is rubbed into fine lines engraved into a metal (usually gold or silver). When heated, the alloy becomes fused with the surrounding metal and provides contrasting detail.

nishiki-e A multicolored and ornate Japanese print.

nocturne A night scene in painting, usually lit by artificial illumination.

nonrepresentational art An **abstract** art that does not attempt to reproduce the appearance of objects, figures, or scenes in the natural world. Also called nonobjective art.

oculus (oculi) In architecture, a circular opening. Oculi are usually found either as windows or at the apex of a **dome**. When at the top of a dome, an oculus is either open to the sky or covered by a decorative exterior lantern.

ogee An S-shaped curve. See **arch**.

olpe Any Greek vase or jug without a spout.

one-point perspective See **perspective**.

opithodomos In greek temples, the entrance porch or room at the back.

oracle A person, usually a priest or priestess, who acts as a conduit for divine information. Also: the information itself or the place at which this information is communicated.

orant The representation of a standing figure praying with outstretched and upraised arms.

orchestra The circular performance area of an ancient Greek theater. In later architecture, the section of seats nearest the stage or the entire main floor of the theater.

order A system of proportions in Classical architecture that includes every aspect of the building's plan, elevation, and decorative system. Composite: a combination of the Ionic and the Corinthian orders. The **capital** combines acanthus leaves with **volute** scrolls. **Corinthian:** the most ornate of the orders, the Corinthian includes a **base**, a fluted **column shaft** with a capital elaborately decorated with acanthus leaf carvings. Its **entablature** consists of an **architrave** decorated with **moldings**, a **frieze** often containing **sculptured reliefs**, and a **cornice** with dentils. Doric: the column shaft of the Doric order can be fluted or smooth-surfaced and has no base. The Doric capital consists of an undecorated **echinus** and **abacus**. The Doric entablature has a plain architrave, a frieze with **metopes** and **triglyphs**, and a simple cornice. Ionic: the column of the Ionic order has a base, a fluted shaft, and a capital decorated with volutes. The Ionic entablature consists of an architrave of three panels and moldings, a frieze usually containing sculpted relief ornament, and a cornice with dentils. **Tuscan:** a variation of Doric characterized by a smooth-surfaced column shaft with a base, a plain architrave, and an undecorated frieze. A colossal order is any of the above built on a large scale, rising through several stories in height and often raised from the ground by a **pedestal**.

orthogonal Any line running back into the represented space of a picture perpendicular to the imagined picture plane. In linear perspective, all orthogonals converge at a single **vanishing point** in the picture and are the basis for a **grid** that maps out the internal space of the image. An orthogonal plan is any plan for a building or city that is based exclusively on right angles, such as the grid plan of many modern cities.

pagoda An East Asian **reliquary** tower built with successively smaller, repeated stories. Each story is usually marked by an elaborate projecting roof.

palace complex A group of buildings used for living and governing by a ruler and his or her supporters, usually fortified.

palmette A fan-shaped ornament with radiating leaves.

parapet A low wall at the edge of a balcony, bridge, roof, or other place from which there is a steep drop, built for safety. A parapet walk is the passageway, usually open, immediately behind the uppermost exterior wall or battlement of a fortified building.

parchment A writing surface made from treated skins of animals. Very fine parchment is known as **vellum**.

parterre An ornamental, highly regimented flowerbed. An element of the ornate gardens of seventeenth-century palaces and châteaux.

pastel Dry pigment, chalk, and gum in stick or crayon form. Also: a work of art made with pastels.

pedestal A platform or **base** supporting a sculpture or other monument. Also: the block found below the base of a Classical **column** (or **colonnade**), serving to raise the entire element off the ground.

pediment A triangular gable found over major architectural elements such as Classical Greek **porticoes**, windows, or doors. Formed by an **entablature** and the ends of a sloping roof or a raking **cornice**. A similar architectural element is often used decoratively above a door or window, sometimes with a curved upper **molding**. A broken pediment is a variation on the traditional pediment, with an open space at the center of the topmost angle and/or the horizontal cornice.

pendentive The concave triangular section of a **vault** that forms the transition between a square or polygonal space and the circular base of a **dome**.

peplos A loose outer garment worn by women of ancient Greece. A cloth rectangle fastened on the shoulders and belted below the bust or at the waist.

peripteral A term used to describe any building (or room) that is surrounded by a single row of **columns**. When such columns are engaged instead of freestanding, called pseudo-peripteral.

peristyle A surrounding **colonnade** in Greek architecture. A peristyle building is surrounded on the exterior by a colonnade. Also: a peristyle court is an open colonnaded courtyard, often having a pool and garden.

perspective A system for representing three-dimensional space on a two-dimensional surface. Atmospheric perspective: A method of rendering the effect of spatial distance by subtle variations in color and clarity of representation. **Intuitive perspective:** A method of giving the impression of recession by visual instinct, not by the use of an overall system or program. Oblique perspective: An intuitive spatial system in which a building or room is placed with one corner in the picture plane, and the other parts of the structure recede to an imaginary vanishing point on its other side. Oblique perspective is not a comprehensive, mathematical system. **One-point** and multiple-point **perspective** (also called linear, scientific or mathematical perspective): A method of creating the illusion of three-dimensional space on a two-dimensional surface by delineating a horizon line and multiple orthogonal lines. These recede to meet at one or more points on the horizon (called **vanishing** points), giving the appearance of spatial depth. Called scientific or mathematical because its use requires some

knowledge of geometry and mathematics, as well as optics. **Reverse perspective:** A Byzantine perspective theory in which the orthogonals or rays of sight do not converge on a vanishing point in the picture, but are thought to originate in the viewer's eye in front of the picture. Thus, in reverse perspective the image is constructed with orthogonals that diverge, giving a slightly tipped aspect to objects.

photomontage A photographic work created from many smaller photographs arranged (and often overlapping) in a composition.

picture plane The theoretical spatial plane corresponding with the actual surface of a painting.

picture stone A medieval northern European memorial stone covered with figural decoration. See also **rune stone**.

picturesque A term describing the taste for the familiar, the pleasant, and the pretty, popular in the eighteenth and nineteenth centuries in Europe. When contrasted with the sublime, the picturesque stood for all that was ordinary but pleasant.

piece-mold casting A casting technique in which the mold consists of several sections that are connected during the pouring of molten metal, usually bronze. After the cast form has hardened, the pieces of the mold are disassembled, leaving the completed object.

pier A masonry support made up of many stones, or rubble and concrete (in contrast to a **column shaft** which is formed from a single stone or a series of **drums**), often square or rectangular in plan, and capable of carrying very heavy architectural loads.

pietra dura Italian for "hard stone." Semi-precious stones selected for color variation and cut in shapes to form ornamental designs such as flowers or fruit.

pietra serena A gray Tuscan limestone used in Florence.

pilaster An **engaged** columnar element that is rectangular in format and used for decoration in architecture.

pillar In architecture, any large, freestanding vertical element. Usually functions as an important weight-bearing unit in buildings.

plate tracery See **tracery**.

plinth The slablike **base** or **pedestal** of a **column**, statue, wall, building, or piece of furniture.

pluralism A social structure or goal that allows members of diverse ethnic, racial, or other groups to exist peacefully within the society while continuing to practice the customs of their own divergent cultures. Also: an adjective describing the state of having many valid contemporary styles available at the same time to artists.

podium A raised platform that acts as the foundation for a building, or as a platform for a speaker.

polychrome See **polychromy**.

polychromy The multicolored painted decoration applied to any part of a building, sculpture, or piece of furniture.

polyptych An altarpiece constructed from multiple panels, sometimes with hinges to allow for movable wings.

porcelain A high-fired, vitrified, translucent, white **ceramic** ware that employs two specific clays—kaolin and petuntse—and that is fired in the range of 1,300 to 1,400 degrees Celsius. The

relatively high proportion of silica in the body clays renders the finished porcelains translucent. Like **stonewares**, porcelains are glazed to enhance their aesthetic appeal and to aid in keeping them clean. By definition, porcelain is white, though it may be covered with a **glaze** of bright color or subtle hue. Chinese potters were the first in the world to produce porcelain, which they were able to make as early as the eighth century.

porch The covered entrance on the exterior of a building. With a row of **columns** or **colonnade**, also called a **portico**.

portal A grand entrance, door, or gate, usually to an important public building, and often decorated with sculpture.

portico In architecture, a projecting roof or porch supported by columns, often marking an entrance. See also porch.

post-and-lintel construction An architectural system of construction with two or more vertical elements (posts) supporting a horizontal element (lintel).

potassium-argon dating Technique used to measure the decay of a radioactive potassium isotope into a stable isotope of argon, an inert gas.

potsherd A broken piece of ceramic ware.

Praire Style A style of architecture initiated by the American Frank Lloyd Wright (1867-1959), in which he sought to integrate his structures in an "organic" way into the surrounding natural landscape, often having the lines of the building follow the horizontal contours of the land. Since Wright's early buildings were built in the Prairie States of the Midwest, this type of architecture became known as the Prairie Style.

primitivism The borrowing of subjects or forms usually from non-Western or prehistoric sources by Western artists. Originally practiced by Western artists as an attempt to infuse their work with the naturalistic and expressive qualities attributed to other cultures, especially colonized cultures, primitivism also borrowed from the art of children and the insane.

pronaos The enclosed vestibule of a Greek or Roman temple, found in front of the **cella** and marked by a row of **columns** at the entrance.

proscenium The stage of an ancient Greek or Roman theater. In modern theater, the area of the stage in front of the curtain. Also: the framing **arch** that separates a stage from the audience.

psalter In Jewish and Christian scripture, a book containing the psalms, or songs, attributed to King David.

punchwork Decorative designs that are stamped onto a surface, such as metal or leather, using a punch (a handheld metal implement).

putto (putti) A plump, naked little boy, often winged. In classical art, called a cupid; in Christian art, a cherub.

pylon A massive gateway formed by a pair of tapering walls of oblong shape. Erected by ancient Egyptians to mark the entrance to a temple complex.

qibla The mosque wall oriented toward Mecca indicated by the mihrab.

quatrefoil A four-lobed decorative pattern common in Gothic art and architecture.

quincunx A building in which five **domed** bays are arranged within a square, with a central unit and four corner units. (When the central unit has similar units extending from each side, the form becomes a **Greek cross**.)

quoin A stone, often extra large or decorated for emphasis, forming the corner of two walls. A vertical row of such stones is called quoining.

radiometric dating A method of dating prehistoric works of art made from organic materials, based on the rate of degeneration of radiocarbons in these materials. *See also* **relative dating, absolute dating**.

raigo A painted image that depicts the Amida Buddha and other Buddhist deities welcoming the soul of a dying worshiper to paradise.

raku A type of **ceramic** pottery made by hand, coated with a thick, dark **glaze**, and fired at a low heat. The resulting vessels are irregularly shaped and glazed, and are highly prized for use in the Japanese tea ceremony.

readymade An object from popular or material culture presented without further manipulation as an artwork by the artist.

realism In art, a term first used in Europe around 1850 to designate a kind of **naturalism** with a social or political message, which soon lost its didactic import and became synonymous with naturalism.

red-figure A style and technique of ancient Greek vase painting characterized by red clay-colored figures on a black background. (The figures are reversed against a painted ground and details are drawn, not engraved, as in black-figure style.) See also **black-figure**.

register A device used in systems of spatial definition. In painting, a register indicates the use of differing **groundlines** to differentiate layers of space within an image. In sculpture, the placement of self-contained bands of **reliefs** in a vertical arrangement. In printmaking, the marks at the edges used to align the print correctly on the page, especially in multiple-block color printing.

registration marks In Japanese **woodblock** printing, these were two marks carved on the blocks to indicate proper alignment of the paper during the printing process. In multicolor printing, which used a separate block for each color, these marks were essential for achieving the proper position or registration of the colors.

relative dating See also **radiometric dating**.

relief sculpture A three-dimensional image or design whose flat background surface is carved away to a certain depth, setting off the figure. Called high or **low (bas) relief** depending upon the extent of projection of the image from the background. Called **sunken relief** when the image is carved below the original surface of the background, which is not cut away.

reliquary A container, often made of precious materials, used as a repository to protect and display sacred relics.

repoussé A technique of hammering metal from the back to create a protruding image. Elaborate reliefs are created with wooden armatures against which the metal sheets are pressed and hammered.

reverse perspective See **perspective**.

rhyton A vessel in the shape of a figure or an animal, used for drinking or pouring liquids on special occasions.

rib vault See **vault**.

ridgepole A longitudinal timber at the apex of a roof that supports the upper ends of the rafters.

rosette A round or oval ornament resembling a rose.

rotunda Any building (or part thereof) constructed in a circular (or sometimes polygonal) shape, usually producing a large open space crowned by a **dome**.

round arch See **arch**.

roundel Any element with a circular format, often placed as a decoration on the exterior of architecture.

rune stone A stone used in early medieval northern Europe as a commemorative monument, which is carved or inscribed with runes, a writing system used by early Germanic peoples.

running spirals A decorative motif based on the shape formed by a line making a continuous spiral.

rustication In building, the rough, irregular, and unfinished effect deliberately given to the exterior facing of a stone edifice. Rusticated stones are often large and used for decorative emphasis around doors or windows, or across the entire lower floors of a building. Also, masonry construction with conspicuous, often beveled joints.

salon A large room for entertaining guests; a periodic social or intellectual gathering, often of prominent people; a hall or **gallery** for exhibiting works of art.

sanctuary A sacred or holy enclosure used for worship. In ancient Greece and Rome, consisted of one or more temples and an altar. In Christian architecture, the space around the altar in a church called the chancel or presbytery.

sarcophagus (sarcophagi) A stone coffin. Often rectangular and decorated with **relief sculpture**.

scarab In Egypt, a stylized dung beetle associated with the sun and the god Amun.

scarification Ornamental decoration applied to the surface of the body by cutting the skin for cultural and/or aesthetic reasons.

school of artists An art historical term describing a group of artists, usually working at the same time and sharing similar styles, influences, and ideals. The artists in a particular school may not necessarily be directly associated with one another, unlike those in a workshop or **atelier**.

scribe A writer; a person who copies texts.

scriptorium (scriptoria) A room in a monastery for writing or copying manuscripts.

scroll painting A painting executed on a rolled support. Rollers at each end permit the horizontal scroll to be unrolled as it is studied or the vertical scroll to be hung for contemplation or decoration.

seals Personal emblems usually carved of stone in **intaglio** or **relief** and used to stamp a name or legend onto paper or silk. They traditionally employ the archaic characters appropriately known as "seal script," of the Zhou or Qin. Cut in stone, a seal may state a formal given name, or it may state any of the numerous personal names that China's painters and writers adopted throughout their lives. A treasured work of art often bears not only the seal of its maker but also those of collectors and admirers through the centuries. In the Chinese view, these do not disfigure the work but add another layer of interest.

seraph (seraphim) An angel of the highest rank in the Christian hierarchy.

serdab In Egyptian tombs, the small room in which the ka statue was placed.

sfumato Italian term meaning "smoky," soft, and mellow. In painting, the effect of haze in an image. Resembling the color of the atmosphere at dusk, sfumato gives a smoky effect.

sgraffito Decoration made by incising or cutting away a surface layer of material to reveal a different color beneath.

shaft The main vertical section of a column between the capital and the base, usually circular in cross section.

shaftgrave A deep pit used for burial.

shikhara In the architecture of northern India, a conical (or pyramidal) spire found atop a Hindu temple and often crowned with an *amalaka*.

shoji A standing Japanese screen covered in translucent rice paper and used in interiors.

sinopia The preparatory design or underdrawing of a **fresco**. Also: a reddish chalklike earth pigment.

site-specific sculpture A sculpture commissioned and/or designed for a particular spot.

slip A mixture of clay and water applied to a **ceramic** object as a final decorative coat. Also: a solution that binds different parts of a vessel together, such as the handle and the main body.

spandrel The area of wall adjoining the exterior curve of an arch between its **springing** and the **keystone**, or the area between two arches, as in an **arcade**.

springing The point at which the curve of an arch or vault meets with and rises from its support.

squinch An **arch** or lintel built across the upper corners of a square space, allowing a circular or polygonal **dome** to be more securely set above the walls.

stained glass Molten glass is given a color that becomes intrinsic to the material. Additional colors may be fused to the surface (flashing). Stained glass is most often used in windows, for which small pieces of differently colored glass are precisely cut and assembled into a design, held together by **cames**. Additional painted details may be added to create images.

stele (stelae) A stone slab placed vertically and decorated with inscriptions or reliefs. Used as a grave marker or memorial.

stereobate A foundation upon which a Classical temple stands.

still life A type of painting that has as its subject inanimate objects (such as food, dishes, fruit, or flowers).

stoa In Greek architecture, a long roofed walkway, usually having columns on one long side and a wall on the other.

stoneware A high-fired, vitrified, but opaque **ceramic** ware that is fired in the range of 1,100 to 1,200 degrees Celsius. At that temperature, particles of silica in the clay bodies fuse together so that the finished vessels are impervious to liquids, even without **glaze**. Stoneware pieces are glazed to enhance their aesthetic appeal and to aid in keeping them clean (since unglazed ceramics are easily soiled). Stoneware occurs in a range of earth-toned colors, from white and tan to gray and black, with light gray predominating. Chinese potters were the first in the world to produce stoneware, which they were able to make as early as the Shang dynasty.

stucco A mixture of lime, sand, and other ingredients into a material that can be easily molded or modeled. When dry, produces a very durable surface used for covering walls or for architectural sculpture and decoration.

stupa In Buddhist architecture, a bell-shaped or pyramidal religious monument, made of piled earth or stone, and containing sacred relics.

stylobate In Classical architecture, the stone foundation on which a temple **colonnade** stands.

stylus An instrument with a pointed end (used for writing and printmaking), which makes a delicate line or scratch. Also: a special writing tool for **cuneiform** writing with one pointed end and one triangular wedge end.

sublime Adjective describing a concept, thing, or state of high spiritual, moral, or intellectual value; or something awe-inspiring. The sublime was a goal to which many nineteenth-century artists aspired in their artworks.

sunken relief See **relief sculpture**.

syncretism In religion or philosophy, the union of different ideas or principles.

taotie A mask with a dragon or animal-like face common as a decorative motif in Chinese art.

tapestry Multicolored pictorial or decorative weaving meant to be hung on a wall or placed on furniture.

tatami Mats of woven straw used in Japanese houses as a floor covering.

tempera A painting medium made by blending egg yolks with water, pigments, and occasionally other materials, such as glue.

tenebrism The use of strong **chiaroscuro** and artificially illuminated areas to create a dramatic contrast of light and dark in a painting.

terra cotta A medium made from clay fired over a low heat and sometimes left unglazed. Also: the orange-brown color typical of this medium.

tessera (tesserae) The small piece of stone, glass, or other object that is pieced together with many others to create a mosaic.

tetrarchy Four-man rule, as in the late Roman Empire, when four emperors shared power.

thatch A roof made of plant materials.

thermo-luminescence dating A technique that measures the irradiation of the crystal structure of material such as flint or pottery and the soil in which it is found, determined by luminescence produced when a sample is heated.

tholos A small, round building. Sometimes built underground, as in a Mycenaean tomb.

thrust The outward pressure caused by the weight of a vault and supported by buttressing. See **arch**.

tierceron In **vault** construction, a secondary rib that arcs from a **springing** point to the rib that runs lengthwise through the vault, called the ridge rib.

tokonoma A niche for the display of an art object (such as a screen, scroll, or flower arrangement) in a Japanese hall or tearoom.

tondo A painting or **relief sculpture** of circular shape.

torana In Indian architecture, an ornamented gateway arch in a temple, usually leading to the stupa.

toron In West African **mosque** architecture, the wooden beams that project from the walls. Torons are used as support for the scaffolding erected annually for the replastering of the building.

tracery Stonework or woodwork applied to wall surfaces or filling the open space of windows. In **plate tracery**, opening are cut through the wall. In **bar tracery**, **mullions** divide the space into vertical segments and form decorative patterns at the top of the opening or panel.

transept The arm of a cruciform church, perpendicular to the **nave**. The point where the nave and transept cross is called the crossing. Beyond the crossing lies the **sanctuary**, whether **apse**, choir, or chevet.

travertine A mineral building material similar to limestone, typically found in central Italy.

trefoil An ornamental design made up of three rounded lobes placed adjacent to one another.

triglyph Rectangular block between the **metopes** of a **Doric frieze**. Identified by the three carved vertical grooves, which approximate the appearance of the end of a wooden beam.

triptych An artwork made up of three panels. The panels may be hinged together so the side segments (**wings**) fold over the central area.

trompe l'oeil A manner of representation in which the appearance of natural space and objects is re-created with the express intention of fooling the eye of the viewer, who may be convinced that the subject actually exists as three-dimensional reality.

trumeau A column, pier, or post found at the center of a large portal or doorway, supporting the lintel.

tugra A calligraphic imperial monogram used in Ottoman courts.

Tuscan order *See* **order**.

twisted perspective A convention in art in which every aspect of a body or object is represented from its most characteristic viewpoint.

ukiyo-e A Japanese term for a type of popular art that was favored from the sixteenth century, particularly in the form of color **woodblock prints**. Ukiyo-e prints often depicted the world of the common people in Japan, such as courtesans and actors, as well as landscapes and myths.

urna In Buddhist art, the curl of hair on the forehead that is a characteristic mark of a buddha. The urna is a symbol of divine wisdom.

ushnisha In Asian art, a round turban or tiara symbolizing royalty and, when worn by a buddha, enlightenment.

vanishing point In a **perspective** system, the point on the horizon line at which **orthogonals** meet. A complex system can have multiple vanishing points.

vanitas An image, especially popular in Europe during the seventeenth century, in which all the objects symbolize the transience of life. Vanitas paintings are usually of **still lifes** or **genre** subjects.

vault An **arched** masonry structure that spans an interior space. Barrel or tunnel vault: an elongated or continuous semicircular vault, shaped like a half-cylinder. **Corbeled** vault: a vault made by projecting courses of stone. **Groin** or cross vault: a vault created by the intersection of two barrel vaults of equal size which creates four side compartments of identical size and shape. Quadrant or half-barrel vault: as the name suggests, a half-barrel vault. Rib vault: ribs (extra masonry) demarcate the junctions of a groin vault. Ribs may function to reinforce the groins or may be purely decorative. See also **corbeling**.

veduta (vedute) Italian for "vista" or "view."

Paintings, drawings, or prints often of expansive city scenes or of harbors.

vellum A fine animal skin prepared for writing and painting. See also parchment.

veneer In architecture, the exterior facing of a building, often in decorative patterns of fine stone or brick. In decorative arts, a thin exterior layer of finer material (such as rare wood, ivory, metal, and semiprecious stones) laid over the form.

verism A style in which artists concern themselves with capturing the exterior likeness of an object or person, usually by rendering its visible details in a finely executed, meticulous manner.

vihara From the Sanskrit term meaning "for wanderers." A vihara is, in general, a Buddhist monastery in India. It also signifies monks' cells and gathering places in such a monastery.

vimana The main element of a Southern Indian Hindu temple, usually in the shape of a pyramidal or tapering tower raised on a **plinth**.

volute A spiral scroll, as seen on an Ionic **capital**.

votive figure An image created as a devotional offering to a god or other deity.

voussoirs The oblong, wedge-shaped stone blocks used to build an **arch**. The topmost voussoir is called a **keystone**.

warp The vertical threads in a weaver's loom. Warp threads make up a fixed framework that provides the structure for the entire piece of cloth, and are thus often thicker than **weft** threads. See also **weft**.

wash A diluted watercolor or ink. Often washes are applied to drawings or prints to add tone or touches of color.

wattle and daub A wall construction method combining upright branches, woven with twigs (wattles) and plastered or filled with clay or mud (daub).

weft The horizontal threads in a woven piece of cloth. Weft threads are woven at right angles to and through the **warp** threads to make up the bulk of the decorative pattern. In carpets, the weft is often completely covered or formed by the rows of trimmed knots that form the carpet's soft surface. See also **warp**.

white-ground A type of ancient Greek pottery in which the background color of the object is painted with a slip that turns white in the firing process. Figures and details were added by painting on or **incising** into this **slip**. White-ground wares were popular in the Classical period as funerary objects.

wing A side panel of a **triptych** or **polyptych** (usually found in pairs), which was hinged to fold over the central panel. Wings often held the depiction of the donors and/or subsidiary scenes relating to the central image.

woodblock print A print made from one or more carved wooden blocks. In Japan, woodblock prints were made using multiple blocks carved in relief, usually with a block for each color in the finished print. See also **woodcut**.

woodcut A type of print made by carving a design into a wooden block. The ink is applied to the block with a roller. As the ink remains only on the raised areas between the carvedaway lines, these carved-away areas and lines provide the white areas of the print. Also: the process by which the woodcut is made.

x-ray style In Aboriginal art, a manner of representation in which the artist depicts a figure or animal by illustrating its outline as well as essential internal organs and bones.

yaksha, yakshi The male (yaksha) and female (yakshi) nature spirits that act as agents of the Hindu gods. Their sculpted images are often found on Hindu temples and other sacred places, particularly at the entrances.

ziggurat In Mesopotamia, a tall stepped tower of earthen materials, often supporting a shrine.

BIBLIOGRAPHY

Susan V. Craig

This bibliography is composed of books in English that are appropriate "further reading" titles. Most items on this list are available in good libraries, whether college, university, or public institutions. I have emphasized recently published works so that the research information would be current. There are three classifications of listings: general surveys and art history reference tools, including journals and Internet directories; surveys of large periods that encompass multiple chapters (ancient art in the Western tradition, European medieval art, European Renaissance through eighteenth-century art, modern art in the West, Asian art, and African and Oceanic art and art of the Americas); and books for individual chapters 1 through 32.

General Art History Surveys and Reference Tools

Adams, Laurie Schneider. *Art across Time*. 2nd ed. New York: McGraw-Hill, 2002.

Barnet, Sylvan. *A Short Guide to Writing about Art*. 8th ed. New York: Pearson/Longman, 2005.

Boströöm, Antonia. *Encyclopedia of Sculpture*. 3 vols. New York: FitzroyDearborn, 2004.

Broude, Norma, and Garrard, Mary D., eds. *Feminism and Art History: Questioning the Litany*. Icon Editions. New York: Harper & Row, 1982.

Chadwick, Whitney. *Women, Art, and Society*. 3rd ed. New York: Thames and Hudson, 2002.

Chilvers, Ian, ed. The Oxford Dictionary of Art. 3rd ed. New York: Oxford Univ. Press, 2004.

Curl, James Stevens. *A Dictionary of Architecture and Landscape Architecture*. 2nd ed. Oxford: Oxford Univ. Press, 2006.

Davies, Penelope J.E., et al. *Janson's History of Art: The Western Tradition*. 7th ed. Upper Saddle River, NJ: Prentice Hall, 2006.

Dictionary of Art, The. 34 vols. New York: Grove's Dictionaries, 1996.

Encyclopedia of World Art. 16 vols. New York: McGraw-Hill, 1972–83.

Frank, Patrick, Duane Preble, and Sarah Preble. *Preble's Artforms*. 8th ed. Upper Saddle River, NJ: Prentice Hall, 2006.

Gardner, Helen. *Gardner's Art through the Ages*. 12th ed. Ed. Fred S. Kleiner & Christin J. Mamiya. Belmont, CA: Thomson/Wadsworth, 2005.

Gaze, Delia, ed. *Dictionary of Women Artists*. 2 vols. London: Fitzroy Dearborn Publishers, 1997.

Griffiths, Antony. *Prints and Printmaking: An Introduction to the History and Techniques*. 2nd ed. London: British Museum Press, 1996.

Hadden, Peggy. *The Quotable Artist*. New York: Allworth Press, 2002.

Hall, James. *Illustrated Dictionary of Symbols in Eastern and Western Art*. New York: Icon Editions, 1994.

Holt, Elizabeth Gilmore, ed. *A Documentary History of Art*. 3 vols. New Haven: Yale Univ. Press, 1986.

Honour, Hugh, and John Fleming. *The Visual Arts: A History*. 7th ed. Upper Saddle River, NJ: Prentice Hall, 2005.

Hults, Linda C. *The Print in the Western World: An Introductory History*. Madison: Univ. of Wisconsin Press, 1996.

Johnson, Paul. *Art: A New History*. New York: HarperCollins, 2003.

Kaltenbach. G. E. *Pronunciation Dictionary of Artists' Names*. 3rd ed. Rev. Debra Edelstein. Boston: Little, Brown, and Co., 1993.

Kemp, Martin. *The Oxford History of Western Art*. Oxford: Oxford Univ. Press, 2000.

Kostof, Spiro. *A History of Architecture: Settings and Rituals*. 2nd ed. Rev. Greg Castillo. New York: Oxford Univ. Press, 1995.

Mackenzie, Lynn. *Non-Western Art: A Brief Guide*. 2nd ed. Upper Saddle River, NJ: Prentice Hall, 2001.

Marmor, Max, and Alex Ross, eds. *Guide to the Literature of Art History 2*. Chicago: American Library Association, 2005.

Onians, John, ed. *Atlas of World Art*. New York: Oxford Univ. Press, 2004.

Roberts, Helene, ed. *Encyclopedia of Comparative Iconography: Themes Depicted in Works of Art*. 2 vols. Chicago: Fitzroy Dearborn, 1998.

Rogers, Elizabeth Barlow. *Landscape Design: A Cultural and Architectural History*. New York: Harry N. Abrams, 2001.

Sayre, Henry M. *Writing about Art*. 5th ed. Upper Saddle River, NJ: Pearson/Prentice Hall, 2006.

Sed-Rajna, Gabrielle. *Jewish Art*. Trans. Sara Friedman and Mira Reich. New York: Abrams, 1997.

Slatkin, Wendy. *Women Artists in History: From Antiquity to the Present*. 4th ed. Upper Saddle River, NJ: Prentice Hall, 2000.

Sutton, Ian. *Western Architecture: From Ancient Greece to the Present*. World of Art. New York: Thames and Hudson, 1999.

Trachtenberg, Marvin, and Isabelle Hyman. *Architecture: From Prehistory to Postmodernity*. 2nd ed. Upper Saddle River, NJ: Prentice Hall, 2001.

Tufts, Eleanor. *Our Hidden Heritage: Five Centuries of Women Artists*. New York: Paddington Press, 1974.

West, Shearer. *Portraiture*. Oxford History of Art. Oxford: Oxford Univ. Press, 2004.

Wilkins, David G., Bernard Schultz, and Katheryn M. Linduff. *Art Past, Art Present*. 5th ed. Upper Saddle River, NJ: Prentice Hall, 2005.

Watkin, David. *A History of Western Architecture*. 4th ed. New York: Watson-Guptill Publications, 2005.

Art History Journals: A Select List of Current Titles

African Arts. Quarterly. Los Angeles: Univ. of California at Los Angeles, James S. Coleman African Studies Center, 1967–

American Art: The Journal of the Smithsonian American Art Museum. 3/year. Chicago: Univ. of Chicago Press, 1987–

American Indian Art Magazine, Quarterly. Scottsdale, AZ: American Indian Art Inc, 1975–

American Journal of Archaeology. Quarterly. Boston: Archaeological Institute of America, 1885–

Antiquity: A Periodical of Archaeology. Quarterly. Cambridge, UK: Antiquity Publications Ltd, 1927–

Apollo: The International Magazine of the Arts. Monthly. London: Apollo Magazine Ltd, 1925–

Architectural History. Annually. Farnham, UK: Society of Architectural Historians of Great Britain, 1958–

Archives of American Art Journal. Quarterly. Washington, D.C.: Archives of American Art, Smithsonian Institution, 1960–

Archives of Asian Art. Annually. New York: Asia Society, 1945–

Ars Orientalis: The Arts of Asia, Southeast Asia, and Islam. Annually. Ann Arbor: Univ. of Michigan Dept. of Art History, 1954–

Art Bulletin. Quarterly. New York: College Art Association, 1913–

Art History: Journal of the Association of Art Historians. 5/year. Oxford: Blackwell Publishing Ltd, 1978–

Art in America. Monthly. New York: Brant Publications Inc, 1913–

Art Journal. Quarterly. New York: College Art Association, 1960–

Art Nexus. Quarterly. Bogata, Colombia: Arte en Colombia Ltda, 1976–

Art Papers Magazine. Bi-monthly. Atlanta: Atlanta Art Papers Inc, 1976–

Artforum International. 10/year. New York: Artforum International Magazine Inc, 1962–

Artnews. 11/year. New York: Artnews LLC, 1902–

Bulletin of the Metropolitan Museum of Art. Quarterly. New York: Metropolitan Museum of Art, 1905–.

Burlington Magazine. Monthly. London: Burlington Magazine Publications Ltd, 1903–

Dumbarton Oaks Papers. Annually. Locust Valley, NY: J. J. Augustin Inc, 1940–

Flash Art International. Bimonthly. Trevi, Italy: Giancarlo Politi Editore, 1980–

Gesta. Semiannually. New York: International Center of Medieval Art, 1963–

History of Photography. Quarterly. Abingdon, UK: Taylor & Francis Ltd, 1976–

International Review of African American Art. Quarterly. Hampton, VA: International Review of African American Art, 1976–

Journal of Design History. Quarterly. Oxford: Oxford Univ. Press, 1988–

Journal of Egyptian Archaeology. Annually. London: Egypt Exploration Society, 1914–

Journal of Hellenic Studies. Annually. London: Society for the Promotion of Hellenic Studies, 1880–

Journal of Roman Archaeology. Annually. Portsmouth, RI: Journal of Roman Archaeology LLC, 1988–

Journal of the Society of Architectural Historians. Quarterly. Chicago: Society of Architectural Historians, 1940–

Journal of the Warburg and Courtauld Institutes. Annually. London: Warburg Institute, 1937–

Leonardo: Art, Science and Technology. 6/year. Cambridge, MA: MIT Press, 1968–

Marg. Quarterly. Mumbai, India: Scientific Publishers, 1946–

Master Drawings. Quarterly. New York: Master Drawings Association, 1963–

October. Cambridge, MA: MIT Press, 1976–

Oxford Art Journal. 3/year. Oxford: Oxford Univ. Press, 1978–

Parkett. 3/year. Züürich, Switzerland: Parkett Verlag AG, 1984–

Print Quarterly. Quarterly. London: Print Quarterly Publications, 1984–

Simiolus: Netherlands Quarterly for the History of Art. Quarterly. Apeldoorn, Netherlands: Stichting voor Nederlandse Kunsthistorische Publicaties, 1966–

Woman's Art Journal. Semiannually. Philadelphia: Old City Publishing Inc, 1980–

Internet Directories for Art History Information

ARCHITECTURE AND BUILDING
http://library.nevada.edu/arch/rsrce/webrsrce/contents.html

A directory of architecture websites collected by Jeanne Brown at the Univ. of Nevada at Las Vegas. Topical lists include architecture, building and construction, design, history, housing, planning, preservation, and landscape architecture. Most entries include a brief annotation and the last date the link was accessed by the compiler.

ART HISTORY RESOURCES ON THE WEB
http://witcombe.sbc.edu/ARTHLinks.html

Authored by Christopher L. C. E. Witcombe of Sweet Briar College in Virginia since 1995, the site includes an impressive number of links for various art historical eras as well as links to research resources, museums, and galleries. The content is frequently updated.

ART IN FLUX: A DIRECTORY OF RESOURCES FOR RESEARCH IN CONTEMPORARY ART
http://www.boisestate.edu/art/artinflux/intro.html

Cheryl K. Shutleff of Boise State Univ. in Idaho has authored this directory, which includes sites selected according to their relevance to the study of national or international contemporary art and artists. The subsections include artists, museums, theory, reference, and links.

ARTCYCLOPEDIA: THE FINE ARTS SEARCH ENGINE

With over 2,100 art sites and 75,000 links, this is one of the most comprehensive web directories for artists and art topics.
The primary searching is by artist's name but access is also available by artistic movement, nation, timeline and medium.

MOTHER OF ALL ART HISTORY LINKS PAGES
http://www.art-design.umich.edu/mother/

Maintained by the Dept. of the History of Art at the Univ. of Michigan, this directory covers art history departments, art museums, fine arts schools and departments as well as links to research resources. Each entry includes annotations.

VOICE OF THE SHUTTLE
http://vos.ucsb.edu

Sponsored by Univ. of California, Santa Barbara, this directory includes over 70 pages of links to humanities

and humanities-related resources on the Internet. The structured guide includes specific sub-sections on architecture, on art (modern & contemporary), and on art history. Links usually include a one sentence explanation and the resource is frequently updated with new information.

YAHOO! ARTS>ART HISTORY
http://dir.yahoo.com/Arts/Art_History/
Another extensive directory of art links organized into subdivisions with one of the most extensive being "Periods and Movements." Links include the name of the site as well as a few words of explanation.

European Renaissance through Eighteenth-Century Art, General

Black, C. F., et al. *Cultural Atlas of the Renaissance*. New York: Prentice Hall General Reference, 1993.

Blunt, Anthony. *Art and Architecture in France, 1500–1700*. 5th ed. Rev. Richard Beresford. Pelican History of Art. New Haven: Yale Univ. Press, 1999.

Brown, Jonathan. *Painting in Spain: 1500–1700*. Pelican History of Art. New Haven: Yale Univ. Press, 1998.

Cole, Bruce. *Italian Art, 1250–1550: The Relation of Renaissance Art to Life and Society*. New York: Harper & Row, 1987.

Graham-Dixon, Andrew. *Renaissance*. Berkeley: Univ. of California Press, 1999.

Harbison, Craig. *The Mirror of the Artist: Northern Renaissance Art in Its Historical Context*. Perspectives. New York: Abrams, 1995.

Harris, Ann Sutherland. *Seventeenth-Century Art & Architecture*. Upper Saddle River, NJ: Pearson Prentice Hall, 2005

Harrison, Charles, Paul Wood, and Jason Gaiger. *Art in Theory 1648–1815: An Anthology of Changing Ideas*. Oxford: Blackwell, 2000.

Hartt, Frederick, and David G. Wilkins. *History of Italian Renaissance Art: Painting, Sculpture, Architecture*. 6th ed. Upper Saddle River, NJ: Prentice Hall, 2007.

Jestaz, Bertrand. *The Art of the Renaissance*. Trans. I. Mark Paris. New York: Abrams, 1995.

Levenson, Jay A., ed. *Circa 1492: Art in the Age of Exploration*. Washington: National Gallery of Art, 1991.

McCorquodale, Charles. *The Renaissance: European Painting, 1400–1600*. London: Studio Editions, 1994.

Minor, Vernon Hyde. *Baroque & Rococo: Art & Culture*. New York: Abrams, 1999.

Murray, Peter. *Renaissance Architecture*. History of World Architecture. Milan: Electa, 1985.

Paoletti, John T., and Gary M. Radke. *Art in Renaissance Italy*. 3rd ed. Upper Saddle River, NJ: Prentice Hall, 2006.

Ripa, Cesare. *Baroque and Rococo Pictorial Imagery: The 1758-60 Hertel Edition of Ripa's 'Iconologia.'* Introd., transl., & commentaries Edward A. Maser. The Dover Pictorial Archives Series. New York: Dover Publications, 1991

Smith, Jeffrey Chipps. *The Northern Renaissance*. Art & Ideas. New York: Phaidon Press, 2004.

Stechow, Wolfgang. *Northern Renaissance, 1400–1600: Sources and Documents*. Upper Saddle River, NJ: Prentice Hall, 1966.

Summerson, John. *Architecture in Britain, 1530–1830*. 9th ed. Yale Univ. Press Pelican History of Art. New Haven: Yale Univ. Press, 1993.

Waterhouse, Ellis K. *Painting in Britain, 1530 to 1790*. 5th ed. Yale Univ. Press Pelican History of Art. New Haven: Yale Univ. Press, 1994.

Whinney, Margaret Dickens. *Sculpture in Britain: 1530–1830*. 2nd ed. Rev. John Physick. Pelican History of Art. London: Penguin, 1988.

Modern Art in the West, General

Arnason, H. Harvard. *History of Modern Art: Painting, Sculpture, Architecture, Photography*. 5th ed. Rev. Peter Kalb. Upper Saddle River, NJ: Prentice Hall, 2004.

Ballantyne, Andrew, ed. *Architectures: Modernism and After*. New Interventions in Art History, 3. Malden, MA: Blackwell, 2004.

Barnitz, Jacqueline. *Twentieth-Century Art of Latin America*. Austin: Univ. of Texas Press, 2001.

Bjelajac, David. *American Art: A Cultural History*. Rev. & exp. ed. Upper Saddle River, NJ: Prentice Hall, 2005.

Bowness, Alan. *Modern European Art*. World of Art. New York: Thames and Hudson, 1995.

Brettell, Richard R. *Modern Art, 1851–1929: Capitalism and Representation*. Oxford History of Art. Oxford: Oxford Univ. Press, 1999.

Chipp, Herschel Browning. *Theories of Modern Art: A Source Book by Artists and Critics*. California Studies in the History of Art. Berkeley: Univ. of California Press, 1984.

Clarke, Graham. *The Photograph*. Oxford History of Art. Oxford: Oxford Univ. Press, 1997.

Craven, David. *Art and Revolution in Latin America, 1910-1990*. New Haven: Yale Univ. Press, 2002.

Craven, Wayne. *American Art: History and Culture*. Rev. ed. Boston: McGraw-Hill, 2003.

Doordan, Dennis P. *Twentieth-Century Architecture*. New York: Abrams, 2002.

Doss, Erika. *Twentieth-Century American Art*. Oxford: Oxford Univ. Press, 2002.

Edwards, Steve, and Paul Wood, eds. *Art of the Avant-Gardes*. Art of the 20th Century. New Haven: Yale Univ. Press in assoc. with the Open Univ., 2004.

Foster, Hal, et al. *Art Since 1900: Modernism, Antimodernism, Postmodernism*. New York: Thames & Hudson, 2004.

Gaiger, Jason, ed. *Frameworks for Modern Art*. Art of the 20th Century. New Haven: Yale Univ. Press in assoc. with the Open Univ., 2003.

———, and Paul Wood, eds. *Art of the Twentieth Century: A Reader*. New Haven: Yale Univ. Press, 2003

Hamilton, George Heard. *Painting and Sculpture in Europe, 1880–1940*. 6th ed. Pelican History of Art. New Haven: Yale Univ. Press, 1993.

Hammacher, A. M. *Modern Sculpture: Tradition and Innovation*. Enlg. ed. New York: Abrams, 1988.

Harrison, Charles, and Paul Wood, eds. *Art in Theory: 1900–2000: An Anthology of Changing Ideas*. 2nd ed. Oxford: Blackwell, 2002.

Hunter, Sam, John Jacobus, and Daniel Wheeler. *Modern Art: Painting, Sculpture, Architecture, Photography*. 3rd rev. & exp. ed. Upper Saddle River, NJ: Prentice Hall, 2004.

Krauss, Rosalinde. *Passages in Modern Sculpture*. Cambridge, MA: MIT Press, 1977.

Mancini, JoAnne Marie. *Pre-Modernism: Art-World Change and American Culture from the Civil War to the Armory Show*. Princeton: Princeton Univ. Press, 2005.

Marien, Mary Warner. *Photography: A Cultural History*. New York: Harry N. Abrams, 2002.

Meecham, Pam, and Julie Sheldon. *Modern Art: A Critical Introduction*. 2nd ed. New York: Routledge, 2005.

Newlands, Anne. *Canadian Art: From Its Beginnings to 2000*. Willowdale, Ont.: Firefly Books, 2000.

Harris, Ann Sutherland, and Linda Nochlin. *Women Artists: 1550–1950*. Los Angeles: Los Angeles County Museum of Art, 1976.

The Phaidon Atlas of Contemporary World Architecture. London: Phaidon, 2004.

Powell, Richard J. *Black Art: A Cultural History*. 2nd ed. World of Art. New York: Thames and Hudson, 2002.

Rosenblum, Naomi. *A World History of Photography*. 3rd ed. New York: Abbeville, 1997.

Ruhrberg, Karl. *Art of the 20th Century*. Ed. Ingo F. Walther. 2 vols. New York: Taschen, 1998

Scully, Vincent Joseph. *Modern Architecture and Other Essays*. Princeton: Princeton Univ. Press, 2003

Stiles, Kristine, and Peter Howard Selz. *Theories and Documents of Contemporary Art: A Sourcebook of Artists' Writings*. California Studies in the History of Art, 35. Berkeley: Univ. of California Press, 1996.

Tafuri, Manfredo. *Modern Architecture*. History of World Architecture. 2 vols. New York: Electa/Rizzoli, 1986.

Traba, Marta. *Art of Latin America, 1900-1980*. Washington, D.C.: Inter-American Development Bank, 1994.

Upton, Dell. *Architecture in the United States*. Oxford History of Art. Oxford: Oxford Univ. Press, 1998.

Wood, Paul, ed. *Varieties of Modernism*. Art of the 20th Century. New Haven: Yale Univ. Press in assoc. with the Open Univ., 2004.

Woodham, Jonathan M. *Twentieth Century Design*. Oxford History of Art. Oxford: Oxford Univ. Press, 1997.

Chapter 29
Eighteenth-Century Art in Europe and the Americas

Bailey, Colin B., Philip Conisbee, and Thomas W. Gaehtgens. *The Age of Watteau, Chardin, and Fragonard: Masterpieces of French Genre Painting*. New Haven: Yale Univ. Press in assoc. with the National Gallery of Canada, Ottawa, 2003.

Boime, Albert. *Art in an Age of Revolution, 1750–1800*. Chicago: Univ. of Chicago Press, 1987.

Bowron, Edgar Peters, and Joseph J. Rishel, eds. *Art in Rome in the Eighteenth Century*. London: Merrell, 2000.

Craske, Matthew. *Art in Europe, 1700–1830: A History of the Visual Arts in an Era of Unprecedented Urban Economic Growth*. Oxford History of Art. Oxford: Oxford Univ. Press, 1997.

Goodman, Elise, ed. *Art and Culture in the Eighteenth Century: New Dimensions and Multiple Perspectives*. Studies in Eighteenth-Century Art and Culture. Newark: Univ. of Delaware Press, 2001 Irwin, David G. Neoclassicism. Art & Ideas. London: Phaidon, 1997.

Jarrassée, Dominique. *18th-Century French Painting*. Trans. Murray Wyllie. Paris: Terrail, 1999.

Kalnein, Wend von. *Architecture in France in the Eighteenth Century*. Trans. David Britt. Pelican History of Art. New Haven: Yale Univ. Press, 1995.

Levey, Michael. *Painting in Eighteenth-Century Venice*. 3rd ed. New Haven: Yale Univ. Press, 1994.

Lewis, Michael J. *The Gothic Revival*. World of Art. New York: Thames & Hudson, 2002.

Lovell, Margaretta M. *Art in a Season of Revolution: Painters, Artisans, and Patrons in Early America*. Early American Studies. Philadelphia: Univ. of Pennsylvania Press, 2005.

Monneret, Sophie. *David and Neo-Classicism*. Trans. Chris Miller & Peter Snowdon. Paris: Terrail, 1999.

Montgomery, Charles F., and Patrick E. Kane, eds. *American Art, 1750–1800: Towards Independence*. Boston: New York Graphic Society, 1976.

Poulet, Anne L. *Jean-Antoine Houdon: Sculptor of the Enlightenment*. Washington, D.C.: National Gallery of Art, 2003.

Summerson, John. *Architecture of the Eighteenth Century*. World of Art. New York: Thames and Hudson, 1986.

Wilton, Andrew, and Ilaria Bignamini, eds. *Grand Tour: The Lure of Italy in the Eighteenth Century*. London: Tate Gallery, 1996.

Young, Hilary, ed. *The Genius of Wedgwood*. London: Victoria & Albert Museum, 1995.

Chapter 30
Nineteenth-Century Art in Europe and the United States

Adams, Steven. *The Barbizon School and the Origins of Impressionism*. London: Phaidon, 1994.

Bajac, Quentin. *The Invention of Photography*. Discoveries. New York: Harry N. Abrams, 2002.

Barger, M. Susan, and William B. White. *The Daguerreotype: Nineteenth-Century Technology and Modern Science*. Washington, D.C.: Smithsonian Institution, 1991.

Benjamin, Roger. *Orientalist Aesthetics: Art, Colonialism, and French North Africa, 1880-1930*. Berkeley: Univ. of California Press, 2003.

Bergdoll, Barry. *European Architecture, 1750-1890*. Oxford History of Art. New York: Oxford Univ. Press, 2000.

Blakesley, Rosalind P. *Russian Genre Painting in the Nineteenth Century*. Oxford Historical Monographs. New York: Oxford Univ. Press, 2000.

Blüühm, Andreas, and Louise Lippincott. *Light!: The Industrial Age 1750-1900: Art & Science, Technology & Society*. New York: Thames & Hudson, 2001.

Boime, Albert. *Art in an Age of Bonapartism, 1800–1815*. Chicago: Univ. of Chicago Press, 1990.

Boime, Albert. *Art in an Age of Counterrevolution, 1815-1848*. Chicago: Univ. of Chicago Press, 2004.

Butler, Ruth, and Suzanne G. Lindsay. *European Sculpture of the Nineteenth Century*. The Collections of the National Gallery of Art Systematic Catalogue. Washington, D.C.: National Gallery of Art, 2000.

Callen, Anthea. *The Art of Impressionism: Painting Technique & the Making of Modernity*. New Haven: Yale Univ. Press, 2000.

Chu, Petra ten-Doesschate. *Nineteenth Century European Art*. New York: Abrams, 2003.

Denis, Rafael Cardoso, and Colin Trodd. *Art and the Academy in the Nineteenth Century*. New Brunswick, NJ: Rutgers Univ. Press, 2000.

Eisenman, Stephen. *Nineteenth Century Art: A Critical History*. 2nd ed. New York: Thames and Hudson, 2002.

Eitner, Lorenz. *Nineteenth Century European Painting: David to Cezanne*. Rev. ed. Boulder: Westview Press, 2002.

Frazier, Nancy. *Louis Sullivan and the Chicago School*. New York: Knickerbocker Press, 1998.

Fried, Michael. *Manet's Modernism, or, The Face of Painting in the 1860s*. Chicago: Univ. of Chicago Press, 1996.

Gerdts, William H. *American Impressionism*. 2nd ed. New York: Abbeville, 2001.

Greenhalgh, Paul, ed. *Art nouveau, 1890-1914*. London: V&A Publications, 2000.

Grigsby, Darcy Grimaldo. *Extremities: Painting Empire in Post-Revolutionary France*. New Haven: Yale Univ. Press, 2002.

Groseclose, Barbara. *Nineteenth-Century American Art*. Oxford History of Art. Oxford: Oxford Univ. Press, 2000.

Harrison, Charles, Paul Wood, and Jason Gaiger. *Art in Theory 1815–1900: An Anthology of Changing Ideas*. Oxford: Blackwell, 1998.

Herrmann, Luke. *Nineteenth Century British Painting*. London: Giles de la Mare, 2000.

Hirsh, Sharon L. *Symbolism and Modern Urban Society*. New York: Cambridge Univ. Press, 2004.

Holt, Elizabeth Gilmore, ed. *The Expanding World of Art, 1874–1902*. New Haven: Yale Univ. Press, 1988.

Kaplan, Wendy. *The Arts & Crafts Movement in Europe & America: Design for the Modern World*. New York: Thames & Hudson in assoc. with the Los Angeles County Museum of Art, 2004.

Kapos, Martha, ed. *The Post-Impressionists: A Retrospective*. New York: Hugh Lauter Levin Associates, 1993.

Kendall, Richard. *Degas: Beyond Impressionism*. London: National Gallery Publications, 1996.

Lambourne, Lionel. *Japonisme: Cultural Crossings between Japan and the West*. New York: Phaidon, 2005.

Lemoine, Bertrand. *Architecture in France, 1800–1900*. Trans. Alexandra Bonfante-Warren. New York: Harry N. Abrams, 1998.

Lochnan, Katharine Jordan. *Turner Whistler Monet*. London: Tate Publishing in assoc. with the Art Gallery of Ontario, 2004.

Noon, Patrick J. *Crossing the Channel: British and French Painting in the age of Romanticism*. London: Tate Pub., 2003.

Pissarro, Joachim. *Pioneering Modern Painting: Cézanne & Pissarro 1865-1885*. New York: Museum of Modern Art, 2005

Rodner, William S. *J.M.W. Turner: Romantic Painter of the Industrial Revolution*. Berkeley: Univ. of California Press, 1997.

Rosenblum, Robert, and H. W. Janson. *19th Century Art*. Rev. & updated ed. Upper Saddle River, NJ: Pearson Prentice Hall, 2005.

Rubin, James H. *Impressionism*. Art & Ideas. London: Phaidon, 1999.

Rybczynski, Witold. *A Clearing in the Distance: Frederick Law Olmsted and America in the Nineteenth Century*. New York: Scribner, 1999.

Smith, Paul. *Seurat and the Avant-Garde*. New Haven: Yale Univ. Press, 1997.

Thomson, Belinda. *Impressionism: Origins, Practice, Reception*. Thames & Hudson World of Art. New York: Thames & Hudson, 2000.

Twyman, Michael. *Breaking the Mould: The First Hundred Years of Lithography*. The Panizzi Lectures, 2000. London: British Library, 2001.

Vaughan, William, and Francoise Cachin. *Arts of the 19th Century*. 2 vols. New York: Abrams, 1998.

Werner, Marcia. *Pre-Raphaelite Painting and Nineteenth-Century Realism*. New York: Cambridge Univ. Press, 2005.

Zemel, Carol M. *Van Gogh's Progress: Utopia, Modernity, and Late-Nineteenth-Century Art*. California Studies in the History of Art, 36. Berkeley: Univ. of California Press, 1997.

Chapter 31
Modern Art In Europe And The Americas

Ades, Dawn, comp. *Art and Power: Europe under the Dictators, 1930-45*. Stuttgart, Germany: Oktagon in assoc. with Hayward Gallery, 1995.

Antliff, Mark, and Patricia Leighten. *Cubism and Culture*. World of Art. London: Thames & Hudson, 2001.

Bailey, David A. *Rhapsodies in Black: Art of the Harlem Renaissance*. London: Hayward Gallery, 1997.

Balken, Debra Bricker. *Debating American Modernism: Stieglitz, Duchamp, and the New York Avant-Garde*. New York: American Federation of Arts, 2003.

Barron, Stephanie, ed. *Degenerate Art: The Fate of the Avant-Garde in Nazi Germany*. Los Angeles: Los Angeles County Museum of Art, 1991.

Barron, Stephanie, and Wolf-Dieter Dube, eds. *German Expressionism: Art and Society*. New York: Rizzoli, 1997.

Bochner, Jay. *An American Lens: Scenes from Alfred Stieglitz's New York Secession*. Cambridge, MA: MIT Press, 2005.

Bohn, Willard. *The Rise of Surrealism: Cubism, Dada, and the Pursuit of the Marvelous*. Albany: State Univ. of New York Press, 2002.

Bowlt, John E., and Evgeniia Petrova, eds. *Painting Revolution: Kandinsky, Malevich and the Russian Avant-Garde*. Bethesda, MD: Foundation for International Arts and Education, 2000.

Bown, Matthew Cullerne. *Socialist Realist Painting*. New Haven: Yale Univ. Press, 1998.

Brown, Milton. *Story of the Armory Show: The 1913 Exhibition That Changed American Art*. 2nd ed. New York: Abbeville, 1988.

Chassey, Eric de, ed. *American art: 1908-1947, from Winslow Homer to Jackson Pollock*. Trans. Jane McDonald. Paris: Reunion des Musees Nationaux, 2001.

Corn, Wanda M. *The Great American Thing: Modern Art and National Identity, 1915–1935*. Berkeley: Univ. of California Press, 1999.

Curtis, Penelope. *Sculpture 1900–1945: After Rodin*. Oxford History of Art. Oxford: Oxford Univ. Press, 1999.

Elger, Dietmar. *Expressionism: A Revolution in German Art*. Ed. Ingo F. Walther. Trans. Hugh Beyer. New York: Taschen, 1998.

Fer, Briony. *On Abstract Art*. New Haven: Yale Univ., 1997.

Fletcher, Valerie J. *Crosscurrents of Modernism: Four Latin American Pioneers: Diego Rivera, Joaquín Torres-García, Wifredo Lam, Matta*. Washington, D.C.: Hirshhorn Museum and Sculpture Garden in assoc. with the Smithsonian Institution Press, 1992.

Folgarait, Leonard. *Mural Painting and Social Revolution in Mexico, 1920-1940: Art of the New Order*. New York: Cambridge Univ. Press, 1998.

Forgáács, Eva. *The Bauhaus Idea and Bauhaus Politics*. Trans. John Báátki. New York: Central European Univ. Press, 1995.

Frank, Patrick. *Los Artistas del Pueblo: Prints and Workers' Culture in Buenos Aires, 1917-1935*. Albuquerque: Univ. of New Mexico Press, 2006.

Grant, Kim. *Surrealism and the Visual Arts: Theory and Reception*. New York: Cambridge Univ. Press, 2005.

Green, Christopher. *Art in France: 1900–1940*. Pelican History of Art. New Haven: Yale Univ. Press, 2000. Reissue ed. 2003.

Haiko, Peter, ed. *Architecture of the Early XX Century*. Trans. Gordon Clough. New York: Rizzoli, 1989.

Harris, Jonathan. *Federal Art and National Culture: The Politics of Identity in New Deal America*. Cambridge Studies in American Visual Culture. New York: Cambridge Univ. Press, 1995.

Harrison, Charles, Francis Frascina, and Gill Perry. *Primitivism, Cubism, Abstraction: The Early Twentieth Century*. New Haven: Yale Univ. Press, 1993.

Haskell, Barbara. *The American Century: Art & Culture, 1900–1950*. New York: Whitney Museum of American Art, 1999.

Herbert, James D. *Fauve Painting: The Making of Cultural Politics*. New Haven: Yale Univ. Press, 1992.

Hill, Charles C. *The Group of Seven: Art for a Nation*. Toronto: National Gallery of Canada, 1995.

Karmel, Pepe. *Picasso and the Invention of Cubism*. New Haven: Yale Univ. Press, 2003.

Lista, Giovanni. *Futurism*. Trans. Susan Wise. Paris: Terrail, 2001.

McCarter, Robert, ed. *On and by Frank Lloyd Wright: A Primer of Architectural Principles*. New York: Phaidon Press, 2005.

Moudry, Roberta, ed. *The American Skyscraper: Cultural Histories*. New York: Cambridge Univ. Press, 2005.

Rickey, George. *Constructivism: Origins and Evolution*. Rev. ed. New York: G. Braziller, 1995.

Taylor, Brandon. *Collage: The Making of Modern Art*. London: Thames & Hudson, 2004.

Weston, Richard. *Modernism*. London: Phaidon, 1996.

White, Michael. *De Stijl and Dutch Modernism*. Critical Perspectives in Art History. New York: Manchester Univ. Press, 2003.

Whitfield, Sarah. *Fauvism*. World of Art. New York: Thames and Hudson, 1996.

Whitford, Frank. *Bauhaus*. World of Art. London: Thames and Hudson, 1984.

Zurier, Rebecca, Robert W. Snyder, and Virginia M. Mecklenburg. *Metropolitan Lives: The Ashcan Artists and Their New York*. Washington, D.C.: National Museum of American Art, 1995.

Chapter 32
The International Scene Since 1945

Alberro, Alexander, and Blake Stimson, eds. *Conceptual Art: A Critical Anthology*. Cambridge, MA: MIT Press, 1999.

Archer, Michael. *Art Since 1960*. 2nd ed. World of Art. New York: Thames and Hudson, 2002.

Atkins, Robert. *Artspeak: A Guide to Contemporary Ideas, Movements, and Buzzwords*. 2nd ed. New York: Abbeville, 1997.

Ault, Julie. *Art Matters: How the Culture Wars Changed America*. Ed. Brian Wallis, Marianne Weems, & Philip Yenawine. New York: New York Univ. Press, 1999.

Battcock, Gregory. *Minimal Art: A Critical Anthology*. Berkeley: Univ. of California Press, 1995.

Beardsley, John. *Earthworks and Beyond: Contemporary Art in the Landscape*. 3rd ed. New York: Abbeville, 1998.

Bird, Jon, and Michael Newman, eds. *Rewriting Conceptual Art*. Critical Views. London: Reaktion, 1999.

Bishop, Claire. *Installation Art: A Critical History*. New York: Routledge, 2005.

Blais, Joline, and Jon Ippolito. *At the Edge of Art*. London: Thames & Hudson, 2006.

Buchloh, Benjamin H. D. *Neo-Avantgarde and Culture Industry: Essays on European and American Art from 1955 to 1975*. Cambridge, MA: MIT Press, 2000.

Carlebach, Michael L. *American Photojournalism Comes of Age*. Washington, D.C.: Smithsonian Institution Press, 1997.

Causey, Andrew. *Sculpture since 1945*. Oxford History of Art. Oxford: Oxford Univ. Press, 1998.

Corris, Michael, ed. *Conceptual Art: Theory, Myth, and Practice*. New York: Cambridge Univ. Press, 2004.

Craven, David. *Abstract Expressionism as Cultural Critique: Dissent during the McCarthy Period*. Cambridge Studies in American Visual Culture. New York: Cambridge Univ. Press, 1999.

Day, Holliday T. *Crossroads of American Sculpture: David Smith, George Rickey, John Chamberlain, Robert Indiana, William T. Wiley, Bruce Nauman*. Indianapolis, IN: Indianapolis Museum of Art, 2000.

De Oliveira, Nicolas, Nicola Oxley, and Michael Petry. *Installation Art in the New Millennium: The Empire of the Senses*. New York: Thames & Hudson, 2003.

De Salvo, Donna M., ed. *Open Systems: Rethinking Art c.1970*. London: Tate, 2005.

Fabozzi, Paul F. *Artists, Critics, Context: Readings In and Around American Art Since 1945*. Upper Saddle River, NJ: Prentice Hall, 2002.

Fineberg, Jonathan David. *Art Since 1940: Strategies of Being*. 2nd ed. New York: Abrams, 2000.

Flood, Richard, and Frances Morris. *Zero to Infinity: Arte Povera, 1962-1972*. Minneapolis, MN: Walker Art Center, 2001.

Follin, Frances. *Embodied Visions: Bridget Riley, Op Art and the Sixties*. London: Thames & Hudson, 2004.

Ghirardo, Diane. *Architecture after Modernism*. World of Art. New York: Thames and Hudson, 1996.

Goldberg, Roselee. *Performance Art: From Futurism to the Present*. Rev. ed. World of Art. London: Thames and Hudson, 2001.

Goldstein, Ann. *A Minimal Future?: Art as Object 1958-1968*. Los Angeles: Museum of Contemporary Art, 2004.

Grande, John K. *Art Nature Dialogues: Interviews with Environmental Artists*. Albany: State Univ. of New York Press, 2004.

Grosenick, Uta, and Burkhard Riemschneider, eds. *Art at the Turn of the Millennium*. New York: Taschen, 1999.

Grunenberg, Christoph, ed. *Summer of Love: Art of the Psychedelic Era*. London: Tate, 2005.

Herskovic, Marika, ed. *American Abstract Expressionism of the 1950s: An Illustrated Survey: With Artists' Statements, Artwork and Biographies*. New York: New York School Press, 2003.

Hitchcock, Henry Russell, and Philip Johnson. *The International Style*. New York: W. W. Norton, 1995.

Hopkins, David. *After Modern Art: 1945–2000*. Oxford History of Art. Oxford: Oxford Univ. Press, 2000.

Jencks, Charles. *The New Paradigm in Architecture: The Language of Post-Modernism*. New Haven: Yale Univ. Press, 2002.

Jodidio, Philip. *New Forms: Architecture in the 1990s*. New York: Taschen, 2001.

Johnson, Deborah, and Wendy Oliver, eds. *Women Making Art: Women in the Visual, Literary, and Performing Arts Since 1960*. Eruptions, vol. 7. New York: Peter Lang, 2001.

Jones, Caroline A. *Machine in the Studio: Constructing the Postwar American Artist*. Chicago: Univ. of Chicago Press, 1996.

Joselit, David. *American Art Since 1945*. World of Art. London: Thames and Hudson, 2003.

Katzenstein, Ineés, ed. *Listen, Here, Now!: Argentine art of the 1960s: Writings of the Avant-Garde*. New York: Museum of Modern Art, 2004.

Legault, Rééjean, and Sarah Williams Goldhagen, eds. *Anxious Modernisms: Experimentation in Postwar Architectural Culture*. Montrééal: Canadian Centre for Architecture, 2000.

Lucie-Smith, Edward. *Movements in Art since 1945*. World of Art. London: Thames and Hudson, 2001.

Madoff, Steven Henry, ed. *Pop Art: A Critical History*. The Documents of Twentieth Century Art. Berkeley: Univ. of California Press, 1997.

Moos, David, ed. *The Shape of Colour: Excursions in Colour Field Art, 1950-2005*. Toronto: Art Gallery of Ontario, 2005.

Paul, Christiane. *Digital Art*. World of Art. London: Thames and Hudson, 2003.

Phillips, Lisa. *The American Century: Art and Culture, 1950–2000*. New York: Whitney Museum of American Art, 1999.

Ratcliff, Carter. *The Fate of a Gesture: Jackson Pollock and Postwar American Art*. New York: Farrar, Straus, Giroux, 1996.

Reckitt, Helena, ed. *Art and Feminism*. Themes and Movements. London: Phaidon, 2001.

Risatti, Howard, ed. *Postmodern Perspectives: Issues in Contemporary Art*. 2nd ed. Upper Saddle River, NJ: Prentice Hall, 1998.

Robertson, Jean, and Craig McDaniel. *Themes of Contemporary Art: Visual Art after 1980*. New York: Oxford Univ. Press, 2005.

Robinson, Hilary, ed. *Feminism-Art-Theory: An Anthology, 1968-2000*. Malden, MA: Blackwell Publishers, 2001.

Rorimer, Anne. *New Art in the 60s and 70s: Redefining Reality*. New York: Thames & Hudson, 2001.

Rush, Michael. *New Media in Late 20th-Century Art*. World of Art. London: Thames and Hudson, 1999.

———. *Video Art*. New York: Thames & Hudson, 2003.

Sandler, Irving. *Art of the Postmodern Era: From the Late 1960s to the Early 1990s*. New York: Icon Editions, 1996.

Shohat, Ella. *Talking Visions: Multicultural Feminism in a Transnational Age*. Documentary Sources in Contemporary Art, 5. New York: New Museum of Contemporary Art, 1998.

Sylvester, David. *About Modern Art*. 2nd ed. New Haven: Yale Univ. Press, 2001.

Waldman, Diane. *Collage, Assemblage, and the Found Object*. New York: Abrams, 1992.

Weintraub, Linda, Arthur Danto, and Thomas McEvilley. *Art on the Edge and Over: Searching for Art's Meaning in Contemporary Society, 1970s–1990s*. Litchfield, CT: Art Insights, 1996.

CREDITS

Chapter 29

29-1 Photograph © 2007 Museum of Fine Arts, Boston; 29-2 Wim Swaan / The Getty Research; 29-3 Martin von Wagner Museum der Universitat Wurzburg / Antikensammlung; 29-4, 29-5, 29-18 © Achim Bednorz, Koln; 29-7 Picture Press Bild - und Textagentur GmbH, Munich, Germany; 29-8 Gerard Blott / Reunion des Musees Nationaux / Art Resource, NY; 29-9 Erich Lessing / Art Resource, NY; 29-10 National Museum of Stockholm; 29-11 Frick Art Reference Library; 29-12 Photograph © 1990 The Metropolitan Museum of Art; 29-13 John Hammond / National Trust Photographic Library, England; 29-14 The Royal Collection © 2008, Her Majesty Queen Elizabeth II; 29-15 Fine Arts Museums of San Francisco; 29-16 IKONA; 29-17 C. Jean / Art Resource, NY; 29-20 Palazzo Barberini, Galleria Nazionale d' Arte Antica / Canali Photobank; 29-21 English Heritage / National Monuments Record / (c) Crown copyright; 29-22 A.F. Kersting; 29-23 Richard Bryant / Arcaid; 29-24, 29-25 Courtesy Wedgwood Museum Trust Limited, Barlaston, Staffordshire; 29-26, 29-29 © National Gallery, London; 29-27 Photograph © 2007, The Art Institute of Chicago. All Rights Reserved; 29-28 Photograph © Board of Trustees, National Gallery of Art, Washington, D.C.

29-30 Katherine Wetzel / Virginia Museum of Fine Arts, Richmond; 29-31, 29-36 National Gallery of Canada, Ottawa; 29-32 The Detroit Institute of Arts; 29-33 Tate; 29-34 French Government Tourist Office; 29-37 Portland Art Museum; 29-38 Caisse Nationale des Monuments Historique et des Sites, Paris; 29-39 Photograph © 1980 The Metropolitan Museum of Art; 29-40 © Reunion des Musees Nationaux, Paris, France / Art Resource, NY; 29-41 Cussac / Musees Royaux des Beaux-Arts de Belgique; 29-42 Musee National du Chateau de Versailles / Art Resource / Reunion des Musees Nationaux; 29-43 The Library of Virginia; 29-45 Denver Art Museum; 29-47 © David R. Frazier Photolibrary, Inc. / Alamy Images; 29-48 Photograph © 2006 Board of Trustees, National Gallery of Art, Washington, D.C.; BOX: National Museum of Women in the Arts, Washington, DC; BOX: Courtesy of Philip Pocock; BOX: The Royal Collection © 2006, Her Majesty Queen Elizabeth II; BOX: British Embassy.

Chapter 30

30-1 Lauros-Giraudon / Art Resource, NY; 30-2, 30-3, 30-4, 30-8 RMN Reunion des Musees Nationaux / Art Resource, NY; 30-5 The Cleveland Museum of Art; 30-6 Yale University Art Gallery; 30-7 Getty Images – Stockbyte; 30-9 © Bernard Boutrit / Woodfin Camp and Associates, Inc; 30-10 Gregory; 30-11 Courtesy of the Hispanic Society of America; 30-12 © Museo Nacional Del Prado / Erich Lessing / Art Resource, NY; 30-13 Oronoz / © Museo Nacional Del Prado; 30-14 Osterreichische Galerie im Belvedere, Vienna; 30-15 Tate Gallery / Art Resource, NY; 30-16 Photo by Graydon Wood, 1988; 30-17 Frick Art Reference Library; 30-18, 30-32, 30-35, 30-52 Erich Lessing / Art Resource, NY; 30-19 Photograph © 1995 The Metropolitan Museum of Art; 30-20 © The Royal Academy of Arts; 30-21 Photograph © 1997 The Metropolitan Museum of Art, NY; 30-22, 30-24 The New York Public Library / Art Resource, NY; 30-26 © Leo Sorel; 30-27 Societe Francaise de Photographie; 30-28, 30-82 George Eastman House; 30-29 Science & Society Picture Library; 30-30 Caisse Nationale des Monuments Historique et des Sites, Paris; 30-31 V & A Images / Victoria and Albert Museum; 30-33 Roger-Viollet Agence Photographique, 30-34 Giraudon / Art Resource, NY; 30-36 © 2006 Dahesh Museum of Art, NY. All Rights Reserved; 30-37 Bridgeman Art Library; 30-38, 30-39, 30-49, 30-55, 30-73, BOXES: RMN Reunion des Musees Nationaux / Art Resource, NY; 30-40 The Carnegie Museum of Art, Pittsburgh; 30-41 Gerard Blot / Art Resource / Musee d'Orsay; 30-42 © 1922 The Metropolitan Museum of Art, NY; 30-43 © State Russian Museum / CORBIS. All Rights Reserved; 30-44 Thomas Jefferson University; 30-44 The Bridgeman Art Library; 30-45 Philadelphia Museum of Art; 30-46 Manchester City Art Galleries; 30-47 William Morris Gallery; 30-48 Photograph © 1988 The Detroit Institute of Arts; 30-50 RMN Reunion des Musees

Nationaux/Art Resource, NY / © 2007 Edouard Manet/ARS,NY; 30-51 Photography © The Art Institute of Chicago; 30-53 Photograph © 2007 The Metropolitan Museum of Art; 30-53 Photograph © 1996 The Metropolitan Museum of Art; 30-54 The Nelson-Atkins Museum of Art; 30-56 © 1980 The Metropolitan Museum of Art; 30-57 Photography © The Art Institute of Chicago; 30-58 Philadelphia Museum of Art; 30-59 Dean Beasom / Photograph © Board of Trustees, National Gallery of Art, Washington, D.C.; 30-60 © National Gallery, London; 30-61 John Webb / Courtauld Institute of Art; 30-62 The Samuel Courtauld Trust / Courtauld Institute of Art Gallery; 30-63 Photograph © 2007, The Art Institute of Chicago. All Rights Reserved; 30-64 Philadelphia Museum of Art; 30-65 Photograph © 2006, The Art Institute of Chicago. All Rights Reserved. 30-66 Photograph © 2000 The Museum of Modern Art, New York / Art Resource, NY; 30-67 Photograph © 2007, The Art Institute of Chicago. All Rights Reserved; 30-68 J. G. Berizzi / Art Resource / RMN Reunion des Musees Nationaux, France; 30-69 The Museum of Modern Art / Licensed by Scala Art Resource, NY; 30-70 Koninklijk Museum voor Schone Kunsten, Antwerp © 2007 ARS, NY / SABAM, Brussels; 30-71 J. Lathion / © Nasjonal galleriet / © 2007 ARS,NY / ADAGP, Paris; 30-72 Art Resource, NY / Smithsonian American Art Museum; 30-74 Hirshhorn / Smithsonian; 30-75 Bayerische Staatsgemaldesammlungen, Neue Pinakothek, Munich; 30-76 Ch. Bastin & J. Evrard / © ARS,NY / SOFAM, Brussels; 30-77 Fine Arts Museums of San Francisco; 30-78 Corbis/Bettmann; 30-79 Bildarchiv der Osterreichische Nationalbibliothek; 30-80 Digital image © The Museum of Modern Art / Licensed by SCALA Art Resource, NY; 30-81 San Diego Museum of Art; 30-83 Museum of the City of NY; 30-84 © Corbis. All Rights Reserved; 30-85 Library of Congress. 30-86 © Art on file / Louis H. Sullivan / Corbis-NY; BOX: Musee Fabre; BOX: City of NY, Department of Parks; BOX: Tate Gallery / Art Resource, New York; BOX: The Brooklyn Museum of Art / Central Photo Archive; BOX: Van Gogh Museum Enterprises.

Chapter 31

31-1 New York Public Library / Art Resource, NY; 31-2 Photograph © Board of Trustees, National Gallery of Art, Washington, D.C.; 31-3 San Francisco Museum of Modern Art / © Succession H. Matisse, Paris /ARS,NY / Photo: Ben Blackwell; 31-4 © 1995 the Barnes Foundation / 2008 Succession H. Matisse, Paris / ARS,NY; 31-5 Staatliche Museen zu Berlin, Preussischer Kulturbesitz, Nationalgalerie / Art Resource, NY; 31-6 Photograph by Jamison Miller; 31-8 Digital Image © The Museum of Modern Art / Licensed by SCALA Art Resource, NY; 31-9 © 2007 ARS, NY / Art Resource / Bildarchiv Preussischer Kulturbesiz; 31-10 Martin Buhler / Kunstmuseum; 31-11 Photograph © 2007 The Metropolitan Museum of Art, NY; 31-12 Walker Art Center, Minneapolis; 31-13 The Solomon R. Guggenheim Museum, NY / © 2008 ARS, NY; 31-14 The Solomon R. Guggenheim Museum, NY / © 2008 ARS, NY; 31-15 Photograph © The Metropolitan Museum of Art / © ARS, NY / VG Bild-Kunst, Bonn; 31-16 RMN Reunion des Musees Nationaux / Art Resource, NY / © 2008 Estate of Pablo Picasso / © ARS, NY; 31-17 Photograph © Board of Trustees, National Gallery of Art, Washington, D.C.; 31-18 Museum of Modern Art / Licensed by SCALA Art Resource, NY / © 2007 Estate of Pablo Picasso / © ARS, NY; 31-19 Peter Lauri / Kunstmuseum Bern; 31-20 The Solomon R. Guggenheim Museum / George Braque © 2002 ARS, NY / ADAGP, Paris; 31-21 Art Resource, NY / © 2007 Estate of Pablo Picasso / ARS, NY; 31-22 © 2007 Estate of Pablo Picasso / ARS, NY; 31-23 RMN Reunion des Musees Nationaux / Art Resource, NY / © 2008 Estate of Pablo Picasso / ARS, NY; 31-24, 31-25 Emanuel Hoffman Foundation. Kunstsammlung Basel, Switzerland / © L & M Services, B.V. Amsterdam, 20031010; 31-26 Museum of Modern Art / Licensed by SCALA Art Resource, NY; 31-27 Digital Image © The Museum of Modern Art / Licensed by Scala / Art Resource, NY; 31-28 Art Resource, NY; 31-29 Stedelijk Museum Amsterdam; 31-30 © Estate of Vladimir Tatlin / RAO Moscow / Licensed by VAGA, NY; 31-30 Annely Juda

Fine Art; 31-31 Photograph ©2006 Museum Associates / LACMA; 31-35 © Philadelphia Museum of Art: The Louise and Walter Arensberg Collection, 1950. 1998-74-1 / © 2007 ARS, NY / ADAGP, Paris / Succession Marcel Duchamp; 31-36 Lynn Rosenthal, 1998 / Philadelphia Museum of Art / © 2006 ARS, NY; 31-37 Solomon R. Guggenheim Museum, NY / © 2008 ARS, NY; 31-39 Photo by James Via; 31-40 Photograph © 2000 The Metropolitan Museum of Art, NY; 31-41 Photography © The Art Institute of Chicago; 31-42 The Minneapolis Institute of Arts / © 2008 The Georgia O'Keeffe Foundation / ARS, NY; 31-43 Guilherme Augusto do Amaral / Malba-Coleccion Costanini, Buenos Aires; 31-44 The Museum of Fine Arts, Houston; 31-45 Art Museum of the Americas; 31-46 Bob Schalkwijk / © 2001 Banco de Mexico Diego Rivera & Frida Kahlo Museums Trust. Av. Cinco de Mayo No. 2, Col. Centro, Del. Cuauhtemoc 06059, Mexico, D.F. Reproduction authorized by the Instituto Nacional de Bellas Artes y Literatura / Art Resource, NY; 31-47 National Gallery of Canada; 31-48 Trevor Mills / Vancouver Art Gallery; 31-49 Gerald Zugmann Fotographie KEG; 31-50 Vanni / Art Resource, NY; 31-51 Anthony Scibilia / Art Resource, NY / © 2001 ARS, NY / ADAGP, Paris / FLC; 31-52 Heidrich Blessing / Chicago Historical Society; 31-53 David R. Phillips / Chicago Architecture Foundation; 31-54 Fallingwater; 31-55 Sante Fe Railroad; 31-56 Cass Gilbert / The New-York Historical Society; 31-57 © Estate of Aleksandr Rodchenko / RAO Moscow Licensed by VAGA, NY; 31-58 Van Abbemuseum; 31-59 Estate of Vera Mukhina; 31-60 Hickey-Robertson / The Menil Collection, Houston. © 2008 Mondrian / Holtzman Trust c/o HCR International, Warrenton, VA; 31-61 Florian Monheim / Artur Architekturbilder Agentur GmbH; 31-62 Jannes Linders Photography; 31-63 Fred Kraus / Bauhausarchiv-Museum fur Gestaltung; 31-64 Michael Nedzweski / The Busch-Reisinger Museum / © President and Fellows of Harvard College, Massachusetts; 31-65 The Museum of Modern Art/Licensed by SCALA Art Resource, NY; 31-66 © Banco de Mexico Trust / Reproduction authorized by the Instituto Nacional de Bellas Artes y Literatura. Palacio de Bellas Artes, Mexico City; 31-67 Schomburg Center for Research in Black Culture, New York Public Library / Art Resource, NY; 31-68 Howard University Libraries; 31-69 © 2007 ARS, NY; 31-70 Tate Gallery, London / Art Resource, NY; 31-71 The Henry Moore Foundation / Tate Picture Gallery; 31-72 The Museum of Modern Art / Licensed by SCALA Art Resource, NY / © 2007 ARS, NY; 31-73 Stedelijk Museum, Amsterdam; 31-74 The Solomon R. Guggenheim Foundation, NY / © 2008 ARS, NY; 31-75 The Museum of Modern Art / Licensed by SCALA Art Resource, NY / © 2006 ARS,NY; 31-76 Image © 2006 Board of Trustees, National Gallery of Art, Washington; BOX: Photograph © 1986 The Metropolitan Museum of Art; BOX: Akademie der Kunste/Archiv Bildende Kunst; BOX: Courtesy of the Library of Congress.

Chapter 32

32-1 Claudio Abate / Index Ricerca Iconografica; 32-4, 32-24 Museum of Modern Art / Licensed by SCALA Art Resource, NY; 32-5 Digital Image © The Museum of Modern Art / Licensed by SCALA Art Resource, NY; 32-6 Solomon R. Guggenheim Museum, NY; 32-7 Solomon R. Guggenheim Museum, NY / © 2008 ARS, NY; 32-8 Art Resource, NY; 32-9 © ARS, NY; 32-10 Hans Namuth Ltd; 32-11 Photograph © 1998 The Metropolitan Museum of Art, NY / © 2007 The Pollock-Krasner Foundation / ARS, NY; 32-12 Geoffrey Clements / © 1997 Whitney Museum of American Art, NY / © 2007 ARS, NY; 32-13 © The Phillips Collection, Washington, DC; 32-14 National Gallery of Canada; 32-15 Photograph © Board of Trustees, National Gallery of Art, Washington, DC; 32-16 Valerie Walker / Museum of Contemporary Art, Chicago / © ARS, NY; 32-17 The Museum of Modern Art / Licensed by SCALA Art Resource, NY / © 2007 ARS, NY; 32-18 Whitney Museum of American Art, NY / © Estate of David Smith / Licensed by VAGA, NY; 32-20 Albright-Knox Art Gallery / © 2008 ARS, NY; 32-21 Galerie von Bartha; 32-22 Gyula Kosice; 32-23 Photograph © 2004, The Art Institute of Chicago. All Rights

Reserved; 32-25 © The Minor White Archive, Princeton, NJ / Museum of Modern Art / Licensed by SCALA Art Resource, NY; 32-26 Sonnabend Gallery / Art © Robert Rauschenberg / Licensed by VAGA, NY; 32-27 Digital Image © The Museum of Modern Art / Licensed by SCALA Art Resource, NY / © Jasper Johns / Licensed by VAGA, NY; 32-28 Marilyn Stokstad / Courtesy of Shozo Shimamoto; 32-29 Marilyn Stokstad / Lawrence Shustack; 32-30 Harry Shunk; 32-31 Digital Image © Museum of Modern Art / Licensed by SCALA Art Resource, NY / © 2003 ARS, NY / ADAGP, Paris; 32-32 Kunsthalle Tubingen, Sammlung G.F. Zundel / © 2007 ARS, NY / DACS, London; 32-33 © 2003 Andy Warhol Foundation for the Visual Arts / ARS, New York / (TM)2002 Marilyn Monroe LLC under license authorized by CMG Worldwide Inc., Indianapolis, Indiana 46256 USA www.MarilynMonroe.com; 32-34 photo © National Gallery of Canada, Ottawa / © 2008 Andy Warhol Foundation for the Visual Arts / ARS, NY / SODRAC Montreal; 32-35 © Estate of Roy Lichtenstein; 32-36 Yale University Art Gallery; 32-37 Art Museum of the Americas; Art © Estate of Jesus Rafael Soto / Licensed by VAGA, NY; 32-38 Philip Johnson Fund / Museum of Modern Art / Licensed by SCALA Art Resource, NY; 32-39 National Gallery of Canada ; 32-40 The Menil Collection, Houston / © ARS, NY; 32-42 Geoffrey Clements / Collection of the Whitney Museum of American Art, NY; 32-43 Photo by Peter Schaelchli, Zurich; 32-44 Gongella / Ikona; 32-45 Walker Art Center, T.B. Walker Acquisition Fund, 2001; 32-46 Museum of Modern Art /Licensed by SCALA Art Resource, NY / © 2006 ARS, NY; 32-47 Eric Pollitzer / Leo Castelli Gallery, NY / © 2007 ARS, NY; 32-48 © Ute Klophaus / VG Bild-Kunst, Bonn / © ARS, NY; 32-49 Venuri, Scott Brown & Associates, Inc; 32-50 Gianfranco Gorgoni / VAGA; 32-51 Wolfgang Volz; 32-52 Benjamin Blackwell / University of CA / Berkeley Art Museum; 32-53 Robert Hickerson; 32-54 Solomon R. Guggenheim Museum, NY / Photo © Faith Ringgold; 32-55 Galerie Lelong; 32-56 Andrew Garn; 32-57 Ezra Stoller / Esto Photographics, Inc; 32-58 Courtesy Moshe Safdie and Associates; 32-59 Matt Wargo / VSBA; 32-61 Richard Payne, FAIA; 32-62 Cindy Sherman / Metro Pictures; 32-63 Mary Boone Gallery; 32-64 Jeff Wall / Marian Goodman Gallery; 32-65 V & A Images / © Vic Muniz and the Estate of Hans Namuth / VAGA, NY / DACS, London 2006; 32-66 Matthew Marks Gallery, NY / Monika Spruth Galerie, Cologne / © 2001 Andreas Gursky; 32-67 Van Abbemuseum / © 2007 The Estate of Anseim Kiefer / ARS, NY; 32-68 Photograph © 2007, The Art Institute of Chicago. All Rights Reserved; 32-69 © 2007 ARS, NY / ADAGP, Paris; 32-70 Tujunga Wash Flood Control Channel SPARC / Social and Public Art Resource Center; 32-71 Smith College Museum of Art; 32-72 Photography © The Art Institute of Chicago; 32-73 KaiKai Kiki Co., Ltd; 32-74 Robert Newcombe / Nelson-Atkins Museum of Art; 32-75 Tate Gallery, London / Art Resource, NY; 32-77 Susan Einstein / © 2000, The Art Institute of Chicago; 32-78 Skoto Gallery; 32-79 Ian Lambot / Foster and Partners; 32-80 Richard Bryant / Esto Photographics, Inc; 32-81 © AAD Worldwide Travel Images / Alamy; 32-82 Jack Tilton Gallery, NY; 32-83 Mel Chin; 32-84 William H. Struhs; 32-85 © Peter Mauss / Esto; 32-86 Holly Solomon Gallery; 32-87 © 2000 Shirin Neshat. Photo: Larry Barns / Barbara Gladstone Gallery; 32-88 San Francisco Museum of Modern Art; BOX: Photograph © Donald Woodman / © 2005 Judy Chicago / ARS, NY.

INDEX

Italic page numbers refer to illustrations and maps.

A

Notes

Notes

Notes

Notes